MEDIEVAL AND RENAISSANCE ART

PEOPLE AND POSSESSIONS

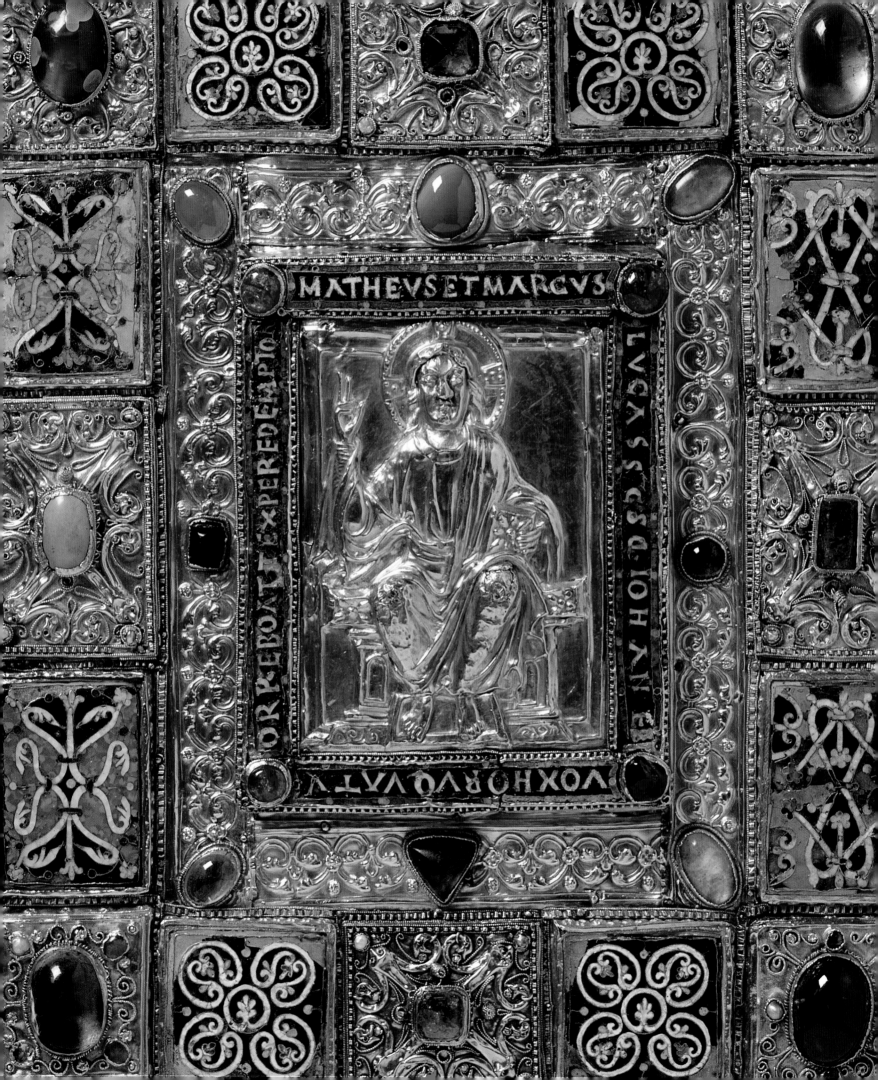

GLYN DAVIES

KIRSTIN KENNEDY

MEDIEVAL AND RENAISSANCE ART

PEOPLE AND POSSESSIONS

V&A PUBLISHING

First published by V&A Publishing, 2009

V&A Publishing
Victoria and Albert Museum
South Kensington, London SW7 2RL

Distributed in North America by
Harry N. Abrams, Inc., New York

ISBN 978 1 85177 579 8
Library of Congress Control Number 2009923083

10 9 8 7 6 5 4 3 2 1
2013 2012 2011 2010 2009

A catalogue record for this book is available from
the British Library.

Designer: Nigel Soper
Copy-editor: Alison Effeny

New V&A photography by Christine Smith, Paul Robins, Pip
Barnard and Richard Davis from the V&A Photographic Studio

Contributors' initials for objects featured in chapter 1:
GD Glyn Davies
KK Kirstin Kennedy
SS Stephanie Seavers

Jacket illustrations: Apollonio di Giovanni, panel from a
marriage chest showing the Continence of Scipio (details
of pl.201)

Page 4: Front cover of a manuscript of the Gospels (The Sion
Gospels) (detail of pl.128)

Page 6: *Giving Drink to the Thirsty* (detail of pl.168)

Printed in Singapore by C.S. Graphics

V&A Publishing
Victoria and Albert Museum
South Kensington
London SW7 2RL
www.vam.ac.uk

To P.M. and M.B.
with grateful thanks for giving us
the opportunity and support

CONTENTS

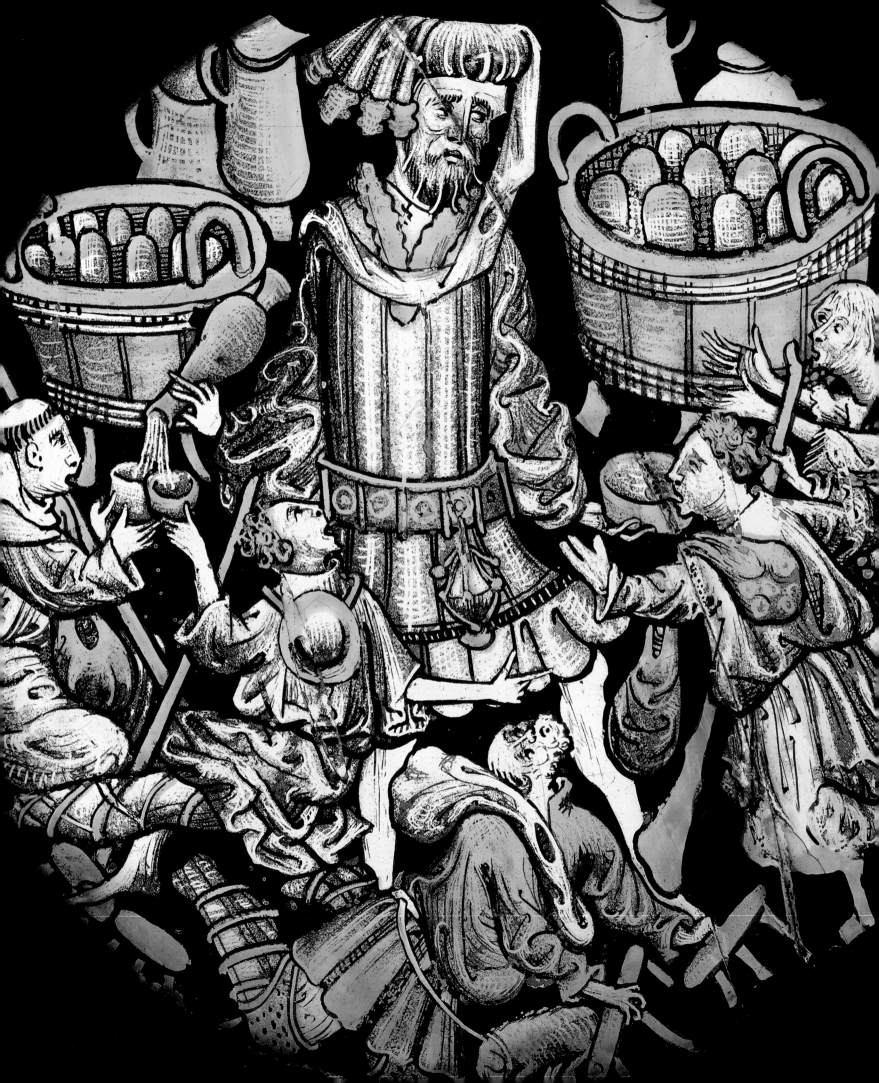

DIRECTOR'S FOREWORD

THIS BOOK HAS BEEN produced not only to complement the new galleries but also to provide a stimulating introduction to the material culture of medieval and renaissance Europe. Using the Museum's great collections as the foundation upon which they have built their intellectual arguments, Glyn Davies and Kirstin Kennedy encourage the reader to view these works of art within a broad social and cultural framework. The book may either be used as an *aide-mémoire* for visitors to the galleries or may stand alone as a new and original contribution to the literature on the art of the Middle Ages and Renaissance for those who have yet to enjoy the Museum. Together with the online entries on our website, where every object in the galleries is illustrated and discussed, we hope that it will provide the strongest impetus for a journey to visit the great treasures at South Kensington.

MARK JONES

DIRECTOR, VICTORIA AND ALBERT MUSEUM

ACKNOWLEDGEMENTS

WITHIN THE MUSEUM, the authors would like to thank first of all the team who have brought the Medieval and Renaissance Galleries to completion. Alexis Ashot, Sarah Bercusson, Anne-Marie Eze, Kitty Jacobs, Matthew Lawrence, Francesca Manucci, Ana Caterina Matias, Romola and Francesca Nuttall, Polly Puttenham, Charlotte Soehngen and Beatrice Spengos all lent their skills for a time at various stages of the Project. We are also profoundly grateful to the longer-serving members of the team, both for their advice and assistance in putting the book together, and for their understanding in allowing us time to write: Caroline Bulloch, Simon Carter, Stuart Frost, Moira Gemmill, Katherine Hunt, Sonja Marzinzik, Leela Meinertas, Gwyn Miles, Rosie Mills, Colin Mulberg, Kate Rhodes, Wanda Sheridan, Elin Simonsson, Matthew Storey, Katy Temple, Megan Thomas and Eleanor Townsend.

The V&A forms a close-knit research community, and particular debts are owed to many curators and conservators for their insights and comments during the preparation of the text: Marta Ajmar-Wollheim, Nigel Bamforth, Terry Bloxham, Christopher Breward, Clare Browne, Mary Butler, Albertina Cogram, Alexandra Corney, Nicola Costaras, Judith Crouch, Elizabeth Currie, Mark Eastment, Ann Eatwell, Richard Edgcumbe, Mark Evans, Jim Goddard, Sarah Grant, Alun Graves, Melissa Hamnett, Frances Hartog, Carmen Holdsworth-Delgado, Charlotte Hubbard, Nick Humphrey, Merryl Huxtable, Anna Jackson, Amin Jaffer, Fiona Jordan, Eowyn Kerr, Marion Kite, Robert Lambeth, Sophie Lee, Reino Liefkes, Sofia Marques, Ann Matchette, Sarah Medlam, Lesley Miller, Tim Miller, Juanita Navarro, Victoria Oakley, Angus Patterson, Helen Persson, Hanneke Ramakers, Frances Rankine, Mariam Rosser-Owen, Jane Rutherstone, Elisa Sani, Carolyn Sargentson, Stephanie Seavers, Christine Smith, Tim Stanley, Donna Stevens, Mor Thunder, Rowan Watson, Joanna Whalley, Sophy Wills, Tom Windross, Linda Woolley and James Yorke.

The members of the academic Advisory Committee, past and present, commented on the early plans for the book, and took part in debate about the structure of the Galleries themselves: Malcolm Baker, Stephen Bann, Sara Holdsworth, Mark Irving, Lisa Jardine, Joseph Koerner, Scott McKendrick, Lawrence Nees, Beatrice Paolozzi-Strozzi, Philippe Senéchal, Luke Syson, Evelyn Welch, Hiltrud Westermann-Angerhausen and Christopher Wright. In this context, we are particularly grateful for their contributions to the manuscript.

Outside the Museum, a number of friends and colleagues cheerfully provided information and generously shared their ideas with us: Patricia Allerston, Peter Barber, Doris Behrens-Abouseif, Paul Binski, Martin Brett, Andrew Brown, Caroline Campbell, Tom Campbell, Beatriz Chadour-Sampson, Laura Cleaver, Donal Cooper, Penelope Curtis, Martina Droth, Hazel Forsyth, Amelia Gallego de Miguel†, Jim Harris, John Henderson, Martin Henig, Jacques Le Goff, Deirdre Jackson, Marika Leino, Amanda Lillie, John Lowden, Mark McDonald, Elizabeth McGrath, Sarah Blake McHam, Hayden Maginnis, Giles Mandelbrote, C. Griffith Mann, Jean-Michel Massing, Michael Michael, Lisa Monnas, Jacqueline Musacchio, Susie Nash, William Noel, Michelle O'Malley, John T. Paoletti, Debra Pincus, Andreas Puth, James Robinson, Patricia Rubin, David Rundle, Dora Thornton, Rose Walker and Kim Woods.

Special thanks are due to the following people for their friendship, support and incisive comments: Virginia Brilliant, Meghan Callahan, Marian Campbell, Joanna Cannon, Surekha Davies, Flora Dennis, Peter Dent, Alison Effeny, David Hook, Mark Jones, Norbert Jopek, Kate Lowe, Bet McLeod, Liz Miller, Peta Motture, Rachel Sloan, Nigel Tattersfield, Barry Taylor, Michele Tomasi, Marjorie Trusted, Jeremy Warren, Paul Williamson and Tim Wilson.

Finally, we are grateful to both to Nigel Soper, our designer, and all of the writers of the specialist texts – their knowledge and expertise have greatly enhanced the final book.

PREFACE

T HE GENESIS OF THIS BOOK stems from the redisplay of the V&A's stellar medieval and renaissance collections, which date from 300 CE to 1600. Housed in a series of ten galleries, each with its own narrative, the displays are organized chronologically to tell the story of European art and design within the wider cultural perspective. Adopting a thematic approach, the galleries explore the styles, uses and contexts of a spectacularly diverse range of objects – including ceramics and glass; prints, drawings and paintings; sculpture and metalwork; furniture, textiles and tapestries. Some were made by craftsmen and women whose identities remain unknown: others were created by the most talented artisans or artists of their time, including such great masters as Donatello, Albrecht Dürer, Leonardo and Michelangelo. These makers form another focus, as do the people and institutions for which the objects were created and the methods by which they were exchanged. As with any extended period, this one is characterized by traditions existing alongside developments and innovations that were, at times, dramatic. Earlier ideas and practices were adopted and adapted, while new technologies sometimes transformed the nature of production. This theme of continuity and change is also one that underpins the ideas in this book.

As Research Assistants and Curators on the gallery project team, Glyn Davies and Kirstin Kennedy played a central role in developing a new approach to the interpretation and display of the galleries and in bringing them to fruition. This provided them with unparalleled access to the objects, which underwent an extensive research and conservation programme. Using the extraordinary richness of the V&A's collections as a lens through which to view the material culture of the past, they have explored contemporary attitudes towards artistic practice, bringing to bear the social contexts and beliefs of the time, and thereby unravelling at least some of the meanings that were attached to these artefacts by their original owners and viewers.

The Museum's mission when it was founded as the Museum of Manufactures in 1852 was to provide exemplars to inspire the designers and makers of the day. The nature of the collections is due, therefore, not only to the vicissitudes of survival, particularly of objects from the early period, but also to the interests of the nineteenth-century founders and curators. This combination has resulted in stronger holdings in works produced after 1200, as far more have survived, as well as those from Western rather than Central Europe, as the interests of those building the collection lay there. There is a particular concentration on the arts of Italy, which was seen by early curators as being the cradle of good artistic practice; indeed, the Byzantine art of Constantinople, for example, was collected largely because of its perceived influence on Italian art. These chronological and geographical biases are reflected in the choice of objects for display, and therefore in the discourses in this book, which takes those displays as its starting point.

Almost without exception, the artefacts discussed here were owned or commissioned by the wealthy, the ennobled and the powerful, who could afford such highly worked artistic objects. This is, then, primarily a story about the elite and those who serviced their needs, both worldly and spiritual. It nonetheless touches on how cheaper, and often novel, alternatives were developed to cater for a broader market, most particularly the growing merchant classes of the fourteenth to sixteenth centuries. Those more modest and ephemeral objects that have miraculously survived offer a further glimpse of what has been lost. The loss of material goods of all kinds, which was at times the result of wanton destruction through iconoclasm or war, inevitably and immeasurably skews our perspective on history. Nevertheless, these collections are telling fragments of past life. Analysis of these objects, often drawing on new conservation and scientific research, combined with documentary evidence, can reveal the worth and significance accorded to material culture across the period.

The existing literature that tackles the complex story of European art and design in these centuries is both vast and varied, spanning general surveys to detailed investigative studies of particular artists, places or communities, some of which are aimed at the specialist. Many focus on either the 'medieval' or 'renaissance' period, but without using any consistent definitions of these terms. There has in recent years, however, been an increasing acknowledgement of the interconnections that characterize artistic production and cultural exchange across the date range, as well as across geopolitical boundaries, which were constantly changing as a result of shifting allegiances, alliances and conflicts. Critical thinking is now less likely to be concerned exclusively with identifying the style, maker or school of an object, and expected more to consider what we can learn about the milieu that produced it. It is testament to the quality of the V&A's collection that it benefits from both types of scrutiny. This crossing of boundaries, geographical, chronological and critical, extending into the very nature of art, belief and society, is a feature of the book, challenging the commonly perceived divisions between art and artefact, sacred and secular, and the private and public domains.

One recurring element is the constant reference to the past – notably the classical past, which was often emulated and used as a point of reference to establish legitimacy. Equally central is the role of an increasingly organized Christian Church, and the changing religious practice that governed the lives of the faithful. It is within these contexts that the making and meaning of the material and visual culture is examined, often using individual objects as portals through which to enter a specific place and time. One of the key arguments here is that objects, be they caskets, clothing, collectors' items or devotional aids, were often of great significance to their owners, and

reveal much about their attitudes and values. Their decoration and ornament, as well as the materials from which they were made, were intended to send clear signals about status, allegiance and ideology. Much of this may, at first sight, seem alien to our modern society, though it remains at the heart of it. Now, as then, our most valued possessions can say much about our identity and how we see ourselves within society.

This book is not set out chronologically, but instead offers an alternative approach to the gallery displays. Each chapter takes up a theme that allows fundamental ideas to be explored across the whole period. This facilitates comparisons between cultures and of different eras, highlighting connections as well as diversity. A chronological framework is provided by the introductory chapter, which sets out key aspects of Europe's social and political history during the years 300–1600. The next six chapters are conceived as pairs, exploring complementary aspects of three principal issues: the perception and practice of artistic endeavours; historical and design sources for the conception of artistic objects; and the role of belief – spiritual and scientific – in shaping the material culture of society.

The story commences with a close look at the men and women who made luxury objects, the ways in which these artisans were perceived by others and the manner in which they worked. 'Making a reputation: objects, fame and notions of art' engages with theoretical debates behind the concept of art and the figure of the artist, and compares these ideas to surviving works. Alongside, 'Makers and markets' takes a practical look at the circumstances within which luxury objects were produced, with a particular focus on guilds, workshops and points of sale.

The next two chapters concentrate on the world of ideas that lurked behind the forms and types of objects created in this period. 'Using the past' looks at the way in which the past was perceived, and how those perceptions were expressed in surviving images and objects. In 'Ornament' the meanings of the term are examined, together with the use of design elements derived from a wide variety of sources. An insight is also provided into the sometimes surprising layers of meaning that could be ascribed to them.

Belief systems were also reflected in luxury goods. 'Devotion and display' unravels the powerful mixture of faith and worldly aspiration that lay behind the production of religious paraphernalia, as well as emphasizing the total interpenetration of the sacred and secular worlds. This chapter is complemented by 'Protecting the body, portraying the soul', which explores how beliefs about the cosmos, particularly in relation to medicine and physiognomy, governed the materials selected for particular objects and the properties they were thought to embody.

The final chapter, 'People and possessions', draws all these themes together and looks at how

luxury objects represented the ideals and ambitions of the person that commissioned or owned them. In examining portraits, clothing and jewellery, the author considers the extent to which such objects were intended to conjure up the life, family history and social status of an individual.

Throughout the book, double-page spreads written by different authors address topics relevant to each chapter, allowing the spotlight to fall on particular aspects of art manufacture and use, or onto individual objects. Most of the authors are V&A curators, and all of them have contributed to the research associated with the new galleries.

The story of European medieval and renaissance art, both north and south of the Alps, is presented as a coherent whole for the first time in the redisplay at the V&A. In this book, Glyn Davies and Kirstin Kennedy have followed a similarly ambitious approach in order to set the Museum's collections within a broader story. They have taken the objects themselves as the starting point, while drawing on a wide range of literary and archival sources. Their individually authored chapters complement each other and not only provide an accessible narrative for those who are less familiar with the subject, but also a fresh take for the specialist. They have introduced new ideas and information based on their own scholarly research, as well as on the wealth of material gathered by their colleagues during the preparations for the new displays. This volume both complements the V&A's Medieval & Renaissance Galleries and presents a novel and informed exploration of art and culture from the fall of the Roman Empire to what is arguably the establishment of modern Europe.

PETA MOTTURE

CHIEF CURATOR, MEDIEVAL & RENAISSANCE GALLERIES

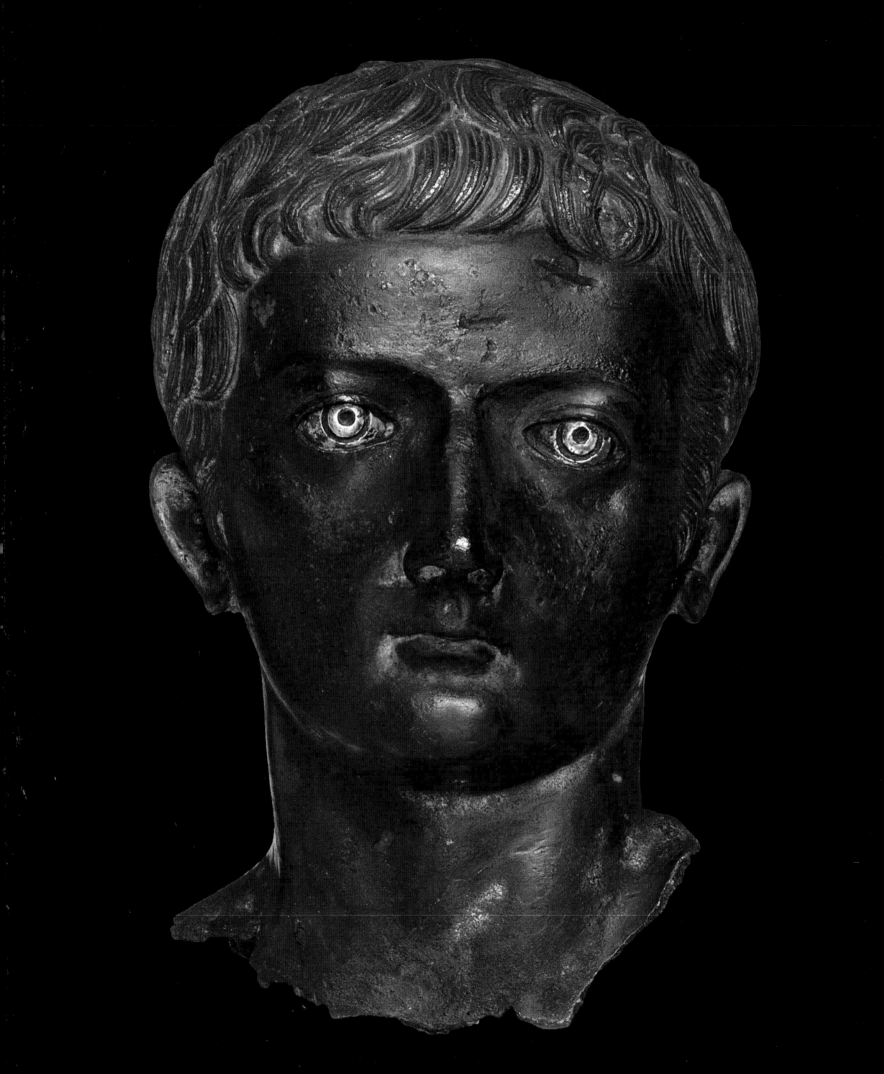

1

DEFINING EUROPE 300–1600

Glyn Davies

WHAT DO WE MEAN BY 'EUROPE'? The term can be more slippery than it seems. The Spaniard Orosius, writing in the fifth century, described the world – and Europe's place within it – in the following terms:

Our ancestors fixed a three-fold division of the whole world surrounded by a periphery of ocean, and its three parts they called Asia, Europe and Africa; although some have thought that there should be two, that is Asia, and then Africa to be joined with Europe…

Europe begins, as I have said, in the north at the Don river… This river, flowing past the altars and boundaries of Alexander the Great… swells the Maeotic marshes, whose immense overflow spreads afar to the Euxine sea near the city of Theodosia. From there, near Constantinople, a long strait flows forth until the sea which we call *Mare Nostrum* receives it. The Western ocean forms the boundary of Europe in Spain precisely where the pillars of Hercules are viewed near the Gades islands and where the Ocean tide empties into the mouth of the Tyrrhenian sea.[1]

The division of the world into the three continents of Asia, Europe and Africa dates back to the ancient Greeks, and was common throughout the Middle Ages (see pl.1). This tripartite division was still widespread in the sixteenth century, even after the discovery of the Americas, which were often discussed under the headings of 'new islands' or 'Spain', or were simply ignored by classically minded geographers.

But as Orosius noted, the division between the three old continents is far from clear. Europe, Asia and Africa are a single landmass, and the boundaries selected between Europe and the rest are ultimately arbitrary.[2] The traditional boundary between Europe and Asia, as Orosius reports, is the

River Don, which runs from Novomoskovsk (south-east of Moscow) to the Black (Euxine) Sea. Orosius' reference to Europe and Africa as a single entity implies that some geographers of his day were prepared to consider the whole Mediterranean, including modern-day Turkey, Syria and the Arabian peninsula, along with Africa and Europe as a single unit in opposition to Asia.

This distinction, curious to a modern reader, reflects a key fact of life in Late Antiquity, which held true to some extent throughout our period. The heart of the ancient world was the Mediterranean, with its civilizations, in Plato's memorable phrase, perched around it like 'frogs round a pond'.[3] The sea, and Europe's major waterways, offered the easiest, fastest and cheapest methods of travel. Far from constituting barriers between cultures, these masses of water were the conduits for their interconnection.[4] Not for nothing did the ancient Romans call the Mediterranean 'Our Sea' (*Mare Nostrum*), a term still in use in Orosius' day, when the civilizations around the Mediterranean continued to form a more homogeneous group than did the inhabitants of Europe.

Modern terms for geography and ethnicity are often false friends for interpreting the past. Modern nations, particularly in Western Europe, often seem 'natural', in that they possess to a greater or lesser degree distinct languages, a centralized political organization, and a sense of shared history and culture. The historical roots of these nations are often traced back to the 'peoples' (in Latin, *gens*) of the distant past. Thus, the French idolize Vercingetorix, who led a Gaulish war against Julius Caesar, and Clovis, the sixth-century ruler who united the Franks and converted to Roman Catholicism. The assumption is that these 'peoples' were distinct ethnic and cultural groups, and that the territories under their control were early versions of the modern nations that succeeded them. As we shall see, both of these assumptions are unfounded.

Very often, there is little or no relationship between historical 'nations' and the modern nation-states that bear their names. Sometimes, the territories covered are similar; sometimes, they are surprisingly different, and this fact has had tragic consequences. The changing shapes of nations are especially obvious on the Central European plain, where few natural boundaries exist. Poland, for example, fluctuated in size dramatically, especially under the Jagiellonian dynasty of the fourteenth to sixteenth centuries, which came to rule a greatly expanded territory. This included the Grand Duchy of Lithuania, a series of dependencies on the shores of the Baltic, and other states which briefly passed under its control, such as the Kingdom of Hungary. The territories in Western Europe known first as the 'Kingdom of the East Franks', then simply as 'the Empire' and finally as the 'Holy Roman Empire' can be seen as the foundation of modern Germany, but in reality they hardly formed a cohesive unit. Within the empire, the relationships of different towns and territories, each with its own governmental arrangements, to the notional central government was hazy in the extreme. Nor was the influence of the emperor consistent across his lands – for example, numerous Italian towns professed allegiance to the empire, but for all practical purposes ignored the emperor's rule.

Some 'nations' in this period, then, consisted of little more than the sum of territories owing allegiance to a particular ruler. Although some states, such as England, had by the sixteenth century

1. **Panel from a cope with Christ in Majesty (detail of pl. 60).**
Woven silk twill, embroidered with silver-gilt, silver and silk threads and pearls, 100 × 42 cm. England (probably London), 1300–20. V&A: T.337–1921. Presented by The Art Fund

Christ holds an orb naming the three continents known in the 14th century, Europe, Asia and Africa.

2. **The arms of Maximilian I von Habsburg as Archduke of Austria, from the Chapel of the Holy Blood, Bruges.**
Clear, coloured and flashed glass with paint and silver stain, 150 × 41.8 cm. Bruges, *c.*1496. V&A: C.446–1918

The complex Habsburg coat of arms represented the dynasty's claims to a huge variety of different territories.

assumed a much more stable and centralized form, others were an amazing international patchwork comprising different types of personal rule. One such state was the Habsburg Empire of the sixteenth century, in which territories separated from each other by vast distances were controlled by individual Habsburg rulers in a myriad of different forms (see pl.2). Charles V, Holy Roman Emperor from 1519, ruled territories in modern-day Germany, Austria, the Netherlands, Spain, Portugal, Italy and the New World.[5] The nature of his rule varied across his territories: there were the family lands in Austria and Germany; the territories ruled as hereditary duchies, such as Burgundy, Brabant and Luxembourg; arch-dukedoms such as Austria; kingships, such as Aragon and Castile (which included the 'New Spain' of the Americas); and of course, those areas that owed allegiance to the elected position of Holy Roman Emperor. The complexity and contingency of these arrangements means that the Habsburg Empire was a very different creature from later empires. Although Charles is a striking example of the fragmented nature of kingship in his time, the circumstances under which he governed were not unusual throughout the period considered by this book.

As will already be clear, the 'countries' discussed here were not homogeneous in any sense. Their borders were not clearly defined, their governmental arrangements varied, and their inhabitants could be bewilderingly diverse. This was particularly true of Central Europe, where it was not unusual for distinct ethnic and cultural groups to live side by side, speaking different languages and sometimes administering their own laws. Lithuanians, Ruthenians, Armenians and Jewish groups amongst many others inhabited sixteenth-century Poland, for example.[6]

Nor were nations, cultures or languages synonymous with ethnic groups. Instead, if the history of the period teaches anything, it is that historical ethnicity is hard to pin down, and that culture and language are chosen rather than 'natural'. This is most obvious in the case of the barbarian 'tribes' who are so characteristic of early medieval European life. More properly, these groups were confederations.[7] The Huns, for example, famous for their fifth-century raids into Gaul and northern Italy, certainly possessed a shared nomadic warrior culture. But they were not ethnically unified. In fact, the Hunnic army was able to swell its ranks so quickly because defeated or ambitious warriors could 'join up' and prosper. Such men were Goths, Vandals, Franks, Skirians and Romans. Attila, the most famous Hun of all, had a Gothic name.[8] Similar arguments can be made about the 'Normans' who accompanied William the Conqueror to England centuries later. Much more important than who people descended from was who they believed and declared themselves to be – an idea to which we will return.[9]

Religion also varied to a greater extent than one might expect. Christianity was the largest single religion during the period, but other faiths were a constant presence. Jews could be found throughout Europe, and were especially numerous in Spain (see pl.3), although from the thirteenth century onwards increasing persecution and expulsions from countries such as England meant that their populations became more localized (see pl.4). Islamic Spain, known to Muslims as al-Andalus, existed from the eighth to the fifteenth centuries, with Christians and Muslims on both sides of the

borders between 'Christian' and 'Islamic' states. The ebb and flow of conquest meant that Muslims were also found in other areas of Europe – Sicily, southern Italy (Lucera), Hungary and Constantinople/Istanbul, to name a few key sites. Pagans, far from being converted to Christianity *en masse* in the early medieval period, lived in Europe for centuries, not only as isolated individuals but also as large groups like the Cumans of Hungary. Nor was Christianity itself a single entity. The sixteenth century, of course, saw religious conflicts between Protestants and Catholics, but the previous centuries had also produced diverse strands of belief, above all the schism between Catholic and Orthodox Christians after the eleventh century. Many other variations of Christian faith were branded 'heresies' by the Catholic Church, but at their most developed they constituted organized religions in their own right. Such beliefs included Arianism, Catharism and Hussitism. Rather than constituting unusual eddies in the placid waters of Christian belief, these movements were the norm, characteristic of European religious life.

If Europe was politically, culturally and linguistically diverse, this emphasis on diversity should not blind us to the strong ties which united Europe during this period, perhaps more so than at any time until the creation of the European Union. These ties took the form of two ideas, which although sometimes honoured more in the breach than the observance, were undoubtedly powerful cultural phenomena in their own right. Indeed, in many ways, their circulation is what defines European identity in the period 300–1600.

The first of these ideas was that of the universal Roman Empire (see pl.5). Although Rome ceased to be a dominant political centre after the sixth century, its cultural inheritance was claimed by many

3. **Havdalah spice box.**
Engraved gilt bronze, 15 cm high.
Spain, 13th century.
V&A: 2090–1855

Jewish medieval objects do not commonly survive. This spice box was used during the Havdalah ceremony on the Sabbath and Holy Days.

4. *Saint Paul debating with Greeks and Jews.*
Copper-gilt with champlevé enamel, 8.5 × 12.8 cm. England, 1170–80. V&A: 223–1874

Jews were often identified in medieval art by the characteristic hat that they wore.

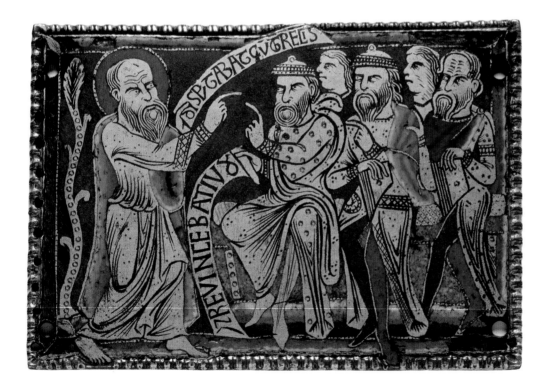

Giovanni Francesco Rustici, *The Rape of Europa*

Glazed terracotta, 32.7 × 40.3 cm. Florence, *c.*1495. V&A: A.8–1971

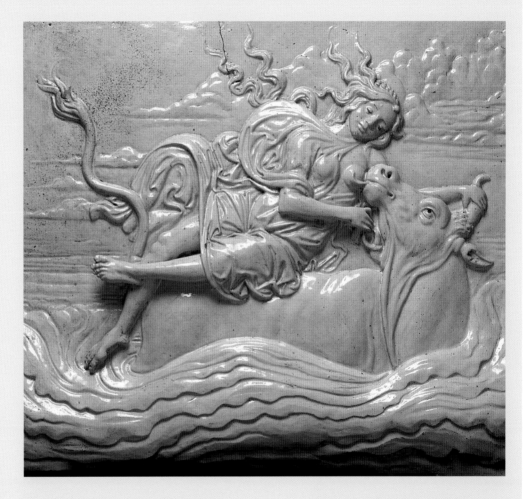

THE NAME 'EUROPE' to describe one of the continents (or three 'parts of the world' as they were first known) is an established one but its origins are as nebulous as the area it defined. Herodotus, writing his *Histories* in the fifth century BCE, concluded uncertainly that no one knew how Europe had come to be named, but did suggest that it could have been named after Europa of Tyre.

Europa is a figure from Greek mythology. The daughter of Agenor, King of Tyre, her beauty attracted the attention of Zeus, king of the gods. He appeared to her by the sea shore in the guise of a white bull and carried her off across the waters to Crete. The tale of Europa's 'rape', or abduction, was known to later, Christian, readers from different literary sources. Perhaps the most widely disseminated was the account in the Roman writer Ovid's poem, the *Metamorphoses*. The popularity of this work (with added commentaries that supplied moralizing meanings) ensured it was published numerous times, often with woodcut illustrations that closely followed elements of Ovid's text.

If Europe's name derived from a mythical figure, its visual representation was a different matter. Despite the medieval taste for allegory, the continents were not personified in literature or in the visual arts and, as renaissance scholars came to realize, the classical world had not prescribed any specific characteristics for them either. The image of Europa riding a bull as a personification of Europe satisfied the sixteenth-century taste for classicizing motifs, but it was ultimately superseded by the sterner imperial image of an enthroned female holding the sceptre of world domination.

Representations of the myth as a racy story of mutual attraction were nevertheless popular. The composition of this relief, attributed to the Italian Rustici, may ultimately have been inspired by a classical intaglio but also emphasizes the tale's sensual aspects. The relief may have been one of a series depicting Zeus's love affairs, and given by Rustici to his apprentice, Ruberto di Filippo Lippi. **KK**

successor states. This phenomenon is one of the themes of Chapter Four, but it is worth remarking here on the two most important among these successors. The Byzantine Empire was to many Europeans the Roman Empire itself. Its political power could be challenged but its cultural influence was immense. Meanwhile the Frankish (and later, Holy Roman) Empire deemed itself the successor to the Western Roman Empire. Although, as noted above, the power of the Holy Roman Emperor was limited in practice, he was nevertheless usually seen as the natural leader of Western Europe, along with the pope, and many of Europe's other kings were notionally subject to him.[10] An important corollary to the continuing significance of the Roman Empire as an idea was the survival of Latin as the international language of learning. Throughout the period, no one could be considered educated who could not read and write it. Across Europe, students learned Latin through the study of the same rich corpus of ancient texts, absorbing a shared literary heritage as well as a shared language. It was the mechanism by which all scholarship, and much politics, was conducted. Nor could the multinational inhabitants of monasteries have communicated without it.[11]

Europe's other great unifier was the notion of Christendom, or more properly, the '*Corpus Christianum*'. The great strength of this idea, implying as it did both Christians as a body and the territories that they occupied as a single entity, was precisely in its vagueness. It implied that Christians were united although there was little agreement about how this unity was to be expressed. The papacy had the strongest motivation to push the idea of Christian unity, particularly those popes who believed that Christ had granted them supremacy over kings, emperors and all ecclesiastical authorities. The high-water mark of this approach was Pope Boniface VIII's extraordinary claim in

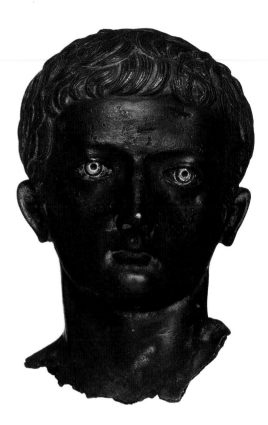

5. **Portrait bust, probably of the Emperor Tiberius.**
Bronze with silver inlays, 17.5 cm high. Rome, c.4–37 CE. V&A: A.584–1910

Autocratic Imperial Rome as it liked to present itself.

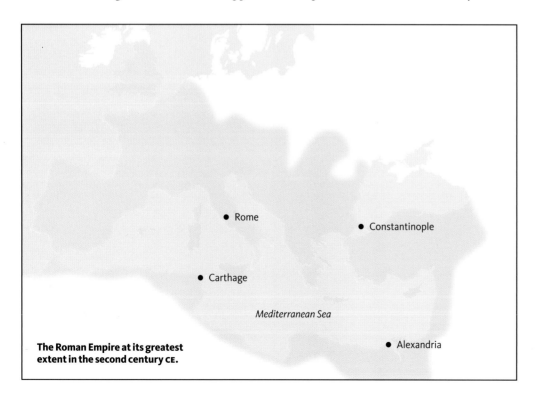

The Roman Empire at its greatest extent in the second century CE.

Rome

Constantinople

Carthage

Mediterranean Sea

Alexandria

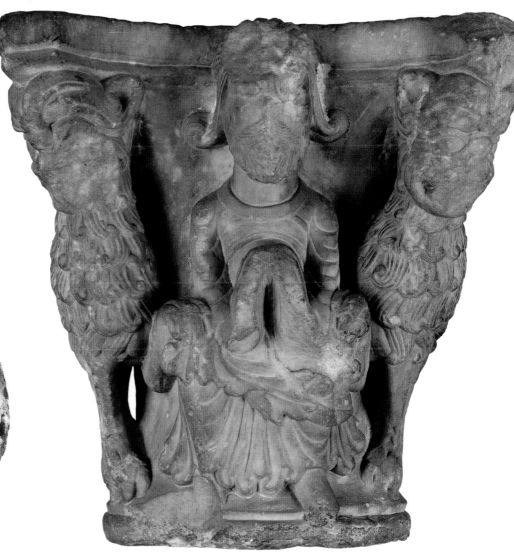

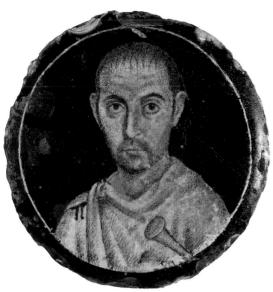

6. Capital showing Daniel and the Lions.
Marble, 39 cm high. From St-Pons-de-Thomières, Languedoc (France), *c*.1140. V&A: A.6–1956

The Roman persecutions quickly became part of Christian mythology. Daniel's story was particularly popular throughout the medieval period.

7. Portrait of a man.
Gold leaf on dark blue glass, 4.4 cm diameter. Rome, 3rd century. V&A: 1052–1868

The face of late Roman Christianity.

1302 that 'we declare, we proclaim, we define that it is absolutely necessary for salvation that every human creature be subject to the Roman Pontiff.'[12] Christendom, then, was not synonymous with Europe. It was, however, an important unifying idea, and at certain charged moments, notably during the crusades, it could function as a powerful way of defining European identity.

'OUR SEA': EUROPE AND THE MEDITERRANEAN WORLD 300–800

The Europe of 300 CE was on the face of it more culturally, politically and economically unified than it would be for over a thousand years. The Roman Empire covered Western Europe, parts of Asia and North Africa. The formidable Roman army furnished the empire with its rulers and the whole system was supported by tough taxes.[13] At the same time, Christianity had emerged as a religion universal in its reach. The empire-wide persecutions of the third and early fourth centuries acknowledged this fact (see pl.6). Christians were now too numerous to ignore, constituting as much as ten per cent of the population in the empire's heartlands of the Mediterranean, Syria and Asia Minor (see pl.7).[14]

The Christianization of the Roman world was already well underway, then, when in July 306 Constantine was proclaimed Augustus (a co-ruler of the empire) by the army at York. So began eight years of political strife, which ended with Constantine defeating his rival Maxentius in battle at the

Milvian Bridge, just outside Rome, to become emperor of the Western Empire. On entering the city, Constantine seems to have gone straight to the imperial palace, forgoing the traditional sacrifices in thanks to the gods.[15] According to reports, Constantine had dreamed that the Christian God came to him, announcing that he would win victory if he painted the *Chi-Rho* symbol (derived from the first two letters of Christ's name in Greek) on his soldiers' shields (see pl.8). An account by Eusebius of Caesarea suggests that Constantine had had this thought in his mind for some time. According to Eusebius, the symbol was made into a standard: 'A long spear, overlaid with gold, formed the figure of the cross by means of a transverse bar laid over it. On the top of the whole was fixed a wreath of gold and precious stones; and within this, the symbol of the Saviour's name… From the cross-bar of the spear was suspended a cloth, a royal piece, covered with a profuse embroidery of most brilliant precious stones…'[16] A standard such as this was no last-minute assemblage.

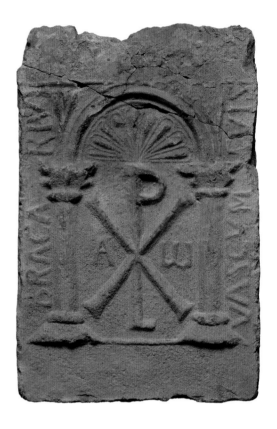

8. Relief with the *Chi-Rho*.
Terracotta, 32.5 cm high. Spain, 400–600. V&A: A.62–1930

The *Chi-Rho* symbol used by Constantine was a popular one amongst early Christians.

Regardless of whether or not Constantine had his dream, his coming to power signalled a new era in the Christian religion. Constantine founded churches and organized the Council of Nicaea (modern Iznik, Turkey) in 325, the first council that aimed to define doctrine for the whole Christian faith. He also founded the city of Constantinople as a new capital, on the Bosphorus strait in Thrace (modern Turkey). According to the fifth-century writer Sozomen, 'he therefore enlarged the city formerly called Byzantium, and surrounded it with high walls; likewise he built splendid dwelling houses… He erected all the needed edifices for a great capital – a hippodrome, fountains, porticoes and other beautiful adornments…'[17]

These three factors alone – his role as the first Christian emperor, the calling of the Council of Nicaea and the founding of Constantinople – ensured Constantine's reputation throughout the succeeding centuries. He was remembered in the East as '*isapostolos*' – an equal to the apostles. As we shall see in Chapter Four, Constantine's legacy would be claimed by many different successors over the centuries.

As a consequence of the rise of Christianity, the fourth and fifth centuries also saw the increasing popularity of monasticism as a way of life. The practice of retiring from the world either in small communities or as an individual hermit was widespread in the Christian heartlands of Syria and North Africa, and texts describing the lives of these holy men and women were avidly read in the Latin West.[18] Most influential of all was Anthony (later Saint Anthony), who in the early fourth century emerged as the model charismatic Christian hermit.

The way of life led by these men of the desert began to be codified for communities of devout Christians. John Cassianus, who had spent time in Palestine and Egypt, formed one of the first such communities in the West at Marseilles in the early fifth century. His writings described the behaviour expected of them. Cassianus recognized that there was a kind of pride in apparent humility – for example, in the monks' dress. According to him, the saints of old had 'utterly disapproved of a robe of sackcloth as being visible to all and conspicuous, which from this very fact will confer no benefit on the soul but rather minister to vanity and pride, as being inconvenient and unsuitable for the performance of necessary work for which a monk ought always to go ready…'[19] Around 530, the

monastery of Monte Cassino was established on a hill in the southern region of Lazio, Italy. Its founder, Benedict, provided the community with a rule for living that was gradually adopted by most of the other monasteries of Europe. This 'Benedictine Rule' was intended to steer a middle path between asceticism and the needs of communal life – hence its popularity. Similar religious communities were soon spreading across Spain, southern France and Italy.

Meanwhile, much of the Western Roman Empire was passing from centralized Roman control. Various groups entered the old territories of the empire both to settle and to conduct warfare. As we have noted above, these 'barbarian' groups were of debatable ethnic cohesion, although they undoubtedly possessed distinctive cultures.[20] Most of them were attracted to aspects of Roman life and culture, which they eventually adopted. The Visigoths, for example, founded a kingdom in southern France and Spain.[21] Although they subscribed to a version of Christianity called Arianism, they peacefully co-existed with Spain's Catholic inhabitants. The remarkable sixth-century bishop of Seville, Isidore, was from one such native family and was instrumental in converting the Visigoths to Catholicism. His voluminous writings show him to be very comfortably within the traditions of late Roman literature and culture. 'Barbarian' invasions did not necessitate a rupture in cultural life.

Other groups that established control over former areas of the empire were Franks (in France and Germany), Vandals (North Africa) and Slavic peoples (Central Europe). The story of their kingdoms used to be told in terms of their having displaced or destroyed the existing populations of these areas. Today, we know that this is inaccurate. Many of the 'barbarian' war bands that invaded parts of the former empire constituted only a fraction of the populations in those areas, and would have been quickly assimilated into them.[22] Nevertheless, by the seventh and eighth centuries, large areas of Europe, and especially those outside the charmed circle of the Mediterranean, had adopted significant degrees of 'barbarian' culture.[23] They were ruled by kings. They had different legal codes from the Romans, such as the Salic Law of the Franks. A majority did not speak Latin. Some of these groups had converted to Christianity, but many others had not.

Nevertheless, during the period 600–1000 the orthodox Catholicism of Rome achieved dominance over Western Europe. In some cases, this meant the conversion of peoples from paganism to Christianity. In others, it was a struggle between local forms of Christian worship and those sanctioned by Rome. In Britain, for example, there was an ongoing rivalry between those who adhered to Irish forms of worship introduced by Christian missionaries and those who looked to Rome. The debate polarized in Northumbria during the 660s, when the inflexible ecclesiastic Wilfrid challenged the Irish party on the most public of issues – the way that they wore their hair (or 'tonsure') and the dating of Easter. It says much for the continuing power of the idea of the Roman Empire, and the acceptance of the popes' claims to universality, that Wilfrid's arguments were eventually victorious. Nobody wanted to feel that they were out of touch with Roman norms.

Elsewhere, Islam, which throughout the medieval and renaissance periods would be the main rival faith to Christianity, developed under the Prophet Muhammad in the early seventh century. From its twin centres, Mecca and Medina, it rapidly spread throughout the Arab world. The

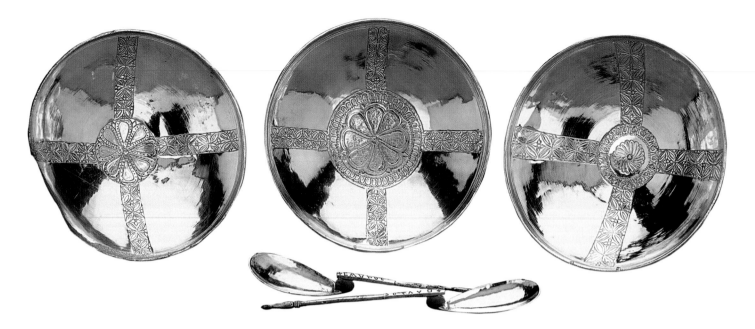

9. **Bowls and spoons.**
Silver, 22.5 cm diameter (bowls)
and 25.5 cm long (spoons).
Byzantine Empire, early 7th
century. British Museum, London,
M&ME 1939, 10-10, 79-81, 88 and 89

The Byzantine bowls buried in the
7th century at Sutton Hoo in
Suffolk would have been
important signifiers of their
owner's status.

Umayyad caliphs of the seventh and eighth centuries built an empire which at its greatest extent included Sicily, Spain and parts of southern France. By no means all the inhabitants of this empire were Muslims, however. The economy depended on non-Muslim *dhimmis*, who were offered toleration in return for taxation.

Despite lively debate and international contact in religious matters, European economic life continued on only a slow burn in the seventh century. Many Roman towns had long since been abandoned and populations were spread out across the countryside. The number of trading ships plying the Mediterranean was greatly reduced from the boom years of the first century.[24] Yet goods were still travelling long distances, both over sea and over land. The seventh-century burial of a king at Sutton Hoo in East Anglia contained a number of silver Byzantine bowls (pl.9).[25] Glass beads from the Mediterranean are a common find in Northern European graves. Within the Mediterranean, trade seems to have taken place between Italian and Islamic centres, and the accounts of pilgrims suggest that sea travel was still a viable option.[26]

IMPERIAL IDEALS AND THE TRIUMPH OF THE PAPACY 800–1200

The kingdoms of Northern Europe and the more romanized Mediterranean were brought under a single political umbrella by the Carolingian Empire, founded by the eighth-century ruler Charles Martel. This Frankish kingdom achieved international importance when Charles's grandson Charlemagne began campaigning in Italy. The papacy, tiring of the lack of military assistance offered them from Constantinople, turned to the Franks to aid them against the Lombards of northern Italy, who threatened the papal cities of Ravenna and Rome. The Lombards were decisively defeated by Charlemagne in the 770s. In succeeding years, he campaigned on all the frontiers of his ever-expanding empire – across the Pyrenees in Spain, in the pagan territories of Saxony, in Bavaria, in southern Italy on the borders of Byzantine territory, and in Hungary. It is a measure of Charlemagne's influence that the Byzantine Balearic islands transferred their allegiance to him in 798, because he was able to guarantee their safety from Tunisian raiders. Charlemagne's empire may have been land-based, but if necessary, it could also become sea-borne.[27]

Charlemagne was now one of the four main players in European politics, along with the

The Basilewsky Situla

Ivory, 16 cm high. Milan, *c.*980. V&A: A.18–1933. Presented by The Art Fund

HOLY WATER BLESSED by a priest was a feature of church ceremonial from at least the ninth century, when the Carolingian archbishop Hincmar of Reims described its use as follows: 'every Sunday, before the celebration of Mass, the priest shall bless water in his church, and, for this holy purpose, he shall use a clean and suitable vessel. The people, when entering the church, are to be sprinkled with this water...'

Water for sprinkling was kept in small buckets, which could be held in one hand while the other hand dipped an 'aspergillum' into the water and sprinkled it around the church and over the congregation. This is an example of just such a bucket, or 'situla'. The body of the bucket is made from a single ivory tusk, while the base is formed from a separate piece of ivory. The two heads on the rim are pierced to take a handle.

The dense imagery on the bucket rewards close inspection. The upper row tells the story of Christ's Passion and burial and in the lower row we follow Christ's resurrection and his appearances to his followers. Also included is the 'Harrowing of Hell', when Christ journeyed to hell to liberate those righteous souls who had died prior to his birth. This is the only episode on the situla not to have appeared in the Bible, although the Harrowing of Hell did form part of the Creed, a Christian statement of belief. In most of the scenes, Christ is shown beardless, in the fashion of early Christian images. Only in the scene of the Crucifixion is he shown with a beard, which became the standard representation of Christ during the following centuries.

The long and complex inscription, comprehensible only to a literate audience, is typical of Carolingian and Ottonian artworks. Objects such as this were not for the edification of lay people, but were intended to form the basis of contemplation for educated ecclesiastics. **GD**

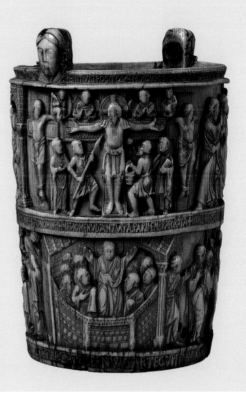

Byzantine emperor, the pope and the Abbasid caliph Harun al-Rashid. This fact was recognized when on Christmas Day 800, as Charlemagne knelt at the altar in St Peter's, Pope Leo III crowned him Emperor of the Romans, in theory the successor to the Western Emperors of centuries before.

Charlemagne's empire was culturally characterized by two facts: his alliance with the papacy, and his role as emperor. He attempted to spread orthodox Catholic belief through a centralized education programme; during the ninth century at least seventy of his schools were active in Western Europe.[28] Students were taught reading, how to write the Psalms, notarial writing styles, grammar, basic mathematics and religious chant, along with standard versions of religious texts.[29] A building programme more ambitious than any seen for centuries proceeded apace, characterized especially by the construction of major new churches in stone. It has been estimated that between 768 and 855 at least twenty-seven cathedrals, over four hundred monasteries and one hundred royal residences were constructed. The decoration and furnishing of these buildings created a demand for highly worked goods. Specialist centres for the production of such goods quickly appeared, often at significant ecclesiastical sites, such as Reims.

The Carolingian Empire and its successors, the kingdoms of the East and West Franks, shared two

important characteristics: they were land-based, and their focus was to the north. The Mediterranean was no longer the notional 'centre' of Europe. *Mare Nostrum*, 'Our Sea', had become a place of boundaries rather than of connections. Three quite different cultures now regarded each other across this sea, the Western European, the Byzantine and the Islamic. This development was exacerbated by an increasing hardening of perceptions of ethnicity and religion. The Carolingians, although descended from a mixture of Franks, Gauls and other early peoples – and despite the fact that many of them spoke a romance language (derived from Latin) – believed themselves to be Frankish, and were proud of the fact. The Byzantines despised them accordingly. When Bishop Liutprand of Cremona visited Constantinople in the tenth century, he was accused of being a barbarian. 'You are not Romans, but Lombards!' he was told. Liutprand replied, 'You who call yourselves *kosmocratores*, that is emperors, descend from this nobility, but we Lombards, Saxons, and Franks despise you so much that when we wish to insult an enemy of ours we simply call him a Roman.'[30]

Between the sixth and eighth centuries, the Byzantine Empire underwent massive stresses. It lost territory to Arabs and Slavs in the east, and to the Lombards in Italy. Only after the second Arab siege of Constantinople in 717–18 did the Byzantines slowly reverse this trend. Byzantine society became more Greek, less Latin in culture; and less concentrated in cities. There were also religious tensions. The eighth-century Byzantine Emperor Leo III forbade the production of most religious images as idolatrous, provoking huge controversy. As images were systematically destroyed, religious life polarized into two camps – the Iconodules, who supported the destruction, and the Iconophiles, who opposed it. This controversy raged on and off until 843, when it was finally accepted that religious images could be sacred things in themselves, establishing a direct connection with divinity. In the West, both the papacy and the Carolingian authorities, who were in favour of images, nevertheless sharply rejected this view. To them, images, unlike relics, were not sacred, but were merely teaching tools and appropriate ornaments (for example, pl.10).[31] The Western and Eastern approaches to religious images would retain such distinctions, even though there would be fruitful exchange between the traditions for centuries to come.

Byzantium still had a strong presence in the West, especially in Italy, where, before the eighth century, Venice and the whole area south of Rome were Byzantine provinces. The papacy came into regular conflict with the Byzantine emperors, and used the Iconoclastic Controversy as a lever definitively to reject Byzantium in favour of an alliance with Charlemagne. The antagonism between the papacy and Byzantium culminated in 1054, when a papal delegation to Constantinople insisted on the pope's supremacy over the whole Church. The resistance of Constantinople's patriarch, Michael Cerularius, led to the enraged delegation anathematizing him (that is, applying the most extreme form of excommunication). The bull of anathema was publicly burned in Constantinople, and a formal schism set in between the Eastern and Western churches.

The popes' new alliance with the Frankish emperors also became a burden, as inevitably the emperors sought to influence both the choice of who should be pope and his policies. By the eleventh century, the popes were in need of a new ally. They found one in the Normans, their former

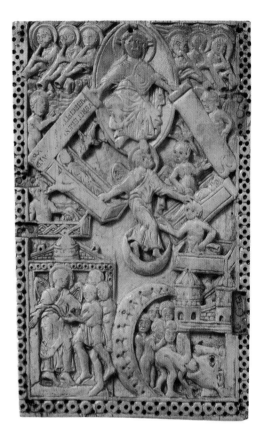

10. ***The Resurrection of the Dead.***
Ivory, 13 cm high. Southern
Germany or Northern Italy, *c*.800.
V&A: 253–1867

The end of the world as envisaged
by a 9th-century artist.

enemies in southern Italy. Norman adventurers had been travelling there since the early eleventh century, where they fought both Arabs and the local Byzantine authorities. Pope Nicholas II met the Norman leaders Richard of Capua and Robert 'Guiscard' (the Wily) at Melfi in 1059, concluding a treaty of mutual support. The pope granted to Robert the dukedoms of Apulia and Calabria, as well as Sicily, despite the fact that these were not his lands to give. Robert had to take southern Italy from the Byzantines and Sicily from its Islamic rulers. The Norman conquest of Sicily was completed in 1091 by his brother Roger.

The papacy now took a more belligerent attitude, inaugurating a dispute between itself and the empire (and to a lesser extent between secular rulers generally and the Church) which rumbled on into the twelfth century.[32] The issue was whether the emperor or the pope took precedence. To the reforming Pope Gregory VII, even the humblest priest was superior to a king because he was able 'with his own mouth to consecrate the body and blood of the Lord'.[33] It was the pope's duty to interfere in the affairs of nations when issues of morality were at stake. In practical terms, this meant that he claimed the right to depose emperors, and denied the emperor the right to appoint churchmen. The emperor's theologians claimed almost the exact opposite. When Emperor Henry IV continued to appoint bishops, Gregory threatened to excommunicate him. In reply, Henry tried to force Gregory to abdicate. Gregory then declared Henry deposed and

The Crucifixion with the Virgin and Saint John

Carved jasper, 6.5 cm high. Constantinople (modern Istanbul), c.900. V&A: A.77–1937

MANY CHRISTIANS IN THE Byzantine Empire would have owned personal religious images. Cameos – gems or hardstones carved in relief – met this demand, and were produced in numbers between the tenth and twelfth centuries in a variety of semi-precious stones. They depicted Christ, the Virgin Mary or saints. In effect, images of this sort were portable icons or amulets.

This example shows the central image of Christian art, the Crucifixion. To Christ's right stands the Virgin Mary, to his left John the Evangelist holding a scroll. Above are representations of the Sun and the

Moon. It is made of jasper, a semi-precious hardstone, which was popular for images of this sort. The suspension loop, although not original, almost certainly reflects how the object would have been used – it was probably an *enkolpion*, a sacred image to be worn at the breast.

Images of this kind were exported from Byzantium to Western Europe, where they were sometimes incorporated into book covers and reliquaries. The sack of Constantinople in 1204 by the soldiers of the Fourth Crusade led to the plunder of large numbers of Byzantine artworks, of which this may have been one. **GD**

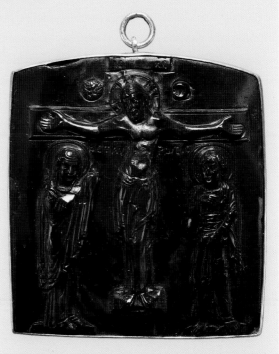

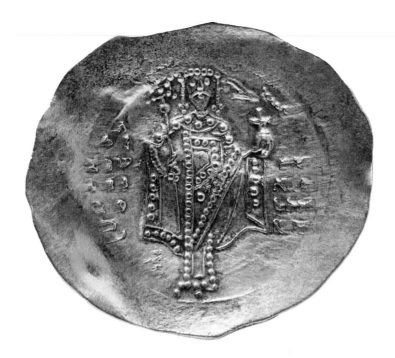

11. **Hyperpyron coin of Alexius I Comnenus.**
Gold, 3 cm diameter. Constantinople (modern Istanbul), 1081–1118. V&A: A.10–1960

Alexius I Comnenus was one of the most successful Byzantine rulers. Here he is shown being crowned by the hand of God.

excommunicated. When Henry's German rivals sided with the pope, he found himself pushed into a political corner. With few options left to him, Henry and a small retinue crossed the Alps and in January 1077 he appeared for three days before the pope at the gates to the fortress of Canossa, as a barefoot penitent, until Gregory absolved him.[34] But this was far from the end of the dispute. With the absolution, Henry's enemies' lever vanished and he was able to strengthen his position in Germany. Within a few years, he was deposing Gregory and setting up his own anti-pope, Guibert of Ravenna. The rivalry between pope and emperor would become a standard theme of medieval life.[35] Another characteristic aspect of medieval European history was initiated by Pope Urban II, when he preached the First Crusade in a field outside Clermont in 1095. Offering as it did 'to all those submitting to the labour of this journey personally and at their expense full forgiveness of their sins', the crusade immediately caught the imagination of Western Europe's knightly class.[36] It was, incredibly, successful in taking Jerusalem from its Arab Fatimid rulers, and in setting up a series of principalities and kingdoms in modern-day Turkey, Syria, Palestine and Lebanon. The whole experience of the crusades and their aftermath underlined the gulf that had emerged between Western Europe and the Eastern Mediterranean: the predominantly French-speaking crusaders referred to the new territories as '*Outremer*' (the Land Beyond the Sea) – 'there', rather than 'here'. The Byzantines tended to think of these Westerners, 'Franks' as they called them, as uncultured and untrustworthy savages: 'their greed for money… always led them, it seemed, to break their own agreements without scruple', said Anna Comnena, daughter of the Byzantine emperor Alexius I (see pl.11).[37]

Thus, during the eleventh and twelfth centuries, the Mediterranean was disputed between Western Europeans, Byzantines and Arabs. Nevertheless, political and cultural differences did not prevent the transfer of goods and ideas. Europe's three greatest sea-trading cities – Pisa, Genoa and Venice – came to prominence at this time. Venice's main trading links were with Byzantium and the Crusader Kingdoms in Palestine; Pisa's and Genoa's with the markets of Alexandria and the

12. Lectern top.
Limestone, 59 cm high. Shropshire (England), c.1180. V&A: A.21–1984

This lectern comes from one of the many Cluniac priories in England, at Much Wenlock, Shropshire.

13. Initial A from an antiphoner.
Pigment on vellum, 29.8 × 15.6 cm.
Beaupré (Belgium), 1290.
V&A: 7940

Cistercian monks kneel to either side of the pope and a bishop in this image from a manuscript of the Cistercian abbey at Beaupré.

Maghrib. In 1087, Pisan and Genoese fleets, acting together, had captured Mahdiyah, the harbour of the Zairid emirs (in modern Tunisia), burnt its fleet and imposed a humiliating peace.[38]

The period in which the popes achieved greater control over the Church coincided with a flowering of monastic life. One of the pioneers of a more rigorous monastic lifestyle was the abbey of Cluny in east-central France. Established in the tenth century, Cluny was for its time remarkably free from control by the local aristocracy due to its direct subordination to the pope.[39] Furthermore, Cluny's monks did little manual labour on the abbey's lands. Instead, they paid workers to do this for them, freeing their time to offer perpetual prayer to God. This established Cluny's reputation and attracted potential donors to offer gifts in return for prayers for their souls. In the eleventh century, Cluny pioneered a new centralized structure, with a network of subsidiary Cluniac houses (see pl.12). These priories were not abbeys in their own right because they were subject to the abbot of Cluny, which allowed for greater control. Cluniac priories existed in Britain and as far afield as Poland.

The Cluniacs' reforms primarily concerned the organization of a Benedictine monastery, not the spiritual life of its monks. At the end of the eleventh century, however, a splinter group established itself at a new monastery near Dijon called Cîteaux. This became the centre from which a new monastic order, the Cistercians, spread rapidly (see pl.13). Cistercian life was harder than that in a traditional Benedictine monastery. The monks did manual labour – although choir monks did less, and large numbers of 'lay brothers' were required to help work the land. To create time for this, the elaborate church services of the Benedictines were pruned to a more manageable length. Church decorations and furnishings were expected to be moderate and to fulfil some practical purpose.

While the Cistercians were building their monasteries on wilderness sites, Western Europe's social and economic make-up was drastically changing through the growth of towns and cities. Although they often held agricultural lands, the inhabitants of the towns usually made their living pursuing commercial trades. Between the eleventh and thirteenth centuries, the towns of Western

Europe reached their greatest levels of population and political independence, many of them organized as self-governing 'communes' with privileges freeing them from feudal obligations.

At the same time, places of learning were becoming sites of vigorous debate and intellectual ferment.[40] In the twelfth century, church and monastic schools began to attract students from great distances. In the thirteenth, these schools, in towns such as Paris, Montpellier and Bologna, primarily places for learning theology and law, began to incorporate themselves into unified bodies – universities – with syllabuses, exams and degrees. In 1215, the papacy granted its first statutes to the masters and scholars of Paris.[41] The vibrancy of this intellectual world was fuelled by a series of rediscovered texts that flooded into Europe via Spain and Sicily, where they had been translated from Arabic. Most importantly, these included the *Physics*, *Metaphysics* and *Ethics* of Aristotle; the works of his Arab commentators, such as Avicenna and Averroes; and works of mathematics by Arab scholars such as al-Khwarizmi.

The new approach to philosophy – dialectic – that was developed from Aristotle's teachings was quickly recognized as a dangerous tool. It was easy for scholars to be labelled as heretics, as happened to such luminaries as Abelard and Gilbert de la Porée.[42] Nevertheless, schools and universities contributed to a number of developments in Western European society. For example, by encouraging a textual rather than an oral approach to scholarship, and driven by the need for school books in large numbers, the universities fostered the first commercial book trade in Europe and played their part in encouraging the literacy of lay people.[43]

The conflicts between Church and state continued to rumble on into the late twelfth century. The most famous example is the dispute between Thomas Becket, Archbishop of Canterbury, and King Henry II of England in the 1160s over the degree to which the Church was independent of secular interference (see pl.14). It culminated on the evening of 29 December 1170, when four knights and a sub-deacon nicknamed '*mauclerc*' (the evil cleric) attacked and killed Becket near the choir of Canterbury Cathedral. Becket, who had been perceived as a proud and overly elegant man, was immediately revealed as a saint who wore a hair shirt in penitence beneath his rich robes. Becket's canonization rapidly followed and took the new form of being authorized centrally by the pope – previously, local bishops had been able to pronounce on sainthood. Canterbury, along with Santiago de Compostela and Rome, became one of Europe's chief pilgrimage centres.[44]

Pilgrimages to these three sites were sometimes set as punishments in judicial cases. Most of the pilgrims, however, came for healing, as was the case for an Italian and his son at Canterbury: 'He drank the water that was brought from the tomb of the martyr, his blood reddened and he healed. The son of this same man suffered an ailment, and he also recovered.'[45] According to Jacques of Vitry, 'Nothing is more efficacious or satisfying than the labour of the pilgrimage.' He went on, 'For just as a man sins with all his limbs so too must he make reparation by labouring with all of them.'[46] On the other hand, long pilgrimages could also take on aspects of a holiday, a complaint made later by the fourteenth-century poet William Langland in *Piers Plowman*: 'I saw pilgrims and palmers banding together to visit the shrines at Rome and Compostela. They went on their way full of clever talk, and took leave to tell fibs about it for the rest of their lives.'[47]

14. **Panel from an altarpiece.**
Alabaster, painted and gilt, 42.5 cm high. England, 1450–1500.
V&A: A.167–1946

Thomas Becket lands at Sandwich following his political exile in France, part of a cycle of images of the saint's life from an English altarpiece.

The Gloucester Candlestick

Cast copper alloy, 58 cm high. England, early 12th century. V&A: 7649–1861

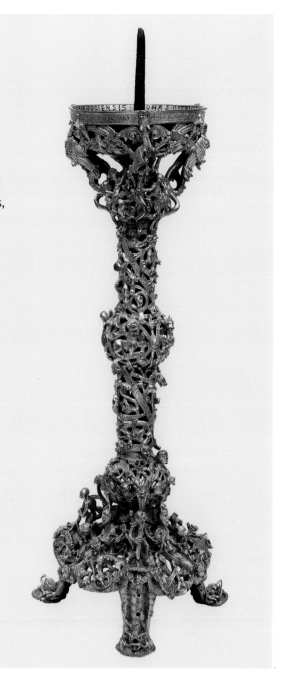

THE GLOUCESTER CANDLESTICK is an exceptionally rare survival of English Romanesque metalwork. Its intricate form, cast in three sections, demonstrates the expert craftsmanship of metalworkers in the 1100s. The candlestick is decorated with an array of monstrous creatures that climb and slide over it, grabbing, pulling and biting at one another. The figures create a snakes-and-ladders effect as they toil towards the light of the candle or slide towards the darkness at its base.

This exquisite object was presented to St Peter's Church (now Gloucester Cathedral) by Abbot Peter. The gift, confirmed by an inscription upon the object's stem, secures the date of the candlestick between 1104 and 1113. Such a donation not only enriched the status of this church and the Benedictine abbey it served but also identified Abbot Peter's role as leader of the community, which by the early twelfth century had grown to over a hundred monks. For the monks who used it, the candlestick held both functional and symbolic significance.

Possibly used on the altar during the Mass, the object represented the light of God and the virtue of the Christian faith. This sentiment is described in a Latin inscription on the outer rim of the drip pan which reads, 'The burden of light is the work of virtue. Shining doctrine teaches that man be not shadowed by vice.' The clambering figures depicted upon the candlestick, illuminated and be-shadowed by the flickering candle above, appear to interpret the inscription.

One final intriguing inscription on the inner rim of the drip pan reveals that Thomas Pociencis, a figure thought to be medieval, brought the candlestick to Le Mans Cathedral. Records indicate that in 1254 at the inauguration of Le Mans, the cathedral was filled with candlelight by the congregation as a sign of their faith. This evidence connects closely to the symbolism of the Gloucester Candlestick and suggests that it may have featured in this ceremony. While it remains uncertain if the candlestick was used during the inauguration, it was certainly a treasured possession at Le Mans and remained there until the eighteenth century. **SS**

KINGDOMS, COMMERCE AND THE COMING OF THE FRIARS 1200–1400

The twelfth and thirteenth centuries can be characterized as a period of the expansion – political, cultural and religious – of Western Europe into the lands on its borders.[48] During this period, French and German knights established new estates for themselves in southern Italy, the Eastern Mediterranean and Poland, as well as fighting in Egypt and Palestine. One of the most symbolic campaigns of this sort was the diversion of the Fourth Crusade towards Zadar (Croatia) and Constantinople, in order to pay off the huge debt owed by the crusading army to the Venetians, who had built their war fleet. In April 1204, Constantinople fell to the crusaders, who immediately set about plundering the city's riches in the most destructive manner (see pl.15). Although the Byzantines eventually regained control of their empire in 1261, its economic and political power

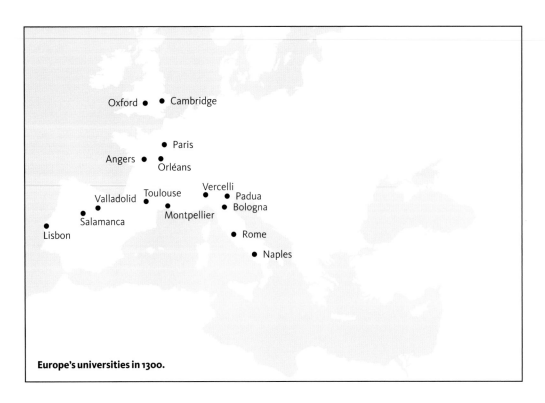

Europe's universities in 1300.

Oxford • • Cambridge
• Paris
Angers • Orléans
Vercelli
Valladolid Toulouse • • Padua
• • Bologna
Montpellier
Salamanca
• Rome
Lisbon
• Naples

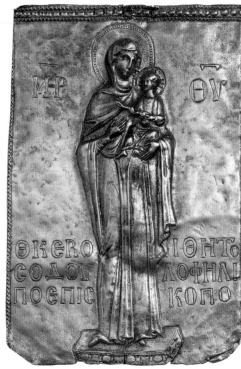

15. **The Virgin *Hodegetria*.**
Embossed copper-gilt, 21.2 cm
high. Byzantine Empire (probably
Constantinople), 1050–1100.
V&A: 818–1891

This Byzantine image may have
been amongst the objects
plundered from Constantinople
in 1204.

never fully recovered. In the meantime, the greatest beneficiaries of the whole debacle were the Venetians, who proceeded to fill their city with the plunder they had taken and whose ships dominated the trade and pilgrimage routes of the Eastern Mediterranean.

The power and confidence of the Western European kingdoms is nowhere better represented than in the Capetian kingdom of France, one of the most cohesive and centralized territories of the period. Paris in the thirteenth century was Western Europe's largest city, with a population of more than 200,000 by 1300.[49] Under King Louis IX – later Saint Louis – cultural patronage in the form of ambitious buildings and the commissioning of luxury goods began to be as important for secular rulers as it had long been within the Church. Louis obtained the important relic of the Crown of Thorns from Constantinople and, in the words of a contemporary description, 'He ordered to be built a chapel, marvellous in its decoration, appropriate to this royal treasure, in which he himself later placed it with appropriate honour.'[50] With the construction of this building, the Ste-Chapelle, within the palace complex in Paris, the power of the king to create new fashions was dramatically stated. The building's light-filled upper church was especially influential and spawned a whole range of architectural innovations that were quickly imitated across Europe (pl.16).

French affairs cast a long shadow. For example, Louis's brother Charles of Anjou was installed, with the connivance of Pope Urban IV, on the throne of Sicily. Despite the native Sicilians' hatred of his rule, Charles was able to use the crown to build the foundations of a new kingdom, based in Naples, which remained part of the European political scene throughout the rest of the period covered by this book.[51] The political links between the papacy and the French dynasty ultimately led to the period between the years 1309 and 1376 during which the papacy resided at Avignon in Provence, territory belonging to the Angevin dynasty of Naples.[52] The power of the French cardinals reached its apogee at this time, and they were able to ensure that each of the popes who presided in Avignon was a Frenchman.

16. **The Ste-Chapelle, Paris
(interior of upper church).**
*c.*1243–8.

The interior of the Ste-Chapelle
has been described as a huge
reliquary casket.

The Luck of Edenhall

Gilded and enamelled glass, 15.8 cm high. Syria or Egypt, 13th century.
V&A: C.1–1959. Presented by The Art Fund

THIS EXTRAORDINARY BEAKER is one of the best surviving examples of the enamelled glass vessels produced in Syria or Egypt during the thirteenth century. Glass-making skills in Europe at this date were far less developed, and the appeal of this delicately ornamented glass to a Western European would have been all the stronger for its curiosity value. Certainly, a number of glasses of this type made their way to the West, although today they are known mainly through archaeological digs, and are inevitably discovered in fragments.

This beaker is different, in that it is in almost pristine condition. It has long been one of the most celebrated objects in the V&A, and one of the most well-known medieval objects in Britain. Its history demonstrates the strong imaginative hold that highly fashioned artefacts could have on their owners.

The glass has a leather case, probably made in England or France, and dating to the fourteenth century. This means that the glass has been in Europe since at least that time, and was probably brought back from the East by a crusader. It eventually found its way to Edenhall, the seat of the Musgrave family in Cumbria, where a tradition developed that the family's fortunes depended on the safe-keeping of the glass. In one eighteenth-century telling of the tale, the beaker belonged to a group of fairies who were disturbed near Edenhall. As they fled, they abandoned it, calling, 'If this cup should break or fall / Farewell the luck of Edenhall.' **GD**

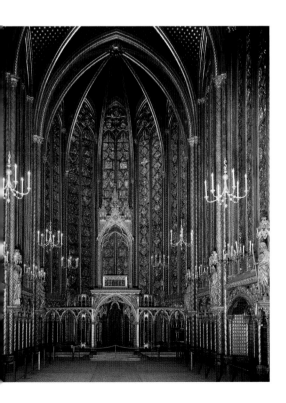

The thirteenth and fourteenth centuries were also the period in which international trade in luxury goods, many produced in specialist centres, really took off in Western Europe. The conditions under which many of these specialist products were made are discussed in Chapter Three. Sea-borne trade in particular was on the rise at this time. The main Mediterranean ports were Venice, Genoa and Barcelona, whilst those in the North were Bruges, Lübeck, Danzig and Riga. The two trade networks were joined by 1277, when the Genoese fleet began appearing at Bruges.[53] The largest mercantile companies had permanent representatives in the main cities with which they traded; often these merchant communities were small colonies.[54] At Constantinople, the Genoese colony constituted almost a new town, known as Pera. It had at least fifteen Latin churches and monasteries.[55]

The Italian merchant was a familiar figure in all Europe's major cities. He might be involved in top-level banking (see pl.17), as in the case of the Bardi and Peruzzi families of Florence, who acted as bankers to Edward II of England.[56] Alternatively, he might undertake smaller-scale activities, like the merchant Filippo of Florence, who in 1290 sold rings and other jewellery to Eleanor of Castile, Queen of England.[57] Italian merchants introduced a number of innovative business practices, including shareholding, holding companies, marine insurance and double-entry book-keeping.[58]

The merchants of Northern Europe were dominated by a loose confederation of mercantile towns known as the Hansa.[59] Its heartland was in Germany, in towns such as Lübeck and Cologne.

Hanseatic merchants also maintained colonies in London, Bruges and Riga. By the fifteenth century, the Hansa merchants faced stiff competition from two towns in southern Germany which were not part of the confederation, Nuremberg and Augsburg. The newcomers took a share of the lucrative trade with the Low Countries, and also gained a foothold in Lübeck.[60]

Political developments affected trade. The stability established in Central Asia under the Mongols encouraged the opening up of overland trade routes to the East.[61] Textiles from Iran and China found their way via this route into Europe, where they were much admired (see pl.18). On the other hand, whole trade routes could be shut down by protectionist disputes, such as occurred between Bruges and the Hanseatic merchants in the years 1358–60, as well as by wars, famines and other crises.

The enormous growth in population size and density, although slowing by the early fourteenth century, was brought to an abrupt halt by a series of poor harvests and outbreaks of pandemic disease in the mid-century.[62] The plague known today as the Black Death arrived in Constantinople and Sicily in 1347, having already ravaged Mongol territories. By early 1348 it had travelled the trade routes to Pisa, Genoa, Venice, Marseilles and Barcelona. In a short time, every European country felt its effects.[63] Recurring bouts of plague over the following years seem to have contributed to a long-lasting reduction in Europe's population. The cultural effects of the plague are much harder to quantify.[64]

The thirteenth century saw unprecedented changes in the organization and practice of religious life. In 1215, a general council held at the Lateran Palace in Rome standardized and clarified many aspects of church practice, including the number of times lay people were expected to take communion per year (once), and the manner in which the miracle of transubstantiation (the transformation of bread and wine into the body and blood of Christ) took place – a point on which even learned theologians got confused.[65] The Lateran council also refocused the energies of the Church on pastoral care – the instruction of lay people in living a Christian life.[66] Only a few years earlier, the pope had given his support to a radical new religious group, the followers of Francis of Assisi (pl.19). Francis's followers eventually became the Franciscan Order. Along with the order founded by Saint Dominic, and other groups such as the Augustinians and Carmelites, they were known as 'friars'.[67] Rather than retreating behind the walls of a monastery, the friars aimed to galvanize religious life by appearing in public, preaching, begging for alms, and leading by example. Whilst the Cluniacs and Cistercians had taken a hundred years or so to establish themselves internationally, the friars spread with astonishing speed (see pl.20). Within seven years of the foundation of the Dominican Order in France, a Dominican house had been established as far afield as Lund (in modern Sweden).[68]

The increased interest in pastoral instruction fostered in religious life, and especially the encouragement given to lay people to involve themselves in a meaningful and emotional way with scripture (see pl.21), created ideal conditions for the spread of radical religious ideas in the late fourteenth century. In the 1370s the Oxford theologian John Wyclif developed the idea that only the text of the Bible had authority, and that its interpretation was the responsibility of each of its readers. Wyclif's ideas contributed to religious disputes right into the Reformation of the sixteenth

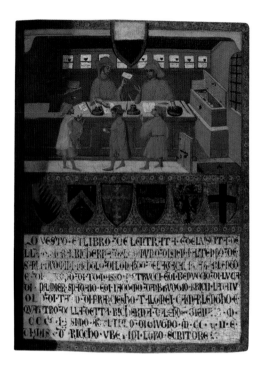

17. **Workshop of Paolo di Giovanni Fei, cover from an account book.**
Tempera and gilding on panel, 44 × 32 cm. Siena, 1402.
V&A: 414–1892

Medieval bankers at work. Note the presence of the strong box in the corner.

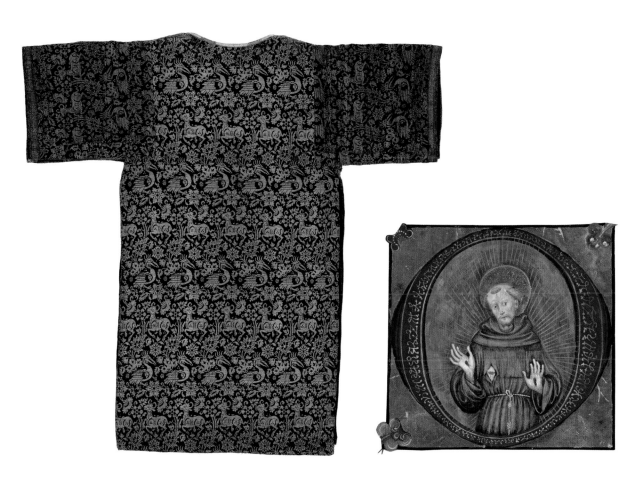

18. Dalmatic.
Woven silk and metal thread, 171.5 cm long. Silk, Iran; tailoring, Western Europe, c.1300. V&A: 8361–1863

Luxurious silks such as this were imported into Europe from the Mongol kingdom in Iran.

19. Master of the Budapest Antiphonary, *Saint Francis*.
Pigments and gold leaf on parchment, 12.2 × 13.1 cm. Lombardy (Italy), c.1450. V&A: 4925

Saint Francis displays his stigmata, wounds in the same places as those of Christ.

20. Chalice.
Silver, silver-gilt and enamel, 27.6 cm high. Venice, 1475–1500. V&A: 631–1868

Despite relying on charitable donations, many friars' convents became rich. This grand chalice comes from a Dominican convent near Venice.

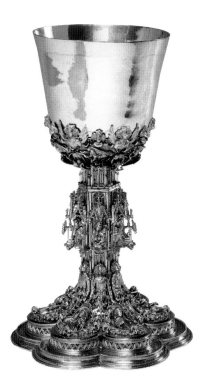

century. In the immediate aftermath of his writings, a succession of reformers in Prague drew on his ideas to challenge the established Church. Their most important leader was Jan Hus. The main aim of his followers was Utraquism, the right of the laity to take both bread and wine during communion, rather than just the bread. After years of military conflicts, Hussitism successfully established itself in the 1430s as a breakaway church in Bohemia.

RELIGIOUS WAR, DYNASTIC DISPUTE 1400–1600

As the fifteenth century dawned, the two most centralized states in Western Europe found themselves engaged in endemic warfare. France and England had been in dispute for centuries over the lands claimed by the English within France. This long-simmering argument came to a head in the so-called Hundred Years War, sparked by Edward III of England's provocative claim to the French crown.[69] The distraction of this protracted struggle gave rivals of the French royal family an opportunity to develop their own power bases. The most important of these was the Duchy of Burgundy. Although the dukes of Burgundy were close relatives of the French monarchs, during the fourteenth and fifteenth centuries they often allied themselves with the English in order to bolster their own power. The duchy incorporated towns that were leading centres for the production and trade of such high-end goods as textiles and wine, and the dukes became prodigiously rich, acting as major artistic patrons.[70] The conflict within France between the Burgundian party and their rivals the Armagnacs became particularly nasty. Assassinations were carried out by both sides, such as the killing of Louis, Duke of Orléans by agents of John the Fearless, Duke of Burgundy in the Marais district of Paris in November 1407.

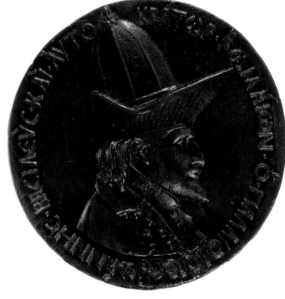

21. **Bartolomeo Bon, *The Virgin and Child with Members of the Guild of the Misericordia.***
Istrian stone, 251.5 cm high. Venice, c.1445–50. V&A: 25–1882

The members of a Venetian confraternity shelter under the Virgin Mary's cloak.

22A, B. **Pisanello, medal of John VIII Paleologus.**
Cast bronze, 8.5 cm diameter. Italy (probably Ferrara), after 1438. V&A: 7711–1863

The Byzantine Emperor John VIII's exotic dress clearly fascinated the Florentine artist Pisanello, in this, possibly the first true portrait medal of the Renaissance.

Constantinople entered the fifteenth century in a parlous state. Although the Byzantines had freed themselves from the rule of Venice during the thirteenth century, the revived Byzantine Empire found that its shrunken territorial base did not provide the emperors with enough wealth to secure their state. The emperors took to asking for funds from sympathizers in the West. In 1438, the Emperor John VIII Paleologus came to Europe looking for military support against the increasingly desperate threat posed to his state by the Turks. His best hope to secure this aid was to negotiate with the pope a way of healing the schism between the Eastern Orthodox and Catholic churches. In practice, he must have been aware that this would mean submitting the Eastern Church to the pope's authority. The negotiations were to take place during the ongoing Church Council at Ferrara. A lack of funding threatened the council, and the pope's banker Cosimo de' Medici suggested moving it to Florence. Thus it was that one of the last acts of the Byzantine emperors was to lend some glamour to the rise of one of Europe's leading new families (see pl.22A, B).

John VIII left Florence having negotiated a settlement between the Eastern and Western churches, and with the hope of military aid. Both were soon dashed, as the people of Constantinople refused the new settlement outright. In truth, the maritime powers of the Mediterranean had strong

commercial reasons for maintaining good relations with the Turks, and were not keen to respond to the pope's calls for a new crusade.[71] Soon after the accession of Sultan Mehmed II in 1451 (pl.23), Turkish plans for the seizure of Constantinople were put into effect. Against the manpower and wealth available to Mehmed the Byzantines stood little chance, and on 29 May 1453 the city duly fell. The last emperor, Constantine XI Paleologus, disappeared into the fray, his body never to be recovered.

One effect of Constantinople's fall was the dispersal of Greek texts and scholars to the West. Here they met a hungry public. Inspired by the writings of the fourteenth-century poet and scholar Francesco Petrarch, erudite readers were taking a much more scientific interest in the analysis of ancient texts. They discovered that close attention to and comparison of the use of words within texts could help resolve problems within them and produce more accurate editions. The administrators working for the papacy included many such young scholars.[72] These men, whom we know as humanists, liked nothing better than to root around in monastic libraries turning up forgotten texts by ancient authors (see pl.24). During the Council of Florence, they had seized their opportunities to meet like-minded intellectuals and to swap texts. For example, the northern Italian Cyriacus of Ancona, who acted as an agent collecting Greek texts, inscriptions and coins for his Florentine contact Niccolò Niccoli, made a special visit to Florence in order to attend the council.[73]

23. Gentile Bellini, *Mehmed II*.
Oil on canvas, perhaps transferred from wood, 69.9 × 52.1 cm. Constantinople (modern Istanbul), 1480 (19th-century repaint). National Gallery, London, NG3099

Venice was in diplomatic contact with the court of Mehmed II, and sent Gentile Bellini there to produce paintings and drawings for the Sultan.

24. Map of the world, from Claudius Ptolemy, *Geographia Vniversalis* (Sebastian Münster edition).
Ink on paper, 30 cm high. Basle, 1545. V&A: NAL special collections

One of the greatest rediscoveries made by humanist scholars was the ancient geographical writer Ptolemy, whose method of making map projections was eagerly adopted.

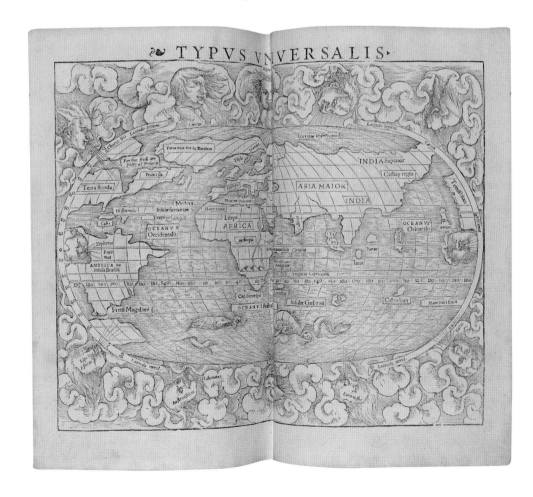

Giambologna,
Samson Slaying a Philistine

Carved marble, 210 cm high. Florence, 1560–62. V&A: A.7–1954. Presented by The Art Fund

GIAMBOLOGNA IS THE NAME by which a Flemish sculptor, whose name was Jean Boulogne (or Giovanni Bologna), became known in Italy. His work for the Medici Grand Dukes of Tuscany in Florence during the second half of the sixteenth century eventually made him the most influential sculptor in Europe, with a host of imitators.

This marble group, depicting the biblical hero Samson killing a Philistine, was Giambologna's first major commission from Francesco de' Medici, and was originally placed atop a fountain in Francesco's herb garden in Florence. Marble groups depicting more than one figure had become a standard way for sculptors to demonstrate their mastery. Giambologna daringly chose to balance the group on only five small points, pushing marble to the limits of its load-bearing capacity. Clearly proud of his achievement, he signed the marble on the strap across Samson's chest.

Giambologna's works were used by the Medici as part of the imagery of their rule. They gave copies of famous bronzes as diplomatic gifts but very few of Giambologna's large works left Italy. This marble, however, has travelled extensively. In 1601 the fountain of which it was a part was sent as a gift to the Duke of Lerma in Spain. It was then presented to Charles, Prince of Wales on his visit to Spain in 1623. On its arrival in England, it was given to the king's favourite, the Duke of Buckingham. Giambologna's work had thus become a kind of currency, to be exchanged amongst those who wanted to be seen as connoisseurs of fine things. **GD**

Through its fostering of a wider enthusiasm for the ancient world, humanism became much more than a group of scholars chasing old manuscripts. Occupying positions as city administrators, university teachers or theologians, and as teachers to the sons of Italy's richest men, humanist scholars gradually achieved dominance within the world of learning. As they did so, they contributed more generally to the fashionability of ancient culture.

A new invention contributed to the rapid spread of humanist scholarship, as well as to the growth in interest in reading on the part of lay people. Printing with movable type was developed in the 1440s by Johannes Gutenberg of Mainz. Although scribal book production had already been turned into a remarkably streamlined process, printing offered a way of standardizing books more effectively. Two scholars living hundreds of miles from one another, who owned the same edition of a book, could be certain that their texts were identical and were organized in the same way. The standardized edition, hitherto difficult for the humanist scholar to aspire to, was now more easily achievable. Printing began as a fairly labour-intensive process but printers quickly learned how to reduce their costs enough to render the business profitable. By 1500, there were more than 250 presses in Italy, Germany and France, and about 27,000 editions had been produced.[74] In England, William Caxton, the first English printer, produced celebrated copies of Chaucer's *Canterbury Tales*

and Malory's *Le Morte d'Arthur* in the 1470s and 1480s. Handwritten books were by no means completely ousted. Instead, the bottom end of the market for manuscripts dropped away and handwritten texts were now the preserve of the richest patrons.

Politically, the fifteenth century saw a gradual reduction in the power of towns as independent entities in Western Europe. The communes of the previous centuries, organized with at least a modicum of democracy, fell one by one into the hands of elites and autocratic rulers. At the same time, kings, dukes and princes tightened their control over their territories. After the long struggle against England, France began an economic and political recovery towards the end of the fifteenth century. Many German towns passed under the control of tightly knit guilds, representing an urban oligarchy.[75] Between the later thirteenth century and the end of the fifteenth, Italy became a patchwork of hereditary dukedoms. In the fifteenth century Florence was nominally a republic but the truth was rather different: the Medici family had risen to the position of first among equals in the city.[76] In the second half of the century, Lorenzo de' Medici aspired to further power. He married a non-Florentine aristocrat, Clarice Orsini, and cemented his family's control over the governmental councils. Lorenzo's apparently irresistible rise was opposed by other factions in the city, as well as by Pope Sixtus IV. In 1478, a conspiracy to murder Lorenzo during High Mass at Florence Cathedral failed, but resulted in the death of his brother Giuliano.[77]

The papacy also resumed a more autocratic stance. The popes had returned to Rome in the late fourteenth century, although the power struggle between Italians and French in the college of cardinals continued, leading to the disastrous period in the 1380s when two rival popes ruled, Urban VI in Rome and Clement VII in Avignon. By 1409 there were three claimants. Difficulties were finally resolved through a general Church Council, held at Constance, which deposed or took resignations from the contending candidates, and elected Pope Martin V in 1417. The idea that a Church Council could depose an elected pope was a dangerous one which would have further repercussions, but for the moment it was the only way out. The popes of the fifteenth century gradually strengthened their position (see pl.25) and by the time of Sixtus IV were secure enough to direct substantial resources into new building projects, including the construction of the Sistine Chapel. Sixtus also deserves mention as the pope who, in 1471, granted the city of Rome the artefacts that form the basis of the Capitoline Museum.[78]

The essentially Mediterranean focus of much European life, which we have observed to a greater or lesser extent throughout this history, underwent a radical change during the fifteenth century. New sea-trading routes were established in the Atlantic, forming the basis for the economic rise of Iberia, the Netherlands and England. The first of these routes was established by Portuguese seafarers, who gradually explored further and further south along the West African coast. In 1487, John II of Portugal decided to ascertain whether it was possible to sail around Africa by dispatching two expeditions, under Bartolomeu Dias and Pêro de Covilhã, the first to go south along the west coast of Africa, the second to chart the continent's eastern side via the Red Sea. By 1497, the

25. Dish showing Pope Leo X in procession.
Tin-glazed earthenware, 49.6 cm diameter. Montelupo (Italy), *c.*1516. V&A: 8928–1863

Embodying the pomp and ceremony of the Renaissance papacy, Pope Leo X rides in procession, along with his elephant Hanno.

Screen showing the arrival of a Portuguese ship in Japan

Artist of the Kano School. Ink, colours and gold leaf on paper, 141.6 × 350.3 cm. Japan (probably Kyoto), 1600–30. V&A: 803–1892

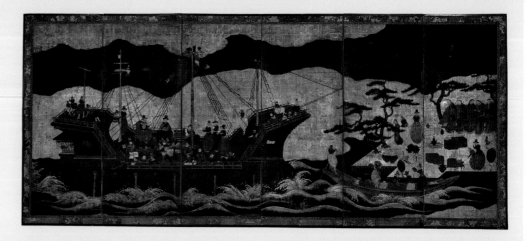

JAPAN'S FIRST ENCOUNTER with European culture took place in the 1540s when Portuguese sailors arrived to negotiate trading rights. The Portuguese ships docked at Nagasaki, where local people gathered along the harbour to observe the Indian sailors furl the sails high in the rigging and unload the cargo. The *nanbanjin* or 'Southern Barbarians', as the Japanese called these newcomers, became a popular subject for painted screens in Japan.

The screens were made in pairs: the image of the docking ship usually complemented another of the Portuguese processing through the town to visit the local ruler or shogun. In keeping with the exotic subject matter, the artists painted the sequence of scenes from left to right, reversing the usual Japanese arrangement. While they appear to be an accurate representation of the docking ships, the scenes are not in fact rooted in any specific reality. They were painted in Kyoto and there is no firm evidence to suggest that any of the artists there ever travelled to Nagasaki. Instead, the Kano painters based their representations on glimpses of European visitors to Kyoto, and on secondary reports.

The image of a ship arriving laden with treasures from a distant land was a familiar emblem in Japanese art, representing wealth and good fortune. Unsurprisingly, it was favoured by wealthy Japanese merchants who dealt with the Portuguese and who were mainly responsible for commissioning these screens. The artists reworked the traditional motif to include reference to the Europeans and their

Indian crew. Their careful depiction of European clothing reflected their fascination with its strangeness: ruffs and buttons were unknown in Japan (see detail). The Japanese also wondered at the dark skin of the Indians. As one Portuguese merchant observed, 'they like seeing black people… and they

will come 15 leagues just to see them and entertain them for three or four days'. After the Jesuits, who had preached Christianity, caused the Portuguese to be expelled from Japan in 1639, screens such as this one were no longer painted. **KK**

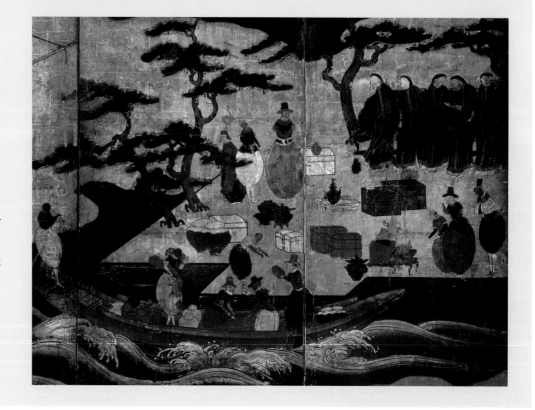

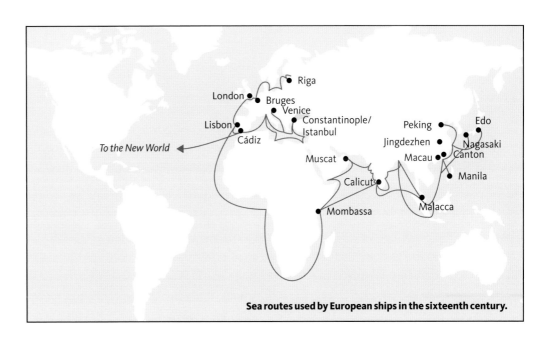

Sea routes used by European ships in the sixteenth century.

26. **The Robinson Casket.**
Carved ivory, silver and gold
mounts, and sapphires,
13.7 cm high. Kotte (Sri Lanka),
c.1557. V&A: IS.41–1980

This casket was a gift to the
Portuguese royal family, probably
produced on the occasion of the
conversion to Christianity of the
King of Kotte, Sri Lanka. A number
of diplomatic gifts of this sort
survive from the 16th century.

ground was laid for Vasco da Gama's epic voyage to India, which opened the way for the new Portuguese trade route to the East, all the way to Japan (see pl.26).[79]

The second new route was, of course, that to the Americas, opened by Columbus in 1492. Unlike the Portuguese in the East, the Spanish did not voyage to the Americas to trade for luxury goods. Rather, they went to conquer, colonize and convert, drawn by the idea that huge natural resources, especially gold and silver, could be found in this New World. In addition to precious metals, the New World provided Europe with brazilwood, a much sought-after commodity from which red dyes were obtained for the cloth industry. The conquest of the Americas was achieved as much through the clever exploitation of existing rivalries between the Amerindians, and through the stroke of luck that they proved susceptible to European diseases, as by any military genius on the part of the conquistadors.[80]

Trade with the East underlined Europe's subordinate position in world affairs. Prior to the Portuguese and Spanish voyages of discovery at the very end of the fifteenth century, the European economy had a permanent trading imbalance with the Islamic world, and European territorial expansion had been checked (or even reversed) on all sides.[81] The only commodity with which European traders could tempt the merchants of Turkey and the East Indies was precious metal.[82] For centuries to come, Europe would export bullion in exchange for luxury goods. It was a consumer, much more than a producer, society.

Just before Columbus claimed the New World for Spain, the monarchy of Castile finalized its annexation of the Islamic territories of the Iberian peninsula. On 2 January 1492, the last Muslim sovereign of Granada, Boabdil (Muhammad XII), handed over the keys to his city to Ferdinand and Isabella of Castile. Spain was on its way to becoming a centralized monarchy. The new Catholic dominance of Spain quickly led to a hardening of religious attitudes. On the advice of Torquemada, head of the Inquisition (a tribunal set up to suppress heresy), Ferdinand and Isabella issued an edict of expulsion to all Jews living within their territories. Rather than leave their homes, many Jews converted to Christianity. The same process was applied to Muslims, who by 1502 were being offered the choice between baptism and exile.[83]

The hardened religious climate in Spain went hand in hand with an outpouring of devotional activity on the part of lay people across Western Europe in the latter part of the fifteenth century. A typical example is the short-lived regime established in Florence by the firebrand preacher Girolamo Savonarola, under which many Florentines, including the painter Botticelli, rejected life's luxuries in a quest for salvation. Savonarola's attitude was extreme, but enthusiasm for traditional religion can be traced across the continent in this period (pl.27).[84] Many devout Catholics were frustrated by the lack of piety amongst clergymen, especially monks and friars. The leading scourge of such men in the early sixteenth century was the Dutchman Desiderius Erasmus (the scholarly *nom de plume* of Gerrit Gerritszoon) who wrote from Basle. In a series of hugely influential texts, Erasmus expressed doubts over the usefulness of monasteries, satirized corrupt clerics and poured scorn on the cult of relics, proposing instead a Christianity based on an austere devotion derived from inner contemplation. Like other humanists, he proposed to read the text of the Bible much like a historical source, rather than simply accepting traditional doctrines.[85]

The abuse of indulgences – the remission of punishment for a confessed sin – was a ripe target for those who longed to reform church practices. When Albrecht of Hohenzollern obtained the archbishopric of Mainz in 1518, he had to pay off the large sums of money that he had borrowed. He therefore obtained permission from Pope Leo X to sell indulgences, forwarding half the profits to Rome where the pope himself was in some financial difficulties over the rebuilding of St Peter's basilica. The operation, however, went badly wrong. A Dominican friar, Johann Tetzel, was employed as the public face of the indulgence-selling campaign but as he went from place to place, his hard-sell and his sales jingle – 'as soon as gold in the basin rings, right then the soul to heaven springs' – shocked many of his more educated listeners. Indulgences had been a bone of contention for many years. In the late fourteenth century, William Langland had described 'a Pardoner, preaching like a priest':

> He produced a document covered with Bishops' seals, and claimed to have power to
> absolve all the people from broken fasts and vows of every kind. The ignorant folk
> believed him and were delighted. They came up and knelt to kiss his documents, while
> he, blinding them with letters of indulgence thrust in their faces, raked in their rings and
> jewellery with his roll of parchment![86]

Martin Luther, an Augustinian canon and doctor of theology at the university of Wittenberg, used Tetzel's indulgence-selling enterprise to launch his own disaffected critique of many Catholic practices. By 1520, Luther found himself pushed into a revolutionary conflict with the established Church. He burned the papal bull pronouncing him a heretic, along with volumes of canon law, at the gates of Wittenberg.[87] In essence, Luther wanted to get away from the idea that Christianity was about amassing enough credit points to enter heaven. Instead, he proposed that faith in God was in itself enough for the Christian. Good works were unnecessary, although in truth they should come naturally to the saved Christian. From the beginning, Luther benefited from powerful

27. **Altarpiece with the Passion and Resurrection of Christ.**
Limestone, painted and gilded, 187 cm high. Troyes (France), c.1525.
V&A: 4413–1857

The enthusiastic piety of pre-Reformation Europe is embodied in the complex iconography of this elaborate altarpiece.

supporters. Most important of these was Frederick III ('the Wise'), Elector of Saxony. After Luther was condemned by the emperor at the Diet of Worms in 1521, Frederick had him kidnapped by masked men and secreted in the castle of Warburg in Eisenach, ensuring his safety.

The message of reform now swept through the empire, through the agency of printing above all. Gradually, a number of princes and cities passed into the Lutheran camp. In 1530, at the Diet of Augsburg, they presented to the Emperor Charles V a 'confession' of their beliefs. Although these negotiations collapsed, religious reform of one sort or another had acquired an unstoppable momentum. Lutheranism made headway in Denmark and Sweden, while the even more radical ideas of John Calvin and Huldreich Zwingli acquired adherents everywhere, but most especially amongst the Swiss.

By 1600, a number of countries in Northern Europe were committed to Protestantism of one stripe or other. For a ruler, this commitment offered an opportunity to reflect the religious climate of his or her country, thereby stabilizing it. It also provided a chance to seize the lands and goods of the Church. In Sweden, for example, the Church had owned 21 per cent of the land in 1500. When in the 1520s the king Gustav Vasa switched his allegiance to Lutheranism, he was able to liquidate all of this real estate to his own benefit.[88] In 1538, Henry VIII of England pursued a similar policy, breaking with Rome and liquidating Church assets. England's move towards Protestantism ensured the destruction of the vast majority of its medieval church treasures.[89] Nevertheless, conflict persisted over religious issues within each European country, often threatening to destabilize government. Between the 1530s and the end of the sixteenth century, England embraced first a tentative Protestantism, then a more

Léonard Limosin, *Charles de Guise, 2ⁿᵈ Cardinal of Lorraine*

Painted polychrome enamel (later frame), 74.8 × 57.8 cm (inc. frame). Limoges, *c.*1556. V&A: 551–1877

'I SHALL FEEL VERY FORTUNATE when I have the means to set my hand to the extermination of such vermin,' wrote Charles de Guise to the Spanish ambassador in May 1570. The 'vermin' were French Protestants, known as Huguenots, while Charles himself was from one of the most powerful Catholic families in France. Born in 1524, his rise was swift. As Archbishop of Reims, he crowned Henry II King of France in 1547: the following day he became Cardinal. When Henry died in 1559, a contemporary described Charles as 'pope and king' in France. This portrait, by the court enameller Léonard Limosin, shows him in his cardinal's robes. It probably formed part of a series of portraits of illustrious contemporaries and may have been set into panelling in the royal apartments.

Charles used his position to further his own dynasty and defend the Catholic cause. He established special courts to root out heresy during Henry II's reign.

A persuasive orator, he played a key role in debates with Protestant leaders during the lengthy Council of Trent. The Church had convened the council in 1545 to revise and standardize Catholic religious practice as a response to Protestant doctrines. At its close in December 1563, Charles pronounced the anathema against Protestantism, confirming his reputation among contemporaries as a true protector of the Catholic faith.

Protestant pamphleteers accused Charles of involvement in one of the most notorious episodes in French history. The massacre of St Bartholomew's Day began in Paris on 24 August 1572. In the days that followed, around 4,000 Huguenots were slaughtered. Charles's nephew Henry, 3rd Duke of Guise, supervised the murder of several Huguenot leaders, but there is no concrete evidence to implicate Charles in the violence. The bloodshed was a grim episode in a wider context of religious conflict in France, known as the Wars of Religion, which had been ignited in 1562 and were fanned by

the fanaticism of the Guise family.

Charles did not live to witness the religious truce, known as the Edict of Nantes, that grudgingly accommodated Huguenot beliefs in 1598. He died at Avignon in December 1576, of a persistent and virulent fever. **KK**

entrenched version that went beyond Luther's moderate stance, then a return to traditional religion under Queen Mary, and finally a more determined compromise approach to Protestantism under Queen Elizabeth. Throughout each of these phases there were many who disagreed with the current state of affairs – under Elizabeth I, for example, many Calvinists, trained on the Continent, believed the religious establishment to be too traditional.[90] At the same time, many prominent men and women were forced to practise their traditional Catholicism in secret.

The papacy realized that in the face of these breakaway movements, religious reform would have to be embraced. The Council of Trent, held during the years 1545–63, set out to propose solutions to the problems posed by Protestantism. It did so by seeking to reimpose piety and excellence of conduct on all ecclesiastics, and by reaffirming the centrality of the seven sacraments in Christian experience. As the Church began to apply the reformed attitude across the Catholic world, so it was strengthened by new saints and martyrs. Especially important was the Society of Jesus, an order of mendicant priests established in 1540. One of the key missions of the Jesuits was to convert non-

Catholics, thus putting them in the front line against Protestantism, as well as making them leading protagonists in the struggle to evangelize the inhabitants of the new territories across the sea.

Against this background of religious controversy, international power politics was played in its usual manner. The early sixteenth century was characterized by a struggle between France and Spain, one that for the most part took place on Italian soil. The French had achieved dominance over northern Italy through their capture of the Duchy of Milan but in the Four Years War of 1521–6 an alliance between the Emperor Charles V, Henry VIII of England and the papacy dislodged the French, and captured the French king Francis I. As so often happened in European politics, this result was immediately turned on its head by the defection of the pope to the French party and France, the papacy, Venice and Milan formed the League of Cognac to oppose the emperor. They were decisively defeated, and in May 1527 imperial troops entered Rome. The army, which had been left unpaid, immediately began sacking and looting the city.

It was when religious disputes began to impinge on international relations that the map of Europe was redrawn. Religious dissent disrupted old alliances and created new ones. In the 1550s the scene of most turmoil had moved away from Germany. There, the Emperor Ferdinand I worked out a deal whereby the ruling prince of each territory determined the religious confession observed within it. This was promulgated as the Peace of Augsburg. By contrast, the territories controlled by Spain were in danger of coming apart at the seams. Spain resolved its disputes with France just in time to face the rapid spread of Protestantism in its Netherlandish territories. During the 1560s a wave of Protestant preachers saturated the Low Countries.[91] Outbursts of iconoclasm were rife, and Habsburg authority was breaking down. However, internal disagreements among the Protestants gave King Philip II the chance to launch a counter-revolution. Fernando Alvarez, Duke of Alva, at the head of an army of 10,000 men, instituted a repressive new regime that particularly targeted the wealthy middle classes.[92] In 1572, rebellion broke out. War would rage in the Netherlands into the mid-seventeenth century, as the United Provinces won their independence from Spanish rule. By 1600, the Netherlands were split between north and south, Protestant and Catholic.

* * *

The Europe of 1600 no longer owed as much to the Roman Empire as it had throughout the medieval and renaissance periods. With the fall of Byzantium, no ruler could claim an unbroken line of succession back to the Roman emperors. The mystique of the Holy Roman Empire had also died – no emperor was crowned by the pope after Charles V in 1530. Europe no longer had a Mediterranean focus – the wealthiest and most powerful nations were those with Atlantic trading empires, whose ships could reach the East Indies and the Americas. Despite the successes of Charles V and Philip II of Spain in mobilizing Christian forces against the Turks on the eastern borders of Christendom, nobody contemplating Europe in the later sixteenth century could have perceived Christianity as a single unifier between the peoples of the continent. The wars of religion had encouraged a higher degree of nationalism in Western Europe and in the following centuries, the new European outlook on the wider world would allow internal conflicts to be played out on an even greater scale (see pl.28).

28. Inlaid cabinet.
Walnut and inlay of various woods, 81.3 cm high (not including stand). Mantua or Ferrara, c.1530 (with 19th-century restorations). V&A: 11–1891

This cabinet bears the emblem and motto of the Habsburg Emperor Charles V, '*plus ultra*' (still farther). Charles's emblem signified his claims to territories all over the world.

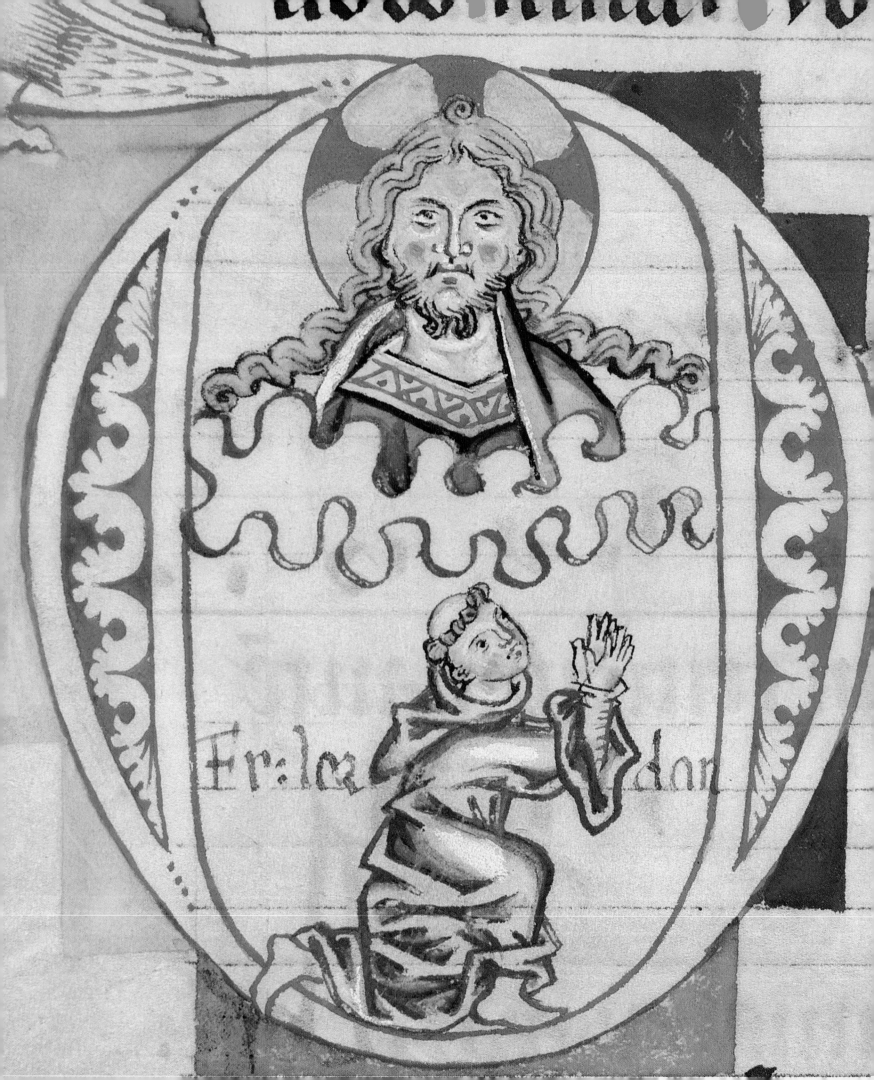

2

MAKING A REPUTATION: OBJECTS, FAME AND NOTIONS OF ART

THE TECHNIQUE OF THE late thirteenth- or early fourteenth-century English earthenware jug illustrated here (pl.29) imitates French examples, imported from Normandy. Its form, on the other hand, is unusual. The potter has adapted the vessel's baluster shape to that of a well-to-do lady, wearing a fashionable, pleated headdress and a ring-brooch.[1] While the jug is serviceable, neither its form nor its decoration – traces of shiny brown glaze and applied and incised elements on the body – is strictly functional. Even if the identity of the potter was of no consequence, the jug's survival testifies to its owners' appreciation of the potter's skill in producing a novel object.[2]

Three centuries later, the technical skill of potters and the novelty of their products were still admired. The aesthetic, however, was very different and the reputation of individual makers might now play a more decisive role. The ewer shown here (pl.30) was a special commission, part of a 272-piece service given to Duke William V of Bavaria by Francesco Maria II della Rovere, Duke of Urbino, in 1587. The ewer's painted motifs (including William's arms) on a white tin glaze exemplify the type of ceramic decoration, loosely based on classical models, which had made the potters of Urbino famous from the 1560s onwards.[3] Francesco's decision to patronize the Patanazzi potters was determined not only by local pride but also by the renown of the workshop abroad. William, for his part, was delighted with his gift, despite the fact that many of the pieces had broken by the time they reached Munich. As William's Italian agent observed, this was a minor matter. The service was for display, not for use, and so could easily be repaired.[4]

In the medieval and renaissance period, art, it could be said, lay in the eye of the beholder. It did not depend upon the inherent value of materials, nor always upon the identification of its skilled execution with a particular person or persons (see also pp.74–5).[5] Splendid and valuable materials attracted comment, but the viewer who praised an object as art also had to be attuned to elements

Leaf from an antiphoner (detail). See pl.47, p.71.

29. Jug.
Earthenware with traces of brown glaze, 34.2 cm high. England, *c*.1280–1320. V&A: C.50–1929

30. The Patanazzi workshop, ewer with the arms of the Duke of Bavaria.
Tin-glazed earthenware, 6.2 cm high. Urbino, 1586–7. V&A: 4693&A–1858

such as technique and the appropriate combination of form, function and decoration. This was a framework for appreciation that derived ultimately from Aristotle, who had argued in his *Politics* that a knowledge of drawing enabled children to judge the beauty of the human form.[6] The relationship between viewer and object was a two-way phenomenon: art brought honour to the person who owned or commissioned it, signalling intellectual discernment, social status and, if patronage was involved, the virtue of liberality and often piety as well.[7]

Art was also subject to changing fashions. Admiration for the works of the engraver and painter Martin Schongauer, for example, had earned him the sobriquet 'Hübsch Martin' at the height of his fame in the late fifteenth century; both *hübsch* and *schön* mean 'pretty' in German. Yet standards for aesthetic appreciation had altered some fifty years later. Hans Plock, an embroiderer from Halle in Saxony, revealed how perceptions of an artist's talent were constantly revised in the light of his

successors. Plock had pasted an engraving by Schongauer into his bible. In a note he made beneath the engraving around 1550, he explained that 'this image was judged in my youth to be the finest work of art to have come out of Germany; therefore I pasted it in my Bible, not because of the story, which may or may not be true [i.e. accurately portrayed]. However, once the unsurpassed engraver Dürer of Nuremberg began to make his art, this no longer holds.'[8] Plock's comment is as rare as it is revealing. Written sources that give a sense of what was thought to constitute a work of art and how it was appreciated are scarce, particularly from the medieval period. In part this reflects the rarity of any written evidence, but it is also due to the fact that earlier writers appear to have been unconcerned to expound theories of aesthetics at length.[9] With the onset of the fourteenth century, theorists increasingly considered the relationship between the artist's choice of composition and the appropriateness of this to the subject matter. By the sixteenth century, not only art, but artists themselves had become subjects for study and comment.[10]

Art also lay in the eye of the maker, whose aims and perspective were slightly different from those of the patron and observer. Although to some viewers the identity of the artist was unknown or unimportant, the evidence of many objects from both the Middle Ages and the Renaissance suggests that, for a number of reasons, makers were anxious to identify themselves in their works. This chapter will explore what art meant to those who made it: how it was a means to make a living, enhance a reputation and even, perhaps, win its maker a measure of grace before God. It will also consider the importance of the artist's relationship with his patron, a figure who could dictate and alter the way in which a work developed. The activities of both artist and patron were conditioned by attitudes and expectations that had their origins in classical and Christian thought, such as notions of decorum and social hierarchy.

'ART': SKILL, VIRTUE AND THE SOCIAL HIERARCHY

The word 'art' (in Latin, *ars*) appears frequently in the writings of early Christian and medieval theologians and fifteenth-century theorists. Its sense derived ultimately from Ancient Greek philosophy, and it was defined as a skill that required rational thought and which possessed a set of rules that could be taught.[11] Yet that broad definition could be subdivided to refer to those arts which required materials and manual labour and those which involved intellectual activity alone. The perceived extent of the intellectual input required for a task was highly significant because it determined the esteem in which the person doing the task was held and, by extension, his social status. Seneca stated bluntly in his *Epistolae* that 'philosophy has nothing to do with tools or anything else which involves a bent body and a mind gazing on the ground', an image which implies the unthinking activity of the slave.[12] A short dialogue composed by the second-century Greek Lucian of Samosata made the same point about the relationship between intellect, social status and manual labour with similar imagery and a lot more humour. Lucian imagined himself addressed by the allegorical figures of Sculpture and Culture, each of whom was trying to persuade him to make his career with them. Sculpture's very appearance was off-putting: she appeared as 'a working

woman of masculine appearance, with filthy hair and calluses all over her hands'. Culture, meanwhile, warned Lucian that if he decided to pursue a career as a sculptor he would be 'a slave… humble in every way… with never a single manly or noble idea'.[13] Perhaps unsurprisingly, Lucian chose to follow the intellectual charms of Culture.

This distinction between arts perceived as worthy and those that were not was preserved and transmitted to the medieval West in the work of the early fifth-century writer, Martianus Capella. In *The Marriage of Philology and Mercury*, a treatise that outlined the fundamental categories of learning for later generations of scholars, Capella applied the epithet 'celestial' to those arts that did not involve anything material. He excluded from this category such disciplines as medicine and architecture because they 'were concerned with mortal subjects and their skill lies in mundane matters'.[14] Others labelled the arts 'liberal' or 'mechanical'. Hugh of St-Victor, writing for his students at the abbey school of St-Victor, Paris, in the 1120s, based his distinctions on the authority of classical Antiquity. The term 'liberal' reflected the 'liberal and practiced mind' of the practitioner, and derived either from the intellectual subtlety involved in exercising the art or from the fact that in ancient society, 'only free and noble men were accustomed to study them'.[15] 'Mechanical', on the other hand, was a term which medieval etymologists had traced to the Greek and Latin for 'adulterer' (*moechus*), and the deception which that word implied was transferred to the mechanical arts, in their capacity to deceive through the ingenuity of their execution.[16] As Hugh explained (in another echo of the classical sources that provided authority for his words), the mechanical arts were the work of 'the populace and the sons of men not free'.[17]

The exercise of the intellect in the mechanical arts was not necessarily desirable from a Christian theological point of view. 'With what endless variety are designs in pottery, painting, and sculpture produced, and with what skill executed!', exclaimed Augustine, Bishop of Hippo (in modern Algeria), in his early fifth-century work, *The City of God*. Yet delight and admiration for the skilful creativity of a painter or a potter brought with it spiritual dangers, 'for at present', the bishop continued, 'it is the nature of the human mind which adorns this mortal life which we are extolling, and not the faith and the way of truth which lead to immortality'.[18]

Christian writers were also inclined to emphasize the material rather than the intellectual aspects of the artist's work because they were influenced by the idea that God was the ultimate source and authority for images and designs. The Bible provided suitable instances of this divine direction, for example, in the Old Testament account of God's instructions to the Israelites on the construction of the holy ark and tabernacle.[19] All the artists had done was to follow a heavenly template and act as a conduit of God's wisdom. The authorship of the Bible itself was seen in similar terms. The role of the human prophet, evangelist or disciple in the composition of the work was, at least according to some, reduced to that of unthinking amanuensis (pl.31).[20] Alternatively, the artist was limited to

31. *Saint Peter dictating the Gospel to Saint Mark.* Ivory, 13.4 cm high. Probably Syria-Palestine, 650–700. V&A: 270–1867

copying God's creations. Hugh of St-Victor distinguished between 'the work of God, the work of nature, and the work of the artificer, who', he concluded, 'imitates nature'. The very etymology of the word 'mechanical', with its connotations of deception, suited the negative assessment of artists as falsifiers of nature that still ran through the thought of Hugh and his twelfth-century contemporaries. If this ingenious imitation could be harnessed to the service of God and avoidance of sin, however, it was worthy of praise. Hugh also saw the (visual) arts as a vehicle to demonstrate man's God-given ingenuity and talent for producing objects necessary for basic human needs, such as shelter and clothing.[21] Hugh's near-contemporary Theophilus, author of a treatise on the arts of painting, glazing and goldsmithing, equally argued that the arts were gifts by which God provided man with the opportunity to labour in a virtuous way. He, too, saw that the skilful imitation of nature could pay homage to God's creation and move the viewer to greater adoration of the deity.[22]

Fifteenth- and sixteenth-century artists and commentators were more concerned with the status of the different branches of the visual arts (see p.63 below), though their distinctions were still based on the extent of intellectual or physical activity involved in producing a work. As had classical writers before them, they praised the role of artists' intellectual skills as much as their technical accomplishment. One of the speakers in Baldassare Castiglione's *Book of the Courtier* of 1528, a work on the virtues that noblemen and women should possess, asserts that the writers Petrarch and Boccaccio followed no mentors, but 'I believe that their true teacher was their own instinctive judgement and genius'. The same forces, he continues, guide contemporary painters such as Mantegna, Michelangelo and others, who 'are all outstanding; nevertheless they are all unlike each other in their work. So considered separately, none of them seems to lack anything, since each is perfect in his own personal style.'[23]

Bound up with the perceived relationship between the practice of the different arts and social class were issues of moral value. In his *Politics*, Aristotle defined as 'vulgar' (i.e. something belonging to the low-born) any task, art or science that rendered the body, soul or mind of a free man useless for the 'employments and actions of virtue'.[24] The arts, therefore, could also be categorized according to moral worth. Seneca, for example, excluded painters (along with perfumers and cooks) from the list of those who practised worthy arts, because their activities provoked luxurious, and therefore unvirtuous behaviour.[25]

Complementing Aristotle's idea that the practice of an art should be an exercise in virtue was the equation between physical beauty and a state of moral grace. It was an equivalence stressed by twelfth- and thirteenth-century ecclesiastical commentators. William of Auvergne's 1228 treatise on the nature of good and evil argued that the goodness of the human soul manifested itself in the beauty of the person's external features (see also Chapter Seven).[26] The ultimate example of this correlation was, of course, God himself. 'God is the most perfect perfection, the fullest completeness, the most beautiful form and the most splendid beauty,' wrote William's contemporary, Robert Grosseteste, Bishop of Lincoln.[27] That said, moralists and churchmen were also wary of beauty, because it could mislead and distract (see Chapter Five). Indeed, sometimes it was an ugly, tortured

appearance that was the shining indication of spiritual virtue. Christ's bleeding and anguished body on the Cross, for example, was proof of his holiness.[28] An image of the crucified Christ, made in 1305 for the chapel of Conyhope, near the parish church of St Mildred, Poultry, in the City of London, was adored by the chapel congregation. But it was described as 'terrifying' (*horribilis*) in a contemporary chronicle and was removed by the church authorities, in part because its ugly appearance did not suit their notions of decorum.[29]

Such equivalences could also influence perceptions of the person who made an object. From the tenth to the thirteenth centuries in particular, the moral goodness inherent in a beautiful work was considered an automatic reflection of the moral virtue of the person who had created it.[30] Tuotilo, a tenth-century monk from St Gallen who worked as an ivory carver, goldsmith, painter, musician and poet, was renowned not only for his artistic skill but also for his goodness. The historian Ekkehart, recording the deeds of famous monks over a century later, tells how these qualities were miraculously endorsed by the Virgin Mary (see p.63 below).[31] The effect could rub off on patrons, too: another eleventh-century chronicler deduced that William of Passavant, Bishop of Le Mans, was a beautiful man because he had beautiful buildings built.[32]

By the late sixteenth century, however, writers were complaining that artists were setting themselves apart from the rest of society not by their skill and virtue, but by their shocking behaviour and pretensions. Concern over this focused not on the moral implications for their work, but on the impact such activities had on its quality. Giovanni Battista Armenini, himself a painter, warned in his 1587 treatise on the rules of painting that 'artists must keep away from the vices of madness, uncouthness and extravagance, nor should they aim at originality by acting disorderly and using nauseating language.' Such behaviour, he concluded, was completely profitless.[33]

Armenini's warning to sixteenth-century artists suggests they were quite a different breed from the lowly workers described by Aristotle and Seneca, or the industrious, self-effacing ideal envisaged by Theophilus in the twelfth century. To some extent, this was true, although the image of the artist as eccentric or different from his fellow men because of an uncontrollable need to create had its roots in Pliny the Elder's pen-portraits of Greek and Roman painters. The fourth-century Greek artist Protogenes, for example, was said to have eaten only soaked lupin seeds while painting because they were an appetite suppressant.[34] By the sixteenth century, Pliny's sketches had become a literary genre in their own right. The publication in 1550 of the first edition of *Le Vite delle più eccellenti pittori, scultori ed architettori* (The Lives of the Most Excellent Painters, Sculptors and Architects) by the painter Giorgio Vasari was the most significant example among a growing body of biographical and autobiographical literature on artists. Vasari's aim had been to ennoble the status of the artist and his endeavour was echoed by others.[35] The popularity of such writings appears to have fuelled expectations among non-artists about the behaviour of painters and sculptors. Armenini argued that the brutish gestures he condemned were encouraged by a belief among the common people (and shared by the learned) that any outstanding painter naturally displayed such traits.[36]

CREATORS AND CONTRACTS

Throughout the Middle Ages and into the Renaissance, there was no single group of people known as 'artists'. Instead, the makers of objects were referred to by their skill in working particular materials: enamellers, embroiderers, potters, glaziers, and so on.[37] They might labour in urban workshops, or in monasteries and convents.

The formal organization of skilled labour required specialization and regulation to ensure quality and distribution, and is discussed in detail in Chapter Three. Within this organization there was also a hierarchy of intellectual authority. The supreme artist in the Christian world was, of course, God, who had created not just the earth and the heavens, but mankind as well. Many writers referred to him as *summus artifex* or 'most perfect maker'.[38] Other depictions and descriptions were more specific. God was sometimes represented as the divine architect, holding a pair of compasses in accordance with descriptions found in the Old Testament.[39] God was also a worker of clay, who had moulded the first man from earth: in a sixth-century sermon Augustine described him as the 'heavenly potter' (*figulus caelestis*).[40] Sixteenth-century writers, influenced by contemporary debates on the nobility of different branches of the visual arts, preferred to designate him a sculptor instead.[41]

God's role as author and director of man's works, meanwhile, was paralleled on earth by the relationship between patron and artist and, further down the scale, between workshop supervisor and employee. This hierarchical arrangement rested on the presumed degree of intellectual involvement in the work, rather than the extent of labour in its execution. The author of the work might be the patron who provided the plans and funding or the head of the workshop who provided designs and employment, not the apprentices who carried out the mechanical task of making the objects.[42] These relationships were often formalized in contracts.

All types of object – paintings, pots, lengths of cloth and chests – were made in workshops and could be bought ready-made. If the people who required them were wealthy, however, they could commission the relevant craftsmen to make the object especially. This often required a written contract, which could be explicit about the composition of a painting, the designs on a set of tiles or the materials to be used. Contracts were also careful to specify the individuals who were to carry out a particular work, to ensure the quality of its execution and completion and, sometimes, to avoid a particularly famous artist being poached by another, more powerful, patron.[43] Finally, contracts could be used to match materials and subject matter with price. Designs, especially when they involved narrative scenes, were often broken down into individual components. Leonardo da Vinci, when drawing up an estimate for the decoration of a room in a Milanese palace, listed separate prices for painting 'four philosophers', 'twenty-four Roman stories', and various pilasters in blue and gold.[44]

Although artists frequently complained they were not being paid enough, some contracts explicitly provided for additional payment if the work was considered exceptional.[45] A contract drawn up in 1501 between the parish authorities of the church of St Jacob, Rothenburg (southern

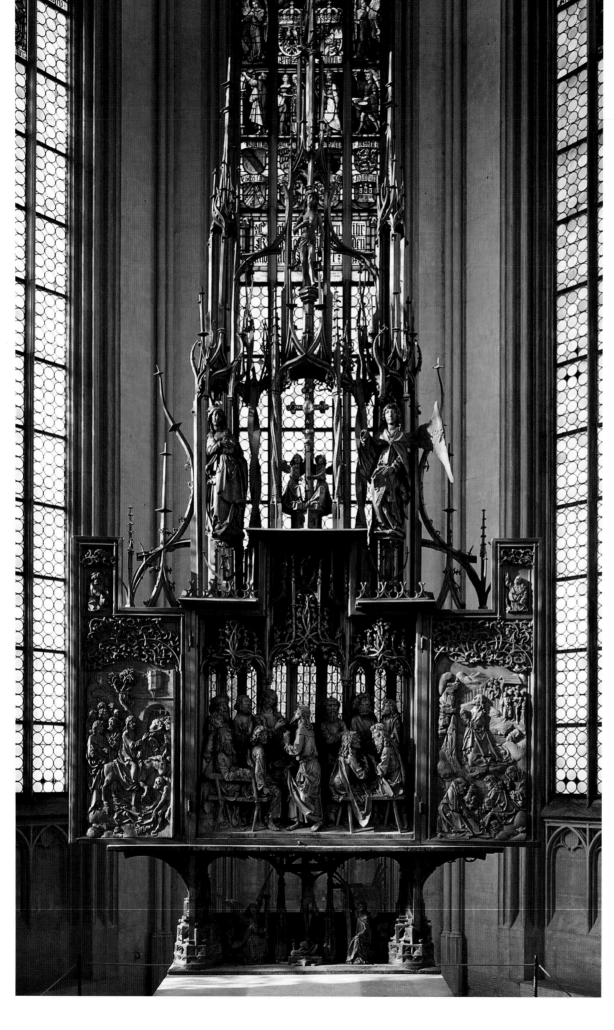

32. **Tilman Riemenschneider, the Holy Blood Altarpiece.** Limewood, *c.*9 m high cm. Rothenburg (Germany), 1501–5. Jakobskirche, Rothenburg

33. **Tilman Riemenschneider,**
Two Angels holding Candlesticks.
Limewood with traces of paint,
each 64 cm high. Würzburg
(Franconia, Germany), c.1505.
V&A: A.16, 17–1912

Germany) and the Würzburg sculptor Tilmann Riemenschneider required him to carve (but not paint) an altarpiece for the church in return for 50 Rhenish guilders (pl.32). If 'at the time of the placing and installing of the figures in the shrine, it should become manifest that Master Till made the reliefs and figures in such a way as to merit more than those fifty guilders, the matter shall be judged by the… commissioners'. In the event, Riemenschneider received an additional ten guilders as part of the final payment for his work in January 1505, so his carving clearly impressed the authorities.[46] The two kneeling angels holding instruments of Christ's Passion at the base of the altar are similar in style to a pair now in the V&A (pl.33).

Patrons frequently supplied their own designs for painters to copy. In Valencia in 1411, the pottery painters Sancho Almurcí and Mahomat Alcudo were contracted to make 1,200 tiles with different images of trees on them after designs supplied by Francisco, a cloth merchant from Lorca.[47] There is no longer any trace of Francisco's sketches or his finished tiles, but many other drawings of a contractual nature do survive. A number show the relationship between the designer and those who were to carry out his instructions. In Venice in 1578, the carpenter Andrea da Faenza and the carver Francesco da San Moisè signed a contract with the painter, engineer and cartographer Cristoforo Sorte. Andrea and Francesco were to build a new ceiling for the Senate room in the Doge's Palace according to Sorte's design (pl.34). The large paper sheets that bore the sketch they were to follow were also the contractual document, which equally bound Sorte to provide Andrea with the measuring tools that would ensure he achieved the correct dimensions.[48] The shifting nature of contracts as a result of institutional politics is evident in a complaint that Sorte put to his employers

34. **Cristoforo Sorte, design for the ceiling in the Doge's Palace.** Pen and ink and wash on paper, 86.5 × 45.7 cm. Venice, 1578. V&A: E.509–1937

in 1582. He protested that the Senate secretary had subsequently insisted another carver do the work, and that he had 'failed to abide by his obligation to make cartouches with a figure within them on the frieze… and he [had] not made the foliage on the frieze according to the drawings'. A letter of 1596 revealed that holes had been punched into the ceiling to let out smoke.[49]

This emphasis on the creative role of patrons over that of the artists is also found in written appreciations by third parties. Felix Faber, describing the progress of the construction of the cathedral of Ulm, in southern Germany, explained how 'the spectators admire not so much the huge structure as they do the high-mindedness and courage of the founders who… dared to erect… such a grand edifice'.[50] Even though the spectators' amazement was principally born of the disparity between the town's small size and the project's colossal expense, Faber's assessment reveals the extent to which intellectual and social prestige were given to the patron rather than the artist he employed. It was a point not lost on those who made the works themselves. One of the anonymous compilers of a thirteenth-century chronicle of world history made for Alfonso X of Castile noted the disjuncture in (appropriately) a gloss to Peter Comestor's discussion of Moses's role as author of the Ten Commandments. Inspired perhaps by Peter's affirmation in his *Historia scholastica* that God was the author of the text and Moses merely his instrument, the glossator commented that 'the king makes a book not because he writes it with his hands, but because he composes its arguments'. Similarly, he added, kings can be said to 'make' palaces because they order them built and provide the materials, not because they engage in physical labour. 'We thus, I see, are accustomed to speak.'[51]

NAMES ON WORKS

These contractual obligations, divisions of labour and hierarchies are sometimes reflected in the names that appear on works. The eight names on an illuminated Byzantine manuscript known as the Menologion (a chronological account of saints' lives) of Basil II almost certainly record the extent of the work carried out by each artist for the purpose of payment.[52] It was more usual, though, for credit for the work's production (in the sense of its conception rather than execution) to be assigned to the patron. Enamelled crosiers set with gems or paste imitations were fashionable in fourteenth-century Europe and were produced in quantity by specialist workers. The inscription wrapped around the base of the staff head illustrated here (pl.35), however, makes no reference to the artists. Instead it records the fact that the crosier was made for Reichenau Abbey in 1351, while the names of the abbot, Master Eberhard of Brandis, and the treasurer, Master Nicholas of Gutenberg, suggest their role in commissioning the piece. The two small figures shown in prayer to the Virgin are almost certainly Eberhard and Nicholas as well; their presence reflects their piety and role as patrons, their positioning their status relative to one another. Eberhard, as head of the abbey, is depicted closest to the Virgin; Nicholas is further away and lower down.

Some patrons, however, required artists to refer to themselves in their commissions.[53] A work that was clearly attributable to a famous artist reflected well on the patron's discernment and wealth, particularly if the patron's name appeared too. The name of the sixth-century Frankish patron of a bronze reliquary is found in the border inscription, next to that of the artist: 'Long live Tonancius and me, Maximus, who made it, I made it well.'[54] In the case of monumental and tomb sculpture, naming the artist helped assert dynastic importance.[55] Such is the case of a tomb monument to Bishop Jean d'Asside, erected a year or so after his death in 1169, in the cathedral of St-Étienne-de-la-Cité, Périgueux (western France). The brief statement 'Constantin de Iarnac made this work' is inscribed just below the tomb's roof and just above the inscription that refers to the bishop himself, although in slightly smaller lettering.[56] Its presence suggests not only the value that his patrons put upon his work but also the admiration they anticipated it would attract from later viewers.

An artist's self-reference was not always, or even exclusively, added at the behest of a patron. Names, often condensed into marks and monograms, were also added to an object to guarantee the quality of materials and workmanship, as well as signalling that a piece had been made and inspected by the relevant guild and government authorities, who used their own marks. The work of goldsmiths provides an obvious example, because the purity of the gold and silver they used needed to be verified and the maker traceable. The practitioners of other arts, such as manuscript illuminators, were equally required to mark their works with a personal symbol for (among other reasons) purposes of professional identification.[57] The long-running dispute between manuscript illuminators and painters in fifteenth-century Bruges was the result of the former usurping activities that traditionally had fallen within the remit of the latter. The illuminators painted pictures on single sheets of parchment, yet remained members of the bookmakers' Guild of Saint John.

35. **The Reichenau Crosier (detail).**
Gilded copper, with silver and enamel, set with paste gems, 59.8 cm high. Germany (probably Constance), 1351. V&A: 7950–1862

36. **Jacob Marquart, tableclock and sundial.**
Brass and iron, damascened and partially gilded, 21.5 × 21.5 × 10.4 cm. Augsburg, 1567 (dial replaced c.1700). V&A: 9035–1863

To resolve the conflict, they were required to register with the painters' guild and identify their works with a sign. Such signs included initials, flowers, keys and more abstract designs.[58]

Contractual and legal obligations aside, artists had other, personal, motives for reflecting themselves in the works they made. The German nuns who embroidered their names around an enormous hanging depicting the allegorical figure of Philosophy were using their art as an offering to God and a memorial that would act as an example to their successors (see pp.78–9). The way in which artists – those who engaged in a mechanical art – sometimes presented themselves in their works suggest not only their attitude towards their own oeuvre but also their perception of their activities in the wider context of the social hierarchy. Their own personal standing before God and before other men was inextricably bound up in their work.[59]

An artist's intellectual authority and aspirations were not only expressed on objects made for a particular patron. They could be recorded on more or less expensive objects made for a more general market. The clock-maker Jacob Marquart, whose patrons included the Emperor Maximilian II, added a lengthy rhyming inscription in German around the edge of one of his instruments (pl.36, and pl.124, p.165): 'Jacob Marquart of Augsburg I am named. My name as maker in 1567 is well known in foreign lands. The instrument is termed a sundial, recognized in foreign and German lands.'[60] Marquart's

37. Martin Schongauer,
Virgin and Child.
Engraving, 16.6 × 12 cm. Colmar,
c.1474. V&A: E.674–1940

emphasis on geography suggests the extent of his personal renown but may also have had the practical purpose of promoting Augsburg-made goods abroad: the device may have been intended for export.[61] The trade in objects made by artists and their workshops was increasingly an international one (see p.102), and Marquart would have taken advantage of this. His use of German rather than Latin in the inscription underlines his pride in his Augsburg origins, although it would have limited the number of viewers who could understand it. Albrecht Dürer, the earlier Nuremberg painter and engraver, had also specified his country of origin in works carried out for Italian patrons, referring to himself in Latin as 'Germanus'. It was an emphasis designed to affirm the talent of a Northern European working in Italy, and to distinguish him from its indigenous artists.[62]

The signing practices of goldsmiths particularly influenced fifteenth- and sixteenth-century printmakers, as engraving is a metalworking technique and many engravers had trained as goldsmiths, or moved in goldsmiths' circles. They were therefore familiar with the concept of marking a work to denote the quality of the metal and the identity of the master smith, and transferred the practice to the much less valuable medium of paper.[63] Martin Schongauer, although not a goldsmith himself, was the son and brother of goldsmiths.[64] This may explain why he was the first engraver to consistently sign his prints with a monogram, engraved (and sometimes punched) into the plate. Schongauer also extended the representational possibilities of prints, varying the density of shading and incorporating areas of dotting and fine, hatched lines to give new depth and modelling to the figures he engraved (pl.37).[65] By consistently adding his monogram to his prints, Schongauer may have wished to connect his name with these graphic techniques in the viewer's mind, and thereby advertise his personal skill.

For others, signing was an opportunity to proclaim their social standing. After 1508, Lucas Cranach the Elder dispensed with his 'LC' monogram on paintings and engravings from his workshop, and substituted for it the motif of a crowned, bat-winged serpent with a ruby ring in its mouth.[66] This was the device which his patron, the influential Elector of Saxony, Frederick the Wise, had given him in recognition of his achievements. Perhaps paradoxically, its symbolism reflects Cranach's physical skill rather than his intellectual talent in at least one respect, namely his ability to paint at great speed. According to twelfth- and thirteenth-century bestiaries, winged serpents were the fastest of all creatures, and the belief was still current in Cranach's day.[67]

Artists in other media could also proclaim their social status, although they may not always have done this as consistently as Cranach. The fourteenth-century sculptor Wölflin de Rouffach (or Strasbourg) may have been required to add his name to the tomb he made for Ulrich de Werd, Landgrave of Alsace, in 1344, but the wording was perhaps his own choice: 'Master Wœlfelin von

Ruffach, a burgher of Strasburg, made this work.'[68] By proclaiming himself a 'burgher', Wölflin declared not only his local loyalties but also his membership of the town guild of sculptors.

Yet not all Wölflin's works were signed in this way or, indeed, signed at all, and the same is true of works by others. This suggests that the artist's own perception of the intellectual value of a work could also determine the presence or absence of a signature. Around 1455, the Florentine sculptor Donatello designed a bronze statue of the Old Testament heroine Judith decapitating the Assyrian general Holofernes, who had laid siege to her town (see pl.38).[69] According to Giorgio Vasari, Donatello had not hitherto signed his works, but he was 'so satisfied with this work that he wanted to put his name on it'.[70] Donatello's inscription in Latin on Holofernes' pillow proclaims the statue 'the work of Donatello of Florence', although his involvement in the finished object was intellectual rather than manual: he designed the figure but did not carry out the extraordinary technical feat of casting it himself.[71]

Perhaps a similar sense of satisfaction, possibly allied to the desire to impress a patron, explains François Briot's decision to sign a cast pewter dish depicting the allegorical figure of Temperance (pl.39A). It is the only known work to bear his name. Briot worked as a modeller and designer at the court of Frederick I, Duke of Württemberg in the late sixteenth century. The dense, learned imagery of this display dish is focused on Temperance, in the centre, and it is at the foot of the bench on which she sits that Briot has added his initials, 'FB'. On the reverse of the dish, directly behind this scene, is a roundel which contains a profile portrait of Briot, above which runs a Latin text, 'SCVLPEBAT FRANCISCVS BRIOT' (Francis Briot was sculpting [this]) (pl.39B).

Briot's profile recalls contemporary portrait medals and the Ancient Roman coins that were their inspiration. By setting it into the back of the dish, Briot echoes the contemporary fashion for setting Roman coins into vessels, thereby reinforcing the message that his own work should be similarly prized and displayed by erudite collectors.[72] Moreover, he is not depicted with the tools of his trade, but wears a cuirass to suggest that he is of a higher status, and one who combines the intellectual aspects of his art with the skills of a noble warrior.[73] Briot's choice of verb, 'to sculpt' is also revealing, connected as it is to notions of the hierarchy of the arts (see pp.63, 65) and implying a combination of intellectual skill and manual dexterity. (Briot did not, though, cast this dish from the mould he had made and maintained a distance from the finished object that was appropriate to his image as an intellectual.)[74] Briot's use of the Latin imperfect tense – 'was sculpting' – in the inscription also implies his classical learning and, indeed, his connection with classical sculptors and painters. These, according to Pliny, had phrased their signatures in this way to suggest their works were in a constant state of evolution towards perfection.[75] Briot's dish, then, is a brilliant example of an object designed to celebrate the skill of its designer through a series of references to classical ideals about art and the practice of making it.

38. **Donatello,**
Judith and Holofernes.
Cast bronze, 236 cm high.
Florence, 1460.
Palazzo Vecchio, Florence

39A. **From a mould by François
Briot, dish with the figure of
Temperance.**
Cast pewter, 45.1 cm diameter.
France (probably Montbéliard),
c.1585. V&A: 2063–1855

39B. **Dish with the figure
of Temperance** (detail of the
reverse, with a portrait of the
designer Briot).

HIERARCHY IN THE ARTS: MATERIAL, SKILL AND ORIGINALITY

The emphasis placed on the intellectual aspects of an artist's work rather than the mechanical, physical process of its execution informed a perceived hierarchy of materials and techniques. Although this appears to have been a concern throughout the period, the surviving sources show it becoming progressively more nuanced from the twelfth century onwards. The criteria for this hierarchy varied according to writer and period.

Not surprisingly, gold was regularly cited as the most noble material. Thus, Theophilus' twelfth-century treatise is structured to conclude with works in gold, because they are the most precious. He also recalls their association with Solomon: the Old Testament King David 'desired the embellishment of the material House of God… and entrusted almost all the needful resources in gold, silver, bronze and iron to his son Solomon'.[76] These factors aside, however, Theophilus does not refer to any intellectual engagement on the part of the goldsmith, or indeed of the painters and glaziers whose work he also discusses. Instead, they are all equally noble because all three combine to furnish God's house and honour his name.[77] Sometimes admiration for the material would be

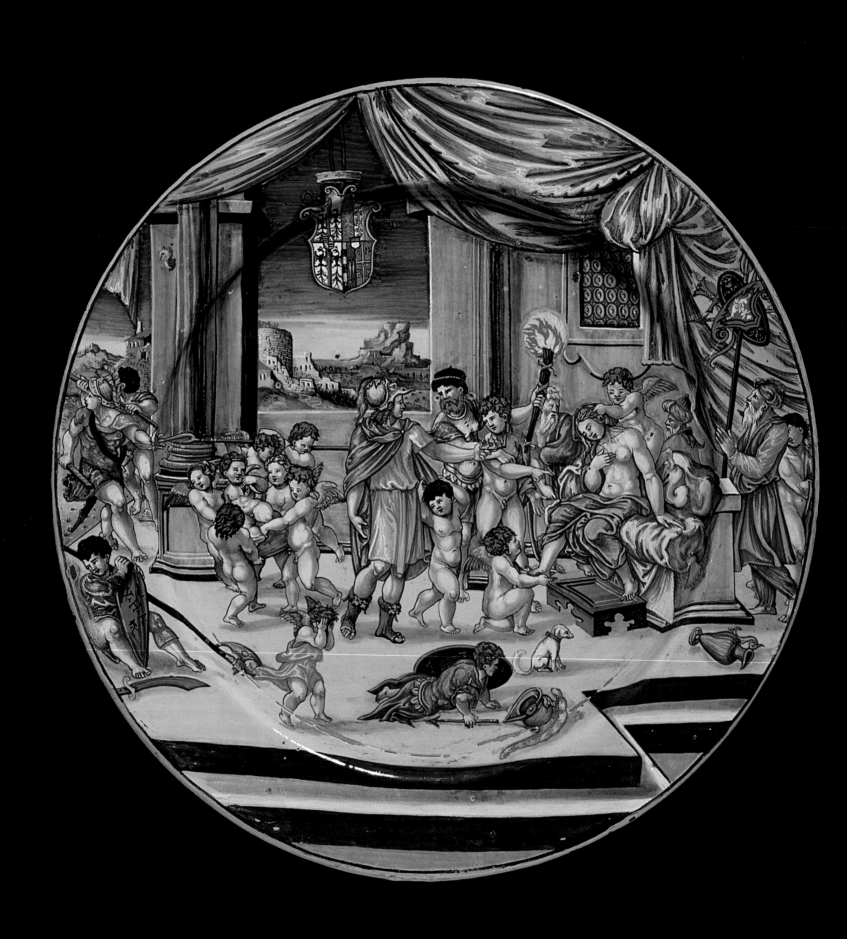

40A. Francesco Xanto Avelli, dish showing the Marriage of Semiramis and Ninus.
Tin-glazed earthenware, 46.9 cm diameter. Urbino, 1533.
V&A: 1748–1855

40B. Dish showing the Marriage of Semiramis and Ninus (reverse, showing inscription and the signature of the maker Xanto).

combined with appreciation for the artist. Writing in around the mid-thirteenth century, Matthew Paris, monk and chronicler of the abbey of St Albans, praised a small pyx made by the goldsmith Master Baldwin. In this piece, he claimed, Baldwin's skilled workmanship surpassed the gold and jewels used to make it. It is not clear, however, how far Matthew's praise was directed towards the artist's intellectual contribution to the work; indeed, assessments in such terms seem to have been something of a cliché.[78]

A century later, the French legal scholar and papal aide William Durandus, writing on the appropriate decoration for a church interior, implied that at least a degree of intellect as well as mechanical activity was an element in painting, allowing that a painter was free to depict Old and New Testament scenes as his imagination saw fit.[79] To prove his point, he cited (but did not acknowledge) a pagan authority, Horace, who in his *Ars poetica* had granted painters and poets equal daring in their creative talents.[80] In a Christian context these acts of creativity were at times even believed to be divinely inspired. A number of miracle stories associated with the Virgin Mary and other saints recount the visionary experiences of painters, sculptors and goldsmiths moved to make a beautiful effigy or offering for a church.[81] For example, witnesses described how a woman of dazzling appearance handed the artist-monk Tuotilo (see p.52 above) his chiselling tools and showed him how to continue his work. She later identified herself as the Virgin.[82]

Durandus was not concerned to argue a broader, intellectual status for the arts of painting, sculpture and metalworking but fifteenth- and sixteenth-century artists and scholars were. They focused particularly on the distinction between sculpture and painting, and looked to classical authorities such as Horace, Pliny and Lucian to support their arguments. Their debates now survive only as written texts, although sculptors and painters almost certainly addressed them through objects as well.[83] Leonardo da Vinci, for example, argued in the 1490s that painting was superior to sculpture because it involved less manual effort, and that a painter's skill was superior to a poet's because brush strokes could express the infinite workings of his imagination, whereas the poet's stock of vocabulary was a limited one.[84] His arguments were labelled *paragone* (literally 'comparison' in Italian) by a nineteenth-century editor, and the term now also refers to the mid-sixteenth-century debates on the matter that followed in his wake.[85]

According to other commentators, painting was arguably better than sculpture because its use of colour offered the most realistic way of recording the natural world.[86] Durandus, too, had recommended the naturalistic depiction of leaves and flowers to decorate church interiors, though to him their function was to be a symbolic reminder of the virtue of good works.[87] Later scholars had a different agenda: to argue that the use of colour elevated the status of the practitioner from mechanical craftsman to skilled intellectual. Fifteenth-century writers such as the Italian scholar Poliziano drew on arguments marshalled by classical figures such as Philostratus the Elder to argue that painters could use colour to depict landscapes, the weather, a person's expression, or the vivid effects of light and shade. In short, painting illuminated 'hidden things', whereas sculpture did not, and could not.[88] Arguments such as these explain Francisco de Holanda's comment in his 1549

treatise on painting that painters performed 'the greatest [task] that men could do' when they imitated the world around them.[89]

Painters who applied their art to smaller objects were also concerned to stress their intellectual abilities. The maiolica painter Francisco Xanto Avelli traced painting's source to nature, but at the same time proclaimed his identity as a poet. By so doing, Xanto sought to promote his imaginative skill and his status alongside painters who worked on a much larger scale.[90] He wrote his name on many of the maiolica vessels he painted, often adding an explanation of the scene depicted on the other side. In the example shown here (pl.40A, B), image and text relate to two different scenes. The painting foregrounds the marriage of Semiramis to the Assyrian king Ninus, while the verses on the back refer to the revolt of the Babylonians that took place after Ninus' death.[91] Although the text is credited to the Roman historian Pompey, in fact the lines derive from Petrarch's *Trionfo della Fama* (Triumph of Fame). Xanto's confusion is curious, although the conflation of stories may have been intended to show off his erudition and ingenuity, and his use of the work of one of Italy's most renowned fourteenth-century poets perhaps reflects his own pretensions.

Significantly, the sources for Xanto's painted scenes derived from woodcuts and engravings. The central group on the dish, for example, is based on the Italian engraver Caraglio's copy of a work by Raphael.[92] This was not unusual. Painters, embroiderers and carvers had long derived iconography for narrative and non-narrative scenes from sources as diverse as literary accounts and textiles (see pp.80–81). The woodcuts in early printed books, and sheets of printed motifs, offered an alternative fund of designs that, by the nature of their production, could be widely and quickly circulated (pls 41, 42). Not everyone agreed that such cutting and pasting of visual sources was a sign of intellectual skill. A painter once showed Michelangelo a scene he had executed in which the details were copied from various drawings and pictures. According to Vasari, Michelangelo's wry comment was that the painter had 'done very well, but when the Day of Judgement arrives and all the bodies take back their own parts, what will become of this scene when nothing is left?' Vasari underlined the intellectual point: 'This was a warning that those who work in the arts should learn to do their own work.'[93]

Nevertheless, an artist's deliberate citation of visual motifs from the works of a contemporary could be at once a form of tribute and a sign of rivalry. Lucas Cranach the Elder reworked elements from a composition by a much-praised Bolognese contemporary, Francesco Francia.[94] In this way he demonstrated his own ability skilfully to recontextualize the work of another successful painter. He also flattered his viewers by giving them the opportunity to recognize such a borrowing.

The proliferation of writings about art in the fifteenth and sixteenth centuries which continued

these debates about material and hierarchy, imagination and imitation was supplemented by biographies of artists and, indeed, artists' autobiographies. Leonardo, for example, was the subject of a brief biography in 1527, but it was Vasari's *Vite* that was to prove most influential. This text (revised and republished in 1568) harmonized the supposed differences between painting and sculpture by arguing that the intellectual and technical skill for both were united in the figure of the man he considered to be almost divine in his creative abilities, the Florentine Michelangelo Buonarroti.[95] Indeed, so successful was Vasari in fostering Michelangelo's reputation that, according to the rather less successful Neapolitan painter and antiquarian Pirro Ligorio, 'so as to appear as excellent as was Michelangelo Buonarroti [his emulators] put on a hat and short boots with shoes over them and have bushy eyebrows under the shaggy hat to imitate his knowledge, as if that were in the hat or boots.'[96]

As well as changing perceptions of the figure of the artist, these debates and other writings raised questions about how the genius they transmitted to their works should be defined. It was an aspect which was referred to as *ingenium* in Latin, or, as the term was translated into Italian, *ingegno*.

IDEAS OF INGEGNO

Around 1554, the Mantuan painter Filippo Orsoni bound up his designs for armour, perhaps with a view to having them published, and prefaced them with a short Latin poem (pl.43).[97] His verse prologue is essentially an advertisement of his skills to prospective clients rather than a model of poetic style, but the ways in which Filippo claims to surpass the Ancient Greek painter Apelles reveal a broader conception of the artist's talents which emerged in the fifteenth century:

> If you wish to learn the varied forms of arms,
> And the splendid [new] ornaments of the warrior,
> Then see the wonderful drawings of Filippo Orsoni,
> Whose skilled [*docta*] hand has lent them life and colour.
> Arms such as not even Vulcan devised for gods or men,
> …
> Every age will marvel how his hand
> has excelled in the art of Apelles.[98]

Tellingly, Orsoni claims his painted armour designs are superior to those invented by Vulcan, god of fire and metalworking who, by

43. Filippo Orsoni, album including 306 designs for armour and weapons.
Ink and wash with yellow watercolour, 44 × 30.1 cm. Mantua, c.1554. V&A: E.1725–1929

implication, is linked to mechanical rather than intellectual arts. On the other hand, Orsoni's own physical involvement in drawing the designs does not carry with it negative ideas of the mechanical. Instead, his drawings reflect the many and varied workings of his imagination. It is important to note that Orsoni's drawings are not spontaneous sketches, but carefully considered illustrations: the workings of the imagination could not be set down in too summary a fashion, otherwise they would lack the requisite element of skill.[99]

Orsoni's stress on his imagination and on his hand as the instrument that translated it into visible drawings was a pairing that had its origins in the fourteenth century, in Petrarch's praise of the works of his contemporary, the painter Giotto. Giotto, wrote Petrarch, combined manual dexterity and talent (*manus et ingenium*), and *ingenium* (in Italian, *ingegno*) came to stand for artists' imaginative skill, technical prowess and ability to lend their works the illusion of living reality.[100] It was a term adopted across Europe and although it was often used in the context of particular individuals or works, it could also be applied to artists and objects outside the Western tradition. In his diary Dürer, admiring the work of Mexican goldsmiths and weavers which the Emperor Charles V had put on show in Brussels, 'wondered at the subtle ingenuity [*jngenia*] of people in foreign lands'.[101]

As Orsoni's prologue demonstrates, *ingegno* also involved a certain amount of rivalry with the ancient world. The fifteenth century was well acquainted with Pliny's account of two Greek painters from the fourth century BCE, Apelles and Protogenes. In this tale of artistic rivalry, Protogenes recognized Apelles' work not by any identifying symbol or name, but by the skill and finesse with which he executed a single line in paint.[102] Stories such as this one stoked the ambition of fifteenth- and sixteenth-century artists to emulate and, indeed, surpass, the work of their classical forebears. They were particularly well-placed to do so. Not only were new editions of Greek and Latin texts increasingly available, but there was great interest in the excavation and study of ancient sculptures, gems and coins. Rome in particular was the scene of much archaeological activity: as Roman remains, notably statues, were unearthed, artists and collectors, armed with knowledge gleaned from their classical readings, were able to identify them. When the marble sculpture depicting Laocoön, the Trojan priest, and his two sons being crushed to death by two giant serpents was brought to light in a Roman vineyard in 1506, its subject matter was immediately recognized. 'This is the Laocoön that Pliny had mentioned,' exclaimed the architect Giuliano da Sangallo. Once it had been uncovered, both he and Michelangelo began to draw it, discussing the antiquities of Rome and Florence as they did so.[103] Vasari records how the young Michelangelo carved a life-size figure of a sleeping Cupid which contemporaries judged could pass 'as an ancient work' if the marble were treated to make it appear aged.[104] Dürer was said by Erasmus to excel Apelles in skill because, while the Greek painter used colour to give his paintings their realistic appearance, Dürer vividly represented the world using only black and white lines. 'He who would spread colours on Dürer's prints', concluded Erasmus, 'would injure the work.'[105] Dürer's genius was such that he could dispense with classical ideas about realism and colour.

APPRECIATING ART AND ARTISTS

Suitability to its context, function and owner – in other words, decorum – was a constant consideration in the assessment of any object, whether sculpture, painting or delicately wrought metalwork (see also Chapter Five). This was true not only in the context of the Christian Church, where writers such as Archbishop Durandus and, in the fifteenth century, Antonino, Bishop of Florence, emphasized the role of the arts as a reflection of the glories of God's creation. Vasari's bitter rival Pirro Ligorio also argued that a work should be appropriate to its context and reflect the order of the natural world. Among the errors against nature perpetrated by painters, he cited 'small rivers navigated by large boats like those of the sea which are not fit for rivers'.[106]

The art of its maker was secondary to the social messages an object transmitted about its owner. Bernard Palissy, the late sixteenth-century French potter, observed that if things kept in the houses of princes and lords were to circulate among the common people, 'they would be held in less esteem than old kettles', and his view would have found an echo in earlier centuries.[107] In 1284, Sancho IV of Castile inherited from his father a collection of gem-set crowns, rings and cameos, objects which were described in the bequest as 'noble gifts that belong to kings'.[108] Cameos and carved gems were still prized in the sixteenth century, by which time their status as symbols of wealth and nobility had been supplemented by appreciation of them as indicators of an artist's *ingegno*.[109] Thus Valerio Belli demonstrated his learning and technical skill by carving the hard surface of rock crystal with a scene that almost certainly reworks one from a Roman gem or cameo (see p.257).

An artist's efforts to demonstrate *ingegno* naturally required the reciprocal admiration of a cultured viewer. The extent to which these efforts were at the mercy of the viewer's own agenda are indicated in Vasari's two accounts of how Michelangelo came to sign the marble Pietà he sculpted for St Peter's Basilica, Rome. Carved along a band that runs across the Virgin's breast, the words 'MICHAEL. ĀGELVS. BONAROTVS. FLORENT. FACIEBA[T]' represent the first and only signature that Michelangelo added to his work. In the first edition of his *Vite*, Vasari rather disingenuously explained this as a sign that the artist was satisfied and pleased with his work. By 1568, when the second edition of the *Vite* appeared, Vasari had received additional information from an anonymous correspondent. It seems that visitors from Lombardy had admired the Pietà but had attributed it to a fellow Lombard, so Michelangelo corrected their misconceptions by adding his name (and birthplace) to the statue that same night.[110] Vasari's second account of the signature reinforces his image of Michelangelo's genius while simultaneously reproaching the ignorance of those who had failed to recognize it. The unknown correspondent, on the other hand, provides a prosaic analysis intended to reinforce the veracity of his story: 'And this is the reason behind the writing of these letters, which truly one can recognize had been done at night and practically in darkness, as they are not finished.'[111] Vasari does not comment on Michelangelo's use of the imperfect tense, '*faciebat*' (was making), which suggests the signature was also a self-conscious reference to classical predecessors (see also p.60 above). By truncating the verb, Michelangelo emphasized the conceit that his work was still in a state of evolution towards perfection.

It suited Vasari to return to the theme of the ignorant viewer on other occasions. In the case of his comparison between the *cantorie* (choir galleries) sculpted by Luca della Robbia and Donatello in Florence Cathedral, it was not nationalism but social status that determined the viewer's response. Vasari praised the highly wrought detail and realism of Luca's work, but he judged Donatello's carving to be superior precisely because it was not so finished, and therefore revealed the force of his creative intellect. Vasari conceded that 'the vulgar prefer a certain external and obvious delicacy, in which diligence conceals the lack of essential qualities, to a work of good quality completed with reason and judgment but not so polished and smooth on the outside'.[112] Donatello himself gratefully presented his physician, Dr Chellini, with a bronze roundel depicting the Virgin and Child, designed as a mould in which glass copies could be cast. Donatello's choice of gift was perhaps carefully tailored to the educated interests of its recipient, a man known to have appreciated the artist's *ingegno* (see pp.76–7).[113]

Other artists encouraged patrons and potential patrons to admire their talents by different means. One strategy was to dismiss one's competitors. Leonardo da Vinci, in a letter that sought to persuade the authorities of Piacenza Cathedral that they should employ him to make some bronze doors, disparaged his counter-bidders by implying the minor and mechanical nature of their skills: 'one is a potter, another an armourer, another a bell-ringer, one is a maker of bells for harnesses'.[114] The Florentine sculptor and goldsmith Benvenuto Cellini was even bolder. In his treatise on sculpture, he recalled how Cosimo I de' Medici admired a small sketch model he had made for a statue of Perseus (pl.44), but doubted he had the courage to create a much larger one. Cellini replied, 'My lord, in the Piazza are works by Donatello and the great Michelangelo, both of them men that in the glory of their works have beaten the ancients; as for me I *have* the courage to execute this work to the size of five cubits, and in so doing make it ever so much better than the model.'[115]

It was only in the sixteenth century that the intellectual and individual qualities of an artist came to be of significant concern to the patron, purchaser or owner. Prior to that, it seems that an artist's mastery of a particularly sought-after technique or extraordinary skill were defining criteria. Thus, to emphasize the extent to which Cistercian patrons were prepared to honour God, it became something of a topos in twelfth- and thirteenth-century accounts of monastic patronage that artists had been brought 'from foreign parts' to work on Church building projects because the particular skills they possessed were unavailable locally.[116] Aubert Audoin, cardinal and former bishop of Paris, sent for potters from Valencia to produce lustred tiles for his Avignon palace in the late 1350s, because the technique of producing such a golden glaze was particularly associated with muslim craftsmen.[117]

The function of an object also continued to outweigh considerations of the identity of its maker. An image of the Virgin and Child, for example, was primarily a work to inspire devotion in the viewer rather than admiration for the artist who had carried it out (pl.45). Until the end of the fifteenth century, palace, church and household inventories rarely name the artist or workshop responsible for objects.[118]

In the sixteenth century, however, the increasingly competitive nature of patronage, coupled

44. **Benvenuto Cellini, *Head of Medusa* (sketch model for a statue of Perseus).** Bronze, 13.8 cm high. Florence, c.1545–50. V&A: A.14–1964

45. **After Donatello, *Virgin and Child* (frame probably painted by Paolo di Stefano).** Painted stucco in a wooden frame, 36.5 × 20.2 cm. Florence, c.1435–40. V&A: A.45–1926. Presented by The Art Fund with the aid of a body of subscribers in memory of Lord Carmichael of Skirling

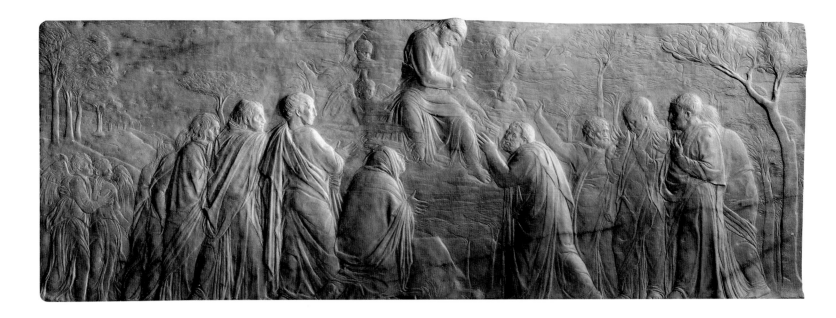

46. **Donatello,** *The Ascension with Christ giving the Keys to Saint Peter.*
Marble, 40.6 × 114.3 cm. Florence, *c.*1428–30. V&A: 7629–1861

with the fashion for collecting and classifying examples of rare, precious or skilfully wrought objects, helped provide an environment in which the identity of the artist became a significant concern in the acquisition of works that were not direct commissions. The attempt by Francis I, King of France, to wheedle from Michelangelo 'some work, even small, of yours' is a striking instance of this.[119] Vasari records that Cosimo de' Medici kept a bronze bust of his wife by Donatello together with many other works in bronze and marble, also by the artist's hand, in his study.[120] This was a privileged location in a household and, significantly for perceptions of the visual arts, it was a place where objects were used to display the owner's intellectual interests.[121] Inventories, too, reveal this growing emphasis on the artist's persona. The 1492 record of possessions in the Medici Palace in Florence, made for Cosimo's heir Lorenzo, is one of the first in Italy to specifiy the names of many of the artists responsible for works owned by the family. These include several attributed to Donatello, including 'an Ascension by the hand of Donato', kept in Lorenzo's quarters (pl.46).[122]

THE ARTIST AND SALVATION

There was another viewer besides a patron or purchaser whom an artist could strive to impress: God. We have seen how Christian writers had emphasized the mechanical aspects of the visual arts, to the detriment of their intellectual possibilities, and that this enabled them to argue that an artist's work was also labour in the service of God. Sometimes this work was carried out in the expectation that no human eye would see it once completed, as was the case for a shroud and cushion which were placed in the tomb of Saint Remi (Remigius) at Reims, France. The textiles were given by Hincmar, Bishop of Reims, and embroidered by the sister of Charles 'the Bald' of France, who added an inscription dedicating her work to God.[123] The references to artists on other objects associated with church ritual and devotion, however, suggest a more complex relationship between God, maker and fame.

Despite the gradual shift in book production from monasteries to secular, urban workshops in the thirteenth century, some monastic communities still copied their own texts for their daily round of prayers and meditations. The fragment illustrated here is from an antiphoner probably copied in Germany between 1250 and 1300 (pl.47; see detail p.46). The ostensible purpose of the painted initial

showing a kneeling monk was to mark a new section in the text. The initial signals the start of the first in a sequence of seven psalms which had been known as the 'penitential psalms' since the sixth century. The Psalms are a collection of songs in the Old Testament attributed to David, King of Israel; the penitential psalms are David's plea for the forgiveness of his sins. Copies of the Psalms could include miniatures depicting the crowned David, to emphasize his authorship of the texts. Yet in this manuscript, the anonymous painter of the initial to the psalm 'O Lord rebuke me not in thine anger' has shown himself instead of the penitent king. In so doing, he has made a visual plea for divine forgiveness, despite the generic nature of his self-portrait. Indeed, the kneeling figure can also stand for all the other members of the monastic community. That other readers interpreted it in this way is suggested by the fact that a 'Brother Jordan' added his own name within the initial a century or so later, rather clumsily and in light-brown ink. Brother Jordan's appropriation of the image, turning it

47. Leaf from an antiphoner.
Watercolour and ink on parchment, 30.4 × 40.6 cm. Germany, c.1250. V&A: 1517

48. Alessandro Coticchia, pax.
Gilded silver, decorated with niello, 13.4 cm high. Ascoli Piceno (Italy), 1547. V&A: M.35–1951

into a picture of himself in prayer, is unlikely to be an attempt to claim authorship of the painted initial itself. Instead, by adding his name he too is presenting himself as a good monk, pious and penitent.

The anonymous monk's decision to depict himself in this way arguably reveals more about him than his faith. For a start, it may well have been that by equating himself with King David he was also referring to his own name.[124] Moreover, amongst the books of the Old and New Testaments, the Psalms were noteworthy because they were thought to reflect David's own thoughts rather than the Word of God.[125] By associating himself with David, the monk-artist also suggested his own creative powers: in this antiphoner, King David's own offering of psalms to an impassive, judgmental deity are paralleled in the thirteenth-century monk's painted artistry. By inserting this visual reference to himself where he did, the artist revealed both his piety and his sense of his role as one able to manipulate pictorial traditions in order to praise God and commemorate himself.

Some three hundred years later, an Italian goldsmith called Alessandro Coticchia also wanted to have himself remembered in the daily rituals of church blessing, specifically at the consecration of the host. The nielloed image on a pax (pl.48) shows a kneeling friar clutching and kissing the dead Christ's wounded hand, paralleling the Virgin Mary's kiss to Christ's face above. His emphatic association with Christ's wound identifies him as a Franciscan friar – Saint Francis, founder of the order, miraculously received five wounds, or 'stigmata', that replicated those of Christ on the cross, on his hands, feet and side. The nielloed inscription immediately below identifies him as 'Fr[iar] Peter of Ascoli, Guardian [GVARDIANVS]' (i.e. the leader of a group of friars, in this case perhaps those in the convent of S. Francesco at Ascoli Piceno).[126] Below this is another line of text, which refers not to someone depicted but to the person who designed and executed the nielloed scene and lettering: 'Alisandro Cotichia made [fecit] this 1547.' The addition of the date suggests the object was made to commemorate a particular event – perhaps Peter's appointment as *guardianus*. Every time the pax was held up to be kissed by the congregation after Mass, Peter and Alessandro's names would be remembered and also, perhaps, kissed.

Alessandro's name appears prominently on the pax, but there is nothing about the way in which he has written it to suggest he is also making a comment about his skill as a metalworker. The painter Carlo Crivelli, however, combined a plea for salvation with a reference to his artistry in a devotional panel made around 1480 (pl.49). His name appears immediately below the Virgin and Child, a prominent location that advertises not just his authorship but also ensures his symbolic presence during the owner's prayers. Yet the way in which Crivelli has inscribed his name is also significant. He has painted it to appear as though it were incised into stone – as though, indeed, it were written by a sculptor. This *trompe l'oeil* effect is in keeping with others in the picture, such as the minutely rendered fly which sits on the parapet. In the context of the debate between painting and sculpture such illusionism also reminds the viewer of the superiority of paint over stone to render a representation of reality. It also suggests the quasi-divine powers of the artist to create images which appear to be alive. In this painting, Crivelli has fused the intellectual and the spiritual, as he appeals not only for eternal life in heaven, but for eternal fame on earth.

49. **Carlo Crivelli,**
Virgin and Child.
Tempera on panel, 48.5 × 33.6 cm.
Ascoli Piceno (Italy), *c.*1480.
V&A: 492–1882. Jones Bequest

OPVS · CAROLI · CRIVELLI · VENETI ·

1. Germanic jewellery of the early Middle Ages: status, beauty, artistry

SONJA MARZINZIK

THE V&A'S COLLECTIONS include a small group of jewellery and dress fittings of the fifth to eighth centuries from England and the Continent. They are beautiful examples of Germanic craftsmanship which feature a wide range of jewellers' and fine smiths' skills: casting, gilding and filigree work coupled with the inlay of metal wires, niello, glass and semi-precious stones. Such accessories usually come from graves, as people were buried fully dressed and bejewelled. This custom continued into the Christian period and demonstrates that the manner of burial reflected status as well as faith. These objects thus reveal early medieval perceptions of fashion and beauty, allow glimpses of beliefs and mythology and bear witness to trade and exchange over enormous distances.

Ornament from all parts of the Germanic world shows a love of animal shapes, stylization and ambiguity, often difficult to decipher for the uninitiated eye. Whether in the form of protomes (1.1) or as complex interlace (1.4), the significance of animals is hard to interpret: animal forms may have comprised evil-averting, ethnic or dynastic meanings as well as offering visual riddles. Similarly, cross-shapes were already common on round brooches and pendants in the pre-Christian period and did not necessarily have religious significance.

Brooches were essentially elaborate safety pins, used by women to fasten dresses or cloaks. Their sometimes ostentatious design was a means of status display as much as adornment and demonstrated far-reaching connections as well as fashion sense. Pieces such as the Milton and Faversham brooches (1.2 and 1.3) combined materials from large parts of the then known world: gem stones that may have been traded from as far away as India or Sri Lanka; white inlays cut from shells, some of which have been identified as Mediterranean species; glass inlays made either from melted-down Roman tesserae or from raw glass produced in the Eastern Mediterranean; gold sourced from Frankish coins; and finally, mercury for fire gilding imported from Spain, the Balkans or Italy.

All these materials were brought together by the ingenuity of a craftsman or a workshop. Yet, although appreciative of skilled artisans and their products, historical sources rarely mention jewellers by name, with the notable exception of the Frankish bishop and goldsmith Eligius (d. 659/60), later patron saint of metalworkers.

This uncertainty reflects how little we know about the production of jewellery. It is likely that outmoded dress ornaments went into the melting pot and Gregory of Tours writes in the sixth century about a workshop in Paris where silver coinage brought in by customers was made into jewellery. Numerous female graves from this time contained small collections of odds and ends, among which the scrap metal and glass sherds may well have been meant for recycling.

Political changes in the wider world had a direct impact on the design of Germanic dress ornaments. The rise of the Sassanian Empire (in the region that is now Iran) in the later sixth century disrupted garnet trade routes through the Red Sea and southern Arabia. In north-western Europe, this resulted in the increasing popularity of iron buckles and brooches with intricate silver and brass inlay during the seventh century (1.4). Late jewellery, such as the brooch from Bad Kreuznach (1.5), is often set with hemispherical glass paste gems, prefiguring medieval fashions for large cabochon shapes.

1.1 ▼ Bow brooch.
Silver, partially gilded, niello and garnet inlay, 10.4 × 5.1 cm. Herpes (France), 6th century. V&A: M.114–1939

Protomes in the form of birds of prey frame the headplate of this brooch. The fine black decoration on the bow is executed in niello.

1.2 ▼ The Milton Brooch.
Gold, silver, bronze, with gold filigree, garnet and shell inlay, 7.7 cm diameter. Oxfordshire (England), 7th century. V&A: M.109–1939

It is unusual for the pin to survive so well on a brooch. It is fixed on the right and hooked into the holder on the left.

1.3 ▲ The Faversham Brooch.
Silver, with gold filigree, garnet and glass-paste inlay, 4.9 cm diameter. Kent (England), 7th century. V&A: M.110–1939

This brooch came from a grave in Kent. The wafer-patterned gold foils visible below the garnets reflect light and increase their brilliance.

1.5 ▼ Disc brooch.
Gold, bronze, gold filigree, paste gems and garnets, 4.7 cm diameter. Bad Kreuznach (Germany), 7th century. V&A: M.119–1939

Glass gems, gold filigree and small garnet splinters, as used on this brooch from the Rhineland, replaced large-scale cloisonné in the course of the 7th century.

1.4 ▲ Buckle.
Iron with silver and brass inlay, 7.4 × 17.9 cm. Northern France, Belgium or Germany, 7th century. V&A: 4510–1858

Fantastic animals in silver and brass inlay writhe on the plate of this iron buckle. Their long jaws are clamped around each other's ribbon-like bodies.

2. Masterpiece and multiple: Donatello's gift to his doctor

KATHERINE HUNT

IN AUGUST 1456, the Florentine doctor Giovanni Chellini (2.1) recorded in his diary that the sculptor Donatello, grateful for medical treatment he had received, 'gave me a roundel the size of a trencher in which was sculpted the Virgin Mary with the Child at her neck and two angels on either side, all of bronze, and on the outer side hollowed out so that melted glass could be cast into it and it would make the same figures as on the other side'.

When the bronze roundel (2.2 and 2.3) came to light in the 1960s, it was immediately recognized as the long-lost gift Chellini mentions. It shows, in relief, the Virgin Mary, surrounded by angels, holding the infant Christ to her in a tender maternal pose. To her left, one of the angels offers Mary a plate of sweetmeats, a traditional gift to a new mother. In shape and in proportion, the roundel suggests a trencher, a typical plate of the period, evoking the gift-giving depicted on it. It is, however, much too heavy to be used. Gold imitation Kufic script is inscribed around its rim; traces of gilding also remain on the haloes and elsewhere around the figures. A mould must have been taken from the original wax model to create both the positive front and negative back of the roundel.

The roundel is an ingenious object which is at once a finished piece and a mould to use for reproduction (2.3). Although no contemporary glass casts are known, two renaissance casts in stucco still exist. When the V&A acquired it in 1976, moulds were made of the roundel from which glass casts were taken (2.4). The resulting glass roundels show the image in crisp relief and beautiful translucence, and are a testament to Donatello's careful artistry.

The roundel was probably made around 1450, when Donatello was in Padua. While there he had become interested in the possibilities of sculptural reproduction: his Verona Madonna from this period, copies of which survive in stucco and terracotta, was probably designed so that it could be reproduced easily. The great glassworks around nearby Venice may have suggested to him an unusual, highly prized material with which to make a different sort of multiple copy. Glass was associated with purity, echoing Mary's own purity and the virgin birth of Christ. Making a cast from such an expensive material shows a remarkable audacity, particularly when the bronze matrix is such a beautiful object in itself. It suggests that, for Donatello, making multiples of his works could enhance, rather than dilute, his inventiveness.

It seems unlikely, however, that Donatello intended Dr Chellini to make casts from the roundel, a process which may have damaged the gilding. Nevertheless, the object's innovative characteristics would have interested Chellini, and brought both enjoyment and prestige. He may have kept the bronze in his *studiolo* (study), a place where a well-off and educated man might contemplate precious and interesting objects he had collected. Chellini clearly valued this unusual gift from his patient, whom he calls 'the singular and principal master in making figures of bronze and wood and terracotta'.

The Chellini roundel is unique. A beautiful, expensive bronze, a devotional image, an object designed to self-replicate, and a gift, with gift-giving represented on it, it embodies the ingenuity, curiosity, and beauty of art in the renaissance period.

2.1 ▼ **Antonio Rossellino, bust of Giovanni di Antonio Chellini da San Miniato.** Marble, 51.5 × 57.6 × 29.6 cm. Florence, 1456. V&A: 7671–1861

This portrait bust was made the same year that Donatello gave Chellini the roundel, when the doctor was 84. It is inscribed underneath with the names of sitter and artist, and the date.

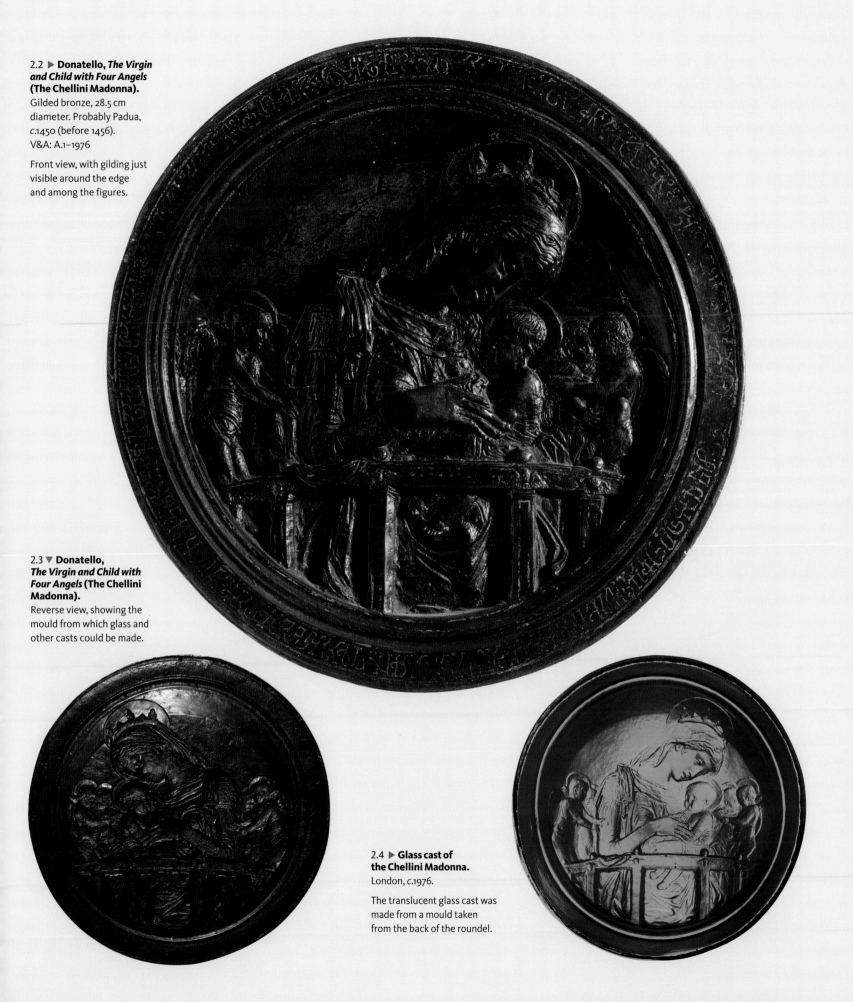

2.2 ▶ **Donatello,** *The Virgin and Child with Four Angels* **(The Chellini Madonna).**
Gilded bronze, 28.5 cm diameter. Probably Padua, *c.*1450 (before 1456).
V&A: A.1–1976

Front view, with gilding just visible around the edge and among the figures.

2.3 ▼ **Donatello,** *The Virgin and Child with Four Angels* **(The Chellini Madonna).**
Reverse view, showing the mould from which glass and other casts could be made.

2.4 ▶ **Glass cast of the Chellini Madonna.**
London, *c.*1976.

The translucent glass cast was made from a mould taken from the back of the roundel.

3. Labour and meditation: a convent embroidery

NORBERT JOPEK

T HIS LARGE EMBROIDERY (3.1) and a fragmentary counterpart used to hang in the choir of the church of the convent of the Canonesses Regular of the order of Saint Augustine at Heiningen. They are examples of extraordinary craftsmanship and of the theological and classical education in a nunnery on the eve of the Reformation.

The annals of the convent for the year 1516 recorded: *Item eodem anno ward ock geneiget de grote tapet philosphia* (in the same year the large tapestry of Philosophy was also completed). This embroidery, which measures nearly 25 square metres, depicts the seated figure of Philosophy in the centre, surrounded by five smaller figures representing the branches of philosophical learning: theory, logic, practical science, mechanical science and physics. An outer ring shows the figures of the seven Liberal Arts alternating with the Virtues and the gifts of the Holy Spirit. The seated men in the corners represent the four wise men of Antiquity: Ovid, Boethius, Horace and Aristotle. Numerous inscriptions in Latin refer to the figures. The inscription on the double band enclosing the outer ring, for instance, is taken from works by Saint Bernard of Clairvaux. All the inscriptions reflect the christianization of classical learning. The name of the prioress, 'D[omi]na Elisabet', the date 1516 and the names of 58 nuns appear on the two outermost bands. The naming of the nuns is quite exceptional although embroidery was a typical occupation for them; it means not only that the entire convent was involved in making this hanging, but also that they expected that future generations of canonesses should remember them in their commemorative prayers. The border inscription also lists their spiritual mentors, the Augustinian canons Arnold Stenwick, Anton Colhof and Heinrich Hovensse. The design of the embroidery was probably based on a twelfth-century model, since it does not provide a narrative scene and neglects completely any perspective.

The Heiningen nunnery was established in 1013 to commemorate its founders, Hildeswid and Alburgis, and provide a spiritual home for the unmarried daughters of aristocrats. From the twelfth century onwards, nunneries in Lower Saxony as well as on the Middle and Upper Rhine had become centres of embroidering and weaving textiles, mainly for religious purposes. By about 1260, an embroidered altar frontal (now in the Marienberg convent in Helmstedt) had already been made in Heiningen featuring Hildeswid and Alburgis. In 1517, a year after the completion of the Philosophy hanging, the convent embarked on another that was finished two years later. The central section originally depicted the figures of Ecclesia (the Church) and Synagogue surrounded by Sibyls. It was also duly recorded in the annals, identified by these last figures: *1517 ward geneyhet de tapet myt den Sibellen* (in 1517 the hanging with the Sibyls was stitched).

Both hangings remained in the church until the dissolution of the convent in 1810. They later entered the collection of the bishop of Hildesheim, Eduard Jakob Wedekin, when the textiles collector Canon Franz Bock cut a large piece from the upper left corner of the Sibyl embroidery which depicts Alburgis, the first abbess. This section was sold by Bock to the South Kensington Museum in 1863 (V&A: 8712–1863), while the rest is now housed in the Moravian Gallery in Brno.

3.1 ▶ **Embroidered hanging.** Embroidery on linen, 538.5 × 467.5 cm. Heiningen (Germany), 1516. V&A: 289–1876

Prioress Elizabeth's name appears along the top left border. The inscription immediately below refers to the convent itself and the devoted labour of its nuns.

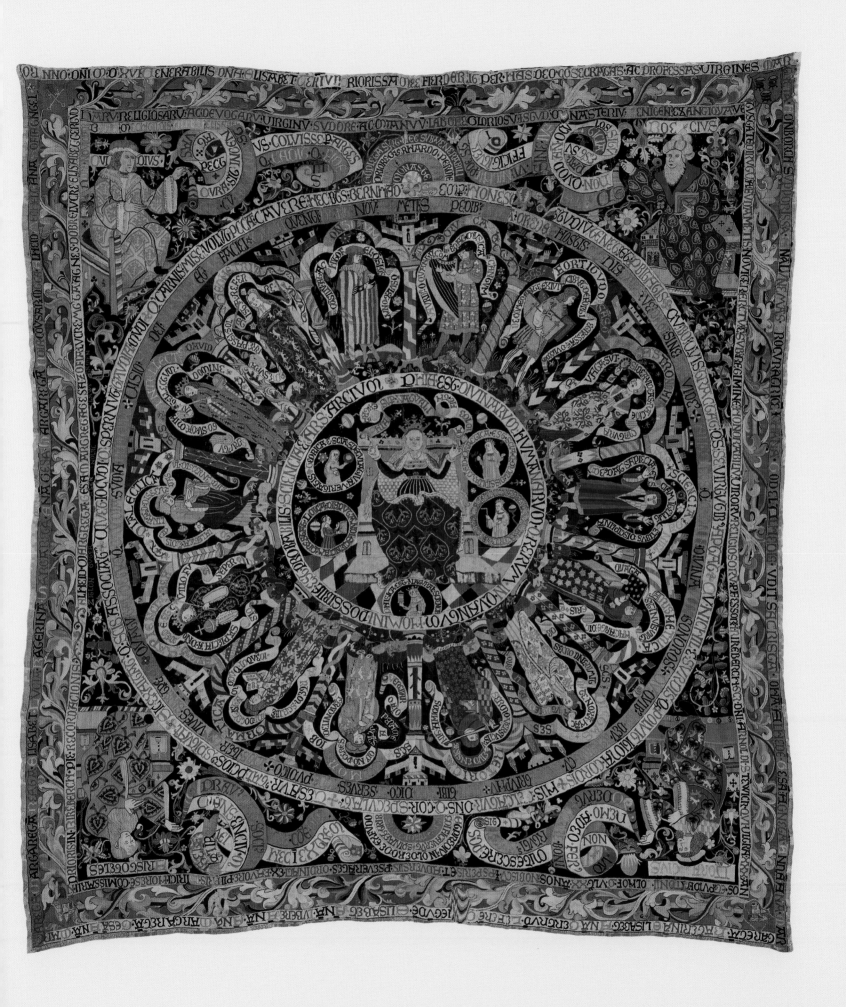

4. Art as narrative: telling stories

MATTHEW LAWRENCE

TALES OF CHIVALRIC ROMANCE proliferated in Europe from the end of the twelfth century until the sixteenth century. Written in the vernacular rather than Latin, this was a literature composed for a courtly audience with ample time for leisure. The tales were full of adventure, magic and fabulous creatures. Many celebrated the legendary exploits of King Arthur's court and the brave deeds of knights inspired by love for their ladies. While the texts that have come down to us in written form are, in themselves, evidence of a literate culture, their references to listening and hearing suggest that they were performed as well as read.

Romance literature was a source of iconography for craftspeople working in a wide variety of media, from textiles and ceramics to ivory carving and stonemasonry. Individual scenes and whole cycles were illustrated on small and large domestic objects (caskets, bed covers, tapestries) as well as in ecclesiastical settings (such as the depiction of an Arthurian cycle carved into the north portal of Modena Cathedral). Their ubiquity suggests that they were familiar to people from all sections of society and the conventions of the genre were so recognizable that they were even parodied by contemporary writers including Chaucer (*The Tale of Sir Thopas*).

One of the most enduringly popular tales from the romance tradition concerned Tristan (the nephew of King Mark of Cornwall) and his adulterous love for his uncle's wife, Isolde. The entire Tristan romance is depicted in a series of mid-thirteenth-century tiles excavated from Chertsey Abbey in Surrey (and thought to have been made for one of Henry III's palaces) but most known representations focus on discrete episodes. A colourful example is a late fourteenth-century wool hanging from North Germany ornamented with scenes of Tristan slaying a fearsome dragon (4.1).

Another narrative sequence is depicted in relief on a linen quilt from Florence from about 1360–1400 (4.2). Embroidered captions describe the action, which loosely follows a fourteenth-century Italian prose version of the tale. The Morold, an Irish duke, demands tribute from Cornwall. Tristan puts himself forward as King Mark's champion and agrees to go into single combat with the Morold on an islet. They take two boats, but cast one off so that only one of them can return. The coat of arms on Tristan's shield is that of the Guicciardini family and the emblem of three lilies on the Morold's shield and boat possibly relates to the Acciaiuoli family's coat of arms. The two clans were united by marriage in 1395, and we can speculate that the quilt, which may have been used as a bedcover, commemorates this union, the artist selecting these scenes for their depiction of family loyalty and defence of honour.

The most common representation of the Tristan romance reduces the story to a single image: the adulterous lovers meet at night by a pool, while the suspicious King Mark spies on them from a tree (4.3 and 4.4). Few single scenes from romance literature recur as frequently as this one. The symmetrical composition, which the scene invites, may account in part for its popularity but the episode also fits with the medieval fascination with adultery, idealized in the concept of *fin'amors* (courtly love) that was central to the romance tradition.

4.1 ▶ Wall-hanging.
Wool and gilded leather, 109 × 256.6 cm. Northern Germany, c.1370–99. V&A: 1370-1864

The hanging employs appliqué, a technique commonly used as a cheaper alternative to woven tapestry.

4.3 ▼ **Casket.**
Oak, 15 × 29.3 × 25.5 cm. The Netherlands(?), c.1350–75. V&A: 2173-1855

The box is carved with the motif of Tristan and Isolde's tryst beneath the tree. Isolde points to the pool, where King Mark's telltale reflection is often shown in other depictions of the scene.

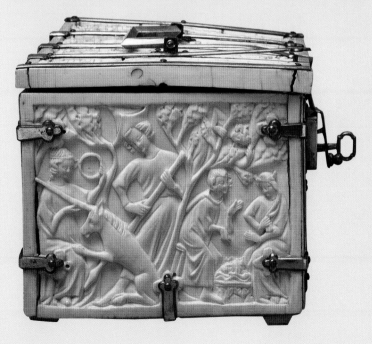

4.2 ▲ Quilt (detail).
Linen and wool, 320 × 287 cm. Florence, c.1360–1400. V&A: 1391-1904

The embroidered caption reads, 'How Tristan wounded the Morold in the head'.

4.4 ▶ Casket.
Ivory, 12 × 25.2 × 13.5 cm. Paris, c.1330–40. V&A: 146-1866

The casket is carved with Tristan and Isolde's tryst beneath the tree and other scenes from romance literature.

3

MAKERS AND MARKETS

Glyn Davies

T HE MERCANTILE CHARACTER of the Renaissance is firmly fixed in the popular imagination. Indeed, for some commentators it is one of the defining characteristics of the period.[1] In the field of luxury goods, the role of Italy has been especially emphasized. As well as being the home of many of Europe's banking houses, Italy was the outstanding centre for the production of silk in Western Europe and was one of the leading producers of ceramics, glass and woollen fabrics. The late fifteenth-century ecclesiastic Pietro Casola left us a magnificent description of Venice, one of Italy's greatest international entrepôts:

> I was taken to see various warehouses, beginning with that of the Germans – which it
> appears to me would suffice alone to supply Italy with the goods that come and go – and
> so many others that it can be said that they are innumerable. I see that the special products
> for which other cities are famous are all to be found there… And who could count the
> many shops so well furnished that they seem also warehouses, with so many cloths of every
> make – tapestry, brocades and hangings of every design, carpets of every sort…[2]

The vibrant markets of fifteenth-century Venice are emblematic of renaissance consumerism, but vigorous international trade was not a new phenomenon during the Renaissance, nor was it confined to the Mediterranean.

This chapter focuses on the working and trading conditions experienced by artists, merchants and consumers in medieval and renaissance Europe. Although medieval merchants did not travel as far as the adventurous sea captains of the Renaissance, luxury goods themselves travelled across vast distances throughout the period. Surviving objects and documents allow us to bring the commercial activities of Western Europe's artists and craftspeople to life to a surprising degree from at

Designed by Jan van der Straet (Stradanus), *Book Printing* (detail). See pl.76, p.101.

least the twelfth century: they tell us how the crafts were organized, where the artists lived and traded, and to whom they sold their products. Byzantine commerce is well documented from much earlier. In Western Europe, the period before the twelfth century is more mysterious, because of a paucity of written evidence, but fascinating glimpses of the way in which luxury goods were produced and sold can still be gained.

SUPPLYING LUXURY: THE TRADE IN IVORY

Luxury goods often took part of their value from the precious nature of the materials used to make them. It is characteristic of much medieval and renaissance art that it was made from materials that had travelled long distances by circuitous routes. The medieval trade in ivory is a good example. Ivory had been valued since Antiquity for its colour, rareness and qualities as a sculptural medium, and esteem for this material continued after the disintegration of the Roman Empire.

The Byzantines sourced their ivory from the same sites that had supplied Ancient Rome – predominantly the markets of Egypt (such as Cairo and Alexandria), which obtained the ivory from Ethiopia. Some material may also have come overland from India. The ivory diptychs customarily distributed by new consuls, such as Flavius Anastasius, consul in 517 CE (see p.194), were produced in relatively large numbers, indicating that ivory was not hard to obtain in the Byzantine world at that time.[3]

The markets of North Africa also supplied ivory to Western Europe – before the eleventh century mainly, it would seem, via Italy, through Arab merchants.[4] The expansion in book production under the Carolingian and later the Ottonian emperors of the Frankish kingdoms, as well as a taste for antique imagery and art forms, led to a huge demand for ivory during the ninth, tenth and eleventh centuries in the territories of modern-day France and Germany. Because many of the ivory panels formed book covers, the centres producing illuminated manuscripts, such as Reims, St Gallen and Metz, also acted as centres of ivory carving. A now somewhat damaged panel of the Crucifixion probably once acted as the cover for a manuscript of the Gospels produced in Metz in the third quarter of the ninth century (pl.50). The book was owned by Queen Aedgifu, wife of the Carolingian emperor Charles the Simple, and sister of King Athelstan of England.

Many, although by no means all, the craftspeople who made such books were clerics – for example, the fourteen nuns at Tours who worked on a manuscript of Saint Augustine of Hippo's *De Trinitate*.[5] It is less clear whether ivory workers were ecclesiastics or professional laymen.[6] The style of carved ivories certainly reflects that of the illuminations carried out by ecclesiastical artists, as in an early eleventh-century walrus ivory representing the Virgin and Child, which is in the characteristic Anglo-Saxon style associated with the scriptorium at Winchester Cathedral, with lively zig-zagging drapery folds (pl.51).[7] The designs used by ivory workers also reflect compositions used by manuscript illuminators, and can sometimes be traced in different media – an ivory from St Gallen, depicting the arrival of the Three Maries at Christ's empty tomb, and a later manuscript

50. **Panel from a book cover depicting the Crucifixion.**
Ivory, 23.5 cm high. Metz (France), c.860. V&A: 251–1867

51. *The Virgin and Child.*
Walrus ivory, 10 cm high. Winchester or Canterbury, c.1000–20. V&A: A.5–1935

52. *The Three Maries at the Sepulchre* from an antiphonary.
Paint on parchment, 22 × 16.5 cm. Switzerland, 986–1017. Library of St Gallen, Cod. Sang. 391, p.33

53. *The Three Maries at the Sepulchre.*
Ivory, 9.2 cm high. Switzerland (probably St Gallen), 900–50.
V&A: 380–1871

at the abbey both used the same composition as their prototype (pls 52, 53). On the other hand, at least one ivory, a Spanish panel dating to 1073 now in the Hermitage Museum, St Petersburg, depicts a lay craftsman, 'Master Engelram', and his son Ridolfo at work scraping down an ivory panel.[8]

What we know of artists at this date is often equivocal over their status as lay or ecclesiastic: the famous Master Hugo of Bury St Edmunds in Suffolk carved sculpture, worked bronze and illuminated manuscripts, but there is still debate over whether or not he was a monk.[9] The seventh-century goldsmith Eligius, born near Limoges in Aquitaine, seems in the early part of his career to have been a layman – but later in life he was elected bishop of Noyon. It is hard to imagine that so many ivories, manuscripts and other artworks could have been manufactured exclusively by monks, given that their way of life required them to spend much of the day in prayer, and it seems likely that at least some of the ivory carvers were laymen. The potential for a lay workforce of ivory carvers certainly existed. The centres producing ivories were often comparatively urbanized. For example, Winchester had a population of around 5,500 in 1148.[10]

There appear to have been periodic shortages of elephant ivory in Northern Europe between the eighth and twelfth centuries. Sometimes, it was easier for Carolingian artists to re-carve existing ivories than it was for them to get hold of new material. For example, a Crucifixion from Metz was carved on the reverse of an older consular diptych (pl.54A, B). This practice was carried out in a surprisingly systematic way in the Carolingian world.[11] Artists in England and elsewhere resorted

54A, B. **Panel with the Crucifixion and other scenes (and reverse).**
Ivory, 17 cm high. Reims or Metz (France), *c.*850–75. V&A: 266–1867

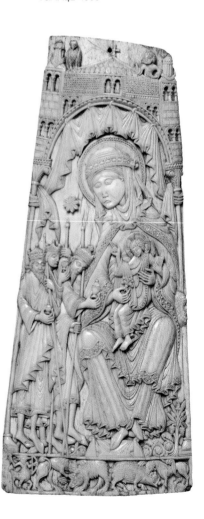

55. *The Adoration of the Magi.*
Whalebone, 36.5 cm high. Northern Spain, *c.*1120–40. V&A: 142–1866

to using smaller, harder-to-carve alternatives, such as walrus ivory and whalebone, some of which was sourced in Scandinavia (see pl.55).[12]

Prior to the twelfth century, the carvers of Cologne usually used elephant ivory, which they must have obtained from Italy. But during the twelfth century, they too increasingly used walrus ivory, especially for the sets of games pieces, or tablemen, made in the city. Some elephant ivory was clearly still available, however, as some of the best tablemen were still produced in this medium (see p.125). The reasons for such local fluctuations in availability are not always clear, although wars and other disturbances must have played their parts.

As noted above, medieval and renaissance luxury arts often involved the acquisition and working of materials from far distant locations. Thus, the enamellers of the Limoges region used copper that probably came from the mines in Lower Saxony or southern Spain, and English embroiderers worked silks from as far afield as China.[13] In the same way, the unquestioned centre of ivory carving in the thirteenth and fourteenth centuries was Paris, a town with no direct links to North Africa and the East. The routes by which the ivory arrived there are not known for certain. Mediterranean trade in the eleventh century was mainly in the hands of ships from Pisa, Genoa and Venice, a development often traced to the capture in 1087 of the port of Mahdiyah (see pp.28–9). The book known as the *Pratica della Mercatura* (Guide for Merchants) by Francesco Pegolotti, an agent of the Bardi family of Florence, confirms that ivory was available to Italian merchants in Alexandria, Acre, Famagusta and Venice in the 1330s.[14] The main points of contact between the merchants of these towns and Northern Europe were the trade fairs of the Champagne region, and ports such as Marseilles. The Genoese were trading in Bruges by at least 1277, and Genoese records of 1376–7 show boats transporting ivory from Alexandria to Flanders. By the

56. **Triptych with the Coronation of the Virgin flanked by saints.**
Ivory, painted and gilded,
27 cm high. Venice, 1360–70.
V&A: 143–1866

fifteenth century, documents certainly demonstrate an active commerce in ivory from Portuguese West Africa between Bruges and Paris.[15]

It seems likely, therefore, that a large proportion of the ivory worked in medieval Paris would have been imported via Bruges, although it may also have come via Marseilles or over the Alps. As has often been noted, however, none of this explains why the towns that distributed ivory did not become centres for carving it, when Paris (and to a lesser extent, a number of German towns) did. Of the major ports, only Venice developed much of an ivory-carving tradition (see pl.56).[16] Ivory carving took place where the art buyers were.

PROFESSIONAL ARTISTS AND THE ORGANIZATION OF TRADES

Whilst the evidence for artists, merchants and the market for luxuries in Western Europe is patchy before the twelfth century, it is clear that many of the crafts which interest us were already highly developed (see pp.116–17).[17] In many towns, trades were already grouped together in particular districts: 'the goldsmiths sit before their furnaces and tables on the Great Bridge' wrote the philologist and university teacher Jean de Garlande in the 1220s, describing the many goldsmiths'

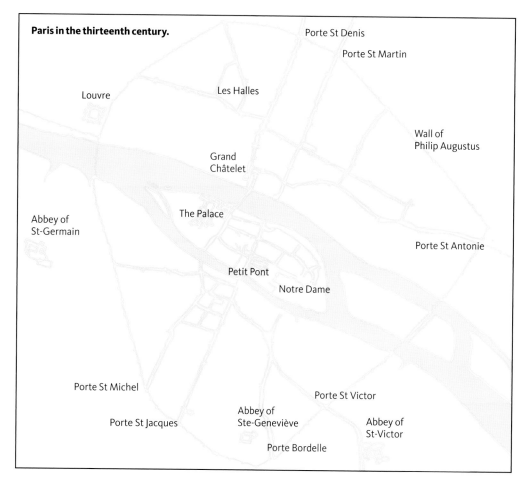

Paris in the thirteenth century.

Porte St Denis
Porte St Martin
Louvre
Les Halles
Wall of Philip Augustus
Grand Châtelet
The Palace
Abbey of St-Germain
Porte St Antonie
Petit Pont
Notre Dame
Porte St Michel
Porte St Victor
Abbey of Ste-Geneviève
Abbey of St-Victor
Porte St Jacques
Porte Bordelle

57. Leaf from a copy of Peter Lombard's *Sentences*.
Ink on parchment,
32.7 × 24.5 cm. Paris, c.1170.
V&A: MSL/1983/19

58. Remède de Fortune Master (miniatures only), missal from the royal abbey of St-Denis.
Ink on parchment with watercolour and gold,
24.6 × 36 cm (when open). Paris, 1350. V&A: MSL/1891/1346

shops on Paris's Pont au Change.[18] This bridge was the key access point to the Ile-de-la-Cité, the religious and political heart of the city. Nevertheless, it was not the safest spot for a workshop, as the whole bridge was swept away during floods in 1296–7.[19] It was also not the only site on which goldsmiths were operating, as a Parisian tax document, the *taille* of 1292, makes clear. Many of the wealthiest and most successful occupied the streets directly opposite the palace and the Ste-Chapelle, near the abbey of their patron saint, Eligius.[20]

Nor was it just the goldsmiths' trade which had become centred in particular areas of Paris: during the twelfth century, the book trade moved out of the monasteries and into the hands of lay book dealers. This process began within monastic schools like that at the Parisian abbey of St-Victor. Schools needed multiple copies of key texts, such as the *Sentences*, a theological commentary written in 1152 by Peter Lombard (pl.57). The consistency of such books across multiple copies demonstrates the increasingly commercial approach being taken to their production: page layouts, rubrics and chapter headings are all standardized. The School of St-Victor hired freelance scribes to work on such books.[21]

By the late thirteenth century, most book production in Paris was commissioned from lay booksellers, known as *libraires*. They had access to texts for copying, which they sent out in sections to scribes and illuminators, effectively sub-contracting the work to various teams of specialists, before assembling and binding the completed leaves into a book. A missal (outlining the procedures for the Mass) from the royal abbey of St-Denis, just outside Paris, made about 1350, would have been produced in this way (pl.58). This volume was a luxury item, highly illustrated and decorated, and made with fine, high-quality parchment. Several specialist artists contributed to the decoration, including a skilled pen flourisher (possibly the artist Jacques de Macy), who made the spiralling

patterns around many of the initials, and the artist who produced the monochrome (*grisaille*) narrative images, some of which represent the history of the abbey. Working mainly as sub-contractors on commissioned books of this sort, the illuminators did not choose the subjects they illustrated. The abbey's representative would have specified, and probably had to describe, the scenes he wanted depicted. The artist's role was to realize these images in a skilful and accomplished manner.

This degree of specialization and sub-contracting in the Paris book trade could only take place because the men and women involved lived in tight groups in only a few districts. Most of the *libraires* were based on the Rue Neuve, a wide road running directly away from the façade of Notre Dame. Many scribes and illuminators lived on the Left Bank near the parish church of St-Severin. The two neighbourhoods were directly linked by the bridge known as the Petit Pont. Everyone involved in the Paris book trade would therefore have known each other well, and it is hardly surprising that the illuminator of the narrative scenes in the St-Denis missal took inspiration from the work of a well-known illuminator of the previous generation, Jean Pucelle.[22]

Textile production was another trade that lent itself to specialization. This involved many different activities, from the carding of raw wool to weaving on looms, dyeing, embroidery and tailoring. The Paris tax records show that from the thirteenth century much of the textile trade was concentrated in the area of the Right Bank bounded on the north by the cemetery of the Holy Innocents and the market of Les Halles, and on the south by the church of St-Germain l'Auxerrois and Châtelet.

Some textile workers, however, were spread across Paris much more widely: in 1303, over two hundred Parisian embroiderers signed a set of regulations which had been approved by the overseer of Paris trade, Guillaume de Hangest.[23] Although several men's names appear, the overwhelming majority of the artists were women. Some of their names, such as Ameline of St-Germain, suggest that they lived in the textile district. Tax documents show that the male embroiderers certainly did, such as 'Jacques the embroiderer', who lived in the Rue Jean-Evrout in the parish of St-Germain.[24] Unfortunately, most of the women embroiderers' names do not appear in tax records, probably because they were married and taxed under their husbands' names, and it is therefore more difficult to say where they lived and worked. The names of some of the embroiderers' husbands are listed, however. Most of them were also artists or tradesmen, including 'Jean the glazier', 'Philippe the crystal worker' and 'Simon the parchment-maker', and the couples lived in districts determined by the husbands' careers. Thus we know that the embroiderer Julianne, who was married to 'Nicholas the illuminator', lived and worked in the illuminators' district of Rue Erembourg-de-Brie, on the Left Bank, where the couple could have known the famous manuscript painter Honoré.[25]

Familial relationships, like that between the embroiderer Jehanne and her husband, the goldsmith Seguin, who worked on the Grand Pont, and the fact that many embroiderers came from as far afield as Lombardy, help to explain how artistic ideas circulated between different media and between different production centres. Family connections also ensured that the tools, models and patterns used in the workshop could pass from one generation to the next, as in the 1491 will of the London goldsmith William Amadus, who bequeathed his tools to his son.[26]

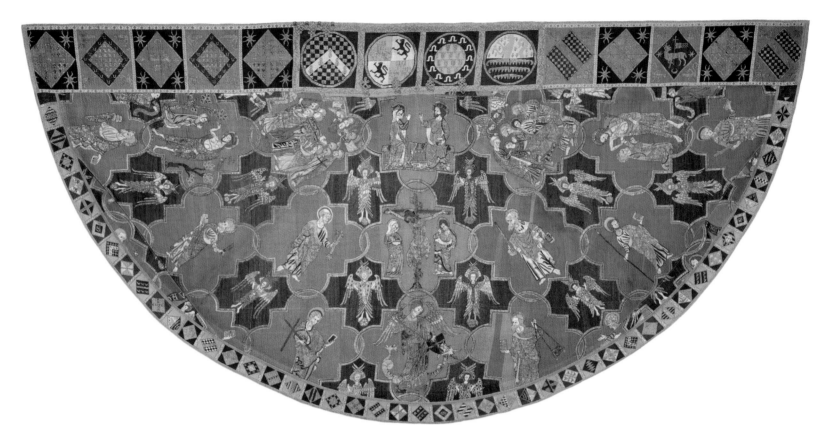

59. **The Syon Cope.**
Linen embroidered with silk and precious metals, 147.5 × 295 cm. England (probably London), 1300–20. V&A: 83–1864

60A, B. **Panel from a cope with Christ in Majesty (and detail).**
Woven silk twill, embroidered with silver-gilt, silver and silk threads and pearls, 100.2 × 42 cm. England (probably London), 1300–20. V&A: T.337–1921. Presented by The Art Fund

61. Plaque with Saint Matthew and the Prophet Isaiah.
Copper gilt with champlevé enamel, 13.1 × 10 cm. Limoges, c.1160–80. V&A: M.207–1938

Although embroidery was a field in which women were prominent before the fourteenth century, this situation did not last. By the end of that century, references to embroiderers in France, England and elsewhere almost always describe men, who, like the Parisian *libraires*, would often have been in control of designs and workshops, rather than being the makers of each commission. An object like the Syon Cope, originally made in England as a chasuble in the early fourteenth century, would have been produced by several artists: it is worked on a base of linen, but the visible surface is entirely embroidered with silk, a product which was imported, probably from Italy (pl.59). The design, drawn onto the linen before it was embroidered and now visible where the cope has worn, may have been provided by a painter or illuminator, and reflects artworks in other media produced in London at the same date.

Nevertheless, there was plenty of opportunity for the team of embroiderers to interpret the design in their own creative way. We can see this by looking closely at part of an early fourteenth-century cope, probably from Canterbury Cathedral or Battle Abbey (pl.60A, B).[27] The preliminary drawing would have shown the large figure of Christ primarily as a series of outlines. The embroiderers, however, skilfully carried out the work to suggest different volumes and textures. They varied the direction and patterns of the stitching: the interior of Christ's cloak is shown with a herringbone pattern, whilst the folds of cloth around his elbow are indicated with swirls in the pattern of stitches. This was taken to an extreme in Christ's cheeks and the gatherings of cloth around his belly, where the embroidery is deliberately worked so that it stands proud of the surface or falls back into it in a series of mounds and pits – a characteristic technique at this date.

Works of this sort were tremendously expensive: in 1307, the London embroiderer Alexander Settere was paid £40 for an embroidered cope.[28] The daily wage of an average farm labourer in England was about two pence or less at this time.[29] Other records describe jewelled copes worth hundreds of pounds. These prices reflect the nature of the raw materials more than the value accorded to the artists' work. For this reason, goldsmiths' work and de-luxe manuscripts were often sold for even more.

The organized trades of Paris, London and other great cities are well documented, even when few actual objects survive. But for some areas the opposite is true. Large numbers of enamelled objects were produced in the area of Limoges, in south-western France from at least the mid-twelfth until the mid-fourteenth century. What we know of their makers, however, must be painstakingly reconstructed from scattered and incomplete evidence. During the second half of the twelfth century, Limoges emerged as a predominant centre in southern France for the production of enamels on engraved copper backgrounds, a typical piece being a plaque pairing Saint Matthew with the prophet Isaiah (pl.61). These were mounted on a variety of objects, including shrines, book covers, crosiers and candlesticks.

The craftsmen involved were laymen. Some of them were based in the Château, an area of town around the abbey of St-Martial, while others lived in the area near the cathedral known as the Cité.[30] In 1346, Aymeric Chrétien, of the Château of Limoges, signed a head reliquary made for the church at Nexon.[31] Aymeric describes himself as an '*aurifaber*' – literally, a 'worker of gold' – so at least

some of the Limoges enamellers were not just specialists in enamelling on gilt copper; they were also qualified to work the precious metals.

The earliest written reference to Limoges enamels is a letter of 1167–9 from the monk John of St-Satyre to Richard, prior of the abbey and school of St-Victor in Paris. John mentions that the pair had discussed an enamelled book cover in the infirmary of St-Victor, which he describes as '*opere lemovicino*' (Limoges work).[32] Book covers like that described by John became a Limoges speciality, usually representing the Crucifixion on the upper cover and Christ in Majesty on the lower (see pl.62). John's casual use of the term 'Limoges work' is striking. During the next 150 years, the phrase became a standard description for such pieces, implying that the style of Limoges enamels was well known, and was particularly associated with the town.

John was a follower of Thomas Becket, who during his French exile spent time in the Limousin region, a territory ruled by Henry II of England. Richard of St-Victor also knew Becket. Becket, although no Latin scholar himself, had spent a year in the Paris schools, and as archbishop of Canterbury surrounded himself with a coterie of intellectuals trained in Paris. These men were immersed in the theology promulgated from the School of St-Victor. Indeed, Becket had preached there in 1169.[33] Connections between Limoges, Canterbury and the schools of Paris can also be traced in objects: the book covers discussed in the letter were to be sent from St-Victor to a church dependent on Canterbury, at Wingham in Kent.

Such international connections are particularly interesting when we look at the subject matter and dissemination of Limoges enamels. The earliest surviving pieces often commemorate saints local to Limoges, such as Saint Martial. The earliest to commemorate foreign saints included a series of reliquary caskets (*châsses*) depicting Saint Thomas Becket produced between Becket's martyrdom on 29 December 1170 and the early years of the thirteenth century. This group, which numbers some fifty-two surviving examples, constitutes the largest group of Limoges *châsses* dedicated to a saint.

Each *châsse* probably held Becket relics. In the years immediately after his death, these seem to have been deliberately distributed from Canterbury. One such *châsse* may have been taken to Peterborough Abbey by Becket's friend Benedict, when he became abbot there in 1177 (pl.63). Becket was a traditional saint, in that he was a martyr. But he also represented a new kind of sainthood, distinguished not so much by miracles as by inner virtue. It is therefore entirely appropriate that his cult was commemorated through the innovative medium of the Limoges caskets.[34] It is unclear whether or not this was a policy encouraged or even initiated by the monks of Canterbury. What can be said with certainty is that Becket's circle patronized Limoges enamels prior to his death, and that the caskets commemorating him formed a significant conduit by which Limoges enamels reached a much wider European audience.

The increasing specialization and commercialization that we have observed did not mean that ecclesiastics were entirely excluded from producing artistic works after 1200. Monks and nuns still made artworks, both for their own use and for sale to benefit their communities. One such work, contemporary with the Syon cope, is an embroidered strip with the words 'IN HORA MORTIS

62. **Gospel cover with Christ in Majesty.**
Copper gilt, champlevé enamel and wood, 33 × 24.1 cm. Limoges, *c*.1200. V&A: 651–1898

63. Reliquary *châsse* commemorating Saint Thomas Becket.

Copper gilt, champlevé enamel and wood, 29.5 × 34.4 × 12.4 cm. Limoges, *c*.1180–90.
V&A: M.66–1997

Purchased with the assistance of the National Heritage Memorial Fund, with contributions from the Po Shing Woo Foundation, The Art Fund, the Friends of the V&A, the estate of T.S.Eliot, the Hedley Trust and many private donations.

64. Johanna of Beverley, altar frontlet (detail).

Linen embroidered with silks and silver gilt, 264 cm long. England (probably Yorkshire), 1300–50.
V&A: T.70–1923

SUCCURRE NOBIS DOMINE' (pl.64). This may have formed part of an altar decoration. The words are an extract from a longer text – 'Lord, may you succour us in the hour of our death. Lord may you free us on the Day of Judgement. We sinners ask that you hear us.' This formula and variants upon it make up part of a number of litanies (responsive prayers) that would have been recited during masses. The back of the strip has an inscription: 'the nun Johanna of Beverley made me'. The act of making an object like this was in itself a prayer, or act of worship, although this was not always appreciated by Church authorities – a 1314 injunction to the nuns of Yorkshire complained that they were absenting themselves from divine services in order to make embroideries.[35] But the tradition of nuns producing embroideries continued into the sixteenth century, as is shown by a huge hanging depicting the Liberal Arts, Virtues and a number of classical and Late Antique authors, made at the Augustinian convent of Heiningen, Lower Saxony, in 1516 (see pp.78–9).[36]

Other artists in holy orders produced works for the commercial market. For instance, monks at the Camaldolese monastery of Sta Maria degli Angeli in Florence produced illuminated books for other churches and for secular customers, including a large-format choir book illuminated in the 1390s by the artist Silvestro dei Gherarducci for a Camaldolese house in Venice, S. Michele a Murano (pl.65). In the same years, several pieces of goldsmiths' work were signed by the Carthusian Giacomo di Tondo of Siena, including an enamelled chalice (pl.66).[37]

GUILDS AND GUILD LIFE

The development of luxury trades into profitable businesses was dependent on a number of factors: increasing specialization, the presence of entrepreneurial merchants, a ready market and a distribution network. Towns, with their dense populations, markets, ports, banks and wealthy consumers, were the inevitable centres of this development. As the trades took off within towns, so their practitioners realized that they would be more able to protect their livelihoods, combat competition and lobby for favours from the authorities by banding together. In doing so, they formed guilds – bodies for the regulation of a trade.

The earliest documentary references to guilds are from Constantinople, where the production of luxury goods was more fully developed than in any Western European town or monastic precinct of the tenth or eleventh century. Constantinople produced silks, carved ivories, goldsmiths' work and linen. A document known as the *Book of the Prefect*, written in about 900, describes the way in which the state governed the various manufactures. The producers and merchants were organized into 'public' guilds, for workers in the imperial factories, such as the silk workshops, and 'private' guilds, for the smaller manufacturers. The relationship between such Byzantine guilds and those that later developed in Western Europe is still a matter for debate but the two systems employed very similar rules and regulations.[38]

Guilds were found in Western Europe from the twelfth century onwards, from the Dalmatian coast, through Italy, Germany and France to England.[39] From an early date, many of them had legislation governing the ways in which their members could conduct business. One of the earliest surviving sets of guild rules relating to the luxury arts governs the goldsmiths of Venice, and was promulgated by the magistrates there in 1233. The magistrates were civic officials and the guild was therefore closely under the eye of government. The same was true for the goldsmiths' guilds of Paris (earliest surviving ordinances 1260s) and London (earliest surviving ordinances 1478). Many of the Venetian rules were taken up by other goldsmiths' guilds over the next few centuries.[40]

Firstly, and most importantly, the standards of purity for gold and silver were established. Secondly, what might be termed 'best practice' was set down – for example, it was forbidden to set crystal or glass into gold, and it was stated that prices should be agreed at the time of accepting the commission, not renegotiated later. Rules like this were important for establishing the guild's good reputation. The policing of the guild was also provided for: members were held on oath to denounce any fraud or wrongdoing that they knew of in the trade; and officials were appointed to enter

65. Silvestro dei Gherarducci, leaf from a choirbook, depicting Pentecost.
Pigment, gilding and ink on parchment, 57.5 × 40 cm. Florence, 1392–9. V&A: 3045

66. Giacomo di Tondo, chalice.
Copper-gilt and silver with translucent enamels, 21 cm high. Siena, c.1360–1410. V&A: 237–1874

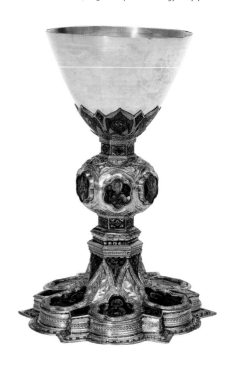

67. Chalice.
Silver-gilt, 17.2 cm high. Avignon, 1305–34. V&A: M.200–1956

68. Lampas fragment with wyverns, eagles and palmettes.
Woven silk and metal thread, 32.5 × 22 cm. Lucca (or Spain), *c*.1270–1330. V&A: T.66–1910

goldsmiths' workshops and assess the purity of the silver and gold being used. The duties of similar officials are discussed at length in the goldsmiths' guild regulations of other centres as far apart as Siena and London. In Siena, the *Ricercatori* (Investigators) were always appointed in threes – two to oversee the goldsmiths, the third to check the honesty of his own colleagues.

The Venetian goldsmiths' regulations also had a protectionist aim. Products from outside Venice were resisted, not least because their quality could not be guaranteed – no master was allowed to keep for sale gold and silver objects that were below Venetian purity standards. Rules like this posed a problem for the freedom of trade because purity standards tended to differ from town to town. For example, Florentine silver was slightly purer than that of nearby Siena. The Florentine goldsmiths' rules of 1408 made a specific exception for 'chalices and other ecclesiastical works' that, it seems, were being imported into the city for sale from 'Siena and elsewhere'.[41] The complexities created by differing standards of purity in the precious metals were especially pronounced during the period in the fourteenth century when the papacy was based at Avignon. The goldsmiths of Avignon used silver of greater purity than that employed by the papal court. When the papal court commissioned works it was therefore essential that they be marked to indicate that this lower standard had been used. The mark of the papal keys can be seen on a chalice of 1305–34 (pl.67).[42] Further guild protectionism prevented non-guild members from practising their trade within a city and foreigners would usually have to pay to join the guild before being allowed to work there.

In many cases, guild and local authorities played a role in maintaining monopolies on specialist knowledge. Until the early years of the fourteenth century, Venice possessed only a small number of silk workers; the Venetians had always concentrated on importing silks from the Byzantine and Arab worlds.[43] Nevertheless, production was important enough that the authorities had established guild legislation by 1263. In 1309, civil upheavals in Lucca caused by the triumph of the Ghibellines (the imperial political party) meant that 450 Guelf families (supporters of the pope) departed the city for Venice. Lucca was the leading producer of silk in Italy at this date, its products available to Northern European markets in the Champagne region and Bruges, and in the South of France (see pl.68).[44] At first four families of Lucchese Guelfs arrived in Venice, with 'artists numbering 300'.[45] That four families brought so many artists helps us to understand how the silk trade had been organized in Lucca. As with the wool and embroidery trades in Paris, textile production lent itself to quasi-industrial organization. The raw silk was owned by a merchant-entrepreneur, who passed it to the winders, spinners, dyers and weavers, based in a number of different workshops. Each of them exclusively worked for one merchant-entrepreneur. Thus, the movement of a few Lucchese silk merchants also necessitated the mass exodus of their subordinates, spelling disaster for the industry within Lucca. During the next few years, more artists moved to Venice and Pisa, while others were enticed to Bologna by offers of loans and workshop facilities.[46] These movements stimulated the production of textiles elsewhere, and led to the loss of trade skills and secrets in Lucca. By the late fourteenth century, its heyday as the dominant silk-weaving centre in Italy was long past. By 1453, the Venetian silk industry was so well established that the Senate restricted (with

69. **Glass beaker with a dragon.**
Glass, blown and enamelled,
10.7 cm high. Murano (Venice),
1250–1325. V&A: Lent anonymously

70. **Goblet with the arms of the
Salviati family of Florence.**
Glass, enamelled and gilt,
13 cm high. Murano (Venice),
1500–20. V&A: C.174–1936

a few exceptions) the export of silk not woven in the city.[47] The story of silk production in Western Europe is in fact the story of importers gradually acquiring the means to become producers.

Venetian glass-makers acquired their guild regulations in 1271, at a time when the authorities were also producing legislation for many other guilds in the city,[48] and the glass of Murano became synonymous with Venetian craftsmanship. Murano is an island in the Venetian archipelago on which the glass furnaces were based following a decree of 1291. The decree sought to contain the inevitable fires that furnaces caused, but also helped to regulate the glass industry by keeping it all in one location. Venice was the perfect place for a glass trade to develop. Living in a centre of importation from the Orient, Venetians were aware of the technical skill of Islamic and Byzantine glass-makers, and the latter were probably working within Venice itself during the late thirteenth and early fourteenth centuries.[49] Venice was also known for the skill of its artists in carving rock crystal, surely an inspiration for the development of the colourless glass of the type known as *cristallo*, for which Venice became famous. Finally, as a centre for international trade, Venice was perfectly placed to export its glass around the world: a fourteenth-century beaker excavated at Launceston Castle, Cornwall, demonstrates how far such objects could travel, even at an early date (pl.69). By this time, Venetian glass was doing so well that it was even exported to Byzantium.

An observer in 1494 noted of Murano, 'There are many furnaces there for making glass, and work in glass of every colour is carried on there constantly. All the beautiful glass vases which are taken throughout the world are made there.'[50] The reputation of Venetian glass-making continued into the sixteenth century (see pl.70), although the production process was still fraught with difficulties. In late 1544 the Medici agent Donato Bardi di Vernio was in Venice ordering various items for the Florentine court, including two glass vases for Eleonora di Toledo, wife of Cosimo I de' Medici. In the company of Cardinal Ercole Gonzaga, Donato visited the Murano glassworks. This kind of supervisory visit must have been a common public relations exercise for the glassworks

but in this case it was a disaster, as the visitors watched Eleonora's vases exploding in the furnace. Donato blamed this mishap on the craftsmen having set the temperature too high, and in his report to Florence he opined that 'this craft has been much in decline'.[51]

By this time the Venetians were seeking to protect their trade by forbidding glass-makers to work outside Murano. This decree was almost impossible to enforce, as was tacitly recognized when in 1549 the Council of Ten – Venice's governing body – asked envoys in every country to prepare lists of Venetian glass-makers known to be working abroad.[52]

A final important aspect of guild life reflected in the Venetian legislation was its religious role. All members were expected to observe specific feasts and not to work on those days. In some respects, trade guilds resembled other, specifically religious, lay confraternities. As we will see in Chapter Six, they often patronized chapels within churches, which they endowed with images and furnishings. They also provided for the funerals of their members – an otherwise expensive undertaking.

So far, we have concentrated on trades that were quite self-contained – notably glass-making and goldsmithing. But some trades were by their very nature less clearly defined. Perhaps the best example is sculpture. Medieval and renaissance sculptors, depending on where they were working and when, might be expected to use materials as diverse as marble, limestone, wood, ivory, bronze or the precious metals. They might work on monumental, site-specific sculpture to ornament buildings, or produce something as small and personal as a carved rosary. These crafts were organized on a much more variable and contingent basis across Europe than the other trades so far considered. In medieval Paris, for example, there were separate guilds for various types of rosary-makers, depending on whether they worked amber, ivory or some other material. Stonecutters and masons had a guild; figurative sculptors could belong to one of two guilds – the 'guild of image-maker carvers', including those who carved crucifixes, and that of the 'painters and image-carvers'. Both of these groups worked in more than one material, including stone, wood and ivory.[53]

We have already seen that Paris was Europe's leading centre for ivory carving in the thirteenth and fourteenth centuries. But there was no single ivory-carving guild, and the artists involved must have been scattered among various groups. Furthermore, the objects which they made and sold, to judge from surviving works and documents, overlapped with the interests of artists in other guilds. For example, one fashionable accessory of the period was an ivory toilet set, consisting of combs, mirrors, and gravoirs (hair-parting tools), often supplied with a carry-case of cured and worked leather (*cuir bouilli*). Although they would have been made by a number of different craftsmen, documents show these being supplied to clients by *pigniers* (comb-makers). For example, in 1387, Colinet of Lille, barber to the French king, was supplied with a toilet set 'for combing the hair of the said *seigneur*' by the comb-maker Jehan de Couilli.[54] The relationship between the guild structures within Paris, and the ivories which we know to have been carved and sold there, is therefore still far from clear.[55]

While guilds tried to protect their members from external competition, in other ways the organization of the trades contributed to the movement of artists around Europe. Sculptors were often attached to the masons' lodges of major building projects, whose ornamentation could take

71. Vault console depicting a man's head.
Marble. Castel del Monte, Apulia (Italy), *c.*1240–50.

many years, and by moving from one project to another, some sculptors travelled extensively. One artist whose travels certainly seem to have left a mark on his style is Nicola Pisano, one of the most well-known sculptors of thirteenth-century Tuscany, who operated a large workshop known for innovative free-standing monuments including pulpits, shrines and fountains. Nicola hailed from Apulia, in the south of Italy. Here, he was aware of, and was probably trained in, one of the workshops producing sculpture for the Hohenstaufen emperor Frederick II, who aimed to present himself in the guise of an Ancient Roman emperor by adding conspicuous classical references to his castles and cities in Campania and Apulia. Sculptures from Troia, and especially from Castel del Monte in Apulia (pl.71), combined a classical seriousness of approach with an interest in realism and expression, which compare well with contemporary sculpture in France, such as that at Chartres or Reims. This realism and an awareness of Northern European art are visible in the productions of Nicola's Tuscan workshop, but they are overlaid with a much more visible use of ancient prototypes as recognizable 'quotations'. Many of the sources for these were visible in Tuscany at that time. Nicola's art is thus a reflection of his peripatetic background (see pl.72).

WORKSHOPS AND THEIR MASTERS

From at least the thirteenth century, the layout and functioning of workshops producing small-scale luxury objects was fairly standardized across Europe. We have seen that most commercial workshops were located within towns and cities, often in regional clusters. The Grand Pont in Paris was mainly given over to goldsmiths' shops – their placement on the bridge made it harder for the shops to be robbed, and gave them the added protection of the fortified Châtelet building at the northern end.[56] The shop was opened for business in the most literal way – the street side was covered with shutters, which when pulled back meant that those in the workshop could deal directly with potential buyers in the street.[57] A fourteenth-century Italian painting of Saint Eligius the goldsmith gives a good idea of what such a shop would have looked like: the cloth over his counter probably corresponds to the '*tappeto al banco*' specified in Tuscan guild regulations (pl.73).[58] The times at which shops could be opened were strictly enshrined within the relevant guild's rules.[59]

Most of the making was done on the ground floor of the building, with the aid of natural light coming in from the counter or *banca* on the street side of the shop. This was partly because the light was better here, but also guaranteed that the workshop's practices were (quite literally) above board. Not for nothing did the Florentine goldsmiths' guild rules forbid the making of works 'in any way in any secret place not obvious, but so that all can see; nor in the dark, which is not plain to passers by and to those passing through the streets; nor during the night time….'[60] The quality of the work was also at stake – Parisian sculptors were forbidden to work during the night because they could not see well enough, and the Parisian embroiderers' regulations state that 'works made at night cannot be as good… as works made by day'.[61] The shops of Parisian manuscript illuminators were also commonly on the ground floor, with a kitchen behind, and living space above accessible by external stairs.[62]

The commerce on these lively streets must have been very competitive: one statute of the

72. **Workshop of Nicola Pisano, lectern support with the symbols of Saints Matthew, Mark and Luke.**
Marble, 77 cm high. Pisa, *c.*1270.
V&A: 5799–1859

73. **Master of the Madonna of the Misericordia,** *Saint Eligius in His Shop.* Tempera on panel, 35 × 39 cm. Florence, mid-14th century. Prado, Madrid, no.2842

Veronese goldsmiths states that no one should try to attract a buyer to his stall if he is already dealing with another master.[63] Although guild regulations sought to ensure best practice on the part of the maker or merchant (a difficult enough task), they could do little to ensure the good behaviour of the customer, and disputes were common – as in the 1307 complaint made by Margaret le Chaundler of London that she had sold a cope embroidered with gold and jewels to William de Trente, who sold it to the king for £200; she had only received £100, and had been threatened as well.[64]

Small to medium-sized workshops would have had a number of people working within them. Each master was entitled to accept a set number of apprentices, which varied from trade to trade and from place to place. The master's children, who were expected to learn their father's trade, were usually not counted. The 'guild of image-maker carvers' of Paris stipulated a lengthy apprenticeship of eight years if the boy was paid for, or ten years if he had to pay his way through service.[65] There would also be a number of adult employees, who were not themselves masters – we can see a number of them working in Saint Eligius' shop in the Italian painting mentioned earlier. Adult artists can be seen at work painting plates in Cipriano Piccolpasso's description of a *maiolica* studio in Castel Durante (see p.115). Neither apprentices nor assistants enjoyed full guild status, although clearly many such assistants were talented artists in their own right. This led to rules against workshops poaching assistants, as in the 1361 regulations of the Sienese goldsmiths' guild.[66]

We know the names of several of the artists who passed through Nicola Pisano's workshop, including his son Giovanni, Arnolfo di Cambio and an artist called Lapo. Nevertheless, we can only hypothesize how they divided up the work. For example, two angels produced in the shop, palpably

74A, B. **Workshop of Nicola Pisano, *The Angels Michael and Gabriel*.**
Marble, heights 97 cm and 96 cm. Pisa, 1260–70. V&A: 5798 and 5800–1859

75. *An Ironworker's Forge*, **from the Piccolomini manuscript of *Historia Naturalis* by Pliny the Elder (detail)**
Ink on parchment with watercolour and gold, 43.2 × 65 cm (when open). Rome, c.1460. V&A: MSL/1896/1504

from the same monument (a pulpit or shrine), have been finished very differently (pl.74A, B). Saint Michael has been decorated with a characteristic use of the drill, notably in the corners of the eyes, and dotted around the hair. Gabriel's eyes, on the other hand, have not been drilled, and where the drill has been employed on the hair and lower drapery, it has been used to produce a row of holes from which the interstices have been removed – the technique known as a 'running drill'. The effect is of tubular excavations in the surface, very different in character from the more 'perforated' finish on Saint Michael. This indicates that two different hands worked up these pieces in the shop, but this observation gives us only a superficial understanding of the role played by workshop assistants.[67] Painters in fourteenth-century Siena not only employed full-time apprentices but also made use of part-time workers, who could be active for months or just a few days. These artists were required to produce work that matched the dominant style of the workshop.[68] Sculptors would at times have taken trusted assistants with them when they moved to a different town, but they would also use local workers, who were often already schooled in local traditions and practices.[69] This partly explains the variations in appearance between works produced by the same named sculptor in different locations.[70]

Stone sculpture needed ample space to be worked, and trade between these artists and their customers could not always have taken place through a shop window. Other trades that required furnaces and kilns, such as glass- or pottery-making, would have needed an outside yard. We can

76. Designed by Jan van der Straet (Stradanus), *Book Printing*, **from** *Nova Reperta*.
Engraving, 26 × 31.4 cm.
The Netherlands, 1584.
V&A: E.1232–1904

get some idea of what such shops looked like from an illustration of an ironworking forge in a fifteenth-century manuscript of Pliny's *Natural History* (pl.75).

Other commercial enterprises were of their nature more complex and cooperative – Jan van der Straet's sixteenth-century image of a printing house illustrates the variety of tasks involved in the production of a book (pl.76). An ambitious printer like Aldus Manutius, founder of the Aldine Press in Venice, employed a substantial staff in the preparation, printing and sale of his books, particularly for his famous editions of works in Greek. Manuscripts needed to be collated and edited, proofs needed to be read, woodcut decorations created, the type set, proofs printed and checked, and the printing carried out. Books in Venice were not sold from the printing workshop because space was limited, but printers displayed unbound books for sale in the commercial area, the Mercerie. Effective dissemination of the volumes was crucial if they were to avoid the fate described by the Florentine firm of Giunti in 1563, that of books 'standing guard over the warehouses and after a while being used to wrap groceries'. Manutius' competitor, the Venetian printer Nicholas Jensen, retained another shop in Pavia, and had agents as far afield as France.[71]

77. **Master of Rimini,**
The Virgin with the Dead Christ.
Alabaster, 38.4 cm high.
Southern Netherlands, *c.*1430.
V&A: A.28–1960

MARKETS AND EXPORTS

During the fourteenth and fifteenth centuries, as with the earlier Limoges wares, a number of art forms developed which were characteristic of a small production area but were exported throughout Europe. Of these, one of the most well known is the alabaster-carving industry that flourished in England, producing altarpieces and devotional figures, often at an affordable price (pp.110–11).[72] The export of carved alabasters across Europe was not just confined to the lower end of the quality scale. Sculptors in this medium were also producing work in the most fashionable styles, and were able to sell it to a wide market in the first half of the fifteenth century. The best example is a mysterious Netherlandish sculptor known today as the 'Master of Rimini' because two of his carvings were in Rimini – the first a magnificent Crucifixion group (now in the Liebieghaus in Frankfurt), the second a highly charged Pietà (the Virgin Mary holding the dead Christ in her arms) in the church of S. Francesco.[73] His workshop seems to have specialized in these kinds of sculptural groups (pl.77). These works have survived over a surprisingly wide geographical area, although not in large numbers, and it is only because of the instantly recognizable style of the carving, in which figures are placed on rocky outcroppings over which their robes spill in crisp folds, as well as the shop's preference for alabaster, that this artist's oeuvre has been reconstructed. Nevertheless, the reconstruction has had its problems. At first, historians assumed that the sculptor might have been a German artist, perhaps one living in Italy – it was even suggested that he might be identified as the Cologne goldsmith Gusmin, who was celebrated by Lorenzo Ghiberti. We now recognize that the style of these works is incontestably Netherlandish, and of the most adventurous sort: the strong noses, double-pointed beards and striated hair can be paralleled very closely in work by leading Netherlandish painters such as Robert Campin.[74] The Master of Rimini, therefore, was a South Netherlandish artist selling the high-quality products of his workshop, possibly through intermediaries, to a clientele that was widely dispersed, with particular connections in Northern Italy. Similar Netherlandish alabasters travelled as far afield as Wroclaw in the Silesian area of Bohemia (now part of Poland).[75]

The Pietà in S. Francesco, Rimini is especially interesting, as the church was extensively remodelled and decorated in the mid-fifteenth century under the auspices of Sigismondo Pandolfo Malatesta. He attracted important Italian renaissance artists such as Leon Battista Alberti, Matteo de' Pasti, Agostino di Duccio and Piero della Francesca to work on the project. But if, as seems likely, he was the purchaser of the Rimini Pietà, then Sigismondo also appreciated Netherlandish art very different in appearance from the classical style of renaissance Italy.[76]

Unfortunately, we can only speculate about the identity of the Master of Rimini, the organization of his workshop and the nature of his trade links with Italy. Did he, for example, produce these works to order, or were they, as a few documentary sources might suggest, made 'on spec' and sold through middle men? Certainly, his work must have been as well-known at home in the Netherlands as it was abroad: a number of alabasters survive, slightly later in date than those of the Master of Rimini's workshop, but clearly indebted to his compositional style, such as an Annunciate Virgin of about 1440–60 (pl.78).[77]

78. *The Virgin Annunciate.*
Alabaster, 51 cm high. Southern
Netherlands, c.1440–60.
V&A: 6970–1861

79. **Workshop of Baldassare
Ubriachi, casket with the story
of Jason and the Argonauts.**
Bone plaques with wood and bone
inlay, 28.2 cm high. Venice, c.1400.
V&A: 3265–1856

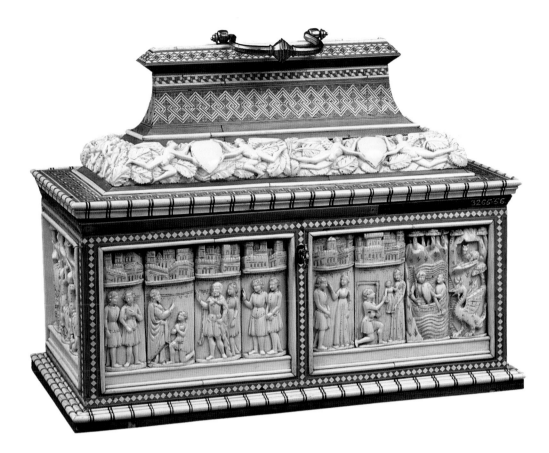

The success of a specialist exporter such as the Master of Rimini depended on finding a niche in the market. A similar enterprise, about which rather more is known, is the fifteenth-century 'Embriachi' bone-carving workshop of Florence, and later, Venice.[78] Baldassare Ubriachi, its founder, was a Florentine merchant whose workshop was producing carvings around 1370–80. He moved to Venice around 1390 and before 1395 established a bone-carving workshop there. The workshops primarily produced two types of object: caskets illustrating classical stories and romances, and large-scale altarpieces. Both types of work were exported abroad almost from the moment of the workshop's inception. A casket of exceptional quality, representing the story of Jason (pl.79), had found its way into the treasury of the Ste-Chapelle in Paris by the time of the French Revolution.[79] An Embriachi altarpiece is known to have adorned an altar in the Chartreuse de Champmol, the Carthusian abbey and burial church of the dukes of Burgundy. This abbey complex was a treasure house of art by some of the most talented Northern European artists of the day, including Claus Sluter, Jean de Marville, Jacques de Baerze and Melchior Broederlam.[80] At first sight, the lively but unsophisticated scenes characteristic of the Embriachi workshop, as well as its use of bone as a substitute for ivory, would seem a surprising choice for such exalted company. But these works were also deemed suitable for other great institutions in France: another Embriachi altarpiece, from the abbey of Poissy, was the gift of Jean, Duke of Berry, one of the most prominent art patrons of his day.[81]

Baldassare Ubriachi played a central role in disseminating the productions of the workshop through his various social, commercial and diplomatic contacts. He performed diplomatic missions for Gian Galeazzo Visconti of Milan, and became a confidant of Martin I, King of Aragon. In 1369 he was made Count Palatine by Charles IV of Luxembourg. In other words, Baldassare was able to promote Embriachi products in the course of his travels to those who had the money to spend on them. He was

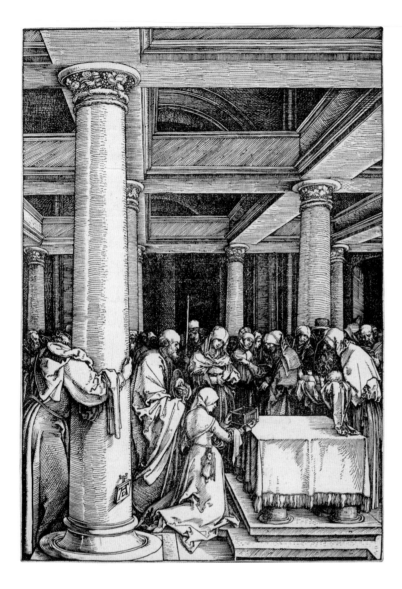

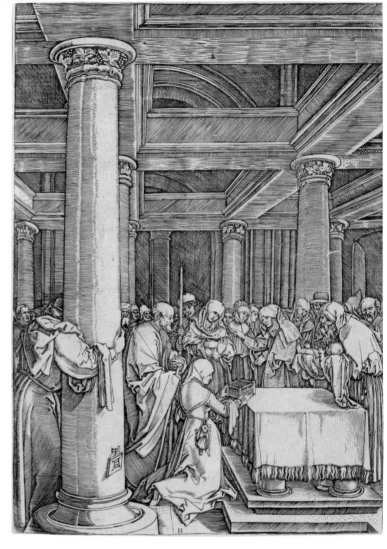

aided by the Northern European taste for novel types of artwork from Italy and elsewhere. Jean, Duke of Berry, famously wrote to the Sienese sculptor and intarsia worker Domenico di Niccolò to say 'we take pleasure in foreign things'.[82] In addition, the cheaper medium of carved bone allowed the Embriachi workshop to experiment with objects on a scale unimagined by the Parisian ivory workers.

The literate merchant bourgeoisie of Italy formed another group of buyers for the Embriachi productions. Baldassare himself was a member of this class. Their libraries often contained romances of exactly the sort depicted on Embriachi caskets. For example, the story of Jason as depicted on the V&A's casket almost certainly derives from the *Historia destructionis Troiae* (The Story of the Destruction of Troy), composed between 1272 and 1287 by Guido delle Colonne, which circulated around Europe in a number of vernacular translations. Given the demonstrable interest of the merchant class in these romances, we must conclude that they were the intended audience for the caskets, which were probably used as gifts during the complicated negotiations over marriage. The example of the Embriachi workshops allows us to picture the relationship between a particular type of luxury good and its various markets.

80. **Albrecht Dürer,**
The Presentation of
Christ in the Temple.
Woodcut, 29.9 × 21 cm.
Nuremberg, 1511 edition.
V&A: E.698–1940

81. **Marcantonio Raimondi,**
after Albrecht Dürer,
The Presentation of
Christ in the Temple.
Engraving, 29.2 × 20.9 cm.
Venice, 1505–6. V&A: 26127:11

NEW DEVELOPMENTS IN RENAISSANCE MANUFACTURES

The guilds of the fifteenth century were privileged bodies, jealously guarding their positions. In German cities, for example, many guild members enjoyed seats on the town council. But their world was coming under increasing pressure from the wider economy.[83] Nowhere is this clearer than in the field of tapestry production. Netherlandish weavers of the fifteenth century were employed by merchant-entrepreneurs, who owned the designs and the looms. It was they who dealt with the clients, and they who made the big profits, although when the tapestries were commissioned over a long distance, other middle men could become involved. For example, the Medici bank in Bruges regularly placed tapestry orders for its Italian clients.[84] In these circumstances, craftspeople inevitably experienced a decline in their wealth and social status.

This situation was only exacerbated by the existence of object types that necessitated a combination of craft skills. Collaborative art products were especially prone to falling into the hands of merchant-entrepreneurs. An obvious example is the production of large-scale winged altarpieces (see pp.112–13). These were made in substantial numbers in Germany and the Low Countries during the fifteenth and early sixteenth centuries and involved painters, sculptors and carpenters. Collaboration across guilds tended to destabilize the market in favour of merchant-entrepreneurs, especially when such works were intended to be sold via retail rather than as commissions.[85]

At the same time, retrenchments in princely power taking place across Europe also had an effect on the organization of trades and workshops. The Medici rulers of the Grand Dukedom of Tuscany were certainly keen to assert their control over production: for example, the famous ducal hardstone workshops were set up by Ferdinando I, who in 1588 combined all the court workshops in the Uffizi building as the Galleria dei Lavori.[86] Ferdinando also compelled Florence's goldsmiths to move their workshops onto the bridge called the Ponte Vecchio in 1593, an edict that led to civil unrest after it was published.[87] The retained court artist, based in workshops on land owned by the patron, was a common figure during the sixteenth century, especially when he produced work of a unique type, ensuring that the patron held a monopoly: Bernard Palissy, who worked near the Louvre in the 1560s under the protection of Catherine de' Medici, is a prime example (see p.239).

This interest of noble patrons in monopolizing production was part of a wider new development – the protection of intellectual property (see pp.118–19). This became an especially lively issue with the invention of printing. Albrecht Dürer is renowned for his attempts to prevent other artists, notably Marcantonio Raimondi, from copying his prints, and particularly from copying his 'AD' monogram (see pls 80, 81).[88] Among clients, some cathedral chapters demanded designs and even the wooden templates used to define moulding profiles from the architects of their buildings. An early example of this behaviour was at Toul in 1381.[89] This phenomenon may have played a part in the increasing survival from the late fourteenth century onwards of design drawings for buildings: a handsome example is the elevation of the lower part of the West Tower of Ulm Cathedral, probably made by the Master of Works, Moritz Ensinger in the 1470s (pl.82).[90] The fifteenth century was also the period in which patent law developed: in Venice, a law of 1474 allowed

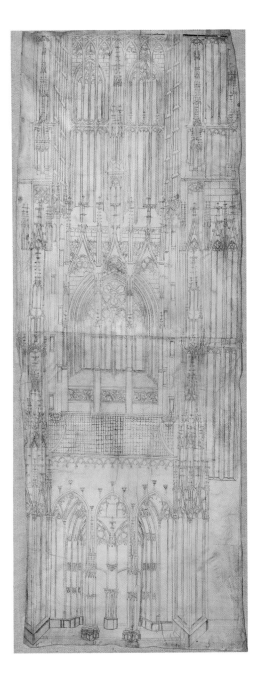

82. **Probably by Moritz Ensinger, front elevation of Ulm Cathedral.**
Ink on vellum, mounted on linen, 181 × 68 cm. Ulm (Germany), c.1470. V&A: 3547

83. **Master I.P.,**
The Judgement of Paris.
Pearwood, 23.5 cm high. Germany
(Salzburg, Passau or Regensburg),
*c.*1530. V&A: 4528–1858

84. **Jean Bourdichon,**
The Nativity.
Tempera on vellum, 29.3 × 17 cm.
Paris, *c.*1498. V&A: E.949–2003.
Purchased with the assistance of
the National Heritage Memorial
Fund and The Art Fund and the
Friends of the V&A

for the registering of innovations, with a ten- to twenty-five-year monopoly being granted.[91]

At the same time, however, guilds were undergoing novel and revitalizing impulses. New guilds were formed or officially recognized: the London embroiderers presented rules to the mayor and aldermen only in 1431,[92] although embroiderers had been banding together in a corporate manner for some time, as when they petitioned the king against the former mayor of London, Nicholas Brembre in 1387–8. (Brembre had made enemies amongst the London craft guilds, and the embroiderers joined with the mercers and others in submitting charges against him, including the forcible rigging of the 1384 mayoral elections at the Guildhall.)[93] The Scuola dei Pittori, the guild of painters in Venice, built itself a dedicated meeting place as late as 1532. In Rome, the earliest surviving goldsmiths' statutes date from 1508, when they were 'reformed'. It was probably only at this point that the Roman goldsmiths established themselves as a separate group from the other metalworkers, and were granted the right by the pope to construct their own church, dedicated to their patron, Saint Eligius.[94]

During the sixteenth century new markets were also developing, most notably that of the collector. The German carvers who would have specialized in making altarpieces in the 1490s were, by the second decade of the century, just as likely to be producing small works with classical subject matter intended for the collector's cabinet. Artists who followed this path included Loy Hering and the Master known as 'I.P.' (see pl.83).[95] The invention of printing eventually killed off the large-scale production of manuscripts, but the top end of the market was still served by men like Jean Bourdichon of Tours, the artist of an outstanding Book of Hours produced for Louis XII of France (pl.84).[96] Jean was a court artist, working as official painter to several French kings. Other manuscript painters, among them Simon Bening, combined the decoration of traditional products such as prayer books for great patrons including Cardinal Albrecht of Brandenburg with the production of innovative types of artwork, such as devotional images on parchment. From his Bruges atelier, Bening sent works to Portugal and the Holy Roman Empire.[97]

The sixteenth century, then, saw many new currents and impulses in the production of and trade in luxury objects. At the same time, there were many ways in which little had changed: a sixteenth-century goldsmith made his works using mostly the same techniques and in workshop arrangements that were virtually identical to those of his medieval predecessors. He would have been a member of a similar guild. Although sixteenth-century artists faced increasing competition from luxury goods imported from the East, Europe's internal trade in artworks was still in good shape. The most important trend was the growth in demand from the middle classes. The luxury goods that are the main subject of this book were, by 1600, no longer the dominant consumables in the marketplace. Instead, the majority of goods were produced for people of the middling sort, who aspired to fashionable living. Cheaper alternatives produced for this market were still for the most part determined by the tastes of society's elite. The patronage of princes, such as Rudolph II of Prague, offered great rewards to artists. But many of the most innovative developments in the arts of the next century would be amongst those goods intended for the bourgeois merchants of the newly independent United Provinces (Netherlands), England and France.[98]

5. English alabaster sculpture

ELEANOR TOWNSEND

IN 1491, NICHOLAS HILL, an alabaster carver based in Nottingham, sued William Bott, a salesman, for non-payment for 54 alabaster sculptures of the head of Saint John the Baptist (see 5.1). This scenario encapsulates several features of the thriving trade in alabaster carvings that built up around the quarries of Staffordshire and Derbyshire in the 200 years before the Reformation. Large quantities of sculptures, generally of religious subjects, were produced on a semi-industrial scale. The carvers worked within a highly developed system of agents to disseminate their work widely.

Alabaster, a stone prized from ancient times for its whiteness and translucency, is also soft and easily carved. It provides an excellent base for colour, and most English alabasters were painted and gilded. It came to prominence in English sculpture when used for royal effigies in the 1330s, such as that of Edward II at Gloucester. The fashion quickly spread, and by the 1370s the production of individual devotional figures and of rectangular panels to make up altarpieces was advanced. Alabaster is soluble in water, and so unsuitable for external architectural sculpture.

Until the Reformation, the carvers supplied individually commissioned tombs (5.2), retables and devotional figures, alongside large numbers of increasingly repetitive figures and altarpiece panels. The latter were hugely popular in churches and homes across England. Most depicted subjects favoured generally in the late fifteenth century, particularly scenes from the lives of saints as related in the *Golden Legend*, a widely enjoyed devotional book of the period. Unsurprisingly, panels and figures of favourite

saints such as Catherine, Christopher and Peter survive in the greatest number. But unusual subjects also appear, and the carvers reacted to changes in fashion, producing images of the newly popular Saint Erasmus, for example. The record of Nicholas Hill's 54 heads of John the Baptist demonstrates the demand for this particular type, which had spread from Germany. Surviving panels show that the Passion of Christ and the Joys and Sorrows of the Virgin were also frequently chosen as subjects for altarpieces (5.3). This reflects an increasing interest in the emotional life of Jesus and his mother, shown also in the popularity of associated pilgrimage sites in late medieval England.

In spite of the relatively high survival rate for English alabasters, certain categories have been lost. A will records the commissioning of a five foot high (1.5 m) alabaster image of Saint Nicholas for Thanington church, Kent, in 1532. This is larger than any surviving English alabaster figure (see 5.4).

Altarpiece panels, alongside devotional figures, were popular across Europe, depicting familiar subjects at a relatively modest price. Hundreds of English alabaster carvings can be found today from Iceland to Spain. There does not seem to have been an export trade for English alabaster tombs, no doubt for reasons of practicality, and because the prevailing fashion in Europe remained for effigies in stone. Alabaster sculptures of high quality were carved on the Continent, notably in the Southern Netherlands. But no producers seem to have matched the breadth of distribution, or the sheer quantity of work, achieved by the English carvers.

5.1 ▶ Head of Saint John the Baptist.

Alabaster with paint and gilding, 20 × 15.7 × 9.2 cm. Midlands (England), c.1470–90.
V&A: A.79-1946. Given by Dr W.L. Hildburgh FSA

Inventories show that alabaster heads of St John, though also found in churches and guildhalls, were particularly popular in English homes in the late 15th and early 16th centuries.

5.2 ▼ Thomas Prentys and Robert Sutton of Chellaston, Derbyshire, tomb of Ralph Greene and Katherine Mallory.

Alabaster. England, 1419–20. St Peter's Church, Lowick, Northamptonshire

This is one of very few alabaster tombs for which the contract survives, so we know who carved it, when it was carved and how much it cost (£40).

5.3 ▲ Altarpiece showing the Joys of the Virgin (The Swansea Altarpiece).

Alabaster and oak, with paint and gilding, 83.1 × 216 × 6.3 cm. England, late 15th century.
V&A: A.89-1919. Given by Dr W.L. Hildburgh FSA

Alabaster altarpieces were made up of a number of individual panels. Relatively few survive in their original wooden housing, and with this amount of original colour.

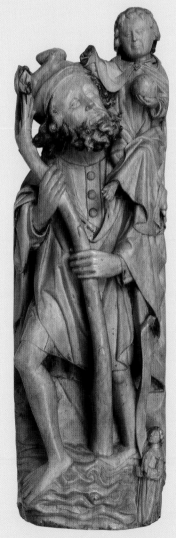

5.4 ▶ Saint Christopher and the Christ Child.

Alabaster and oak with traces of paint and gilding, 95 cm high. Midlands (England), c.1450.
V&A: A.18-1921. Given in memory of Cecil Duncan Jones by his friends

The figure is relatively large, and finely carved, indicating a special commission. Unusually for an English alabaster, the donor (a cleric) is shown at the feet of the saint.

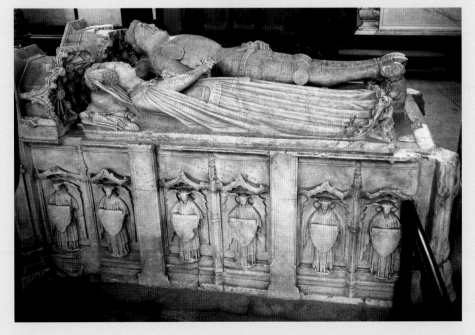

6. Sculptural altarpieces in late medieval and renaissance Europe

GIORGIA MANCINI

THE IMPORTANCE OF SACRED ART in the Catholic liturgical tradition is evident in the great altarpieces of medieval and renaissance Europe. The decrees of the Council of Lyons (1274) had codified the tradition of priests facing the altar rather than the congregation. A consequence of this change was the increasing importance of devotional artwork on the altar. Altarpieces varied enormously in size and conception, from tiny portable pictures to huge structures embracing the arts of architecture, sculpture and painting.

The greatest patrons of altarpiece production were religious institutions. Churches, convents and monastic orders, cardinals and bishops, all regularly expressed their piety and power by commissioning altarpieces. Sometimes a group of ecclesiastics formed a consortium for the purpose, and occasionally an entire monastic community would participate. Parishes might also be involved, building a fund through donations, the sale of pews or funerary concessions, and special collections. Contracts for altarpieces are the richest and most reliable documents we have for determining the means of their fabrication, the materials employed, the choice of iconography and the influence of the donors' taste.

Many such contracts required an appraisal of the materials and workmanship. These constituted the value of an altarpiece, and determined the final price to be paid to the artist. Altarpiece production involved materials – marble, wood, colour pigments and gold leaf – which were often costly imports; furthermore, there was the cost of packing, transport and installation of the finished piece. They required the labour of whole workshops, which sometimes relied upon subcontractors. A single altarpiece was often produced by a team of sculptors, painters and specialists in gilding, polychromy and architectural ornament.

Wooden altarpieces were found all over Europe. Important areas of production were southern Germany, Austria and the Italian Tyrol (6.1). Equally important were the Netherlands, in particular the Brabant region, whose main towns were Antwerp and Brussels. Netherlandish altarpieces usually comprised a sculpted middle section with painted wings, and combined abundant architectural ornamentation with elaborate narratives. Their striking standardization of format and iconography was the result of pressures on the demand side in both domestic and export markets. Many Brabantine carved altarpieces were not commissioned specially, but produced speculatively to be sold at local outlets and art fairs (6.2). Production grew so abundant and exports so frequent that the reputations of certain makers were protected by trademarks branded onto each of the elements. Altarpieces could also be acquired ready to be customized, with wings prepared for the insertion of donor portraits.

Similar techniques for standardization were developed by the della Robbia family of Florence in the fifteenth and sixteenth centuries (6.3). In the 1440s Luca della Robbia started glazing fired clay (terracotta) in astonishingly bright colours. Clay could also be moulded to create replicas, a benefit that was increasingly taken up by Luca's successors in the family workshop. Made in sections that would fit in the kiln, even large altarpieces could be transported and assembled quite easily. Ideal for delivering a powerful religious message, they were particularly sought after by the Franciscans.

6.1 ▼ **Rupert Potsch and Philipp Diemer, altarpiece showing the Virgin and Child with saints (The Brixen Altarpiece).**
Limewood and pine, painted and gilded, 416 × 465.5 × 190 cm. Brixen/Bressanone (Tyrol), *c.*1500–10. V&A: 192–1866

Many sculpture workshops flourished in Tyrol in the late 15th and early 16th centuries. Of the estimated two thousand altarpieces produced in this region, a good number have survived compared to other countries.

6.2 ◄ **Altarpiece with the Life of the Virgin.**
Oak, 250.5 × 210 × 37.5 cm. Southern Netherlands (probably Brussels), *c.*1520. V&A: 1049–1855

The scenes are assembled from numerous small groups and single figures. The majority of altarpieces devoted to the Infancy and Passion of Christ and the Life of the Virgin would have been bought ready-made.

6.3 ▼ **Workshop of Andrea della Robbia, *The Adoration of the Magi*.**
Tin-glazed terracotta, 221.7 × 184 × 28.3 cm. Florence, *c.*1500–10. V&A: 4412–1857

Andrea della Robbia based the composition of this altarpiece on a painting by Perugino. It was assembled from many parts that were fired separately.

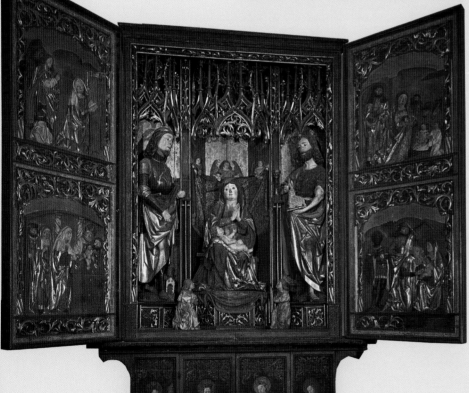

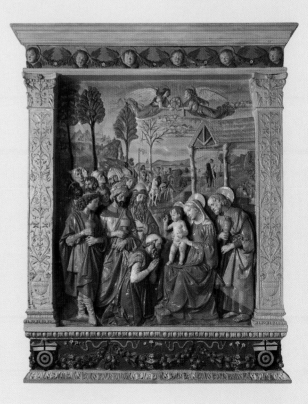

7. Istoriato maiolica of the Italian Renaissance

ELISA P. SANI

MAIOLICA, OR TIN-GLAZED EARTHENWARE, was produced in Italy long before the Renaissance. By the second half of the fifteenth century maiolica painters had achieved technical perfection and succeeded in creating an extraordinary pictorial language never before seen in pottery. This highly specialized craft, characterized by bright colours painted on sophisticated shapes, flourished across Italy, with Faenza, Venice, the Duchy of Urbino, Deruta, and sites in Tuscany all becoming important centres of production.

The dish shown in 7.1, probably made by Pesaro potters around 1485–90, is part of a set created for the King of Hungary, Matthias Corvinus and his Italian wife. It represents figures in a landscape within a central medallion. Soon after, skilled maiolica painters were covering the entire surface of plates or vessels with narrative scenes drawn in perspective, creating the new style termed *istoriato* ('narrative' ware). This type of pottery painting developed in several places around 1500.

The availability of graphic source material deeply influenced the development of narrative painting: potters often copied from prints and book illustrations. A drawing from Cipriano Piccolpasso's manuscript treatise *The Three Books of the Potter's Art* of about 1557 shows four maiolica painters at work, with drawings or prints pinned to the wall behind them (7.2). Subject matter was often mythological; to a much lesser extent, religious themes were also depicted (7.3). The palette was limited to a few metal-based pigments able to resist the high temperature of the kiln: green, based on copper; yellow and orange from iron and antimony; blue from cobalt; and purple and brown from manganese. Colours were sometimes enriched with metallic lustre.

Production of *istoriato* maiolica was always small, destined for elite clients who took a serious interest in it and commissioned large table services. The most famous *istoriato* service was made by the talented painter known as Nicola da Urbino for Isabella d'Este, Marchioness of Mantua, as a gift from her daughter in 1524–5 (7.4). In a letter addressed to her mother, Eleonora Gonzaga explains that the service (*credenza*) was suitable for use at Porto, Isabella's country villa. *Istoriato* maiolica was probably displayed but was also meant for occasional use; dining services included many different shapes, mostly functional.

Maiolica workshops were normally both places of production and sales outlets. The head of the workshop would have a number of painters working for him who inscribed their output only with the workshop mark. Often pieces were not inscribed at all, and the names of many talented painters remain unknown to us.

Though most maiolica painters were illiterate journeymen, the prolific *istoriato* painter Francesco Xanto Avelli da Rovigo, active in Urbino (the major centre of *istoriato* production) from about 1530, not only marked his pottery with his signature but would also add long inscriptions, adapted from literary sources. Xanto also began the practice of inscribing on the underside of an *istoriato* plate a description of the subject matter on the front. This information may have been used as playful entertainment among guests at an intimate banquet.

By the end of the sixteenth century, *istoriato* had gradually fallen out of fashion in Italy, but its influence continued to be felt throughout Europe, particularly in France.

7.3 ▼ **Dish showing the Presentation in the Temple.**
Earthenware with cobalt-blue *berettino* tin-glaze, 25.4 cm diameter. Faenza, inscribed with the 'Casa Pirota' mark, *c*.1520–25. V&A: C.159–1937

The main scene is after a woodcut by Albrecht Dürer (pl.80). To fill out the circular shape of the dish the painter introduced two figures from a different print by the German artist.

7.4 ▼▼ **Nicola di Gabriele Sbraghe known as Nicola da Urbino, plate showing Phaedra and Hippolytus, with the arms and devices of Isabella d'Este, Marchioness of Mantua, and her husband Gianfrancesco Gonzaga.**
Tin-glazed earthenware, 27.5 cm diameter. Urbino, *c*.1524–5. V&A: C.2229–1910. Salting Bequest

Nicola was arguably the most talented of all renaissance maiolica painters. He was head of a pottery workshop in Urbino but only a handful of his signed pieces are known.

7.1 ▲ **Dish showing boys picking fruit, and the arms of Matthias Corvinus, King of Hungary and his wife, Beatrice of Aragon.**
Tin-glazed earthenware, 46.8 cm diameter. Pesaro, 1485–90. V&A: 7410–1860

This dish is part of the earliest known set of Italian maiolica made for foreign royalty.

7.2 ▼ **Drawing, 'Maiolica painters at work', from *The Three Books of the Potter's Art* by Cipriano Piccolpasso of Castel Durante.**
Manuscript, ink on paper, 28 × 23 cm. Italy, *c*.1556–9. V&A: MSL/1861/7446, f.57v

This drawing is from a unique manuscript treatise, our main source of information on renaissance maiolica techniques.

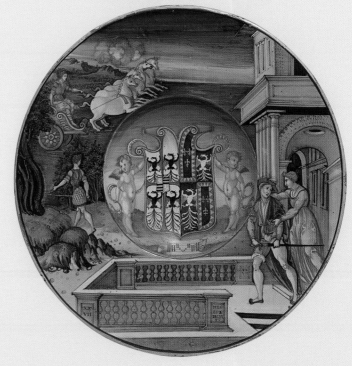

8. Mosan metalworkers and enamellers

MARIAN CAMPBELL

TO THE MEDIEVAL EYE, enamel had the unique attraction of allowing a story to be told in brilliant colour, by firing powdered glass onto metal. The skilful enamelling of Mosan craftsmen still excites admiration and wonder at its technical expertise. Mosan metalwork can be decorated with exceptionally complex theological scenes inspired by the Bible and the liturgy, engraved or enamelled in a wide range of colours, with a fondness for greens, yellows and brilliant turquoise. Figures are generally enamelled and set against a copper-gilt ground, which has first been boldly and deeply engraved to take the glass powder. Important features like heads and hands are usually engraved and gilded, the outlines being filled with red or blue enamel.

Mosan enamels and metalwork were made in such centres as Liège and Maastricht, in a region located between the rivers Rhine and Meuse (hence the name Mosan), which now includes parts of modern Belgium, Germany and Holland. Most surviving Mosan enamels were made around 1140–80, at a time of increasing prosperity. Between 1050 and 1200, new churches were being built or extended and their need for liturgical objects doubtless spurred production. Altars, candlesticks, crosses (8.1), reliquaries and crosiers were made of copper, silver or gold, often enamelled. Today only fragments generally survive, and it is rarely possible to know for whom such pieces were made.

Nevertheless, we know that a patron might draw together into one place specialists from many countries to work on a particular commission. Abbot Suger of St-Denis near Paris, great prelate and patron of the arts, summoned several goldsmiths from 'Lorraine' (the Meuse area) to make his six-foot-high altar cross, which was consecrated by the pope in 1147. The cross has perished, but it is known from Suger's own account that it had a pedestal enamelled with episodes from the life of Christ, as well as scenes from the Old Testament that theologians believed prefigured those in the New Testament.

The earliest datable Mosan piece to survive today is the reliquary containing the head of Pope Alexander (now in the Musées Royaux, Brussels) made for Abbot Wibald of Stavelot Abbey in 1145. Enamels decorate the copper-gilt base, the part concealing the head being made of silver. Wibald commissioned other major Mosan work, including the huge Remaclus Altarpiece, which was destroyed in the French Revolution except for two enamel medallions (now in museums in Frankfurt and Berlin). Wibald is likely also to have commissioned the Stavelot altarpiece triptych of 1155–8 (Morgan Library and Museum, New York), which is decorated with Mosan enamels and encloses two small Byzantine reliquaries of the True Cross. The Holy Roman Emperor, Frederick Barbarossa probably commissioned the bracelet-like *armillae* which he would have worn as part of his imperial regalia (now in museums in Paris and Nuremberg). One is enamelled with the Crucifixion, the other with the Resurrection.

A tantalizingly incomplete series of twelve plaques, likely to have originated from a single altarpiece, is now scattered between countries and collections, including that of the V&A (8.3). Their style is very close to a Mosan semicircular enamel (British Museum) depicting the powerful and wealthy English Bishop of Winchester, Henry of Blois, brother of King Stephen. This has inspired the speculation that all might have been commissioned by this patron of the arts, perhaps for an altarpiece.

8.1 ◄ Altar cross with figures of the Archangels Gabriel, Michael and Raphael.
Gilded copper, with niello and champlevé enamel, 38.6 × 19.7 × 13 cm. Meuse valley, c.1150–1200.
V&A: 7938–1862

The style of the finely modelled heads of the figures is close to several Mosan enamels, suggesting that the workshops that produced them were related. The hollow body of Christ once enclosed a relic of the True Cross.

8.2 ▼ Leaf from a bible, psalter or model book, showing Melchisedech blessing Abraham (top) and the Capture of Lot (below).
Watercolour on parchment, 22.7 × 15.9 cm. Southern Netherlands (possibly Liège region), c.1160.
V&A: 8982

This leaf may be from a pattern book used as a design source for the Mosan enamel plaques shown in 8.3.

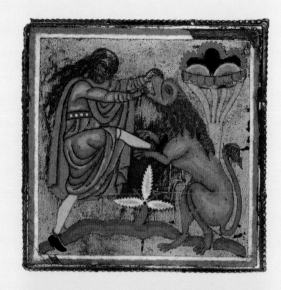

8.3 ◄ Enamel plaques showing, from the top: a man fighting a lion (perhaps *Samson and the Lion*); a man riding a camel, both champlevé enamel on copper; and *Moses and the Brazen Serpent*, copper with traces of champlevé enamel and gilding, all 10.2 × 10.2 cm. Meuse valley, c.1160.
V&A: M.53a–1988, M.53b–1988. Acquired with the support of the National Heritage Memorial Fund and The Art Fund; V&A: M.59–1952. Given by Dr W.L. Hildburgh FSA

Damage is visible on all these plaques, from complete loss of enamel and scraping away of the gilding to dents from hammer blows. Such deliberate violence characterized periods of religious upheaval.

9. Sculptors' models and multiples in renaissance Florence

GLYN DAVIES

BEFORE THE FIFTEENTH CENTURY, Italian sculptors seem to have relied mainly on drawings to transmit their ideas to assistants in the workshop. But after 1400, this situation started to change. Sketches, models and other preparatory works exist in wax, clay and terracotta. Their survival is no accident. By the sixteenth century, the new class of art connoisseurs valued the preparatory works of artists such as Michelangelo, giving them a status they had hitherto lacked. Michelangelo himself was well aware of this, making a present of two boxes of clay and wax models to his assistant Antonio Mini, so that he could sell them in France.

The sculptor Giambologna made few drawings, but large numbers of sketch-models by him survive. One of his most important commissions was to create a pendant to Michelangelo's famous marble group of *Victory* for Francesco de' Medici's marriage to Joanna of Austria in 1565. Giambologna worked up initial ideas for it in wax (9.1). Further models survive, showing later stages of the design process. The final marble was mainly carved by his assistant Francavilla, on the basis of a full-sized clay model. The remarkable freshness of Giambologna's sketch-models reflects his own emphasis on the idea rather than the final execution, much of which was left to his expert assistants.

The design process could take several stages. Another preliminary wax by Giambologna, a preparatory version of *The Rape of the Sabines* (9.2), features elements which were cast from a mould taken from another model. Evidently, several different versions of this composition were created.

Highly finished sketches were sometimes used as presentation models. This phenomenon was encouraged by the practice of awarding major commissions via a competition process. One such model survives from the hand of Andrea del Verrocchio (9.3). The liveliness and sketchy qualities of this piece are surprising in a presentation model.

Drawings, models and moulds represented the artistic assets of the workshop. Nowhere is this clearer than in the scrabble for control of Giambologna's models and designs on his death in 1608. Over the next few years, the bulk of this material passed from his nephew, to his assistant Pietro Tacca, and finally to Grand Duke Cosimo II de' Medici. Cosimo's ownership of the models was the easiest way of gaining control over the making of 'official' reproductions of well-known compositions.

Models and drawings enabled artists to adapt motifs for new contexts. Lorenzo Ghiberti's workshop seems to have been a centre for the production of devotional images in terracotta and stucco, some of them recycling compositions Ghiberti had used elsewhere. Moulds could be used over an extended period to create works of this sort, which often survive in multiple versions, making them difficult to date precisely. One painted terracotta relief of the Virgin and Child is based on a lost design by Benedetto da Maiano (9.4), although it is unclear whether the composition was designed specifically for replication in this way. Nor is it known whether this copy was made in Benedetto's workshop, or in another Florentine studio. Designs were shared or copied across workshops, and little is known for certain about the way Florentine artists produced and sold them.

9.1 ▼ **Giovanni Bologna, known as Giambologna, sketch-model for *Florence Triumphant over Pisa*.**
Wax, 25 × 9.8 × 10 cm.
Florence, 1565.
V&A: 4118–1854

More models have survived by Giambologna than any other renaissance sculptor.

9.2 ▼ Giovanni Bologna, known as Giambologna, sketch-model for *The Rape of the Sabines* (two views).
Wax, 47.2 × 14.7 × 12.3 cm.
Florence, *c*.1579–80.
V&A: 1092–1854

The female figure is hollow, suggesting that it was cast from another model.

9.3 ◄ Andrea del Verrocchio, sketch-model for the monument of Cardinal Niccolò Forteguerri.
Terracotta,
44.6 × 31.8 × 8.5 cm.
Florence, *c*.1476.
V&A: 7599–1861

Verrocchio won this commission against five other sculptors, but it was never finished as he had intended.

9.4 ▼ After Benedetto da Maiano, *Virgin and Child with Saint John the Baptist and Two Cherubs.*
Painted and gilded terracotta,
57.2 × 44.5 × 7.5 cm.
Florence, *c*.1475–1500.
V&A: 5–1890

Much of the paint is original. Reliefs were often dispatched to a painter's workshop to receive such decoration.

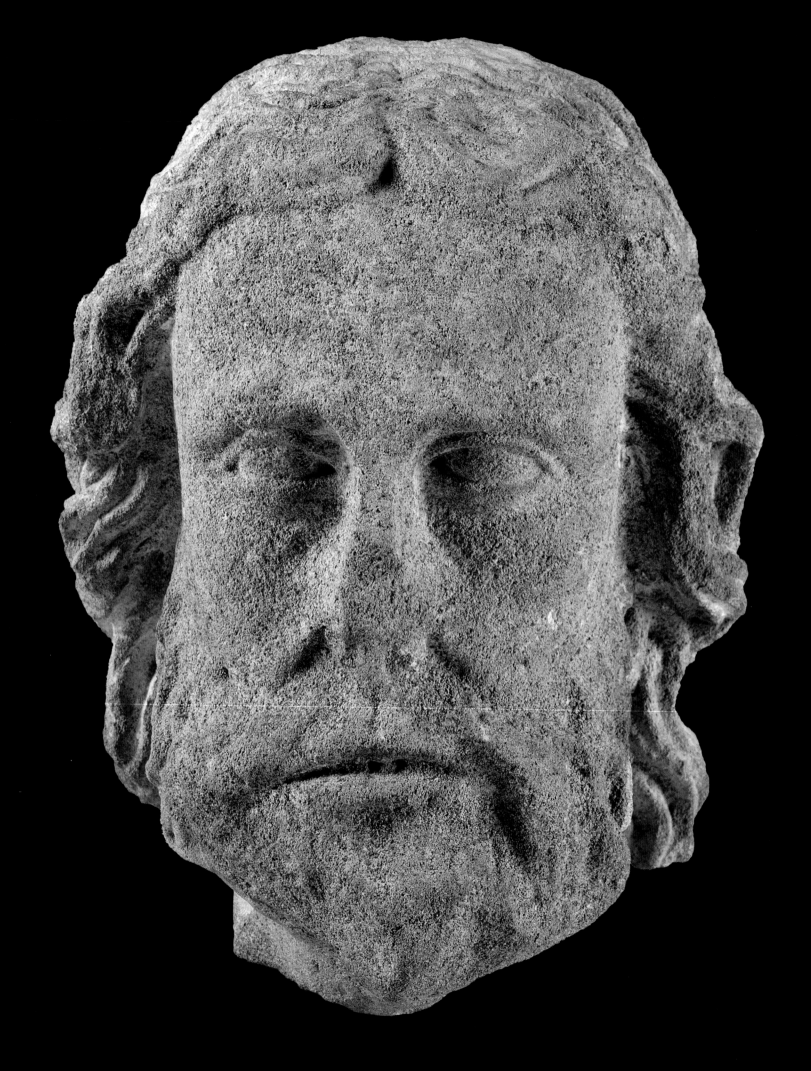

4

USING THE PAST

Glyn Davies

MAKING SENSE OF THE PAST can be difficult. Writing a chronicle in the early years of the thirteenth century, Bernard Itier, librarian of the abbey of St-Martial in Limoges, became puzzled over a reference he had found in an old history: 'In the year of grace 802, Michael was named the most pious marshal of the palace; he reigned for two years as Emperor of the Romans, as we read in the chronicle of Anastasius; although we know that Charlemagne, who was called Augustus, ruled during those thirteen years.' Bernard suggested a solution to the conundrum: 'Perhaps Michael ruled in Constantinople?'[1] His intuition was correct – Michael and Charlemagne had ruled concurrently as emperors in the eastern and western halves of the old Roman Empire. Nevertheless, Bernard's perplexity is understandable. As librarian of a rich Benedictine abbey, he had access to a relatively wide variety of sources: in addition to ecclesiastical books, the library possessed works of history and literature by Ancient Roman authors such as Livy, Julius Caesar, Seneca, Cicero, Suetonius and Pomponius Mela; and more recent historical writings by authors such as Isidore of Seville and the local historian Adémar of Chabannes.[2] But there were clearly large gaps in the histories available to Bernard, and the sources he consulted did not always seem to agree. Historians always have to piece together their knowledge from different, often conflicting, sources. This issue was an especially pressing one for medieval scholars. In the period before mass printing, there was little standardization in the canon of texts available to them. By the sixteenth century, the advent of printing, the increase in standardized editions, and the expansion in the letter-writing culture of the learned meant that historians no longer laboured so much alone.[3]

Of course, literary sources were not the only means of reconstructing history: when medieval and renaissance Europeans tried to understand the past, they could always look around them. They were inevitably confronted with physical remains. Prehistoric burials and stone circles were important local landmarks. In the early medieval epic poem *Beowulf*, the final battle takes place in

Head, probably representing Christ.
See pl.85, p.122.

a prehistoric barrow used by a dragon to store its treasure.[4] Sites of this sort, associated with dead pagans, were often places of fear and witchcraft. But they could also be places whose power was attractive to medieval Europeans. During the sixth and seventh centuries, for example, a number of Bronze Age burial sites in England were adapted and enlarged for reuse.[5]

THE VISIBLE PAST

Roman buildings, sometimes on a vast scale, were visible above ground throughout the period. The Maison Carrée, a Roman temple at Nîmes in southern France, survived first as a church, and then during medieval times as a meeting place for the town's officials,[6] while the massive Roman city gate at Trier (the Porta Nigra) was in the eleventh century used as a hermitage by the Sicilian monk Simeon. Smaller objects also survived, notably the many ancient sarcophagi found all over the old Roman world.[7] Extensive burial grounds survived at sites such as Pisa and Cologne. In addition, the soil itself yielded up curiosities from the past. In the sixteenth century, Benvenuto Cellini turned a tidy profit from such discoveries, buying from local collectors and selling on these purchases to his wealthier clients in Rome:

> …peasants were always finding ancient medals and agates, chrysoprases, cornelians and cameos, and also precious stones like emeralds, sapphires, diamonds and rubies. The collectors were sometimes able to buy these from the peasants for a few coins. And sometimes – in fact quite often – when I met these collectors I gave them, for what they had, more than as many gold crowns as they had paid *giulios*. These transactions, without taking into account the great profit I made which was easily ten-fold, also helped me establish good relations with nearly every cardinal in Rome…[8]

The buildings and artworks of more recent generations were also part of the local landscape. Renaissance Europe contained far more medieval art than does the Europe of today. Sometimes these remains were misunderstood: in the fourteenth and fifteenth centuries the medieval baptistery of Florence was thought to be a Roman temple of Mars. Even during the height of the Renaissance, when people might be expected to have known better, the proud Florentine Giorgio Vasari repeated this story as fact.[9]

Religious buildings were strongly embedded in local history, and were often valued as venerable representatives of local identity. In 1553, during his war with France, Emperor Charles V razed the town of Thérouanne. Canons from the nearby cathedral of St-Omer immediately obtained permission to salvage material from Thérouanne's own destroyed cathedral. They saved several large pieces of sculpture, including a limestone head from the west portal, probably representing Christ (pl.85).[10] Some religious buildings were potent political signifiers – the current cathedral of Seville was constructed out of the city's old mosque. But the mosque itself had been built on the site of the old Visigothic cathedral. The building thus epitomizes Seville's history.

85. **Head, probably representing Christ.**
Oolitic limestone, 36.1 cm high.
Thérouanne (France), 1230–40.
V&A: A.25–1979

86. **Folding triptych with religious scenes.**
Gold and translucent enamel,
7.2 × 8.4 cm (when open). England,
1350–70. V&A: Lent anonymously

Occasionally, the artistic value of old artefacts – both classical and more recent – was also acknowledged. In the fifteenth century, Pope Pius II, the humanist pope, reconfigured Corsignano, his birthplace in Tuscany, into the ideal town of Pienza. Amongst his gifts to the cathedral was an old English cope made some two hundred years earlier.[11] Another medieval object still in use during the Renaissance was a tiny folding triptych, decorated with enamelled scenes on gold (pl.86). The triptych, which depicts Christ's Passion as well as scenes from the life of the Virgin and Saints James, Edmund and Giles, would have been an aid to personal prayer. In the 1580s, it was given to Claudio Aquaviva, General of the Jesuit Order by Elizabeth Vaux, a member of a prominent family of English Catholics.[12] The triptych was still functioning as a powerful symbol of this family's religious faith. The afterlives of such objects are a central theme of this chapter.

WHICH PAST, AND WHY?

Despite Europe's cultural heterogeneity (see Chapter One), the past as it was understood during the medieval and renaissance periods was remarkably consistent. For Christians, the history of their religion and the Church as an entity was by far the most significant past: the events described in the New Testament were (and are) historical fact. Christians and Jews shared the past described in the Old Testament which was, for them, just as valid as history as the Roman past described by writers such as Livy.

This interest in the Old and New Testaments as history rather than as a matter of faith is worth bearing in mind when looking at art objects produced in the period. Characters from the Old

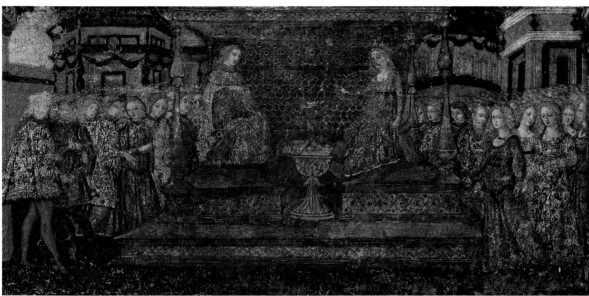

87. **Workshop of Francesco di Giorgio Martini,** *cassone* **with Solomon and the Queen of Sheba (detail).**
Wood, with tempera and gilt gesso, 99 cm high. Siena, 1469–75.
V&A: W.68–1925

88A, B. **Sword scabbard with the emblems of Cesare Borgia (with detail of the front).**
Tooled calf leather, 61 cm long.
Northern Italy, c.1498.
V&A: 101–1869

Testament in particular were often selected for representation as exemplars of virtue. For example, in fifteenth-century Italy, Old Testament subjects were a common choice for representation on *cassoni*, chests containing a bride's trousseau, which could be processed through the streets on the wedding day to the couple's new home. One such chest, with a painting from the workshop of the Sienese artist Francesco di Giorgio Martini, represents the meeting of Solomon and Sheba, an example of a woman's virtuous submission to a man's wisdom (pl.87). Another popular Old Testament heroine was Judith, who defended the virtue of her city by seducing the enemy general Holofernes and cutting off his head while he lay in a drunken stupor. She is represented holding his head aloft on an early sixteenth-century maiolica dish painted by the talented artist Maestro Jacopo of Cafaggiolo.[13]

The other past embraced by Christian (and sometimes Muslim) Europeans was the Roman past, which was so dominant in the European imagination that it sometimes displaced more 'accurate' histories. This certainly happened in Byzantium. With Greek as their native tongue, and as the heirs to the Hellenistic civilization of Ancient Greece, the Byzantines might have been expected to celebrate their Greek past as much as their Roman one. And yet, although some educated Byzantines proudly proclaimed their Greek descent, and after the fall of Constantinople in 1204 it became more common for them to describe themselves as 'Hellenes',[14] most Byzantines were far more aware of their Roman antecedents.[15] Indeed, they tended to describe themselves as 'Romans' (*Rhomaioi*), indicating Byzantium's role as the eastern half of the Roman Empire.

Just as Old Testament characters could exemplify virtues, so the classical world also provided moral exemplars. The most obvious example was martial prowess. The Renaissance saw the important development of armour and weaponry styled *all'antica* (after the antique), enabling the armour's lucky wearer to seem another Caesar, Scipio or even Hercules.[16] The comparison was

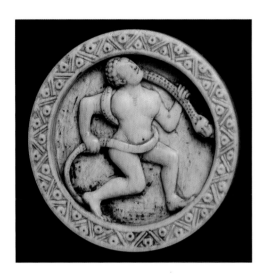

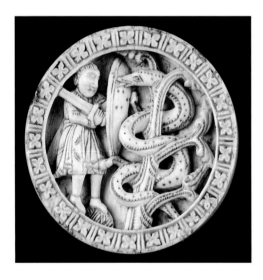

89. **Two tablemen.**
Ivory, diameters 7.5 cm and 6.6 cm.
Cologne, c.1150.
V&A: A.3–1933. Presented by
The Art Fund. V&A: 374–1871

especially apt for the formidable Cesare Borgia, illegitimate son of Pope Alexander VI, and praised by Machiavelli in his book *Il Principe* (The Prince). A highly worked scabbard (pl.88A, B), apparently unfinished due to a flaw in the leather, is a perfect example of how *all'antica* references could be used to flatter the owner of a piece of armour. The scabbard bears Cesare's *impresa* or personal device (a group of three flames), and a number of monograms with the Latin version of his name, CAESAR.[17] In addition, a sacrifice to the Goddess of Peace (or Venus, who could be understood in much the same way) is shown – Cesare is presented in classical guise as the friend of peace rather than as a warmonger.

Characters from these different pasts were sometimes explicitly compared or juxtaposed. In the twelfth century, for example, numerous sets of games pieces were produced for playing 'tables' (related to backgammon). At least one set represents the Labours of Hercules, along with the deeds of his biblical counterpart Samson, the stories of each character making up one player's set of pieces. In games pieces like these, it is unclear whether Samson and Hercules are presented as equals, or whether the pagan Hercules was to be understood as inferior to the more pious Samson. Two pieces, in the distinctive, 'pricked' style of the ivory workers of Cologne, show the different ways in which such stories could be represented (pl.89).[18] On one, the figure of a naked man struggling with a snake is certainly inspired by classical antecedents.[19] On the other, a medieval knight, wielding a large sword and carrying the distinctive oval shield of the Frankish warrior, battles a huge serpent. For modern viewers, this second image seems to represent an epic tale like Beowulf's confrontation with the dragon – but it actually illustrates Hercules' eleventh labour, where he attacks a serpent in order to gain the apple of the Hesperides. The shape of the serpent may well be based on astrological manuscripts in the Roman tradition.[20]

RESPONDING TO THE PAST: WRITERS AND TRAVELLERS

The physical remains of the Roman past were often mentioned by writers. They were discussed in two contrasting ways, either lamenting the loss of past grandeur, or berating the pride and folly of pagan Rome. Visiting the Greek and Roman remains at Pergamon in the thirteenth century, the Byzantine emperor Theodore II Lascaris took the former line: 'the city is full of theatres, grown old and decrepit with age, showing us as through a glass their former splendour and the nobility of those who built them… Such things does the city show unto us, the descendants, reproaching us with the greatness of ancestral glory… The works of the dead are more beautiful than those of the living.'[21] On the other hand, Hildebert of Lavardin, Bishop of Tours in the early twelfth century, acknowledged the grandeur of pagan Rome but thought that its destruction was a price he was comfortable to pay in order to usher in the kingdom of heaven, saying 'I prefer this present disgrace to those triumphs.'[22]

The ancient monuments and artefacts of Rome and Constantinople were especially influential for later viewers because in these places the ruins were most closely associated with the political power of the Roman Empire. The most popular guide to Rome was known as the *Mirabilia*

90. *The Emperor Marcus Aurelius on horseback.*
Bronze, 424 cm high.
Rome (Piazza del Campidoglio),
*c.*176 CE. Photograph *c.*1900–10
Museo Capitolino, Rome, MC3247

91. *Boy removing a Thorn from his Foot (Spinario).*
Bronze, 73 cm high.
Rome, probably 1st century CE.
Museo Capitolino, Rome, MC1186

(Marvels). Versions of the text were in circulation from at least the twelfth century and its popularity persisted through the fifteenth century and well into the age of printing.[23] New translations were still being produced in the sixteenth century. The text describes, often with approbation, the wonders that any visitor to the city would want to see, for example, Trajan's Column: 'The palace of Trajan and Hadrian… in which is the marvellous column of great height and beauty, with stories in relief about those emperors…'[24] There are descriptions of the gates, baths, palaces and theatres of the city, as well as the various Christian marvels, including a detailed description of St Peter's.

Of great interest to many visitors to Rome were the free-standing bronze statues to be seen in the city.[25] The Tuscan poet, Fazio degli Uberti, mentions one of these in his poem *Dittamondo* (About the World), written in the mid-fourteenth century: '… and you can see another there where he stands,

that great curly-headed figure near the Lateran, whom men call Constantine, but who was not.'[26] The statue in question was the equestrian bronze representing the Emperor Marcus Aurelius (pl.90), which had long stood in front of St John Lateran, the papal church and palace complex. Although the official reason for its display was that it was thought to represent Constantine, it seems that few people believed this. The twelfth-century English writer Gregorius recounted four theories as to the statue's identity, none of which was accurate, but which clearly demonstrate the interest taken in it by the people of Rome, the papal curia and pilgrims to the city.[27]

Next to Marcus Aurelius stood a figure which Gregorius described as 'that ridiculous figure of Priapus', and which is known today as the *Spinario* (pl.91).[28] This statue, representing a young man removing a thorn from his foot, had a long influence on European art. The general posture – a seated figure, with one leg raised onto the other – was often used by artists wishing to demonstrate their familiarity with the principles of antique art. One such relative of the *Spinario* – not a direct copy, but more of a distant cousin – is a figure representing the sea, once part of the base of a crucifix (pl.92).[29] This miniature figure, cast in bronze and gilded, was made in the Mosan region in around 1180. The metalworkers of this region were especially interested in adding something of the flavour of Roman sculpture to their works, perhaps partly because the area, part of the bishopric of Cologne, was comparatively rich in Roman survivals.

The statues of Constantinople also held an attraction for its inhabitants and visitors. As with the statues of Rome, many strange stories about them grew up over the centuries. In Constantinople, as in the West, free-standing statuary was associated with paganism. Indeed, in the years after the Iconoclastic Controversy (see p.26), almost no statues were produced in the Byzantine world. They were commonly thought to be the home of demons, which possessed magical powers. Nevertheless, many Byzantines were prepared to invoke these powers for their own benefit: a ninth-century Byzantine patriarch was said to have averted a barbarian invasion by mutilating a three-headed bronze statue in the Hippodrome.[30] Similar beliefs were found in Western Europe, where pagan idols were always conceived of as free-standing images, and the performance of magic could involve manipulation of statues.

Rome's statue of Marcus Aurelius was paralleled by an equestrian statue of Justinian in the Augusteion, outside Constantinople's main church of Hagia Sophia.[31] The statue was believed to embody Byzantium's claims to universal empire and, according to the thirteenth-century Arab writer al-Harawi, the figure carried 'a talisman that prevents the enemy from invading the country'.[32] It is hardly surprising that when Constantinople was seized by the Ottoman Turks in 1453, one of Sultan Mehmed II's first acts was to remove this statue, symbolizing the finality of Byzantium's fall.[33] As in Rome, pagan statues were sometimes interpreted as representing Christian figures: in the thirteenth century, a figure of the Greek hero Bellerophon was thought to be the Old Testament hero Joshua.[34]

Thus the advent of Christianity caused a major re-evaluation of the pagan past. For historians such as Eusebius and Orosius, this re-evaluation took place immediately in the fourth century, with the Roman Empire still master of Europe. Orosius, for example, wrote his world history so that

92. **Figure representing the Sea (*Mare*).**
Gilt bronze, 9.4 cm high. Meuse valley, 1180–90. V&A: 630–1864

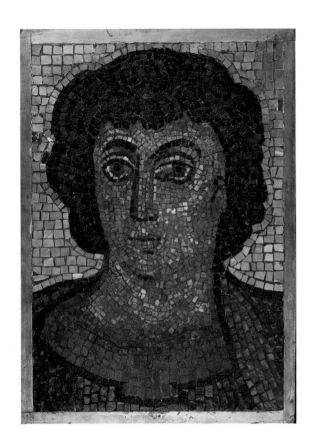

'those who grumble about our Christian times may know that one God has directed the course of history, in the beginning for the Babylonians and in the end for the Romans'.[35] A parallel process took place within art – the original meanings of artworks were transformed through Christian or folkloric reinterpretation. The transition from pagan art to Christian art was largely a process of adaptation rather than revolution, and Christian images did not immediately set themselves apart from their pagan counterparts. One example is a fragment of sixth-century mosaic that survives from the church of S. Michele in Africisco, Ravenna (pl.93).[36] It depicts Christ, and was once part of the apse mosaics of the church. The beardless, youthful Christ, so typical of early medieval art, had antecedents in pagan images, as can be seen in a fourth- or fifth-century Egyptian textile panel representing Hermes, surrounded by a halo (pl.94).

It is essential to emphasize that when medieval and renaissance scholars talked about the Roman world, it was often Christian, rather than pagan, Rome that they had in mind (see pp.150–51).[37] This raises the crucial question of when exactly the Roman Empire ended and when the medieval period began. For some Europeans, it was simply answered – the Roman Empire had never ended, because it continued in Constantinople. It was only in 1204 with the Sack of Constantinople during the Fourth Crusade that a decisive break occurred. Nevertheless, for Flavio Biondo, writing in the fifteenth century, Byzantium was in decline after the reign of Theodosius the Great (379–95).[38] The Western Empire, based in Rome, caused far greater difficulties for historians. Fifteenth-century

93. **Mosaic head of Christ.**
Glass and gold tesserae in plaster, 78.1 cm high. Ravenna, c.545 (with 19th-century restorations). V&A: 4312–1856

94. **Panel from a tunic, representing Hermes.**
Tapestry woven wool and linen, 17.5 × 17.5 cm. Egypt, 4th or 5th century. V&A: 651–1886

95. Leaf from a diptych (The Symmachi Panel).
Ivory, 29.5 cm high. Rome, c.400.
V&A: 212–1865

humanists such as Flavio and Leonardo Bruni dated the end of Rome to the barbarian wars of the fifth century.[39] But another tradition insisted that it, too, had never ended at all. This tradition based its claims on a document known as the Donation of Constantine, which purported to show that the Emperor Constantine had passed control of the empire over to the Roman Church. Needless to say, there was always a degree of scepticism over the authenticity of this document, especially from the political opponents of the papacy.[40] In the fifteenth century, several writers demonstrated conclusively that it was a fake but it remained influential. Some renaissance authors continued to treat the document as genuine – Ludovico Ariosto, author of *Orlando Furioso*, was one of them, as when he described 'the gift (if indeed it is correct to call it that), which Constantine gave to the good Silvester'.[41] It was an historical *topos* that was too good to abandon. For writers from Saint Bernard in the twelfth century to Petrarch in the fourteenth, and Luther in the sixteenth, the Donation of Constantine was a convenient point from which to argue that the virtue of early Christianity had been replaced with corruption and a concern for worldly things. The early Church, and especially the age of Constantine, was therefore often presented as a golden age.

All of the above makes it clear that the Ancient Roman past was especially rich in meaning for Europeans. References to Rome could evoke a wide variety of conflicting themes. It could be seen as a cultural powerhouse, an example of luxury and pride, a justification for a Europe-wide political hegemony, the seat of early Christian simplicity and virtue, or a time of heroes whose deeds were to be emulated. When references are made to Rome in later art, the question should always be: to which Rome is it referring?

MEANINGS: CHRISTIAN OR PAGAN?

The political meanings that could be extracted from artistic references to the Roman past can be explored by comparing examples from three different periods of time. The first is the fifth century, while the Roman Empire still existed. A panel from an ivory diptych, possibly made to commemorate a marriage alliance between two senatorial families in Rome, was made around 400 (pl.95).[42] It shows a priestess or initiate, her head bound with ivy, sprinkling incense on an altar. The subject matter, therefore, is a pagan ceremony, probably directed towards Bacchus or Jupiter. The style of the piece is striking. Rather than carve the work in a contemporary manner, the artist rendered it in a style recalling the statuary of Hadrianic Rome, several centuries earlier. Scholars have disagreed as to the significance of this, but it seems most likely that it was a deliberate attempt to link the two families, the Symmachi and the Nicomachi, with pagan Rome. Both families were leading adherents of the old religion, and opposed the dominance of Christianity.[43]

The second example comes from the time of the Carolingians and their successors the Ottonians in the ninth and tenth centuries. After Charlemagne was crowned Emperor of the Romans on Christmas Day 800, artists in the Frankish kingdom increasingly produced works that made explicit references to the past, in just about every conceivable manner. Techniques associated with Roman art were revived, including bronze casting, gem carving and ivory carving. Ivories, in

particular, took their inspiration from Roman models. The covers produced for the Carolingian manuscript known as the Lorsch Gospels (pl.96) obviously used a sixth-century five-part diptych as their point of departure, and in style are close to the ivories on the sixth-century throne of Archbishop Maximian in Ravenna (pl.97).[44] Roman ivory diptychs certainly survived in church treasuries, for example, the 'two ivory panels joined into one' that were recorded in the chapel of Berengar I, King of Italy, in Monza in around 910.[45]

The extent to which ancient models – especially those of the fifth and sixth centuries – were emulated by Carolingian artists is demonstrated by a problematic object known as the 'Andrews Diptych' (pl.98). This pair of ivory panels represents Christ's miracles in a manner that strongly recalls early Christian art: Christ is depicted beardless, and he wields a wand almost like a magician.[46] The dating of this object has always been highly controversial. It seems most likely that it is a Carolingian product of the ninth century, but if so, then the diptych follows the form of fifth-century models to an extraordinary degree.[47]

Carolingian artists emulated Late Antique models for reasons beyond their obvious visual appeal. These reasons are made most obvious in the field of architecture. The important Carolingian abbeys of St-Denis (near Paris) and most especially of Fulda (in Germany), were planned and laid out along the lines of the famous basilicas of Rome.[48] This relationship with the central buildings of early

99. **Agostino di Duccio, *The Virgin and Child with Five Angels.*** Marble, 55.9 cm high. Rimini, c.1450–60. V&A: A.14–1926. Purchased with the asistance of The Art Fund and Sir Joseph Duveen

Christianity helps to explain what was happening in Carolingian art at this time. Charlemagne had brought together a coterie of intellectuals from all over Europe with the aim of pushing through a programme of religious revitalization based on schools and book-study.[49] Charlemagne's political link to the papacy, and his role as emperor, caused both him and his leading churchmen to commission artworks recalling the Christian empire of Constantine. Indeed, Charlemagne took great trouble to bring to his palace in Aachen a bronze equestrian statue of the Emperor Theodoric from Ravenna, which was placed under a portico linking the throne room and the chapel.[50] This statue could hardly fail to recall the bronze statue of Marcus Aurelius in front of the Lateran Palace in Rome. The figure was not to the taste of all of Charlemagne's retinue. In an elegant poem inspired by Roman authors such as Virgil, Ovid and Boethius, the churchman Walafrid Strabo took the statue to task. He disliked the fact that it represented an emperor who had embraced a heresy, Arianism, and complained that 'avarice shines in its arms adorned with golden decorations'.[51]

The third example of a contemporary political point contained in a classical reference comes from renaissance Italy. If Carolingian artistic patronage tended to favour Christian Rome, then fifteenth-century patrons could see the propaganda value of references to Imperial Rome. Much of

Italy at this time was dominated by powerful warlords, known as *condottiere*, many of whom wished to demonstrate their influence and taste through progressive art patronage. The town of Rimini was the seat of Sigismondo Pandolfo Malatesta, one of renaissance Italy's most feared military leaders. Sigismondo spent huge sums remodelling the Franciscan church of Rimini into a mausoleum for himself and his mistress (later his third wife), Isotta degli Atti. He employed on this project the cream of Italian artists, including Leon Battista Alberti, Matteo de' Pasti, Piero della Francesca and Agostino di Duccio (see p.102). His selection of personnel was deliberate – these artists all gave their works an especially strong flavour of Antique art. Agostino di Duccio is a case in point – whilst working for Sigismondo, this unusual Florentine artist developed a style of relief carving whose firm outlines and chilly precision strongly recalled ancient artworks.[52] He combined this with a figure style reminiscent of Donatello, and a method of rendering faces that recalled the masks used in Roman theatre. A carved relief of the Virgin and Child is typical of his work (pl.99). The stylized rose on the foreheads of the angels is a Malatesta emblem, and would seem to confirm the hypothesis that the relief was a commission from Sigismondo, either for the church of S. Francesco or for a more private setting. The pendant around the Christ Child's neck is based on a Greek coin and represents a figure in a chariot crowned by Victory – a discreetly pagan element.

The overall direction taken by Sigismondo Malatesta's art patronage at S. Francesco recalled the ambitious monuments of Imperial Rome. This could be given a Christian gloss, just as the pendant worn by the Christ Child in Agostino's relief could be interpreted as an allusion to the victory of Christ. But the fact that Sigismondo himself was at the centre of this grandiose project meant that there was an implicit comparison between him and the Roman emperors. Alberti, architect of the S. Francesco project, designed the front of the building to recall the triumphal arches built by the emperors, and installed niches on either side that were originally intended to house the sarcophagi of Sigismondo and Isotta.

REUSE AND COPYING

The high symbolic value of Roman art and culture during the medieval and renaisssance periods did not lead to the preservation of ancient monuments. On the contrary, it was very tempting to reuse historical remains, both large and small, to create new buildings and works of art. Far from being an unusual practice, it was often the easiest way to source building materials. One of the most well-known examples is St Albans Abbey in England, which was built with reused bricks deliberately quarried from the Roman town nearby.[53] Such plundering was in full flow during the Renaissance – in the mid-fifteenth century, Pope Nicholas V took 2,500 cartloads of travertine from the Colosseum in one year.[54] Marble was in especial demand, because it seems to have been only sporadically quarried during the medieval period, although increasingly after the eleventh century.[55] Much of the marble incorporated into medieval buildings, or carved into statuary, was taken from older structures.

Such basic reuse of materials need not have carried any special meaning. A Carolingian book-cover of the Crucifixion and other scenes produced in Metz in the ninth century was formed from

100. **Gregorio di Allegretto (attributed), sarcophagus of Saint Justina.**
Marble, 65.4 cm high. Padua, c.1450–76. V&A: 75–1879

a reused Roman diptych. The back of the panel still bears traces of the original image (see pl.54B, p.86). Tuscan marble sculptors of the late thirteenth century also reused material. For example, the large seated figure of the ruler Charles of Anjou executed in Rome by Arnolfo di Cambio was carved from a large fragment of the architrave of a Roman building.[56] A beautiful Paduan sarcophagus of the fifteenth century (pl.100), carved with a low-relief scene of a saint who has been identified as Justina, is probably another such reuse.[57] The tomb's opening is not on the top, as one would expect, but at the rear. The ancient, plain sarcophagus was turned on its side so that the sculptor could use the thicker marble of the base for his image of the saint.

Reuse could have strong political overtones, however. This is made obvious by the fact that stone was sometimes transported long distances.[58] During the tenth century, Ottonian buildings at Hildesheim, Essen, Magdeburg and other centres used stones from the Mediterranean to demarcate significant areas, rather than making use of abundant local Roman remains.[59] In the eleventh and twelfth centuries, the people of Pisa made extensive use of stones from Rome and Ostia for the buildings of the Camposanto, instead of using more local sources.[60] The marble blocks reused for the apse of Pisa Cathedral were placed in such a way as to emphasize that they were taken from other buildings – partial inscriptions were left quite visible.[61] The viewer was to take note that the stones demonstrated the wealth and influence of the city, that they illustrated the triumph of Christianity over paganism, and that the virtue of the marble was now being put to better use.

The reuse of smaller objects could often change or subvert their original meanings. This practice was already common in the Late Antique world. Just as the Emperor Constantine had used sculpture from other monuments to adorn his triumphal arch near the Colosseum (pl.101), so other patrons reused earlier art objects. The late fourth-century ivory panel commemorating the Roman

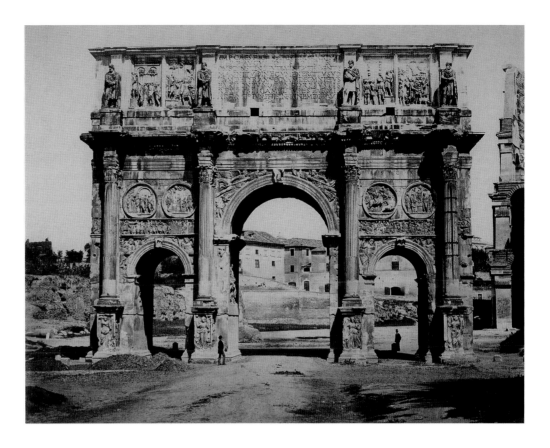

101. **The Arch of Constantine.**
Rome (Imperial Forum), 315 CE.
Photograph c.1870

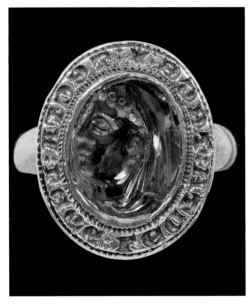

102. **Signet ring set with
a Greek intaglio.**
Gold and sapphire, 2.5 cm
diameter. Probably France,
1250–1350. V&A: 89–1899

Symmachi family (see above, p.129) was in the thirteenth century incorporated into a reliquary shrine at Montier-en-Der (Haute-Marne, France), where it now acted as a door giving access to the relics within.[62] The pagan imagery of the panel, which shows a Roman priestess at an altar, clearly did not bother the patron of the medieval shrine. If the subject matter were considered at all, the ivory's presence would probably have been interpreted as demonstrating once again the triumph of Christianity over paganism.

Small-scale cameos or intaglios provide further examples. These survived in large numbers in medieval Europe, and were certainly highly valued.[63] Many such gems were reused in rings, as is the case with an ancient Hellenistic sapphire depicting a veiled female head, which was set into a ring some time between 1250 and 1350 (pl.102). The inscription in French translates as 'Read what is held, hold what is read.' This motto was common on seals, indicating that the intaglio was used as a personal seal by its medieval owner. Antique coins and cameos were sometimes imitated by medieval seal-makers.[64] Talismanic qualities were certainly attributed to ancient gems, and it may be that this was one reason for their popularity in rings and seals.[65]

Older artworks could also be used as design sources. For example, in the tenth century, the maker of a carved ivory casket (pl.103) based his image of the biblical hero Joshua receiving the envoys from Gibeon on illustrations in a manuscript, contemporary with the casket, which survives today in Rome. This 'Joshua Roll', as it is known, appears to have been a conscious attempt on the part of Byzantine artists to reproduce compositions of the type found on ancient triumphal columns. The images found in the Joshua Roll, and on the casket, are probably based on a fifth- or sixth-century artwork.[66]

Ancient compositions could be copied wholesale, or some part of them could be appropriated.

This might be a figure group, or the style of heads or draperies. These elements could then be used in completely new contexts. Sometimes viewers might be expected to have recognized the use of ancient models; sometimes they were seamlessly integrated (see pp.148–9).[67]

THE PAST AS PLAYGROUND: THE FALL OF TROY

Historians such as Orosius, Isidore of Seville and Peter Comestor dealt with a standard corpus of material. One regular ingredient was the Fall of Troy, which, as Orosius noted, is a tale 'that seems known to all'.[68] The Trojan story remained the most well-known of all ancient incidents throughout our period.

Its popularity meant that it was often used as an origin myth for the peoples and nations of Europe. This process began as early as the seventh century, when refugees from Troy were described as the ancestors of the Franks.[69] Nor were the Franks the only group to claim that they were descended from Trojan nobility. Over the years, almost every major family, town or nation in Europe seems to have made such claims. Unlikely Trojans included Elizabeth I of England, the Habsburg dynasty and the Venetians, who in the thirteenth century were assured by Martino da Canal, in his *Estoires de Venise* (Histories of Venice), that the first inhabitants of the lagoon had been Trojans, led by Antenor.[70] Antenor was also credited as the founder of Padua, which from the thirteenth century proudly displayed his tomb in the centre of town.[71] During the fourteenth and fifteenth centuries, even the Turks were said to descend from a Trojan called Torquatus.[72]

Other groups traced their origins elsewhere in the past. The Tolomei family of Siena could not resist claiming descent from Egyptian rulers. Edward I of England linked himself to King Arthur, even going so far as to open Arthur's (spurious) tomb at Glastonbury Abbey when he visited the site in 1278.[73] Arthur's body had been 'discovered' by the enterprising monks of Glastonbury in the twelfth century.[74] In Reims and Siena, historians wrestled with the question of whether or not their cities had been founded by soldiers loyal to Romulus' brother Remus. The priest Flodoard, writing in the tenth century, invoked the local archaeology of Reims to bolster his argument: 'it seems, therefore, most probable that the soldiers of Remus, fleeing from their country, came together at

103. *Joshua receiving Envoys from Gibeon.*
Ivory, 7.5 × 27 cm. Constantinople (modern Istanbul), *c.*950–1000.
V&A: 265–1867

104A. **Tapestry from a set showing the Trojan war (*The Arrival of Penthesilea, Queen of the Amazons, at Troy*).**
Wool and silk, 416 × 737 cm.
Tournai, 1475–90. V&A: 6–1887

our town and founded the Reman nation, because the walls carry the insignia of the Romans… and because the highest gate is known by the name of Mars.'[75]

Given the interest in the role of the ancient world as the begetter of present virtues, it is hardly surprising that secular readers were increasingly drawn to read romances based on the Trojan cycle. Their source was not Homer. Instead, a genre of Trojan story grew up that was based on two fictitious accounts of the war written by Dictys of Crete in the second century and Dares the Phrygian in the sixth. These authors were the authoritative voice on matters Trojan even to the Byzantines.[76] The story was retold several times, notably by Benoît of Ste-Maure in the twelfth-century, Guido delle Colonne in the thirteenth century and Domenico da Montechiello in the late fifteenth century .[77]

The Trojan stories lent themselves to depiction on a large scale, and formed the subject matter for tapestries from the 1360s onwards. Many of the themes of this chapter emerge in one such object, a tapestry depicting the arrival of Penthesilea, Queen of the Amazons, at Troy (pl.104A). This huge hanging, made at Tournai, was once part of a set of eleven, which when displayed, would have covered one hundred metres of wall.[78] Several sets of tapestries were produced to this design and were acquired by the most notable artistic patrons of Europe: Charles the Bold, Duke of Burgundy; Federigo da Montefeltro, Duke of Urbino; Henry VII of England; Charles VIII of France; James IV of Scotland; Matyás Kiraly, King of Hungary; and Ludovico il Moro, Duke of Milan.[79]

The designer of the scenes, an artist known as the Coëtivy Master, did not trouble to make the

action archaeologically correct. Instead, he followed the lead of the authors of the Trojan romances, taking many details from them. The imagery of the tapestry therefore reflects the tastes and atmosphere of the literature that was hugely popular in this period. Nor was it only popular with society's elite. For example, in 1462 one merchant of Venice, Giovanni Corner, left a book about Troy to a scribe in his will.[80] This combination of both erudite and more popular appeal is also reflected in the fact that the tapestry originally had explanatory texts in both Latin, the language of the learned, and French.[81] Only the Latin inscriptions now remain, in a band along the bottom.

None but the very wealthiest of patrons could afford tapestries of this sort. They were one of the most expensive luxury goods of the period. But people of lesser means flocked to see them when they got the chance – hence the propaganda value of tapestries depicting the heroes of the past. During the coronation festivities of Louis XI of France in the 1460s, his rival the Duke of Burgundy came to Paris and made an enormous impact simply by displaying his tapestry collection:

> The Duke of Burgundy, being in Paris, showed in his reception room in the Hotel d'Artois, and in his living quarters, the most noble tapestries that anyone in Paris had ever seen, most especially that with the story of Gideon… the duke also showed the history of Alexander and others; almost all were made of gold and silver and silk, and because he had so many, they were shown one on top of the other… there was no one who did not marvel at the estate he kept.[82]

The circular, sun-like emblem at the top left of the Penthesilea hanging is another aspect of its propaganda value (pl.104B). This is the Sun of Justice (*Sol Iustitiae*), which was associated with the Emperor Constantine and adopted as a symbol by Charles VIII of France. The tapestry's viewer would be reminded not only of the Trojan ancestry of the French nation but also of the virtues Charles shared with the first Christian emperor.[83] In 1496, this device was added to a tapestry of the Trojan War at Charles's château at Amboise.[84] Recent conservation work on the V&A tapestry has revealed that if the sun motif was indeed added later, the work was extremely skilfully done. It may even be that the motif is original to the tapestry. Therefore, although the V&A tapestry may be the one Charles owned at Amboise, it is possible that it comes from another set in his possession.[85]

The dense, rich imagery of the tapestry allows another reading. A number of the figures are represented in a distinctly 'orientalized' manner. Priam, ruler of Troy, receives the kneeling Penthesilea wearing a turban and sporting an elaborate beard. Other characters carry scimitars, or wear Turkish hats. Whilst the setting is certainly fantastic, visual clues would have allowed a contemporary viewer to recognize this as a historical, rather than a contemporary, scene. Some of the armour, for example, is of the type thought at this time to be typical of the ancient world, with prominent lion masks on the shoulders.[86] As we saw earlier, in the fifteenth century the Turks were believed to have descended from Trojans. This allowed the artists of the tapestry to project Turkish dress backwards onto the Trojans. Essentially, the Trojans in the tapestry have become Turks.[87]

105. **Mirror case (The Martelli Mirror).**
Bronze with gold and silver inlay, 17.3 cm diameter. Italy (possibly Mantua), *c.*1495–1500.
V&A: 8717–1863

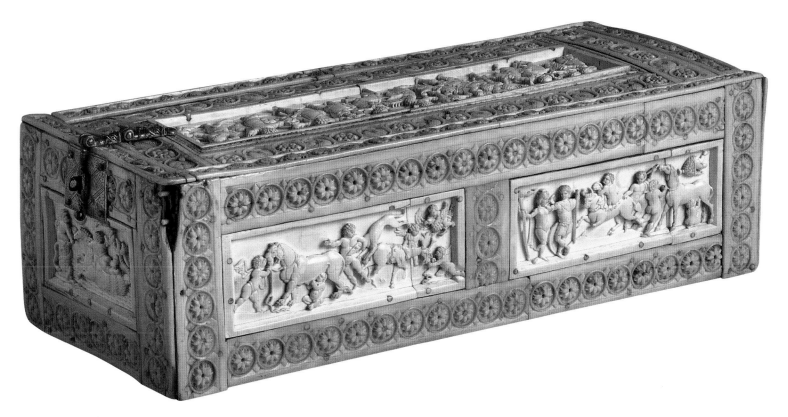

106. The Veroli Casket.
Ivory, bone and wood, 11.5 cm high. Constantinople (modern Istanbul), c.950–1000. V&A: 216–1865

As the Trojan War tapestry demonstrates, the fifteenth and sixteenth centuries enjoyed a particularly intense relationship with the classical past. One manifestation of this was a vision of the past as a metaphor for the concerns of the present. The antique world was a fashionable garb in which to dress propaganda, titillation and entertainment. This might be called the playful use of antiquity. The Priapic fertility imagery on the late fifteenth-century Martelli Mirror is a case in point (pl.105). As the Latin inscription on the mirror points out, 'Nature encourages what necessity demands.' The composition of the mirror is fully within the classical spirit – at least part derives from ancient gems that were in the Medici collection. The approach, however, is far from reverential. The probable use of this object as a marriage gift means that first and foremost it perfectly expressed the needs and sentiment of fifteenth-century Italian society.[88]

This attitude was by no means a novelty of the Renaissance. Byzantine artists and patrons of the tenth century were capable of the same spirit. The so-called 'Veroli Casket', a long wooden box covered with ivory and bone plaques, is a perfect example (pl.106).[89] At first sight, the images, which include the Rape of Europa and the Sacrifice of Iphigenia, might be seen to represent the deep debt owed to ancient art by Byzantine ivory carvers. But the subject matter is not being taken entirely seriously.[90] In one image, a putto seems to enact a parody of the Rape of Europa scene, delicately perched side-saddle on a bull's back. In fact, few of the compositions have a complete pedigree in ancient art, and there is a definite sense of *bricolage* – the assembly of existing units to form a new and rather different whole. The meanings given to these scenes by the casket's original Byzantine owners are hard to reconstruct, but clearly they did not represent to them the doings of their gods and goddesses, or indeed events from history, as they might have to an ancient audience. Instead, the playful imagery seems to reflect a taste for the ancient world as diverting and learned entertainment.[91]

When, in the 1440s, Lorenzo Ghiberti said of Giotto, 'he… invented or discovered doctrines which had lain buried for about 600 years,' it is notable that the language he used was that of excavation.[92] It was exactly at this time that the first moves towards a more strictly archaeological understanding of ancient monuments were being undertaken. From this point of view, the Renaissance was an exhumation, a digging-up and resuscitation of a dead past.

The attempt to understand the ancient past through scientific examination of texts and physical remains is one of the key characteristics of the Renaissance. For example, writing in the mid-fifteenth century, Angelo Decembrio described a technical examination of the Ancient Egyptian obelisk that stood near Old St Peter's and is now in the Vatican Square. Decembrio wrote that popular beliefs about its magical origins and scholarly debates based on incorrect presumptions should be abandoned in favour of direct observation: 'let us ignore the confused accounts of the writers, and produce a verdict about what can clearly be seen.'[93]

Credit for this more scientific approach to the past is often given to Petrarch, the campaigning scholar of the mid-fourteenth century.[94] Observing that the Church had become involved in secular affairs, Petrarch argued that the only legitimate subject for study was the greatness of classical and early Christian Rome.[95] The notion of the medieval past as a dark age was further developed in the sixteenth century, receiving a classic (although partly ironic) statement from Rabelais, in his novel *Pantagruel*, first published in 1532. Whilst attending university in Paris the main character, Pantagruel, receives a letter from his father, who reminisces about his own time at university in the 1420s: 'the time then was not so propitious or commodious for learning as it is at present… That time was still dark, and knew the infelicity and calamity of the Goths, who had destroyed all good literature.'[96] Nevertheless, other authors saw the medieval period more positively – for example, Flavio Biondo, writing in the 1440s, dated the revival of Italy's condition to the twelfth and thirteenth centuries, the heyday of communal democracies in the peninsula.[97]

Meanwhile, the confident artists of fifteenth-century Tuscany dated the growth of all good art back to the naturalistic innovations developed by Giotto and his contemporaries in the period around 1300.[98] As well as naturalism, another element was especially prized by this group of artists and their patrons – the ability to incorporate visual 'quotations' and references to the arts of Antiquity. It was in this spirit that the Florentine architect Filippo Brunelleschi included a version of the *Spinario* in his proposal for the bronze doors of the Florentine baptistery in 1401.

The sudden popularity of ancient references in fifteenth-century Tuscany was partly down to education. The children of the rich – the artistic patrons of the future – were increasingly educated by the new breed of humanist scholars. Men like the formidable Niccolò Niccoli gathered circles of admirers and pupils around them, all of whom shared a taste for ancient literature, which they admired, copied and emulated (see pp.154–5). Their obsession with ancient texts could become bogged down in pedantry – Angelo Poliziano spent much time and energy debating whether a philosophical term used by Aristotle should be spelt '*endelechia*' or '*entelechia*'.[99] Nevertheless, the

107. Miniature mosaic of the Annunciation.
Tesserae of gold, silver and semi-precious stones set in wax, 15.2 cm high. Constantinople (modern Istanbul), 1300–25.
V&A: 7231–1860

enthusiasm of these scholars for the ancient world was transmitted to their wealthy pupils. Poliziano, for example, was the tutor of Piero de' Medici.

Perhaps most significantly for the antiquarian direction that art was about to take, a number of humanists formed influential collections of antiquities. The two most important early collections were the gems, coins and small bronzes of Cardinal Pietro Barbo (Pope Paul II, 1464–71), and the remarkable collection of Niccolò Niccoli, which also included statues and hardstone vessels. Niccoli's collection was not limited to ancient artefacts. It included more traditional high-status objects such as porcelain and rock crystal. According to his friend Vespasiano da Bisticci, 'when he was at table, he ate from very beautiful antique vessels, and almost all his table was filled with porcelain vases, or other most ornate vessels. The one from which he drank was a cup of rock crystal, or some other hard-stone.'[100] Niccoli's broad tastes also encompassed what Vespasiano refers to as 'many pieces of mosaic in small tablets'.[101] This seems to describe the miniature mosaics of medieval Constantinople (pl.107).

The key pieces of both these collections became the most prized artworks of the Renaissance, for their provenance as much as their beauty. Extraordinary prices were paid for them – for example, a carving of Diomedes, bought by Niccoli from a street urchin in Florence, passed from his collection to that of Ludovico Trevisan, and from him to Pietro Barbo, before finally being bought by Lorenzo de' Medici.[102] Although Niccoli had bought it for five florins, by 1492 it was valued at 500.[103]

A more scholarly approach to the ancient world was therefore fashionable amongst Tuscany's elite in the fifteenth century. Artists were quick to catch on, even to take part. Ghiberti amassed his own collection of antiquities, which at his death was valued at 1,500 florins.[104] Just as humanist scholars tended to assemble their essays and discussions from quotations and forms used by the ancients – suitably modified, inverted or elaborated – so artists realized that they could 'quote' ancient art in their work. Far from being solely characterized by a new combination of ancient style with ancient subject matter, fifteenth-century Italian art was typified by the clever adaptation of ancient motifs, style and subject matter to modern settings.[105] During the fifteenth century, Italian renaissance artists usually presented ancient source material in a new, Christian guise.

Donatello's workshop was one early site for such experimentation. In a series of bronze reliefs depicting the life of Saint Anthony for the church of the Santo in Padua, Donatello used a number of motifs reflecting his knowledge of ancient art, including the barrel-vaulted architecture, the fluttering draperies and a number of individual figures.[106] Donatello's workshop, or a follower who was aware of his work, took a similar approach in the mysterious terracotta relief known as the 'Forzori Altar' (pl.108).[107] The relief seems to be taken from an incomplete composition in wax.[108] The subject matter is the most standard of Christian subjects, the Flagellation and Crucifixion of Christ, but the treatment is resolutely novel and would have struck contemporary viewers as strange, to say the least. Both episodes are set under a barrel-vaulted loggia. This was a reasonable setting for the Flagellation, which took place in Pilate's judgement hall, but the inclusion of the Crucifixion in such a context was almost unprecedented.[109] The grieving women at the foot of the cross recall

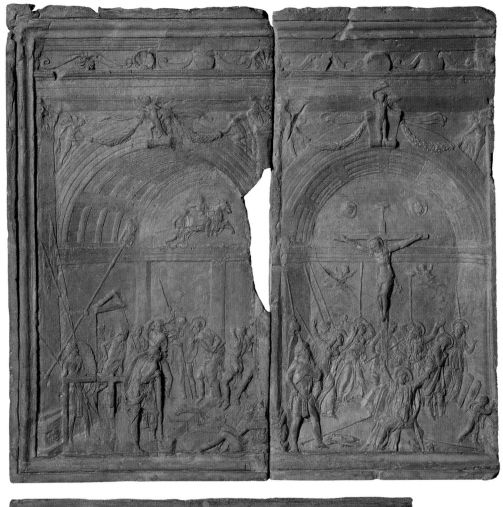

108. **Possibly by Donatello or his circle, *The Flagellation and Crucifixion* (The Forzori Altar).** Terracotta, heights 54.5 cm (*Flagellation*), 53.5 cm (*Crucifixion*), 11.6 cm (predella). Italy (probably Padua), *c*.1445–50. V&A: 7619–1861

ancient maenads, and the manner in which they are treated is similar to the figures on Roman ceramics from Arezzo that were well known in this period.[110] A familiarity with Roman art and architecture is made plain throughout – the architecture, the putti with swags and the numerous figures watching the main action would all have been recognized as *all'antica*. And yet no single part of the scene can be said to derive from Roman reliefs, statues or painting.[111]

While the inspiration of ancient textual sources was particularly important for humanist-educated critics, artists often adopted a much more pragmatic approach based on first-hand observation.[112] Artists like Ghiberti favoured close examination of surviving antiquities. When the figure of a hermaphrodite was discovered in Siena, he praised its subtleties: 'in this statue was the greatest refinement, which the eye would not have discovered, had not the hand sought it out.'[113] Renaissance sculptors in particular saw a value in having ancient artefacts to hand in their workshops.[114] The Sienese sculptor Jacopo della Quercia owned two large nudes in metal, probably Roman bronzes.[115]

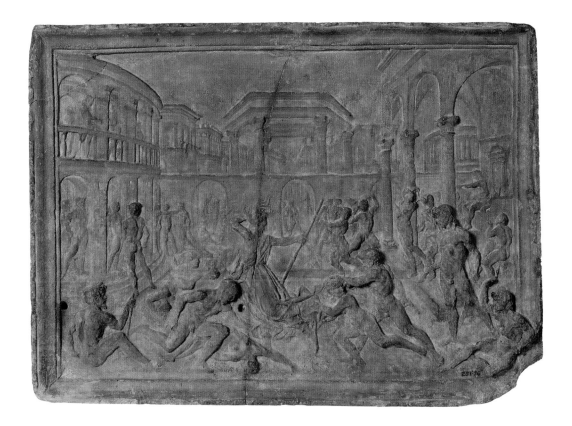

109. **Francesco di Giorgio Martini, relief with an unidentified scene.**
Moulded and painted stucco, 47.5 cm high. Siena, *c.*1475–1500.
V&A: 251–1876

Practitioners during the Renaissance recognized that the ancients were wrong perhaps just as often as they were right; for example, Alberti pointed out errors in the architectural theories of the Roman author Vitruvius.[116] Indeed, the poet Ugolino Verino clearly believed that Alberti was the superior of the two authors, declaring, 'Nor does Alberti give ground to Euclid; he triumphs over Vitruvius.'[117] Albrecht Dürer was initially inspired by his reading of Vitruvius' canon of human proportions, but after 'investigating about two or three hundred living persons', he eventually rejected Vitruvius' scheme in favour of a much more complex and contingent one of his own devising.[118] This critical attitude permeated other fields of endeavour. In the 1580s travel writer José de Acosta memorably recorded when his boat crossed the equator: 'I will confess here that I laughed and jeered at Aristotle's meteorological theories and his philosophy, seeing that in the very place where according to his rules, everything must be burning and on fire, I and all my companions were cold.'[119]

During the second half of the fifteenth century in Italy, with the stylistic 'look' of renaissance art firmly established, a number of artists with an antiquarian outlook emerged. These artists generally served an elite clientele of collectors and patrons. Artistic works produced in this sector are in stark contrast to the variations on standardized religious subjects that were the bread and butter of renaissance art. A characteristically dense and impenetrable example is a plaster relief by the Sienese artist Francesco di Giorgio (pl.109). This animated battle scene, whose contorted nude figures certainly owe much to the study of ancient art, has resisted interpretation by modern scholars. It is possible that learned Sienese patrons might have recognized a classical subject here, such as Lycurgus Killing the Maenads. On the other hand, the nudity of the figures and the plain finish of the plaster might indicate that the relief was intended more as inspiration for other artists than as a story-telling vehicle.[120]

Despite their displays of learning, such 'antiquarian' artworks did not always reflect a 'correct' understanding of Antiquity. The sculptor Pier Jacopo Alari-Bonacolsi, known as 'Antico' because of the way his works captured the look of ancient statues, produced sought-after bronze statuettes.[121] This form was both a startling innovation of the Renaissance, aimed at the new collector market, as well as an embodiment of antique inspiration, since it emulated surviving figures from the Roman period (see pp.152–3). One of Antico's statuettes was based on a well-known statue in Rome, known popularly as 'The Peasant' (*contadino* or *villano*).[122] The marble original eventually passed into the hands of the Medici, and it was displayed in the Uffizi next to an antique figure of a boar.[123] This indicates that at least some sixteenth-century commentators believed the marble represented Meleager, the Greek warrior who killed a boar ravaging his land, and who was best known through Ovid's popular *Metamorphoses*. Although modern scholarship identifies Antico's statuette as *Meleager*, that is not how it was described in the sixteenth century. Instead, it seems to be 'the little peasant' referred to in an inventory of 1496, responding to the popular name of the marble original rather than linking it to a classical text.[124] As this chapter has demonstrated, ancient works of art were constantly misidentified, or creatively re-identified.[125]

THE RENAISSANCE RECEIVED: FRANCE

By the end of the fifteenth century, the stylistic 'look' of Italian renaissance art, a general interest in the ancient world and a campaigning scholarly concern for editing ancient texts were increasingly taken notice of outside Italy. In this sense, the renaissance project was about to go international. Responses across Europe to the art and culture of Italy were creative, fertile and surprisingly heterogeneous.

Often, it is hard to disentangle where the inspiration for this development came from. Was it inspired by the art of the ancient world, or was it simply aping the fashionable forms of contemporary Italy? When one comes across 'antique' ornament in the arts of sixteenth-century Europe, it must often be understood as representing 'Italianate' art as much as that of the ancients. For example, in a limestone relief of the Virgin and Child of about 1520 by the Augsburg sculptor Gregor Erhart, the figures of the Virgin and Child are fully within the German tradition (pl.110).[126] The crowned Virgin stands on a crescent moon as the 'woman clothed with the sun' from the Book of Revelation. The foreground figures, however, have little to do with the architecture behind them, which consists of highly decorated columns, entablature and vaults. Copied from a woodcut by Hans Burgkmair, these features are best understood not as a response to Roman architecture, but as a nod to Italian fashions. This fascination with foreign (*Welsch*) things was complained of by a number of German commentators.[127]

The way in which the Renaissance was experienced outside Italy is best discussed by taking a single country as an example. France is particularly interesting, in that embracing the Renaissance involved a rejection of French history in favour of an ancient past in which France's own part was small. Until the early fifteenth century, France had been the home of arguably the leading artistic

110. **Gregor Erhart,**
The Virgin and Child.
Solnhofen limestone, 43.3 cm high.
Augsburg, *c*.1520. V&A: 7957–1862

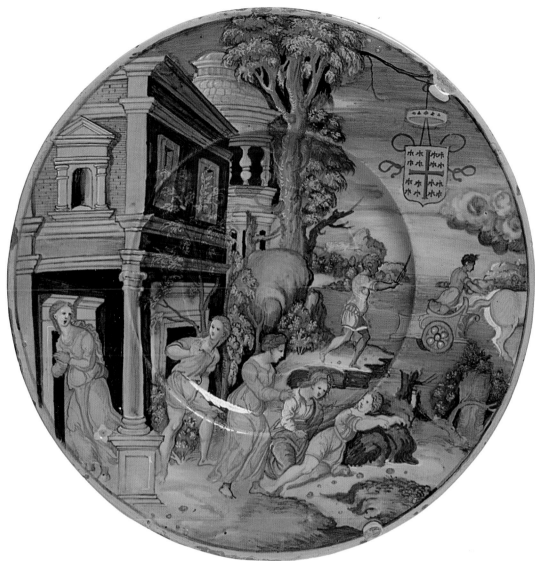

111. **Workshop of Guido Durantino, dish with Hippolytus and Phaedra and the arms of Anne de Montmorency.**
Tin-glazed earthenware, 29.9 cm diameter. Urbino, 1535.
V&A: C.2243–1910. Salting Bequest

112. **Candlestick.**
Lead-glazed earthenware, 32 cm high. France (Paris or Fontainebleau), 1550–90.
V&A: 261–1864

patrons in Europe. Economic problems had crippled the French monarchy, but even then other patrons, notably the powerful dukes of Burgundy, had stepped into the breach. Yet at some point during the fifteenth century there was a crisis in confidence about the state of French culture. This manifested itself in the sudden rejection of France's history and arts by a new generation of scholars and poets, who instead hitched themselves definitively to contemporary Italian developments. The strongest condemnations of medieval culture during the Renaissance were undoubtedly those made by sixteenth-century French humanists. For example, Jean Despautère stated definitively that Petrarch, 'not without divine inspiration, about the year 1340 opened war on the barbarians; and, recalling the Muses who had fled, vehemently excited the study of eloquence'.[128] The sense of inadequacy felt by some French authors in the face of Italian culture was summed up by Guillaume Budé, when he claimed that the French were 'unsuited to letters, in contrast to the Italians, whose sky and soil enabled even infants to wail eloquently and poetically'.[129]

The Italian Renaissance's first inroads into France were made via French artists who had spent time in Italy, such as Jean Fouquet, and itinerant Italian artists who adapted their styles and working practices to their new environment, such as Cellini. French patrons were keen to acquire works similar to those that they might have seen in Italy. Anne de Montmorency, the powerful friend of

King Francis I, commissioned Italian maiolica, like the dish illustrated here (pl.111). It is part of a set made in 1535 by the artist Guido Durantino.[130] In the fashion typical of maiolica (see pp.114–15), it depicts the story of Hippolytus and Phaedra in a colourful and lively way, with little concern for antiquarian accuracy – Aesculapius, the Greek god of medicine, is wrongly represented as a woman. Montmorency was demonstrating not so much his knowledge of antique culture as his taste for things Italian.

Alongside these Italian works, the collections of great French patrons contained French art objects which approached the past with as much, or greater, seriousness. A candlestick (pl.112) dating to the reign of Henry II (1547–59) is one of a mysterious group of ceramics known as St-Porchaire wares, after the site from which their clay comes. It is unclear who made these pieces, but all are highly refined, taking their forms from contemporary metalwork.[131] The decoration owes much to Italianate renaissance conventions. The swags, herm figures and masks derive from a classical ornamental vocabulary. More modern Italian decorative motifs inspired the scrolls and arabesque patterns.

Renaissance motifs were perhaps most obviously embraced in the field of architecture, and especially in secular buildings. A window from the château of Montal, near Cahors in southern France, is typical of the classicizing details added to French renaissance houses (pl.113), of which dormer windows facing onto the central courtyard were an especially noticeable feature. They were a key element in the buildings illustrated by the architect Sebastiano Serlio, whose *I sette libri dell'architettura* (Seven Books on Architecture) became a standard treatise on architectural practice in Northern Europe.

Italian styles did not replace indigenous French ones overnight, but there was a clear change in fashion towards Italian norms.[132] The only element of French culture that remained resistant was the style of church buildings. New churches were still being constructed in the gothic style well into the sixteenth century.[133] Apparently, the stirring example of France's extraordinary heritage of gothic cathedrals and abbeys was simply too strong to ignore. This was also true to some extent of the art that filled these churches, although here, the attraction of Italianate forms made itself felt more quickly. A stunning altarpiece from Troyes owes the richness of its imagery to the art of the medieval past but there are nevertheless many discreet references to more contemporary concerns (see pl.27, p.43). For example, the sarcophagus from which Christ is resurrected is decorated with an Italianate low relief. Stylistic novelty was creeping in by the back door.

It was arguably French art patronage that established the canon of ancient works that were to be most valued and studied in the coming centuries. The Bolognese artist Primaticcio persuaded King Francis I to dispatch him to Rome to produce moulds from the best ancient statues in the city. Many of them were in the statue court of the popes, the Belvedere, itself one of the most influential collections of ancient art ever formed. Once back in France, Primaticcio filled the gardens of Fontainebleau, Francis's palace, with bronze replicas.[134] The story of the arrival in France of these figures highlights the tension between the authority of the past and the attractions of novelty – Primaticcio's bronze copies were displayed to the king alongside Benvenuto Cellini's new figure of

113. **Dormer window from the Château de Montal.**
Stone, 747.5 cm high. Dordogne (France), 1523–35. V&A: 531–1905

114. **Hubert Gerhard and assistants, *Moses*, from the Fugger Altarpiece.**
Gilt bronze, 22.2 cm high.
Augsburg, *c*.1581–4.
V&A: A.27–1964

115. **Johan Gregor van der Schardt, *Night* and *Dawn*.**
Terracotta, heights 14 cm (*Dawn*),
16.9 cm (*Night*). Italy, *c*.1560–65.
V&A: A.5 and 6–1938

Jupiter. Cellini claimed that Francis much preferred his own innovation to the splendours of the ancients: 'the comparison with these splendid works of art only serves to make it apparent that his is more impressive and beautiful by a long chalk.'[135] Cellini may well have been embroidering the truth, but his story makes use of the common renaissance trope of surpassing Antiquity. This notion was important, in that it paved the way for future generations to pay more attention to the work of modern artists than to that of the ancients.

As the sixteenth century went on, the inspiration of ancient art, although remaining a touchstone, started to recede in favour of a new canon of art based on the achievements of modern Italian masters. This narrative, which was enshrined in Vasari's *Vite*, linked the most significant achievements of ancient art to a new group of modern masters who emulated or surpassed them.[136] One of the leading figures was Michelangelo. For example, when Hubert Gerhard designed figures for a gilt-bronze altarpiece for members of the Fugger family of Augsburg (pl.114) he took the inspiration for Moses not from an ancient Jupiter, but from Michelangelo's Moses in Rome, as well as the works of Giambologna.[137] The Netherlandish sculptor Johan Gregor van der Schardt, who was famous for his copies after ancient works, also produced figures of Dawn and Night (pl.115) based on Michelangelo's marbles for the New Sacristy of S. Lorenzo, Florence.[138]

The return to the artistic values of Antiquity promised by renaissance artists inevitably led to the creation of a new continuity, a new history, for art. The power of this narrative to some extent disguises the fact that the art and culture of the past had been constantly referred to throughout the period 300–1600. Indeed, the use of the past to express new artistic and cultural aims was one of the most important characteristics of the period as a whole.

10. The Easby Cross

SIMON CARTER

MONUMENTAL, FREE-STANDING STONE CROSSES were a feature of early medieval art unique to the British Isles. Standing in solitary grandeur across the landscape of Anglo-Saxon England, they probably acted as either a meeting place for prayer or as boundary markers. In spite of the exposed locations in which such monuments were often erected a small group of them survives, of which the Easby Cross is the latest and finest example (10.1).

The cross is composed of four large fragments. The stone itself is unusual in that it is not local to the site where the cross was found at Easby in North Yorkshire; the material probably originated near Whitby, fifty miles to the east. Three of the pieces owe their remarkable preservation to reuse as building blocks in the walls of St Agatha's Church, Easby.

The carving on the narrower sides of the shaft follows a well-established tradition. Each bears the remains of distinct panels containing either vine scroll or an interlace pattern in an arrangement which demonstrates continuity in layout and repertoire from earlier crosses, such as that found at Bewcastle. The delicately carved vine provides a visual reference to a passage from the New Testament in which Christ describes himself as 'the true vine' (John 15:1–11). The elaborate interlace patterns find close parallels in manuscript decoration, most notably in the illumination of the Lindisfarne Gospels (10.2 and 10.3).

While decorative elements on the sides of the shaft are associated with English designs, aspects of the two broader faces show the influence of continental Europe. The front face (10.1) is populated with a crowd of austere, unmistakably classical figures: Christ accompanied by the apostles, their faces abraded by weather, their deep dished halos and the folds of their garments retaining a crisp definition. Carved in the half-round, Mediterranean mode rather than conventional Anglo-Saxon low relief, the figures overlap to create an illusion of depth which would have been heightened by the light and shade cast by the sun moving over the monument. The back of the shaft is carved with a gracefully rendered vine scroll, the sinuous tendrils inhabited by a variety of active beasts. One of the creatures, a bird, bears close comparison to the same subject depicted on a Carolingian ivory panel (10.4 and 10.5).

In the late eighth and early ninth centuries the arts of the region were responding to the interaction of literate and well-travelled ambassadors from the North of England, the papacy in Rome and the flourishing court of Charlemagne. A traffic of art and ideas had been established in which the Archbishopric of York exchanged learning with the Emperor's retinue, looked to Rome for spiritual authority and emulated Late Antique and contemporary Roman iconography – probably filtered through the art of Charlemagne's court. The replication of Mediterranean stylistic elements on the Easby Cross must reflect the patron's wish to associate with Rome, the power centre of Christendom, and to assert the orthodox and Roman roots of the Church.

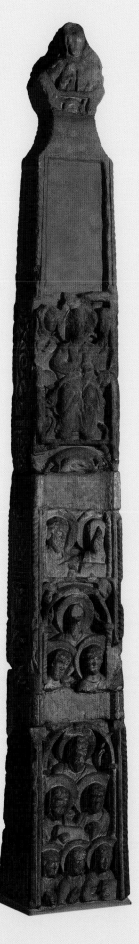

10.1 ◀ **The Easby Cross.**
Sandstone, 302.5 × 62 × 51 cm (base). Yorkshire (England), c.800–820. V&A: A.9–11–1931 and A.88–1930

Four fragments of the cross shaft have been reassembled. Their carved decoration draws inspiration from continental and English sources.

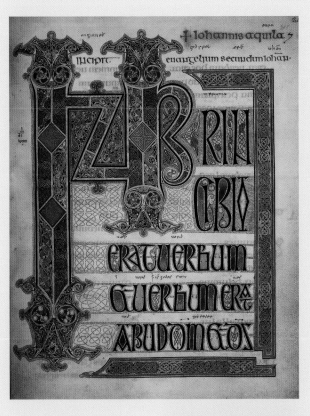

10.2 ▲ **The Easby Cross (detail showing interlace).**

10.3 ▲ **Eadfrith, Bishop of Lindisfarne(?), page from the Gospel of St John the Evangelist from the Lindisfarne Gospels (and detail showing interlace).**
Animal, vegetable and mineral pigments on vellum. England, late 7th or early 8th century. British Library Cotton MS Nero D.IV, f.211r

The interlace pattern on the Easby Cross is unique in Anglo-Saxon sculpture but bears close comparison to a pattern in the Lindisfarne Gospels.

10.4 ▶ **The Easby Cross (detail showing pecking bird).**

10.5 ◀ **Panel showing birds in a vine-scroll (detail).**
Ivory, 21 × 81 cm. Carolingian Empire (modern France and Germany), 9th century. Vatican Museums, Rome (Kanzler no. 160)

From Roman times onwards, a scrolling vine was a common decorative motif. The style of decoration on the Easby Cross links it to works produced in Carolingian Europe.

11. Raphael's tapestry cartoons for the Sistine Chapel

MATTHEW STOREY

RAPHAEL'S TAPESTRY CARTOONS are among the most important renaissance artworks in the V&A and have been on loan to the Museum from the Royal Collection since 1865. The cartoons are full-scale designs for a set of tapestries commissioned from Raphael by Pope Leo X, a member of the Medici family, in 1515. Raphael received his first payment for the cartoons on 15 June 1515, and his final payment on 20 December 1516. The tapestries themselves survive, and are now in the Vatican Museums in Rome.

The cartoons were sent to Brussels to be woven into tapestries in the workshop of Pieter Van Aelst. These were to be hung in the Sistine Chapel, the most important chapel in the Vatican. Leo's commission of a set of hangings from Flemish weavers, the most highly skilled in Europe, woven with silk and silver and gold thread, was suitably magnificent for this prestigious space. The existing frescoed decoration in the chapel had been designed to illustrate biblical history with a strong emphasis on the authority of the papacy. Raphael's tapestries, which were to hang beneath the frescoes and continue this theme, illustrate events from the lives of Saints Peter and Paul, founders of the Church in Rome. Scenes such as *Christ's Charge to Peter* (11.1), in which Christ is shown giving spiritual and temporal authority to the saint, underlined the authority of the popes as Peter's spiritual successors.

Raphael's cartoons deliberately reference Antiquity: Saint Paul is shown preaching or performing miracles in cities with classical architecture, and in *The Sacrifice at Lystra* (11.2) a triangular altar based on archaeological examples is prepared for a pagan sacrifice. The cartoon of *The Healing of the Lame Man* (11.3) shows Saint Peter performing a miracle in Solomon's Temple in Jerusalem. The twisted columns of the interior are a deliberate attempt at archaeological accuracy and are based on twelve columns Raphael would have seen in St Peter's Basilica in Rome, which at the time were mistakenly believed to have come from the Temple.

Raphael and Leo were certainly interested in the archaeological remains of Rome. In August 1515 Leo gave Raphael a brief to oversee the reuse of material from Ancient Roman ruins, making sure that any inscriptions carved into the stones were recorded. Later Raphael would begin a drawn reconstruction of Ancient Rome, and he explained his approach in a letter to Leo. The attempt to accurately evoke a historical period was important to Raphael at this stage in his career and lends veracity to his depictions of the biblical events shown in the tapestry cartoons. It demonstrates that the remains of Antiquity could be read as much as the relics of a Christian past as of a lost pagan society. The twisted columns of the Temple at Jerusalem were a reminder of the ancient roots of Christianity, as well as of the first Christian Roman emperor, Constantine, who had brought them to St Peter's. In the context of the Sistine Chapel the glittering finished tapestries designed by Raphael reinforced the ancient origins of papal authority, and emphasized the erudition and splendour of the modern papal court.

11.1 ▶ **Raphael,** *Christ's Charge to Peter.* Bodycolour on paper mounted onto canvas, 340 × 530 cm. Rome, 1515–16. The Royal Collection, on loan to the V&A

The cartoons show Raphael's skill at creating harmonious compositions with a clear narrative.

11.2 ▶ **Raphael,** *The Sacrifice at Lystra.* Bodycolour on paper mounted onto canvas, 350 × 560. Rome, 1515–16. The Royal Collection, on loan to the V&A

This composition is based on depictions of sacrifices on Ancient Roman relief carvings.

11.3 ▶▶ **Raphael,** *The Healing of the Lame Man.* Bodycolour on paper mounted onto canvas, 340 × 530. Rome, 1515–16. The Royal Collection, on loan to the V&A

This scene emphasizes the miracle-working power and authority of St Peter.

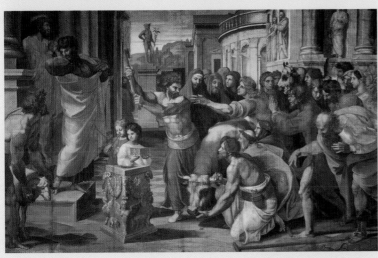

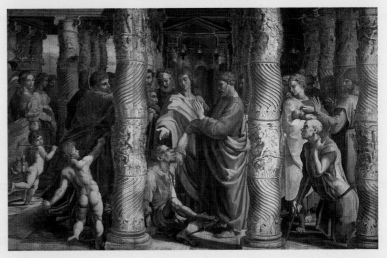

12. Riccio and the bronze statuette

PETA MOTTURE

THE REVIVAL OF THE BRONZE STATUETTE in the fifteenth century was part of the growing preoccupation with the classical past. Having developed in Florence from the large-scale works of Donatello and others, these intimate pieces appealed to erudite patron and artist alike, and were collected and displayed alongside antique examples. Towards the end of the fifteenth century, the focus for bronze production shifted further north. In Mantua, Pier Jacopo Alari-Bonacolsi, aptly called Antico, was making highly sophisticated and richly decorated bronzes for his Gonzaga patrons, largely based on classical marbles, such as the *Meleager* (12.1), while in Padua from the early sixteenth century there were a variety of workshops feeding the now growing market for such works.

The undoubted master of the bronze statuette was Andrea Briosco (1470–1532), known by his nickname Riccio, or 'Curly head', who trained originally as a goldsmith. According to his friend, Pomponius Gauricus, whose treatise *De Scultura* was written in Padua in 1503, Riccio learned sculpture with Bellano, the one-time assistant of Donatello, and turned to producing bronzes because of his podagra – gout or arthritis. Riccio's masterpiece is the great Paschal candelabrum that stands in the choir of the basilica of St Anthony (the Santo) in Padua and was made in 1507–16. Commissioned through the philosophy professor Giambattista del Leone, this complex work combines Christian and pagan iconography, and comprises reliefs and figures in the form of statuettes (12.2).

Riccio's small, vibrant bronzes, created in the circle of the humanist elite of Padua University, were designed to be handled or admired at close quarters in the privacy of a scholar's study. Unlike Antico and the other Paduan bronzists, virtually all Riccio's statuettes were directly modelled in wax onto a clay core, making them unique casts. Equally unique was his vision of the classical past, which combined knowledge of literary and artistic sources with observation of the world around him. The *Shouting Horseman*, for instance, dressed in antique armour, evokes a Roman battle, with the horse mimicking the rider's cry and tension (12.3). It was probably inspired by passages in Gauricus' treatise that included a quotation from the Roman poet Statius describing the Emperor Domitian's equestrian statue. Such ancient monuments were reflected in Donatello's heavily armed equestrian bronze of the *condottiere* (mercenary general) Gattamelata that stands outside the Santo. Riccio's figure recalls instead the fast-moving Venetian *stadiotti* or light cavalry that he would have seen during the War of the League of Cambrai (1508–13).

Riccio's small bronzes carried various layers of meaning, some of which are difficult to unravel. In the *Satyr and Satyress* (12.4) he challenges the perceived view of the satyr as a creature driven only by sexual desire, showing him in a tender embrace with the satyress. Her slung leg covers his manhood, usually a prominent attribute, declaring her as the dominant partner – and is she turning towards his embrace or pulling away, distracted? Though evocative of human passion, this sensual image was acceptable partly because it showed creatures from Greek mythology.

12.1 ▼ **Pier Jacopo Alari-Bonacolsi, called Antico,** *Meleager.* Bronze, partially gilded, with silver inlay, 33 × 18 × 10 cm. Mantua, c.1484–95. V&A: A.27–1960. Purchased from the Horn and Bryan Bequests with the assistance of a contribution from The Art Fund

This richly decorated bronze is probably the 'figure of metal called the little peasant' recorded in a Gonzaga inventory of 1496.

12.4 ◀ Andrea Riccio, *Satyr and Satyress.*
Bronze, 24 × 16.5 × 17.9 cm. Padua, *c.*1510–20. V&A: A.8–1949. Presented by The Art Fund

The composition relates to contemporary prints and influenced more explicitly sexual bronzes that catered to the taste for erotic images.

12.3 ▼ Andrea Riccio, *Shouting Horseman.*
Bronze, 33 × 33 × 8 cm. Padua, *c.*1510–15. V&A: A.88–1910. Salting Bequest

Leonine features, seen here in the warrior's expressive face, were believed to embody strength and virtuous heroism.

12.2 ◀ Andrea Riccio, Paschal candelabrum.
Bronze, 536 cm high (inlcuding marble base). Padua, 1507–16. Basilica of St Anthony (the Santo), Padua

The candelabrum, Riccio's most celebrated work, originally stood in a prominent position in front of the high altar in the Santo.

13. Western scripts 800–1500

ROWAN WATSON

REFORM AND DEVELOPMENT of the Church were a major part of Charlemagne's policies. Great numbers of books were required to ensure uniformity in government and worship, quite apart from the renewed study of ancient texts. A handwriting was developed that could be written swiftly and clearly; today we know this script as 'Caroline minuscule' (13.1). It became the standard from the ninth century, even beyond the lands controlled by the emperor and his successors. A new family of scripts, known as Gothic scripts, appeared in north-eastern France in the eleventh century. These were more compressed and angular and allowed more text to be fitted onto the page. By the thirteenth century, such scripts were in general use throughout Europe as formal book hands. The most formal versions were reserved for books necessary for the liturgy (13.2), while simpler versions were used for patristic and literary works and for books kept for business purposes. A professional scribe was able to write a variety of scripts for different rates of pay.

The fourteenth-century scholar and poet Petrarch famously complained about the 'litterae scholasticae' of his day and called for a simpler, clearer handwriting. He developed a script based on the common cursive scripts used for administrative and business documents. Driven by the desire to discover classical texts, humanist scholars in Italy sought out early manuscripts in libraries around Europe. Most of the texts in which they were interested survived in copies that derived from the 'Carolingian Renaissance' in the ninth and tenth centuries. Coluccio Salutati, Chancellor of Florence, and his pupil Poggio Bracciolini, sought to reproduce the features they found in these manuscripts and in doing so developed a version of Caroline minuscule known today as humanistic book script – contemporaries referred to it as *littera antiqua* (13.3). A cursive version of the script, known today as italic, was developed by Niccolò Niccoli. These scripts were initially used for the classical texts that humanists studied so intensely; by the mid-fifteenth century, they were being used by the book trade in Italy for other works. The Florentine bookseller Vespasiano da Bisticci organized the production of very many manuscripts with humanistic script and its associated 'white vine-stem' ornament (see p.164). These books set a pattern for classical, patristic and other texts destined for the scholar's study in Italy and elsewhere.

An expert professional practitioner of these humanistic scripts was Bartolomeo Sanvito, whose career took him from Padua to Rome and back to provide manuscripts for aristocratic and scholarly clients. His manuscript of Cicero's *De officiis*, signed and dated November 1495 (13.4), was written in a fluent italic script for Cardinal Raffaello Riario; the format of such manuscripts was copied by the publisher Aldus Manutius in Venice after 1500 for his extraordinarily successful pocket printed editions of classical and other texts. Italic script became synonymous with humanistic education – the daughter of Henry VIII and Anne Boleyn, Queen Elizabeth I of England, could write a very good italic hand at a time when the wealthy had professional secretaries. Others could learn the technique for themselves from books published by writing masters such as Ludovico Vicentino degli Arrighi (working 1520–5), which had a Europe-wide distribution.

13.1 ▼ Caroline minuscule.
Fragment from a manuscript of the *Liber Regulae Pastoralis* (Book of Pastoral Care) written in France, *c*.850–60 (detail). V&A: PDP 4115

The *Liber Regulae Pastoralis* was composed by Pope Gregory the Great *c*.590.

13.2 ▶ Gothic book hand.
Beginning of Psalm 69, *Deus in adiutorium meum intende*. Page 17.5 × 13 cm. From a Psalter written in Germany, *c*.1225–50. NAL, MSL/1870/7789, f.98r

A large illuminated initial introduces the Psalm; verses are marked by alternating red and blue initials.

13.3 ◀ Humanistic book script. Fom a manuscript of *De providentia dei* (On the Providence of God) by Saint John Chrysostom. Page 30.5 × 22 cm. Written out in Florence, *c*.1470. NAL, Reid 78, f.149v

The scribe of this manuscript worked on occasion for Vespasiano da Bisticci.

13.4 ▶ Humanistic cursive script (italic). From a manuscript of Cicero's *De officiis*. Page 17 × 11 cm. Written out by Bartolomeo Sanvito in Rome, 1495. NAL, MSL/1954/1609, f.52r

Sanvito's career can be followed from *c*.1453 to his death in 1511.

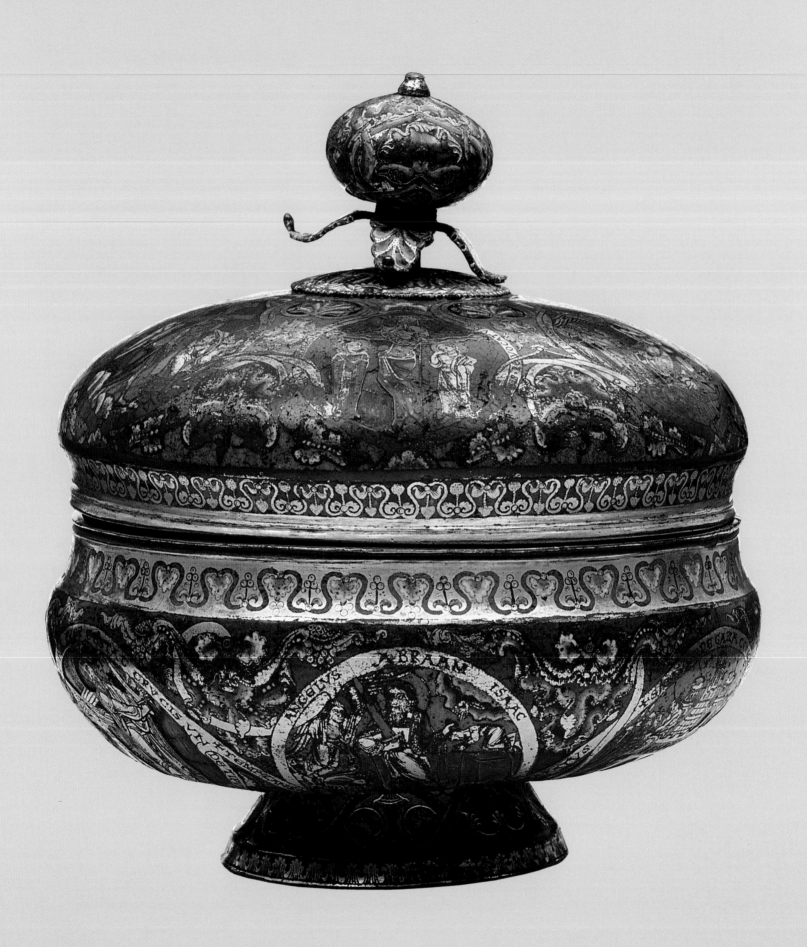

5

ORNAMENT

Kirstin Kennedy

FAMILIAR TERMS CAN BECOME treacherous when placed in a medieval and renaissance context. The modern definition of the word 'ornament' is a patterned surface or a small, inexpensive, domestic object intended solely for decorative display.[1] In the period 300 to 1600, the term referred to the decoration on a building or object that was supplementary to a viewer's main focus. Yet while this sense is recognizable to modern eyes, medieval and renaissance uses of the word could also refer to any furnishings, jewels or textiles that embellished a person or his surroundings. More importantly, this earlier sense of the word linked aesthetic delight with a moral message. The purpose of ornament was to embellish, but it was an embellishment that could only be applied in contexts that were appropriate because ornament was, ultimately, the outward manifestation of inner or abstract moral value. Buildings, clothes and possessions were ornaments that reflected a person's virtue, his wealth and standing in society. Ornament as surface decoration was a message that guided a viewer to more profound meditation on spiritual mysteries, or engaged the intellect with its variety and detail.

The equation between ornament and moral value was an ancient one, made in Marcus Tullius Cicero's account of how appearance and behaviour should be appropriate, or decorous, to their context. In *De officiis*, written in first-century BCE Rome, Cicero, or 'Tully' (later writers and translators preferred his family name to his sobriquet) explained that decorum was intimately bound up with a person's deeds and appearance and 'is apparent in three ways: in natural beauty, in the due order of parts, and in outward embellishment suited to the appropriate function'.[2] This link between 'outward embellishment' and decorum naturally extended to the arts: Cicero stressed the importance of other tangible indicators of moral worth when he discussed the appearance of 'the sort of house which is becoming for a man of eminent position'. The construction, he argued, 'should take into account the use to which [the house] is to be put, but style should be considered just as much as function'.[3]

Although Cicero did not expand on what he meant by style, his contemporary Vitruvius set out

Ciborium.
See pl.117, p.160.

very clearly the equation in architecture between decorum, appearance, function and message. Vitruvius was the author of the only treatise on Roman architecture to have remained in circulation in the West after the fall of the empire, a work that came to be known as *Ten Books on Architecture*. Its broad subject matter, encompassing building techniques, farming practices and pigment preparation, ensured it was consistently copied and read by subsequent generations. The early readers of one late twelfth-century copy were particularly interested in Vitruvius' classical sources and recipes for colours, while the ownership note of 1592 added by 'John Pilkington of Durham' shows that this text was still being consulted centuries later.[4] Vitruvius' work was also among the earliest books to be published, appearing first in Rome in 1486 under the title *De Architectura* and then in Venice in 1511 as an illustrated edition.[5] Vitruvius proposed a symbolic reading for architectural elements according to their function. Thus, he argued, Corinthian columns which are 'slender, ornamental and… decorated with leaves and volutes' were particularly suited to a temple dedicated to the goddess of sensual love, Venus (pl.116). The stark profile of Doric columns, on the other hand, was appropriate for a temple dedicated to Mars, god of war.[6]

The expectations of Cicero and Vitruvius that the appearance of a building should reflect its purpose and the activities of those who dwelt inside were echoed by another Roman author, Pliny the Elder. In his *Natural History*, a work composed in the first century CE and constantly mined for information on ancient beliefs by medieval and renaissance scholars, Pliny described the homes of some of his contemporaries. These were decorated with enemy spoils hung round the doorways and battle scenes painted on the façades. Yet this imagery, he observed, was quite at odds with the current householder's tranquil existence and so 'every day the very walls reproached an un-warlike owner with intruding on the triumphs of another'.[7]

CHURCH DECORATION AND DEVOTION

Christian writers, too, were sensitive to the correlation between beauty and decorum in an architectural context. Written in the sixth century, Isidore of Seville's work on etymologies defined 'beauty' as 'whatever ornaments are added that are appropriate to buildings, such as the different golden layers of ceilings, and inlay of precious marbles, and images in colour'.[8] His loose definition of 'ornaments' – essentially anything of value that embellished an architectural setting – was echoed in Abbot Suger's account of his reconstruction and renovation of the dilapidated abbey church of St-Denis, outside Paris, in the 1150s. Suger described the 'ornaments' – the altar, altar frontal, crucifix and church vessels of gold and precious stones – that he had provided to decorate it, embellishments which he explained were to show appropriate reverence to the sacred contents of a sacred space.[9] The crucifix which Suger commissioned, for example, was to be made by

> The most experienced artists from diverse parts [who] would with diligent and patient
> labor glorify the venerable cross on its reverse side by the admirable beauty of… gems;
> and on its front – that is to say in the sight of the sacrificing priest – they would show
> the adorable image of our Lord the Saviour.[10]

116. **Monogrammist 'PS', a Corinthian column from a vineyard by the Antonine Baths, Rome.**
Engraving, plate size 22 × 13.9 cm.
Engraved *c*.1535; published by Antonio Lafréry in Rome, *c*.1573.
V&A: E.1995-1899

The glow of gemstones, moreover, could inspire more intense devotion – Suger himself admitted to being transported to a higher spiritual plane when contemplating such lovely things.[11] His programme of embellishment was not, however, an indiscriminate operation. In his account of the consecration of the abbey church, Suger records how he was concerned to restore, embellish and redisplay the reliquaries that held the bones of its saints, martyrs and the patron saints. The reliquaries did not all have the same amount of expenditure lavished upon them: the *châsses* containing relics of the abbey's saintly patrons were given greater attention than the others.[12]

A hundred years later, in a work which set out to explain the spiritual and symbolic significance of all aspects of a church interior, William Durandus established that 'the ornaments of the church consist of three things: the ornaments of the nave, the choir and the altar'. Durandus had in mind principally expensive textiles such as cushions of silk and hangings dyed with costly (and symbolically regal) purple dye, a notably focused definition at a time when lists of ecclesiastical gifts were wide-ranging in their accounts of 'ornamenta'.[13] The objects presented in the twelfth century by Henry of Blois, Bishop of Winchester, to the church of St Swithun's in the same city were recorded under the heading 'ornamenta' in a thirteenth-century inventory. They included gem-studded textiles, a quantity of gold church plate, two mitres and 'nine ivory horns and the claws of a griffin'.[14] By the fifteenth and sixteenth centuries, though, the sense of the term had narrowed to refer principally to textiles. A 1463 inventory for the Parisian abbey and monastery of Notre-Dame-la-Royal lists only altar cloths and frontals as 'church ornaments'; the same identification of textiles with church ornaments is found in a 1575 post-mortem inventory of Jean de Seyssel, a French noblewoman.[15]

It was the value and richness of the textiles themselves rather than the designs woven into them that made them particularly appropriate ornaments for the church. The exotic, imported textiles that made their way into church treasuries illustrate how material value could be as appropriate as ecclesiastical imagery in the case of church vestments and furnishings (see pp.188–9).[16] Other liturgical vestments presented to churches by noble donors, or used in their own chapels, were made of expensive textiles but also deliberately incorporated their own devices to proclaim their piety. Five garments of violet velvet, worn by Philippa, wife of Edward III of England, after the birth of her first child in 1330 were later embroidered with her device of gold squirrels and presented shortly afterwards to Ely Cathedral. In 1332–3 they were cut up and made into three copes.[17] John 'the Fearless', Duke of Burgundy, recycled clothing (or perhaps hangings) bearing his personal motto for the vestments of one of his own private chapels;[18] and a chasuble of red Italian silk satin with exotic camel motifs bears the embroidered arms of Sir Thomas Erpingham, an English noble of the early fifteenth century (see p.198).

The patterns chosen to decorate other church 'ornaments', on the other hand, arguably had a greater relevance to theology. Natural forms were especially appropriate because they honoured God's creation (see p.50). The twelfth-century enamelled ciborium shown here (pl.117 and p.156) once held thin wafers of bread that, for Christians, miraculously became the body of Christ during

the Mass. Twelve roundels, surrounded by explanatory text, appear on the bowl and its cover: those on the lid depict scenes from the life of Christ as told in the New Testament, while those on the bowl show the characters and events from the Old Testament prefiguring them.[19] It is a decorative scheme which has been identified with a now-lost series of frescoes (or stained-glass windows) in Worcester Cathedral chapter house.[20] The leaf and flower patterns which surround the roundels and cover the remaining surface of the ciborium are echoed in the berry-and-leaf-shaped knop on the top of the lid that acts as a handle and, in combination with the vessel's rounded shape, makes the ciborium resemble a rather exotic form of fruit.

The choice of this particular type of vegetal ornament is also unlikely to have been a careless decision. It was probably intended to remind the priest who handled the ciborium that the words inscribed on it and the bread it contained were the fruit that should be taken to ensure the eternal life of the soul. The association between trees, fruit and salvation was a biblical one: the Old Testament book of Ezekiel described the bank of a river upon which 'shall grow all trees that bear fruit: their leaf shall not fall off, and their fruit shall not fail: every month shall they bring forth first fruits… and the fruits thereof shall be for food, and the leaves thereof for medicine'.[21] The number twelve, symbolizing the months of the year, was also significant in this context and the makers of the vessel were careful to include twelve scenes.

On a more general level, leaves and flowers were frequent ornamental motifs in church settings. Leo of Ostia, describing the new basilica at Montecassino in the early twelfth century, marvelled at its particularly fine inlaid floor and commented that viewers might think 'that flowers really grow in the diverse beauty of many colours from the marble pavement'.[22] Aesthetics and illusionism aside, the use of flower motifs to decorate the fabric of the church building itself was imbued with layers of symbolism that derived from biblical texts, such as the Old Testament 'Song of Songs', and their commentaries. The growing popularity of the cult of the Virgin Mary in the twelfth and thirteenth centuries lent this floral imagery an increasingly Marian resonance. Bernard of Clairvaux, for example, stressed in a sermon the association between the Virgin Mary, Jesus and flowers: 'the flower wanted to be born from a flower, in a flower, in the season of flowers'.[23] Stylized flower shapes, similar to those on the ciborium, frame the frescoed roundels showing the life of Christ on the vaults of the twelfth-century chapel of Petit-Quevilly (near Rouen), which was once part of the leper hospital founded by Henry II of England in 1183. Similar floral motifs also appear in other churches of the period, as in a late twelfth-century border panel of stained glass, which probably came from the Trinity Chapel in Canterbury cathedral (pl.118).

Other motifs drawn from nature and found in religious contexts throughout the period might

117. Ciborium (top and side views).
Gilded copper with champlevé enamel, 17.3 cm diameter. England, c.1150–75. V&A: M.1–1981. Purchased with the assistance of the National Heritage Memorial Fund

118. **Section from a border panel (detail).**
Clear, coloured and flashed glass, with
paint, 82 × 45.4 cm (maximum). Canterbury
(England), 1180–1200.
V&A: C.2–1958

have an equally established use. The acanthus-leaf motif, adopted and adapted from Roman art, suited the architectural symbolism of paradise in early Christian churches of the Near East as well as in the mosques of North African Tunis.[24] On a much smaller scale, acanthus leaves were repeatedly used (with variants) as a border motif on ivory plaques depicting biblical or devotional scenes, produced in the Carolingian Empire. The plaque shown here (pl.119), which depicts Christ's entry into Jerusalem and his stay in the house of Simon, may have been attached to a book cover. This constant association between the acanthus and biblical scenes lends the leaves a significance that can be transferred when they are used to frame a different type of iconography. Such, arguably, is the case for an ivory plaque probably made at Reims, and now in the Musée de Picardie, Amiens. This plaque includes a rare surviving representation of an historical figure, the sixth-century bishop of Reims, Remi. By setting this image within an acanthus-leaf frame, the ivory carver has used ornament to suggest that the saintly Remi's miracles are on a par with the biblical scenes more usually surrounded by such borders.[25] The Umayyad rulers of al-Andalus (Islamic Spain), on the other hand, absorbed the imperial associations of acanthus-leaf ornament into their own traditions of regal iconography (see pp.190–91).

Yet, despite the ubiquity of ornament in and on church buildings, too much ornament in an ecclesiastical context was considered profligate. The anonymous chronicler of the French abbey of St-Bertin described a new refectory built for the monks in 1180. 'It is', he observed, 'like a mirror and an ornament, yet considering its great cost, it is more beautiful than useful.'[26] More seriously, ornament could also interfere with the intellectual business of meditating upon the holy scriptures. Gregory the Great, in the preface to his commentary on the Old Testament book of the Song of Songs, observed that 'Sacred Scripture consists of words and meanings as a picture consists of colours and objects; and it is a foolish person who loses himself in the colours of a picture to the extent that he ignores what is being painted.'[27] Durandus stressed the importance of decorating a church with images of saints and holy symbols 'so that we may meditate perpetually, not indiscreetly or uselessly, on their holiness'.[28] For others, much church decoration was irrelevant to this purpose. In a letter to William, a friend and monk of the Benedictine order, Bernard of Clairvaux attacked the carvings on the cloister columns and capitals of Cluniac monasteries not only for their expense, but also because they were a distraction to the meditating monks:

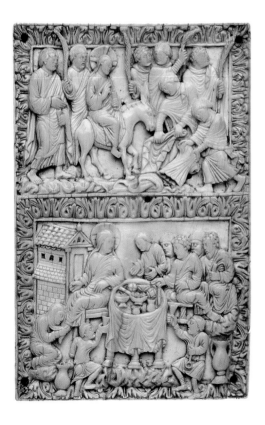

119. **Panel from a book cover.**
Ivory, 13.2 × 8.6 cm. Metz,
c.870–80. V&A: 257–1867

> In the cloisters, before the eyes of the brothers while they read – what is that ridiculous monstrosity doing, an amazing kind of deformed beauty and yet a beautiful deformity? What are the filthy apes doing there? The fierce lions? … The creatures, part man and part beast? The many bodies under one head, and conversely many heads on one body. On one side the tail of a serpent is seen on a quadruped, on the other side the head of a quadruped is on the body of a fish.… In short, everywhere so plentiful and astonishing a variety of contradictory forms is seen that one would rather read in the marble than in books, and spend the whole day wondering at every single one of them than in meditating on the law of God.[29]

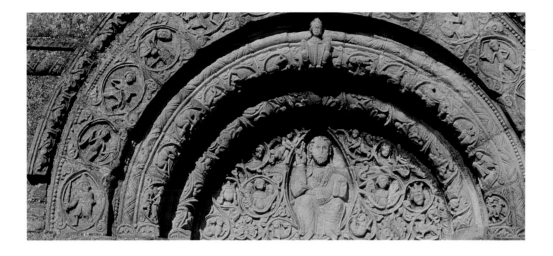

Although he chose such combinations of men and beasts for rhetorical rather than realistic effect (they cannot be matched with the imagery on the columns of the most important surviving monastery of the Cluniac order, Moissac) Bernard's point was that this type of ornament was inappropriate in this particular context and for these particular viewers.[30] This disjunction between the sacred function of a building and the ornament on its façade can be seen above the south doorway of the church of St Nicholas in Barfreston, Kent, built and carved around 1180 (pl.120A,B). The reliefs on the outer arches, framing the central figure of Christ, include a dog playing the harp, a seated man flanked by devils, a knight and a lady, and a man playing the viol.

Bernard's concerns were shared by contemporaries and by later writers, such as Leon Battista Alberti. Alberti, whose literary models and subjects were classical rather than biblical, stipulated in his work *On the Art of Building in Ten Books* (probably completed in 1452) that a temple should not contain 'anything to divert the mind away from religious meditation toward sensual attraction and pleasure'.[31] Despite his calling, the fifteenth-century archbishop of Florence, Antonino Pierozzi (canonized in 1523; pl.121), was particularly interested in the commercial world. In the final years of his life he composed a treatise on the activities of the different trades in the city.[32] In this *Summa Theologica*, Antonino included a short chapter on painters, in which he outlined appropriate and inappropriate subjects for religious paintings. Unlike Bernard, who was addressing an audience of monks, Antonino had in mind both priests and their congregation: 'It seems superfluous and vain in the stories of saints or in churches to paint oddities, which do not serve to excite devotion, but laughter and vanity, such as monkeys and dogs chasing hares, and the like, or vain adornments of clothing.'[33]

Bernard and Antonino were both wary of ornament in a spiritual context because it distracted from meditation and because it could encourage profligate expenditure. Their comments also suggest that the function and appreciation of ornament were bound up in the status and profession of the viewer. Abbot Suger, whose perception of the function of decoration was a much more positive one, also appreciated the importance of the viewer's status in relation to the ornament observed. In Suger's account of the gem-studded crucifix he commissioned, only the priest, who celebrated Christ's sacrifice and set in motion the miraculous events that would culminate in God's actual presence at Mass, was privileged to see the depiction of the Crucifixion. Similarly, Suger was careful to specify that only 'reverend persons, as was fitting' should be allowed to contemplate the holy relics ('ornaments', as he called them) of St-Denis. The disturbance-causing *populorum tumultus*

121. **Figure of a saint of the Dominican Order, probably Antonino of Florence.**
Wool and linen, tapestry woven, 179 × 78.5 cm. Ferrara or Florence, 1450–1550. V&A: 846–1884

(i.e. 'people who cause disturbances', the low-born) were to be kept apart from them by means of an uninterrupted series of gates.[34]

In part, Suger's words reflected a mistrust of the low-born that had its roots in the social theories of Ancient Greece and Rome. In part, he was also being practical: valuable objects could be stolen if exposed to large crowds. In another sense, though, these passing comments echo the expectations outlined in Chapter Two about the relationship between social status and the observer's capacity to apprehend the intellectual implications of a work. Ornament, whether on display in a church or embellishing a secular house, was not for everyone because it reflected moral virtue and social standing, and had therefore to be employed and appreciated accordingly.

ORNAMENT IN THE SECULAR WORLD

Beyond the confines of the church or monastery, ornament was considered in similarly hierarchical ways that were linked to notions of social order. The purpose of ornament here was a fitting display of social status rather than a means to spiritual salvation. A detailed and subtle account of this interpretation, laden with classical allusions, was published by the Neapolitan courtier Giovanni Pontano in 1498, shortly before his death. In his treatise *On Splendour*, Pontano argued that the material value and beauty of some functional objects meant they should be acquired not for their ostensible purpose, but as symbols of the refinement and wealth of their owner: 'we call objects ornamental if we acquire them not so much for use as for embellishment and polish such as seals, paintings, tapestries, divans, ivory seats, cloth woven with gems, cases and caskets with which the house is adorned according to one's circumstances.'[35] In his list of objects Pontano is very much influenced by classical models, and although his educated readers may not have displayed all the items he mentions in their own homes, they would have been well aware of ideas of decorum and good taste which such objects embodied.

But while the correct ecclesiastical ornament could effect a spiritual change on viewers of every status (regardless of their proximity to the object) by encouraging meditation on the holy, fine objects seen in a secular context had no such transformative power. In another passage, Pontano characterized the natural inclinations of two different types of person by a description of their possessions at table:

> The base man and the splendid man both use a knife at table. The difference between them is this. The knife of the first is sweaty and has a horn handle; the knife of the other man is polished and has a handle made of some noble material that has been worked with an artist's mastery.[36]

It is no coincidence that the splendid man's knife is polished. Objects that seemed to emit light, or glowed with its reflection, had long been prized (as, for example Suger's gems at St-Denis). More pertinently, however, not only is its handle made of a 'noble' (and by implication, costly) material,

it is also decorated with unspecified ornament (pl.122). This not only enhances its monetary value but also proclaims its owner a person intellectually capable of appreciating the carver, painter or engraver's art. The horn-handled knife that belongs to the base man (*sordidus*) is not only made of an inexpensive material, it also lacks ornament.[37] Pontano himself had identified two different types of people who were *sordidus* a few pages before this passage (they were mean rather than poor),[38] but his reference to sweat suggests that here he is recalling Cicero's definition of the term. In his *De officiis*, Cicero lists a series of professions which he regards as *sordidi*. These include all the mechanical professions – trades which required no intellectual engagement and were practised by the low-born or enslaved.[39] In Ciceronian terms, Pontano's *sordidus* would not have the intelligence to appreciate the ornament on a knife handle; his sweat is a sign of his brutish, unintellectual nature. Such possessions arguably characterized rather than transformed, and the presence or absence of ornament was a factor in the social messages they conveyed.

Pontano's theorizing aside, this is also suggested by the material evidence of surviving objects, where ornament may be said to reflect an owner's fashionable intellectual interests. The initials in a compilation on the art of geomancy guide the reader by drawing the eye to the start of a new section in the text (pl.123). Their particular style of ornamentation, though, updates the look of a twelfth-century text for a fifteenth-century reader. The white vine-stem decoration that surrounds the initials originated in learned Florentine circles and represented fifteenth-century ideas of the ornament used in Antique Roman texts. Added here to an Arabic work that had been translated by a scholar in Toledo some three centuries previously, it suggests that the book's owner was someone anxious to give a non-classical text the appearance of being one, and in so doing perhaps associate himself with the fashion for ancient scholarship.

Scientific instruments, too, were embellished with ornament. Designs which resembled the intricate interlace and knot-patterns of Near Eastern and Turkish metalwork engraving filled the covers and spaces between dials and numbers on late sixteenth-century scientific instruments (pl.124; see also pl.36, p.58, and a diptych dial made for the Fugger Family, V&A: M.86–1921). Far from diminishing their status as functioning objects, ornament emphasized their value and rarity, and by extension their owner's discernment.[40]

Ornament could also have obscure layers of personal meaning for its owner, most of which are now utterly lost. A glimpse of the complex readings a maker and patron could ascribe to an object and its decorative programme can, however, be found in a letter dated October 1546 from the sculptor and bronzist Vincenzo de' Grandi to Cristoforo Madruzzo, Cardinal of Trent. In it, he outlines the significance of the ornament on a bronze inkstand he has just completed for Madruzzo. Not surprisingly, Grandi's commentary on the decoration emphasizes how it relates to the cardinal's own interests and aspirations. He begins by explaining that the inkstand itself is 'an instrument that serves gentle spirits in the writing of things important and worthy of memory, through which… one can

122. Knife with the arms of the Renier family of Venice.
Steel, the handle partially gilded, 22 cm long. Italy, *c.*1550.
V&A: 109–1901

123. Treatises on divination headed *Ars completa geomancie* (The Complete Art of Geomancy), written out by Bartolomeo Sanvito (detail).
Ink on parchment with watercolour and gold, 34 × 24 cm.
Italy, possibly Padua, *c.*1466–9.
V&A MSL/1950/2464, f.20v

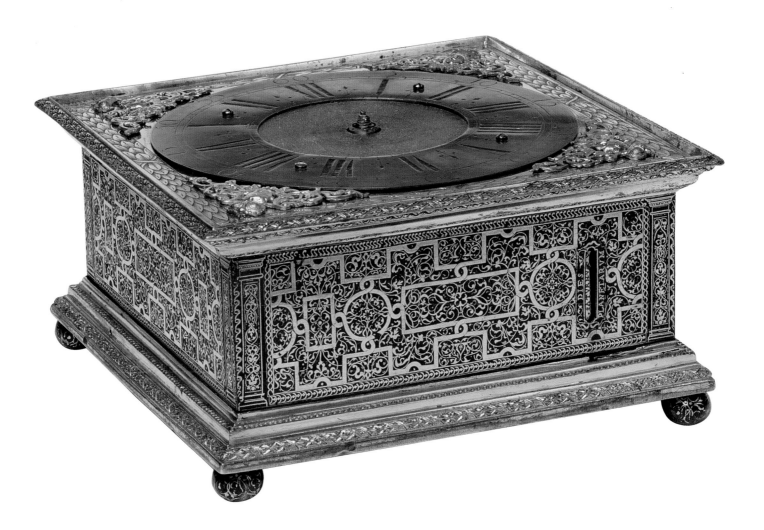

124. **Jacob Marquart,
tableclock and sundial.**
Brass and iron, damascened
and partially gilded, 10.4 cm
high. Augsburg, 1567 (dial
replaced c.1700). V&A:
9035–1863

gain perpetual glory and immortal fame, dedicating one's name to the temple of Divinity'. Familiar elements of sixteenth-century ornament derived from classical iconography include the *bucrania* (ox skulls) that 'signify the hardship on which glory depends', while the festoons or swags that hang from them 'stand for no less than the triumph of virtue and the honour of glory'.[41] Meanwhile, the eagle on the inkstand was both the symbol of Saint John the Evangelist and Madruzzo's personal device, a connection that enabled Grandi to relate Madruzzo's own use of the inkstand to the saint's writings in the name of Christ.[42] Given that Madruzzo was participating in the Council of Trent at the time, Grandi's references to his dedication to 'the temple of Divinity' perhaps had a particular resonance. The council, convened by the pope and Catholic rulers in December 1545, was intended to reform the Catholic Church and present an official response to what it regarded as the Protestant heresy.

PERSONAL ADORNMENT: MORALS AND MEANING

The expectation in classical and Christian writings that façades, furnishings and domestic possessions should reflect the status and virtue of their purpose or owner applied equally in the matter of personal appearance and dress. The word 'ornament' was often specifically equated with jewellery, as in the observation found in the Old Testament book of Ecclesiasticus that 'learning to the prudent is as an ornament of gold, and like a bracelet upon his right arm'.[43] The equation is also vividly illustrated in the depiction of Cain and Abel in a painted leaf of the 1160s, perhaps from a bible (pl.125). The Mosan artist emphasized the different moral character of the brothers by

depicting them in very different clothing. Abel, who pleased the Lord and incurred Cain's jealous wrath,[44] wears a cloak and a long robe with a broad gold hem and what appears to be a gold, gem-encrusted belt. Both cloak and robe are dyed with expensive colours, purple and red. Cain, his murderer, is dressed more simply: his short tunic is undyed, he has only a narrow gold belt, and he does not wear a cloak. Suger made a similar equation between clothes and virtue in his account of the consecration ceremonies at St-Denis, when he described how the prelates who performed them were 'decorous in white vestments, splendidly arrayed in pontifical miters and precious orphreys embellished by circular ornaments… the King and the attending nobility believed themselves to behold a chorus celestial rather than terrestrial'.[45]

Yet personal ornament, too, was the target of censure from some classical and Christian writers because it distracted the wearer from cultivating a serious and virtuous existence. Among the tenets espoused by Stoics, the followers of the school founded in Athens by Zeno of Cittium in 322 BCE, was the rejection of superficial and frivolous things. Seneca the Younger, who espoused Zeno's philosophy, advised his friend Lucilius that 'virtue rewards everyone both in his life and after his death, provided he has sincerely cultivated it, and provided he has not tricked himself out with adornments [*si se non exornavit et pinxit*], but has remained the same individual'.[46] Later Christian scholars were able to appreciate this pagan philosophy, which echoed biblical exhortations to reject worldly pleasures. Cyprian, Bishop of Carthage (martyred in 258), writing on the correct attire for female virgins, condemned women who adorned their bodies with jewellery and cosmetics. The natural look was best, as Bernard of Clairvaux explained to 'the Virgin Sophia'. 'The ornaments of a queen', he wrote in an undated letter, 'have no beauty like to the blushes of natural modesty which colour the cheeks of a virgin.'[47]

A superficially beautiful appearance was therefore not necessarily a sign of inner virtue. In his discussion of the different senses of similar-sounding words, composed in the sixth century, Isidore of Seville distinguished the two, observing that 'glory [*decus*] belongs to the soul, decoration [*decor*] to the body'.[48] Others warned that ornament, if coveted for its own sake, would lead not to virtue but to vice. The beauty and material value of gems, precious metals and fine clothing were as nothing compared to the incalculable worth of heavenly salvation, before which ornament was a superfluous adjunct that in fact corrupted virtue. The austere Bernard of Clairvaux wrote sternly to a monk called Fulk who had decided to leave the brotherhood that 'wisdom prays to be given only what is necessary for life, not what is superfluous, and the Apostle [i.e. St Paul] says that he is content with food and clothing, not with food and ornament… let us then be content just with clothes for covering ourselves, not for wantonness, not for effeminacy,

125. **Leaf from a bible, psalter or model book, showing Abel and Cain making offerings to God, and the murder of Abel by Cain.** Watercolour on parchment, 22.7 × 15.9 cm. Southern Netherlands (possibly Liège region), *c*.1160. V&A: 8982

not for pleasing lewd women'.[49] His complaint would have been familiar to later readers and listeners. In a poem reprinted many times in the sixteenth century because of its moralizing sentiments, Jorge Manrique sarcastically observed how much effort men and women expended on beautifying their bodies while at the same time making no attempt to embellish the true and lasting beauty of their souls.[50]

Manrique's criticism is somewhat unusual in that it is aimed at both sexes. In moralizing literature of this period the word 'ornament', when used in the sense of cosmetics and perfumes, is more often associated with women. Enrique de Villena, writing on the art of carving at table in 1423, observed how in classical times men had annointed their hands with perfumes before serving food, for reasons of hygiene. He goes on to say, however, that 'I will not treat of such things here because this is not fitting in men, according to the customs of this time, and is more suited to women's make-up.'[51] Even so, both sexes would regularly have applied ointments and plasters to disguise facial disfigurements caused by infection, disease and scarring.[52] To their critics, not only did cosmetics produce a misleading impression of beauty, but they could be interpreted as sinful because they represented an attempt to redefine God-given facial features. Cyprian had rehearsed this argument in the third century, and it was still a concern in the sixteenth.[53] Juan Luis Vives, in his 1523 treatise on the education of the Christian woman, wondered how 'a rotten, stinking worm' could seek to alter what God had completed so perfectly.[54]

Others cited more immediate, practical reasons to dissuade women from using cosmetics. Richard Haydocke, who translated Giovanni Lomazzo's treatise on painting into English in 1598, pointed out the toxicity of a range of cosmetic preparations: 'it often falleth out, that in steede of beautifying, [women] doe most vilely disfigure themselues'.[55] Commercial interests, however, required a different approach, one that relied on the equation between outer beauty and inner virtue. In 1530 André Le Fournier, a Parisian doctor, published a book of cosmetics and perfume recipes targeted at women. The title – *La décoration d'humaine nature et à ornement des dames* – emphasized that such adornment was an embellishment of human nature, and it was a connection that he restated in his preface. 'The decoration and goodness of which we shall speak henceforth', wrote Le Fournier, 'should not just be taken to decorate the head alone, but the whole of the body as well.'[56] The fact that Haydocke and Le Fournier could allude to these – very different – arguments suggests the persistence of the connection between ornament and moral worth.

OBJECTS, ORNAMENT AND FUNCTION

Ornament did not just serve to convey moral and social messages. Its use and concentration were also informed by practical considerations. The embroidered ornament along the neckline and edges of a garment served not only to embellish it but also to reinforce areas subject to additional wear. Ornament could also be used deliberately to obscure the workings of objects. For security purposes, for example, on an early sixteenth-century document chest forged iron bands studded with bosses conceal three locks. To disguise the opening further, a row of fake hinges along one edge duplicates

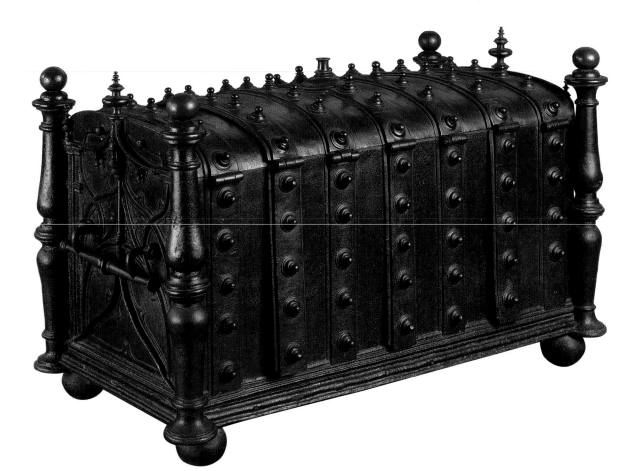

126. **Chest.**
Wrought iron, 71.7 cm high,
weight 200 kg approx.
Southern Netherlands,
1500–1520.
V&A: M.295-1912

127. **Carved well-head.**
Marble, 80.3 cm high. Venice,
c.800–900. V&A: 54-1882

the real ones along the other (pl.126). On mortars, ornament may have been used to identify the drugs and minerals ground up in them. Sixteenth-century mortars often displayed decorative motifs that were associated with their function: a brass example in the V&A, made in Hengelo (Holland) and dated 1540, includes in its ornament images of Saint Sebastian, a saint associated with healing. It is possible that the decoration of others identified them as vessels in which to grind only poisons.[57]

The presence or absence of ornament also suggested how an object should be placed and viewed, in ways that might combine reverence with function. All four sides of the Italian well-head shown here are carved with ornament (pl.127). The detailed interlace pattern is much wider around the two sides of the well that include as their central motif the Christian symbol of the cross than it is on the two faces that are filled with foliage and geometric patterns. This fact reflects the symbolic importance of the crosses relative to the other ornament.[58] The decoration of the sides probably also reflects the positioning of the well-head: the side with a hole pierced to allow for a pulley system has foliage ornament rather than a cross. Towards the end of the eleventh century the authorities of the church of Notre-Dame-de-Valère, in the Swiss canton of Valais, had gems, pearls, Roman glass fragments, chased gold plaques and enamels set into the binding of a copy of the Gospels (pl.128). The precious binding acts as a foretaste of the spiritual riches that await the viewer and reader: the decision to embellish the cover may also have been influenced by the belief that the manuscript had been a gift from the Emperor Charlemagne.[59]

In domestic contexts, too, ornament could suggest how an object should be seen and used. The

128. **Front cover of a manuscript of the Gospels (The Sion Gospels).**
Beechwood boards with gold sheets, gems, enamel and metalwork plaques, 25 cm high. Valais (Switzerland), binding c.1180–1200; enamel plaques c.980–1000. V&A: 567-1893

narrow Venetian hall chairs known as *sgabelli* were designed principally for display against the wall in a room where guests were received but did not linger (pl.129).[60] The deep carving on one side of their narrow triangular backs could incorporate coats of arms and family devices and, if gilded, also reflected light from their surfaces. These small chairs were appropriate to their space both because of their appearance and because their size and ornament made them uncomfortable as functional seats. The same aesthetic often applied to chests. Their backs were left undecorated because they were to be placed against a wall or bed. The inside of the lid was sometimes embellished, however, suggesting it might be left open for a period of time while the chest's contents were in use. Similarly, the drug jars which lined the shelves of apothecaries' shops and monastic hospitals were usually painted with decorative patterns or scenes on one side only, the painted surface tailing off on the other (pl.130A, B). Leather pouches and containers which hung at the belt, however, tended to be worked on both sides, because either side might be visible when they were being carried.

TEXTILES, SCRIPT AND PRESTIGE

Some designs for ornament were more prestigious than others, a hierarchy that derived not from any association with the people who had conceived them, but from the materials on which they had first appeared. Gold and silver, naturally, were valuable, but the cost and desirability of the finest textiles were equivalent, if not superior, to those of these metals. Thus not only were hangings, tapestries, carpets and clothes admired and carefully preserved, but the worth they conveyed was often evoked in imitations of textile motifs and ornament applied to materials of comparable or

129. Hall chair (*sgabello*).
Walnut and gilding, 107 cm high.
Venice, 1580–1600.
V&A: 7183–1860

130A, B. Workshop of Mariotto di Gubbio, drug jar for rhubarb pills.
Tin-glazed earthenware, 13.8 cm high. Italy, possibly Castel Durante (modern Urbania), 1541.
V&A: C.72–1931

131. Textile fragment showing a *senmurv* (detail).
Woven silk, 36.5 × 54.3 cm.
Iran or Central Asia, 700–799.
V&A: 8579–1863

132. Ewer in the shape of a dog-headed dragon.
Gilded copper alloy with silver overlay and niello, 18.7 cm high.
Meuse valley, 1120.
V&A: 1471–1870

cheaper value. The most dramatic examples of this imitation are found in architecture: the brickwork of many Islamic buildings was laid to resemble woven cloth.[61] Meanwhile wooden panelling on walls and furniture in Northern Europe was often carved to resemble hanging lengths of linen: in the 1492 accounts of Hereford Cathedral the doors of the Audley Chapel are described as 'undulating wood', a reference to this imitation of folded textile now known as 'linenfold'.[62] More specific transfers of textile motifs also took place. A popular image on early Iranian textiles was a winged beast with a lion-like head known as a *senmurv*. This mythical animal, a symbol of royal power in Iran, was an appropriate decoration for expensive silk textiles, a number of which were imported into Western Europe from at least as early as the eighth century onwards. Although the original symbolism of the beast would have been lost on wealthy European buyers, the prestige it acquired by appearing on a sumptuous bolt of silk was not, and this encouraged its reproduction in similarly valuable media, such as gilded metalwork (pls 131, 132).

Textiles were also particularly associated with embellishment that involved inscriptions. The prestige of words woven into a garment with gold thread had a classical precedent. In his much-copied *Natural History*, Pliny described how the unrivalled Greek painter Zeuxis advertised his wealth 'by displaying his own name woven in gold lettering on the checked pattern of his robes'.[63] But it was in the Islamic world that text became an important element in the ornamental repertoire, and textiles woven with inscriptions and letter symbols were the most prestigious vehicle for this.[64] Islamic rulers, for example, presented their most favoured subjects with garments that included a band of script (*tiraz*, naming the ruling caliph and recording the date) woven into the upper part of the sleeve.[65] Yet not all examples of woven lettering necessarily had specific spiritual or political

significance for the viewer. The tapestry-woven decorations applied to an eighth-century tunic from Egypt incorporate the Arabic word '*li-llaah*' (unto God), a fragmentary rendering of a longer phrase which was probably 'Dominion unto God' (pl.133). The material value of these decorative textiles meant that they were often removed from the clothing to which they had originally been attached and were reapplied elsewhere, or sold and resold by second-hand clothes merchants. The coded messages of prestige conveyed by patterns of script would have been lost in this constant process of recycling and the value of the decoration would have been principally based on the perennial value of the woven cloth itself.[66]

Similarly, it was the costly and exotic associations of these Arabic script patterns on textiles which prompted Christian painters, sculptors and metalworkers to incorporate derivative designs into their own works, many of which were of a devotional nature. The mid-thirteenth-century artist responsible for the images of Christ on a parchment leaf has framed them with borders of ornament inspired by Arabic script (pl.134), while pseudo-Kufic script, probably inspired by the Arabic letters *alif* and *lam*, combines with part of a Latin verse on Christ's crucifixion on an enamelled plaque of the 1250s from Limoges.[67]

Two objects intended for a non-devotional context also use this type of decoration to emphasize both their value and the significance of their subject matter. A tapestry series depicting scenes from the mythical siege of Troy emphasizes the nobility and heroism of Pyrrhus – who is being equipped with

133A, B. **Tunic (and detail showing applied decoration around shoulders).**
Linen and wool,
131 cm long.
Egypt, 700–799.
V&A: 291–1891

the armour of his dead father Achilles – by trimming the doorway of the tent he stands outside with script patterns that derive from Islamic, Greek and Western alphabet forms (pl.135).[68] And actual fragments of Islamic script, recognizable as such despite errors, are included in sixteenth-century Western metalworkers' imitations of the densely patterned, inlaid brasswares imported from the Near East (and see also the pseudo-Kufic lettering around the Chellini Madonna on p.77).

DESCRIBING ORNAMENT

Throughout the period, ornament that consisted of patterns rather than a series of figurative designs was usually perceived in terms of what the viewer understood to be its place of origin.[69] This is illustrated most strikingly in the case of the extraordinary fresco patterns uncovered during excavations of the Emperor Nero's palace at Rome in around 1480. The palace, completed in 68 CE and known as the Domus Aurea (Golden House), had been an extensive complex that included gardens with elaborately decorated rooms. By the late fifteenth century, these had been swamped by earth and debris, so much so that those carrying out the excavations believed that what they had found were underground caves. The frescoed designs covering their walls very quickly became known as 'grotesques' (from *grotta*, the Italian for 'cave'). Their novel iconography, which could be endlessly varied to include different motifs and adapted to different contexts, also meant they very quickly became extremely popular among artists and patrons: designs of antique ornament were circulating in print as early as 1476.[70]

134. **Leaf from a psalter, showing Christ's Resurrection and Ascension.**
Watercolour on parchment with burnished gold, 18 × 12.3 cm.
Upper Rhine (Germany), c.1250.
V&A: 800–1894

135. **Tapestry from a set showing the Trojan war (detail).**
Wool and silk, 416 × 737 cm.
Tournai, 1475–90. V&A: 6–1887

136. Basin, perhaps for a ewer, with the arms and device of the degli Agli family of Florence.
Tin-glazed earthenware with lustre decoration, 42.8 cm diameter. Valencia, probably Manises, c.1400–1440. V&A: C.2053–1910. Salting Bequest

137. Agostino dei Musi, design for an ornamental panel.
Engraving on paper, 23.6 × 18.8 cm. Rome, c.1520. V&A: E.1076–1922

When the viewer was unable to situate the ornament (and by extension, the object itself) within a geographically definable context, alternative descriptive terminology was elusive. A crown official purchasing goods at Southampton in 1289 for Eleanor of Castile did not recognize what were almost certainly lustred ceramics from Malaga, and recorded them simply as 'pottery jars of foreign colour'. Had the queen seen them at that moment, however, she would almost certainly have recognized their place of origin.[71] French and Italian inventory descriptions of later Hispano-Moresque lustreware exported from nearby Valencia, by contrast, specify different geographical locations. These reflect attempts to locate the origin of the goods or the identification of certain ornamental motifs with local ones. Thus 'Malaga' became 'maiolica' in many Italian inventories until the sixteenth century, when its sense shifted to refer to painted ceramic wares produced in Italy.[72] Two large dishes in René of Anjou's castle at Angers were described as 'of white [ie. tin-glazed] Valencian clay, with golden leaf patterns'.[73] Florentines who also admired this type of leaf ornament emphasized its resemblance to the emblem of their own city and termed it '*fioralixi*' (fleur de lys). The basin shown here, made in Valencia for the degli Agli family of Florence, shows the type of swirling flower and leaf pattern that appealed to Italian taste during the fifteenth century (pl.136).[74]

Other descriptive terms for ornament seem confusing now, but were perhaps intended to convey a generic aesthetic rather than a precise origin. A frequent qualifier in Italian documents is the term *alla domaschina*, used to describe metalwork, ceramics, woodwork and textiles, but it may not always have referred to objects made in Damascus. Sixteenth-century Venetian metalworkers, for one, were able to produce brass salvers, ewers, caskets and candlesticks in a style which closely imitated the dense, inlayed silver designs characteristic of their fellow craftsmen in the Near East (pl.138). In some circumstances, then, *alla domaschina* probably also meant 'made according to Islamic patterns'.[75] If this ambiguity is taken into account, however, the term does broadly serve to describe a very Islamic aesthetic, namely the tendency to extend a pattern so far across a given surface that the background is completely eliminated.[76]

In other cases, documents use very specific terms, the significance of which can now only be tentatively established by comparison with surviving objects. So, for example, the 1535 contract for a new rood screen at the Gommaruskerk in Lier (modern Belgium) stipulated 'arches with a *chambrant* and with filler tracery behind the arches'. Although not a term which appears to have circulated widely, the use of '*chambrant*' in a notarial document suggests it described a once familiar and identifiable type of ornament – perhaps the bell-shaped forms inserted within fields of filler tracery.[77]

Other descriptions combine the familiar with uncertainty. A 'Turquey carpett with borders at

138. **Ewer.**
Brass with silver wire, copper
repairs, 28.5 cm high. Venice,
1500–1600. V&A: M.31–1946. Given
by Dr W.L. Hildburgh FSA

139. **Thomas Geminus, design
for moresque ornament.**
Engraving on paper, 4.1 × 7.7 cm.
London, 1548. V&A: 19012

th[e] endes with lions' was recorded at Hampton Court in 1547 among the furnishings that Princess Mary had inherited from her father, Henry VIII. It was probably of Spanish provenance,[78] but the inventory-maker was clearly unfamiliar with Spanish carpets and therefore focused on the geometric elements, which resembled more familiar Turkish examples.[79] The presence of the lions, which in fact suggest the carpet's Hispanic origin, clearly distinguished it but also defeated the scribe.

Since the early fifteenth century, the technology of printing had enabled abstract ornamental designs to circulate on sheets of paper. Initially images and designs had been reproduced by incising and inking wooden blocks, but the invention of engraving in the mid-fifteenth century provided a more flexible and more durable method of reproducing motifs.[80] Engravers produced single sheets of patterns for sale, varying in size, shape and subject-matter, some of which were subsequently bound up by their owners into what are now termed 'pattern books' (pl.137). This was ornament divorced from a supporting object and, as a result, unattached to a material, technique and geographical location that could help define it, although enterprising printers and artists still attempted an identification. The year 1527 saw the publication of Giovanni Antonio Tagliente's book of embroidery patterns, which included a section of knot-work (*groppi*) and scrolling patterns which he described as '*moreschi et arabeschi*'. This is the first printed use of the term 'moresque', but there were many subsequent instances, thanks to the popularity of the apparently exotic origins of this style of ornament.[81] One example is the collection of prints issued by Thomas Geminus in London in 1548, titled *Morysse and Damashin* [Damascene] *renewed and increased, very profitable for Goldsmythes and Embroderars* (pl.139). These intricate designs, however, often owed far more to Western traditions of calligraphy and ornament than they did to Eastern ones. Interlace and scroll patterns had also been a feature of Western penmanship during the medieval period.[82]

The single-sheet format of the designs themselves, though now known as 'ornament prints', did not at the time have a standard name. The inventory of the vast print collection amassed by Ferdinand Columbus, whose father Christopher had claimed the Americas for the Castilian crown, includes no particular section devoted to what we would think of as ornament prints.[83] Instead, Columbus described prints according to particular features, rather than as an overall composition. Thus '*follaje*' or '*follajes*' describes the presence of foliage in a print, but does not specify whether it is the dominant element of the design or peripheral to it.[84] Similarly, although knot-work and interlace patterns were extremely popular in the fifteenth and sixteenth centuries, Columbus categorizes them simply as '*lazos*' (interlaces), which, although descriptive, is equally vague as to origin.[85] That said, however, the inventory does reveal that a broader distinction between figurative and non-figurative ornament was being made, a distinction which in ecclesiastical contexts was often still elided.

ORNAMENT, VARIETY AND MEMORY

Endless ornamental variation was an indication of the quality of craftsmanship and an aesthetic ideal.[86] Although Vitruvius had criticized the illogical designs of grotesque ornament in his treatise on architecture (see p.184), sixteenth-century European artists and craftsmen were impervious to his objections. Instead, they embraced its infinite variety and pleasing symmetry with enthusiasm. They also elaborated upon it by expanding the repertoire of motifs and corralling them into structured patterns which literally resembled leather straps and have come to be known as 'strapwork'.[87] What had originally been a type of design intended solely for an architectural context (walls and ceilings) became, in the sixteenth century, a resource of infinitely variable and adaptable patterns that could be reworked according to circumstance. It could also be combined with designs of a completely different pedigree. The front of the dish pictured here is painted with the type of 'illogical' ornament that so annoyed Vitruvius (see p.185). The reverse uses blue on a white background to imitate the painting on Turkish ceramics, themselves an imitation of Chinese pottery imports (pl.140).[88] The designs on the front and back of the dish, then, are quite different in cultural origin, although each conveys a flattering message about the breadth of the owner's aesthetic interests, and possibly also his wealth. Whether this dish was bought as part of a service already made in the Cafaggiolo workshop, or decorated according to a patron's strict orders, the grotesques on the front are an early (around 1515) interpretation of a fashionable design, while the blue flowers on the back are a reinterpretation of the most expensive – and, in terms of Western technology at this date, inimitable – ceramic of the day, porcelain (see pp.186–7). The continued importance of Turkish interpretations of Chinese designs for Western ideas of ornament is apparent in a design labelled '*porcelana*' in Cipriano Piccolpasso's manuscript treatise, *The Three Books of the Potter's Art* (completed around 1558; pl.141).[89] Later in the sixteenth century, the scientist Girolamo Cardano explained that the leafy decoration of genuine Chinese porcelain was among the factors which caused it to be particularly admired by Western collectors.[90]

The variety of ornament was also a feature deliberately intended to engage the viewer's intellect, in both Western and Eastern cultures. The tenth-century author of *The Book of Curious Information* and the chronicler al-Muqaddasi both drew attention to the ways in which the variety of colour and form in ornament aroused the constant curiosity of the viewer and invited contemplation.[91] It was this call on the attention of the viewer that had, at different times, provoked condemnation from Saints Bernard of Clairvaux and Antoninus of Florence (see pp.161–2), but it was also precisely ornament's visual appeal that gave it another important function, that of a prompt to memory.[92]

140. **Decorated underside of a dish.** Tin-glazed earthenware, 39.5 cm diameter. Cafaggiolo (Italy), *c*.1515. V&A: C.2153–1910. Salting Bequest

The elaborate tracery and carving on the façades of ecclesiastical and secular buildings from the thirteenth to the sixteenth centuries were deliberately varied: the complexity and concentration of carved motifs conveyed messages about the importance of a space or of a statue displayed below (see pl.82, p.107).[93] The emergence of the grotesque as a form of ornament at the end of the fifteenth century provided artists with a new framework in which to convey such messages. The two panels on the predella of a late 1520s carved altarpiece from Lombardy (Northern Italy) show how the grotesque aesthetic has been adapted to a Christian context to provide an opportunity for meditation on Christ's Resurrection (pl.142). The panels flank a central scene showing Christ's Nativity, and thereby provide the viewer with a subtle reminder of later events in the Christian narrative. Both panels adopt the symmetrical compositional structure of grotesque ornament, but they adapt classical motifs of military trophies and scrolling acanthus leaves to include Christian symbols of the Passion and Resurrection. Saint Veronica's handkerchief, with the face of Christ miraculously imprinted on it, hangs above a tomb that has harpies at the base and the face of the

141. **A '*porcelana*' pattern, from *The Three Books of the Potter's Art* by Cipriano Piccolpasso of Castel Durante.**
Manuscript, ink on paper, 28 × 23 cm. Italy, *c.*1556–9. V&A MSL/1861/7446, f.69v

pagan snake goddess Medusa carved upon it. At the top of the panel is a pelican feeding its young with the blood from its breast – a symbol of Jesus's self-sacrifice for humankind. The right-hand panel alludes to Christ's Resurrection. Again, the base of the ornamental motif is classical in inspiration, recalling a chariot drawn in triumph. The five unicorns harnessed to it, however, are Christian symbols of purity, a theme continued in the figure of the naked female carved above. She represents Daphne, transformed into a laurel tree, according to classical legend, in order to escape the advances of the sun-god Apollo. She holds a wreath of oak leaves, a classical symbol of heroism equally appropriate in this ornamental context, where it reflects Christ's sacrifice.[94] The phoenix emerging from the flame of a Roman-style lamp at the top symbolizes Christ's triumph over death.

THE PERSISTENT SIGNIFICANCE OF ORNAMENT

The steady increase of goods in circulation and the availability of new printing technologies to disseminate designs may suggest a ubiquity that debased ideas of decorum and symbolic meaning.[95] Certainly the range of patterns available to workshops and individuals increased as goods, books and prints travelled further and among more people. Yet the fundamental assumption that ornament embellished, whatever its appearance, held as firm in the twelfth and sixteenth centuries as it had in Isidore of Seville's day in the sixth. Theophilus, the shadowy author of a twelfth-century treatise on painting and goldsmithing, had described how narrow sheets of silver could be stamped with patterns of flowers, animals, birds or linked dragons. Significantly, he did not associate these designs with any particular object type. Instead, he explained how 'this work is very useful around borders,

142A, B. **Giovanni Angelo del Maino and Tuburzio(?) del Maino, altarpiece predella (and detail).**
Pearwood, 63.7 cm high.
Lombardy, 1527–33.
V&A: 137–1891

when making altar frontals, on pulpits, on reliquaries for the bodies of saints, on book covers, and wherever it is required, because the relief is beautiful and delicate and easily wrought.'[96] The general application he suggests for his motifs anticipates the broad audience of artists and craftsmen who were the target of the authors and printers of pattern books in the sixteenth century. Only occasionally were these ornamental designs provided with a specific decorative purpose, as in the case of six ornament prints now in Vienna. Signed in monogram by a shadowy figure whose identity rests on them alone, the designs are specifically recommended for particular areas on particular objects, together with a note on the orientation the ornament should take. Thus, for example, one print is accompanied by the note: 'for the borders of a dish or basin or for a frieze to be used lengthwise'.[97]

Despite the increased variety of ornament sources and styles at the close of the sixteenth century, the process of adding ornament to an object was still laborious, and it still increased the basic cost of an object. Hence ornament still had a material value and this monetary worth continued to reinforce the equation between ornament, honour and status. In theory at least, ornament was still considered in terms of its appropriateness to particular objects, contexts and people (for the last, see the discussion of sumptuary laws in Chapter Eight). As a result, some observers continued to view its messages with suspicion. The English traveller Robert Dallington, writing in 1596 about the pilgrims who came once a year to see a relic in the town of Prato in neighbouring Tuscany, observed that:

> There were in view vpon the Market place of people at the shewing of this Relike, about eighteene or twenty thousand, whereof we iudged one halfe to haue hats of strawe, and one fourth part to be bare legged; that we know all is not gold in Italy: though many Trauellers gazing onely on the beauty of their Cities, and the painted surface of their houses, thinke it the onely Paradize of Europe.[98]

Dallington was not a disinterested observer: his scepticism often reflects a patriotic desire to deflate what he considered un-English pretensions. But his opinion that the appearance of Italian urban buildings disguised the poverty that was the lot of the majority of their inhabitants echoes the disapproval that Cicero and Pliny would have felt for the disparity between architectural façade and social reality.

The Italian peasants watched by Dallington would have seen briefly the splendid church vestments and precious plate involved in the ceremonial display of the Virgin Mary's girdle, but – like Suger's low-born congregation at St-Denis – they would not have been allowed to look at them in close proximity. At the end of the sixteenth century, as in the twelfth, ornament still carried with it important connotations of wealth and moral symbolism for the more prosperous, urban sections of society which the poor could only glimpse.[99] Its messages were written on church buildings and furnishings, in palace façades, on people's clothing (pl.143) and even painted on their faces.

143. **Three standing figures: (left to right) a knight, a squire and a man-at-arms.**
Oak, 110 cm high. England, c.1500–1525. V&A: A.11 to 13–2001. Purchased with the assistance of the National Heritage Memorial Fund and The Art Fund

14. The grotesque

ELIZABETH MILLER

NOWADAYS, THE WORD GROTESQUE refers to something which is repellant, distorted or bizarre. In the context of renaissance art and design it has altogether different associations: with fantasy, playfulness, exuberance and, in some instances, eroticism.

The grotesque style is just one example of fifteenth- and sixteenth-century design taking its inspiration from the classical past (see Chapter Four). It was inspired by the discovery towards the end of the fifteenth century, near the Colosseum in Rome, of the long-buried and forgotten palace complex of the Emperor Nero (r.54–68 ce). The principal interiors of this vast palace, called the Domus Aurea (Golden House), were extravagantly decorated with expensive materials, gilding, stuccowork, and fresco painting in strong and contrasting colours (14.1). The remains of the palace – which had subsequently been used as the foundation for the Baths of Trajan, and were thus below the new, raised, ground level – were perceived as subterranean, and were compared to a cave (grotta in Italian). The style of painted and relief decoration in the Domus Aurea – so startlingly novel to the renaissance mind – thus became known as the grotesque.

This style is characterized by the juxtaposition of real objects and imaginary creatures. Strange hybrids of men, women, animals, birds and plants are combined in ways which defy the laws of nature, together with structures which could not exist, supporting loads they could not bear. In his influential treatise *De architectura*, the only work of its kind to survive from Antiquity, the Roman architectural theorist Vitruvius had deplored the style of fresco painting which the Domus Aurea exemplifies:

... volutes growing up from roots and having human figures senselessly seated upon them; sometimes stalks having only half-length figures, some with human heads, others with the heads of animals. Such things do not exist and cannot exist and never have existed. ... Yet when people see these frauds they find no fault with them but on the contrary are delighted, and do not care if any of them can exist or not.

Despite Vitruvius' condemnation, after the discovery of the Domus Aurea, artists readily took up the grotesque style, first in Rome and then in Siena (14.2).

Some renaissance grotesques have an airy but nonetheless strongly architectural or geometrical structure (14.3). Others omit architectural content, cramming every available space with a symmetrical profusion of figures, foliage, birds and insects, animal heads, arms and armour and other man-made objects (14.4). The designs frequently incorporate erotic elements such as satyrs – mythical beasts, half-man and half-goat, renowned for their promiscuity. This eroticized grotesque style was chosen as the appropriate framing for certain mythological subjects, such as Jupiter transformed into a swan, copulating with Leda.

Perhaps as much for its ancient precedent as for its novelty and fascinating unreality, the grotesque style became very widely disseminated throughout Italy and beyond during the sixteenth century, often via drawings and prints.

14.1 ▲ **Vault of the Domus Aurea (detail).**
Fresco. Rome, 64–8 CE.

This Ancient Roman ceiling decoration incorporates fantastical beasts and half-human figures that inspired 15th- and 16th-century artists and designers.

14.2 ▶ Two border tiles from the floor of the 'beautiful room' of the Petrucci Palace.
Tin-glazed earthenware, each 19 × 38.3 cm (approximately). Siena, *c*.1509. V&A: from sequence 4915–5386–1857

The ruler of Siena chose the grotesque style for the floor of the room celebrating his son's marriage.

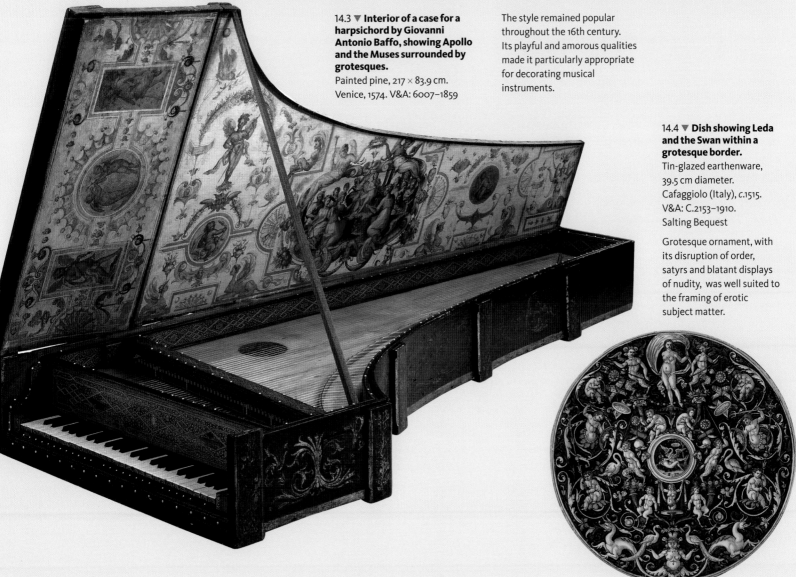

14.3 ▼ Interior of a case for a harpsichord by Giovanni Antonio Baffo, showing Apollo and the Muses surrounded by grotesques.
Painted pine, 217 × 83.9 cm. Venice, 1574. V&A: 6007–1859

The style remained popular throughout the 16th century. Its playful and amorous qualities made it particularly appropriate for decorating musical instruments.

14.4 ▼ Dish showing Leda and the Swan within a grotesque border.
Tin-glazed earthenware, 39.5 cm diameter. Cafaggiolo (Italy), *c*.1515. V&A: C.2153–1910. Salting Bequest

Grotesque ornament, with its disruption of order, satyrs and blatant displays of nudity, was well suited to the framing of erotic subject matter.

15. Medici porcelain

CHRISTOPHER MAXWELL

PORCELAIN WAS FIRST CREATED in China during the Tang dynasty (618–907 CE). By the mid-fifteenth century porcelain from the East had captured the imagination of Europe but only wealthy collectors could afford to purchase it from the precious cargoes carried by merchants to the West (15.1). There, despite the enthusiasm for porcelain, the secret ingredient of its manufacture (a type of clay called kaolin) remained a mystery. Shortly after it was first made in China, potters in Persia (modern Iran) developed an opaque white glaze, including tin ash, which superficially imitated the white body of porcelain and served as an ideal background for blue decoration. The technique of tin-glazing was soon adopted by Spanish and then Italian potters who used the white glaze as a background for various styles of decoration, some of which were inspired by Chinese porcelain and the Middle Eastern wares that imitated it (15.2).

Around 1575 the Grand Duke Francesco I de' Medici set up a special workshop in the Boboli Gardens of Palazzo Pitti, in Florence, in an attempt to discover the formula for porcelain. Numerous experienced potters were assisted in their endeavours by a 'Levantine' – probably a Greek or a Turk familiar with the Iznik potteries of Ottoman Turkey – and succeeded in producing a soft-paste or 'artificial' porcelain. The composition of this is, in fact, close to the fritwares made in Turkey, Iran and elsewhere in the Islamic Near East. It combines marzacotto (a heated frit mixture of sand, wine sediments and salt) with fine white sand and white clay. The result is a beautiful ceramic with a remarkably glassy, white surface but which lacks the translucent quality and resistance to heat of Chinese porcelain.

Over sixty surviving pieces of 'Medici porcelain' have been identified, almost all of which betray an experimental character. Their forms recall the shapes of contemporary Italian pottery and metalwork, whilst the hazy underglaze decoration is influenced by a variety of sources. The pilgrim bottle, with moulded classical masks on either side, is decorated with a grotesque design typical of the Italian Renaissance, with the addition of Chinese-inspired chrysanthemum and insect motifs (15.3). The jug, however, is decorated with palmette and swirling foliate designs common to Iznik pottery (15.4).

Medici porcelain would have been considered a luxury material, as precious as Chinese porcelain, painted maiolica, fine glassware and silver. Such objects were often reserved for display and had an important role in the exchange of diplomatic gifts. Contemporary accounts suggest that Medici porcelain might also have been used, albeit in the most luxurious and courtly settings. The posthumous inventory of Francesco's possessions includes 'a small pot for drinking water of our country's porcelain, made in Florence.' A Medici porcelain water dish for birds is also recorded.

Production of this so-called Medici porcelain ceased shortly after the death of Francesco I de' Medici in 1587 and that of hard-paste porcelain (made with kaolin) did not successfully begin in Europe until more than one hundred years later.

15.1 ▲ Bowl.
Hard-paste porcelain, painted in underglaze cobalt blue, 13.1 cm diameter. Jingdezhen (China), 1595–1625. V&A: C.477–1918

This is a typical example of the Chinese porcelain exported to Europe in the late 16th century.

15.2 ▶ Maestro Benedetto or his workshop, plate depicting Saint Jerome.
Tin-glazed earthenware, 24.4 cm diameter. Siena, c.1510. V&A: 4487–1858

The saint is painted in the style associated with the Italian Renaissance; the foliate pattern is derived from Eastern sources.

15.3 ◀ Pilgrim bottle.
Soft-paste 'Medici' porcelain, painted in underglaze blue, 19.7 × 15.2 × 9.8 cm. Florence, 1575–87. V&A: C.2301–1910. Salting Bequest

The mix of Italian and Chinese influences seen in this object reflects the eclectic artistic experimentation of the Medici workshop.

15.4 ▶ Jug.
Soft-paste 'Medici' porcelain, painted in underglaze blue, 15 × 10.3 × 12 cm. Florence, 1575–87. V&A: C.128–1914

The jug became distorted during the firing process, demonstrating the significant technical difficulties encountered by potters attempting to create 'true' porcelain.

16. Mongol silks and the Italian silk industry

HELEN PERSSON

AT ITS HEIGHT in the middle of the thirteenth century the Mongol Empire stretched from the Black Sea in the west to the Korean border in the east, facilitating trade right across Eurasia. The trade routes carried woven silks from the imperial weaving workshops. They included textiles with gold thread demonstrating a rich array of patterns and influences. The design of Mongol silks was incredibly lively, with dramatic scenes involving bizarre monsters, and a mixture of traditional Chinese motifs, Middle Eastern elements and local Central Asian repertoires.

During the late thirteenth and fourteenth century these luxury silks, sometimes called 'Tartar silks' in contemporary Western records, were in high demand from European rulers. The silks represented a recognizable display of status and frequently feature in European paintings from the period. They were also valued for use in Christian rituals, such as wrapping relics, and as vestments (16.1). Many examples have survived in church treasuries and tombs.

With this flourishing trade from the Mongol Empire designs migrated across cultural boundaries and for a brief period there was an international decorative repertoire in Chinese, Near Eastern, Mamluk and Italian silks. It is often not easy to identify the exact area of origin of a particular fabric (16.2). Traditionally, many Mongol silks were attributed to China, but recent research suggests Central Asia as the likely production area. Many must have been specifically made for export as none have so far been found within China or Central Asia.

To compete with the expensive Tartar silks that were being purchased by European nobility, the European silk industries had to adjust and there were significant changes to local silk design. In Venice, Florence, Lucca and Genoa – home to the most important European silk industries of the late fourteenth and early fifteenth century – silk designers increasingly assimilated exotic motifs and styles into patterns that were nevertheless essentially Italian (16.3). This resulted in designs that were completely different from anything previously woven in Italy. Birds and animals that had formerly been trapped in roundels, symmetrically repeated, were allowed to break free, flying, stalking, and clinging to each other, the figures vividly interacting with other elements of the composition. These witty designs featured fabulous beasts, phoenixes, dragons, palmettes, lotus buds and sometimes even pseudo-Arabic inscriptions (16.4), and an emphasis on the diagonal and asymmetrical compositions typical of Chinese silks.

The craze for these exotic designs in Italy lasted only to the early fifteenth century, when they were replaced with motifs deriving from the natural world and there was a return to symmetry and order. Asian silks later than about 1400 are not found in European church treasuries and tombs, reflecting the discontinuation of the silk roads with the fall of the Mongol Empire.

16.1 ▲ Textile fragment. Silk twill damask, 16.5 × 10.5 cm. China or Central Asia, 1275–1350. V&A: 7046–1860

Palmettes and clouds, similar to those on this silk, are elements that recur in Italian silk designs. The stitching holes and seam lines suggest a possible past use as part of a vestment.

16.2 ▼ Textile fragment.
Silk lampas, gold brocading thread (gilded animal membrane wrapped around linen core), 70 × 27.9 cm. Probably Iran, 1350–1400. V&A: 769–1894

The birds are similar to the Chinese mythical *fong-hoang* or phoenix, while the vine leaves are of Italian influence, but the structure of the cloth shows similarities with silks from Mongol-ruled Iran.

16.3 ▲ Design for silk textile.
Pen and bistre on vellum, 18 × 17.2 cm. Italy (probably Venice), 1375–1400. V&A: 2328A

This is probably a full-scale working silk design and was most likely made in a Venetian workshop. The central motif of a phoenix chased by a dog shows the liveliness typical of Eastern-inspired Italian silk.

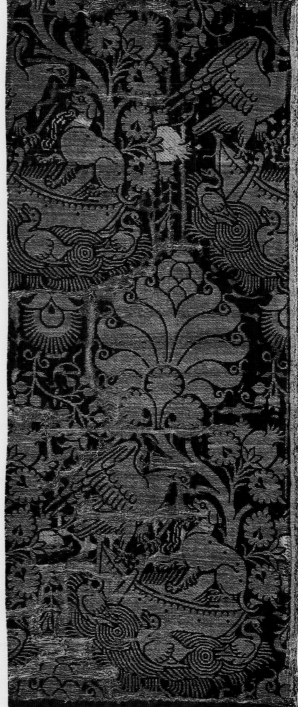

16.4 ▶ Textile fragment.
Silk lampas, gilt brocading thread (gilded animal membrane wrapped around linen core), 53 × 22.7 cm. Italy (probably Venice), 1370–1430. V&A: 756–1875

The central motif of a chained dog and an eagle in a boat on stylized water is typical of the unlikely and bizarre repertoire of late 14th-century Italian silks.

17. Roman ornament in Umayyad Spain

MARIAM ROSSER-OWEN

I N 711 CE, THE ARMIES OF ISLAM swept through the Iberian Peninsula, defeating the ruling Visigoths and establishing their capital at Cordoba, the former capital of the Roman province of Baetica. In 750, the history of this frontier province of the Islamic empire – called *al-Andalus* in Arabic – was transformed by the usurpation of the Umayyad caliphate by a new dynasty, the Abbasids. One member of the Umayyad royal family survived and fled in disguise to Cordoba, where he proclaimed the independence of al-Andalus under Umayyad rule, which lasted until the early eleventh century.

In Spain, as in Syria, the Muslim settlers discovered an architectural landscape littered with the physical remains of six centuries of Roman rule. Hispania had been a flourishing province of the Roman empire, providing her with silver and gold, wine and olive oil, as well as three emperors and many of her great writers. Roman structures were reused for very practical reasons, because they were functional, like the bridge over the River Guadalquivir at Cordoba. The siting of new architectural foundations depended on the location of Roman irrigation systems, especially aqueducts, which were refurbished to supply the Great Mosque of Cordoba and the palace-city of Madinat al-Zahra' (founded in 936). Roman statues were reused as apotropaic devices on city and palace gates, and some of the finest Roman sarcophagi in Spain today were excavated at Madinat al-Zahra', where they had been reused as fountain basins.

When the Great Mosque was founded in 785, its architects reused Roman columns and capitals (17.1), some of which were brought from as far away as the Roman city of Italica, near Seville. The marble capitals were all of different styles, though the Corinthian outnumbered the Composite. This taste was maintained when the mosque was enlarged in 848 and freshly quarried marble was used to make faithful imitations of Roman capitals. Four particularly splendid examples were installed inside the mihrab, and were so well-copied and carved that they have been thought to be Roman.

Roman forms were still a source of inspiration in the late tenth century, when the mosque was extended again, as seen in the use of the 'egg-and-dart' motif on a capital in the V&A (17.2), which probably dates from this time. They also influenced the decoration at Madinat al-Zahra' (17.3), where the walls are covered with marble revetments carved with themes of verdant nature. Ultimately rooted in naturalistic Roman ornament, these motifs appealed to the Islamic model of rulership, whereby the caliph is God's earthly representative and his beneficent treatment of his people is physically manifested in the fertility of the natural world. The same themes are used on the luxury objects made for the Umayyad court (17.4), which are so closely related to the carvings of Madinat al-Zahra' as to indicate an Umayyad dynastic style.

Roman ornament appealed to the Umayyads because it embedded the settlers in their local culture, as well as making a connection with their homeland in Syria. Its reuse and imitation had a lasting impact on the development of an artistic aesthetic that was distinctly 'Andalusi'. Most significantly, it provided a way of defining the Umayyad dynasty's visual identity as not Abbasid. In the tenth century, when the Fatimids came to power in Egypt and challenged the Umayyads' superiority in the Islamic west, the renewal of the Roman style signified al-Andalus as distinct.

17.1 ▼ Jean Laurent and Co., Madrid, *So-called Columns of 'Sulphur' and 'the Captive' in the Mosque*.
Albumen print, 33.5 × 25 cm. Cordoba, *c.*1892–3. V&A: Ph.2208–1893

The photograph shows reused Roman columns and capitals in the oldest part of the Great Mosque of Cordoba (founded in 785), supporting its characteristic red-and-white banded horseshoe arches.

17.2 ▶ Column capital.
Marble, 33.5 × 33 × 33 cm. Cordoba, 950–75. V&A: A.10–1922. Given by Dr W.L. Hildburgh FSA

The composite form of this capital, with its double row of acanthus leaves, is entirely Roman, but the Arabic inscription in Kufic script along its top edge indicates its Islamic origins.

17.3 ▶ Fragment of wall decoration.
Limestone, 24.5 × 22 × 5 cm. Spain (probably Madinat al-Zahra'), 936–76. V&A: A.156–1919. Given by Dr W.L. Hildburgh FSA

The walls of the throne hall at the palace-city of Madinat al-Zahra', near Cordoba, were covered with plant designs, symbolizing the fertility of the realm as the result of the caliph's just rule.

17.4 ▲ Casket.
Ivory with copper-gilt and niello mounts, 8.5 × 13 × 8.5 cm. Spain (probably Cordoba), *c.*962. V&A: A.580–1910. Salting Bequest

This casket was made for a daughter of the caliph Abd al-Rahman III (912–961), and its scrolling decoration of leaves and flowers resembles that on the walls of his palace at Madinat al-Zahra'.

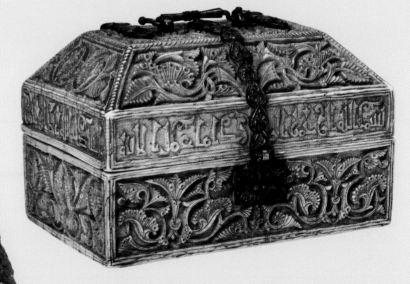

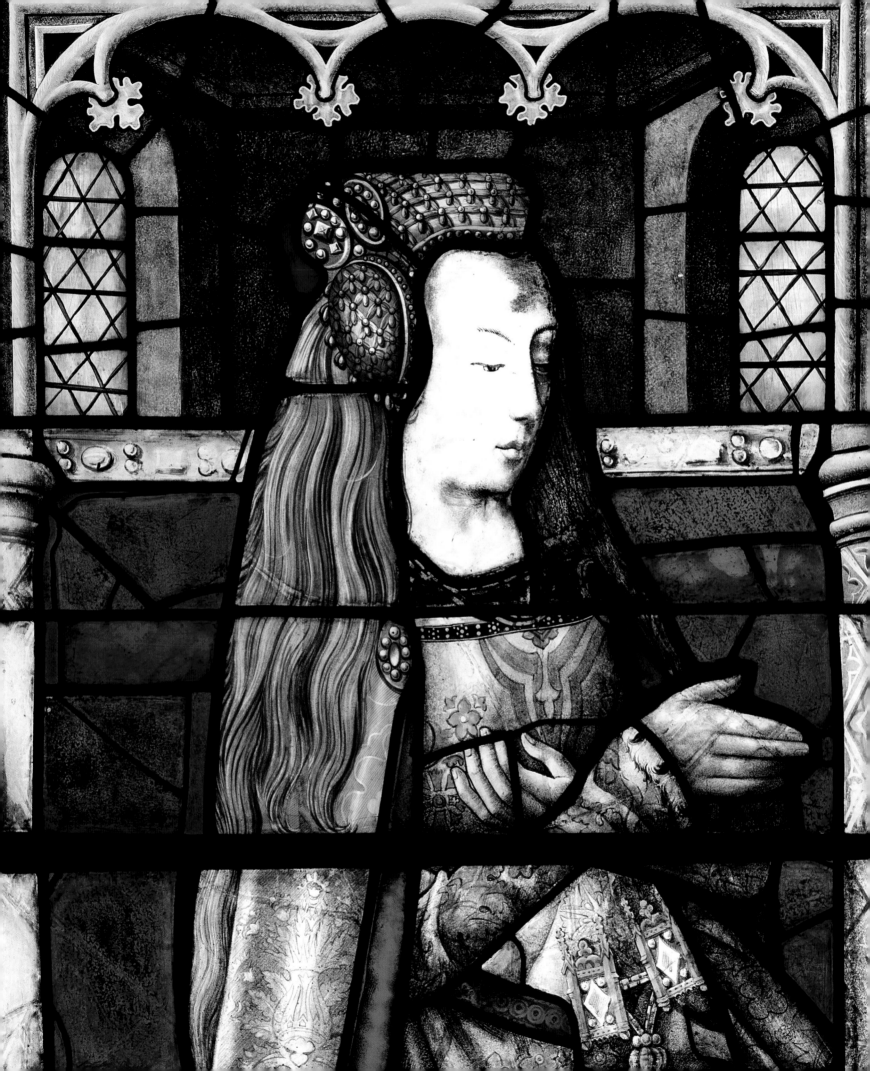

6

DEVOTION
AND DISPLAY

Glyn Davies

I N THE YEAR 984, Odelricus, the bishop of Cremona, decided to conduct an inventory and reorganization of his cathedral church's treasury. He wrote that amongst the treasures were, 'A golden chalice with its paten, for which on our part we sent [to the makers] a pound of gold and a hundred and thirty gems with enamels; we sent on the part of the church eight ounces of gold. We gave four copes, with golden orphreys, and another without gold; there are also three others, which we seized from the hands of thieves... Two censers, having ten pounds of silver; another, which was Luizo's, we seized from the hands of thieves.'[1]

Odelricus' self-satisfaction over his gifts to the church and the goods he had recovered from 'thieves' was palpable and his actions were by no means unusual. In the period covered by this book, bishops and abbots routinely embellished and made gifts to their churches. The most famous medieval case is that of the twelfth-century Abbot Suger of St-Denis, the Benedictine abbey near Paris, who in a series of texts described the extensive renovations he made to his institution.[2] Although he was unusual in the scale of his ambition and in his means of achieving it, Suger's writings fit broadly into a long tradition of Church leaders recording the manner in which they governed and embellished their churches. High-ranking churchmen and women were usually from the upper classes, and this gave them the wealth and connections necessary for such generous patronage.

Nevertheless, the Church could never have acquired the wealth that it did without the enthusiastic cooperation of the laity. The devout – and sometimes not so devout – practices of lay people were responsible for producing a vast array of luxurious and highly worked religious objects. Nor did piety prevent lay people from magnificent display in the field of religious furnishings. Large-scale tombs and heraldic monuments, for example, became a striking feature of church buildings towards the end of our period. On the other hand, religious belief had a very real effect on many lay people, who were in daily contact with religion: as active worshippers, through

Joanna of Castile
from the Chapel of the
Holy Blood, Bruges (detail).
See pl.155, p.201.

membership of religious confraternities, through prayer, in their political and social lives, and via religious images in the home.

Medieval theologians were accustomed to arguing that the world could be divided into three classes of people: those who prayed (ecclesiastics), those who fought (knights) and those who worked (peasants).[3] But the strict division of society implied in this commonplace hardly reflected the complexity of social and religious experience in the period 300–1600. Every area of Christian society, both lay and ecclesiastical, was affected by the multifarious relationship between the sacred and the secular. This chapter discusses the objects that embody such relationships. It concentrates on continuities in Christian practice across the centuries, dealing as much as possible with the ways in which religion was experienced by ordinary people. Of course, Christianity was not Europe's only major religion. This chapter alludes to the important presence of other faiths, but its main focus is on the largely Christian world of Western Europe.

PERSONAL PATRONAGE AND GIFTS TO THE CHURCH

Local nobility and landowners frequently made donations to the Church. In the earlier Middle Ages, this usually meant grants of land. The estates formed by churches and monasteries in this way could provide a substantial income towards upkeep. But pious gifts also took the form of precious goods. Such objects often highlight the links between the Church and the secular world. An example is the ivory holy water bucket (or situla) which, according to its inscription, celebrates 'the august Otto', almost certainly the Emperor Otto II (see p.25).[4] The situla was produced around 980 and was probably used during Otto's ceremonial entry into an Italian city. It is unclear whether it was commissioned by the Church or a local aristocrat. Although presented to Otto, he would not have retained the situla; it was of no use to him. It would most likely have been donated to a church under his patronage. The situla, therefore, was at the same time a liturgical object, a political prop and a symbol of the ties binding Church and state.

The motivation for giving gifts to churches was usually more straightforward. By practising the virtue of charity, the giver hoped to benefit his or her soul after death. This is made clear in documents and surviving objects from quite an early date. In the West, the names of benefactors of the Church who were to be remembered in prayers were read out as part of the liturgy from the fourth century CE. The names inscribed on the back of the Anastasius Diptych leaf may form part of one such list (pl.144).[5] This sixth-century Byzantine ivory originally commemorated the election of the consul Flavius Anastasius in Constantinople, but was later reused in a Western European church – not an unusual phenomenon for objects of this sort.

Members of the nobility joining a religious institution commonly endowed it with gifts; in 833 'Alibertus the priest' gave all his lands and goods to the monastery of S. Silvestro in Nonantola, near Arezzo. Alibertus probably made his donation at the time of taking his monastic vows. He specified that his donation was 'for the benefit of my soul, and those of my parents'.[6] This phrase echoed through the following centuries in countless documents recording donations and last testaments.[7]

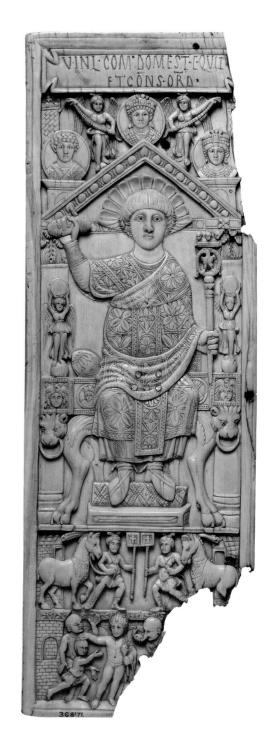

144. **Front of a leaf from a diptych of the Consul Anastasius.**
Ivory, 36.5 cm high. Constantinople (modern Istanbul), 517 CE.
V&A: 368–1871

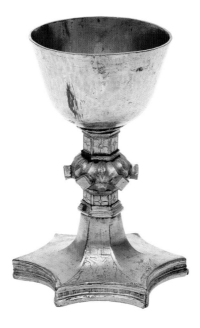

145. Chalice.
Copper-gilt, 16.6 cm high. England, c.1480. V&A: M.42–1961

146. Container, probably for a Kiddush cup.
Leather, 14.5 cm high. Germany, 1412–23. V&A: W.111–1910

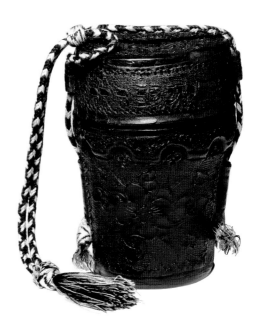

147. Pellegrino di Giovanni, *The Virgin Mary with the Christ Child, surrounded by Angels.*
Tempera on panel, 150 × 61 cm. Perugia, 1428. V&A: 6559–1860

It can often be found on objects themselves, such as an English copper-gilt chalice of the late fifteenth century. The foot of the chalice is engraved with the Crucifixion and a scroll bearing the words 'Pray for the soul of Richard Beauchamp' in Latin (pl.145). This may refer to the Richard Beauchamp who was bishop of Salisbury between 1450 and 1481.[8] The chalice was most likely buried with him, in which case the inscription was less an instruction to the viewer and more a conventional expression of piety.

Nor was it just Christians who sought to perpetuate their memories through giving gifts. In the early fifteenth century, a German Jewish donor called Isaac, son of Jacob Halevi, presented a Kiddush cup to his congregation. Although the cup is lost, its protective leather case still survives, bearing an inscription commemorating the gift (pl.146). Kiddush cups are goblets used for drinking wine at Jewish religious ceremonies, and at Sabbath and festival meals. Whilst there was no benefit to Isaac in the afterlife, the gift can be seen as a good work and as a way of preserving his memory within the community.[9]

Some of the objects that began to appear in church treasuries did not have an immediately obvious religious significance. In 1051, for example, the newly built cathedral of Speyer in the Rhineland possessed an elephant tusk and 'part of the tooth of a fish', probably walrus ivory.[10] Tradition identifies one of these objects as an ivory oliphant (horn) now in the collections of the Islamic Museum in Berlin.[11] A number of such horns were donated to churches across Europe between the eleventh and thirteenth centuries, where they often hung above altars. Some were used as relic containers but others appear to have been given to commemorate victory in battle, or even as a symbol of a transfer of land.[12]

Although the names of donors were often proudly recorded in the inventories and necrologies of religious institutions, the development of heraldry as an international code of identity in the twelfth century meant that donors could now pictorially mark their gifts with permanent proof of who had given them. This proved an irresistible temptation and the penetration of heraldry into the sacred space of the church was rapid. Within two hundred years, it was not unusual to find prominent heraldic markers in even the most sanctified of places. In 1428, the Perugian

merchant Nicola di Giovanni di Benedetto di Giovanni presented a painted panel by the town's leading artist, Pellegrino di Giovanni, to the local Dominican church for use as an altarpiece (pl.147). The painting bears not only his coat of arms, but also the merchant's mark used in his warehouse (bottom right), which would, if anything, have been even more familiar to local people.[13] Luxurious textiles were also tempting vehicles for such display. The early fourteenth-century Marnhull Orphrey, an embroidered band which would have been stitched to the back of a chasuble, prominently bears the arms of the Wokyndon family, patrons of St Paul's Cathedral (pl.148).[14] The orphrey would have been most visible during the mass, when the priest stood with his back to the congregation.

These displays of secular pomp within the sacred space of the church were not just about showing off. In addition to encouraging those who saw them to pray for the donor's soul, they had a more practical function. When the merchant Francesco di Marco Datini gave a chalice to a Franciscan church, a friend advised him to insist that his name appear in an inscription, or that his coat of arms be placed on it so that the friars could not sell it off.[15] Pious gifts might be important to the giver, but often the churches that received them needed money for more pressing concerns. For example, in 1344 an abbess of Montauban in south-western France pawned two chalices as payment for flour, syrup, unguents and medicines.[16] Marking gifts with names or heraldry also helped to guard against theft – a common problem in church treasuries as Odelricus' account makes clear. For example, in November 1500 a young man was arrested in a goldsmiths' shop in Châlons in possession of goods stolen from a local church.[17] This explains the frequent prohibition in guild statutes against buying ecclesiastical metalwork second-hand without proper documentation – a misdemeanor that warranted hefty fines.[18]

Occasionally, personal identifiers were placed within a church without the need for a gift, although in these cases the people named were almost certainly benefactors of the institution in other ways. In 1976, it was discovered that the high altar of the church of Sts Peter and Paul at Reichenau-Niederzell was inscribed with 341 names of local abbots, monks and lay people, added between the ninth and eleventh centuries. One group of male and female names is placed around that of 'Cotzo the priest', with a note that the others were 'all of his family'.[19] It seems likely that these names were added to the altar table as part of a long-standing ritual in the church, ensuring the commemoration of these people after their deaths.

More rewarding for the richest donors than the giving of individual gifts was the foundation of a new church or monastery, which could be counted on to remember its donor in prayers for centuries to come. In around 950, for example, the Count Almeric and his wife Countess Franca of Arezzo set up the monastery of Sta Maria de Vangardicia specifically in order to benefit their souls.[20] While the local aristocracy founded religious institutions throughout the Carolingian and Ottonian periods, after the thirteenth century this practice was increasingly the preserve of only the wealthiest patrons. One such patron was William of Wykeham, Bishop of Winchester and Chancellor to Richard II. In 1382, he founded both New College, Oxford and the school of St Mary's College near Winchester.

148. **The Marnhull Orphrey.**
Linen, embroidered with silver, silver-gilt and silk thread, 110 × 45 cm. England, 1315–35. V&A: T.31–1936

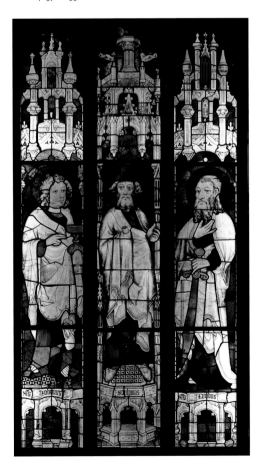

149. **Thomas the Glazier,
*Saint John the Evangelist, the
Prophet Ezekiel and Saint James
the Less*, from Winchester
College.**
Clear, coloured and flashed glass,
with paint and silver stain,
360.7 × 166.9 cm. England, *c.*1393.
V&A: 4237–1855

Their purpose was to educate future clergymen. Wykeham lavished money on the chapel of St Mary's and was particularly proud of its stained glass (pl.149), forbidding dancing, wrestling and other disorderly games in the chapel to preserve this 'sumptuous work'.[21] Both colleges were required to pray not only for his soul, but also for those of his patrons, family and friends.[22]

Although the founding of new churches had become increasingly unaffordable for local elites, the thirteenth century brought opportunities for families to gain control of their own spaces inside existing churches. They were spurred by the desire to bury the dead in family mausolea near altars and by the new emphasis on the prayers of the living to shorten the time that the dead spent in purgatory, where peoples' souls worked off the debts of sin built up during their lifetimes before they could enter heaven.[23] Endowments of this sort ranged from paying for a priest to say Mass at an existing altar to commissioning elaborate newly built spaces, separated from the main church by gates and other closures such as low walls.[24]

We can gain a remarkably clear insight into how these chapels were furnished and used from their foundation documents, which are almost identical from country to country across Europe. Wills and testaments specified their form and furnishings. For example, in December 1385 Giovanni Rufini of Perugia founded a chapel in the local Franciscan church. His will specified that he was to be buried in a newly constructed chapel with an altar; he provided for furnishings such as a cope, textiles and other necessaries, which were to be paid for from the proceeds of the sale of all his own clothes and textiles. The Franciscans were to say masses there for his soul in perpetuity.[25] The following year, a very similar chapel was set up in the church of St Leonard in Prague by a woman called Margaretha, whose husband Enderlin of Budweis had recently died. She must have been a woman of means because she endowed the chapel with a number of precious goods, including a crystal monstrance, a large silver-gilt chalice and three sets of vestments for the different times of the liturgical year. She also employed a priest, Nicholas of Bruna, to say masses at the altar.[26] The vestments commissioned by Margaretha probably resembled the Bohemian chasuble reproduced here (pl.150), with its shockingly expressive image of Christ on the cross, flanked by angels catching his blood in chalices.

As we can see, in addition to building expenses and the payment of a priest, founding a chapel involved providing all the necessary furnishings and embellishments. This gave plenty of opportunity for commemorating a family as well as for magnificent display. The Erpingham Chasuble, a beautifully embroidered silk vestment dating to the early fifteenth century (pl.151), was almost certainly used in a private chapel controlled by Sir Thomas Erpingham of Norfolk, a veteran of the battle of Agincourt.[27] Erpingham's coat of arms is prominent on the back of the chasuble. As on the Bohemian vestment mentioned above, the main image shows angels catching the blood from Christ's wounds in chalices. This iconography was particularly suitable for reminding viewers of the significance of the Mass, when the wine in the chalice was miraculously transformed into Christ's blood. The rich fabric and imagery is a perfect combination of devotion and display – a tension that was just as apparent to some medieval and renaissance viewers as it is to modern ones.

Indeed, the tendency for important churches to fill gradually with new chapels, decoration,

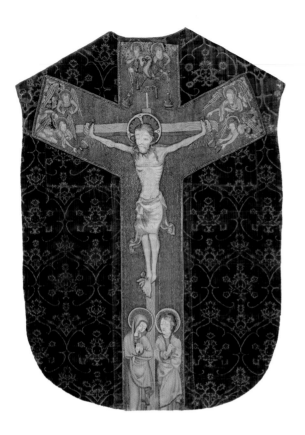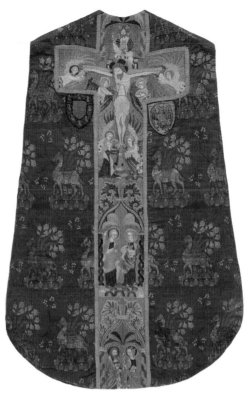

150. **Embroidered chasuble.**
Silks and precious metals on a velvet ground, 95 × 72 cm. Embroidery, Bohemia, c.1375; velvet, c.1470. V&A: 1375–1864

151. **The Erpingham Chasuble.**
Brocaded silk lampas, with embroidery in silk and silver-gilt thread, 148.5 × 76.8 cm. Silk, Italy; embroidery, English, 1400–30. V&A: T.256–1967

paintings, metalwork and vestments was a particular source of concern to those who sought a simpler and more humble religious life. During the thirteenth century, successive resolutions by the General Chapter of the Dominican Order sought (unsuccessfully, for the most part) to restrict the acquisition of rich furnishings, paintings and sculpture.[28] In the sixteenth century, Calvinist reformers found it easy to dismiss the finery of ecclesiastical vestments as mere superstition. Robert Crowley, an English author, had this to say in 1566:

> … no massing priest will take upon him to say Mass, if he lack any one thing that by the order of his Mass is appointed to be had, his alb, his stole, his flannel, his amice, his chasuble, his cup, his corporal cloth, his altar or super-altar. And if any of these things be lacking or not hallowed by the bishop or suffragan, then can he say no Mass, yea if his cup or corporal cloth have been touched by any secular person, it will not serve his turn till it be new hallowed. Thus joineth the massing priest with the Idolaters, and is himself the greatest Idolater of all.[29]

The areas near altars were especially desirable spots in which to be buried, and one of the most striking manifestations of lay peoples' influence within the Church was the construction of tomb monuments, which were often combined with a chantry or family chapel (chantry chapels were endowed with funds to pay a priest to say masses for the founder's soul). Tombs were one of the most potent sites for the mingling of piety with secular ambition. An English tomb effigy from Lesnes Abbey in Kent dating to the mid-fourteenth century depicts a fully armoured knight, wearing sword and shield, although with his hands clasped in prayer (pl.152). The makers of the tomb lavished much attention on the figure, whose chain mail was originally modelled in gesso (a

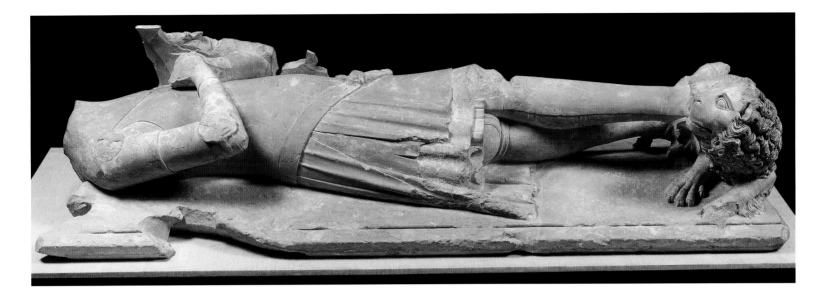

152. **Effigy of a knight of the de Lucy family.**
Totternhoe limestone with gesso and polychromy, 175.7 cm long.
England, 1340s. V&A: A.10–1912

kind of plaster) and which was fully painted. The monument would probably have been completed by a tomb chest below, decorated with arcading and further figures, and an elaborate architectural canopy. Its costliness would have been obvious to any medieval viewer, as other tombs in the abbey, such as that of Abbot Elyas of around thirty years earlier, were much simpler in appearance.[30]

Some tombs dispensed with the effigy altogether but were still sites for displays of achievement. The unusual circular slab which acted as the entrance to the under-floor tomb of Antonio Maggi da Bassano of Padua and his wife Caterina was set up during their lifetimes in the church of S. Pietro in Padua (about 1520; pl.153). Here, too, the imagery commemorates Antonio's social roles. He was a lawyer and the two books inscribed 'DECRET' and 'DIGEST' seen on the slab refer to the two most common books used in canon and civil law. A more pious ingredient is supplied by the hourglass and the candle-snuffer, both of which act as *memento mori* (reminders of death), a common way of suggesting the vanity of worldly ambition, as all were equal in death.[31]

All might have been equal before God, but they were certainly not equal in the grandeur of the monument to which they could aspire. People of the more middling sort of necessity settled for a humbler memorial, such as the smaller than life-size tomb brasses produced in England, which survive in large numbers from the fifteenth and sixteenth centuries.

CIVIC RELIGION

We have seen how private individuals were able to gain a measure of control over the sacred spaces within a church, and how by including markers of personal identification, such as heraldry, their pious gifts were made obvious to all. But there was another key way in which lay people experienced religion, and that was as part of a community.

Parish churches were at the heart of most people's daily experience of religion. Their furnishing and upkeep were the joint responsibility of the Church and the local community. As such, parish churches reflected both local pride and local interests. A series of misericords (choir seats for resting against whilst standing) and pews produced for St Nicholas's Chapel in King's Lynn show the tools of local craftsmen, as well as the trading ships and salt cod that were at the heart of the town's economic life (pl.154).[32]

153. **Tomb stone of Antonio and Catharina Maggi da Bassano.**
Istrian stone, 218.4 cm diameter.
Padua, 1520. V&A: 71–1882

As churches, particularly cathedral churches, were potent sites for the expression of civic identity, their building and furnishing often passed over time under the control of the secular authorities. For example, the rebuilding of Siena Cathedral in the late thirteenth and fourteenth centuries was a matter of civic pride, as more and more grandiose schemes were considered, so that the building should be larger and more ostentatious than those of neighbouring towns.[33] Government officials in many European towns took part in key religious ceremonies, such as the feasts of Easter and the Assumption of the Virgin, and those of locally revered saints. In Pistoia, the town officials bore wax candles at such festivals. They received these free from the Opera, the organization that looked after the altar of Saint James. Lower-ranking officials had to pay for their own.[34] The gift of wax candles was often granted to churches by town authorities during feasts: in 1314 the authorities of Orvieto in Umbria established that each church of the town would receive a gift of wax on the feast day of its patron.[35]

Politics inevitably played a part in such communal religious experiences. In Bruges, for example, the Chapel of the Holy Blood housed the town's most important relic, a vial of Christ's blood supposedly acquired in the twelfth century by Thierry of Alsace, Count of Flanders, from the Patriarch of Jerusalem.[36] Towards the end of the fifteenth century, the upper church of the chapel was rebuilt, and the windows were filled with a series of stained-glass figures commemorating the rulers of the Duchy of Burgundy, of which Bruges was at that time the capital city. The glass depicts the family of the Holy Roman Emperor Maximilian I, who had inherited the Burgundian lands through his wife Mary (pl.12; see also pl.2, p.17). The aim of the stained glass, it would seem, was to emphasize Maximilian's legitimacy as the ruler of the Burgundian territories, and to link him personally to the Holy Blood relic. Holy Blood relics were especially popular with rulers – Henry III of England had obtained one from the Byzantine emperor Heraclius, and deposited it at Westminster Abbey.[37] It is hardly surprising, then, that it is often assumed that the glass was installed as part of Maximilian's attempts to consolidate his territories – that it is, in fact, an extremely personal marker of power, emphasizing his control of the relic.

However, this explanation fails to take into account the way in which the chapel was administered. The town of Bruges had a very volatile relationship with its Burgundian rulers, and fiercely guarded its independent privileges. Notwithstanding attempts by dukes to gain a measure of control over the Holy Blood relic, the administration of the chapel was firmly in the hands of the Holy Blood Confraternity, a group composed of the leading burghers of Bruges. They had charge of the chapel, its furnishings, and the yearly procession of the relic through the streets.[38] It was they who, in the 1490s, paid for the making and installation of the stained glass. The choice of images may have been the confraternity's; or it may have been suggested by Maximilian, who is known to have encouraged other towns to commission stained glass in his honour by granting tax breaks.[39] Nevertheless, since it was commissioned and paid for by the confraternity, the glass reflects not so much Maximilian's private ambitions as a political statement on the part of the burghers of Bruges, a public gesture of the town's loyalty at a time when it was as likely to oppose the emperor's wishes as obey them (see also pp.222–3).[40]

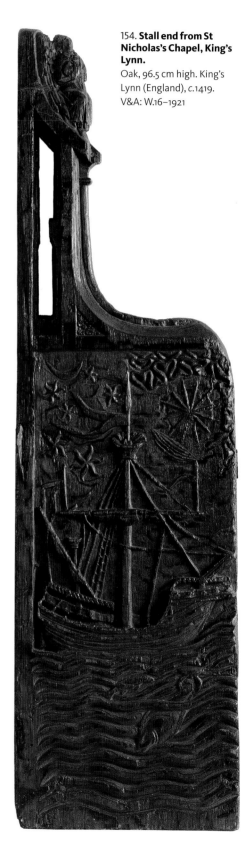

154. **Stall end from St Nicholas's Chapel, King's Lynn.**
Oak, 96.5 cm high. King's Lynn (England), *c.*1419.
V&A: W.16–1921

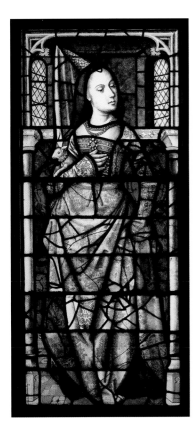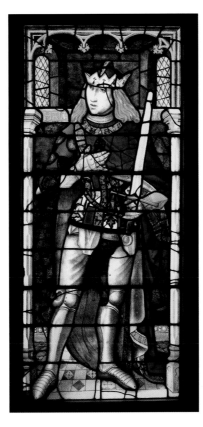

155. *Mary of Burgundy,
Maximilian I, Joanna of Castile*
and *Philip the Fair*,
**from the Chapel of the
Holy Blood, Bruges.**
Clear and coloured glass with
paint and silver stain, 190 cm high.
Bruges, c.1496.
V&A: 438 to 442–1918

The yearly procession of the Holy Blood relic itself was certainly used to demonstrate Bruges's political unity, as well as to emphasize its hierarchy. Each year, the relic was displayed in a public square before being taken on a procession around the town, each guild and social group falling into the procession in a pre-arranged order. Such rituals were not simply about religious devotion. They deliberately expressed the identities and social roles of the town's inhabitants.[41]

SAINTS AND SHRINES

Throughout our period, lay enthusiasm for religion was most readily stimulated through the cult of saints.[42] A saint's remains, or objects which had a close physical association with a holy figure, were known as relics (see also pp.226–7). Initially, cults focused on the physical remains of the saints themselves, which were sometimes instrumental in the spread of Christianity.[43] For example, the discovery in 415 of the body of the martyr Saint Stephen, who preached against those Jews who had not accepted Christ, seems to have happened at a convenient moment for the beleaguered Christian leaders of Jerusalem. Gamaliel II, Patriarch of Jerusalem (at that time the highest spiritual authority for the Jews of Palestine and beyond), had recently been deposed by the authorities because of the numbers of Christians and gentiles converting to Judaism. The discovery of Stephen's body helped to shore up belief in the Christian religion in Jerusalem and the subsequent arrival of the relics on Minorca was thought by contemporaries to be the main cause of the conversion of the Jews there to Christianity.[44] The presence of a saintly body could therefore have a very direct effect on the religious climate.

Charlemagne's attempts in the ninth century to strengthen and reorganize the Church within his empire also involved the promotion of relics, in secular as well as in ecclesiastical life. For example, Carolingian law encouraged the swearing of oaths on relics.[45] The binding nature of such swearing was

VBI HAROLD:SACRAMENTVM:FECIT: HIC HAROLD:DVX:
VVILLELMO DVCI:

still recognized in the fifteenth century, when Thomas, Duke of Exeter made a grant of land 'at Saint Paul's of London, upon the altar attached to and contiguous with the shrine of Saint Erkenwald'.[46] The most famous pictorial representation of the swearing of an oath on relics occurs in the Bayeux Tapestry, where Harold pledges allegiance to his rival William of Normandy (pl.156). Norman commentators argued that he subsequently broke this oath, justifying William's invasion of England.[47]

Relics were brought north to France, England and Germany from the Mediterranean by professional relic traders, such as Deusdona, who in the ninth century agreed to source relics in Rome on behalf of Einhard, Charlemagne's biographer.[48] The international movement of relics also ensured the transport of objects associated with them, notably precious textiles, as was the case with the seventh- or eighth-century Iranian silk depicting a *senmurv* discussed in Chapter Five. This silk seems to have been used for wrapping relics of Saint Helena in the church of St-Leu, Paris.[49] The textile probably came to Western Europe from Constantinople along with the relic it enclosed.

The presence of an important relic or relics in a church could be crucial for raising revenue. The material benefits are made clear by the fourteenth-century Milanese Galvano Fiamma, who described the birth of the cult of Saint Peter Martyr:

> Here, in time, with the growth of miracles, were made votive prayers around the body of the blessed Peter Martyr; more images were brought there than one could believe. Charitable gifts were brought from different parts of the world, and by [Dominican] brothers from different provinces. And then the brothers began to renovate the whole convent with building work… then indeed frontals were made for the altars, and then frontals and textiles of silk and samite for ministering the altars.[50]

156. *Harold Swears Allegiance to Duke William of Normandy*, **from the Bayeux Tapestry (detail).**
Embroidered linen. France or England, *c.*1070–80.

Ecclesiastical institutions were often keen to do all that they could to sponsor such cults and during the twelfth and thirteenth centuries there was an increased willingness to canonize recently deceased holy men and women.[51] The first stage that a nascent cult went through was local promotion and veneration, prior to any application for official saintly status. At this point, the holy person was sometimes known as a *beato*. These cults were sometimes granted official recognition, and sometimes not. A typical local cult of this type was that of the Beata Verdiana Attavanti, a thirteenth-century lay woman of Castelfiorentino in Tuscany who chose to live as a recluse in a sealed cell. This kind of devotion, although extreme, was not unusual for a lay person, especially for an unmarried or widowed woman. From the earliest Christian times many lay people, especially in old age, took vows to become 'penitents', adopting some aspects of the lifestyle of a monk or nun. This could involve wearing penitential clothing, renouncing any public office, sobriety in eating and drinking and some degree of celibacy between husband and wife.[52] Such penitents would have been a common enough sight in towns and acted as a spur to the piety of others.[53] More extreme practitioners of this type of lifestyle confined themselves in small rooms or cells. The early fifteenth-century anchoress Julian of Norwich shut herself up in a cell in the church of Sts Julian and Edward, where she was an inspiration to others, notably Margery Kempe, a devout woman from nearby King's Lynn whose views we know about through a book describing her life prepared by an unknown priest, or perhaps by Margery herself.[54]

Although Verdiana was not a saint, she was nevertheless venerated locally for some time. Physical evidence for this veneration survives in the form of a remarkable fifteenth-century embroidery (pl.157). This is a luxurious object, being well made and featuring a high proportion of silk and gold thread worked in various techniques. It depicts the end of Verdiana's life, at the moment when the clergy and people, having heard the miraculous pealing of bells, break into her cell to find her kneeling dead, while her soul is taken upwards by angels. The two snakes whose company she had adopted in order to mortify her body with their bites lie entwined in front of her. The embroidery was probably part of an altar frontal from a community of Vallombrosan nuns. Verdiana's prayers before an image would have prompted the same response from the viewer of the embroidery.[55]

The primary focus for a saint's cult was a tomb, which could act as a site for pilgrimage and for the healing powers of the saint to manifest themselves. Visibility and accessibility were two of the key requirements that had to be taken into account by those planning the shrine site, as is made clear in a letter of 1267 from Pope Clement IV concerning the shrine of Saint Dominic in Bologna. Clement suggests '…that the precious body of the Confessor himself should be translated to a higher and more dignified place within the church… his tomb placed in a prominent position where it will be more easily and freely gazed at'.[56] The raising up of tomb chests was a common strategy for the presentation of saints' remains and was practised in shrines all over Europe. These shrines could be free-standing monuments, or attached to walls.

When the Poor Clares of Florence – the female branch of the Franciscan Order – were attempting to promote the cult of the Beata Chiara Ubaldini in the early fourteenth century, they

157. *The Death of Verdiana Attavanti.*
Cotton embroidered with silk and metal thread, 31 cm high. Tuscany (Italy), 1425–50. V&A: 4216–1857

placed her body in a sculpted marble tomb, only a part of which now survives (pl.158).[57] After some time, the appearance of the monument was no longer considered appropriate, and during the fifteenth century it was moved, as Saint Dominic's tomb had been, to a 'higher and more honourable place'.[58] The creation of a stone monument such as this for a holy woman who had not yet been made into a saint was a significant moment in the attempt by the Poor Clares to promote her cult. The intended audience for the cult was originally represented on the monument in the form of men and women clothed as penitents.[59]

Often, the reliquary shrine was smaller than a tomb. One typical form is the casket. Large examples were often placed high up in the church, sometimes on top of specially built stone bases. A large wooden casket of this sort survives in the V&A (pl.159A, B).[60] It is from Constance, a significant stop on the European pilgrimage route from Northern Europe to Rome and the Holy Land. The English pilgrim Margery Kempe passed through on her way to Jerusalem in the early fifteenth century.[61]

Containers for the relics of saints could also be much smaller and more portable, and took a plurality of forms. The containers themselves both protected the relics and projected their powers, as explained in a twelfth-century treatise by Thiofried von Echternach. According to him, the power

158. Tomb slab of the Beata Chiara Ubaldini.
Marble, 85.2 cm high. Florence, c.1325. V&A: 46–1882

of the relic could be channelled directly through the container, or reliquary '…if, most reverently, the container of gold or silver leaf, or any of its precious gems, or whatever textile or little ornaments or cast-work or marble or wooden material [it is made of] is touched on the exterior by the hand of the faithful'.[62] Devotees were instructed to kiss a fifteenth-century reliquary of Saint Catherine in Reggio (pl.160) in order to obtain an indulgence of forty days' less time in purgatory. Some of the most striking reliquaries took the form of parts of the body, such as a fifteenth-century hand reliquary with mica windows in the fingers for viewing the relics within. Similar reliquaries were

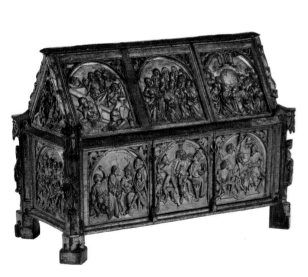

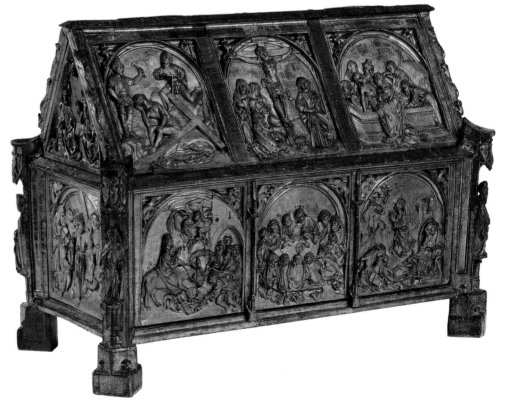

159A, B. Reliquary chest with scenes from the Passion of Christ (front and back).
Limewood, gilded, 61 cm high. Constance (Germany), c.1490–1500. V&A: 357–1854

sometimes used to perform blessings.[63] Relics were not just encountered within the church but could also be seen in public places where they were processed and displayed during festivities. Thirteenth-century records reveal that between Pentecost and the Feast of the Assumption of the Virgin, the monks of St-Vaast in Arras were in the habit of building a temporary altar in the market square and displaying a relic of the Virgin on it 'in order to obtain the charity of the faithful'.[64]

The smallest relics could be worn about the person. For most of our period, this was unusual, and was generally the preserve of the extremely wealthy. For example, a gold and sapphire rosary with a relic holder at its terminal was owned by Clémence of Anjou, wife of King Louis X of France, in 1316.[65] Pectoral crosses worn around the neck were likely to contain relics, and were owned by both ecclesiastics and lay people. The tenth-century king of Italy, Berengar I, owned a cross 'which he was accustomed to wear on his chest'.[66] A particularly grand example of this sort of relic container is the Beresford-Hope Cross, which is named after its nineteenth-century owner (pl.161A, B). This elaborate object almost certainly originally held a relic of the True Cross. While the front face represents Christ, the rear shows the Virgin Mary in prayer, surrounded by busts of Saints John, Peter, Andrew and Paul.[67] It was through prayer to such patrons that salvation might be achieved.

There were, of course, always those who were sceptical about the cult of relics. In the sixteenth century, the Dutch humanist Erasmus described a pilgrimage he had made to the shrine of Saint Thomas Becket at Canterbury, casting his friend John Colet, Dean of St Paul's, in the role of the sceptic. When the shrine's guide gives them the special opportunity to kiss relics, Colet gags on an arm that still preserves blood-stains and decaying flesh. On being shown the relic of Becket's skull, Colet awkwardly asks if the saint would not be more pleased if all his treasures were given to the poor.[68] For some commentators, especially the better-educated, personal virtues such as charity were of much more use than the veneration of relics.

PERSONAL DEVOTIONS AND RELIGION IN THE HOME

As with the personal reliquaries described above, religious images and objects were a significant part of the daily lives of many lay people in the later Middle Ages and Renaissance, and were not simply encountered in the church. They could be worn or carried about the person, and also formed an essential part of the furnishings of the home.

The interior religious experience of the laity often manifested itself in devotions that took place outside the rituals of the church, though prior to the thirteenth and fourteenth centuries these practices are often hard to reconstruct. Christians in the Byzantine Empire favoured wearing a sacred image at their breasts, called an *enkolpion*. A carved jasper representing the Crucifixion was probably used in this way (see p.27). It was produced only about fifty years after the end of the second Iconoclastic period (814–42), during which all religious images had been outlawed. Materials that by their nature yielded small artworks must have encouraged the proliferation of portable religious

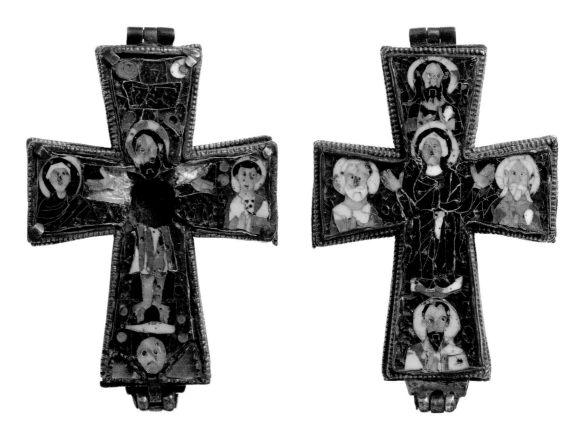

160. **Raffaello Grimaldi, reliquary of Saint Catherine of Alexandria.**
Copper, partly gilded, 63 cm high.
Reggio, 1482–96. V&A: 704–1884

161A, B. **The Beresford-Hope Cross (front and back).**
Gold, enamel and silver-gilt, 8.7 cm high. Italy, 9th century.
V&A: 265–1886

images. For example, the thirteenth-century Polish saint Jadwiga (Hedwig) was buried with an ivory figure of the Virgin Mary, which she had always carried with her,[69] while the fourteenth-century Bavarian mystic Margareta Ebner owned a Christ Child doll and a manger that she used in her meditations.[70]

Books were one of the earliest types of personal devotional aid to achieve popularity. This process began in the thirteenth century with the production of psalters (books of psalms) for lay patrons. Such books were available only to those among the laity who could afford them, and who could read – not a large number any time before the fifteenth century. Gradually, a new type of devotional book evolved – the Book of Hours – which laid out prayers for different times of the day and different parts of the liturgical calendar. It has been pointed out that following the invention of printing, far more Books of Hours were made and sold than could possibly have been read, given the limited spread of literacy in Europe.[71] It is likely that those who were literate would have read them aloud to others, and they were in any case virtuous objects in their own right, to be treated with respect for the sake of their contents. After the thirteenth century, published works also sought to instruct lay people in the basic tenets of Christianity. The late fifteenth-century author Dietrich Colde, a friar of Cologne, produced the hugely popular text *The Mirror for Christians*, containing 'all that should be known for the soul's beatitude'.[72] The key elements of such texts were an explanation of the Creed (a statement of belief which was expected to be known by heart); the Ten Commandments; the basic prayers of the Pater Noster (Our Father) and Ave Maria (Hail Mary); the cardinal sins and the cardinal virtues; devotional exercises; and explanations of church ceremonies such as the Mass.

Rosaries were an especially popular devotional aid. These strings of prayer beads were produced in a huge variety of price ranges.[73] The most expensive examples provided the owner with copious

imagery to contemplate whilst praying. The Langdale Rosary, made around 1500, is the most elaborate English example to survive (pl.162). Each of its beads represents two saints or scenes. Made of gold, it would have been commissioned by a rich patron. The object continued to be treasured and used into the sixteenth century and after the Reformation, when the use of rosaries was outlawed. In the later sixteenth century, it was most likely owned by William Howard, a prominent recusant Catholic.[74] It was altered in the early years of the seventeenth century with the addition of further beads. During the years when English Catholicism went underground, this precious object would have given its owner a strong sense of Catholic tradition and identity.

Another popular prayer aid was the 'decade ring' (pl.163). These rings have ten or more projections, with a larger one forming the bezel. In effect, they are miniature rosaries, an 'Ave' being said at each smaller point, and a 'Pater Noster' at the bezel.[75] The illustrated example has the figures of Saints Christopher and Barbara engraved on the bezel and the words 'to my life' inscribed on the inside in French. This motto recalls the wording of love poetry sometimes found on other objects, and suggests that the ring was also intended as a courtship gift.[76]

After the thirteenth century, the Church placed an increasing emphasis on the need to visualize the lives and suffering of Christ and the saints. Typical of such highly charged devotions – and their often virulently anti-semitic nature – is this meditation on Christ's crucifixion by Margery Kempe: '… she saw the Jews with great violence rend from our Lord's precious body a cloth of silk, which had cleaved and hardened with his precious blood… that it drew away all the hide and all the skin

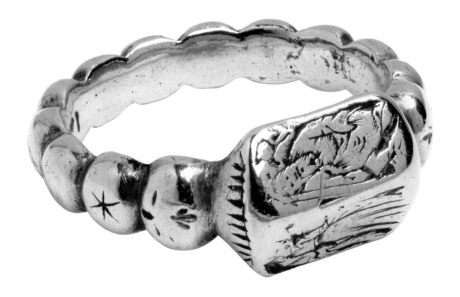

162. The Langdale Rosary.
Gold and niello, 40.5 cm long.
England, c.1500; altered c.1600.
V&A: M.30–1934

163. Decade ring.
Gold, 1.9 cm diameter. England,
15th century. V&A: 690–1871

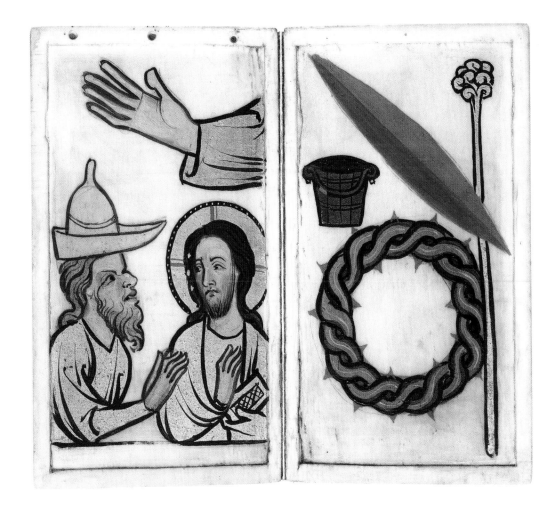

164. Devotional booklet.
Ivory, with pigment and gilding,
10.5 cm high. Germany (possibly
Lower Rhine), *c*.1330–50.
V&A: 11–1872

**165. *The Virgin with
the Infant Christ.***
Woodcut, hand-coloured,
65 cm high. Italy, 1450–75.
V&A: 321A–1894

from his blessed body and renewed his precious wounds and made the blood to run down all about on every side…'[77] A small ivory booklet, made in the Lower Rhineland in about 1340, perfectly exemplifies a similar technique of emotionally provocative visualization (pl.164). One opening represents the various sufferings of Christ in a series of 'code' images – the hand that struck him, the wound in his side, the crown of thorns. The figure spitting at Christ wears an elaborate hat of the type that was prescribed dress for Jews in fourteenth-century Germany.[78] Devotional images like this were increasingly produced in order to stimulate pious contemplation. Specific image types were deemed especially suitable for provoking an imaginative and emotional response.

Some images carried indulgences – time off from purgatory (see p.42). One of the most important of these was the Veronica, the image of Christ's face that had been miraculously imprinted on a cloth before the Crucifixion. This relic was housed in Rome, but copies were available all over Europe. The Veronica was an especially popular souvenir with those who had made the pilgrimage to Rome – copies were being hawked by German salesmen outside the doors to St Peter's in the late fifteenth century.[79]

The Virgin and Child was another extremely common devotional image, which became more widely available following the introduction of printing in the fifteenth century. A remarkable survival of a large devotional print, albeit in very poor condition, shows the Virgin and Child against a starry background (pl.165). Evidence suggests that such prints were often pinned up or displayed permanently

within the home.[80] In the years around 1500, the Nuremberg sculptor Veit Stoss carved a small boxwood figure of the Virgin and Child, possibly for a Polish client (pl.166). The statuette takes a similar theme to that of the woodcut. Both evoke the Virgin Mary of Saint John's Apocalypse, the 'woman clothed with the sun, and the moon under her feet, and on her head a crown of twelve stars' (Revelation 12:1). The images show Mary as the Queen of Heaven and remind the viewer of the Last Judgement soon to come. The sculpture seems to have been aimed at a new market of collector-connoisseurs, rather than for use in devotion. At the same time, however, it was an eminently suitable object in front of which to pray, should the owner wish to do so.[81]

Italian household inventories of the fifteenth and sixteenth centuries make it clear that images of the Virgin and Child in relief were an important part of the furnishings of the well-to-do home, especially in the bedroom, or *camera*.[82] Many of the surviving examples duplicate only a few compositions, reflecting the fact that such works were probably produced 'on spec' rather than as one-off commissions. One of the most popular compositions is attributed to Lorenzo Ghiberti's workshop (pl.167).[83] The flat base (or console) of the illustrated example would have lent itself to display on a high shelf, while the now-blank shields would once have been personalized with the owners' arms.

CHARITY AND ACTIVE PIETY

In addition to regular devotions, one of the most active ways in which Christians might ensure their salvation was through practising the virtue of charity. As Christ himself had said: 'thou shalt love thy neighbour as thyself' (Matthew 22:39). A fifteenth-century English stained-glass roundel depicts just such a charitable act (pl.168).[84] A well-dressed layman dispenses food and drink to the poor, the lame (who walk on all fours with stands for their hands) and an itinerant friar begging for alms (identifiable by his tonsure and characteristic begging bag).[85]

In addition to individual charitable acts, lay people often formed themselves into confraternities in order to do good works on a larger scale. The roots of Europe's confraternities stretch back a long way. Lay confraternities certainly existed in Charlemagne's time: a document of 779 speaks of '*gildoniae*' for charitable purposes.[86] Later confraternities usually fulfilled three main functions: they worshipped together, either singing lauds or performing flagellations; they performed charitable deeds; and they acted as a kind of 'funeral club', providing the materials needed for the burial procession. Members of the thirteenth-century confraternity of the Madonna in Limoges were expected to perform a number of tasks when one of their number died. They attended a mass for the dead man, and another on the seventh day after. They dressed the body, and kept two lights burning until the burial. In the meantime, they were not allowed to work. If a member was unable to make it to the vigil he could pay a cleric to go, but he had to make an

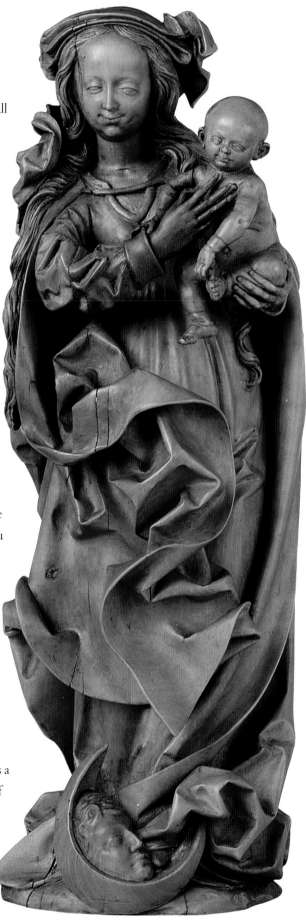

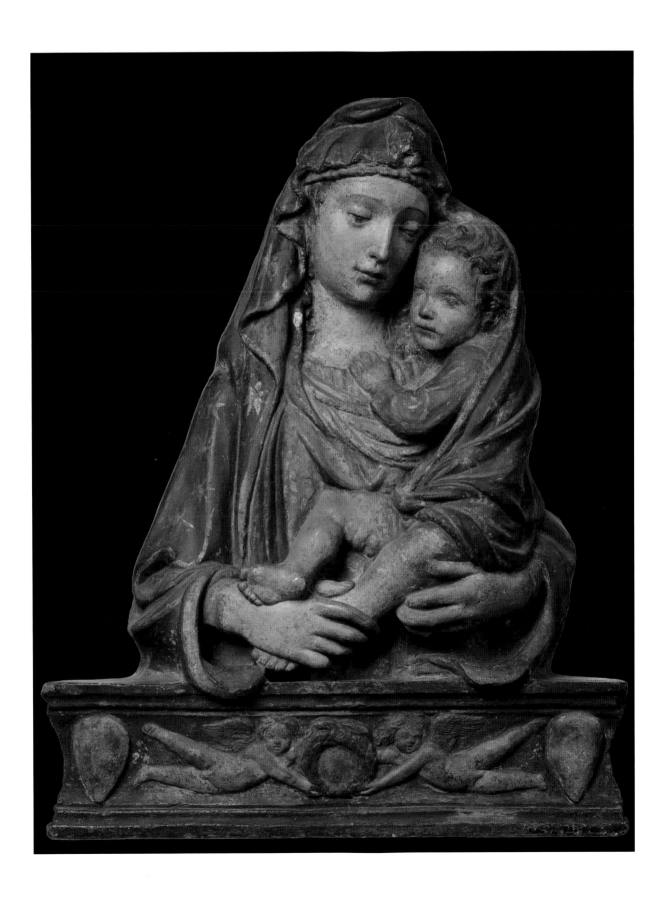

166. **Veit Stoss,**
The Virgin and Child.
Boxwood, glazed with traces
of gilding, 20.3 cm high.
Possibly Krakow, *c.*1495.
V&A: 646–1893

167. **Workshop of Lorenzo
Ghiberti,** *Virgin and Child.*
Pigmented stucco,
88.5 × 74.5 × 23 cm. Florence,
*c.*1425–50. V&A: A.33–1910.
Given by Mr J.H. Fitzhenry

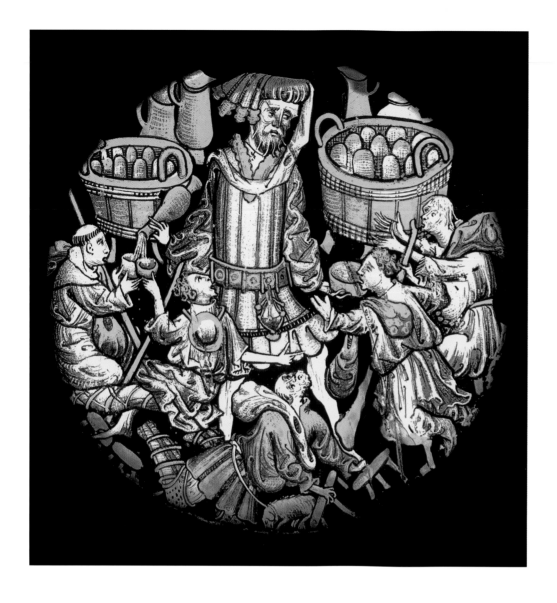

168. *Giving Drink to the Thirsty.*
Glass with grisaille painting and silver stain, 16.8 cm diameter. England (probably Coventry), c.1430–40. V&A: C.56–1953

169. *Christ showing His Wound.*
Terracotta, 104.1 cm high. Florence, 1420–4. V&A: A.43–1937

appearance at the burial, and at absolution afterwards, and also make a charitable payment.[87] Confraternities owned a number of characteristic art objects. Amongst the most important was their processional banner, the most visual marker of the fraternity's identity (see p.225).

The poor relief and care of the sick which confraternities provided as part of their charitable activities could be on a very large scale indeed. In Venice, the five *scuole grande* or flagellant confraternities were wealthy organizations, the largest valued in 1497 at four thousand ducats. Each had a small hospital to care for sick members. Venice also possessed a hospital for the injured, two plague hospitals and a foundling hospital.[88] In medieval and renaissance hospitals – confraternal, civic or privately endowed – religion was never far away. The Hôtel-Dieu in Beaune was a hospital set up by Nicolas Rolin, Chancellor to the Duke of Burgundy, in 1443. Inside, the chapel opens up directly from the hospital beds of the great hall, enabling patients to hear the services without stirring. Many other hospitals possessed impressive chapels, which could be endowed with grand furnishings and gifts. Religious images in such institutions often had a slightly medical bent: the lunette of a doorway at the Florentine hospital of Sta Maria Nuova was embellished with a fifteenth-century figure of Christ displaying the wound in his side (pl.169).

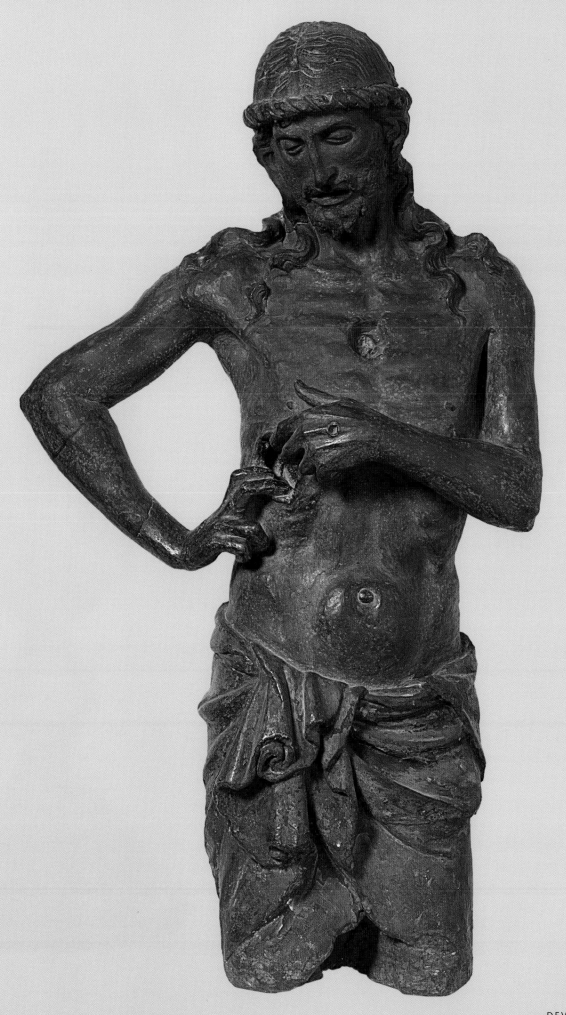

Craft guilds bore many similarities to confraternities. They too had strict rules about the attendance of members at funerals. For example, the goldsmiths' guild rules of Siena required that, when any head of a workshop died, all members above eighteen years of age attend the burial in company with the head of the guild, and walk with him back to his workshop afterwards.[89] Guilds also regularly made gifts to churches. A number of guild-funded stained-glass windows survive across Europe, notably the famous examples at Chartres. In 1254, the locksmiths and vinedressers of Le Mans made a similar gift: 'they made a window having five lancets in which they themselves are depicted in their trades. Nor did we think we should withhold praise of them, simply because they made a window in which they depicted themselves in their trades, for, after all, they did make a splendid window.'[90]

In addition to the fabric of the church, guilds also paid for impressive furnishings. A large copper-gilt reliquary of Saint Homobonus of Cremona was given by the shoemakers' guild of Reggio to a church in the city, probably S. Prospero (pl.170). Homobonus, the son of a well-to-do tailor, was the patron of clothworkers and business people, and it is likely that he was also the patron saint of the local shoemakers.[91] Bells originally hung from beneath the main tabernacle (the receptacle for the relic), which would have sounded as the reliquary was carried within the church or through the streets in procession.

As mentioned above (p.201), processions were one of the most dramatic ways in which religion made itself manifest in the streets of a town (see also pp.224–5). Processions of one sort or another took place regularly: on feast days, to take the sacrament to the dying, or as part of a funeral. Many processions formed an integral part of the ecclesiastical calendar. The stational liturgy of Rome (the practice of processing from church to church or from palace to church), which developed as early as the fifth century, was hugely influential in Europe, and was imitated on a smaller scale at many cathedrals and monasteries.[92] For the lay inhabitant of a town, however, funerals were probably the most commonly encountered procession. For the wealthiest citizens, these could be impressive affairs – such as the procession envisaged in the will of Edmund Shaa, a former mayor of London, who died in 1488. He specified a cortège burning twenty-nine torches to convey his body from his house to his parish church, before going on to the burial site of St Thomas of Acre, the Mercers' church of London. Shaa, anxious not to commit the sin of pride, was at pains to point out that this grandeur was due to his status as mayor, and would be to the honour of London, 'without pompe of the woorlde'.[93] The practice of employing the poor as torch-bearers at funerals was later to be satirized by Sir Thomas More.[94] In addition to flaming torches, and the official clothing of ecclesiastics, guild and confraternity members, funeral processions also featured grand items such as embroidered palls. Objects like this were sometimes borrowed for the occasion, such as the two cloths of diapered gold hired out in 1345 by the Bonis brothers of Montauban in France for the funeral of a local landowner.[95]

Religious feasts provided the opportunity for processions involving even more specialized paraphernalia. A notable example is the *Palmesel*, a large wooden image of Christ riding a

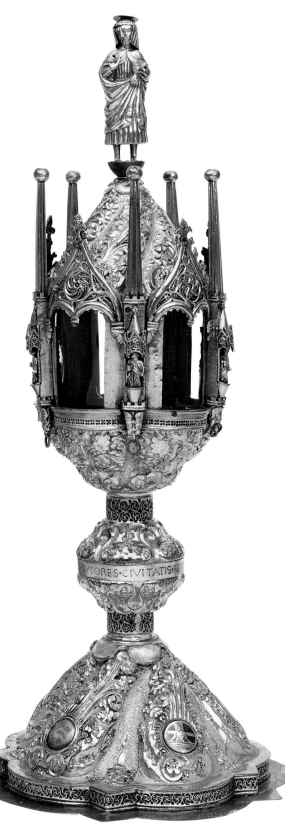

170. **Reliquary of Saint Homobonus.**
Copper gilt with nielloed silver,
53.4 cm high. Reggio, c.1480–1500.
V&A: M.514–1956

171. **Pendant with the letters IHS.**
Gold, enamel and diamonds,
4.2 cm high. Northern Europe,
c.1560. V&A: M.76–1975

donkey, which was mounted on wheels and pulled in a Palm Sunday procession to commemorate Christ's entry into Jerusalem. The example illustrated on p.225 is half life-size, giving it an appealing doll-like quality. Its outlines have been cleverly simplified, giving the figure maximum effect. These figures were especially popular in the German-speaking territories. At Essen, the *Palmesel* was pulled from the church of St Gertrude to the Stiftskirche, a female convent. The palm-waving canonesses received the figure, which arrived at the head of a procession of scholars, male canons and laity, singing the antiphon 'As they drew near Jerusalem'.[96]

RELIGION, CHARMS AND FOLKLORE

Alongside the orthodox religion promulgated by church authorities, the medieval and renaissance period was also characterized by the widespread belief in more folkloric practices. It would be a mistake, however, to assume that these beliefs challenged or undermined the Christian faith. In most instances, there was a clear relationship between the two. For example, a recently discovered wall painting at a public fountain in Massa Marittima in Tuscany depicts a tree of fertility, which blossoms phalluses and is surrounded by birds and women. The placement of this image at a public water source might seem to indicate a survival of pagan fertility beliefs. But the medieval inhabitants of the town would have understood it differently – there was probably a deliberate link with a nearby confraternity building devoted to Saint Michael, who was associated with water and lactation, and who nourished children.[97]

Other practices also blended the devotional with the folkloric. The devil's influence was usually warded off by the recitation of key biblical phrases or short charms based on Christ's name. Many of these charms appear as texts on jewellery, such as a fourteenth-century French ring, the bezel of which is inscribed with the text 'And the Word was made flesh' from John's Gospel. This text carried a well-known indulgence, and was popular as a talismanic quotation. It was often written on parchment and hung around the neck to cure disease.[98] Sometimes, materials themselves were believed efficacious against malice. For example, the physician Anselm Boethius de Boot wrote in 1604 that diamonds could repel plague, witchcraft, madness, terror and evil spirits. At least one of these functions could have been intended by the wearer of a magnificent pendant, with the abbreviated name of Jesus (IHS) formed from twenty-six table-cut diamonds (pl.171).[99] To the same end, and in addition to the personal reliquaries discussed above, lay people sometimes carried sacramentals (consecrated objects), such as Agnus Deis – cakes of wax and oil blessed by the pope on Easter Saturday.[100]

The world of magic sometimes intruded more strongly into actual Christian worship, as is the case with a sixteenth-century Netherlandish chalice inscribed with the rhyming words 'ANANISABTA DEI, MISERERE MEI'.[101] The magical word 'Ananizapta' was commonly recommended as a charm against epilepsy. It was, for instance, copied into a list of the names of God by the Norfolk church-reeve Robert Reynes, who noted that 'the vertue of these names' made the invocation effective.[102] Magical words and talismans were also commonly written on swords and armour in order to strengthen them.

Other aspects of magic were more obviously deviant from Christian values, but although often persecuted, were remarkably resilient. In his autobiography, Benvenuto Cellini tells a remarkable story of how he took part in a magical séance held at the Colosseum in Rome, with pentangles drawn on the floor, incantations in Latin, Hebrew and Greek, and all the other paraphernalia of witchcraft.[103] Cellini believed that it had successfully summoned demons, yet at no point does this appear to have conflicted with his faith in Christianity. Others were more circumspect in what they wrote down. The philosopher Marsilio Ficino, who held the post of priest at Florence Cathedral, was one expert on magic who presented himself as an impartial observer. Describing how astrologers fashioned images of people to cause them good or evil, he said: 'It would be unduly curious and perhaps harmful to recite what images they fashioned and how… for bringing felicity or inflicting calamity… I do not affirm that such things can be done. Astrologers, however, think such things can be done, and they teach the method, but I dare not tell it.'[104]

CARDINALS AND SECULAR MAGNIFICENCE

This chapter has so far looked at the ways in which religion intruded on the lives of lay people, but there were important ways in which the culture of the Church itself reflected secular life. This was most obvious in the rich style of living cultivated by leading churchmen in the later centuries of our period. Such men were often powerful princes in their own right, and were at least as active in the conspicuous consumption of magnificent goods as their secular counterparts. This can be demonstrated by concentrating on a single elite group within the Church – the college of cardinals.

Increasingly from the thirteenth century, cardinals were expected to maintain a household (or *familia*) much like that of a secular ruler. Many of them also entertained on a lavish scale, requiring the same kinds of luxury goods as were used by secular patrons. Amongst the huge range of silver objects pawned for 3,000 marks by Cardinal Ottaviano Ubaldini in 1262 to a group of Florentine merchants were many objects with a distinctly secular flavour, such as four head-coverings for falcons, essential accessories for hunting. Ottaviano's vast collection also featured a large number of rock-crystal vessels, anticipating the taste of later renaissance cardinals.[105]

When Cardinal Tommaso d'Ocre died in Naples in 1300, he left behind him a substantial range of grand dining silver, including many covered cups, most of them featuring decorative enamels in their bowls.[106] Indeed, dining vessels were one of the most common items on which cardinals spent money, despite occasional protests as to the seemliness of such expenditure. In the early 1460s, Pope Pius II considered restricting the more outrageous secular habits of the cardinalate but his reforms – fewer banquets, smaller libraries, and no wall-hangings depicting women or non-moral subjects – were never put in place.[107]

The coats of arms of renaissance cardinals can be found on many grand dining objects. Such services need not represent Christian scenes. The sixteenth-century cardinal Robert de Lenoncourt owned a pilgrim bottle (for chilling and dispensing wine) whose decoration told classical stories of Jupiter and Europa (pl.172). Sometimes, the elaborate nature of such objects took them out of the

172. **Pilgrim bottle with Jupiter commanding Mercury, and the arms of Robert de Lenoncourt.** Tin-glazed earthenware, 36 cm high. Urbino, c.1550. V&A: C.2299–1910

173. **Valerio Belli, altar cross and candlesticks.**
Silver-gilt, with rock crystal and semi-precious stones, heights 84.8 cm (cross), 50.4 cm (candlesticks). Rome, c.1515.
V&A: 757–1864; M.61 & A–1920

realm of the purely practical and into that of the art collector. For example, the wide, flat drinking cups called tazzas belonging to Cardinal Ippolito Aldobrandini might have been displayed during banquets, but would most likely not have been used as dishes. To appreciate the imagery, the viewer needs to hold such objects in his hands and examine them closely – typical characteristics of a collector's item.

Many renaissance cardinals were as keen on art collecting as any other great patron. For example, the sixteenth-century cardinal Francesco Gonzaga's goods certainly included a large collection of hardstones. Like Cardinal Ubaldini before them, cardinals in the sixteenth century had a particular taste for rock crystal, especially the carved intaglios of artists like Valerio Belli. One such Belli production, made for a high-ranking ecclesiastic in Rome, sets carved rock crystal into an elaborate altar cross and candlesticks (pl.173).[108] Artworks could also be used as diplomatic gifts, as was the case of a bronze copy of the ancient *Spinario* statue in Rome (see p.127), which Cardinal Ippolito II d'Este commissioned from two Florentine sculptors and presented to King Francis I on his arrival at the French court in Fontainebleau in 1540.[109]

In addition to portable items, cardinals had a taste for the grand furnishings typical of any powerful patron of the period. Chief amongst these were tapestries, perhaps the most significant luxury goods of the late Middle Ages and Renaissance. Francesco Gonzaga had a well-known collection of tapestries, depicting both religious and non-religious subject matter.[110] These included battles of Alexander the Great and the story of Achilles.[111] This is unsurprising, as the reverse situation was also common enough – kings and princes had long decorated their palaces with tapestries and wall paintings depicting both religious and secular subject matter, although the religion was not always treated in the most pious manner. The thirteenth-century bedchamber of the kings of England in Westminster, for example, was lined with paintings depicting war scenes from the Old Testament.[112]

Perhaps the most surprisingly secular type of object commissioned and used by cardinals was armour and weaponry. To be sure, it was not always deemed fitting for churchmen to be seen in such martial apparel. In 1536, Cardinal Ippolito d'Este took part in an official entry to an army camp at Avignon wearing no armour on his brother's advice. He later complained that he felt as if he had 'left his fleece behind, as if I had been shorn'; a few months later he ordered a suit of armour from Ferrara.[113] Like any other young nobleman, Ippolito loved hunting and jousting; indeed, the list of his armour and weaponry covers three pages of his household inventory.[114]

These 'secular' aspects of ecclesiastical patronage are emblematic of the ways in which religious belief and secular life were fully integrated in Europe throughout this period. The total interpenetration of the two ideas meant that they were only separable as concepts, never in reality. Religious belief and practice could not be compartmentalized and split from the society that supported it. Rather, it was woven into the fabric of daily life, and it was this blurring of divisions between the two worlds that gave the medieval and renaissance experience of religion such richness.

18. The art of death

ELEANOR TOWNSEND

AN AVERAGE LIFE EXPECTANCY of under 40, and the Church's teaching about the uncertain journey faced by the soul in the afterlife, made preparing for death a major preoccupation during the Middle Ages and Renaissance. The *Book of the Craft of Dying*, published in about 1450, summarized it thus:

> ... the passage of death out of the wretchedness of the exile of this world seems extremely hard and very perilous and also very terrifying and horrible...

This concern underlies much artistic production before the Reformation.

The early Church stressed the Last Judgement as described in Saint Matthew's Gospel, when all mortals were resurrected in their bodies at the end of time, and Christ consigned them either to heaven or to hell for eternity (18.1). But increasing attention was paid to the problem of what happened in the meantime, to those who had died while the Last Judgement was still awaited. In a letter to the Eastern Church in 1254, Pope Innocent IV made the first official papal statement about purgatory, the existence of which had long been suggested by theologians. A third state was established, other than heaven and hell, where ordinary souls underwent a period of purging to purify them for paradise.

It was made clear at the second Church Council of Lyons in 1274 that the actions of the living could help to ease the pains of purgatory. This belief was fundamental to the development of art in this period. Patrons manifested their devotion by commissioning works of art and architecture that beautified churches and glorified God. The Church could also grant indulgences (remission of time spent in purgatory) for the truly repentant in exchange for money, specific prayers or other activities, including pilgrimage and church-building.

The Virgin and saints were believed to be able to intercede on behalf of mankind to alleviate suffering in purgatory, and images of them are familiar in all branches of art from this period. Certain saints and prayers were also believed to offer protection from sudden death. It was crucially important to 'die well' (rather than suddenly) having taken the last rites and prepared oneself properly. Manuals were produced advising on how best to achieve this, and received a wide circulation thanks to the printing press (18.2).

Appropriate burial, preferably in a prestigious location inside the church (such as by the altar), was also desirable. After death elaborate tombs and monuments proclaimed family status, as well as encouraging remembrance of – and prayers for – those who had died (18.3). The familiar plea, 'Orate pro anima...' (pray for the soul of...) is repeated on tomb chests, memorial brasses and stained-glass windows (18.4). Soliciting suffrages, or prayers, for one's soul in the afterlife continued from beyond the grave.

From the 1520s, reformed religion rejected notions of purgatory, the value of suffrages and the use of indulgences. This had a seismic effect on art. It was no longer seen as beneficial to commission religious works of art specifically for the good of one's soul. Although the desire for family commemoration remained strong everywhere, believers in the reformed countries were taught to rely on Christ's redemptive powers rather than their own actions for salvation in the hereafter.

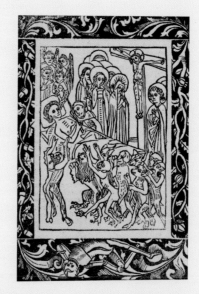

18.2 ◀ **Illustration from *Ars Moriendi* (The Art of Dying), printed by Johann Weyssenburger.**
Printed book, Nuremberg, 1510–11. V&A: L.366–1880

The text describes the temptations threatening a dying man. The woodcut shows his soul (a small figure above his body) being delivered from frustrated demons below by angels and the crucified Christ.

18.1 ▲ **Plaque showing the Last Judgement.**
Ivory, 15 × 21.5 cm. Probably Constantinople (modern Istanbul), *c*.1050–1100. V&A: A.24–1926. Purchased with the assistance of The Art Fund

Christ the Judge is shown centrally, flanked by the Virgin and St John as intercessors, while angels below consign souls to heaven on Christ's right and hell on his left.

18.4 ▼ **Memorial brasses to Elizabeth and Robert Alee.**
Brass, 55.3 × 14.3 and 53.6 × 14.1 cm. From Dunstable Priory church, Bedfordshire (England), 1518. V&A: M.124 and 125–1922. Given by Arthur G. Binns

Patrons were shown in shrouds to reinforce the message that death comes to all and encourage viewers to offer prayers for their souls. Such brasses usually had an inscription plate requesting these prayers.

18.3 ▶ **Tomb for a member of the Moro family.**
Istrian stone, porphyry and marble, 425 × 249 cm. Venice, 1500–50. V&A: 455–1882

Lavish tombs proclaimed the status of the deceased and his or her family, while the use of classical motifs showed the education of patron, artist or both.

19. A choirscreen from 's-Hertogenbosch

STUART FROST

DURING THE PERIOD from the thirteenth to the seventeenth century choirscreens (or roodlofts, after the crucifix or rood that was usually positioned above the screen) emerged as a common feature in Netherlandish churches. Of those that survive none has a more remarkable history than the choirscreen from the cathedral of St John at 's-Hertogenbosch now in the V&A's collections (19.1).

The primary function of a choirscreen was to restrict entry to the choir, an area of the church which was usually only accessible to the clergy (19.2). Choirscreens fulfilled several other very practical liturgical functions but were also occasionally put to less orthodox use. In 1526, for example, nine individuals were compelled to stand on the Gothic predecessor of the 's-Hertogenbosch choirscreen and renounce their alleged 'Lutheran' sympathies.

In 1609 the Twelve Years Truce divided the Netherlands into the Protestant United Provinces in the north and the Spanish Netherlands to the south. 's-Hertogenbosch was the furthest north of the Spanish-dominated towns and occupied a key strategic position. Its earlier choirscreen had been defaced by reformers when the wave of iconoclasm that swept through the Low Countries during 1566–7 reached the city (19.3), but order was soon restored and 's-Hertogenbosch remained a loyal outpost of the Catholic Spanish Netherlands until 1629. In September 1610 the city authorities settled on a design for a new choirscreen and hired Coenraed van Norenberch to oversee its execution.

The design consciously blended sacred and secular references. Its shape recalled Roman triumphal arches, a form appropriate for a monument that marked Christ's victory over death. There were also parallels with ephemeral arches erected for the ceremonial entry of Habsburg rulers into towns in the Spanish Netherlands. The shields held by the four figures on the top tier of the choirscreen once bore richly coloured heraldic designs that reinforced these contemporary allusions. The most significant shield bore the archducal coat of arms of Albert of Austria and Isabella of Spain, the Habsburg rulers of the Spanish Netherlands at the time the choirscreen was made. The taller statues of female figures represented Justice, Faith, Hope, Charity and Peace. The last-named figure was probably a reference to the recently signed truce of 1609 and Justice appears to be a flattering allusion to the role of the archduke in maintaining law and order.

The profusion of figurative and relief sculpture on the choirscreen reflected a commitment to the centrality of images in Catholic worship. Saint Peter, Saint Paul and the Virgin Mary were all given prominent positions reinforcing their importance as pillars of the Church, while the carving of the figure of Saint John the Evangelist, the cathedral's patron saint, was sub-contracted to the leading sculptor in (Protestant) Amsterdam, Hendrik de Keyser.

The choirscreen was finished in 1613 but the future of 's-Hertogenbosch as a bastion for counter-reformation Catholicism was to be of limited duration. In 1629 the Protestant Dutch finally gained firm control of the city. By this date the Calvinist-inspired fervour against images had abated and the choirscreen's sculpture escaped any major damage. Its decorative programme, intended to communicate the city's commitment to Roman Catholicism and its loyalty to its Habsburg rulers, was merely rendered obsolete by the shifting fortunes in the struggle between the Dutch and the Habsburgs.

19.2 ▲ **Pieter Saenredam,** **The Choirscreen from the Choir Side.** Watercolour, 36.1 × 25.5 cm. 's-Hertogenbosch, 1632. Musées des Tissus et des Arts Décoratifs de Lyon, inv. no.875/a

Wooden choir stalls covered most of the rear of the choirscreen beneath the gallery. The large crucifix that was originally suspended above the screen, completing its iconography, had been removed several years prior to this painting.

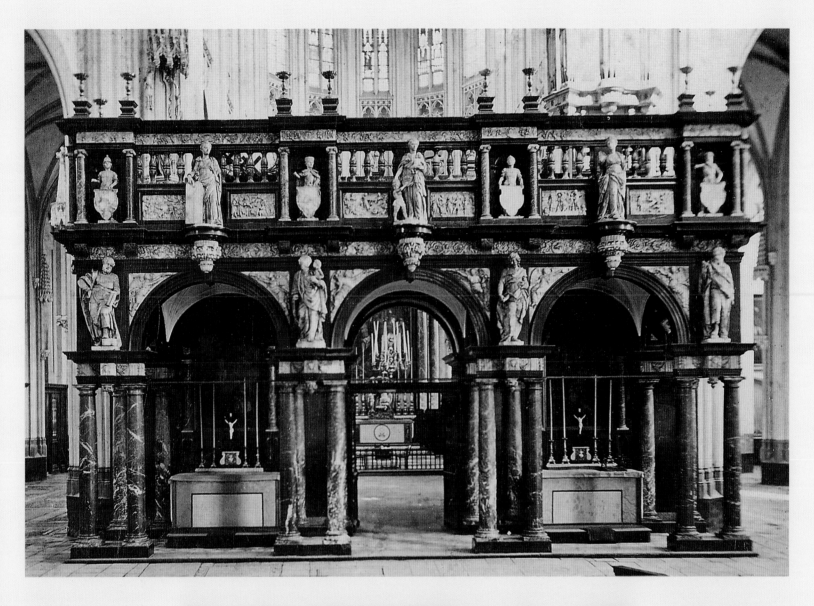

19.1 ▲ Coenraed van Norenberch and others, choirscreen of cathedral of St John, 's-Hertogenbosch.

Marble and alabaster, 780.1 × 1044 cm. 's-Hertogenbosch (Netherlands), 1610–13. V&A: 1046:1–1871

This photograph of the nave side of the choirscreen was taken by A.G Schull in 1866 when it was still in the cathedral of St John. The cathedral authorities decided to remove the screen shortly after.

19.3 ◄ Gaspar Bouttats, *The Destruction of the Choirscreen at Antwerp* (detail).

Engraving. Unknown date. Bibliothèque Royal, Brussels, SII143283

This view of iconoclasts defacing Antwerp Cathedral in 1566 was produced in the second half of the 17th century and parallels events in 's-Hertogenbosch. Note the people removing the crucifix (or rood) above the choirscreen.

20. Religious processions

MEGHAN CALLAHAN

During the medieval and early modern periods, on saints' days or holy days, religious processions wound their way through cities and countryside throughout Europe. As demonstrations of religious devotion and civic pride, processions combined the sacred and secular and involved all levels of society as observers and participants. Richly crafted objects were an integral part of such displays. The most important items were relics (contained in reliquaries, see pp.226–7) or miraculous paintings and sculptures of saints, which were carried high above the crowds so that they might admire the image while receiving the blessings associated with the saint. The processional route would be lined not only with spectators but with banners, flags and carpets hanging over balconies. Italian renaissance frescoes and paintings depict Turkish carpets displayed in this way, adding bright colours and textures to the scene.

A sense of a procession moving through a city is provided in the margins of a small Book of Hours (20.1). The members of a confraternity, dressed in identical black robes, are shown receiving candles and communion from a priest as a funeral cloth is laid out in front of the altar. Confraternities were groups of laymen (and sometimes women) joined by the common bond of neighbourhood, employment or devotion. During processions different confraternities lined up in a strict hierarchy – which was known to lead to fights on more than one occasion.

Processional objects are often characterized by decoration on both sides – an important element when considering their movement through space. The cross shown here was probably created by the goldsmith Ughetto Lorenzoni (20.2). It bears an image of the Virgin and Child on one side and the Crucifixion on the other, so that Christian spectators (and the cross-bearer) could meditate on the birth and death of Christ. Townspeople would also have looked on with pride, as the owl at the bottom is the symbol of the town of Locatello, where the cross was used. The double-sided banner depicts the Crucifixion on one side and on the other Saints Eligius and Anthony Abbot, most likely the patron saints of the unknown confraternity that commissioned it (20.3). The banner would have been held by one of the brothers as the rest followed, dressed in their confraternal robes as a symbol of unity.

Such processions were accompanied and overseen by religious leaders. As they processed, archbishops, bishops, and some abbots and abbesses were allowed to carry a crosier, a staff given at the time of their consecration as a sign of church authority. A crosier in the V&A's collection, for example, has an inscription around the bottom that may commemorate Giovanni de' Ricci's term as archbishop of Pisa from 1567 to 1574, though whether Giovanni ever used it is not known, as he spent much of his time in Rome.

Processions were particularly popular during the Easter period, when Christians acted out the biblical passages marking the days before Christ's Crucifixion. Entire towns were transformed into virtual representations of the Via Dolorosa and Calvary. Christ's entry into Jerusalem on Palm Sunday was marked in England by men and young boys costumed as singing prophets while in Germany wheeled *Palmesel*, or 'Palm donkeys', allowed townspeople to pull Christ into town astride his donkey in a re-creation of the scene (20.4).

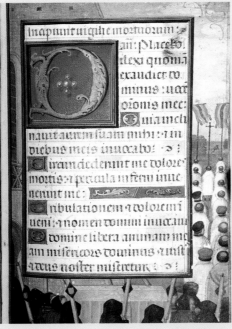

20.1 ▲ Simon Bening, Book of Hours (Use of Rome).
Tempera on parchment. Page 18.5 × 13 cm. Bruges or Ghent, c.1515.
NAL: MSL/1981/39, f.21v

This page accompanied the Office of the Dead, special prayers said in honour of the deceased.

20.2 ▲ Ughetto Lorenzoni (probably), processional cross.
Wood, silver and enamel, 97 × 61 × 16 cm. Italy, c.1390.
V&A: 707–1884

A coat of arms on the stem of the cross is probably that of the Alzano family, who may have commissioned it. Another cross by the same maker survives in Bergamo.

20.3 ▶ Barnaba da Modena (probably), double-sided processional banner.
Tempera on canvas, 97 × 61 cm. Italy (possibly Genoa), c.1370.
V&A: 781–1894

It is still unclear where the confraternity that commissioned this banner was located, though some scholars have suggested the small Tuscan town of Borgo San Sepolcro.

20.4 ◀ *Christ riding on the Ass (Palmesel).*
Limewood and pine, painted and gilded, 147.4 × 47.8 × 133.5 cm. Germany (possibly Ulm), c.1480. V&A: A.1030–1910. Bequeathed by Capt. H.B. Murray

This example of a 'Palm donkey' is missing its wheels.

21. Relics and reliquaries

STEPHANIE SEAVERS

EVERY YEAR, TENS OF THOUSANDS of pilgrims journey to the holy town of Santiago de Compostela in northern Spain, following in the footsteps of their medieval counterparts, who from the tenth century travelled there to visit the shrine and relics of Saint James. The fervent continuation of this tradition, now centuries old, demonstrates the strength of the cult of relics in the medieval period and the impact it had on Western culture. Relics, the bones and possessions of the saints, were highly venerated. Pilgrims sought to kiss, touch or view them in the hope that they would receive the protection of the saints or even witness a miracle.

Relics were placed in containers, known as reliquaries, for their protection and safekeeping. Whether permanent shrines as at Santiago, or smaller portable reliquaries, these containers were often adorned with silver, gold or enamel. The materials used reflected both the wealth of the religious community and the status of the relic. The legendary Holy Grail, one of the most coveted relics, was placed inside 'an ark of gold and precious stones' according to the thirteenth-century French romance *The Death of King Arthur*. Relics of the True Cross and the apostles were held in similar esteem and were often richly encased. For those communities unable to acquire one magnificent relic, the collection of numerous items improved the status and protection of their church. An Umbrian reliquary diptych from the thirteenth century, made from inexpensive wood, is painted with several saintly figures (21.1). Inscriptions beneath identify the relics enclosed. The absence of an inscription below the final figure suggests that the diptych was made before the acquisition of the relics and that the names of the saints were written in as each relic was added.

Reliquaries defined a sense of belonging to a locality and established a common identity for believers who prayed together. A tinned and gilded copper reliquary bust commissioned by a monastery in Brescia demonstrates the power of local identity in the veneration of relics (21.2). An inscription identifies the figure as Saint Antigius, Bishop of Brescia. Antigius was a saint of unknown date whose relics were transferred to the town in the Middle Ages. His true origins forgotten, Antigius was mistakenly added to the list of bishops from Brescia and became a strong symbol of local identity.

The diverse forms of surviving reliquaries demonstrate the variety of ways in which relics functioned in worship and society. Reliquary crosses were often placed upon the church altar and paraded before the congregation on festival days. A thirteenth-century example associated with the priory of St-Nicholas at Oignies-sur-Sambe, Belgium, may have been used in this way (21.3). Personal reliquaries in the form of jewellery allowed a more intimate connection with a relic, enabling its owner to repeatedly touch and hold its container. Such objects blurred the boundaries of religious orthodoxy. As the touch of a relic or its reliquary was believed to impart the protection of the saint to the believer, the constant wearing of relics gave them quasi-talismanic significance (21.4). Both religious and lay people wore reliquary jewellery. The 1418 inventory of Charles VI of France lists more reliquary pendants than any other kind of jewel.

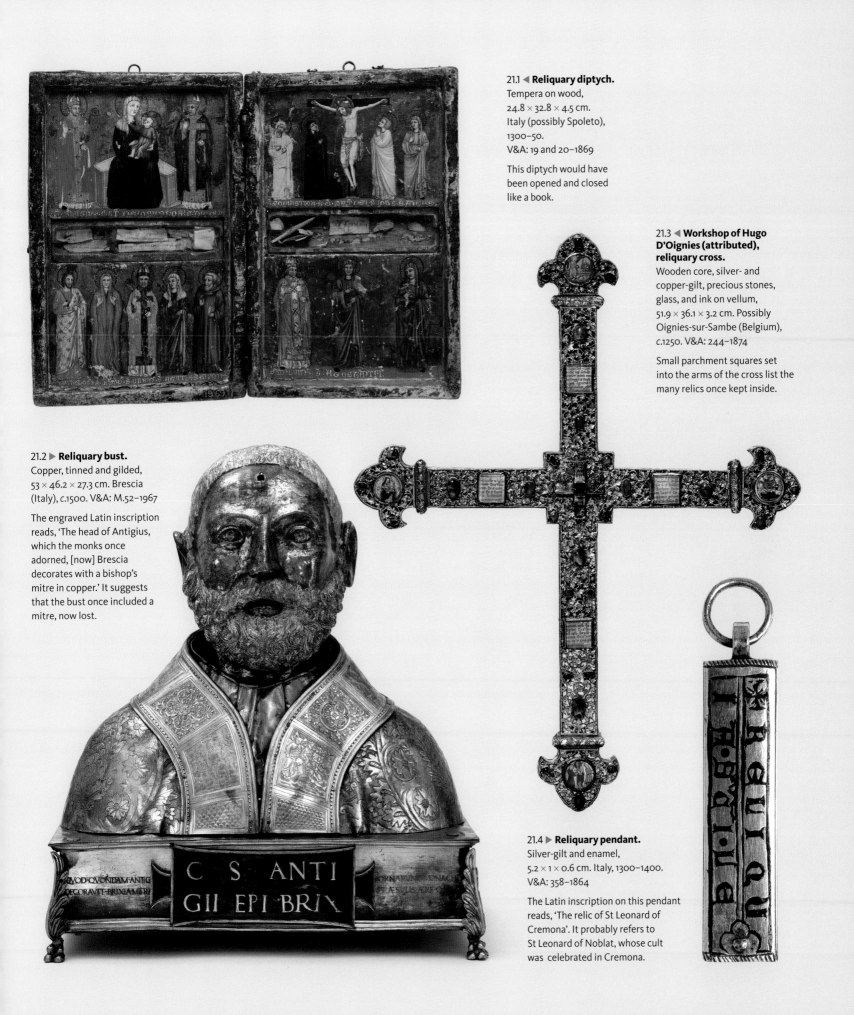

21.1 ◀ **Reliquary diptych.**
Tempera on wood,
24.8 × 32.8 × 4.5 cm.
Italy (possibly Spoleto),
1300–50.
V&A: 19 and 20–1869

This diptych would have
been opened and closed
like a book.

21.3 ◀ **Workshop of Hugo
D'Oignies (attributed),
reliquary cross.**
Wooden core, silver- and
copper-gilt, precious stones,
glass, and ink on vellum,
51.9 × 36.1 × 3.2 cm. Possibly
Oignies-sur-Sambe (Belgium),
c.1250. V&A: 244–1874

Small parchment squares set
into the arms of the cross list the
many relics once kept inside.

21.2 ▶ **Reliquary bust.**
Copper, tinned and gilded,
53 × 46.2 × 27.3 cm. Brescia
(Italy), c.1500. V&A: M.52–1967

The engraved Latin inscription
reads, 'The head of Antigius,
which the monks once
adorned, [now] Brescia
decorates with a bishop's
mitre in copper.' It suggests
that the bust once included a
mitre, now lost.

21.4 ▶ **Reliquary pendant.**
Silver-gilt and enamel,
5.2 × 1 × 0.6 cm. Italy, 1300–1400.
V&A: 358–1864

The Latin inscription on this pendant
reads, 'The relic of St Leonard of
Cremona'. It probably refers to
St Leonard of Noblat, whose cult
was celebrated in Cremona.

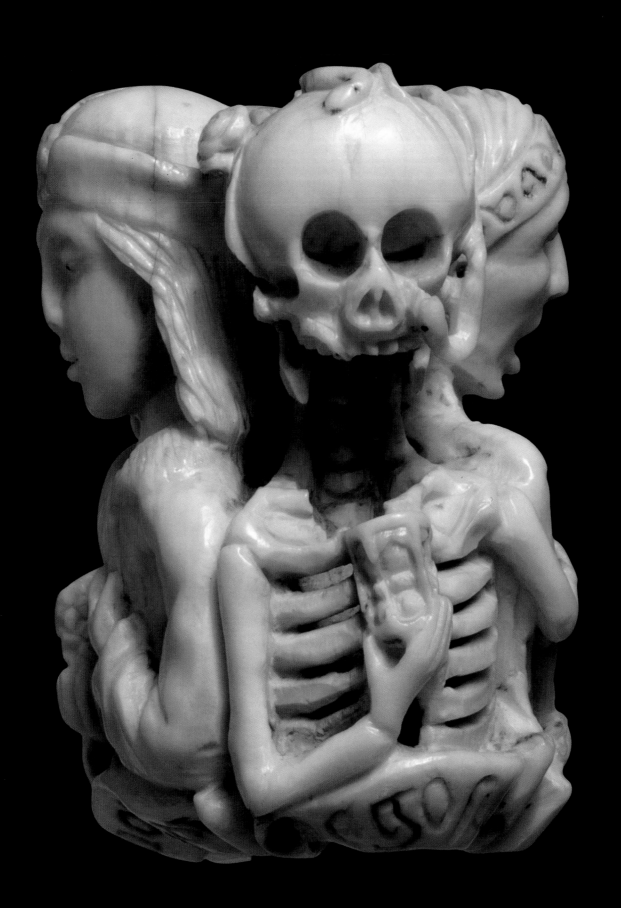

7

PROTECTING THE BODY, PORTRAYING THE SOUL

Kirstin Kennedy

'YOU ARE A WRETCHED MAN who feeds and waters your wretched body and who sates the desires of your flesh that, in a few days, will be eaten up by worms,' admonished Saint Anselm in the eleventh century.[1] It was a sentiment which echoed down the centuries in sermons and religious commentaries, in poetry, prose and possessions, such as a rosary bead of the first half of the sixteenth century, where the carved images of skeletons and worms are accompanied by mottoes that stress the inevitable imminence of death (pl.174). Yet Christian writers' insistence that spiritual well-being in preparation for the afterlife was far more important than physical comfort on earth was no obstacle to the development of theories connected with health, medicine and hygiene.

Such theories were attempts to relate the individual and his or her personality to other people and to the environment. The stars and the 'humours' were believed to rule a person's emotional and physical make-up, while his moral character might be divined from his outward appearance, according to the pseudo-science of physiognomy. This in turn influenced interpretations of beauty and ugliness in the medical sphere, and to some extent determined how different personalities were depicted by artists. Protection from disease might be provided by saintly relics (see also Chapter Six) or by natural substances whose curative powers had been trusted from pre-Christian times, and went on to influence the design of everyday items such as tableware. Other domestic objects, and the spaces around them, were also shaped to combat physical dangers.

The most fundamental and influential ideas about human health in the Western world originated with Ancient Greek physicians.[2] They argued that all matter was divided into opposing pairs of principles (hot and cold, moist and dry) and four elements (air, earth, fire and water). As a microcosm of the universe the human body, too, was composed of these four elements. Air corresponded with blood, water with phlegm, fire with yellow bile (choler) and earth with black bile (melancholy). Each of these 'humours' had its own properties: blood was hot and moist, phlegm

Rosary bead.
See pl.174, p.230.

cold and moist, choler hot and dry, melancholy cold and dry. The combination and balance of these elements determined not just health, but the character (or 'complexion') of a person. Those who naturally had an excess of yellow bile, for example, were characteristically short-tempered.[3] Animals, plants and minerals each had their own particular combination of elements and all things, animate and inanimate, exchanged their powers (or 'virtues') with one another in a hierarchical relationship – based on Aristotelian theories of the universe – which had God at its apex. For an individual to enjoy good health it was necessary to achieve and maintain the correct balance of the humours appropriate to his particular constitution. It was also a matter of exploiting the virtues of different objects to create a healthy environment, that is, by exploiting the qualities of the various natural materials from which they were made. Prevention was naturally better than cure, and many household objects reflect efforts to achieve this.

Another significant source of influence radiated earthwards from the planets, which were believed to have dominance over particular elements and humours. The 'whole system of the medical art is affected by the atmospheric changes caused by the heavens and the stars', wrote the Franciscan friar Roger Bacon in the thirteenth century, 'therefore, the doctor who does not know how to observe the places of the planets and their appearances cannot accomplish anything in the practice of medicine, except by chance and good luck'.[4] These beliefs still circulated in the early sixteenth century, as the image of an astrologer casting a baby's horoscope on the lid of a broth bowl shows (pl.175).

A person's physical appearance and personality, therefore, reflected both his humoral balance and the influence the stars exerted on his temperament. For example, those born under the influence of Saturn, a planet which controlled things that were cold and damp, were depressive by nature and had a sombre appearance.[5] Social status also predetermined a person's physical stature and constitution. Nobles and peasants were born into their stations, and were therefore innately able to cope with the attendant benefits or hardships. It was a perception reinforced by Christian ideas of sin and retribution: 'Christ was crucified by a peasant,' observed the peasant narrator of an early sixteenth-century Italian satirical poem, *Lo Alphabeto delli Villani* (The Peasants' Alphabet), and so 'we are always in the rain, in the wind and in the snow because we committed such a great sin.'[6]

Appearance was also an indicator of moral worth and could be interpreted according to the pseudo-science of physiognomy. Although the Greek physician Hippocrates was credited in the ancient world with its foundation, his successor Galen, working in the second century CE, did much to develop its study. The significance of a person's appearance for an understanding of his inner psychology was alluded to by Plutarch, and detailed by Aristotle, who argued that human traits mirrored animal ones.[7] The earliest surviving treatise on the subject is the *Physiognomonica*, a Greek text incorrectly attributed to Aristotle and compiled around the third century BCE, although the earliest manuscript preserved is some four centuries later.[8] Physiognomical theories continued to have an impact on medical and artistic practice in the centuries after the fall of the Roman Empire and, indeed, were still current at the end of the sixteenth century, for example in the work of the Italian scientist Girolamo Cardano.[9] They offered, however, only one of several ways in which an

174. **Rosary bead (another angle shown on p.228).**
Ivory with traces of red and black paint, 5 × 3.8 cm. Possibly France or Southern Netherlands, c.1525–50. V&A: 2149–1855

175A, B. **Nicola da Urbino (attributed), broth bowl and trencher.**
Urbino, 1533–8. Tin-glazed earthenware, 19 cm diameter.
V&A: 2258–1910. Salting Bequest

artist could convey the identity of his subject, and the degree to which they were used depended not only upon the artist but upon the function of the image itself.

Depictions of the human face and body reflected all these theories up to a point. Thus sages, who were aged and wise, were shown with a long white beard (see pl.175B); sinners had ugly, twisted features which reflected their moral turpitude. Conversely, outer beauty implied inner moral virtue (see also Chapters Two, Five). This type of interpretation of visual qualities was paralleled in theories about the other senses: for example, that anything sweet-tasting or sweet-smelling automatically had health-giving properties. Thus Ruperto de Nola's fifteenth-century recipe for a dish with pumpkin seeds becomes a medicine for kidney ailments if sugar is added.[10] The perception that all food was medicine meant that special precautions had to be taken to ensure it was unadulterated and suitable to eat. Meanwhile, the quality of air was of particular concern, and within the domestic environment different methods existed to ensure its sweetness and, therefore, purity.

The following chapter focuses on objects which reflect some of these beliefs. That this evidence comes from wealthy households is not just a consequence of the disparity in material possessions between rich and poor. Perfumes, spices and sweetmeats were a sign of wealth but, in theory at least, they were also medically appropriate to the delicate constitution of the noble-born person who used and consumed them.

AIR, DISEASES AND SMELLS

Air that smelled sweet was understood to be free of any harmful vapours, poisons or pestilence. 'We must be very careful about the condition of the air that touches us,' wrote the French royal physician Laurence Joubert at the end of the sixteenth century.[11] Disease was a constant threat because it was carried from place to place on the air. Bubonic plague, for example, was believed to come from poisonous vapours caused by the movement of the stars. Humans contracted plague (and all other

diseases) through the pores in their skin, which enabled sickness to enter.[12] Once inside the system, it went straight to the heart and caused instant death.[13]

Belief in this ever-present danger had implications for architecture and domestic ambiance. Aristotle's description of the layout of an ideal house in his *Oeconomia* proved hugely influential. His emphasis on well-positioned, well-ventilated buildings away from damp bogs and cold winds was echoed in thirteenth-century guidelines for founding universities: Alfonso X of Spain stipulates that they should be located in towns where the air is good so that 'the masters… and the pupils… may live there in health'.[14] Sunlight was especially important for the home, because it destroyed thick, corrupt air by thinning it and therefore making it clean.[15] That said, toilets – a source of concern to writers on health because of the foul stench that emanated from them – tended to be designed as small, dark spaces near the kitchen.[16] In part this was to provide access to running water, but another reason was to keep the smells of the toilet as distant as possible from sleeping quarters (at least in a large house).[17] Foul air aside, the dank, watery condition of toilets was itself deemed unhealthy, particularly as these facilities came under the astrological influence of a heavenly body associated with madness and melancholy, namely the moon.[18]

Within a domestic context various steps could be taken to ensure cleanliness whatever the state of the air. Undergarments protected the body from infections which settled on outergarments, and covering as much of the body as possible with clothes was thought to defend against disease. As a consequence, the brushing, shaking and laundering of clothes formed a central part of domestic rituals designed to maintain a hygienic atmosphere.[19] In a passage on the importance of clean air, Joubert urged his readers to 'often change the linen which touches us, to remove all that has come to rest upon it'.[20] As with sweet tastes, sweet smells were associated with health and cleanliness. Henry II of France's linen was perfumed with a powdered mixture that included rose petals, sandalwood, coriander and lavender.[21] Leather gloves were also perfumed for reasons of hygiene as well as social prestige.[22] In his 1423 treatise on the art of carving at table, Enrique de Villena recommended that the carver protect his hands with 'clean and pleasant-smelling gloves' until the moment came to slice the meat. Moreover, he should wear 'rings set with stones… against poison and infected air', demonstrating a belief in the power of certain gems to which we will return (see pp.242–6).[23]

A number of different types of object testify to the concern with maintaining the house full of pleasant smells, so contributing to a salubrious environment. Scented flowers were an effective (though seasonal) means of perfuming a room. Thomas Tusser, a sixteenth-century English writer on agriculture, listed the 'herbs, branches, and flowers, for windowes and pots' that should be sown by the thrifty husbandman in March. They included roses, lavender, sweet williams and rosemary.[24] The important role fresh flowers played in perfuming the household environment is suggested by the fact that flower vases were commissioned as part of tableware sets. In November 1454, Maria, wife of Alfonso V of Aragon, ordered a selection of serving plates, dinner plates, bowls, mortars, jugs and 'vases to hold flowers with two golden handles' from potters in Manises, Valencia (pl.176).[25]

176. **Flower vase.**
Tin-glazed earthenware, 52.7 cm high. Manises (Spain), c.1440–70. V&A: 8968–1863

The Italian chef, Bartolomeo Scappi, who in 1570 published a culinary treatise based on his years as papal cook, included 'pots of perfumed flowers' as a table-setting in a sample menu for May;[26] and the posthumous inventory of Leonard Dalton, taken at Witney, Oxfordshire in August 1581, included '4 Flower pottes' among his kitchen and tableware.[27] The aesthetic appeal of the plants would have supplemented the health-giving properties of their scent. (Other aspects of dining ritual involved perfumes, too. Handwashing, more a courtesy to other diners than a precaution against germs, was performed at table with scented water.)[28] Flowers were also appropriate to the study environment, where pleasant odours stimulated the mind as well as warding off corrupt air and killing book-eating insects.[29]

If flowers were not available, there were alternatives. English sixteenth-century inventories often record chafing dishes among the cheaper possessions owned by the deceased, such as one that belonged to John Whytfyld, a weaver from Landkey, North Devon, in 1575. Chafing dishes were charcoal burners used to heat food, but they could also warm perfumed water.[30] The greater the combination of different scents, the better, according to Luis Lobera de Ávila, physician to the Holy Roman Emperor Charles V, who advised that the air in sleeping quarters should be filled with incense to create an atmosphere of 'many good smells'.[31] Perfume burners, like flowers, could be placed on the dining table or they could stand among the rare, imported and skilfully wrought objects kept by those with scholarly pretensions in their studies (see pl.178).[32] Those wealthy enough to do so, moreover, would continue their night-time activities using beeswax candles, which smelled sweeter and burned more consistently than fatty, smoky sticks of tallow.[33] Erasmus describes candles giving off 'a very pleasant scent' in one of his anti-clerical satires.[34]

Sweet smells were not confined to incense burners, flowers and candles. Jewellery, too, could be scented. Sometimes the same piece of jewellery was designed to contain more than one type of scent to guard against different eventualities, such as the pomander shown here (pl.177). Pomanders (the name derives from the Old French *pomme d'ambre*, an 'apple of ambergris') were small, round containers with compartments filled with scented paste. They were worn hanging at the girdle on a long chain, which allowed them to be lifted to the nose and their scent inhaled as required. Necklace beads could also be filled with scented preparations: Mary Queen of Scots went to the scaffold in 1587 wearing a chain of pomander beads.[35] Not all the mixtures held in the different segments of pomanders or in scented beads were necessarily sweet-smelling: they might, for example, comprise a combination of henbane and opium to combat insomnia.[36] The recipes for most preparations, however, were intended to combat air-borne infections generally, and were not presented as treatments for any specific illness or situation. Recipes for pomander pastes given in a late fifteenth-century Spanish treatise on perfumes and cosmetics are simply 'to inhale and to comfort'.[37] More unexpected objects were also perfumed. Some fifteenth- and sixteenth-century Italian caskets were decorated with a white lead paste, bound with egg, to which musk had been added (pl.179). As the boxes themselves were fragile, they probably held small toiletries such as ear-picks or nail cutters, or inexpensive trinkets.[38]

177. Pomander.
Partially gilded silver and niello,
6.5 cm high. Italy, 1300–1400.
V&A: M.205–1925. Bequeathed by
Francis Reubell Bryan

178. Perfume burner.
Silver-gilt, 17.6 cm high. Mexico,
probably after 1520.
V&A: M.62–1980

Strong- and often foul-smelling air did, however, have one very particular role in medical practice. It was believed that a woman's womb changed position at certain times of the month, and could rise up as far as her throat. This was the cause of severe period pains and cramps, which could only be cured if the womb was forced back down to its correct anatomical position. Since the womb was believed to shrink from pungent smells, the remedy for period pains was to drive it back down the body with a sharp scent. 'Every strong scent is good,' says Celestina, a character in a much-translated tragicomedy published by the Spaniard Fernando de Rojas in 1499. Her list includes 'rue, wormwood, smoke of partridge feathers, of rosemary' and, in the 1631 English version, 'scent… of the soles of old shoes', too.[39] A twelfth-century collection of texts on medical matters, the *Trotula*, also recommended that in such cases 'there be applied to the nose those things which have a foul odor' but also that the vagina 'be anointed with those oils and hot ointments which have a sweet odor, such as iris oil, chamomile oil, musk oil and nard oil'.[40]

Not everyone appreciated a scent in the same way; nor was it believed that they generated the same scent. Those with melancholy personalities were thought to emit the stinking odour of their ruling planet, Saturn. So were the Jews, who were also associated with Saturn by Christian writers.[41] On the other hand, the golden-haired, clear-complexioned and noble ladies admired from afar by thirteenth-century troubadours were frequently compared to fresh and fragrant roses.[42] Moreover, rulers and the nobility were, in the world

179. **Casket with the arms of Cardinal Bernardo Cles.**
Alderwood, gilding and white-lead paste, 9.3 × 22.7 × 12.6 cm. Possibly Venice or Ferrara, 1530–38.
V&A: 777–1891

180. Mortar.
Bronze, 14.9 cm high.
The Netherlands, c.1540.
V&A: M.7–1938.
Given by Dr W.L. Hildburgh FSA

of literature at least, unable to endure the coarse smells and sensations that characterized the life of the poor. A fourteenth-century Spanish collection of didactic tales includes one about a ninth-century caliph of Seville who panders to his wife's whim to mould bricks of mud. Instead of allowing her to join the barefoot women at the riverside, however, he re-creates a lagoon filled with rosewater, with 'mud' that includes sugar, cinnamon, spikenard, cloves, musk and amber. The straw for the bricks consists of threads of sugar.[43] By contrast, a Montpellier peasant's inability to endure sweet scents betrays his low status to all in an early thirteenth-century French poem. Transporting manure into town, he finds himself in the unfamiliar surroundings of the spice-merchants' quarter. The moment he inhales the aroma of spices, he faints. One of the onlookers realizes what has happened and puts a forkful of dung under the peasant's nose. 'When he smells the odor of the dung, and has lost the scent of the aromatic herbs, his eyes open, he jumps up, and says he is completely cured.' The poet concludes with the moralizing comment that no one can go against his own nature.[44]

It also followed that the poor themselves stank, although if true this was probably more to do with cramped living arrangements and physically demanding activities than any inherent bodily condition. The prejudice was widespread, however. A dying inhabitant of the southern French village of Montaillou at the end of the twelfth century found strength to call the priest who visited him 'a vile, stinking rustic'.[45] Some took practical steps to defend themselves against the physical effects of exposure to the lower classes. A 1557 account of the life of the late Cardinal Wolsey, Lord Chancellor of England, described how he appeared before petitioners each morning carrying 'a very fair orange whereof the meat or substance within was taken out and filled up again with the part of a sponge wherein was vinegar and other confections against the pestilent airs'. This he brought to his nose whenever he was mobbed by the crowd.[46]

EATING WELL

As we have already seen, sweet food, like sweet air, was thought to promote health, and food in general could be regarded as medicine. Objects used to prepare food sometimes carry explicit references to this aspect of their function. Stone, metal and wooden mortars were used at home and in the pharmacy to grind and powder bark, leaves, grains and other ingredients for both foodstuffs and cosmetic preparations. The Latin inscription round the rim of a bronze mortar cast around 1540 observes that 'You who are trying to be cured of bitter illness oppose it from the first and avoid worse things' (pl.180). Prevention of sickness with remedies endorsed by ancient authorities was always better than cure.

Allied to the belief in the balance of humours was the oft-cited Hippocratic injunction to eat in moderation and engage in exercise, because food also generated blood. It was therefore best consumed at particular times of the day (not too much too late at night), as good digestion was essential to maintain a healthy constitution.[47] Drink, meanwhile, should ideally be taken sparingly

in the three hours after dining. Failure to do so meant the liquid would isolate food from the stomach, preventing it from being digested and expelling it around the body with poisonous consequences.[48] There was a direct correspondence between the right amount of food to eat and working environment. A landowner overseeing farm labourers toiling outdoors, for example, was advised to ensure they 'eate little and often' because 'the Sunne hurteth the body and the vaynes [and so] theyr diet must be the thinner, that they make not to great meale… : this order keepeth them in health, and helpeth digestion'.[49] A stained-glass roundel of the Labour of the month of March (see p.258) shows a field worker about to lose his packed lunch to an opportunistic crow.[50] The rich, meanwhile, were warned against ruining their digestion by retiring after dinner to their chambers with a glass of fine Greek or Cyprus wine,[51] although in 1601 Joubert was still noting that members of the wealthiest French households kept wine by them during the night in case of thirst.[52]

Such assumptions about the digestive abilities of people at different levels of society, like the theory of the humours, were reflected in the classification of foodstuffs. Twelfth-century French legal scholars drew on the authority of Galen to demonstrate that coarse foods were bad for the rich and that delicacies should not be given to the poor. Indeed, one writer feared that refined food would, if fed to the poor, not just make them ill but also over-excite their libido and stimulate greed, thereby combining medical and moral theories.[53] Root vegetables were suitable for peasants because, like them, they were grubby and earth-bound: 'The others eat cocks, hens, swallows and chickens, and we eat turnips with a few nuts, as swine do,' observed the anonymous peasant in *Lo Alphabeto delli Villani*.[54] Birds, even those that seldom flew, such as the partridge, were the most noble in the food chain because their air-borne environment placed them closest to heaven. Capons (castrated cocks) were the healthiest food it was possible to eat unless you led a slothful existence, in which case the copious amounts of blood generated by the meat would overwhelm your sluggish system.[55] The meat of a young hen was also beneficial, and not just because the Arab medical writer Avicenna had said it strengthened the intellect.[56] Chickens were classified as hot and dry, which made them highly suitable food for new mothers. This was because the constitution of a woman post-partum was thought to be cold and humid, particularly if she had given birth to a daughter. Chicken broth, served (in Italy at least) in a bowl made especially for the occasion (see pl.175 above), would restore much-needed heat and dryness to the mother's balance of humours.[57] Waterfowl, however, were subject to medical suspicion because of their dank habitat. The late fourteenth-century physician Velasco de Tarenta warned against the consumption of 'those birds dwelling in water, because they generate heavy humours and [their flesh] quickly becomes corrupt'.[58] Other water-dwellers, too, could have pernicious effects. In 1135 Henry I of England ignored his physician's advice and gorged himself on his favourite food, the eel-like lamprey. According to the chronicler Henry of Huntingdon, 'this meal brought on a most destructive humour, and violently stimulated similar symptoms, producing a deadly chill in his aged body, and a sudden and extreme convulsion'. A few days later, Henry died, the natural coldness of his elderly body (he was 67) exacerbated by the natural coldness of the lampreys.[59]

181. Bernard Palissy (attributed), dish.
Earthenware with coloured glazes, 53.3 cm long. Paris, 1565–85.
V&A: 5476–1859

Despite such medical calamities, fish was in fact a significant element in the Christian diet. Smoked, salted or eaten fresh, it was consumed during Lent (when meat was forbidden) and on the numerous other meatless days throughout the Christian calendar.[60] Writers also extolled the medicinal properties of other aquatic creatures. Toads, for example, refreshed the liver and were, according to Enrique de Villena, a particular favourite of the French. Italians apparently preferred to consume snakes.[61] On the other hand, the physician and translator Petrus de Abano, in his late thirteenth-century treatise on poisons, warned against the flesh of acquatic snakes, which was unhealthy because its properties were quite contrary to those of the human complexion. Moreover, snakes polluted water with their presence, making it undrinkable.[62]

In the context of these dietary theories, the water-dwelling creatures assembled on an oval dish by the French potter Bernard Palissy are not only a triumph of his art (the animals were cast from life) but also a joke for his princely patrons (pl.181). Palissy, who created watery garden grottoes in Paris for Catherine de' Medici, Queen of France, brought the garden indoors by turning a large serving dish into the representation of a freshwater pond.[63]

Even those who ate the diet most suitable to their complexion could not entirely avoid the danger of poisoning, inadvertent or otherwise. Fear of fire meant the kitchens in a grand house were usually a considerable distance from a banqueting hall, and keeping food hot or cold in transit and at table was problematic.[64] It was a situation that favoured food poisoning, though contemporaries tended to put a more suspicious slant on such circumstances. 'A person fearful of poisons', wrote Arnaldus de Villanova in the thirteenth century, 'should beware the hand from which he receives his food and drink, especially the drink of wine.'[65] Petrus de Abano agreed, and added that since this was the most pernicious and effective way for poison to enter the body, kings and prelates in particular should beware food, drink or medicine handed to them by their enemies.[66]

The design of tablewares often reflects attempts to protect against poisoning. Cups and goblets, for example, often had lids (pl.182).[67] Tableware and cutlery awaiting use on the table or buffet were also exposed to the malice of the poisoner, and so required protection. 'Coverpanes', as they were called in sixteenth-century England, were lengths of cloth (usually linen) placed over the principal place-setting of salt, trencher (a piece of stale bread or wood that served as a plate), knife, spoon and bread. The coverpane was only removed when the meat had been served and the diner seated.[68] More elaborate were the boat-shaped vessels, referred to in French inventories as '*nefs*' or '*vaissels*', that stored the master of the household's plate, cup and napkin until he had sat down. The 1380 inventory of the French king Charles V described a lidded '*navette*' (or 'little nef') of gold, which contained, when Charles was at table, 'his... spoon, his little knife and his fork'. Pope Felix V borrowed 'a small nef with six knives' and a silver-gilt nef with six silver dishes from the dynastic plate of the house of Savoy in 1440.[69] The word 'nef' could also refer to smaller, but equally decorative, containers designed to hold salt. An example of this type is the 'Burghley Nef', so-called after its discovery in the basement of Burghley House, Stamford, in 1956 (pl.183).

Poisons could be mineral, animal or vegetable. Governed in their turn by the humours, they could be hot, cold, dry or wet, but the nature of all of them was to destroy the human complexion by attacking the heart first, and then spreading to other parts of the body.[70] Princes were advised to deploy a battery of poison-detecting materials at table which would alert them to its presence. The scientific basis for this again lay in Aristotelian theories on how every object communicates something of its own inherent virtue to its neighbours in the cosmic hierarchy.[71] Thus the materials used to make a cup, dish, bowl or handle were often significant not just because they were valuable but because they warned of the presence of poison.

The poison-detecting virtues that medieval and renaissance writers ascribed to certain minerals

182. **Covered beaker (The Mérode Cup).**
Gilded silver, *plique-à-jour* enamelling and gold, 17.5 cm high (including cover). France, c.1400–1420. V&A: 403–1872

183. **Salt cellar (The Burghley Nef).**
Nautilus shell mounted in silver, partially gilded, 34.8 cm high. Paris, 1527–8. V&A: M.60–1959. Supported by the Art Fund (Cochrane Trust) and the Goldsmiths' Company

and gems derived from the works of classical authors, in particular Pliny's *Natural History* (see pp.260–61).[72] For example, the sixth-century bishop of Seville, Isidore, followed Pliny when he associated serpentine with snakes because of its markings, and explained that these were the origin of its Greek name *ophites* (for 'serpent').[73] Pliny and Isidore's words are echoed in John of Trevisa's late fourteenth-century English translation of Bartolomaeus Anglicus' work on the properties of things: 'Marble is y-cleped ophites, for it is y-spekked liche an addre'.[74] Serpentine's snake-like appearance meant it was seen as effective in driving away snakes: Pliny recommended serpentine amulets for the relief of snakebites (and headaches, too).[75] Although serpentine is not a mineral listed in the influential eleventh-century lapidary (a treatise on the properties of stones) of Marbode of Rennes, or in later vernacular translations, other written and material evidence suggests its protective properties were well-known.[76] 'A ston ys ther, That the serpent may noght hym noght dere. The name off home serpentyne ys,' wrote the author John Metham around 1450.[77] By extension, it seems that serpentine was an antidote to poison because it literally drove it out of the food or drink it contaminated. Hard and non-porous, serpentine was an ideal material for drinking vessels. The mazer shown here (so-called because the type was usually made of maple wood, or 'mazer') would originally have had a cover as well (pl.184). Sometimes just dipping a piece in a drink was enough to test for poison. Jean de Lut, goldsmith to the Duke of Orléans, recorded in an inventory of 1464 that he had gilded 'the serpentine of my lord which he puts in his cup when he drinks'.[78]

184. **Drinking bowl (mazer).**
Serpentine marble with silver-gilt mounts, 16.3 cm diameter. Britain, c.1500. V&A: M.248–1924

Other materials associated with snakes were also believed to be effective against poison. 'Snake's tongues' (in fact, fossilized fish teeth or prehistoric arrow-heads) were supposed to sweat in the presence of any type of venom.[79] This quality meant they were often set into tableware. Among the valuables owned by Charles V of France in 1380 was a gilded silver and rock-crystal salt, the lid of which had a knop made of five 'serpent's tongues'. They were also suspended from coral branches or silver stands, and placed on the table as poison-detecting ornaments. In the thirteenth century, Edward I of England owned 'five serpents' tongues set in a silver stand' thought to have belonged to Richard the Lionheart.[80] Although the possibility of a snake slithering around a dining table may seem remote, writers did warn against their presence in cellars and pantries, where 'all poisonous animals' were attracted to wine and could drink from – and fall into – wine vats, thus contaminating beverages before they were even brought to a meal.[81]

Cutlery, too, could incorporate materials sensitive to poison. A knife was a personal possession, and in part this was the result of a fear of poisoning. Indeed, so great was the perceived danger that until the 1550s guild regulations throughout Western Europe obliged cutlers, who made knife blades,

185. Carving set.
Steel, jasper handles with silver gilded mounts, 38 cm maximum length. Germany, c.1450–1500.
V&A: 1165–1864

to fill the hollow left by their stamped mark with brass, to prevent poison being introduced there.[82] Pairs of knives were common, one for meat and one for bread. They were carried in a sheath at the belt or in a case, hanging from a cord. The material of the sheath itself could act as an antidote to poison. Enrique de Villena observed that a stag's hide was the best type of leather for a knife-holder, because it had inherent anti-poison properties.[83]

Since the knife handles were usually visible above their sheath, they were often carefully worked or made of an attractive material, which might also detect or neutralize poison.[84] Certain types of jasper were prized for this property. Although writers generally agreed that the 'green and translucent' variety (which also cured fever and dropsy) was best,[85] one twelfth-century source observed that, in general, all 'jasper sweats in the presence of poison'. According to another lapidary, the red-and-white variety changed colour to warn its owner of impending treachery, which would certainly have included poisoning.[86] The gilded silver mounts for the fifteenth-century carving set shown here were doubly effective, as silver was considered the mounting material most suited to bring out the stone's various virtues, while the gilding lent the set an even more luxurious appearance (pl.185).[87] Carving was an art to be performed at table, and so the cutlery used had to be appropriately splendid.[88]

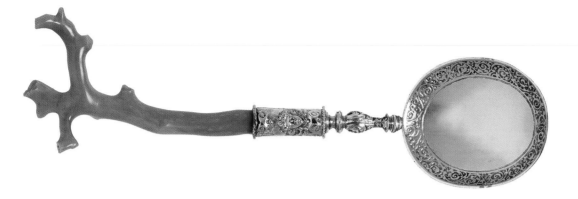

Other, non-mineral, materials with similar properties were also used for cutlery. A will drawn up in England in 1418 includes a pair of knives with handles of unicorn horn, renowned for its power to neutralize poison (see below).[89] Coral, too, had a range of protective properties, including the ability to ward off malignant magic. Among its many uses listed in lapidaries was to make knife handles.[90] A list made in 1566 of the Duchess of Cleves' possessions included 11 spoons with porcelain bowls and coral handles,[91] an invincible combination which certainly promoted admiration but may also have been intended to guard against poisoning (see pl.186).[92]

While notions of the poison-detecting virtues of gems and minerals originated in the ancient world, the belief that Chinese porcelain shattered in the presence of poison seems to have been inherited from the Turks. 'The noblemen mostly use porcelain', explains Pedro, a character in a sixteenth-century Spanish satire, 'because they feel safe in the knowledge that it cannot endure poison.' His dismissive comments about the belief in the West – he attributes it to salesman's patter 'to make money' – at the same time suggest its pervasiveness.[93] By the mid-sixteenth century, the date of Pedro's comments, Portuguese and, increasingly, Dutch ships were importing ever-greater quantities of Chinese porcelain into Europe (pl.187).[94] It had been less familiar to Europeans in earlier centuries, which perhaps explains the confused accounts in culinary and dining treatises of a material that, like porcelain, shattered on exposure to poison, yet was not identified as such. So, for example, the Catalan chef Ruperto de Nola, writing in the fifteenth century, warned that the most important noblemen should only ever drink wine 'in glass beakers, especially in a very fine glass that is called "selicornio", because poison can in no wise be served to drink in such glass because the good glass cannot endure it without shattering'.[95]

Nola's name for this magical glass owes much to that of another material considered a potent weapon in the armoury of poison-detectors: the unicorn horn. Despite its mythical origins, the unicorn featured consistently in accounts of the natural world,[96] and was admired for its power to purify water of poison by dipping its horn into fountains and pools (pl.188, bottom left). It was a belief easily transferred to the dining table. Velasco de Tarenta, who trained at the renowned medical school at Montpellier in the late fourteenth century, explained that a unicorn horn dipped in

drinking water protected the heart from poison and poisonous fumes.[97] In 1414 the Duke of Burgundy gave Henry V of England a large gold cup with a piece of 'unicorn horn' and 'other things against poison' set into the bowl.[98] More than a hundred years later, such fragments were still set into cups, for the same reason. The Duke of Escalona gave the future Philip II of Spain a lidded coconut cup 'from the Indies, mounted in gilded silver' with a fragment of 'alicornio' inside.[99] Rare, whole, examples of 'unicorn horns' were mounted to stand on the table and protect with their presence, but it was more usual for pieces of horn to be incorporated into jewellery and dipped into a cup of wine. Henry VI of England had such a pendant 'to put into our drink'.[100] In fact, these 'unicorn horns' were narwhal horns, but their confused origins did not diminish perceptions of the material's potency.

The rather drab appearance of a material known as 'toadstone' belied its supposedly fantastic origins. An early Greek treatise on the properties of stones, translated into Latin in the twelfth century, appears to be the source for the belief that this mineral comes from the head of a toad.[101] Alexander Neckham, Bishop of Cirencester in 1213, observed in his poem in praise of divine wisdom that 'He [i.e. God] orders the toad to serve us, which grows a little stone in its head that drives out poison.'[102] Petrus de Abano also extolled the virtue of this stone for curing cardiac arrest and death brought about by ingesting the blood or spit of a toad.[103] Toadstones – actually the fossil teeth of a fish, *lepidotes* – were sometimes set into cups, but they were more usually made into rings (pl.189): the Duke of Berry's 1416 inventory lists seven.[104]

If a diner drank too much then another stone, amethyst, would protect against drunkenness. The logical basis for this was the resemblance of the stone's purple shades to drops of red wine – indeed, the very name 'amethyst' means 'not drunken' in Greek. It was sufficient to wear an amethyst ring or pendant to ensure complete sobriety.[105] Not everyone was fully persuaded, however. The

king of France's physician, Laurent Joubert, writing at the end of the sixteenth century, included in his list of erroneous but popular beliefs 'whether amethyst, carried on the person, prevents drunkenness'.[106] Ideally, stones worn as protective jewellery should come into as much contact as possible with the skin, hence the settings for rings were often open on the underside. Rings were also more or less effective depending on which finger they were worn because of their contact with the hand's veins and the relationship between these and other parts of the body. For example, Isidore of Seville's sixth-century treatise outlining the duties of the clergy explained that the vein in the fourth finger of the right hand ran straight to the heart, and thus a ring worn on this finger was a sign of faithfulness.[107]

The health-preserving and status-enhancing aspects of many animal and mineral materials also made them wondrous objects to be sought in their own right. By the sixteenth century, princes and nobles (and wealthy merchants seeking to emulate them) set great store on bringing together collections of natural curiosities embellished with skilful and precious mounts (see pp.256–7). This means it is often difficult to establish precisely whether an object was commissioned for functional use, for its protective qualities, or for the rare and precious nature of its materials. References in inventories to single spoons of stone or shell suggest the last, particularly as such lists tended to specify the materials from which an object was made for the purpose of valuation. In 1493, for example, Bishop Ulrich of Freundsberg owned a serpentine spoon, and two of shell – one of mother-of-pearl, the other of the shell of an unspecified mollusc.[108] The coral-handled spoons commissioned around 1519 by the Elector August of Saxony seem to have been intended as an impressive cutlery set for special occasions, rather than as defensive weapons against poison.[109] As with natural materials, so too with man-made devices: beautifully wrought scientific instruments could be appreciated on the grounds of both function and artistry (see pp.262–3).[110]

189. **Ring.**
Silver set with toadstone, 1.6 cm diameter. Germany, 1500–1600. V&A: 713–1871

APPEARANCE, REFLECTION AND MORAL CHARACTER

The beliefs outlined above have had to do with smell and taste, but medical theory held that of the five senses, sight was the one most closely connected with the soul, and the eyes most clearly revealed a person's thoughts and will.[111] For example, in his biography of Alexander the Great, Plutarch, a Roman philosopher of Greek descent, had compared his literary portrait of the general with that by an artist: 'just as painters get the likenesses in their portraits from the face and the expression of the eyes, wherein the character shows itself…, so I must be permitted to devote myself rather to the signs of the soul in men, and by means of these portray the life of each'.[112]

One set of optical theories, which had originated in the ancient world and continued to be developed and debated by Arab and Christian scholars, argued that vision functioned by means of minute particles that constantly sheered off objects and imprinted themselves upon the viewer's retina. Another hypothesis proposed that the eye itself produced an inner flux or 'hidden light' (in the definition of one fifteenth-century lexicographer) which flowed outwards and into contact with its surroundings.[113] Marsilio Ficino, in his 1470s commentary on Plato's *Symposium*, made the same

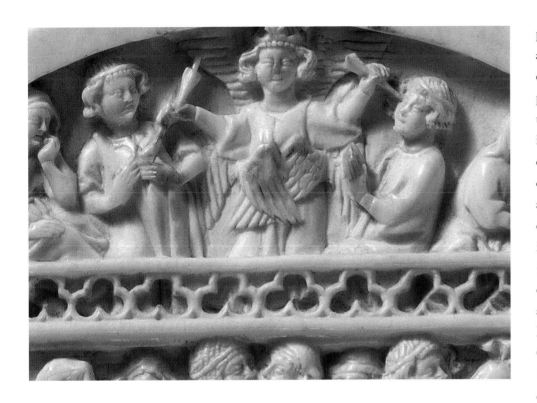

190. **Mirror back (detail showing the god of love).**
Ivory, 14 cm high. Paris, c.1350.
V&A: 1617–1855

point when he observed that the eye, 'open with attention, lets fly the arrow of its rays'.[114] In either case, the act of seeing was a process that made a physical impact upon the seer and the seen. It therefore followed that images left a tangible impression on the viewer, with whatever attendant effects this might bring. This was a belief endlessly exploited in writings on, and representations of, attraction and love. A detail on a fourteenth-century ivory mirror is a symbolic illustration of the importance of sight in the kindling of sexual desire (pl.190; see also p.295). The god of love, at the top of a castle, pierces the eye of the man to his left with an arrow; the man on his right receives one in his heart. Their situation recalls that of Alexander in Chrétien de Troyes's twelfth-century romance *Cligés*, whom Love's dart has struck in the eye. He observes, 'the eye is not concerned with the understanding… but it is the mirror of the heart, and through this mirror passes, without doing harm or injury, the flame which sets the heart on fire'.[115]

The theory also had implications for viewers looking at depictions of people, real and legendary, as it meant they received the visual messages presented by the artists as a physical impression in their brain. An image, therefore, was potentially as soothing or harmful as a spoonful of medicine or a draught of poison, and it followed that non-devotional as well as devotional images should show the faces of those who were morally good. Women (especially pregnant women) were believed to be particularly susceptible to the bodily effects caused by sight on their imagination. Leon Battista Alberti's treatise on architecture recommended that 'wherever man and wife come together, it is advisable to hang portraits of men of dignity and handsome appearance; for they say that this may have a great influence on the fertility of the mother and the appearance of future offspring'.[116]

In this context, mirrors could be instruments not so much for self-admiration as for self-improvement. This was another perception that dated back to classical times. In his *Instrvction Christiana* (Instruction of a Christian Woman) published in 1523, the Spanish scholar Juan Luis Vives cited Socrates to support his advice that women use their mirrors not to beautify their external appearance but to 'seek out any stain on their face which might turn their virtue ugly'.[117] In this moralizing context, mirror frames could be a convenient means of emphasizing the importance of outward beauty as a sign of inner virtue: the presence of a conventionally lovely face in the frame above the reflective surface enabled the person using the mirror to compare his or her own appearance (and therefore morality) with the ideal (pl.191).[118]

The correlation made between facial appearance and spiritual beauty accorded with the more general equation between external trappings, such as clothes, and moral and social worth. In the visual arts, an unambiguous iconographical shorthand developed during the Middle Ages whereby clothing became one of the principal means of conveying a didactic or political message about a pictured character (see also Chapter Five, p.166). Gesture and posture were also elements which an artist could use to convey moralizing information. This is particularly evident in the case of characters depicted in Christian narratives, where a beautiful or ugly appearance, posture and clothing combine to convey moral worth in absolute terms. Such stereotyping is apparent in the faces and gestures of the individuals in the crowd gathered around Christ in a painting from a twelfth-century book of psalms. Their twisted bodies and exaggerated gestures signal clearly their evil moral character (pl.192).[119] More generally, the gaping and distorted mouth, wide flat nose, bulging eyes and low forehead characterize the face carved into a twelfth-century corbel as demonic (pl.193).[120] It may originally have provided structural support for the façade of a building: a corbel of the same type still survives on the outside of the south transept of Winchester Cathedral.

Conversely, those suffering at the hands of such ugly characters are depicted according to conventional ideas of physical beauty, to show their inner purity. So, for example, Margaret, the 15-year-old daughter of a pagan prince of Antioch who was beheaded for her Christian beliefs, is a serene,

fresh-faced teenager throughout the scenes leading up to her murder carved on a German altarpiece of about 1520 (pl.194A). Jacobus de Voragine's widely disseminated account of her legend describes how Margaret's tormentors tore her flesh with iron rakes with such ferocity that 'her bones were laid bare and the blood poured from her body as from a pure spring'.[121] Yet sculptor and painter have depicted a woman whose features conform in every way to contemporary notions of someone beautiful, virtuous, healthy and well-born. Her skin is white and her hair fair and long. Her forehead is high, her features are symmetrical and her eyes are modestly lowered. She even has a slight glow in her cheeks. When not strung up on a gibbet, moreover, her posture is dignified and erect (pl.194B).[122] Her tormentors, by contrast, have ruddy complexions and low foreheads, their squatness made even lower by their hats and hairstyles. They stand with crooked legs and twisted backs as they carry out their grim tasks.[123] Their awkward gait and exaggerated positions suggest immoderate

194A. **Altarpiece dedicated to Saint Margaret (detail showing Margaret hung from a gibbet).** Oak, painted and gilded, 210 cm high (altarpiece). Lüneburg or Hamburg, c.1520. V&A: 5894–1859

194B. **Altarpiece dedicated to Saint Margaret (detail showing Margaret taken by her captors to prison).**

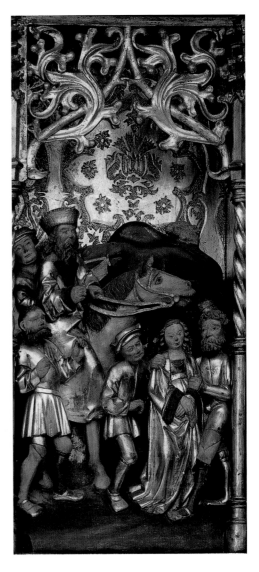

behaviour, a relationship noted since classical times and forcefully restated by Bernard of Clairvaux in the twelfth century: 'the strange movement of the body reveals a new disease in the soul'.[124]

The deforming effects of physical illness could also be presented as the result of moral corruption. Leprosy, in particular, was perceived in this way, in part because of its virulent impact on a person's features, but also because there was a biblical precedent for this interpretation. Ozias, King of Juda, had neglected to worship God and attempted to usurp the duties of the priests in God's temple. As a result, he was smitten with leprosy and deposed.[125] Ozias's fate haunted the rulers of Western Europe: a diagnosis of leprosy was a loaded one. Sancho, the rebellious second son of Alfonso X of Castile, described his father as 'leprous', and Henry IV of England was afflicted by a disfiguring disease which some likened to leprosy, with the implication that it was a sign of divine punishment.[126]

It followed that the ravages of disease, like those of martyrdom, were invisible on the complexions of saints. Saint Roch, patron saint of plague-sufferers, was himself the divinely ordained victim of bubonic plague,[127] yet the Spanish sculptor and painter responsible for his statue (pl.195) have been sparing in the depiction of his medical symptoms. Roch's lymph glands would have swollen at his neck, armpits and groin, forming tender, sore spots called bubos.[128] In this statue, however, although the saint's short tunic has been lifted to reveal his legs, the artist has depicted only one or two sore-looking grazes on his calves and shins. Meanwhile, Roch's complexion is a healthy, youthful balance of white and red, and his teeth are strong and white. The dog at his feet, which in the written account brought him bread as he lurked in self-imposed exile in a forest, licks Roch's sores. This is not only a sign of devotion: dog saliva was believed to heal wounds.[129]

PHYSIOGNOMY, PORTRAITS AND REALITY

In religious narratives, the temperament and moral worth of the characters was established and well-known, and in the context of the ideas discussed above the messages conveyed by their facial features and postures in paintings and sculptures were unambiguous. This direct connection between appearance and inner qualities was much harder to draw when considering representations of actual people.

Earlier centuries, although concerned to observe and analyse in writing the correspondence between facial type and moral character, had not considered it important to pay particular attention to physiognomy when recording the image of an individual.[130] Even in the sixteenth century, dress and gesture continued to convey identity, if not character. An example is the printed leaf reproduced here (pl.196), an account of the defeat of the Turkish naval forces at the battle of Lepanto in 1571. The German text on the leaf claims that the figure depicted both alive and executed with his head on a spike is 'a true likeness of the Turkish officer Ali Bassa'. In fact, the Pasha's short beard, turban and robes (patterned in a way that recalls Ottoman silk velvets) are part of a sixteenth-century tradition of propagandistic images which, in turn, parallel earlier depictions of Eastern sages (compare pl.2, p.231).[131] It is likely the person responsible for designing the print did not in fact

195. **Statue of Saint Roch.**
Wood, painted and gilded,
136 cm high. La Rioja (Spain),
c.1540–50. V&A: A.66–1951.
Given by Dr W.L. Hildburgh FSA

know what Ali Pasha looked like – or, indeed, what he wore in battle. The generic turban he wears here is very different from the headgear described in the inventory of battle trophies taken by the victors in the Spanish royal collections, where the entry for his helmet says it had 'thirty-six rubies, thirty small ones on the top and six in the ear-flaps and four turquoises and two false diamonds, and the whole [helmet] striped from top to bottom in gold'.[132] Ironically, the German account of the Pasha's defeat emphasizes the amount of treasure carried off by the Europeans, so the stereotypical depiction of the Turkish leader and his clothing under-represents his splendour.[133]

Even where ambitions for portraiture were raised above the stereotype, not all artists and theorists of the fifteenth and sixteenth centuries were agreed on how to represent a person in a way that was both physically and psychologically unambiguous. Some, indeed, wondered whether it was possible at all. In his writings, made between 1490 and 1513, and assembled posthumously as a treatise titled 'On Painting', Leonardo da Vinci worried about the artist's ability to convey inner thoughts and emotions. 'The good painter', he observed, 'has two principal things to paint: that is, man and the intention of his mind.' While the first was easy, depicting the concealed workings of the mind was difficult. Leonardo's solution to the problem was not to focus even more on the face, but to represent thoughts 'by gestures and movements of the parts of the body'.[134] Elsewhere he admonished his readers to 'portray figures with a gesture which will be sufficient to show what the figure has in mind, otherwise your art will not be praiseworthy'. Despite this, he also conceded that 'the face shows some indication of the nature of men, their vices and complexions'.[135]

At the start of the sixteenth century, though, a knowledge of physiognomy came to be considered useful for an artist. Pomponius Gauricus, writing in 1504, was the first to include a section on physiognomy in his work on sculpture. He stressed it was indispensable when modelling people from life, or representing them posthumously, because it was the means by which 'we deduce the qualities of souls from the features of bodies'.[136] By mid-century, reference to the subject had become standard in treatises on art. Paolo Pino, writing in 1548, explained that it was an 'honourable and useful' branch of learning for a painter, and cited Gauricus as his source. But Pino went on to imply that knowledge of physiognomy was only useful when depicting recognizable character types, such as a chaste woman, a miser or a cruel man.[137] It was not a means to reveal the inner workings of the human soul, but a source of templates for stereotypes.

The Dutch scholar Erasmus' misgivings about portraiture were based on his conviction that all individuals are unique.[138] He considered literature a more precise, and therefore revealing, means to depict a man's innermost soul. An engraved portrait of Erasmus by Dürer includes the Greek inscription 'his writings present a better picture of the man than this portrait' (pl.197). Leon Battista

196. *True Likeness of the Beheaded Turkish Officer Ali Bassa.*
Woodcut with stencil and hand-colouring on laid paper, 42 × 33 cm. Germany, c.1571. V&A: E.912–2003. Purchased through the Julie and Robert Breckman Print fund, and supported by the Friends of the V&A

197. **Albrecht Dürer,** *Portrait of Erasmus.*
Engraving, 24.5 × 19.2 cm. Germany, 1521. V&A: E.4621–1910. Salting Bequest

IMAGO · ERASMI · ROTERODA
MI · AB · ALBERTO · DVRERO · AD
VIVAM · EFFIGIEM · DELINIATA ·

ΤΗΝ · ΚΡΕΙΤΤΩ · ΤΑ · ΣΥΓΓΡΑΜ
ΜΑΤΑ · ΔΕΙΞΕΙ

· M D X X V I ·

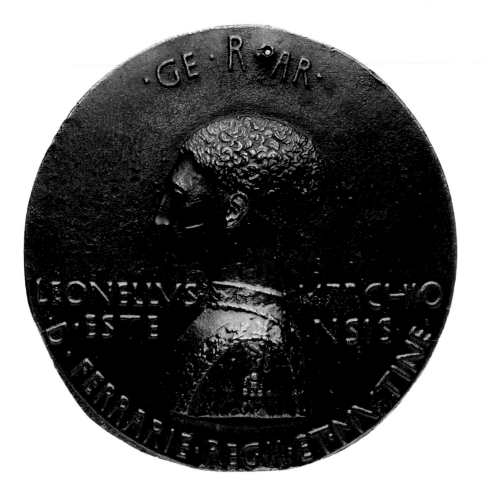

Alberti, writing his treatise on painting in 1436, stressed the technical difficulties involved: 'Who, unless he has tried, would believe it was such a difficult thing, when you want to represent laughing faces, to avoid their appearing tearful rather than happy?'[139] Patrons, too, were sceptical. In 1493, Isabella d'Este, Marchioness of Mantua, complained that she could not find 'painters who can perfectly counterfeit the natural face'.[140]

Sometimes the difficulty lay with the subjects themselves. Michelangelo, dissatisfied with the appearance of two members of the Medici family, deliberately did not represent their features accurately on their tombs in the Florentine church of S. Lorenzo, but altered them so they would appear graceful and splendid. His reason, recorded in a letter by Niccolò Martelli of July 1544, was that 'a thousand years hence no one would be in a position to know they looked otherwise'.[141] Francesco Bocchi, writing on art theory from a Florentine perspective in 1584, was preoccupied by the incongruity between looks and character. He noted how Alexander the Great's physique was 'not favoured by nature', and was at odds with his brave and noble deeds. The tall, wide-eyed and handsome Emperor Domitian, on the other hand, had appeared to be full of '*modestia*' (a word implying temperance and civility) when in fact he was the most wicked and dissolute man in Rome.[142] A small gold coin representing Domitian and issued during his rule illustrates the difficulties of applying physiognomic theory to images themselves. It shows him with staring eyes and quite heavy, wrinkled lids, features which could indeed suggest to the sixteenth-century physiognomist someone who was base of spirit, recklessly daring and prey to flattery and bribery (pl.198).[143] Yet the images of Domitian that circulated stamped on coins were not intended as realistic physical or

AETHERNA IPSE SVAE MENTIS SIMVLACHRA LVTHERVS
EXPRIMIT·AT VVLTVS CERA LVCAE OCCIDVOS

·M·D·XX·

200. **Lucas Cranach,** *Portrait*
of Martin Luther as an
Augustinian Monk.
Copperplate engraving,
14.1 × 9.7 cm. Wittenberg, 1520.
The British Museum
(1837-6-16-363)

psychological portraits: their stylized nature was designed to emphasize Domitian's role as absolute ruler in a form comprehensible to as many people as possible.[144]

Theoretical concerns aside, physiognomical stereotypes were useful artistic shorthand, particularly for official portraits or images intended for circulation. The leonine qualities of Alexander, described in the pseudo-Aristotelian treatise of the fourth century (see p.230 above), were echoed in fifteenth-century profile portraits of rulers and warriors.[145] Leonello d'Este, ruler of the city-state of Ferrara in the mid-fifteenth century, was one political figure depicted in such a way. Christened by his father after Sir Lionel, a character from the tales of Arthurian romance, Leonello alluded to the meaning of his name, 'little lion', in the personal devices he chose. Moreover, the way he was portrayed on bronze medals designed by his court artist Pisanello suggests that the physiognomy of his profile was deliberately enhanced – in line with physiognomical theories dating back to classical times – to convey a lion-like impression, with its attendant positive implications (pl.199).[146] The slightly bulging eyes and long, plain features recorded in other portraits are strategically altered in Pisanello's medallic interpretation to give a more compact and handsome profile. Moreover, the artist paid careful attention to the detail of Leonello's short hair, making it bushy and curly to recall a lion's mane (and a fierce lion at that: lions with long, shaggy manes were not thought to be as active or as brave as their short-haired relations).[147] This was a ruler-portrait for a restricted circle of learned admirers and friends, who would recognize the self-conscious association between Leonello's name and the appropriate physiognomical enhancement of his features.

The subject of many portraits was often the owner, or someone close to the owner.[148] In his treatise on painting, Alberti had observed that painting made the absent present (see also the objects discussed on p.288).[149] Hortensia Borromeo, Countess of Hohenems, whose husband had left to fight in the Low Countries, was overjoyed to receive his portrait in 1574. Thanking him, she wrote that 'the time of your absence now passes with far less pain than at first, for I will now delight in this image until your homecoming'.[150] Portraiture was often commemorative, too: in the early sixteenth century, Albrecht Dürer asserted that a portrait fulfilled one of the principal functions of art, namely that 'it preserves the likenesses of men after their deaths'.[151]

Alberti had also observed that 'painting… represents the dead to the living many centuries later, so that they are recognized by spectators with pleasure and deep admiration for the artist'.[152] Portraiture was informed by the notion of fame, both sitter's and artist's (see also p.72). Both colluded to present to posterity not only the unique physical and psychological presence of the subject, but also the skill of painter, engraver or sculptor. Lucas Cranach's engraving of Martin Luther, notorious for his challenges to the practices and hierarchy of the Catholic Church, encapsulates this idea of the portrait as a joint effort: the inscription reads, 'Luther himself expresses the enduring nature of his spirit, but his mortal traits stem from the wax of Lucas' (pl.200).[153] This kind of portrait said little about the medical complexion of the subject (Luther's lowered eyebrows and pale eyes were signs of madness to the physiognomist),[154] but revealed much about the self-image and self-regard of artist and sitter.

22. Cabinets of curiosity

ALEXANDRA CORNEY

THE PRACTICE OF COLLECTING and studying objects of interest by the wealthy and powerful men of Europe has its origins in the *studioli* or private studies of Italian noblemen of the fifteenth century. By the sixteenth and seventeenth centuries this practice had spread to Northern Europe where influential individuals such as the Holy Roman Emperor Rudolph II and Francis I, King of France amassed personal collections of remarkable objects known as *Kunst-* or *Wunderkammern*. Although these 'cabinets of curiosity' were strictly a private resource for their owners' enjoyment alone, we may see in the way they attempted to identify and classify the world around them the beginnings of what we now know as museums.

The contents of the cabinets could comprise objects as diverse as works of art, antiquities, items of natural history and scientific instruments. Illustration 22.1 shows the cabinet of the Italian apothecary Ferrante Imperato with his impressive collection of natural history specimens hanging from the ceiling. Scientific instruments were admired for the craftsmanship and ingenuity of their construction and also for their often magnificent appearance. The implication that the owner understood their function and the sciences they served, signalling to the outside world his erudition and wealth, made them all the more desirable.

As well as keeping up to date with the latest technology, collectors also had a keen interest in the cultures of Antiquity. By owning and studying a Roman bust like that of the god Zeus-Sabazios (22.2), its owner could identify himself with the great men of that time. Such objects were often displayed to form the focal point of a collector's study and were amongst the most prized in his collection.

Europeans had traditionally traded precious goods with the East Indies via the Silk Road. When the Ottoman Empire was established in the mid-fifteenth century, Europeans sought alternative sea routes. These voyages led to the discovery of the Americas and opened up the sea route to the East via the Cape of Good Hope. Strengthened trading links with distant cultures gave access to materials and objects that seemed exotic to European markets. Coral, mother-of-pearl and ivory were natural curiosities in themselves but were often carved or mounted in precious metals by master craftsmen to increase their allure, as seen in a spoon where a piece of coral forms the handle (pl.186). A porcelain cup would have been valued in China but, once it reached Europe, it might be mounted in silver-gilt and elevated to the status of a work of art (22.3).

European materials could also be finely worked to produce objects of desire. The intaglio of *The Judgement of Paris* by Valerio Belli (22.4) is carved in rock crystal, which would have been a relatively rare and precious material in the mid-sixteenth century. Belli worked in the papal court in Rome and his carved gems were often used to adorn larger pieces such as caskets. Even functional items in glass and maiolica might be made with such skill and decorated so highly that they found a place in the collector's cabinet alongside the more conventional ivory carvings and bronze casts. The wealthiest collectors commissioned or even exclusively employed the most prominent artists of the age – among them the sculptors Riccio and Antico – thereby becoming the arbiters of taste and leaders of contemporary culture.

22.2 ▼ Bust of Zeus-Sabazios.
Bronze, partially gilded and inlaid with silver and niello, 35.6 × 20.5 × 11 cm. Roman, 180–200 CE. V&A: A.581–1910. Salting Bequest

This bust depicts an obscure fertility god worshipped in Roman times in the area which is now modern-day Turkey.

22.4 ▼ Valerio Belli, *The Judgement of Paris*.
Rock crystal, 5.4 × 4.6 cm. Italy, 1500–45. V&A: A.23–1942. Given by Dr W.L. Hildburgh FSA

Belli was a highly regarded and skilled engraver of gems, an activity which necessitated sculpting on a miniature scale in precious materials.

22.1 ▲ Collection of natural history specimens, from *Dell'Historia Naturale* by Ferrante Imperato.
Engraving. Original edition Naples, 1599. V&A: L.8080–1983

This engraving is considered to be the first depiction of a collector's cabinet.

22.3 ▼ Mounted cup (The Von Manderscheidt cup).
Porcelain with silver-gilt mounts, 16.7 × 11.7 cm. China, 1522–66 and Germany, c.1583. V&A: M.16–1970

Known after the collection from which it came, this cup was made in China for export to Turkey and was subsequently intricately mounted in Germany.

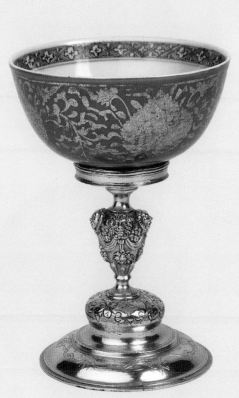

23. The Labours of the Months

MELISSA HAMNETT

THE TERM 'LABOURS OF THE MONTHS' refers to a picture cycle showing rural activities that commonly took place over the course of the year. Each month was typically illustrated by an agricultural task, such as sowing seeds or harvesting wheat, appropriate to the time of year. While most scenes were standardized according to the agrarian calendar, the seasonal cycle did occasionally vary according to region: for example, harvesting was shown a month earlier in southern European depictions compared to northern ones. Each labour was often paired with a corresponding sign of the zodiac, following the long-standing tradition of observing changes in the natural world as affected by the path of the sun.

This iconographical scheme originated in the Ancient Roman world and appeared as a popular topic in many different media across Europe. Although the treatment of comparable scenes often varied in small ways, the iconographical consistency shows that their portrayal was governed by hallowed traditional models. Thus, while the Labours acted as generic depictions of regional peasant life and agrarian rituals, they were not necessarily realistic (23.1). Instead such scenes were idealized, the months and their tasks reflecting conventional ideas of peoples' position in the cosmic order.

In view of this, and of their accessibility, depictions of the Labours were also theologically important. They reinforced a sense of mankind's orderly and productive relationship with the natural world within a specific social hierarchy – those who looked after humanity's spiritual needs, those who defended it against injustice, and those whose job it was to feed it. It was an accepted truth that Adam's fall from grace had led to the punishment of incessant toil, and depictions of the Labours in churches were designed to remind the congregation of original sin while encouraging them to believe that they could leave it behind through the work of divine grace.

Depictions of the Labours became increasingly popular from the twelfth century onwards, going on to achieve full vitality in Western Europe by the sixteenth century. They were shown in public places, such as the interior and exterior of churches through sculpture, carved choir stalls and stained glass, and also appeared on baptismal fonts and doorways. Examples could also be seen in more intimate settings, as the luxury embellishment of stained-glass windows in private houses or in a tapestry hung above a bench in church or home (23.2). Inevitably, however, the context in which the Labours were placed affected the ways in which they were regarded. Devotional manuals known as Books of Hours opened with illustrated calendars of the Labours, not only providing their individual owners with instruction on feast days and harvests (23.3) but also delightful decoration which could be enjoyed just for itself. They could also be used to impress distinguished guests in the intimate space of a study: Luca della Robbia made a series of roundels showing the Labours for the ceiling of Piero de' Medici's study in Florence (23.4). Here, they not only performed a decorative function but also an intellectual one, being based on a Roman agricultural treatise.

Wool and linen, 39 × 273 cm. Alsace (France), 1440–60. V&A: 6–1867

The simple tools shown here with each Labour give an idea, although idealized, of the manual activities of ordinary folk rather than of the nobility who owned such tapestries.

23.1 ◄ **Roundels showing Labours for the months March, June, July and August.**
Clear glass with painted details and yellow stain, each 21.5 cm diameter. England, 1450–75. V&A: C.123 to 6–1923. Presented by The Art Fund

Although they were grown there in Roman times, vines were not an important crop in fifteenth-century England as the scene on the glass suggests.

23.3 ▶ **Simon Bening, double-sided leaf from a Book of Hours.**
Watercolour on vellum, 14 × 9.5 cm. Ghent, 1510–60. V&A: E.4576–1910

This miniature depicts the act of reaping, the Labour for August/September; the other side of the leaf (not shown) depicts the act of ploughing, the Labour for September/October.

23.4 ▲ **Luca della Robbia, roundel showing the Labour for the month of December.**
Tin-glazed terracotta, 59.7 cm diameter. Florence, 1450–56. V&A: 7643–1861

The border, coloured light and dark blue to indicate relative lengths of day and night, bears a crescent moon and possibly traces of gilding that may once have been stars.

24. Pliny's *Natural History*

KATY TEMPLE

THE *HISTORIA NATURALIS* (NATURAL HISTORY) is the sole surviving work by the Roman writer Pliny the Elder (23–79 CE). Comprising 37 books presenting the natural world as he saw it, rambling and anecdotal at times, it encompasses topics as varied as zoology, medicine, geology and art, and veers from the accurate to the wildly fantastical. Pliny combined direct observation with references drawn from older classical sources such as Aristotle and Varro, and remained largely unchallenged as an authority until Niccolò Leonceno's *De Erroribus Plinii* (On the Errors of Pliny) was published in 1492.

The V&A's manuscript of Pliny's *Natural History* is dated to the 1460s and contains the arms of Gregorio Lolli Piccolomini, cousin and secretary to Pope Pius II. This type of illuminated manuscript was very fashionable among wealthy patrons interested in classical texts. The decoration of the historiated initial 'A' for Book VIII, 'On Land Animals' (24.1) reflects the medieval bestiary tradition in the fantastic and human attributes of the animals presented. Although bestiaries were based on an understanding of natural history derived from texts such as Pliny's and from Aristotle's *De Animalia*, their main focus was vividly to illustrate and describe the characteristics and habits of animals as religious allegories of human moral behaviour. Distinctions between real and imaginary animals were not made, and there was little concern for scientific accuracy.

The lion, elephant, dragon and leopard illustrated here are the first four animals discussed in Book VIII. Despite his anthropomorphized face, the lion is the most anatomically accurate of the four beasts, doubtless reflecting the relative accessibility of lions in princely menageries throughout Italy and Europe. Pliny's comment – that 'they do not look at you with

eyes askance and dislike being looked at in a similar way' – is strangely contradicted in this depiction. Using an elephant to illustrate Book VIII was a well-established late medieval tradition. The paws, trunk and ears here are unlike those of real elephants. Feet seem to have been a singular problem when depicting the exotic creature, perhaps because they do not correspond to the feet of any European mammals. There was a tendency to err towards a hoof or paw, as seen here and in the otherwise anatomically accurate reverse of a medal of about 1453 (24.2). Pliny presents the dragon or snake as the elephant's arch enemy, and the former was no less real to the fifteenth-century mind. Indeed, Leonardo da Vinci apparently saw no reason to doubt the existence of dragons when he sketched them in the early sixteenth century.

In contrast, the more familiar guises of the animals illustrating Book XXVIII, about the scientific use of animals for medicine (24.3), demonstrate first-hand knowledge: the hoopoe, tortoise and porcupine were all found in Northern Italy, although not mentioned in the text. The zoological illustrations for the V&A manuscript thus combine medieval iconographic traditions with early renaissance naturalism.

Although some of Pliny's assertions on animals seem fanciful today, he nevertheless helped lay the foundations for the modern discipline of natural history. In the sixteenth century his work was even more widely disseminated and valued as a classical text, although its scientific authority declined. Zoological studies, still heavily influenced by Pliny, were progressed and published by figures such as the Swiss botanist and zoologist Conrad Gesner and the Italian collector and naturalist Ulisse Aldrovandi.

24.1 ▶ Historiated initial 'A' from the start of Book VIII, 'On Land Animals', of the Piccolomini manuscript of *Historia Naturalis* **by Pliny the Elder.**

Ink on parchment, with watercolour and gold, initial 10.5 × 10.5 cm. Rome, *c.*1460. V&A: MSL/1896/1504

The face of the lion was possibly an attempt to humanize the attributes of strength and nobility commonly associated with the king of beasts. In his chapters on lions Pliny frequently refers to their nobility of spirit.

24.3 ▶ Historiated initial 'D' from the start of Book XXVIII, 'On Remedies from Animals', of the Piccolomini manuscript of *Historia Naturalis* **by Pliny the Elder.**

Ink on parchment, with watercolour and gold, initial 10.5 × 10.5 cm. Rome, *c.*1460. V&A: MSL/1896/1504

The man dissecting a kid may be extracting the stomach for rennet, Pliny's recommended antidote for 'the stings or bites of all sea creatures'.

24.2 ▲ Matteo de' Pasti, medal of Isotta degli Atti (reverse), with an elephant in a meadow.

Cast bronze, 8.3 cm diameter. Rimini, *c.*1453. V&A: A.174–1910

Isotta was the mistress and later wife of Sigismondo Malatesta. The elephant was a favoured emblem for the powerful Malatesta family, projecting fortitude and fame.

25. Science in the Renaissance

SOPHIE LEE

THE MINING ENGINEER and metallurgist Georg Agricola caught the spirit of contemporary scientific enquiry when he wrote in 1547 that through a practical study of nature '... man acquired an indefinable something beyond that which seemingly was allotted to the human species'. This educated curiosity about the natural world, a desire to record new knowledge for practical use and profit and a delight in capturing the ingenuity of nature in man-made form were the characteristics of scientific study before the early seventeenth century.

Western scientific, especially astronomical, knowledge expanded in the tenth and eleventh centuries when Islamic texts following the scientific traditions of Ancient Greece (brought into Europe through the Islamic conquest of Spain) were translated into Latin. By 1200, the universities of Paris, Bologna and Oxford included astronomy and natural philosophy (the study of nature) in their curriculum. Importantly, the Church sanctioned these studies as a means of better understanding theology, so allowing free scientific enquiry to flourish. Theologians studied the stars to calculate the shifting dates of the church calendar and argue for calendar reform.

The fields of time-telling, oceanic navigation, surveying and engineering (especially mining and military) were the chief beneficiaries of new ideas in mathematics, astronomy and geometry. Common to each were instruments designed to measure angles between distant objects, using a sight that moved over a circle or arc marked with a scale. Instrument makers needed to be multi-skilled, conversant in the mathematical arts as well as expert at engraving (essential for accuracy) and decorative techniques. The objects could be of great beauty, wrought from brass, silver, polished wood and ivory and of multiple use (25.1).

Alongside a desire for the practical application of new discoveries was an ease, even among leading scholars, with older mystical beliefs such as alchemy, magic and astrology. Astronomical models of the heavens, like the astrolabe, the armillary sphere and celestial globe, were also used for astrological study and the renaissance revival of interest in classical mythology brought the iconography of planetary gods and zodiac signs into decorative use.

From as early as the fourteenth century models of the cosmos were prized as examples of man's technical virtuosity and ability to control nature. Globes were displayed alongside automata and clocks as *scientifica* in court treasuries to dazzle visitors and satisfy the intellectual aspirations of their owners, such as Emperor Rudolph II in Prague (25.2). Instruments even appeared in portraits as hallmarks of learning. The earliest mechanical clocks, found in cathedrals and monasteries, were effectively cosmic models, their complex displays of heavenly bodies in motion suggesting a less mundane purpose than simply announcing the daily offices of the church (25.3).

The seventeenth century would usher in a new age of scientific study: sceptical, objective, compartmentalized and demanding high-precision instruments unencumbered by superstition. Astrology had relied on the classical universe of Plato, fixing the earth at its centre. The cosmic model of Nicolas Copernicus, placing the sun at the centre, was shockingly revolutionary and discredited for much of the sixteenth century, but its adoption in the following would transform the scientific world.

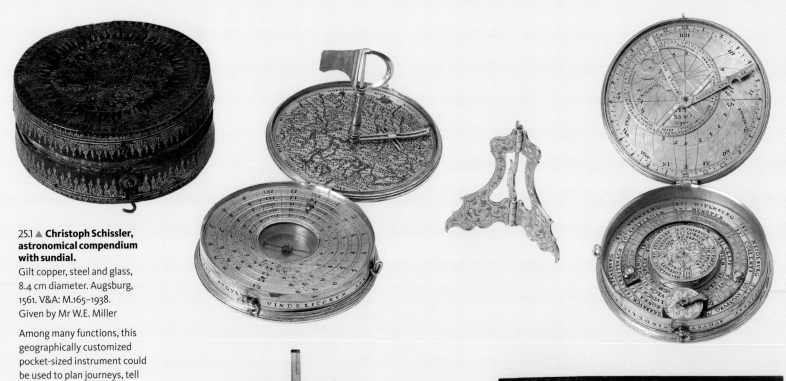

25.1 ▲ Christoph Schissler, astronomical compendium with sundial.

Gilt copper, steel and glass, 8.4 cm diameter. Augsburg, 1561. V&A: M.165–1938. Given by Mr W.E. Miller

Among many functions, this geographically customized pocket-sized instrument could be used to plan journeys, tell the time and the date, calculate the time of sunset and make astrological predictions.

25.2 ▶ Georg Roll and Johannes Reinhold, astrological clock in the form of a celestial globe.

Gilt copper alloy, with steel and brass movement, 30.4 cm diameter. Augsburg, 1584. V&A: M.246–1865

Made at the height of a craze for astronomical clocks as a treasury piece for Rudolph II, this globe simulates the movements of the sun, moon and stars, so could be used for astrological predictions as well as telling the time.

25.3 ▲ Fra Raffaello da Brescia, still life *trompe-l'oeil* panel.

Intarsia (inlay of various woods), 110.4 × 77.7 cm. Bologna, 1513–37. V&A: 150–1878

The Church was an enthusiastic patron of scientific study. Here a mechanical clock stands alongside a chalice, crucifix and religious texts.

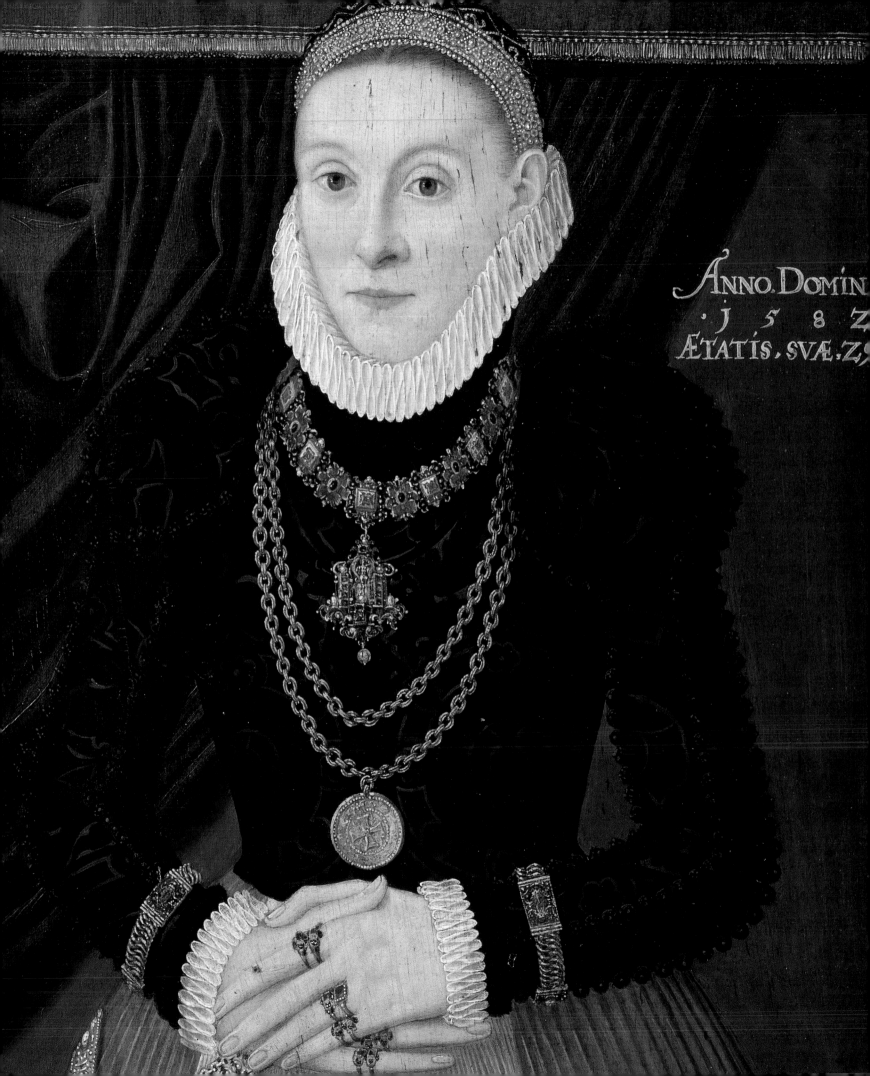

ANNO. DOMIN
·1 5 8 Z
ÆTATIS. SVÆ. Z9

PEOPLE AND POSSESSIONS

Kirstin Kennedy

'LAY NOT UP TO YOURSELVES treasures on earth: where the rust, and moth consume, and where thieves break through and steal,' admonished Saint Matthew. Instead, men and women should 'lay up to yourselves treasures in heaven… : For where thy treasure is, there is thy heart also.'[1] Yet his warning was routinely ignored even by the pious (see Chapter Six): material possessions were vital expressions of people's identity. As earlier chapters in this book have argued, possessions revealed their owner's place in the social hierarchy: the influence they exerted, their financial and moral worth, their family or institutional allegiances, their gender, profession and even their age. Objects also reflected the discernment of their owners, and their concerns for their spiritual and bodily health.

Purchase with money was not the only way to amass possessions: payment in kind, gifts, dowries and inheritance were also significant ways to accrue them. The most important possession was land, and inherited land – which usually passed to the first-born male heir – was a clear marker of a family's status and wealth.[2] Preserving and, if possible, increasing land holdings were significant and perennial concerns that preoccupied tenth-century Catalan farmers and fifteenth-century Ferrarese princes alike, not to mention emperors and kings across Europe.[3] Addressing his heir Alfonso in 1252 the dying Ferdinand III of Castile said,

> Son, you are rich in lands and in many good vassals. If you should manage to
> hold it all in the way in which I leave it to you, then you are as good a king as I;
> and if you should enlarge it, you are better than I; and if you should lose any of it,
> you are not as good as I.[4]

On a different scale to land-ownership, movable possessions too were important in fixing a family

**Anonymous, *Portrait of
a Lady in her 29th Year*
(detail).** See pl.207, p.273.

265

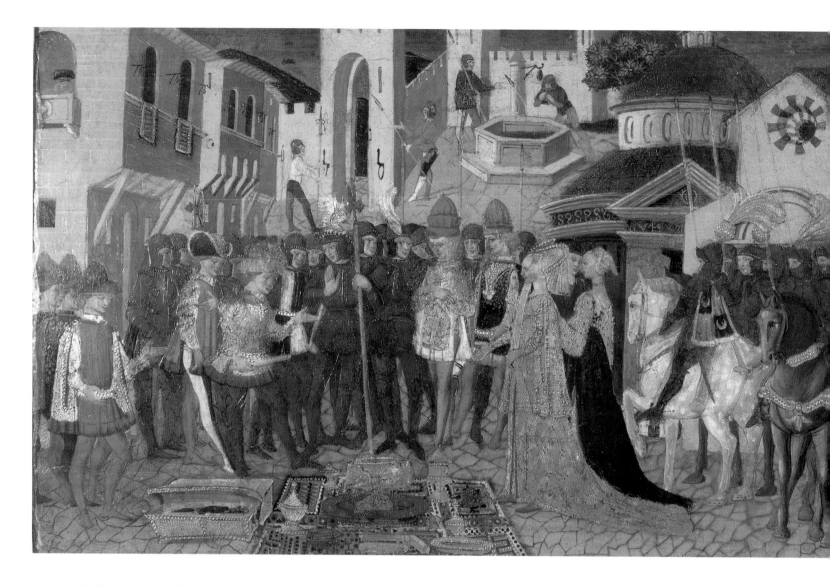

201. **Apollonio di Giovanni, panel from a marriage chest showing the Continence of Scipio.**
Tempera and gilding on poplar panel, 43.5 × 133 cm. Florence, c.1463–5. V&A: 5804–1859

or institution's standing within a community. If made of a valuable material such as silver or silk, they were also a financial asset because they could be reused or sold on. The coded messages such items conveyed remained consistent,[5] but the type, quantity and value of possessions owned by individuals or families varied across Europe according to time, place, circumstance and fashion. In fifteenth-century Italy, for example, wealthy families invested most in clothing, servants and food to proclaim their status. The Venetian ambassador was baffled to observe that their counterparts in England invested their money in silver plate instead.[6] The English love of silver was remarked upon by others: in 1584 a German visitor commented that 'he must be a poor peasant indeed who does not possess silver-gilt salt cellars, silver cups and spoons'.[7]

Nevertheless, this form of self-expression through ownership was still unattainable to the many who continued to exist at subsistence level throughout the medieval and renaissance period. All were at the mercy of extreme weather conditions and poor harvests: 'In 1570 there was the greatest shortage' was the brief but expressive Latin inscription scratched into the religious fresco painting in the chapel of S. Sebastian in Arborio, near Milan.[8] Yet despite periodic interruptions of war and plague, the gradually growing European population and widening trade links meant that the number and range of goods available steadily increased between the fourth and the sixteenth centuries.[9]

NECESSARY EXPENDITURE: OBJECTS, STATUS AND DUTY

Rulers and noblemen were expected to surround themselves with beautiful and valuable possessions: such expenditure was a necessary expression of their status and power. It was a princely duty to own costly objects, such as a serpentine vase that may have belonged to Margaret of York, sister of Edward IV of England and the third wife of the Duke of Burgundy (pl.202). It was mounted as a ewer by the Mechelen goldsmith Zegher van Steynemolen, who is known to have carried out commissions for members of Margaret's family and her circle, and the prominent gold rose on the lid recalls her personal emblem of a white rose. Even without such suggestive evidence, the valuable materials and skilled workmanship of this ewer make it a possession entirely appropriate to someone of her rank.[10]

Clothes were another obvious indicator of power. Cosimo I de' Medici combined splendour and practicality when he entered Rome in November 1560. As one observer recorded, he wore 'a long black velvet overgown with gold embroidery around it… and above a pink cloak richly decorated in gold on account of the rain'.[11] A monarch dressed in less formal attire risked the scorn of onlookers and the criticism of historians. In 1463, Louis XI of France rode to meet the Duke of Burgundy dressed as a huntsman, with a little huntsman's horn slung round his neck. The pro-Burgundian chronicler Georges Chastellain was careful to note the shocked comments of those who lined the

streets to receive him: 'Is that a king of France, the greatest king in the world? He looks more like a groom than a knight. Between them the horse and his clothing are not worth twenty francs.'[12]

Dining in particular provided for displays of wealth, power and generosity. Presenting guests with an array of carefully placed and valuable plates and bowls had been a custom practised in Ancient Greece, Rome and the Islamic world.[13] Christian Western Europe followed suit. Hosts fashioned stepped structures known as dressers, buffets or (in Italy) credenzas upon which to display cups and dishes, which were dismantled once the banquet was over.[14] A three-tiered credenza is depicted in the centre of a mid-fifteenth-century panel from a marriage chest (*cassone*) showing the deeds of the Roman general Scipio Africanus, who captured Cartagena (New Carthage) in 209 BCE (pl.201). According to the Roman historian Livy, Scipio refused to take the most beautiful woman in the city as his bride when he learned she was already betrothed to the son of a local chieftain. The scene on the right of the panel shows the marriage celebrations for the reunited couple, portrayed according to fifteenth-century fashions. As befits the wedding of a nobleman, the credenza is laden with gold plate. There is even a large nef on the top tier (see p.240), a striking detail which may be an allusion to the Florentine family who commissioned the chest.

On specific occasions, the number of tiers on a credenza was intended to symbolize the rank of the most important person present. Eleanor de Poitiers, surveying the intensely fashionable proceedings at the Burgundian court in the 1480s, noted that five tiers signalled the presence of the Queen of France whereas a duchess could command only four.[15] The opportunity to view such splendour was equally determined by rank. Many hundreds of dignitaries and their servants could attend such occasions. The heralds officiating at a dinner hosted by Charles V of France on 5 January 1378 reported that there were eight hundred to a thousand foreigners and Frenchmen present, and that despite such a multitude 'the service was very honourable… and all those who dined were served… both the low [i.e. not on a dais] and distant tables as well as the high and nearby ones'.[16] Another banquet hosted in Paris by Charles V the following day provides a striking illustration of this combination of splendour and etiquette, which continued into the sixteenth century. The dinner was held in the great hall of Charles's palace, and the honoured guests were Charles IV, Emperor and King of Bohemia, and his son Wenceslas, who had been elected King of the Romans two years earlier. Of the three dressers that had been assembled, the largest was in the corner, near the three monarchs. It was decked with gold plate and large bottles of enamelled silver. The second dresser, placed nearer diners of slightly lower rank, was stacked with plate – pots, bottles and other vessels – that was only gilded. The third dresser was in the centre of the hall, and was piled with ungilded silver used for serving. The value of the objects on display meant security was an issue, and the dressers were fenced around with spiked barriers, and the access points to them guarded. The approach to the seats of Charles V and his royal guests was also fenced off and the entryways barred by guards.[17]

Not everyone ate off plates of silver at such events. The type of vessel and the type and quantity of food allocated to diners was strictly determined by social hierarchy, and the conventions were broadly the same across Europe. In 1380 Sybil, wife of Peter IV of Aragon, hired 500 wooden bowls

202. **Zegher van Steynemolen, mounted vase in the form of a ewer.**
Green serpentine and gilded silver mounts, 15.2 cm high. Mechelen (Belgium), 1468–91 (mounts); c.100 BCE–100 CE (vase).
V&A: 627–1868

203. **Trencher.**
Unpainted beech or sycamore wood, 18.2 × 18.6 cm. England, possibly 1500–1700.
V&A: 702b–1891

and plates for the less important members of the court entourage (see pl.203).[18] Even the amount of meat a diner ate was commensurate with his status: a lowly groom could expect to receive little if any.[19]

Commentators were quick to notice when the vessels used did not match the circumstances. A banquet hosted in Rome by the Emperor Frederick III to celebrate his 1451 marriage to Leonor, eldest sister of King Afonso V of Portugal, and her coronation as the new empress, failed to impress the Portuguese contingent, in large part because of the insufficient and shabby objects on show. Lopo d'Almeida, Leonor's private secretary, described the event in a letter to Afonso. He noted that the tablecloths did not reach the edges of the tables and that his hosts had initially used only cakes of wax for lighting. On the emperor's table these were eventually replaced with a silver candlestick, but so grubby was it 'that it seemed to be of iron'. The silver drinking cups displayed on another table, meanwhile, were 'few and poorly repaired'.[20] A few decades later, Nicolaus von Popplau, a German nobleman travelling in Portugal in 1484, gave an equally poor report of the Portuguese court. He thought the tablewares used by King John II and his son Afonso were so ordinary that they made the monarch and his heir seem like 'princes in a countryside court of little importance'.[21]

GIFTS: REWARD AND INFLUENCE

Aristotle had argued that men should exercise 'liberality in the matter of property'. His argument was nuanced by the fifteenth-century political theorist Niccolò Macchiavelli, who advised rulers to 'be more liberal with what does not belong to you or your subjects'.[22] Whatever the source, liberality, in the form of gift-giving, was another important element of royal activity. Monarchs needed to ensure they had an available stock of appropriate gift items, although these need not necessarily be tailored to suit their recipients, as the standard size of velvet 'robes of honour' from Istanbul to Venice suggests.[23] Jewels, too, could be valuable gifts, but it was only in 1530 that Francis I of France established the notion of 'crown jewels', that is to say, jewels which were particularly associated with the royal household and which could be copied and presented as rewards for loyalty.[24] It is believed that Elizabeth I of England gave a fabulous jewel to her admiral Francis Drake some time before 1591, perhaps as a reward for his role in the defeat of the Spanish Armada (pl.204). The jewel commemorates Elizabeth's queenship: the male and female heads carved on the cameo arguably represent the planetary god Saturn and the virgin goddess Astraea (with whom Elizabeth herself identified), a pairing which suggests a return to a legendary golden age of peace and prosperity. The reverse of the pendant opens to reveal a miniature portrait of Elizabeth and, on the underside of the lid, a painting of a phoenix. The mythical bird was another device associated with the queen and symbolized renewal and chastity.

Gift-giving was equally significant at lower levels of society (see pp.294–5). Not everyone gave, or received, the same gifts: the expense of a present was carefully calibrated to suit not only the occasion but also the status of both giver and recipient. Appropriate opportunities for gift-giving included the feast of a local patron saint, the entry of a dignitary or monarch into a town, or annual events determined by the calendar, such as New Year. On 1 January 1556, Sir Frances Englefilde,

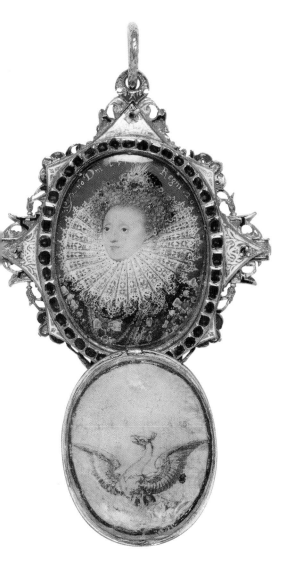

204. Nicholas Hilliard (miniature), pendant (The Drake Jewel).
Sardonyx cameo, rubies, diamonds and pearls, enamelled gold, watercolour on vellum, 11.7 cm high. London (miniature and setting), possibly Italy (cameo), probably 1586.
V&A: Lent anonymously

master of the wards, presented Queen Mary with 'a spice box of silver, and guilt, with a spone in it, guilt'. Henry Mylles, a grocer, also gave her a present, but in keeping with his status and economic resources, his offering was more modest and consisted of 'a bottell of roose water, a lof of suger, sinamon, gynger, and nutmegges, in paper'.[25] Institutions also engaged in the practice. Two silver-gilt, gourd-shaped standing cups are listed in the inventory of plate owned by William, Earl of Pembroke, and are distinguished by the clerk as having been 'geven to my Lorde for an newe yeres gyfte by Sir William Chester and the rest of the Companie of the Stapelares, Anno 1562'.[26] Certain types of object were also associated with particular ceremonies. The ship-like dining vessels known as nefs appear to have been the gift of choice for French town authorities required to present a visiting monarch with a suitable token, as did the townsmen of Paris to Emperor Charles IV in 1378.[27] Less expensive tokens could be reproduced in series as commemorative souvenirs to supporters who had a more distant connection with the giver. The medal shown here, mounted as a pendant, was issued by the bishop of Bamberg, Johan Philipp von Gebsattel (pl.205). It depicts him, aged 44, on the obverse while his insignia appear on the reverse.

Other gifts were intended to smooth diplomatic or mercantile relationships. Anthony Jenkinson, a member of the London-based Worshipful Society of Merchant Adventurers, had travelled to Moscow in 1561 as part of a mission to secure new trading partners. He arrived with 'the present, by your worshippes appoynted, for the Emperours Maiestie'. This gift (which he does not describe) was 'gratefully accepted', but it did not have the desired effect of immediately persuading the tsar to grant Jenkinson permission to travel overland to Persia.[28]

Many presents were passed on to others, thereby reinforcing networks between gift-givers and recipients. In 1541, the Duke of Escalona presented the future Philip II of Spain with an elaborately mounted coconut cup from 'the Indies'; Philip passed the gift to his butler, Antonio de Rojas.[29] Later in the sixteenth century, Elizabeth I was forced by economic necessity to recycle recent gifts. Records show that a gold cup presented to her in 1573 by the Corporation of Sandwich was given away six years later to Jean Simier, favourite of the Duke of Anjou, who was representing his master's interests in his quest for Elizabeth's hand in marriage.[30] Others also passed gifts on as circumstances required. After his trading expedition to Persia, Anthony Jenkinson returned to Moscow in 1563 with goods that the tsar had ordered, as well as wares to take back to England. Among his personal possessions was 'a rich garment of cloth of gold', a gift from the shah who had presented it as he dismissed Jenkinson (and his petitions). When Jenkinson found himself in the tsar's presence, he 'presented vnto him the apparell giuen vnto me by the Sophie'.[31]

POSSESSIONS AND SOCIAL ASPIRATION

Inherited lands or monies were not the only means of acquiring wealth: commerce and trade could also bring riches and influence.[32] An emerging class of wealthy, town-dwelling merchants established dynasties of their own, sought to identify themselves with coats of arms, and engaged in the kinds of art patronage associated with noblemen such as building palaces, endowing churches and

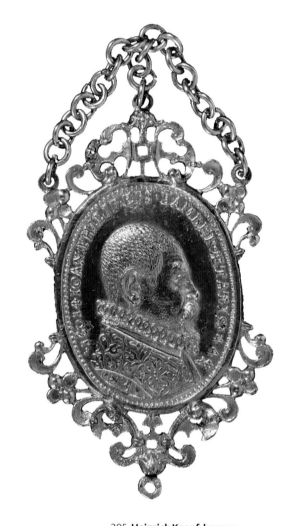

205. **Heinrich Knopf, honour medal (*gnadenpfennig*) of Johan Philipp von Gebsattel.**
Gilded silver, 8.7 × 4.3 cm. Germany, 1601. V&A: 66–1867

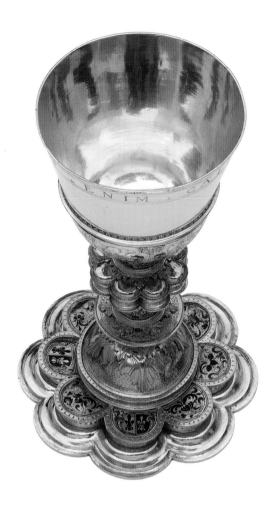

206. **Chalice with the arms of the Fugger family of Augsburg.**
Silver, silver-gilt and enamel, 21 cm high. Probably Spain, c.1550.
V&A: 133–1879

collecting rare and precious objects. Sir Paul Pindar, for example, was a businessman with international trading interests who was so wealthy he could afford to lend money to the English Crown (see pp.298–9). The Fugger family of Augsburg were bankers and merchants who prospered thanks to the financial difficulties of the ruling European houses of the sixteenth century. The chalice pictured here has their arms enamelled around the foot and may have been commissioned for S. Salvador, a church the family founded near Madrid (pl.206).[33]

Such gestures were greeted with suspicion by contemporary commentators. Antoine de Lalaing, who accompanied Philip the Fair of Burgundy on his travels to Spain in 1501, stayed at the mining town of Schwaz, in the Tyrol. He observed how the wealth of the mine had enriched the merchants there, and how they had repeatedly petitioned the king to allow them to pay for refurbishment of the whole town. However, 'the King did not allow this, because he feared… they would claim the mines for their own and… also that their wealth would make them rebel'.[34] The sceptical and nationalistic English traveller Fynes Moryson, in an account of his journey through Germany, dismissed the Fuggers in terms that revealed a view of a social hierarchy still determined by status at birth. Describing the castle at Augsburg, Moryson noted that it belonged to the Fuggers who, he opined, 'are rich and famous for their treasure; and though they have princely revenues, and the title of barons, yet stil are merchants'.[35]

Yet the possessions of the less spectacularly wealthy among this emerging group suggest a preoccupation with the concerns of their own class rather than a desire to emulate the trappings of the aristocracy. Inventory evidence shows that instead of scenes of warfare (especially against the infidel), a subject preferred in court circles, wealthy Barcelona merchants of the late fifteenth century slept beneath baldaquins bearing mottos such as 'He who harvests in time, will have both grains and straw' or 'No one should fear too much work, with time it brings prosperity that enables a man to become established.'[36]

Those who were wealthy but not aristocratic could nevertheless attempt to advertise their status and financial resources in the same way as their social superiors: in 1345 the Barcelona town council attempted to curb the profusion of family coats of arms on display at the weddings of non-noble couples.[37] Other vehicles of self-assertion were garments and jewellery. The image of an unidentified lady illustrated here (pl.207, see also detail, p.264) had a documentary function: thought to be a copy, it may have been commissioned to advertise her marriageable status to potential suitors (despite her relatively advanced years), or painted as part of a series of sets of dynastic portraits intended for different family households.[38] The clothes and jewellery she wears, which conform to Nuremberg regulations on dress for 1583, suggest that her social milieu was the urban world of German civic government.[39] A pearl-studded headdress, gold bracelets, multiple rings and heavy gold chains with pendants (one a Portuguese gold coin, a *português*, the other the allegorical figure of Fortune, standing on a sphere and holding a sail) are not the only indicators of her wealth.[40] Her sober black attire was costly because of its velvet weave and the deep colour of the dye: a true black was difficult to achieve because the colour often faded or turned brown. The scarlet colour of her

skirt was also expensive.[41] The whiteness of her pleated ruff and sleeve trimmings indicates not only the fashion of the day but also that she had servants to wash and maintain such accessories.

While many of the surviving objects from the Middle Ages and Renaissance cannot be linked to anyone at all, similar items are mentioned in documents that do name their owners, such as inventories, wills and so on. The evidence for the type and variety of possessions owned by individuals both in towns and in the country is considerable by 1600, thanks to expanding administrative bureaucracies and the higher survival rate of documentation and objects. This does not necessarily mean that the opportunities to purchase goods had been fewer in earlier periods: archaeological evidence has revealed the range of pottery, textiles and glass objects of different quality produced in tenth- and eleventh-century England for different customers.[42] The increasing evidence for wealth and ownership also brings with it difficulties of classification: how to define the status and activities of those people who were neither very poor nor extremely wealthy? One term used is 'the middling sort'.[43] The household inventories of fourteenth- and fifteenth-century residents of Barcelona and Zaragoza suggest the type of people who made up this loose group and the possessions they owned.[44] Merchants, sailors, widows, scholars, notaries and others lived in one or more rooms furnished with painted chests, benches and tables. Such items would probably have been made locally but others were clearly imported and very expensive.[45] Among the possessions of Barcelona apothecary Pere Camps, inventoried between 1455 and 1467, were a casket described as 'Venetian, of poplar, with a lock', and 'a small Turkish carpet' (see pl.208).[46] Although there is no evidence of how Camps came by his little carpet, its presence in his home suggests he may have been connected to wealthy people who had links with Venice. Turkish carpets were principally imported into Christian Europe via the Venetian Republic, although Italian inventory evidence suggests that before 1500 supply was irregular. Moreover, few Venetians who were not extremely wealthy had the means to purchase them.[47] Camps the apothecary must have been a relatively prosperous town-dweller (drugs and spices were a lucrative business).[48]

By the sixteenth-century, carpets were appearing frequently in household inventories across Europe. William Harrison, who published his *Description of England* in 1577, complained that even 'inferiour artificers' spread carpets on their tables.[49] The term did not necessarily refer to an expensive piece imported from Turkey or Spain, which were the most prestigious types. A 'carpet' was simply a flat textile used as a cover, and could be woven, embroidered or painted.[50] Even the 1542 inventory of Henry VIII's palace at Whitehall includes a number of carpets made of dornix (a type of woollen cloth) painted to resemble woven Turkish ones.[51] Inventory evidence from outside England also suggests the importance of textiles as furnishings in even modest dwellings, revealing, for example, that carpets were found in most sixteenth-century Venetian households.[52] Textiles were not the only object associated with the households of the rich to make their way into the homes of the less wealthy. Towards the end of the sixteenth century, larger mirrors of Murano glass began to take the place of the small polished steel mirrors in Venetian homes. Although poorer people still tended to own the older type, an inventory drawn up in 1580 of the goods that had

207. **Anonymous,** *Portrait of a Lady in her 29th Year.*
Oil on panel, ebonised fruitwood and tortoiseshell frame, 59.4 × 50.7 cm (framed). Northwest Germany, dated 1582 (frame later).
V&A: 4833 and 4834–1857

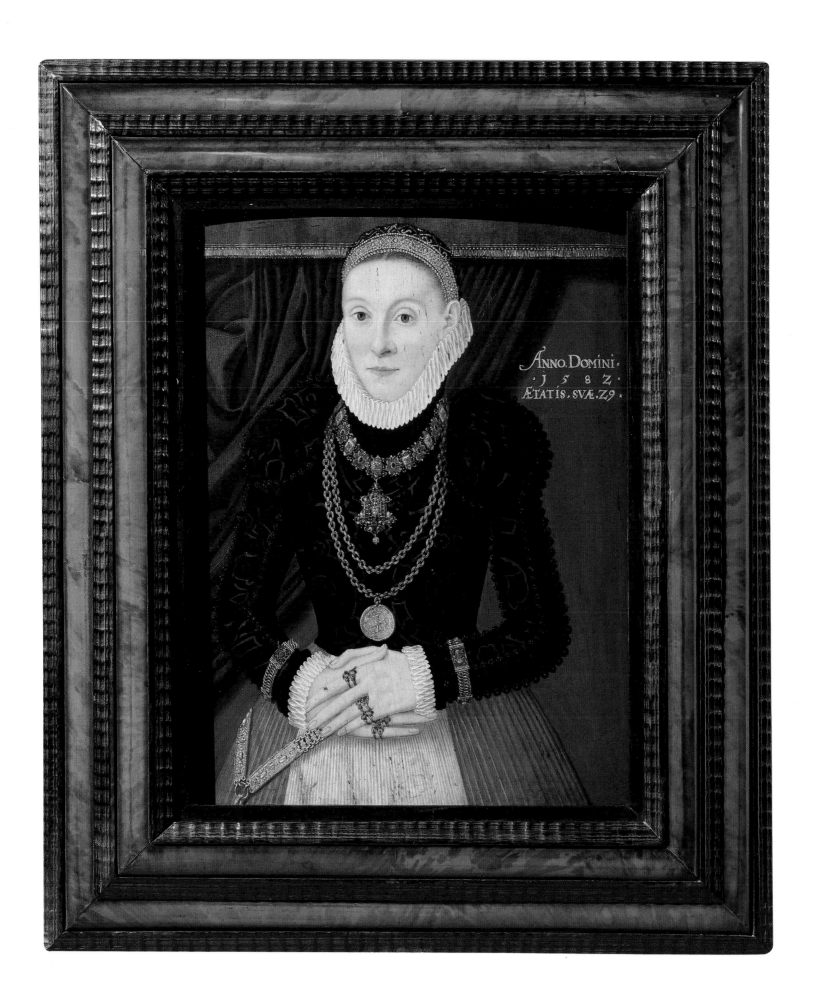

The inscription on the painting reads:

ANNO·DOMINI·
·1·5·8·2·
ÆTATIS·SVÆ·29·

208. **Carpet.**
Wool, hand-knotted, 178 × 114 cm.
Western Turkey, probably Ushak,
1550–1600. V&A: T.348–1920

belonged to Cecilia Simeoni, a widow of modest means who resided in a single room, reveals she owned two *cristallo* mirrors.[53]

Cities naturally offered the consumer of the tenth or the sixteenth century the most choice.[54] In a letter of 1604, Alice Green, the wife of a London merchant, wrote enthusiastically of the 'varietie of fyne embroyd'd gloves and purses, with threads and beeds whate'r my fancie' to be found in a London shop owned by a certain Mrs Price.[55] The archaeological and documentary evidence for rural areas presents a slightly different impression. The wills of yeomen, husbandmen, craftsmen and labourers in late sixteenth-century Essex suggest the narrower range of goods available to them. Despite court fashions for highly embroidered clothes and ruffs, the garments bequeathed in these documents are simple, made of cheap cloth and dyed in shades of red or black, if dyed at all. In part, this is a reflection of the low incomes of the testators. However, the garments of even the wealthiest among them tended only to be distinguished by their black dye.[56] The evidence suggests that coloured clothes were more a feature of urban than rural life.

Fashionable novelties also seem to have been rare in the Essex countryside. Of the estimated 20 per cent of sixteenth-century testators from the county whose wills survive, only two left ruffs, despite the fashion for this garment at the close of the century. John Warden, a young yeoman of Romford, was one, the other was Margaret Aldus of Colchester, who in 1602 bequeathed her stepmother 'four

of my best gorgets with the ruffs belonging'.[57] They appear to have been equally exotic among the farmers and craftsmen of late sixteenth-century Oxfordshire. According to the inventories taken there, only a Banbury cobbler, Thomas Flemynge, owned a 'pair of Ruffes'. Flemynge also owned two handkerchiefs, which were something of a novelty in England in the second half of the sixteenth century, and his interest in such accessories suggests his taste for fashion was somewhat unusual in his milieu.[58] It is important to bear in mind that the detail of inventories varied according to the dedication of, and amount of time available to, the inventory makers. Anthony Hall, a country gentleman of South Newington, near Banbury, may also have owned a ruff, but the clerks preferred to value his clothing as a whole: 'in Apparrell with a sworde & a hanger £2, 6s, 8d.'. It is perhaps not coincidental that this is the last entry in the list.[59] Hall's inventory reveals he also had a small collection of musical instruments (see also pp.296–7), which is unusual in the context of the other Oxfordshire inventories of this period which pertain to his social group. It appears the instruments were barely serviceable: they are described as 'an old paire of Virgynalls out of repaire one githorne [a gittern or cithern, a guitar-like instrument] and an old lute'.[60]

Elsewhere, the Italian and Turkish silks and velvets imported at Southampton were transported straight to London: it seems they barely registered on the local market.[61] A similar division between town and country emerges in areas of continental Europe during the sixteenth century. Lisbon, a centre for imports arriving from India and the Far East, offered shops so full of precious and exotic goods that in 1611 one Polish traveller imagined himself in India itself. Yet when he departed Lisbon for Seville, the contrast between town and countryside was marked. The inns, he wrote, 'lack the usual comforts of hotels: they have no beds or mattresses'.[62] This is consistent with archaeological evidence from sites elsewhere in Europe, such as the central French region of Burgundy. The furnishings of many dwellings in the countryside appear to have been modest at best: as regards seating, most families owned just one chair. Yet the excavations in Burgundy also suggest that, despite leaving little trace in written archives, peasants were not as wretched and dispossessed as might be imagined. Even beggars could own basic eating utensils, such as a wooden spoon.[63]

MAINTAINING THE HIERARCHY

A perennial complaint among writers from Pliny the Elder to the austere, late fifteenth-century Franciscan friar Girolamo Savonarola was that the clothes people wore and the possessions they displayed were examples of profligacy and did not reflect their status in life. Savonarola warned his Florentine audience that no one should 'dress more conceitedly nor more basely than is appropriate to their condition'.[64] The discrepancy between dress and station had become something of a literary topos. Galician-Portuguese poets ridiculed the worn cloaks of miserly nobles and the finery of cowardly princelings and their footsoldiers in the thirteenth century, and the mis-match between garments and social pretension was still a target in the sixteenth. Hans Sachs, a Nuremberg shoemaker and author of a poem (published 1568) that described the different trades of his home town, slyly poked fun at the aspirations of the non-noble in his verse on the armourer's profession.

While the craftsman makes good pieces of steel for the men and horses who do real battle, 'I also make cheaper items for commoners / For use in tournaments, jousts and races'.[65] Orazio della Rena made the same point in a 1589 description of the residents of Ferrara: 'absolutely all of them, mean and great, wear swords at their sides… they are always trying, in all the streets, to appear as knights'.[66] (For armour and its significance to the nobility, see pp.292–3).

It may seem doubtful that rough peasant diggers really could afford the 'silks, velvets, brocades and damasks' that the contemporary Cadiz chronicler Francisco de Thamara claimed they wore but the fact that agricultural labourers in late fifteenth-century England were explicitly forbidden the use of girdles trimmed with silver suggests at least some had managed to invest their wealth in valuable clothing accessories (see pl.209).[67] There is evidence that urban labourers, too, strove to acquire textiles. Like the rich, they did this as a form of economic insurance. Textiles that included a weave of gold or silver still had value even when threadbare, because the precious metal could be recovered by burning away the cloth.[68] Less intrinsically valuable cloth was also a worthwhile investment. A recent study of sixteenth- and seventeenth-century workers in the Venetian shipyards has revealed that despite, or perhaps because of, their rigid pay structure (which did not take inflation into account), a number accumulated textiles such as linen shirts or sheets which could be sold or pawned for a substantial return. A pair of sheets, for example, could be bartered for the equivalent of 16 days' wages.[69]

In the work place, dress informed rank: only the top managers in the Venetian shipyards were allowed to distinguish themselves visually by wearing rich brocaded robes (which they purchased at their own expense).[70] In 1574, a member of the English Merchant Taylors' Company was imprisoned because he arrived at the company's hall 'in a cloak of pepadore [silk fabric], a pair of hose lined with taffety, and a shirt edged with silver contrary to the ordinances'. Another member was warned that he was dressed in 'apparel not fit for his abilities to wear'.[71]

The importance attached to clothing as a marker of social and professional rank stemmed from a belief in the ordered hierarchy of society. Roman emperors, for example, had claimed the exclusive right to wear cloaks dyed with a deep purple colour derived from the murex shell.[72] Inappropriate dress could lead to social confusion and the connection was sufficient to persuade rulers both secular and ecclesiastical to codify distinctions in law.[73] Termed 'sumptuary laws' by historians, these regulations in fact governed aspects of expenditure by individuals on material goods of all kinds.[74] The legislation applicable to clothing concerned issues such as the colour and quality of cloth and the use of jewellery and headdresses, though it was often ineffectual. In 1576, church wardens reported the wives of Paul Elliot, Robert Cross, Lawrence Grosse and of a man identified as 'Bones' to the Court Leet of Southampton because they did not 'weare whyte cappes, but hatts contrarie to the statute'. Perhaps their hats were like the ones 'of taffitie lyned with vellat [velvet]' which caused the wives of Martin Howes and John Goddard to be prosecuted by the Southampton authorities in the following year, 1577.[75]

Until the end of the sixteenth century, regulation in England tended to focus on issues of male,

209. Woman's girdle.
Silk and metal thread, 375 cm long.
Italy or France, c.1540–80.
V&A: T.370–1989

rather than female dress. The length of velvet shown here was made in Italy and imported into England, where it was known as 'tissue' (pl.210). Although it is splendid, the looped metal threads are only silver-gilt: the finest examples used thread of pure gold. The expense of both types of fabric was considerable, but Henry VIII's stipulation in 1509 that 'no man under the astate of a Duke use in eny apparell of his Body or upon his Horses eny clothe of golde of tyssue uppon payne to forfett the same apparell' was probably aimed at reinforcing his own status rather than a plea for thrift.[76] Henry's lord chancellor, Cardinal Wolsey, enthusiastically upheld such laws. A contemporary chronicle recounts how 'he himself one daye called a gentleman named Symon Fitz Richard and took from him an old jacket of crimson velvet and diverse brooches'.[77]

In several Italian states, by contrast, fifteenth-century laws appear to have been inspired by attempts to make female dress conform to a particular, clerical ideal of morality.[78] It was perhaps a combination of concerns about excessive expenditure and modesty that led the Venetian Senate repeatedly to ban certain women from wearing pearls. In 1299, senators addressed the issue of women's clothing at wedding parties, and prohibited the use of pearls on clothing and jewellery to all but the bride. By 1582, pearls were permitted only to women who had been married ten years,

211. Necklace.
Enamelled gold, 59.8 cm long.
Italy, *c.*1540. V&A: M.117–1975.
Given by Dame Joan Evans

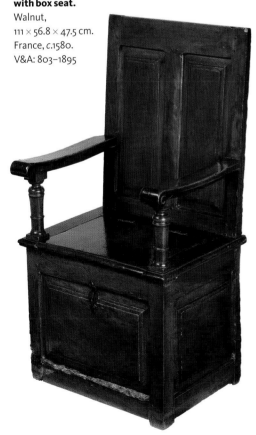

**212. Armchair
with box seat.**
Walnut,
111 × 56.8 × 47.5 cm.
France, *c.*1580.
V&A: 803–1895

the immediate female relatives of the doge, and the wives and brides of foreign ambassadors.[79] In Florence, meanwhile, not everyone was allowed to wear enamelled jewellery. A sumptuary law of 1546 stated that guests at christening parties could wear as many gold and silver necklaces as they liked as long as they were not enamelled (see pl.211).[80]

Although jewellery and clothing were the most consistent and visible expressions of a person's status, and therefore the regular targets of legislation, other possessions, even in the most modest households, also carried with them indications of hierarchy. Furniture, for example, could distinguish the relative importance of different family members. The head of the household sat down to dinner on a chair with a back and, perhaps, arms as well (pl. 212). The rest of the household sat on stools, long benches or piles of straw. Only a particularly honoured guest might be offered the master's seat. It was a hierarchy that, naturally enough, transferred itself across the ocean with the Spanish and Portuguese colonists in the Americas. Among the meagre possessions listed in the 1592 will of Pero Leme and his wife Gracia Rodrigues, settlers in São Vicente (north-eastern Brazil), was 'a chair with a back' for the head of the household.[81]

CARE AND CONSERVATION

The importance of possessions for family identity, status and wealth meant they were looked after as well as could be managed. The insect-repelling properties of sandal or cypress wood, for example, meant these woods were often used to make clothes chests. That said, such was the value and esteem in which textiles were held that even moth-eaten and worn pieces were preserved. A calculation based on the 1542 inventory of Henry VIII's possessions at his Whitehall Palace shows that a high proportion of the king's carpets were in poor condition. One entry, for example, describes 'seven olde fote Carpettes of sondry sortes of frame worke sore woren and some of them mothe eaten alredy'.[82] The most expensive tapestries appear to have been rolled, not folded, when stored for transport, as this better preserved their fabric.[83]

An array of leather-covered chests and sturdy caskets, shaped to suit their contents, existed to protect objects from theft and from damage in transport. The papal chef Bartolomeo Scappi included in his treatise on cooking (1570) a diagram of a saddle with different compartments for carrying 'diverse victuals' and a 'travelling basket for carrying household stuff', with a lid made of net and four carrying handles.[84] Other containers were already in use in earlier centuries. The sturdy, fifteenth-century leather cup case illustrated here would have hung from a cord (pl.213). The lid bears a motto in French, '*boire a tous*' (drink to all), while the base carries an incised drawing of the head of a bearded man. Many people, especially the wealthy, travelled constantly, and even packed possessions offered an opportunity for displays of status.[85] When the papal legate, Cardinal Campeggio, arrived in England in 1518 with eight pack mules to carry his luggage, Henry VIII's chief minister Cardinal Wolsey, himself newly elevated to the status of legate, accompanied him with another twelve mules, laden with chests. The illusion of his new-found ecclesiastical magnificence was shattered, however, when one of the mules broke free. In the ensuing chaos,

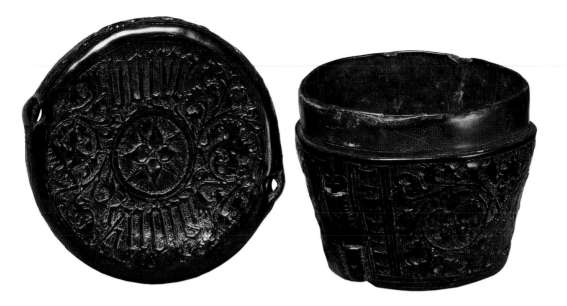

213. **Cup case and lid.**
Cut and embossed leather
(*cuir bouilli*), 6.7 cm high. France,
1400–1500. V&A: W.171–1910.
Salting Bequest

several chests burst open to reveal 'old hosen, broken Shoen, and roasted fleshe, peces of Breade, Egges and much uile baggage'.[86]

Once settled, people also needed to display their possessions in ways that were at once attractive and secure. The historian and writer Francesco Sansovino, describing the households of Venice in 1581, observed that 'the dressers displaying silverware, porcelain, pewter and brass or damascene bronze are innumerable'.[87] Particularly in Northern Europe, temporary stepped structures for cups and dishes (see p.268) were complemented or replaced by permanent cupboards, which combined a tiered display space with a lockable compartment. This new type of furnishing could be found not only in the main hall (and therefore dining) area, but also in the kitchen. Gilles Corrozet's 1539 poem identifying and describing different household objects, *Les Blasons Domestiques*, advises that a 'buffet to store tin and copper dishes' is an appropriate addition to a kitchen, presumably because the tiered section allowed easy access to the vessels. Any dishes of gold or silver, however, were to be kept under lock and key.[88]

Other specialized items of furniture for storage had developed in Catalonia in the fourteenth century. Originally used to store the linens and jewellery that comprised a bride's trousseau, these chest-like items had evolved into cabinets with a front that opened to reveal a series of little drawers and cupboards. The exquisite marquetry on the left-hand cupboard door of the example pictured on p.45 indicates the type of objects it stored: the scissors, inkwell, pen case and folded scrap of paper all suggest it was a cabinet that contained writing materials and documents (pl.214). Made around 1530, the motto '*plus ultra*' (still farther) and the device of columns inlaid onto the inside of the drop-front panel are those of the Holy Roman Emperor Charles V, and it has been argued that the cabinet may been commissioned by his hosts for his apartments when he stayed in Mantua in 1532.[89]

214. **Inlaid cabinet
(detail of pl.28).**
Walnut and inlay of various woods,
81.3 cm high (not including stand).
Mantua or Ferrara, c.1530 (with
19th-century restorations).
V&A: 11–1891

OWNERSHIP AND IDENTIFICATION

One of the more prosaic reasons for putting ownership marks on possessions was to guard against theft. That this was a recognized problem is demonstrated by the scene on an early sixteenth-century wooden panel, which may have been a door (pl.215). But inscriptions and marks could also reveal the different meanings objects had for their owners and the contexts in which they were appreciated.

215. **Wooden panel
(perhaps from a door),
showing the arrest of a thief.**
Oak, 210.1 × 141.6 cm. France,
c.1520–30. V&A: 468–1895

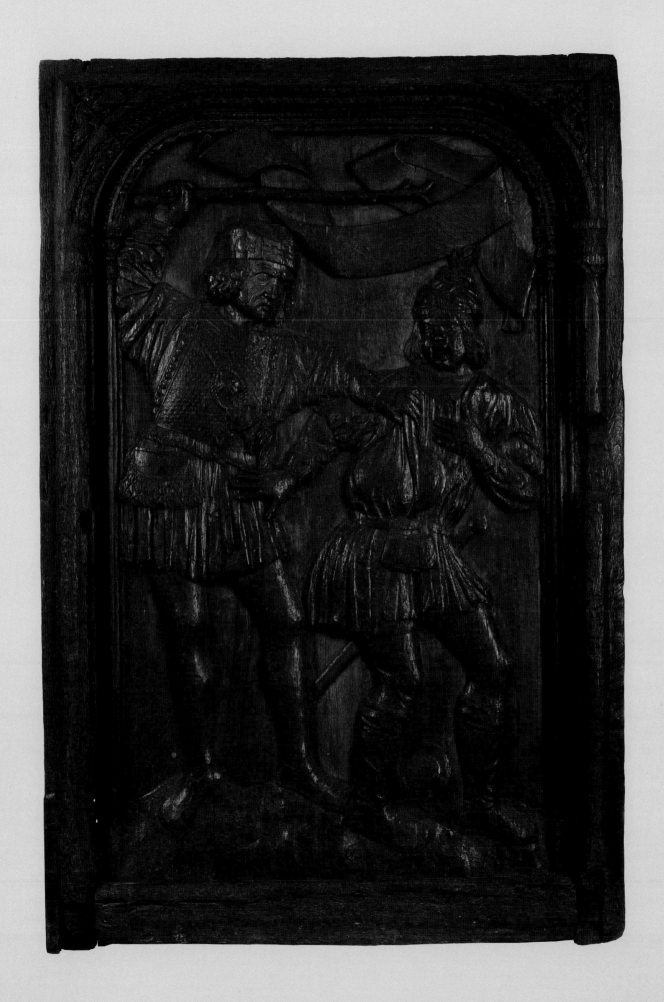

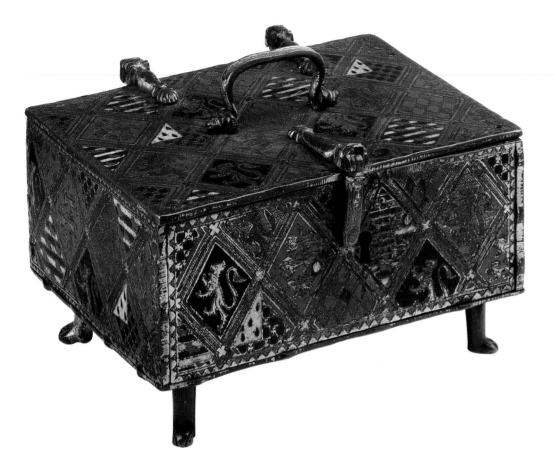

216. **Casket (The Valence Casket).**
Copper alloy with gilding and champlevé enamel,
12.3 × 17.7 × 14.5 cm. Limoges or London, c.1305–12. V&A: 4–1865

217. **Perfume sprinkler (the arms of the Hirschvogel family visible).**
Glass, enamelled and gilded, 22.5 cm high. Venice, 1500–50.
V&A: 1851–1855

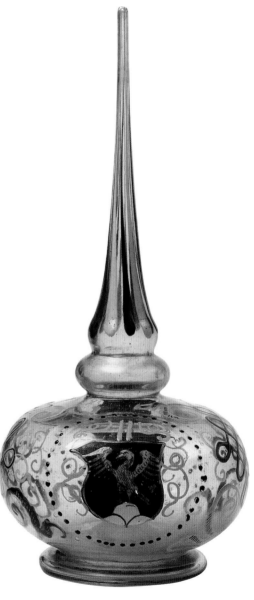

Coats of arms were perhaps the most common means to link an object with an individual, family or institution. Heraldry, the systematic and hereditary use of certain colours, figures and mottos framed within a shield, and related to particular families, emerged across Europe in the mid-twelfth century.[90] In the case of an early fourteenth-century casket heraldry covers the entire surface of an object to decorative effect. The four different family arms enamelled upon the casket include those of its probable owner, William de Valence, Earl of Pembroke (pl.216). The remaining arms were almost certainly chosen to reflect his dynastic loyalties and associations – to the royal house of England and those of Angoulême, Brittany and Brabant.[91] In the same way, the canting arms of the Hirschvogel and Hölzel families of Nuremberg painted on a sixteenth-century Venetian glass perfume flask probably commemorate the alliance of these two dynasties, perhaps by marriage (pl.217). Canting arms are those in which the symbols pun on the family name, here *Vogel* (bird) and *Holz* (wood).[92]

A number of objects survive with blank spaces left for the owner (or donor) to add a coat of arms of their choice. The inkstand illustrated here is one of several with a Nativity scene and, below, the refrain from a carol documented between 1100 to about 1582 (pl.218). This text celebrates the birth of Jesus and is based on a verse from Saint John's Gospel: 'The word is made flesh / by the Virgin Mary.'[93] It was a popular carol, and in the fifteenth and sixteenth centuries was among the songs of praise, or *laude*, sung by Italian confraternities (or on their behalf by professional singers).[94] It may be, then, that this inkstand was intended as a New Year's gift to a member of a confraternity. The fact that five other surviving examples also bear the date '1509' reinforces the argument that the inkwells were made for a particular occasion.[95] The blank shield was presumably intended for the later addition of the recipient's devices or for institutional ones.[96]

218. **Giovanni di Nicola Manzoni, inkstand.**
Tin-glazed earthenware, 24.4 cm high. Colle Val d'Elsa (Italy), c.1500–10.
V&A: 396–1889

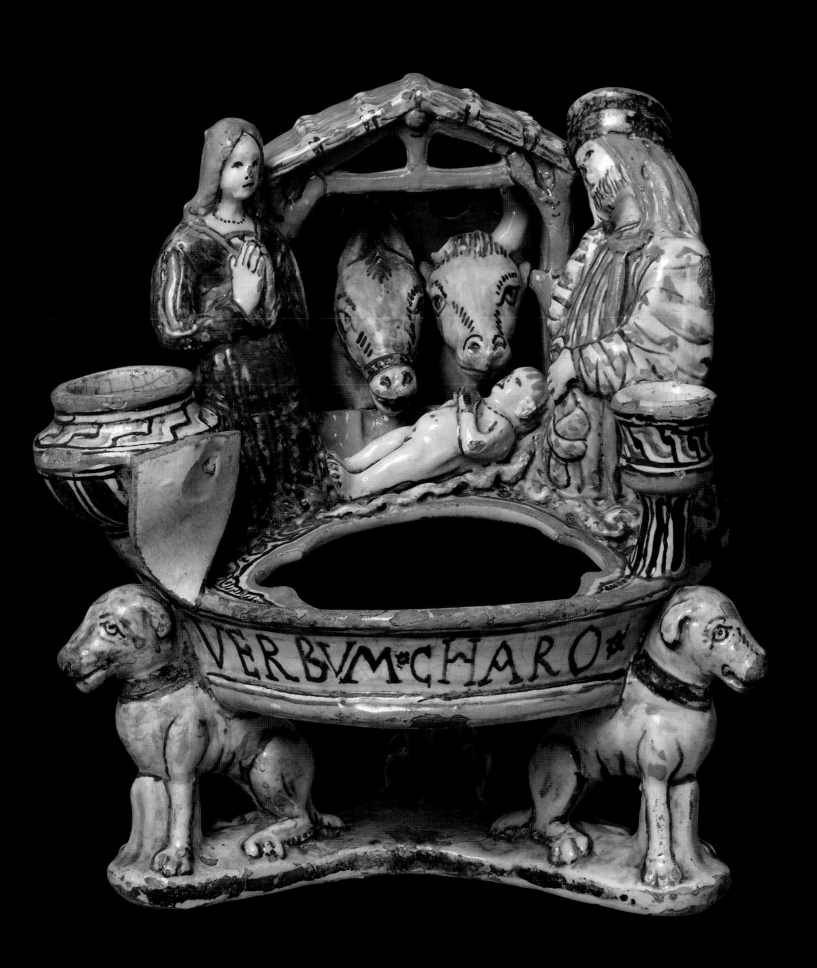

VERBVM CHARO

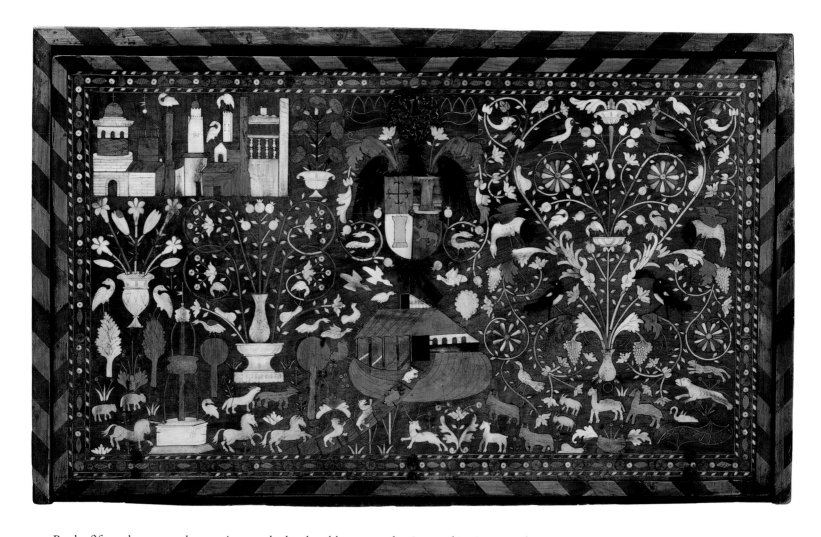

219. **Cabinet (detail).**
Walnut with inlay of bone,
boxwood and other woods,
65 × 105 × 46 cm. Possibly Aragon,
c.1550. V&A: 294–1870

By the fifteenth century the prestige attached to heraldry meant that it was ubiquitous, and people had to apply even more personal devices and mottos to their possessions to assert their ownership. Its popularity also meant that it could be completely fictive. Arms such as those added to the late sixteenth-century Spanish fall-front cabinet shown here (pl.219) do not represent a formal grant of arms but reveal much about family pretensions and also, perhaps, family loyalties: the arms in this instance are composed of various elements from Spanish royal heraldry, the castles and lion standing for the kingdoms of Castile and Leon, while the ornamental pomegranate branches recall an emblem of Henry IV of Castile. The eagle which acts as a supporter for the shield imitates the device of the eagle of Saint John adopted by Isabella I of Castile for her arms.[97] Although these particular rulers had died long before the cabinet was made, their heraldic identifiers continued to have significance.

Dining utensils often had names or heraldic devices added to them. In part this was simply to ensure everyone used his own spoon or knife at table, at a time when diners often brought their own cutlery to a meal (see p.243). Although it is rarely possible to identify the owners who scratched their initials, or had them engraved, onto such objects, the decoration itself may sometimes suggest

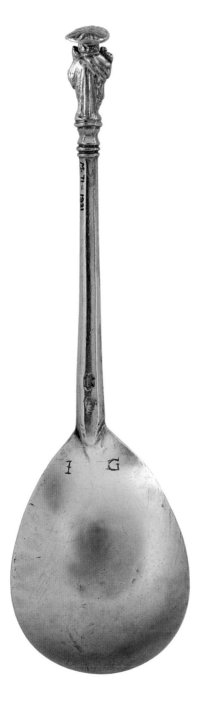

220. Apostle spoon with finial figure of Saint John the Evangelist.
Partially gilded silver, 18.5 cm long. London, 1514–15. V&A: M.71–1921

221. Jug with the royal arms of England.
Copper alloy, 40 cm high. England, c.1380–1400. V&A: 217–1879

a connection between possession and person. An early sixteenth-century London apostle spoon has a figure of Saint John on the finial and the initials 'I.G.' inscribed on the stem, which together suggest the owner may have shared the saint's name (pl.220). (The letters 'I' and 'J' were inter-changeable at this date.)[98] Other spoons from this period, hardly any of which survive, indicate their owner's identity with heraldic emblems on their finials: an inventory of 1574, for example, records 'twelve guilt spones with Staffourde knottes at thendes' – an emblem of the Stafford family.[99]

Other dining vessels reflect their owner's political affiliations as well as their personal identities through heraldry. An imposing jug now in the Wardown Park Museum, Luton, bears the moulded inscription 'My Lord Wenlok'. This is a reference to John, first Lord Wenlock, whose loyalty to the English Crown (he served kings Henry V, Henry VI and Edward IV) and links with East Anglia are commemorated in the royal and ecclesiastical arms also on the body and neck of the jug. Wenlock may have commissioned the jug himself, or it may have been a gift, perhaps a royal one. A similar jug, cast in England around 1390, also includes a prominent representation of the royal arms of England and royal crowns (pl.221). Its large size and therefore great weight suggest it was

222. **Luca della Robbia and workshop, shield of arms of René, Duke of Anjou and King of Naples.**
Tin-glazed terracotta, 335.3 cm diameter. Florence, c.1466–78. V&A: 6740–1860

223. **Ceiling panels.**
Wood, probably pine, painted with tempera, approx. 15 × 30 cm. Spain, c.1400. V&A: 209, 210, 213, 215 & 216–1894

intended purely for display rather than use: when empty, it weighs almost 10 kilos.[100] It, too, was no doubt intended to express or recognize support for the English monarchy by a wealthy and important subject.

Such messages of loyalty sometimes dominated the household environment. The Florentine Jacopo de' Pazzi displayed a huge, circular, tin-glazed terracotta depiction of the arms of his powerful royal friend René, Duke of Anjou on the external wall of his villa at Montughi, near Florence (pl.222).[101] Crosslets, a Pazzi device, are subtly included on the foot of the left-hand brazier, one of René's emblems flanking the central coat of arms; thus Jacopo alludes to his family's princely associations. Other architectural elements formed part of a wider decorative aesthetic designed to reinforce the importance of lineage and ancestral tradition more generally. Painted panels from Spain of around 1400, designed to be set between the beams of a ceiling, include the arms of the kingdom of Aragon and that popular heraldic beast, the lion, as well as an elephant and generic crowned portrait heads (pl.223).

PEOPLE AS OBJECTS

In his *Natural History*, Pliny the Elder had remarked upon the statues displayed in the libraries of wealthy Romans. These statues, Pliny argued, embodied the souls of the noble people they represented and could therefore speak to the living library owner.[102] Portraits also adorned the walls, door lintels and cabinets of fifteenth- and sixteenth-century homes, for example, a terracotta bust cast from a death mask showing a member of the Capponi family of Florence (pl.224). Again, these reinforced dynastic and political ties as well as providing consolation to the living. Francesco Gonzaga, Marquis of Mantua, would not part with a painting of Ferdinand II of Naples, who had died in 1496, because as his wife explained, the image was 'dear to him for the love he bore to Ferdinand's memory'.[103] Families who lived apart also sought solace in portraits of absent members. In 1466 Ippolita Sforza, Duchess of Calabria, wrote to her mother in Milan to request portraits of her father and siblings to hang in her study for 'continual consolation and pleasure'.[104] On other occasions, these portraits were images of noteworthy contemporaries. The Venetian collector and scholar Marcantonio Michiel swapped prints of famous people with Erasmus' friend, Willibald Pirckheimer;[105] and a sixteenth-century Catholic theologian, Louis Richeome, complained bitterly that too many Frenchmen valued the portraits of Protestant reformers Martin Luther and John Calvin, which they kept in their rooms and cabinets, more than the image of the holy cross (see pl.200 on p.255).[106]

Other types of object could stand in for or conjure up the absent and the deceased. A pewter chalice buried with a French priest in the mid-fifteenth century symbolizes his occupation when alive and also, perhaps, the sinful nature of his dead body (pl.225). As Sicardus, the thirteenth-century bishop of Cremona, observed, in a treatise on priestly duties, chalices of pewter 'refer to the similarity between guilt and punishment'.[107] Rings, brooches and pendants, given or worn as a token of affection and loyalty, were often inscribed with rhyming phrases which proclaimed them as substitutes for the person to whom they referred: the ring-brooch illustrated here is engraved with the motto 'I am here in place of a friend' (pl.226).

Wills also reflected the concern to pass on particular possessions as mute reminders of the dead. In her will dated 27 May 1309, María Velázquez stipulated that a scarlet cloak, 'which I have in my chest', should be used to make a tunic for Endieraço Velasco. The cloak had belonged to Velasco's mother. María also bequeathed Endieraço a little silver dish for use in her chapel.[108] John Assetby of Bilsby, a Lincolnshire gentleman, left his son Andrew 'or to whome it shall please God to be my ryght heyre' plate and heirlooms forever in 1527, while in 1558 a Coventry townsman left his mazer 'to be treasured in my cousin's family and used at all banquets and merriments'.[109] Particular items of jewellery also carried with them the presence of the donor. In July 1593, Elizabeth Tuke, a solicitor's daughter from Essex, bequeathed to her sister-in-law, also called Elizabeth, 'my chain of gold and my ring of gold with an emerald in it for a remembrance of my goodwill'.[110]

The power of objects to stand in for people, their family, status and allegiances, was considerable:[111] in this chapter they have been seen to express personal, dynastic and even national

224. **Bust, possibly of Niccolò di Giovanni Capponi.**
Terracotta, 53 cm high. Florence, c.1500. V&A: 7588–1861

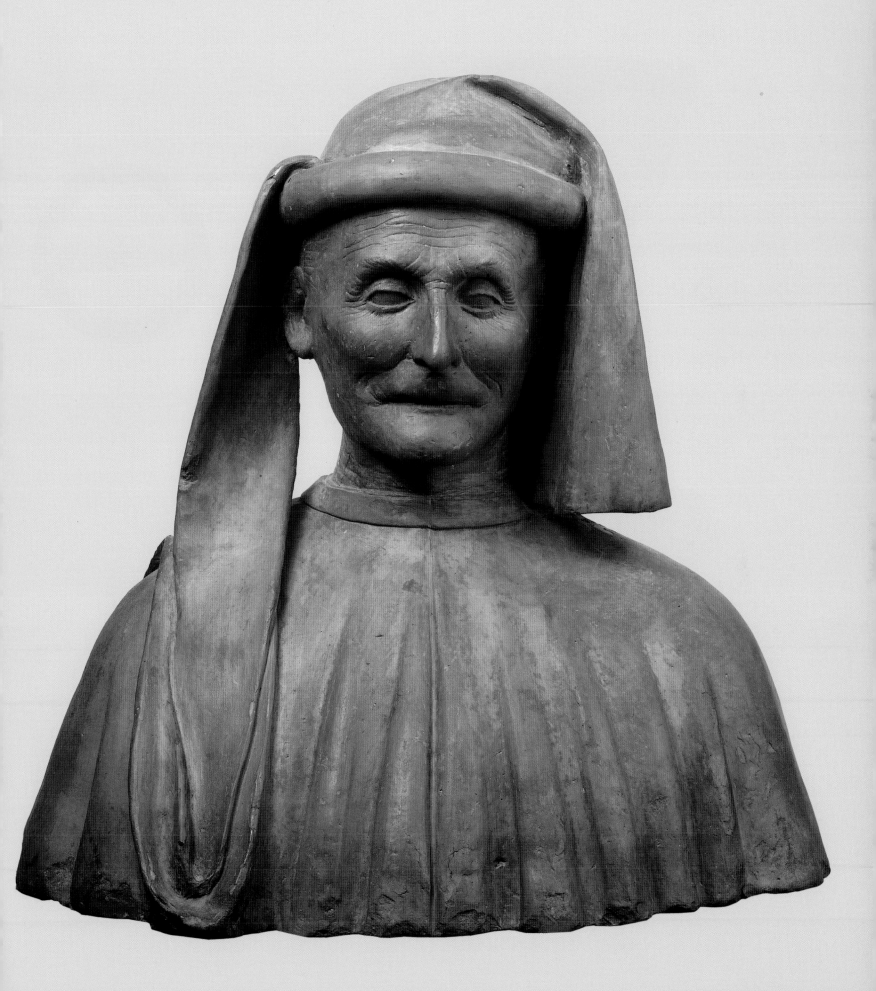

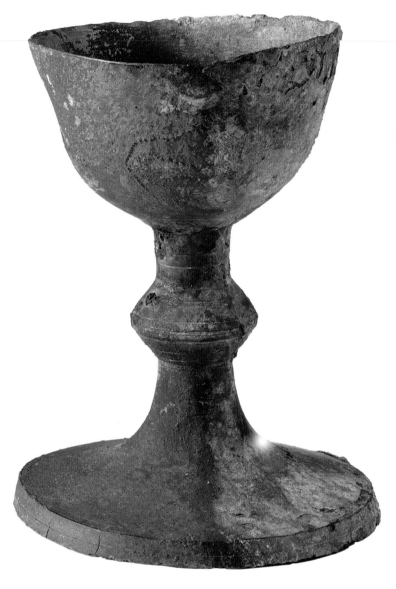

225. **Burial chalice.**
Pewter, 15.6 cm high. France, 1300–50. V&A: 72–1904. Given by Mr J.H. Fitzhenry

226. **Ring-shaped brooch.**
Gold, 1.4 cm diameter. England or France, 1200–1300. V&A: M.49–1975. Given by Dame Joan Evans

227A. **Willem Geverts, pyx.**
Silver, partly gilded, 8.9 cm high. 's-Hertogenbosch (The Netherlands), 1555–6. V&A: M.41–1952

227B. **Willem Geverts, pyx (detail of base showing ownership inscription).**

loyalties, wealth, class and profession. Sometimes, however, tangible possessions allowed their owner to lose themselves in the spiritual. Nuns should not really have owned any personal possessions at all: the rules for religious communities laid down by Saint Benedict in the fifth century stipulated that all belongings should be communal; his sentiments were echoed by Saint Bernard in the eleventh.[112] By the mid-sixteenth century, however, these strictures had evidently been relaxed. Among the things 18-year-old Alyt Hendricks took with her when she entered the convent 'behind the toll-bridge' in the northern Dutch town of 's-Hertogenbosch in 1556 was a little silver casket (pl.227A).[113] It was a pyx, a container to hold the small bread wafers blessed and eaten during Mass and symbolic of Jesus's body sacrificed on the cross. On the base of the pyx Alyt engraved her own and her family name, separating the two with a heart (pl.227B). The presence of her name alone shows her identification with this ritual object; the addition of the heart declares her devotion and communion with Christ's own body. The heart was, in the writings and iconography of female spirituality, Christ himself, his sacraments and salvation.[114] This particular possession, owned by the daughter of a wealthy Brabant family, represented more than the sum of its silver parts, for in it Alyt and her Saviour became one.

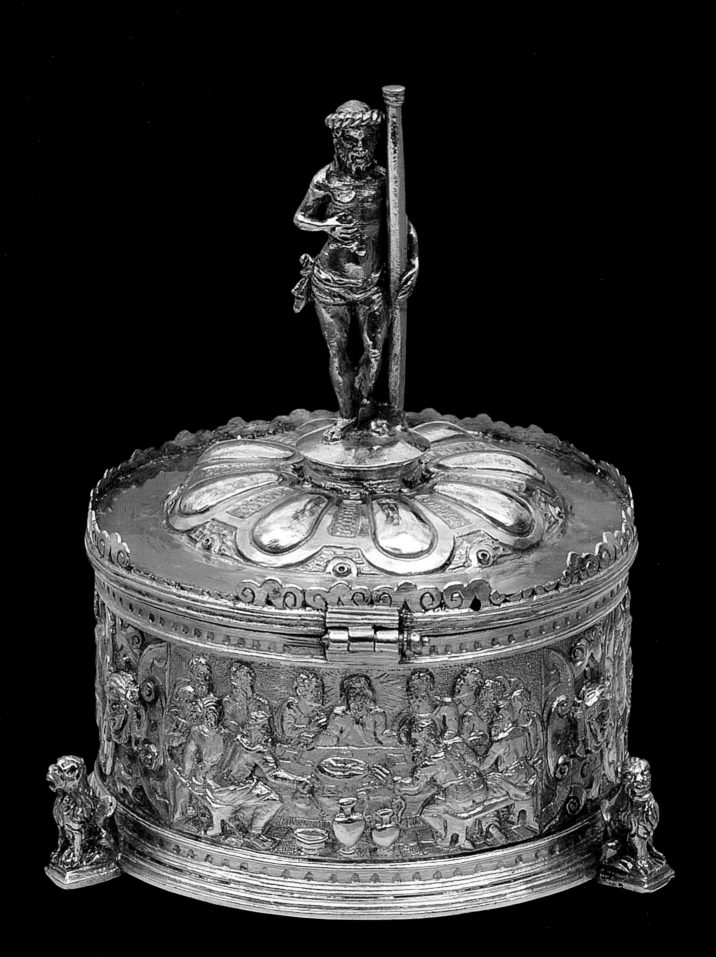

26. Armour and weapons

ANGUS PATTERSON

BRAVERY WAS A KEY ATTRIBUTE of nobility. Hunting and swordsmanship were part of an aristocratic education and to be a man-at-arms was a noble aspiration. Boys were expected to master wearing a full range of armour from a young age. In light, flexible battle armour they learned to defend themselves with agility and speed, while heavy tournament armour protected them during foot combat and the joust. In parade armour they demonstrated their majesty and deportment. To equip your children with armour proclaimed your wealth: armour was made-to-measure and might be outgrown within a year.

Miniature weapons were produced in large numbers as toys, to educate as well as entertain. The most expensive toy guns were working replicas and fired real shot. Learning to fight with swords, pole-axes and hammers tested nerve and dexterity and equipped young nobles for greater battles to come. Organized tournaments took place in which boys fought at barriers on foot, and around the age of sixteen young aristocrats learned the most perilous martial art, jousting.

Hunting, meanwhile, developed strategy, recognition and self-control, useful skills in war (26.1). These were honed under prescribed conditions. Specialist tasks like the rearing of falcons and the carving of meat taught the rituals of the hunt and reinforced the social hierarchy. Accompanied by music and dining, hunting was both a means to an end and a symbolic ceremony.

Theatricality played an increasing role in the martial life of the sixteenth-century noble. Decorated armours often portrayed their wearers as mythological heroes from Ancient Rome, real-life embodiments of the taste for classicism in European art (26.2). The decoration of the best armour was as important as its construction. All-over armours were becoming increasingly the products of the goldsmith rather than the armourer, designed to project an image rather than protect a body. Noblemen collected armour and weapons as works of art as much as military tools.

Of all the treasures of the renaissance prince, none expressed his honour, wealth and status more forcefully than his armoury. Great collections at Madrid, Dresden, Innsbruck and Prague served as both storehouses in time of war and showcases to impress visiting dignitaries.

The art of defence was just one aspect of the whole range of learning that formed a gentleman's education, from art and literature to mathematics and the natural sciences. Civilian rapiers with long, slender, flexible blades with elaborate hilts to protect the hand reflected the dominance of Italian fencing styles focusing on slashing and thrusting. Fencing manuals became increasingly codified, not only outlining useful moves but advising on appropriate methods for settling 'honorable Quarrels' (26.3).

Portraits and the funerary monuments of noblemen frequently celebrated them as warriors and many chose to be remembered wearing armour. By the late sixteenth century their portraits emphasize fine fabrics with sword-hilts visible as a reminder of the sitter's status. A chiselled, gilded and jewel-encrusted sword-hilt mounted on the best Toledo rapier blade and worn in a decorated, fabric sling was an item of working jewellery (26.4). While the fifteenth-century fencing master, Sigmund Ringeck, had claimed that knights should 'skilfully wield spear, sword, and dagger in a manly way', by 1600, the ability to wear a sword was just as important.

26.1 ▶ Hunting crossbows.
Steel with wooden stocks set with panels of engraved antler, 12.5 × 54.3 × 68.8 cm and 8.8 × 35.8 × 43 cm. Large bow: Southern Germany, c.1590. V&A: M.2744–1931. Ramsbottom Bequest through The Art Fund. Small bow: Germany, c.1600. V&A: M.223–1919. Joicey Bequest

These crossbows are both killing machines and works of art. The smaller example was made for a child. By 1600 crossbows had ceased to be war weapons but continued in use for hunting and target shooting.

26.2 ▶ Probably Lucio Marliani (known as Piccinino), breastplate and gauntlets for a young man.
Iron damascened with gold, 45.5 × 33.5 × 33.4 cm and 11.6 × 14 × 23.5 cm. Probably Milan, c.1585. Breastplate: V&A: M.144–1921; Gauntlets: V&A: M.143&A–1921. Currie Bequest

This armour was presented by Charles Emmanuel I, Duke of Savoy to the future King Philip III of Spain.

26.3 ▲ Title-page from *Discourse of Rapier and Dagger* by Vincentio Saviolo.
Printed book, 19 × 14.7 cm. London, 1595

This fencing manual, printed by John Wolfe, has two volumes, the first 'intreating of the use of the Rapier and Dagger. The second, of Honor and honorable Quarrels'.

26.4 ▼ Rapier.
Chiselled steel with blackened hilt, 126.6 × 18.9 × 13 cm. Hilt: Northern Italy; blade: Alonso Pérez, Toledo, c.1590. V&A: M.180–1921. Currie Bequest

The blade is signed 'ALONSO EN TOLEDO'. S-shaped, 'swept' hilts were fashionable on civilian 'dress' swords, giving extra protection to the hand and adding scope for the jeweller and goldsmith.

27. Gift-giving

SARAH BERCUSSON

GIFT-GIVING IN THE MIDDLE AGES and early modern period was an essential means of creating and maintaining personal and societal bonds: gifts could express affection between lovers and other intimates; they could symbolize generosity or loyalty between patron and client; and when given to the Church or to the poor, they could indicate Christian piety and devotion to God.

Particular dates, including important holy days such as Epiphany (6 January), might be commemorated by gift-giving. Lord John Grey gave Queen Elizabeth I of England a cup similar to the one shown here (27.1) to celebrate New Year 1559. Elizabeth could choose to pass such gifts on to others: in this case the symbolic act of giving – which expressed loyalty and allegiance – was more important than keeping the gift itself.

The reycling of gifts and other property was an everyday affair at all levels of society. Used clothes were passed on in the wills of both rich and poor, and old or new clothes were regularly allocated by rulers to their courtiers. In 1572, the Duchess of Ferrara left her two best dresses to one of her favourite ladies-in-waiting in her will. Such gifts always had to be appropriate to the sex and social position of the recipient. Shoes with high platforms were status symbols – servants wore flat slippers. The *pianelle* (backless slippers also known as chopines) shown here (27.2) would only have been given to someone of elevated social status.

Certain objects made appropriate gifts at a particular time in life, for example, during courtship. In his *De Amore*, written in the twelfth century, Andreas Capellanus states that 'a lady can accept from her love whatever small gift may be useful in the care of her person, or may look charming, or may remind her of her lover ...' Capellanus suggests that a mirror makes a suitable present. Mirrors were objects strongly associated with women, and with the private nature of the female *toilette*. This made them personal, almost eroticized gifts. The fact that they were carved from ivory also made them popular presents. The whiteness of the ivory, sometimes enhanced by painted or gilt details, was often compared to a beautiful girl's teeth or fashionably pale complexion (27.3).

Items of jewellery were also highly popular courtship gifts but they could be presented on less romantic occasions. Examples are the rings given as tokens of office by candidates for the English judicial post of serjeant-at-law to the monarch, other dignitaries and friends (27.4). Gifts such as these were not only made on particular occasions or at particular times. Friends and relatives regularly exchanged small objects, such as rings or amulets. Mary, Queen of Scots sent Elizabeth I a heart-shaped diamond ring in 1564, receiving another ring in return, and when the Bishop of Rochester asked Erasmus what he should give the German humanist Johann Reuchlin, one suggestion was a ring.

Other rings were popular presents because of their supposedly magical powers. Edward II of England and his successors gave out so-called cramp rings which were thought to have the ability to heal because he had blessed them. Such rings might then be passed on again in a renewing of the gift cycle: in 1463, John Baret of Bury included 'my crampe ryng of blak innamel and a part silvir and gilt' in his will.

27.2 ▲ Shoes (pianelle).
Wood, covered with velvet, with gilded and stamped leather inner sole, gilded silver braid and bobbin lace (perhaps a later addition), 20.5 cm long. Italy (probably Venice), c.1600. V&A: 929&A–1901

Velvet *pianelle* are mentioned as one of several gifts from a suitor to his lover in a work by the 16th-century satirist Pietro Aretino. Very high versions of these shoes were associated with courtesans.

27.4 ▼ Serjeant's ring.
Gold, prepared for enamelling, 2 × 2 cm. England, 1525–50. V&A: M.51–1960

This ring is inscribed *vivat rex et lex* (long live the king and the law); the mottoes on such rings changed with each new batch of candidates for the post of serjeant.

27.1 ▲ Cup and cover.
Turban shell, with gilded silver mounts, 24.5 × 11.8 × 8.8 cm. Nuremberg, c.1580–90. V&A: 863: 1,2–1882. Jones Bequest

Objects combining natural and man-made materials were favoured for princely *Wunderkammern*. Representing the collector's control over both the natural world and human endeavour, they might have been presented as a graceful compliment to his power.

27.3 ▶ Mirror cases.
Ivory, 9 × 10.3 × 10.7 cm; 10.7 × 10.5 × 1.7 cm. Paris, 1300–50. V&A: 1617–1855, 803–1891

The cases depict allegorical representations suitable to the objects' function as courtship gifts: knights attacking the 'castle of love'; and a knight and a lady playing chess, an established metaphor for the conflict and conquest associated with seduction.

28. Medieval and renaissance music

FLORA DENNIS

THE GREAT CHALLENGE when studying music of the past is to overcome its ephemerality. Sound dies 'as it is born', as Leonardo da Vinci wrote, 'as fleeting in its death as it is in its birth'. Nevertheless, by using a range of objects, images and texts we can go some way towards resurrecting this lost music, as well as understanding who performed it, where and why.

From the ninth century onwards, liturgical plainchant was written down, initially using a system of graphic signs that reminded singers of the contours of chant melodies, developing in the eleventh century into the staff notation with which we are familiar today. As it became customary to sing from a book, rather than from memory, chant manuscripts grew in size, enabling performers clustered around a lectern to read the notes. Created for religious institutions across Europe, these manuscripts were often prestigious, elaborately decorated objects. An antiphoner from the Franciscan convent of St Klara in Cologne (28.1) is unusual in that we know that it was both paid for and executed by nuns.

Music played not only a vital liturgical role, but was also of political importance, celebrating royal and ducal births, marriages and deaths, and victories in battle. The introduction of printing in 1501 brought music books to a much wider amateur audience, increasing musical literacy and leading to music's use as a decorative motif on objects such as maiolica dishes. New instruments developed and their manufacture intensified, particularly in Italy where many were produced by skilled families of Bavarian craftsmen. Laux Maler belonged to such an instrument-making dynasty (see 28.2); on his death,

his house and workshop contained over 800 finished and 1200 unfinished lutes. While the less well-off bought simpler instruments, the wealthy could commission examples made of precious materials such as ebony or ivory, or including their coats of arms. The painted grotesque decoration on the case of a harpsichord (see p.185) includes the arms of the Strozzi, a wealthy Florentine family of bankers.

Music-making in paintings is not always a reliable guide to actual practice. Often the symbolic meanings of music and musical instruments were the principal focus for artist and viewer, from the celestial harmonies of angel choirs to 'vanitas' paintings, in which instruments – echoing da Vinci's complaint – were metaphors for the cruel transience of human existence. From the fifteenth century, musical imagery drew increasingly on classical myth. Orpheus and his lyre exemplified music's captivating power; the nine Muses, often shown with musical attributes, inspired artistic and intellectual endeavours and were seen as particularly appropriate for the decoration of studies, as on a vaulted ceiling taken from Casa Maffi in Cremona (28.3).

Even cutlery can reveal otherwise lost aspects of musical life. A set of knives with musical notation engraved on their blades constituted the voice parts of a polyphonic setting of the benediction, to be sung before a meal, and the grace, to be sung afterwards, when brought together (see 28.4). Although we do not yet know where these knives were used, they illustrate that the most unlikely objects may reveal valuable information about the important binding role music played within medieval and renaissance society.

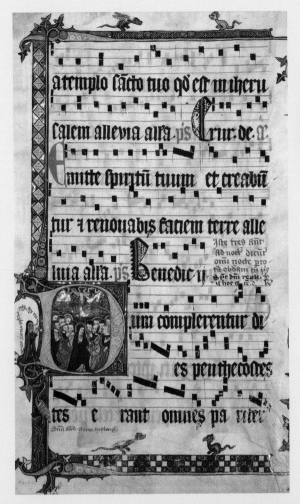

28.1 ◄ **Loppa de Speculo, leaf from an antiphoner from the Franciscan convent of St Klara showing Heylwigis of Beechoven.**
Ink on parchment, with watercolour and gold, 27.7 × 25.3 cm. Cologne, c.1350. V&A: 8997I

The leaf shown here includes a portrait of the convent's abbess kneeling in prayer and contains chants for Pentecost Sunday.

28.3 ▲ **Alessandro Pampurino(?), two roundels from the ceiling vault from Casa Maffi.**
Fresco. Cremona, c.1500. V&A: 428–1889

Famously, paintings of the Muses decorated Leonello d'Este's 15th-century study, or *studiolo*, at Belfiore in Ferrara.

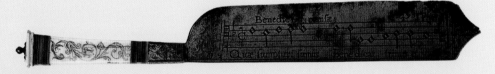

28.4 ▲ **Broad-bladed knife.**
Steel, stained ivory handle with bands of ebony and brass, 29 × 3.5 × 1 cm. Italy, c.1550. V&A: 310–1903

Sixteen of these highly unusual knives survive in museum collections around the world. They may have been made for a court, a confraternity or a monastery.

28.2 ► **Laux Maler, lute back.**
Sycamore, 94.1 × 33.6 × 21.2 cm. Bologna, early 16th century. V&A: 194–1882

Italian lutes were prized and renowned across Europe, and were exported north of the Alps to cities such as London and Augsburg. The neck of the lute is a later replacement.

29. At home in late Tudor England: Sir Paul Pindar and his house

NICK HUMPHREY

SIR PAUL PINDAR'S LONDON HOUSE has long been regarded as an exceptional survival of timber-framed, London architecture from before the Great Fire. In its original form it was considered grand enough to serve as the residence of Pietro Contarini, Venetian ambassador to the Court of St James in 1617–18, and several of his predecessors. By a remarkable coincidence, the wide-ranging letters written by Contarini's chaplain Orazio Busino during the embassy also survive, recording, for example, how Pindar's handsome long gallery was adapted to serve as a chapel where Italians might attend Catholic mass in London.

When his house was built Paul Pindar was already a wealthy merchant trading between Britain and Venice, but resident abroad (29.1). Having purchased several properties and adjoining land on Bishopsgate Without, just outside the old city walls, in 1599–1600 he created a much larger property with a street façade of three storeys and an attic, which Busino would describe as a 'rather comfortable palace' (*assai comodo Palazzo*). The house faced south-east to the street, where it is likely there was a shop or warehouse on the ground floor. It was much deeper than wide, with the main part overlooking a side street.

Pindar followed standard practice by using a pre-assembled oak frame for the façade, which was quicker and cheaper than building in stone or brick, but in scale and character his house must have been striking. The large, exterior oak panels with strapwork and masks were a new fashion in Elizabethan London. Surviving paint traces suggest an exterior scheme of red-brown, possibly contrasting with pale stone colour. The central, semi-circular or 'carell' windows (29.2) were still fashionable in 1600, powerfully evocative of early Tudor

aristocratic buildings. Glazed windows were not uncommon in English cities at this time; Pindar could have used clear Venetian glass or the greenish, native product. Though the interior arrangements are uncertain, descriptions suggest well-appointed rooms with moulded plaster ceilings, elaborate chimneypieces and walls panelled using imported Baltic oak (29.3), elements of which survive in the Museum. A three-storey lodge stood in the large gardens behind.

In 1600 London's population was expanding rapidly and the suburbs were busy with new building. Bishopsgate to the north-east, leading towards East Anglia and paved in 1582, was still close to open land where Londoners went for exercise and pleasure (29.4). The location was particularly convenient for Pindar's professional activities. Less than a mile to the south-west were St Paul's Cathedral, a rendezvous for city merchants, and Cheapside, retail heart of the city. Closer still, at Cornhill, was another important meeting-place, the Royal Exchange, founded in 1571 by Thomas Gresham, another merchant-diplomat living on Bishopsgate.

The years after Pindar's return to London and his occupation of the house (from 1623) saw him develop his enormous wealth, which was assessed at £236,000 in 1639. Business interests in tobacco and alum (valuable for the dyeing of English wool) and his management of the revenues from customs duties allowed him to support speculative trading expeditions, and to make massive loans to Charles I from 1638. (He also gave £10,000 towards the rebuilding of St Paul's Cathedral.) The political upheavals of the 1640s meant that Pindar had huge debts when he died, unmarried, in 1650, and the condition of his house quickly declined.

29.1 ▲ **Thomas Trotter, Portrait of Sir Paul Pindar.** Engraving, 11.4 × 9 cm. England, 1794, after an anonymous painted portrait of 1614. V&A: E.430–1943

Pindar was consul of the English merchants at Aleppo (1609–11), and English ambassador at the Ottoman court in Constantinople (from 1611). He was knighted by James I in 1620.

29.3 ▼ **The great chamber of Sir Paul Pindar's house (from J.T. Smith, *Ancient Topography of London*, London, 1815)**

The first-floor great chamber overlooked Bishopsgate. It had a moulded ceiling that included Pindar's arms, a stone fireplace with a plaster overmantel of Hercules and Atlas and oak panelling (partially removed in 1811).

29.2 ▲ **Surviving portion of the façade from Sir Paul Pindar's house.**

Oak, originally painted, 1006 × 578 × 262 cm. London, c.1600. V&A: 846–1890

In the central panels, the arms of the City of London (first floor) indicate Pindar's identity as a London merchant while a Scottish thistle (second floor) suggests that this part of the façade was not completed until after James I's accession in 1603.

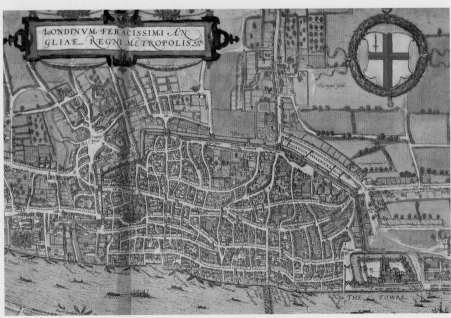

29.4 ◄ **Georg Braun and Franz Hogenberg, *Londinium Feracissimi Angliae Regni Metropolis* (detail showing Bishopsgate running north outside the old city walls).**

Published in *Civitates orbis terrarum*. Antwerp, 1575. Corporation of London

In 1600 Pindar's house and large gardens looked north-westwards to the open land of Moorfields and Finsbury Fields.

NOTES

CHAPTER 1

1 Orosius (1964), pp.7–8.

2 Lewis and Wigen (1997), pp.21–8.

3 Fowler (1966), pp.374–5.

4 For example, the 9th-century voyage between Hedeby in Denmark and Truso in Poland recorded in the Old English Orosius: Lund (1984).

5 For this empire, see Koenigsberger (1971), pp.1–62.

6 Kaufmann (1995), p.19.

7 Halsall (2005), pp.45–7.

8 For a survey of these complexities, see Geary (2002).

9 For similar arguments to those presented here, see Farago (1995), pp.67–72.

10 Abulafia (2002), p.12.

11 Meyvaert (1991), pp.756–63.

12 From the Bull 'Unam Sanctam'. A complete translation is available online at: <http://www.fordham.edu/halsall/source/b8-unam.html>

13 For an introduction, see Brown (1971), pp.22–37.

14 Brown (2003), pp.62–3.

15 Brown (2003), p.60.

16 Eusebius, *The Life of the Blessed Emperor Constantine*. A translation is available online at: <http://www.fordham.edu/halsall/basis/vita-constantine.html>

17 Quoted in Davis (1913), pp.295–6.

18 Brown (2003), p.82.

19 'Quamobrem cilicinam vestem velut circumspectam a cunctis atque notabilem, et quae ex hoc ipso non solum nulla spiritui possit emolumenta conferre, sed etiam elationis concipere vanitatem, quaeque ad necessarii operis exercitium, in quo monachum semper impigrum expeditumque oportet incedere, inhabilis atque inepta sit, omnimodis refutarunt.' Migne (1846), cols.66–7.

20 For a discussion of the Goths, see Heather (1996), pp.1–7 and 84–93.

21 Heather (1999).

22 Gasparri (1997), pp.161–229; Pohl (1998), p.3.

23 Brown (2003), p.104.

24 Lebecq (1997).

25 For an introduction to Sutton Hoo Mound One, see Lowden (1994).

26 Horden and Purcell (2000), pp.153–72. For a less positive view, see Hodges and Whitehouse (1983), pp.20–76.

27 Horden and Purcell (2000), p.155.

28 Contreni (1995), p.721.

29 Contreni (1984), p.64.

30 Barbaro (2004), p.104.

31 Nees (1995), pp.817–20.

32 Blumenthal (1988), pp.135–73.

33 From a letter of 1081. See Cowdrey (2002), p.392.

34 Blumenthal (1988), p.123; Stiegemann and Wemhoff (2006).

35 For the temporal claims of the medieval papacy, see Ullmann (1970).

36 In the words of Pope Innocent III. See Hageneder and Haidacher (1964), p.503.

37 Comnena (1969), p.308.

38 Brooke (1951), p.227. This did not mean that Pisa and Genoa now had 'domination' of Mediterranean waters. See Horden and Purcell (2000), p.155.

39 Blumenthal (1988), pp.65–6.

40 For novelty in the 12th-century renaissance, see Le Goff (2001), pp.641–5.

41 Verger (1999), p.259.

42 Clanchy (1997), pp.288–325.

43 Mews (2002).

44 Birch (1998).

45 'Bibit aquam de sepulchro martyris allatam et sanguine rubricatam, et convaluit. Filius hujus hominis eodem morbo laboravit, et eodem modo convaluit.' Robertson (1875), pp.165–6.

46 'Nulla autem efficacior quam labor peregritionis.' 'Nam sicut omnibus membris homo peccavit ita cunctis membris laborando satisfacit.' Birch (1999), p.84.

47 Langland (1959), p.64.

48 This is the central argument of Bartlett (1993).

49 Leguay (2000), p.104.

50 'capellam mirifici decoris dicto thesauro regio convenientem jussit fabricari, in qua ipsum honore condigno postea collocavit'. Luard (1877), p.92.

51 Runciman (1958). For Angevin art and culture, see Lardeux (2001).

52 Zutshi (2000).

53 Vandewalle (2002).

54 See, for example, Pelus-Kaplan (2007).

55 Evans (2004), pp.19–22.

56 Hunt (1994).

57 Campbell (1987), p.2.

58 Spufford (2002), pp.12–59.

59 For a general survey, see Dollinger (1970).

60 Dollinger (1970), p.196.

61 Spufford (2000), p.190.

62 Klapisch-Zuber (2000), pp.124–30.

63 Herlihy (1997), pp.23–5.

64 For debate about the effects of the plague on art, see Meiss (1951); Van Os (1981); Cohn Jr. (1992); Cohn Jr. (1994). For England, see Lindley (1996).

65 Rubin (1991), pp.14–35.

66 Vauchez (1999a). For a more negative view of Lateran IV, see Binski (2004), pp.150–62.

67 Vauchez (1999b).

68 Bartlett (1993), p.291.

69 For some artistic consequences, see Michael (1994).

70 For Burgundian art patronage, see Jugie and Fliegel (2004).

71 Jardine (1998), pp.37–50.

72 Grafton (2000), pp.48–52.

73 Colin (1981), p.42.

74 Burke (2007), p.192.

75 Baxandall (1980), pp.95–116.

76 Kent (1978).

77 Hale (2000), pp.42–4.

78 Haskell and Penny (1981), p.8.

79 Boxer (1991), pp.15–64; Diffie and Winius (1977), pp.175–86.

80 Kamen (2002), pp.95–150.

81 For this argument, see Fernandez-Armesto (1995), for example, pp.155, 174.

82 For an introduction, see Jackson and Jaffer (2004).

83 Kamen (2002), p.22.

84 See for example, Duffy (1992), esp. pp.1–8.

85 MacCulloch (2003), pp.97–105.

86 Langland (1959), p.65.

87 MacCulloch (2003), pp.121–8.

88 Cipolla (1993), pp.47–8.

89 Duffy (1992).

90 MacCulloch (2003), pp.280–91 and 382–93.

91 Israel (1995), p.141.

92 Israel (1995), p.158.

CHAPTER 2

1 For the fashion in fluted-edged headdresses, see Ribeiro and Cumming (1989), p.46 and Newton (1980), pp.87–8; on brooches, see Hinton (2005), p.219.

2 For a discussion of art, function and fashion in medieval ceramic jugs, see Vince (1991).

3 On the style and its use by Urbino potters, see Poke (2001).

4 Hantschmann (2004), p.48, no.65.

5 For Pliny the Elder's praise of anonymous sculptors' artistry, see Pliny *Historia naturalis* XXXVI.4; Pliny (1958–62), IX, p.21.

6 Aristotle *Politics* VIII.3.1338a, lines 37–43 and 1888b, lines 1–2; Aristotle (1984), II, p.2123. See also Salerno (1951), p.234.

7 See for example Butters (2003); Motture and Syson (2006).

8 Cited in Landau and Parshall (1994), p.52.

9 Heslop (1987), p.31. Scattered comments on aesthetics from the 12th century are gathered together in Schapiro (1977). See also Eco (2002), ch.IX: 'Theories of Art', pp.92–104.

10 On these developments see, for example, Baxandall (1971); Maginnis (1995); Pon (1996b).

11 Kristeller (1951), pp.498 and 507–509.

12 Cited in Whitney (1990), p.26.

13 Lucian *Dream*, verses 6 and 13; Lucian (1991), pp.25, 29–31.

14 Haren (1992), p.68; Whitney (1990), p.29. The text of the treatise is in Capella (1971), II.

15 Hugh of St-Victor *Didascalicon* II.20; Hugh of St-Victor (1991), p.75.

16 See Hugh of St-Victor (1991), p.91 n.64, citing Martin of Laon, *Scholica graecarum glossarum*, in Laistner (1922–3), p.439.

17 Hugh of St-Victor *Didascalicon* II.20; Hugh of St-Victor (1991), p.75.

18 Augustine *City of God* XXII.24, cited in Whitney (1990), pp.26 and 54.

19 Exodus 25–27.

20 Although by the 13th-century biblical commentators were arguing for human involvement in the composition as well: see Minnis (1988).

21 Hugh of St-Victor *Didascalicon* I.9; Hugh of St-Victor (1991), pp.55–6.

22 Theophilus *De diversis artibus*, Preface to Bk II; Theophilus (1961), pp.63–4, and see also the comments pp.xx–xxiii. For a dating of the work between 1110 and 1140, see ibid., p.xxxiii.

23 Castiglione (1967), Bk I, pp.81, 82.

24 Aristotle *Politics* VIII.2.1337b; Aristotle (1984), II, p.2122. Cited in Whitney (1990), p.28, and see also p.32.

25 Seneca cited in Whitney (1990), p.29.

26 For the citation and a discussion of this analogy, see Eco (2002), p.22.

27 Cited in Heslop (1987), p.29.

28 Eco (2002), p.9; Binski (2001), pp.352–5.

29 Binski (2001), esp. pp.350–55.

30 Muratova (1986), p.57.

31 Sansterre (1996), p.186.

32 Grant (2000), p.55.

33 Armenini (1587), Bk III, p.210; translation in Wittkower (1961), pp.298–9.

34 Pliny *Historia naturalis* XXXV.36; Pliny (1958–62), IX, p.337.

35 See the comments in Gardner (1997), pp.451–2. For the importance of biographers to Michelangelo's posthumous reputation, see Pon (1996b).

36 Armenini (1587), Bk III, p.206.

37 Syson and Thornton (2001), p.229.

38 Østrem (2007); see also D'Holanda (1984), p.13.

39 For example, Isaias 44: 13. See also Tachau (1998), p.27.

40 For God creating in clay, see Genesis 2: 7; Augustine *Sermones* 82.1, cited in Lecoq (1975), p.227.

41 Giovanni Lomazzo, *Libro dei Sogni*, cited in Lecoq (1975), p.227.

42 Syson and Thornton (2001), p.242.

43 Baxandall (1972); Kemp (2002), pp.183–4; Pon (2004), p.80. I am grateful to Liz Miller for bringing this last work to my attention.

44 Kemp (2002), p.185. For painters' contracts, see also Kemp (1997), esp. ch.2; O'Malley (2005).

45 Kemp (2002), pp.185–6.

46 Stechow (1989), p.83 and n.11.

47 Osma (1908), p.19.

48 For a transcription of the text in the centre of the drawing, see Wolters (1961), p.138.

49 The contract and Sorte's complaint are translated in Chambers and Pullan (1992), pp.401–403. For the holes, which officials feared would allow unauthorized persons access to secret Senate meetings, see Wolters (1961), p.142. On the artist and court politics see Welch (2004).

50 Felix Faber, *Tractatus de civitate Ulmensi*, translated in Stechow (1989), p.79.

51 Alfonso X (1930), p.477; translation in Cárdenas (1990), p.92; also Montoya Mártinez (1979).

52 Gilbert (2000), p.81.

53 See the comments in Donato (2000), p.10.

54 My translation: original text in Leclercq-Marx (2001), p.2.

55 Gilbert (2000), p.81.

56 'Constantin de Iarnac fecit hoc op[u]s': Beaulieu and Beyer (1992), p.210. See also Dujarric-Descombes (1901), esp. p.56 for a discussion of the identity of Constantin.

57 Overgaauw (1999), esp. pp.87–91; Pon (2004), p.78.

58 Farquhar (1980), pp.372–5.

59 For a discussion of signatures, see Leclercq-Marx (2001); for signatures and salvation, see

Bacci (2000a). On the importance of fame, see Lida de Malkiel (1952); Kallendorf (1989); Enenkel, de Jong-Crane and Liebregts (1998).

60 '[IA]COB. MARQVART. VON. AVSPVRG. BIN. IH. GENANT. MEIN. NAM. IST. IN WELSLANDT. GAR. WOL. BEKANT. DER. HAT. DAS. WERCK. GEMACH[T]. [FIR]WAR. IM. 1567. IAR. AIN. SVNENVR. IST. DAS. GENANT. AVF. WELS. VND. DEISCH. LANDT. ERKANT.'

61 Chastel (1974), p.8.

62 For Dürer see Landau and Parshall (1994), p.313.

63 Syson and Thornton (2001), p.150; Pon (2004), p.78.

64 Heck (2008).

65 Koreny (1993), p.385.

66 Brinkmann (2007), p.19, and p.24, pl.6 for an illustration of Cranach's 'LC' monogram.

67 Nickel (1981), p.127 n.21.

68 'Meister Woelfelin von Ruffach, ein Burger zu Strasburg, der het dis Werk gemaht': Beaulieu and Beyer (1992), p.136.

69 Judith 13: 1–10.

70 Vasari (1991), p.152.

71 'Opvs Donatelli Flor[entini]'. According to Pomponius Gauricus, Donatello did not know how to cast and employed bell-founders for the task: Gauricus (1969), p.219. See also Leoni (1988), p.54.

72 For two mid-16th-century examples, see Schroder (1983), nos 6 and 7 (pp.43–6).

73 Cf. dress in painters' self-portraits, in Boschloo (1998). For arms and letters as knightly pursuits, see Castiglione (1967), for example, Bk I, p.93; Russell (1967).

74 Compare ideas of casting as a manual activity in sculpture in Cole (1999), p.219 and Gauricus (1969), p.217.

75 For this concept see Jůren (1974), pp.27–30.

76 Theophilus De diversis artibus, Preface to Bk III; Theophilus (1961), pp.61–2.

77 Theophilus De diversis artibus, Preface to Bk I; Theophilus (1961), p.4.

78 Cited in Heslop (1987), p.31. See also Chrétien de Troyes (1975), p.111.

79 Durandus Rationale divinorum officiorum III.22; Durandus (2007), p.48.

80 For an accurate transcription of the quotation, see Durandus (1995), I.ii.22, p.42. For the original, see Horace Ars poetica 9–10; text published online at <http://www.thelatinlibrary.com>; English translation in Horace (1965), p.79. See also Maginnis (1995), esp. pp.31–2; Kemp (1997), p.81.

81 Muratova (1986), p.60; Sansterre (1996). See also Alfonso X (1986–9), II, no.202 (for the Virgin helping a Parisian monk complete the rhyme-scheme of his poem) and III, no.362 (for the Virgin restoring the sight of a goldsmith struck blind).

82 Sansterre (1996), pp.185–6.

83 Farago (1992), pp.21–4.

84 For Leonardo's views, see Farago (1992): for example, ch.15, 'A Difference between Poetry and Painting', pp.199–203; and ch.39, 'On the Sculptor and the Painter', p.269. For the relationship between Leonardo's drawings and poetic imagery see Kemp (1985) and (1997); on sculpture and manual labour, see Salerno (1951), esp. pp.236; Lecoq (1975), p.235.

85 Quivigier (1987); Farago (1992), pp.8–9; Gardner (1997).

86 For example, Biondo (1549), in his dedicatory preface, f.iv.

87 Durandus Rationale divinorum officiorum III; Durandus (2007), p.48.

88 For this see Salerno (1951); Baxandall (1971); Jůren (1975).

89 'tirar ao natural aquilo que só Deus fez por tão investigabil sabedoria como Ele sabe. Querê-lo um homem de terra imitar deve ser coisa mui grande e a maior que os homens podem fazer': D'Holanda (1984), p.13.

90 On Xanto, see Syson and Thornton (2001), pp.250–60 (esp. p.255, pl.207); and Mallet (2007).

91 See Mallet (2007), pp.128–9.

92 The print is reproduced in Mallet (2007), p.128, fig.47.

93 Vasari (1991), p.478.

94 Evans (2007), p.53.

95 Clifton (1996); Pon (1996b).

96 Coffin (1964), p.193; for Michelangelo's boots (of dog-skin), see Vasari (1991), p.481.

97 Phyrr and Godoy (1998), cat.15, p.107.

98 Phyrr and Godoy (1998), pp.106–107.

99 Bury (1985), pp.21–2.

100 Kemp (1997) p.231; Syson and Thornton (2001), p.136. For the increasing emphasis on the significance of the artist's hand in the creative process, particularly as argued by the biographer Vasari, see Barolsky (1995). For two early 14th-century Italian sculptors praising the skill of their own hands, see Donato (2000), p.11.

101 Translation and original text cited in Soly and Blockmans (1999), p.134 and n.26.

102 Pliny Historia naturalis XXXV.36; Pliny (1958–62), IX, p.321.

103 The account follows the recollections of Sangallo's son Francesco, recorded in a letter of 1567: Pon (2004), pp.26–7.

104 Vasari (1991), p.423. For analysis and the dating of the work to 1495–6, see Syson and Thornton (2001), pp.133–4.

105 Panofsky (1951), p.35.

106 Coffin (1964), p.196.

107 Palissy (1941) p.9. My translation.

108 'E las coronas con las piedras y con los camafeos e sortyas e otras donas nobles que pertenescen a rey': González Jiménez (1991), doc.521 (Seville, 10 January 1284), p.559.

109 Syson and Thornton (2001), pp.176–81.

110 Vasari (1991), pp.424–5.

111 For Vasari's changing account and his unknown correspondent, see Pon (1996a), and p.18 for this quotation.

112 Vasari (1991), pp.68–9.

113 On the possibility that Chellini kept the roundel in his study, see Preyer (2006), pp.46–7.

114 Cited in Kemp (2002), p.189. For this letter as a sign of the importance of social connections over individual talent, see Welch (2004), p.22.

115 Cellini (1967), ch.VIII, p.144.

116 Grant (2000), pp.51–2.

117 Osma (1908), p.9.

118 Johnson (1997), pp.1–2. For examples of Venetian inventories, including paintings, see Palumbo-Fossati (1984), esp. p.131; for examples of 16th-century English inventory descriptions, see Foister (1981).

119 Cited in Pon (2004), p.26.

120 Vasari (1991), p.157.

121 For the study, see Thornton (1997); Syson (2006).

122 Motture (2005), p.26; Motture and Syson (2006), pp.279–80.

123 Bonne (1996b), p.62.

124 For symbols that allude to a scribe's identity, see Fraenkel (1992).

125 See Minnis (1988), pp.90–92.

126 I am grateful to Glyn Davies for suggesting this possibility. For the title guardianus, see Muscat (2008).

CHAPTER 3

1 Goldthwaite (1993); Jardine (1998); Welch (2005).

2 Newett (1907), p.129.

3 Gaborit-Chopin (2003), pp.19–22 and Koechlin (1924), pp.8–32. For Byzantine ivories, see Cutler (1985). Alan Cameron has recently argued that the letters of Symmachus show that diptychs were intended for distribution after the games laid on by the consuls were completed: see Seeck (1883), p.66, letter LXXXI.

4 It is unlikely that medieval Europe was supplied with ivory directly from the West African coast. Arab merchants obtained much ivory in East Africa. See Horton (1987), p.317.

5 See McKitterick (1989).

6 For differing views, see Vandersall (1976); Nees (2001). For the main ivory groupings, see Goldschmidt (1914).

7 The Benedictional of Saint Aethelwold, written for Bishop Aethelwold by a scribe-monk called Godeman (963–84), is the epitome of this Winchester style. For a facsimile, see Prescott (2002). For discussion, see Deshman (1995).

8 Reproduced and discussed in Legner (1985), p.251.

9 For Hugo, see Arnold (1892), pp.289–90; James (1895), pp.7, 23, 27–128 and 199; Kauffmann (1966); Kauffmann (1975), p.15; Thomson (1975); Parker (1981); Parker and Little (1994), pp.222 and 295 n.100.

10 Biddle (1975).

11 Weitzmann (1973), pp.25–9.

12 For a voyage in search of walrus ivory, see Lund (1984), p.19.

13 Boehm and Taburet-Delahaye (1995), p.49.

14 Evans (1936).

15 For Portugal and Bruges, see Vandewalle (2002), pp.44–6.

16 Tomasi (1999).

17 For production in the 11th and 12th centuries, see Legner (1985), part B, 'Fabrica', pp.117–384.

18 Desmaze (1874), p.594.

19 Vernet (1949), pp.49–50.

20 Taille document in Geraud (1837).

21 Rouse and Rouse (2000), p.26.

22 Watson (2003), pp.90–91 discusses this manuscript.

23 Depping (1837), p.379–81.

24 Geraud (1837), p.12.

25 Rouse and Rouse (2000), p.131.

26 This will is London, Public Record Office, PROB 11/8. For reuse of goldsmiths' moulds over a long period, see Campbell (1991).

27 Christie (1938), pp.134–5; Lee (1941); Greatrex (1997), p.300.

28 Lethaby (1916).

29 See Clark (1999).

30 Boehm and Taburet-Delahaye (1995), p.201.

31 Boehm and Taburet-Delahaye (1995), pp.430–31.

32 Boehm and Taburet-Delahaye (1995), p.47 n.2.

33 For Becket and St-Victor, see Châtillon (1975).

34 For traditional and innovative aspects of Becket's cult, see Binski (2004), pp.81–4.

35 King (1987), p.159.

36 Hamburger and Suckale (2005), pp.529–30.

37 For his career, see Cioni (1998), pp.672–3.

38 For Byzantine guilds, see Runciman (1987), pp.151–63; Lopez (1945). For the Book of the Prefect, see Freshfield (1938).

39 For a 12th-century goldsmiths' guild in Zadar, Croatia, see Krleza (1972), p.148.

40 The following discussion compares guild rules from a number of different cities. For Venice, see Monticolo (1896); for Siena, Milanesi (1854), I, pp.57–101; for Florence, Dorini (1942); for Verona, Simeoni (1914); for Paris, Depping (1837), pp.38–9; and for London, Reddaway (1975).

41 Davies (forthcoming).

42 Taburet-Delahaye (1995).

43 Dini (1993), pp.91–4.

44 Molà (1993); Molà (2000), pp.3–7.

45 Mackenney (1997), p.26.

46 Molà (2000), pp.30–37. For other transferrals of skills, see Molà (2007).

47 For Venetian protectionism, see Mackenney (1997); Muthesius (2003), pp.331–40.

48 For this period, see Mackenney (1997), pp.17–20. He mistakenly gives the date of the first glass-makers' regulations as 1284.

49 Tait (1999).

50 Newett (1907), p.142.

51 '… questo mestiero è andato molto in declinatione': Florence, Archivio di Stato, Carteggio dei Secretari – Pierfrancesco del Riccio, 1171, part 4, f.166.

52 For the glass-makers, see Syson and Thornton (2001), pp.184–200.

53 Sears (2006), p.225.

54 Koechlin (1924), pp.582–3.

55 Sears (1997), pp.29–32.

56 For the Pont au Change during the Renaissance, see Bimbenet-Privat (1992), pp.29–33.

57 Grossi (2000), p.6.

58 Milanesi (1854), I, p.76, no.42.

59 Welch (2005), pp.111–21.

60 1335 statutes, no.122: Dorini (1942), p.146.

61 Discussed in Sears (2006), pp.229–31. The quotation is my translation of the Parisian Embroiderers' Ordonnance of 1303: Depping (1837), p.381.

62 Rouse and Rouse (2000), p.22.

63 Simeoni (1914), p.242, no.24. Statutes of 1319.

64 London, Public Record Office, SC 8/159/7933. Probably the same William Trente lived as a tenant of Christ Church, Canterbury near St Mary-le-Bow in Cheapside: Keene and Harding (1987), pp.261–6.

65 Depping (1837), p.155.

66 Milanesi (1854), I, p.82, no.51.

67 For sculptors' workshops, see Ames-Lewis (1997), pp.17–45; Moskowitz (2001), pp.5–10.

68 Maginnis (2001), p.88.

69 For the example of Donatello in Padua, see Motture (2006).

70 For a case study, see Zuraw (2004).

71 For Manutius, see Lowry (1979). For Jensen's shops and the Giunti quote, see Richardson (1999), pp.27 and 35–7. For a suggestion that a standard print run in the 1480s was 2000 volumes, see Lowry (1991), pp.181–3.

72 Cheetham (1984), pp.30–31.

73 For this artist, see Swarzenski (1921); Krautheimer (1947); Legner (1969). For the V&A Pietà, see Williamson (1988), pp.187–91.

74 Comparisons first detailed by Legner (1969), pp.113–14, suggested by Müller (1966), p.64.

75 For an alabaster bought from a Parisian merchant in 1431 for the abbey of Sandkloster, see Scheyer (1933), p.36.

76 A subject usually discussed in the context of painting. For example, see Weiss (1956); Nuttall (2004), esp. pp.43–132; Aikema (2007).

77 Williamson (2002), pp.64–5.

78 The following discussion derives from: Trexler (1978); Merlini (1988); Tomasi (2001); Tomasi (2003). In particular, I should like to thank Dr Tomasi for his insights and generosity in discussing this topic.

79 During the Revolution, it was moved to the Musée des Monuments Francais: Durand and Laffitte (2001), no.60.

80 Now in the Musée de Cluny, Paris: Du Sommerard (1881), p.84

81 Now in the Louvre: Gaborit-Chopin (2003), pp.537–47.

82 Meiss (1967), p.46.

83 Baxandall (1980), pp.95–116.

84 For tapestries, see Campbell (1976), pp.194 and 197; Campbell (2002), pp.29–40.

85 For ready-made altarpieces, see Jacobs (1998), pp.149–65; Woods (2007), pp.111–16.

86 Molà (2007), pp.144–7.

87 Bemporad (1993), pp.9–12.

88 For a reconsideration, see Pon (2004), pp.39–41 and 137–54.

89 Erlande-Brandenburg (1995), p.69.

90 For discussion, see Recht (1989), pp.409–11.

91 The printer Manutius patented typefaces and texts, such as Bembo's *Asolani*: Richardson (1999), p.42. *Cristallo* glass was the subject of several patents. For Venetian silk-weaving patents, see Molà (2000), pp.186–214.

92 Staniland (1991), p.16.

93 This petition is London, Public Record Office, SC 8/20/1000. For political background, see Goodman (1971).

94 Churchill and Bunt (1926), pp.1–8. For a study challenging the view that guilds were a negative influence on early modern manufacturing, see Molà (2000).

95 Discussed in Jopek (2002), pp.65–6 and 122–3.

96 Discussed in Kren and Evans (2005).

97 For the V&A Virgin and Child, see Kren and McKendrick (2003), pp.447–86.

98 Snodin and Styles (2001), pp.29–30 and 95–6.

CHAPTER 4

1 'Anno Gracie DCCCII, Michael, piissimus curopalates appelatus, est imperator Romanorum, ut legitur in cronica Anastasii, qui per IIos annos regnavit, cum sciamus Karolum postea XIII annos regnasse, qui augustus dicitur. Forsitan Michael Constantinopoli regnabat.' Translation mine. Published in Itier (1998), p.4.

2 Itier (1998), pp.xxix–xxxv.

3 Burke (2007).

4 Alexander (1987), pp.122–3.

5 See Williams (1998) and Semple (1998) for conflicting examples.

6 Caillet (2007), p.110; Adhémar (1939), pp.49–50.

7 Bober and Rubinstein (1986), p.31.

8 Cellini (1956), p.54.

9 Vasari more confidently advanced this idea, alluded to without being endorsed in the *Vite*, in a description of the Baptistery in 1568; see Davis (2008), p.22. For renaissance historical anachronism, see Nagel and Wood (2005).

10 Williamson (1982).

11 Bari (2004), pp.29–30.

12 Campbell (1980).

13 London, V&A: C.2151–1910. The Book of Judith, now part of the Apocrypha in Protestant bibles, was included in the Latin Vulgate that was the standard bible in the West until the 16th century. The main part of the story of Judith is recorded in chapter 13.

14 See Vryonis (1997), p.7.

15 Cutler (2001), p.638 and Jeffreys (1979).

16 Pyhrr and Godoy (1999), pp.7–15.

17 Blair (1966).

18 Williamson and Motture (2007), pp.68–9.

19 Possibly an astronomical symbol: Mann (1977), pp.280–81.

20 Mann (1977), pp.155–7 and 269–70. For negative medieval views of Hercules, see Nees (1991), p.209.

21 Quoted in Mango (1963), p.69.

22 Translation mine. Scott (1969), no.38. For a detailed discussion, see Settis (1986), pp.375–6.

23 Valentini and Zucchetti (1946), pp.3–15. Miedema (1996).

24 'Palatium Traiani et Adriani… ubi est columpna mirae altitudinis et pulchritudinis cum caelaturis historiarum horum imperatorum…' Translation mine. Valentini and Zucchetti (1946), p.53.

25 Camille (1989), pp.73–87.

26 'E vedi l'altro, là dove sta sue; Quel gran ricciuto appresso al Laterano; Ch'uom dice Costantin ma quel non fue.' Translation mine. Valentini and Zucchetti (1946), p.62.

27 Valentini and Zucchetti (1946), pp.145–6. For an English translation, see Osborne (1987), pp.19–22.

28 '… ridiculoso simulacro Priapi.' Translation mine. Valentini and Zucchetti (1946), p.150.

29 Legner (1972), p.204; Williamson (1986b), pp.273–5.

30 Mango (1963), p.61 and James (1996), p.17.

31 Cutler (1968), pp.114–15.

32 El-Cheikh (2001), p.65.

33 Raby (1980), p.242.

34 Mango (1963), p.63.

35 Orosius (1936), p.75.

36 Andreescu-Treadgold (1990).

37 See, for example, Black (1995), p.68.

38 Ferguson (1948), p.13.

39 For renaissance discussions of a decline in quality in late antique art, see Haskell (1993), pp.112–27.

40 The following discussion is largely based on Black (1995).

41 'il dono (se però dir lece), che Constantino al buon Silvestro fece': Ariosto, *Orlando Furioso*, Book 34, stanza 80. The full text is available online at: <http://www.bibliotecaitaliana.it/index.php>

42 The ivory has been radio-carbon dated between 70 CE and 350 CE. Williamson (2003b), pp.47–8.

43 See Kinney (1994) and Cutler (1994a) for debate on this object. See also Williamson (forthcoming).

44 See Stiegemann and Wemhoff (1999), pp.733–6; Schefers (2000).

45 'tabulas eburneas II in unum coniunctus'. Translation mine. Frisi (1794), p.72.

46 For Christ as magician, see Mathews (1993), pp.54–91. For a differing view, see Brown (1995), pp.500–501.

47 For a 5th-century dating, see Hoving (1960), pp.11–12 and 226–30. For a 9th-century dating, see Volbach (1977), p.11; Cutler (1984), p.55 n.68. See also Williamson (forthcoming).

48 Krautheimer (1942), pp.3–11; McClendon (2005), pp.158–61.

49 Contreni (1984), pp.59–63.

50 Barbaro (2004), pp.87–9.

51 'Fulget avaritia exornatis aurea membris.' Translation mine. Duemmler (1884), p.372. For a reconsideration of Carolingian attitudes towards the Roman past, see Nees (1991).

52 Motture (2007).

53 Greenhalgh (1989), p.149.

54 Greenhalgh (1989), p.153.

55 Greenhalgh (1989), pp.119 and 134. Castelnuovo (1992), p.27. For the wide attraction of ancient marble, see Redford (1993).

56 Williamson (1995), p.252. For another example of reuse by Arnolfo, see Romanini (1994).

57 Zampieri (2006). However, there is a lack of documentation to prove the original context for this object.

58 A distinction emphasized by Settis (1986), p.392.

59 Meckseper (2001), p.377.

60 Settis (1986), p.389.

61 Settis (1986), p.397.

62 Williamson and Motture (2007), pp.6 and 16–17.

63 Oman (1930a); Heckscher (1937–8); Zwierlein-Diehl (1997).

64 Wentzel and Mitchell (1953).

65 For examples, see Oman (1930a).

66 Schapiro (1949), pp.173–4.

67 For examples, see Adhémar (1939); Oakeshott (1959).

68 Orosius (1964), p.38.

69 Caillet (2007), p.102.

70 Martino da Canal (1972). The Trojan foundation of Venice was avowed as early as the 10th century. Yates (1975); Tanner (1994); Fortini Brown (1995), p.140.

71 Tomasi (2002), pp.61–2.

72 Harper (2005), p.156.

73 Loomis (1953), pp.115–16.

74 Nitze (1934).

75 'Probabilius ergo videtur, quod a militibus Remi patria profugis urbs nostra condita vel Remorum gens instituta putatur, cum ad menia Romanis auspiciis insignita et editior porta Martis…ex nomine vocitata.' Translation mine. Stratmann (1998), p.61.

76 Mango (1981), p.50.

77 For the illustrative tradition, see Buchtal (1971).

78 McKendrick (1991), p.64.

79 McKendrick (1991), pp.49–54 and 62–4; Campbell (2002), pp.55–9.

80 Connell (1972), p.164.

81 McKendrick (1991), p.64.

82 'Ledit duc de Bourgogne, estant a Paris, feit tendre en sa sale de son hostel d'Artois et dedans les chambers, la plus noble tapisserie que ceulx de Paris avoient oncques veue, par especial celle de l'histoire de Gedeon… Ledit duc feit aussy tendre l'histoire d'Alexandre et aultres; plusieurs toutes faites d'or et d'argent et de soye; et pour la multitude qu'il en avoit, les faisoit tendre les unes sur les autres… n'estoit personne qui ne s'esmerveillat de l'estat qu'il tenoit…' My translation. Reiffenberg (1836), p.171. See also Campbell (2002), p.18.

83 Asselberghs (1969).

84 McKendrick (1991), p.52.

85 Based on scientific examination conducted by Albertina Cogram and Frances Hartog of the V&A Textiles Conservation department, 2008.

86 Pyhrr and Godoy (1999), pp.7–9.

87 Harper (2005), pp.159–66.

88 Pope-Hennessy and Lightbown (1964), I, pp.325–9, no.359.

89 Cutler (1994b), pp.56–7.

90 See the comments of Cutler (2001), pp.631 and 659; Settis (1986), p.408; Cutler (1994b), pp.240–46.

91 Cutler (1998); Williamson (forthcoming).

92 Translation mine. Ghiberti (1998), p.84.

93 Curran and Grafton (1995), p.242.

94 Mommsen (1942).

95 Black (1995), pp.66–7.

96 '… le temps n'estoit tant idoine ne commode es lettres comme est de present… Le temps estoit encores tenebreux et sentant l'infelicité et calamité des Gothz, qui avoient mis à destruction toute bonne literature.' Translation mine. Rabelais (1997), p.107.

97 Ferguson (1948), p.14.

98 Ghiberti (1998), p.83.

99 Politiani (1994), p.224.

100 'Quando era a tavola mangiava in vasi antichi bellissimi, et così tutta la sua tavola era piena di vasi di porcellana, o d'altri ornatissimi vasi. Quello che egli beeva erano coppe di cristallo o d'altri pietre fine.' Translation mine. Greco (1970–76), II, p.239.

101 '… molte cose di musaico in tavolette.' Translation mine. Greco (1970–76), II, p.240. For other collectors of Byzantine mosaics, see Effenberger (2004), pp.211–12.

102 Vespasiano da Bisticci (1938), p.500.

103 Kemp (1997), pp.146–7.

104 Kemp (1997), p.146.

105 The 'principle of disjunction' alluded to here was coined by Panofsky (1960), and has been accepted by many authors, such as Burke (1969), pp.1–6. For reconsiderations, see Holly (1993); Landauer (1994); Kelley (1995); and Grafton (1995).

106 For discussions, see Johnson (1999); Motture (2006).

107 Radcliffe (1989). The attribution to Donatello is not accepted by all scholars. See Wohl (1991) and Rearick (1999); Motture (2006).

108 Radcliffe suggests that the wax was a model for a marble. Radcliffe (1989), p.199; Motture (2006).

109 It does recall Masaccio's Holy Trinity fresco in S. Maria Novella, Florence of 1428.

110 Greenhalgh (1989), p.237 and Greenhalgh (1982), p.24.

111 For its influence, see Holgate (2003), p.15.

112 See, for example, the arguments of Grafton (2000), pp.71–109.

113 For this translation, see Johnson (2002), pp.64–6. For the Italian, see Ghiberti (1998), p.108.

114 Kemp (1997), p.146.

115 Ames-Lewis (2000), p.81.

116 Grafton (1995), p.126.

117 'Nec minor Euclide est Albertus: vincit et ipsum Vitruvium…' Translation mine. Pagliara (1986), p.7.

118 Panofsky (1955), pp.262–70.

119 Quoted in Grafton (2007), p.166.

120 For recent discussions, see Marchand (2007), pp.198–200; Syson (2007), pp.190–93.

121 Radcliffe (1981); Allison (1994).

122 For discussion and bibliography, see Motture and Hamnett (2008).

123 Bocchi (1974), p.105.

124 Radcliffe (1981), p.46.

125 For other examples, see Barkan (1999), pp.124–8.

126 Jopek (2002), pp.86–8.

127 Baxandall (1980), pp.135–42.

128 'Qui non sine divino numine circiter annui domini M.CCC tinae in XL. barberiei revocans, eloquentie studia staurario vehementer exitavit': Despautère (1516), p.9. For a discussion, see Ferguson (1948), p.30.

129 Quoted in Wintroub (2006), p.43. In 1400,

the French reading public had certainly not been ready for Laurent de Premierfait's literal translation into French of Boccaccio's *De Casibus Virorum Illustrium*: Hedeman (2004), p.60.

130 Rackham (1940), pp.205–9.

131 Amico (1996), pp.130–53; Crépin-Leblond and McNab (1997). Elements of the candlestick have been restored.

132 For a contrary view, see Tolley (2007), p.144.

133 Zerner (2003), pp.9–10.

134 Discussed in detail by Haskell and Penny (1981), pp.2–12. For the casting of bronzes in renaissance France, see Bresc-Bautier (2003).

135 Cellini (1956), p.298.

136 Rubin (1995), esp. pp.231–86.

137 Diemer (2004), pp.73–82.

138 Boucher (2001), cat. no.31.

CHAPTER 5

1 For the modern definition, see Snodin and Howard (1996), p.98. I am grateful to Luke Syson for his comments on this chapter.

2 Cicero *De officiis* I.35.126; Cicero (1967), p.83.

3 Cicero *De officiis* I.39.138; Cicero (1967), p.88.

4 London, British Library, Add. MS 38818, ff.49r–109r.

5 McKean (1979), p.16; see more recently, Clarke (2003).

6 Vitruvius (1999), p.25; see also Onians (1988).

7 Pliny *Historia naturalis* XXXV.2; Pliny (1958–62), IX, p.265.

8 Isidore of Seville *Etymologiae* XIX.11; Isidore of Seville (1993–4), II, pp.448–9. My translation.

9 Suger *De administratione* XXXI–XXXIVA and XXXIIIA; Suger (1979), pp.52–81 and p.67; see also Didi-Huberman (2000), pp.87–8.

10 Suger *De administratione* XXXII; Suger (1979), pp.57–8.

11 Suger *De administratione* XXX; Suger (1979), p.63. On the power of precious objects to elevate spiritually those contemplating them, see the arguments by Bonne (1983); and Kessler (1996). For gems as an allusion to the Kingdom of Heaven, see Carruthers (1990), p.246.

12 Suger *De consecratione* V; Suger (1979), p.105.

13 Durandus *Rationale divinorum officiorum* 1.2.3–5; Durandus (2007), pp.48–52.

14 London, British Library, Add. MS 29436: *Chartulary of St Swithun, Winchester*, ff.47r –47v.

15 *Recueil d'anciens inventaires* (1896), p.27 (for 1463 inventory) and p.330 (for 1575 inventory).

16 Piponnier (1997), pp.3 and 6.

17 Staniland (1989), pp.278–9.

18 Piponnier (1997), p.4.

19 The scenes are listed in Williamson (1986a), p.130.

20 Stratford (1984).

21 Ezekiel 47: 12; and see also Revelation 22: 2.

22 Cited in Grant (2000), p.55.

23 Bernard of Clairvaux, *Homiliae super Missus est (in laudibus Virginis matris)* cited in Varazze (1998), I, ch.I, p.327 and n.13; Jalabert (1954), p.26. See also Stratford (1984), p.214.

24 Harrazi (1982); Milburn (1988); and Fleischer (2004). On the acanthus leaf as a motif more generally, see *L'Acanthe* (1993); Vandi (2002).

25 Bonne (1996b), p.65.

26 Cited in Schapiro (1977), p.16; Mortet and Deschamps (1911–29), I, p.122.

27 Cited in Kessler (1996), p.180 n.5.

28 Durandus *Rationale divinorum officiorum* 1.3.17; Durandus (2007), p.47.

29 Translated, with parallel Latin text, in Rudolph (1990), p.106.

30 Rudolph (1990), pp.128–30. For an analysis of Bernard's criticism of art and reference to similar, contemporary views, see Rudolph (1990), pp.104–24.

31 Alberti (1988), Bk VII, ch.10, p.222.

32 Contemporary reference to his writings is in Greco (1970–76), I, p.224.

33 Gilbert (1959), p.76.

34 Suger *De administratione* XXXI; Suger (1979), pp.55–7.

35 Welch (2002), p.215. For a full discussion of the concept of splendour in the period, see Lindow (2007). For Pontano's complete text, with an Italian translation from the original Latin, see Pontano (1999).

36 Welch (2002), p.215.

37 The cost of horn was traditionally low: for 7th-century records valuing it in pennies, see Hinton (2005), p.85.

38 Pontano (1999), Bk II, p.224.

39 Cited in Whitney (1990), p.29.

40 Lightbown (1981), p.461.

41 Cited in Syson and Thornton (2001), p.93.

42 Motture (2001), p.47.

43 Ecclesiasticus 21: 24.

44 Genesis 4.

45 Suger *De consecratione* VI; Suger (1979), p.115.

46 Seneca *Epistulae*, letter 79; Seneca (1988), p.61, para 18.

47 Bernard of Clairvaux (1998), letter 116, p.177.

48 'Decus ad animum refertur, decor ad corporis speciem': Isidore of Seville *Differentiae* I.22, cited in Bonne (1996a), p.218.

49 Bernard of Clairvaux (1998), letter 2, p.17.

50 Manrique (1993), pp.152–3, stanza vii. Ironically, Manrique's real purpose was to praise his father and exalt his own talents as a poet. See Kennedy (2008).

51 'tales cosas de que non curé aquí de tractar porque esto en los omnes bien non paresçe, segúnd el uso d'este tiempo, e más conviene a las mugieres en sus afeites': Villena (1994), I, p.146.

52 On attitudes to and remedies for disfigurement, particularly syphillis, in the 16th century, see Pelling (1986).

53 Colish (1990), p.34. See also Ribeiro (1986), pp.26–7.

54 Vives (1584), Bk I, ch.viii, ff.53v–54r.

55 Haydocke (1598), pp.128–9.

56 Le Fournier (1530), 'Le Prologue' (no folio no). My translation.

57 Motture (2001), p.48. However, the difficulty of interpreting the meaning of abstract ornament in the absence of textual evidence means this must remain a theory.

58 For interlace patterns and the significance of their use, see Kitzinger (1993); Bonne (1996a).

59 See Watson (forthcoming).

60 Fortini Brown (2004), p.71.

61 See Golombek (1988a and b).

62 See Tracy (1988), p.154. An example is V&A: 539–1892.

63 Pliny *Historia naturalis* XXXV.36; Pliny (1958–62), IX, p.307–8.

64 For the original meaning of these inscriptions, see Aanavi (1968); Blair (1997a), p.101; and Blair (1997b), p.137.

65 On *tiraz* bands, see Contadini (1998), pp.39–48 and 52–5.

66 I should like to thank Tim Stanley and Helen Persson for this information. See also Blair (1997a), pp.96–7.

67 London, V&A: M.104–1945. The motif was still popular in the 15th-century, as can be

seen in the pseudo-Kufic pattern inscribed along the hem of the Virgin Mary's robes on devotional statues and in paintings: for example, V&A: 7573–1861. On *alif* and *lam* see Aanavi (1968), p.356; and on Islamic calligraphy generally, see Blair (2006).

68 Perhaps the designer also recalled the Turks' supposed descent from the Trojans (see p.136 and pl.138–9 above).

69 On this, see the comments pertaining to 15th-century Italy in Syson and Thornton (2001), pp.232–40.

70 Snodin and Howard (1996), p.24.

71 'olle terrene extranei coloris': cited in Childs (1993), p.35. For other examples of the reception of lustred Malagan pottery in England, see Gutiérrez (1997).

72 On the origin of the word 'maiolica', see Osma (1908), p.39; and Spallanzani (2006), pp.4–5.

73 René's inventory is transcribed in Lecoy de la Marche (1873), pp.270–71.

74 Spallanzani (2006), p.135.

75 Spallanzani (1989).

76 Baer (1998), pp.89 and 126; and see also Ettinghausen (1979).

77 For the document and analysis, see Kavaler (2000), p.233.

78 King (1983), p.300.

79 On the similarities between some Spanish and Turkish carpet patterns, see Partearroyo (2002), pp.81–2.

80 Ward-Jackson (1967), p.59.

81 Snodin and Howard (1996), pp.195–7.

82 Rogers (1999), pp.138–9. For a printed calligraphy treatise with interlace patterns, see Neudoerffer (1549).

83 Fuhring (2004), p.206.

84 Fuhring (2004), pp.210–12.

85 Fuhring (2004), p.208.

86 Grant (2000), p.55.

87 Ward-Jackson (1967).

88 Snodin and Howard (1996), p.197.

89 For a facsimile and translation of the treatise, see Piccolpasso (1980).

90 Cardano, *De subtilitate*; cited in Lightbown (1981), p.465.

91 Cited in Baer (1998), p.89.

92 Carruthers (1992) alludes to this in the context of rhetoric and architecture.

93 Kavaler (2000), p.230.

94 Apostolos-Cappadona (1995), sub nom. 'oak'.

95 For the increase in goods, see arguments by Goldthwaite (1993); Jardine (1998); Welch (2005).

96 Theophilus *De diversis artibus* LXXV; Theophilus (1961), pp.135–6.

97 O'Dell (1993).

98 Dallington (1605), p.16.

99 See, for example, Harding (1987) on textile imports to London; and Miller (2006) on the ownership of prints.

CHAPTER 6

1 'Calicem aureum cum patena sua, in quibus ex nostri parte libram auri unam et centrum tredecim gemmas cum exmaltis, et ex parte ecclesie uncias auri misimus octo. Pluviales tresdecim cum frisis aureis, et totidem de raptorum manibus eruimus... Thuribula duo habentia decem libras argenti; tercium vero quod Luizonis fuit, de manu raptorum liberavimus.' My translation. Inventory transcribed in Lambertenghi (1873), cols 1442–5.

2 Suger (1979).

3 For 10th-century examples, see Powell (1994).

4 Williamson (forthcoming), cat. no.53.

5 Bowes (2001), p.348.

6 '… remedio anime mee vel parentum meorum…' My translation. Text transcribed in Muratorio (1774), p.387.

7 For Italian examples, see Bacci (2000b) and Cohn Jr. (1992).

8 Fletcher (1938), p.171. Salisbury Cathedral still possesses Beauchamp's episcopal ring, found when his tomb was opened in 1789. There is no record of the chalice.

9 See the forthcoming article by Vivian Mann.

10 Inventory in Schannat (1723), pp.9–10.

11 See Shalem (2004), p.108.

12 Shalem (2004), pp.107–35.

13 Silvestrelli (1986); Laureati and Onori (2006), pp.118–19 and 177–8.

14 Christie (1938), no.72; Alexander and Binski (1987), no.578, p.457; Johnstone (2002), p.42.

15 Piattoli (1929).

16 Forestié (1894), p.75. For pawning generally, see Matchette (2007).

17 Sarazin (2003).

18 For Italian examples, see Davies (forthcoming).

19 Geuenich et al. (1983), p.35.

20 As is recapitulated in a later grant of land by Franca: Muratorio (1774), p.234.

21 Page (1912), pp.14–19.

22 For William's patronage, see Alexander and Binski (1987), pp.468–75.

23 For an introduction to the concept of purgatory, see Le Goff (1981).

24 For English chantry chapels, see Cook (1963).

25 The will is transcribed in Immacolata Bossa (1987), p.50.

26 Based on an inventory of the chapel transcribed in Borovy (1875), pp.239–40.

27 For Erpingham and his chasuble, see Marks and Williamson (2003), cat. nos 236 and 299.

28 See, for example, Cannon (1980), p.128 and Sundt (1987), pp.400–401.

29 Spelling modernized. Crowley (1566), unpaginated.

30 For discussions of the figure, see Williamson (1988), pp.134–8; Clapham (1910); and Southwick (1987).

31 Pope-Hennessy and Lightbown (1964), II, p.514. A new attribution for this object will be published in the Vienna *Jahrbuch*, 2009 by Jeremy Warren.

32 For these pieces, see Tracy (1988), pp.96–106.

33 Norman (1995), pp.17–23.

34 Gai and Savino (1994), p.191.

35 Caponeri and Riccetti (1987), pp.23–4.

36 An event commemorated on a recently discovered processional standard from the chapel, now happily restored to its original home: Fogg (2007), pp.48–51.

37 Binski (1995), pp.142–4; Vincent (2001).

38 Brown (1997). For more on the political use to which Bruges put the Holy Blood relic, see Kernodle (1943), p.62.

39 For example, in Nuremberg in 1514: see Butts and Hendrix (2000), p.157.

40 For a recent discussion of the glass, see Williamson (2003a), pp.144–5.

41 Boogaart (2004), pp.354–76.

42 Abou-el-Haj (1991).

43 Brown (1981).

44 Ginzburg (1992). The discovery of St Stephen's body persuaded Augustine of Hippo of the power and legitimacy of relics: Courcelle (1968), pp.139–53.

45 For Carolingian relic use, see Geary (1978), pp.20–21.

46 On 29 April 1424. '… in ecclesia cathedrali Sancti Pauli Londoniensis apud altare contiguum et annexum feretro Sancti Erkenwaldi.' My translation. London, Public Record Office, PRO C 146/3563.

47 Van Houts (1995).

48 Geary (1978), pp.52–3.

49 Baker (1995), p.42.

50 'Hoc in tempore excrescentibus miraculis circa corpus beati Petri martiris facta sunt vota, allate sunt immagines ultra quam credi possit; elemosine a diversis mundi partibus et provinciis fratribus apportantur. Et tunc fratres apposuerunt totum conventum in hedificiis renovare… Paramenta etiam tunc pro altaribus facta sunt et frontalia paramentaque de serico ac samico pro ministris altaris.' Translation mine. For Latin text, see Odetto (1940), p.330.

51 Vauchez (1997), pp.85–140.

52 From the 13th century, the rules preventing the holding of public office were often relaxed: Thompson (2005), pp.94–7.

53 For a general summary of lay penitents, see Meersseman (1977), I, pp.268–9. For Tuscany, see Osheim (1983).

54 Staley (2001), p.33.

55 Asselberghs (1970).

56 '… ut prestiosum corpus Confessoris ejusdem in altiorem, et digniorem locum ipsius Ecclesiae transferatur… ipsius sepulcrum in eminenti loco positum sibi facilius, et liberius, occurrerit intuendum.' Translation mine. For a discussion, see Tomasi (2002), pp.40–41.

57 There is disagreement over the form of this monument. See Pope-Hennessy and Lightbown (1964), I, pp.94–7; Wood (1996), pp.68–71 and 177–9; Davies (2009).

58 'in luogo più alto e honorevole': Richa (1754–62), p.193. See also Bocalli (1986). Gardner (1995), pp.39–40 has suggested that the V&A fragment is the front of an altar rather than a tomb chest.

59 Richa (1754–62), pp.176–201 quotes the only description of the tomb in its original site.

60 Jopek (2002), I, pp.105–7.

61 Staley (2001), p.46.

62 'Si constantissime manu fidei exterior eius attrectur clausula auri ac argenti bratea, seu cuiuscumque precii gemmula, siue quelibet textiles uel productulis aut fusilis aut marmoreal uel lignea material…' Translation mine. Ferrari (1996), p.37. For a discussion, see Tomasi (2002), pp.32–4.

63 Hahn (1997), p.27.

64 'ad petendum fidelium eleemosinas'. Translation mine. The document, dating to 1252, is transcribed in Espinas and Pirenne (1906), p.115.

65 Douet-d'Arcq (1874), p.47.

66 From an inventory of his private chapel in Monza: Frisi (1794), p.72.

67 Buckton (1994), cat. no.141; Cormack (2000), pp.113–14.

68 For a discussion, see Knapp (1972).

69 Davies and Moorhouse (2002), p.83.

70 For a surviving example, see Hamburger and Suckale (2005), pp.458–9.

71 For England, see Duffy (1992), pp.212–32; and Duffy (2006).

72 Drees (1954).

73 Cooper (2006), pp.196–7.

74 Marks and Williamson (2003), p.343.

75 For the popularity of the 'Ave Maria', see Bériou (1991), pp.174–5; Thompson (2005), pp.352–3.

76 Oman (1930b), pp.97–8.

77 Staley (2001), p.140.

78 Barnet (1997), pp.193–7; Mellinkoff (1999), pp.24–6.

79 Esch (1995), p.77.

80 Miller (2006), pp.321–3.

81 Jopek (2002), pp.52–4.

82 Paoletti (1998), pp.81–5.

83 For the viewing of such reliefs, see Johnson (1997), and Motture and Syson (2006).

84 Williamson (2003a), p.140.

85 For further examples of this imagery, see Cannon (2006).

86 Meersseman (1977), I, p.35.

87 For a detailed study of confraternities in Florence, see Henderson (1994).

88 Mueller (1992).

89 Milanesi (1854), I, p.75.

90 Frisch (1987), pp.29–30.

91 For his iconography, see Bonometti (1999), p.26.

92 Blauuw (2002); Palazzo (2000), p.23.

93 London, Public Record Office, PROB 11/8, f.95r.

94 Duffy (1992), p.361.

95 Forestié (1894), p.103.

96 Lipsmeyer (1995), p.22.

97 Hoch (2006).

98 Duffy (1992), pp.215–16.

99 For examples in inventories and portraits, see Scarisbrick (1995), pp.45–6.

100 Cooper (2006), p.196. For examples, see Cherry (2003).

101 V&A: 4635–1858. Watts (1922), p.57.

102 Duffy (1992), pp.275–6. For an English example, Marks and Williamson (2003), p.233.

103 Cellini (1956), pp.120–24.

104 Ficino (1989), p.341.

105 Levi (1891), pp.297–302.

106 Paravicini-Bagliani (1980), p.331.

107 Chambers (1992), p.20.

108 Burns et al. (2000), pp.111–14 and 305–7.

109 Hollingsworth (2007), p.269.

110 Chambers (1992), pp.81–2.

111 Chambers (1992), pp.150–51.

112 Binski (1986).

113 Hollingsworth (2004), p.117.

114 Hollingsworth (2004), pp.49–50. For Ippolito's patronage of armourers, see Pyhrr and Godoy (1998), p.59 n.68.

CHAPTER 7

1 St Anselm Quaedam dicta utilia collecta ex dictis. See Migne (1853), col.1054B, published online at <http://pld.chadwyck.co.uk/>. The same text is also attributed to St Bernard of Clairvaux; Bernard of Clairvaux (?1475), f.3v (my foliation).

2 Lloyd (1964); Nutton (2005).

3 Arikha (2007).

4 Welborn (1932), p.31.

5 Klibansky, Panofsky and Saxl (1964), p.290.

6 Lo Alphabeto (?1530), f.2r. See also Freedman (1999), p.153.

7 For Plutarch, see p.246 below. For Aristotle, see for example his De Anima 2.9.421a and other works listed in Evans (1935), p.48.

8 Pseudo-Aristotle (1999). See also Kilerich (1988), p.52.

9 Cardanus (1658); for his works, see Maclean (2007). For the influence of physiognomy on the thought of French philosopher Montaigne, see Bontea (2008).

10 Nola (1971), f.22v.

11 Joubert (1601), p.28.

12 See Schupbach (1976). For the modern explanation, see Lawrence (1977).

13 Lobera (1551), f.22r.

14 Aristotle Oeconomica 1345a.1; Aristotle (1984), II, p.2134. Alfonso X, Las Siete Partidas II.xxxi.2; Alfonso X (2001), II, p.527. For 16th-century domestic advice, see Cavallo (2006), p.180.

15 Lobera (1551), f.9r.

16 Cavallo (2006), p.183.

17 Lobera (1551), f.9r.

18 Aben Ragel (1954), Bk I, ch.LI, p.53. For the moon and madness, see Page (2002), p.49 and fig.40.

19 For 16th-century fears that clothes transmitted disease, especially plague, see Allerston (1999), p.48 and n.18.

20 Joubert (1601), p.28. See also Pelling (1986), pp.92–3; Cavallo (2006), pp.182–3.

21 Castle (2000), p.14.

22 For recipes for perfuming gloves, see Markham (1986), p.132; Welch (2008). On the significance of gloves more generally, see Stallybrass and Jones (2001).

23 Villena (1994), I, p.144.

24 Tusser (1638), pp.73–4.

25 The text of her order, couched in a letter addressed to Père Boil, is reproduced in Osma (1906), pp.6–7.

26 Scappi (?1570), f.153r.

27 Havinden (1965), no.83, p.129.

28 Husband and Hayward (1975), p.61; O'Rourke Boyle (1998), pp.131–2. For Francis I washing his hands after touching the poor and before dinner, see Cavendish (1962), pp.57–8.

29 Perry (1989).

30 Cash (1966), will no.6; Castle (2000), p.13; Brears (2008), pp.64–5.

31 Lobera (1551), f.9r.

32 See Contadini (2006), pp.309–10; Wheeler (2009), no.42: 'Room Perfume'. On dining and perfume burners, see Esteras Martín (2006), cat. no.111–1, p.190. For incense to ward off the plague, see Freedman (2008), pp.64–5.

33 On the relative merits of oil lamps and beeswax candles, see Joubert (1601), p.124. See also Laing (1982), pp.43–4.

34 Erasmus, Colloquies, in Rummel (1993), p.96.

35 Evans (1970), pp.101 and 118.

36 Castle (2000), pp.15–16.

37 Manual (1995), p.61.

38 de Winter (1984); Yorke (1996), p.34.

39 Rojas (1987), Act VII, p.193.

40 Trotula (2002), pp.71–2. For the condition and its treatment, see also Gordonio (1991), Bk VII, ch.10, p.134, written in 1305 and published in the 15th century.

41 Zafran (1979), pp.17–18. For literary references to their smell, see Lévi (1890).

42 See, for example, the opening line of the 'contrasto' by the Sicilian poet Cielo d'Alcano, in Segre and Ossola (1997), p.93.

43 Manuel (1969), exemplo XXX, p.183.

44 'Le vilan asnier' in Noomen (1933–98), VIII, pp.213–14. See also Freedman (1999), p.153.

45 Cited in Mellinkoff (1993), I, p.138.

46 Cavendish (1962), pp.24–5.

47 See Gordonio (1991), Bk V, 'Tractato del regímen de la sanidad', pp.230–31. On the preparation of food to aid digestion, see Flandrin (1999), pp.317–19.

48 Gordonio (1991), Bk VI, ch.I, p.263; Pisanelli (1586), p.135.

49 Googe (1577), f.15r.

50 For labourers' snacks or 'nuncheons', see Henisch (1976), p.24.

51 Gordonio (1991), Bk VI, ch.I, p.263.

52 Joubert (1601), p.46.

53 For passages which cite some of these texts, see Tierney (1959).

54 Lo Alphabeto (?1530), f.1v.

55 Pisanelli (1586), p.74.

56 Avicenna (1998), II, p.207.

57 López de Corella (1547), f.lvir. On the dangerous heat-levels which could result from eating fowl, see Grieco (1999), p.305; Grieco (unpublished).

58 Velasco de Tarenta (1475), f.6v.

59 Henry of Huntingdon, Historia Anglorum, cited in Turner (2005), p.136.

60 Henisch (1976), ch.3: 'Fast and Feast'; Montanari (1988); Boulc'h (1997).

61 Villena (1994), I, p.165.

62 Petrus de Abano (1475), ff.13r and 15v. See also Arnaldus de Villanova (1475), f.1r.

63 On Palissy and his creations, see Amico (1996). For identification of some of the species shown on the dish, see Dufay et al. (1987), pp.45–6. Amico (1987, p.64 n.9) wonders cautiously whether this imagery is also a reference to Palissy's personal experience of religious persecution.

64 For English kitchens, see Woolgar (1999), ch.7 'Cooking and the Meal', esp. p.141. For French ones, see Laurioux (1989), pp.96–7.

65 Arnaldus de Villanova (1475), f.1r.

66 Petrus de Abano (1475), f.13v.

67 For lidded drinking vessels and the etiquette surrounding their use, see Glanville (1985), pp.19–20.

68 See Mitchell (1998).

69 Robin (1975), p.5; Lightbown (1978), cat.19, p.29. See also Oman (1963).

70 Petrus de Abano (1475), ff.13r–14r.

71 Haren (1992), pp.19–22.

72 Pliny Historia naturalis XXXVII is devoted to the properties of gemstones and minerals; Pliny (1958–62), X, pp.165–333. See the comments in Studer and Evans (1924), pp.ix–x.

73 Pliny, Historia naturalis XXXVII.11.55; Pliny (1958–62), X, p.43. 'Ophites serpentium maculis simile est, unde et vocabulum sumpsit': Isidore of Seville Etymologiae XVI.5.3; Isidore of Seville (1993–4), II, p.277.

74 Oxford English Dictionary Online, sub nom. 'Ophites'.

75 Pliny Historia naturalis XXXVI.11.56; Pliny (1958–62), X, p.45.

76 Marbode of Rennes (1977); Studer and Evans (1924).

77 Oxford English Dictionary Online, sub nom. 'Serpentine', citing Metham.

78 Recueil d'Anciens inventaires (1896), no.883, p.275.

79 On 'snake's tongues', see Zammit-Maempel (1975); Kemp (1995), p.182. On sweating stones and poison, see Evans (1922), p.114.

80 Cited in Evans (1922), pp.115 and 114. For 'serpents' tongues' suspended from coral, see Kemp (1995), p.182.

81 Petrus de Abano (1475), f.17v.

82 Knives and Forks (1972), 'Introduction'. A brass-filled mark of a heart inside a shield survives on the blade of the narrowest knife in the set shown in pl.185. For a stamped cutler's mark 'V' inlaid with copper, see V&A: M.604–1910.

83 Villena (1994), I, p.153.

84 Marquardt (1997), p.59.

85 For the green variety, see Studer and Evans (1924), p.33.

86 Studer and Evans (1924), 'Second Prose Lapidary', p.122, and 'Apocalyptic Lapidary', p.266.

87 Studer and Evans (1924), pp.147.

88 See the comments in Marquardt (1997), p.21.

89 Bailey (1927), p.3.

90 Studer and Evans (1924), p.146.

91 Hackenbroch (1980); Kemp (1995), pp.182–3.

92 Cited in Tescione (1965), p.262.

93 *Viaje de Turquía* (1986), p.476; see also Raby and Yücel (1986), p.44 and n.127. I am grateful to Regina Krahl for directing me to this reference.

94 See Finlay (1998), pp.167–8.

95 Nola (1971), f.7v.

96 Gotfredsen (1999).

97 Velasco de Tarenta (1475), f.8v.

98 Evans (1922), p.116.

99 Martín González (1990), p.157.

100 For all this see Evans (1922), pp.115–16.

101 Evans (1922), pp.18–19.

102 Studer and Evans (1924), p.323.

103 Petrus de Abano (1475), f.25v.

104 Evans (1922), p.118.

105 See, for example, a French verse lapidary text in Studer and Evans (1924), p.43; on the powers attributed to amethyst, see the comments in Marbode of Rennes (1977), p.53.

106 Joubert (1601), p.114.

107 See Rapisarda (2006), p.177; also Burnett (1987).

108 Marquardt (1997), p.59.

109 Kemp (1995), p.183.

110 For a discussion of these issues, see Kemp (1995).

111 See, for example, the definition of sight in Palencia (1490) II, f.cccxxi recto, sub nom. 'Oculi'.

112 Plutarch *De Alexandro magno* I.3, cited in Kilerich (1988), p.56.

113 For these Ancient Greek theories of perception, and their impact and development in the Arab and Christian worlds, see Smith (1996), pp.21–8. See also Palencia (1490) II, f.cccxxi recto, sub nom. 'Oculi'.

114 Cited in Müller (2001), p.147.

115 Chrétien de Troyes (1975), p.100.

116 Alberti, *De re aedificatoria*, Bk IX, section 4; Alberti (1988), p.299. Cf. Francisco Loçano's coy Spanish translation of 1584, which says the pictures are to be placed 'wherever women gather': Alberti (1582), p.278. On the importance of vision and conception generally, see Bell (1999), pp.39–41.

117 Vives (1584), f.66r. On the classical precedent, see Schwarz (1952), p.110.

118 On the moralizing aspects of household goods, see Ajmar (1999).

119 Schmitt (1989).

120 Williamson (1983), no.40; Barasch (1991), p.102; Mellinkoff (1993), I, pp.121–5.

121 Jacobus de Voragine (1993), I, p.369.

122 On beauty, and in particular female beauty, see Brewer (1955); Cropper (1976); Cropper (1986); Schmitt (1989).

123 See Mellinkoff (1993), I, pp.147–8 (on ruddy skin); pp.189–90 (on hair); pp.211–12 (on posture).

124 Bernard of Clairvaux *Liber de gradibus humilitatis*, cited in Schmitt (1989), p.137.

125 II Paralipomenon [Chronicles] 26: 19–21.

126 For Alfonso, see Kennedy (1997). On Henry IV, see McNiven (1985).

127 On the shadowy but historical figure of St Roch, see Farmer (2003), sub nom. 'Roch' (p.459).

128 For the symptoms of plague, see Lawrence (1977).

129 Twelfth-century bestiaries note the healing properties of dog saliva: see 'Again on the nature of dogs' in a bestiary copied in Aberdeen *c.*1200: Aberdeen University Library, MS 24, f.19v, <http://www.abdn.ac.uk/bestiary/translat/19v.hti>. I am grateful to Katy Temple for the reference. For more recent medical research into the properties of saliva, see Mendel and Underhill (1907); Selare (1939).

130 Sauerländer (2007), p.3; but for pre-16th-century portraits see also Campbell (1990), p.41.

131 For turbans, see Kubiski (2001), pp.164–6. Avicenna was sometimes represented wearing a turban and a crown: see Hasse (1997), pp.231–2 and p.238. On the image of the Turk and Northern propaganda, see Raby (1989), p.42.

132 Inventory of 1594; Soler del Campo (2003), pp.45, 48 and 51 n.4.

133 For Europeans' increasing awareness of the appearance of the Turks in the 16th-century, see Klinger and Raby (1989); Raby (1989), pp.42–4; Campbell and Chong (2005).

134 Leonardo da Vinci, *Treatise on Painting*, Part II, section 248; Leonardo (1956), I, p.104.

135 Leonardo da Vinci, *Treatise on Painting*, Part III, sections 398 and 425; Leonardo (1956), I, pp.150 and 157.

136 Gauricus (1969), 'De physiognomonia', pp.128–9.

137 For all this, see Pino (2000), p.132. See also the comments by L. Defradas in Gauricus (1969), p.126.

138 Erasmus, in his 1528 dialogue *Ciceronianus*, cited in Syson (2008), p.417. On the problematic relationship between portraiture and physiognomical treatises, see also Syson (2008), p.415.

139 Alberti, 'On Painting', Bk II.42; Alberti (1972), p.81; see also Barasch (1975), p.425.

140 Cited in Campbell (1990), p.1.

141 Cited in Campbell (1990), p.2 and n.10.

142 Bocchi in Barocchi (1960–62), III, pp.135–6. On these passages, see Barasch (1975), p.421.

143 Gauricus (1969), 'De Ocvlis', p.144.

144 Bonanno (1983), pp.91–2; Reece (1983), pp.169–74. For ancient texts on physiognomy, see Foerster (1893). For coin portraits in the 15th century, see Syson (1998).

145 Meller (1963), p.54.

146 Evans (1969); Kilerich (1988), pp.52 and 57–8; Pseudo-Aristotle (1999), pp.50–51 and 59–60.

147 Syson and Gordon (2001), pp.87–9. For lions, see Palencia (1490), I, f.cxxxxv sub nom. 'leo'.

148 Syson (2008), p.415. For the deliberate omission of identifying inscriptions from portraits, see Welch (1998), pp.93 and 97.

149 Alberti, 'On Painting', Bk II.25: Alberti (1972), p.61.

150 Campbell (1990), p.193.

151 Cited in Campbell (1990), p.193.

152 Alberti, 'On Painting', Bk II.25: Alberti (1972), p.61.

153 See Brinkmann (2007), cat. no.37, pp.186–7.

154 See Gauricus (1969), 'De Ocvlis', p.138.

CHAPTER 8

1 Matthew 6: 19–21.

2 See, for example, Erickson (1996), p.93.

3 For the 10th-century Llorenç family, see Bonnassie (1967); also comments in Geary (1986), pp.170–71. On Ercole d'Este's tireless quest for dynastic advancement, see Tuohy (1996), pp.17–19.

4 Alfonso X, *Primera Crónica General*, cited in Ruiz (2004), p.107.

5 See, for example, Goldthwaite (1993); Jardine (1998); Hinton (2005); Welch (2005).

6 Goldthwaite (1993), p.36.

7 Cited in Glanville (1990), p.47.

8 '1570 fuit penuria maxima': see Plesch (2002), pp.171–2. For a survey of demographics and diet, see Morineau (1999).

9 On the widely differing data about population and the difficulties of its interpretation, see Biller (2000), p.112.

10 See Marian Campbell in Marti et al. (2008), cat. no.108, p.287.

11 Cited in Orsi Landini and Niccoli (2005), p.61.

12 Cited in Champion (1927), II, p.35. My translation. For 'splendour' as a concept, see Lindow (2007).

13 See D'Arms (1999), p.302 and p.311, p.9. For the artistic and archaeological evidence of Roman banqueting, see Dunbabin (2003). For the display of silver at Iranian and Turkish banquets, see Melikian-Chirvani (1986), p.98; Rogers (1986c), p.117.

14 Eames (1977), p.57.

15 Eleanor de Poitiers, *Les Honneurs de la cour*, cited in Thirion (1998), p.43.

16 *Les Grandes Chroniques* (1910–20), II, p.230. My translation.

17 *Les Grandes Chroniques* (1910–20), II, pp.236–7.

18 Olivar Daydí (1950), p.12.

19 Laurioux (1992), p.90.

20 Almeida (1935), pp.17–18. On the letters, see more recently Askins, Schaffer and Scharrer (2003).

21 *Viajes de extranjeros* (1878), p.32; German text in Radzikowski and Radzikowska (1998), p.82.

22 Aristotle *Politics*, II.5.1263b, lines 11–12; Aristotle (1984), II, p. 2005. Machiavelli (2003), ch.XVI, p.53.

23 Rogers (1986b), p.139. For the use and significance of robes of honour (*hi'lat*) at the Ottoman court, see Atasoy et al. (2001), pp.32–5.

24 For Francis I's decree, see Somers Cocks (1980), pp.3–4; also Rodini (1995), p.20.

25 Transcribed in Nichols (1797), 'New Yere's Guiftes geuen to the Quenis Maiestie', pp.6 and 12.

26 V&A, MS L.30–1982, f.10v. For royal gift-giving at New Year in France, see Buettner (2001).

27 Robin (1975), p.1.

28 Jenkinson (1886), I, p.122.

29 Martín González (1990), p.157.

30 Glanville (1990), p.28. For the significance of gift-giving more generally, see Mauss (1990); for France, Davis (2000).

31 Jenkinson (1886), I, p.155. See also Rogers (1986b), p.139 n.25.

32 See, for example, Spufford (2002).

33 On the Fuggers, see Lieb (1958) esp. p.280, for the family's 1556 financial donation for the purchase of chalices and 'other things' destined for the church.

34 Lalaing (1952–62), I, ch.xxix, p.536. My translation.

35 Moryson (1617), p.20.

36 Lüttenberg (1999), pp.391–2.

37 Lüttenberg (1999), p.392.

38 For the painting as a copy, see Kauffmann (1973), I, no.142 (p.126). On differences in marriageable age between Northern and Southern Europe, see Biller (2000), pp.327–8.

39 Compare a sitter in similar dress identified as 'a wife of a councillor', in *Princely Magnificence* (1980), no.P 23. p.109. For Nuremberg sumptuary legislation on caps, see Von Wilckens (1985), p.94.

40 I am grateful to Dr Barrie Cook, of the British Museum, for the identification of the coin pendant.

41 On the value of scarlet in the mid-16th century, see Hayward (2007).

42 Hinton (2005), p.162; Geary (1986).

43 On the term and its issues, see Barry and Brooks (1994).

44 For the organization of trades in Barcelona at the close of the 15th century, see Bonnassie (1975).

45 Serrano y Sanz (1916–17).

46 Soler y Palet (1916), p.294.

47 Rogers (1986a), p.15.

48 For apothecaries, see Henderson (2006), esp. ch.9; Freedman (2008).

49 Harrison cited in Standen (1981), p.8.

50 See Hayward (2005), I, pp.11–12.

51 Hayward (2005), II, p.55, no.427.

52 Palumbo-Fossati (1984).

53 Palumbo-Fossati (1984), p.149 n.68.

54 For the 10th century, see Hinton (2005), p.162.

55 Transcribed in Hamnett (2004), p.37.

56 Huggett (1999), pp.82–4.

57 Cited in Huggett (1999), pp.78 and 80.

58 Havinden (1965), no.33, p.75.

59 Havinden (1965), no.208, p.264.

60 Havinden (1965), no.208, p.263.

61 Harding (1987), p.214.

62 *Viajes de extranjeros* (1878), pp.251–2.

63 Piponnier (1999), p.344, and p.346 for the reference to a beggar's spoon. More generally, see Pesez (1988); Bazzana and Hubert (2000). For a different view of the possessions of the poor, see Martines (1998).

64 'Non uestendo piu presumptuosamente ne piu uilmente che non s'apartiene al suo stato': Savonarola (?1497), f.6v.

65 For the Galician-Portuguese examples, see Videira Lopes (2002), no.168 and no.50 (in which the soldiers are so afraid that their splendid robes change colour). 'Der Blatner', in Sachs (1568). I am grateful to Flavia Dietrich-England for providing me with this translation.

66 Letter to Ferdinand I, Grand Duke of Tuscany: Campbell (1990), p.210.

67 For the 'rough digger' (*duro cauador*), see Thamara (1556), f.22v. For his English equivalent, see Baldwin (1926), p.106.

68 For burning cloth to recover gold and silver, see Orsi Landini and Niccoli (2005), p.297 n.19; Orsi Landini et al. (1993), pp.35–8.

69 See Davis (1991), esp. p.102. On the second-hand clothes market in Italy, see Allerston (1999).

70 Davis (1991), p.60.

71 Cited in Baldwin (1926), p.231.

72 Ribeiro (1986), p.33.

73 See Hughes (1986); Ribeiro (1986); Hunt (1996).

74 On European sumptuary laws see, for example, Sempere y Guarinos (1788); more recent surveys include Hunt (1996); Richardson (2004). I am grateful to Leslie Fitzpatrick for suggesting these references.

75 Both cases cited in Baldwin (1926), p.237.

76 Cited in Monnas (1998), p.76 and see also pp.66–9.

77 Cited in Baldwin (1926), p.152.

78 Hughes (1983), esp. pp.89–94.

79 Rodini (1995), p.20. See also Fortini Brown (2000), p.322.

80 Orsi Landini and Niccoli (2005), p.55.

81 'cadeira de espaldas': Canti (1999), p.65.

82 Hayward (2005), I, p.11 and II, p.56, no.434.

83 Hayward (1997), p.11.

84 Scappi (?1570), pls 17 and 18.

85 For the practicalities of packing and transporting possessions, see Hayward (1997).

86 Hall (1548), 'x yere of Henry VIII reign', f.lxxiiiir, cited in Hayward (1997), p.13.

87 Cited in Fortini Brown (2000), p.296.

88 'En la cuysine est assez conuenable / D'auoir […] vng buffet à mectre la vaisselle / Qui est d'estain, & de Cuyure, car celle / Qui est d'argent ou d'or, en Garderobe / La fault serrer de peur qu'on la desrobe': Corrozet (1865), f.11v. On this type of furniture, see Crépin-Leblond (1995).

89 Wilk (1996), pp.36–7.

90 On heraldry, see Woodcock and Robinson (1990), pp.1–13. On its use as decoration and a sign of allegiance, see Cherry (1991), esp. pp.125, 127.

91 Williamson (1986a), p.195. On the Valence household and their possessions, see also Woolgar (1999), pp.53–6.

92 Von Saldern (1965), p.36 and fig.13. See also Goodall (1990).

93 John 1: 14, and for the refrain 'Verbum caro factum est / De virgine Maria', see Hughes (1974), pp.38–9; Glixon (1990), p.47.

94 Glixon (1990), p.41.

95 For these and other examples of the type, see Wilson and Sani (2006–7), II, pp.62–5.

96 Inkwells with Nativity scenes were also appropriate marriage gifts: see Matthews-Grieco (2006), p.107.

97 I am most grateful to D. Faustino Menéndez Pidal for generously advising on this interpretation of the arms.

98 For gifts of apostle spoons and the link between the saint and the giver or recipient, see Husband and Hayward (1975), p.249, cat. no.246.

99 Cited in Wilson (1999), p.251.

100 For the jug, see Campbell (forthcoming).

101 For Pazzi (who plotted against the Medici and was thrown from a window to his death), see Acton (1979). For architecture, loyalty and heraldry in England in the 16th century, see Howard (1987).

102 Pliny Historia naturalis XXXV.2; Pliny (1958–62), IX, p.267.

103 See Syson (2008), p.417.

104 Fletcher (2008), p.430.

105 Fletcher (1981), p.459.

106 Richeome (1597), p.368.

107 'Si [calix] stanneus est, innuit similitudinem culpae et poenae': Sicardus Cremonensis Mitrale, sive summa de officiis ecclesiasticis 1.13. See Migne (1855), col.55C–56A; published online at <http://pld.chadwyck.co.uk>.

108 Will transcribed in López Pita (2002), p.233.

109 On heirlooms and Assetby's bequest, see Glanville (1990), p.57; and for the mazer, p.216.

110 Transcribed in Hamnett (2004), p.140.

111 For an interesting discussion of the evidence for this in 15th-century Italy, see Shepherd (2000).

112 See Power (1922), ch.VII: 'Private Life and Private Property', esp. pp.315–16. See also the references in Hamburger (1992), p.119.

113 Van de Meerendonk (1964), p.131. The official name of the convent, under the rule of the Franciscan Order of Tertiaries, was St Elisabeth-Bloemenkamp. For its wealth, see Van de Meerendonk (1964), p.38. For Alyt's name (given as 'Aleijdis') in a 1571 convent census, see Schutjes (1870–76), IV, p.489. On the pyx, see Koldeweij (1990), no.1185, p.300. I am most grateful to Kitty Jacobs and Hanneke Ramakers for providing me with translations of these texts.

114 Hamburger (1997), pp.124–5.

BIBLIOGRAPHY

The following list includes works cited in the chapter endnotes and others of particular relevance. All biblical quotations come from the Douay-Rheims English translation of the Latin Vulgate (Challoner revision).

Aanavi, D., 'Devotional Writing: "Pseudoinscriptions" in Islamic Art', Metropolitan Museum of Art Bulletin, NS 26 (May 1968), pp.353–8

Aben Ragel, A.['Ali ibn Abi al-Rijal], El Libro Conplido en los Iudizios de las Estrellas: Traducción Hecha en la Corte de Alfonso el Sabio, ed. G. Hilty (Madrid, 1954)

Abou-el-Haj, B., 'The Audiences for the Medieval Cult of Saints', Gesta, 30, no.1 (1991), pp.3–15

Abulafia, D., 'Introduction: Seven Types of Ambiguity, c.1100–c.1500', in D. Abulafia and N. Berend (eds), Medieval Frontiers: Concepts and Practices (Aldershot, 2002), pp.1–34

L'Acanthe dans la sculpture monumentale de l'Antiquité à la Renaissance (Paris, 1993)

Acton, H., The Pazzi Conspiracy: The Plot Against the Medici (London, 1979)

Adhémar, J., Influences Antiques dans L'Art du Moyen Age Français (London, 1939)

Aikema, B., 'Netherlandish Painting and Early Renaissance Italy: Artistic Rapports in a Historiographical Perspective', in H. Roodenburg (ed.), Cultural Exchange in Early Modern Europe, IV: Forging European Identities, 1400–1700 (Cambridge, 2007), pp.100–37

Ajmar, M., 'Toys for Girls: Objects, Women and Memory in the Renaissance Household', in M. Kwint, C. Breward and J. Aynsley (eds), Material Memories (Oxford, 1999), pp.75–89

Ajmar-Wollheim, M., and F. Dennis (eds), At Home in Renaissance Italy (exhib. cat., Victoria and Albert Museum, London, 2006)

Alberti, L.B., Los Diez Libros de Architectura de Leon Baptista Alberto, trans. F. Loçano (Madrid, 1582)

—, On Painting and Sculpture: The Latin Texts of De Pictura and De Statua, ed. and trans. C. Grayson (London, 1972)

—, On the Art of Building in Ten Books, trans. J. Rykwert, N. Leach and R. Tavernor (Cambridge, MA, and London, 1988)

Alexander, J., and Binski, P. (eds), The Age of Chivalry: Art in Plantagenet England 1200–1400 (exhib. cat., Royal Academy of Arts, London, 1987)

Alexander, M. (trans.), Beowulf (Harmondsworth, 1987)

Alfonso X, el Sabio, General estoria: Primera Parte, ed. A.G. Solalinde (Madrid, 1930)

—, Cantigas de Santa Maria, ed. W. Mettmann, 3 vols (Madrid, 1986–9)

—, Las Siete Partidas, trans. S. Parsons Scott, ed. R.I. Burns, 5 vols (Philadelphia, 2001)

Allerston, P., 'Reconstructing the Second-Hand Clothes Trade in Sixteenth- and Seventeenth-Century Venice', Costume, 33 (1999), pp.46–56

Allison, A., 'The Bronzes of Pier Jacopo Alari-Bonacolsi, called Antico', Jahrbuch der Kunsthistorischen Sammlungen in Wien, 89, issue 90 (1994), pp.37–310

Almeida, L. d', Cartas de Itália, ed. R. Lapa (Textos de Literatura Portuguesa 3; Lisbon, 1935)

Lo Alphabeto Delli Uillani (n.p., ?1530)

Ames-Lewis, F., Tuscan Marble Carving 1250–1350: Sculpture and Civic Pride (Aldershot, 1997)

—, The Intellectual Life of the Early Renaissance Artist (London, 2000)

Amico, L.N., 'Les céramiques rustiques authentiques de Bernard Palissy', Revue de l'Art, 78 (1987), pp.61–7

—, Bernard Palissy: In Search of Earthly Paradise (Paris, 1996)

Andreescu-Treadgold, I., 'The Wall Mosaics of San Michele in Africisco, Ravenna Rediscovered', Corso di Cultura sull'Arte Ravennate e Bizantina, 37 (1990), pp.13–57

Apostolos-Cappadona, D., Dictionary of Christian Art (Cambridge, 1995)

Arikha, N., Passions and Tempers: A History of the Humours (New York, 2007)

Aristotle, The Complete Works of Aristotle: The Revised Oxford Translation, ed. J. Barnes, 2 vols (Bollingen Series 71; Princeton, 1984)

Armenini, G.B., Dei veri precetti della pittura (Ravenna, 1587)

Arnaldus de Villanova, De arte cognoscendi uenena (Milan, 1475)

Arnold, T. (ed.), Memorials of St Edmund's Abbey (Rolls Series; London, 1892)

Ashton, R., 'Sir Paul Pindar (1565–1650)', Oxford Dictionary of National Biography (Oxford, 2004); online ed., January 2008, <http://www.oxforddnb.com/view/article/22291>

Askins, A.L.-F., Schaffer, M.E., and Scharrer, H.L., 'A New Set of Cartas de Itália to Afonso V of Portugal from Lopo de Almeida and Luis Gonçalves Malafaia', Romance Philology, 57, no.1 (2003), pp.71–88

Asselberghs, J.-P., 'Charles VIII's Trojan War Tapestry', V&A Museum Yearbook (1969), pp.82–3

—, 'Une broderie Florentine du XVe siècle, fragment d'un antependium exécuté pour l'ordre du Vallombreuse', Bulletin de l'Institut Royal de Patrimoine Artistique, 12 (1970), pp.177–94

Atasoy, N., et al., Ipek. The Crescent and the Rose: Imperial Ottoman Silks and Velvets (London and Istanbul, 2001)

Avery, C., The Rood-Loft from Hertogenbosch (London, 1969)

Avicenna [Abu 'Ali al-Husain ibn Abdullah ibn Sina], Al-Qanum Fi'l-Tibb, 2 vols (New Delhi, 1998)

Bacci, M., 'Firme di artisti e iscrizioni pro anima', in Donato (2000a), pp.45–7

—, 'Pro remedio animae': Immagini sacre e pratiche devozionali in Italia centrale (secoli XIII e XIV) (Pisa, 2000b)

Baer, E., Islamic Ornament (Edinburgh, 1998)

Bailey, C.T.P., Knives and Forks (London and Boston, 1927)

Baker, P., Islamic Textiles (London, 1995)

Baldwin, F.E., Sumptuary Legislation and Personal Regulation in England (Baltimore, 1926)

Barasch, M., 'Character and Physiognomy: Bocchi on Donatello's St George. A Renaissance Text on Expression in Art', Journal of the History of Ideas, 36, no.3 (July–September 1975), pp.413–30; reprinted in M. Barasch, Imago Hominis: Studies in the Language of Art (Vienna, 1991), pp.36–46

—, 'The Face of Evil: On the Afterlife of the Classical Theater Mask', in M. Barasch, Imago Hominis: Studies in the Language of Art (Vienna, 1991), pp.100–111

Barbaro, A., Charlemagne: Father of a Continent (Berkeley, 2004)

Bari, F., Munifica Magnificenza: Il tesoro tessile della Cattedrale di Pienza da Pio II Piccolomini agli inizi dell'Ottocento (Siena, 2004)

Barkan, L., Unearthing the Past: Archaeology and Aesthetics in the Making of Renaissance Culture (New Haven, 1999)

Barnet, P. (ed.), Images in Ivory: Precious Objects of the Gothic Age (exhib. cat., Detroit Institute of Arts, 1997)

Barocchi, P., Trattati d'Arte del Cinquecento, fra manierismo e controriforma, 3 vols (Bari, 1960–62)

Barolsky, P., 'The Artist's Hand', in A. Ladis and C. Wood (eds), The Craft of Art: Originality and Industry in the Italian Renaissance and Baroque Workshop (Athens, GA, and London, 1995), pp.5–24

Barry, J., and Brooks, C., The Middling Sort of People: Culture, Society and Politics in England, 1550–1800 (London, 1994)

Bartlett, R., The Making of Europe: Conquest, Colonization and Cultural Change 950–1350 (Harmondsworth, 1993)

Baxandall, M., *Giotto and the Orators: Humanist Observers of Painting in Italy and the Discovery of Pictorial Composition, 1350–1450* (Oxford, 1971)

—, *Painting and Experience in Fifteenth-Century Italy: A Primer in the Social History of Pictorial Style* (Oxford, 1972)

—, *The Limewood Sculptors of Renaissance Germany* (New Haven, 1980)

Bazzana, A., and Hubert, É., *Maisons et espaces domestiques dans le monde méditerranéen au moyen âge* [*Castrum, 6*] (Rome and Madrid, 2000)

Beaulieu, M., and Beyer, V., *Dictionnaire des Sculpteurs Français du Moyen Age* (Paris, 1992)

Bell, R.M., *How to Do It: Guides to Good Living for Renaissance Italians* (Chicago and London, 1999)

Beltrán Fortes, J., 'La colección arqueológica de época romana aparecida en Madinat al-Zahra (Córdoba)', *Cuadernos de Madinat al-Zahra*, 2 (1988–90), pp.109–26

Bemporad, D.L. (ed.) *Un Ponte dalle Botteghe d'Oro. Le botteghe degli orafi sul Ponte Vecchio: quattro secoli di storia* (Florence, 1993)

Bériou, N., *Prier au Moyen Âge: Pratiques et Expériences* (Turnhout, 1991)

Bernard of Clairvaux, *Sermo beati berhardi de humana miseria* (Burgdorf, ?1475)

—, *The Letters of St Bernard of Clairvaux*, trans. B. Scott James, intro. B. Mayne Kienzle (1st ed., London, 1953; repr. with new intro., Stroud, 1998)

Biddle, M., 'Felix urbs Winthoniae: Winchester in the Age of Monastic Reform', in D. Parsons (ed.), *Tenth-Century Studies* (London, 1975), pp.123–40

Biller, P., *The Measure of Multitude: Population in Medieval Thought* (Oxford, 2000)

Bimbenet-Privat, M., *Les Orfèvres Parisiens de la Renaissance (1506–1620)* (Paris, 1992)

Binski, P., *The Painted Chamber at Westminster* (London, 1986)

—, *Westminster Abbey and the Plantagenets: Kingship and the Representation of Power 1200–1400* (London, 1995)

—, 'The Crucifixion and the Censorship of Art Around 1300', in P. Linehan and J. Nelson (eds), *The Medieval World* (London, 2001), pp.342–60

—, *Becket's Crown: Art and Imagination in Gothic England 1170–1300* (New Haven, 2004)

Biondo, M.A., *Della nobilissima pittura, et della sua arte* (Venice, 1549)

Birch, D.J., *Pilgrimage to Rome in the Middle Ages: Continuity and Change* (Woodbridge, 1998)

—, 'Jacques de Vitry and the Ideology of Pilgrimage', in J. Stopford (ed.), *Pilgrimage Explored* (York, 1999), pp.79–93

Bischoff, B., *Latin Paleography*, trans. D. Ó Cróinín and D. Ganz (Cambridge, 1990)

Black, R., 'The Donation of Constantine: A New Source for the Concept of the Renaissance', in A. Brown (ed.), *Language and Images of Renaissance Italy* (Oxford, 1995), pp.51–86

Blair, C., 'Cesare Borgia's Sword-Scabbard', *V&A Bulletin*, 2, no.4 (1966), pp.125–36

Blair, S.S., 'Inscriptions on Medieval Islamic Textiles', *Islamische Textilkunst des Mittelalters: Aktuelle Probleme* (Riggisberger Berichte 5; Riggisberg, 1997a), pp.95–104

—, 'A Note on the Prayers Inscribed on Several Medieval Islamic Silk Textiles in the Abegg Foundation', *Islamische Textilkunst des Mittelalters: Aktuelle Probleme* (Riggisberger Berichte 5; Riggisberg, 1997b), pp.129–37

—, *Islamic Calligraphy* (Edinburgh, 2006)

Blauuw, S. de, 'Contrasts in Processional Liturgy, a Typology of Outdoor Processions in Twelfth Century Rome', in N. Bock, et al. (eds), *Art, Cérémonial et Liturgie au Moyen Âge: Actes du colloque de 3e Cycle Romand des Lettres. Lausanne-Fribourg. 2000* (2002), pp.357–96

Blumenthal, U.-R., *The Investiture Controversy: Church and Monarchy from the Ninth to the Twelfth Century* (Philadelphia, 1988)

Bober, P.B., and Rubinstein, R., *Renaissance Artists and Antique Sculpture* (London, 1986)

Bocalli, G. (ed.), 'Libro delle degnità et excellentie del ordine della seraphica madre delle povere donne Sancta Chiara da Asisi di Fra M. da Firenze', *Studi Francescani*, 83, nos 1–4 (Florence, 1986)

Bocchi, F., *Le Bellezze della città di Firenze* (facsimile, Florence, 1974)

Boehm, B.D., and Taburet-Delahaye, E. (eds), *Enamels of Limoges* (exhib. cat., Metropolitan Museum of Art, New York, 1995)

Bonanno, A., 'Sculpture', in M. Henig (ed.), *A Handbook of Roman Art: A Survey of the Visual Arts of the Roman World* (London, 1983), pp.66–96

Bonnassie, P., 'A Family of the Barcelona Countryside and its Economic Activities Around the Year 1000', in S.L. Thrupp (ed.), *Early Medieval Society* (New York, 1967), pp.103–23

—, *La organización del trabajo en Barcelona a fines del siglo XV* (Barcelona, 1975)

Bonne, J.-C., 'Rituel de la couleur: Foncionnement et usage des images dans le "Sacramentaire" de Saint-Étienne de Limoges', in *Image et signification: Rencontres de l'École du Louvre* (Paris, 1983), pp.129–39

—, 'De l'ornemental dans l'art médiéval (VIIe–XIIe siècle): Le modèle insulaire', in J. Baschet and J.-C. Schmitt (eds), *L'Image: Fonctions et usages des images dans l'Occident médiéval* (Cahiers du Léopard d'Or 5; Paris, 1996a), pp.207–49

—, 'Les ornements de l'histoire (à propos de l'ivoire carolingien de Saint Remi)', *Annales, Histoire, Sciences Sociales*, 51, no.1 (1996b), pp.37–70

Bonometti, P., *Omobono: la figura del Santo nell'iconografia* (Milan, 1999)

Bontea, A., 'Montaigne's On Physiognomy', *Renaissance Studies*, 22, no.1 (2008), pp.41–62

Boogaart, T., *An Ethnography of Late Medieval Bruges: Evolution of the Corporate Milieu 1280–1349* (Lewiston, NY, 2004)

Borovy, C., *Libri erectionum Archidiocesis Pragensis saeculo XIV. et XV.* (Prague, 1875)

Boschloo, A.W.A., 'Perceptions of the Status of Painting: The Self-Portrait in the Art of the Italian Renaissance', in Enenkel, de Jong-Crane and Liebregts (1998), pp.51–73

Boucher, B. (ed.), *Earth and Fire: Italian Terracotta Sculpture from Donatello to Canova* (exhib. cat., Victoria and Albert Museum, London, 2001)

Boulc'h, S., 'Le repas quotidien des moines occidentaux du haut Moyen Age', *Revue belge de philosophie et d'histoire*, 75 (1997), pp.287–328

Bowes, K., 'Ivory Lists: Consular Diptychs, Christian Appropriation and the Polemics of Time in Late Antiquity', *Art History*, 24, no.3 (2001), pp.338–57

Boxer, C.R., *The Portuguese Seaborne Empire 1415–1825* (2nd ed., Exeter, 1991)

Brears, P., *Cooking and Dining in Medieval England* (Totnes, 2008)

Bresc-Bautier, G., 'Parisian Casters in the Sixteenth Century', in P. Motture (ed.), *Large Bronzes in the Renaissance* (New Haven, 2003), pp.95–114

Brewer, D., 'The Ideal of Feminine Beauty in Medieval Literature, Especially "Harley Lyrics", Chaucer, and some Elizabethans', *Modern Language Review*, 50, no.3 (1955), pp.257–69

Brinkmann, B., 'The Smile of the Madonna: Lucas Cranach, a Serial Painter', in B. Brinkmann (ed.), *Cranach* (exhib. cat., Städel Museum, Frankfurt and Royal Academy, London, 2007)

Brooke, Z.N., *A History of Europe 911–1198* (3rd ed., London, 1951)

Brown, A., 'Civic Ritual: Bruges and the Counts of Flanders in the Later Middle Ages', *The English Historical Review*, 112, no.446 (1997), pp.277–99

Brown, M.P., *A Guide to Western Historical Scripts from Antiquity to 1600* (London, 1990)

Brown, P., *The World of Late Antiquity* (London, 1971)

—, *The Cult of Saints: Its Rise and Function in Latin Christianity* (Chicago, 1981)

—, 'Review of *The Clash of Gods: A Reinterpretation of Early Christian Art*', *Art Bulletin*, 77, no.3 (1995), pp.499–502

—, *The Rise of Western Christendom* (2nd ed., Oxford, 2003)

Brown, Peter (ed.), *British Cutlery: An Illustrated History of its Design, Evolution and Use* (exhib. cat., Fairfax House, York, Millennium Galleries, Sheffield and Geffrye Museum, London, 2000)

Buchtal, H., *Historia Troiana: Studies in the History of Mediaeval Secular Illustration* (Studies of the Warburg Institute 32; London, 1971)

Buckton, D., *Byzantium: Treasures of Byzantine Art and Culture from British Collections* (exhib. cat., British Museum, London, 1994)

Buettner, B., 'Past Presents: New Year's Gifts at the Valois Courts, ca 1400', *Art Bulletin*, 83, no.4 (2001), pp.598–625

Bull, M., *The Mirror of the Gods: How Renaissance Artists Rediscovered the Pagan Gods* (Oxford, 2005)

Burke, P., *The Renaissance Sense of the Past* (London, 1969)

—, 'The Circulation of Knowledge', in J.J. Martin (ed.), *The Renaissance World* (London, 2007), pp.191–207

Burnett, C., 'The Earliest Chiromancy in the West', *Journal of the Warburg and Courtauld Institutes*, 50 (1987), pp.189–95

Burns, H., et al. (eds), *Valerio Belli Vicentino 1468c.–1546* (Vicenza, 2000)

Bury, M., 'The Taste for Prints in Italy to c.1600', *Print Quarterly*, 2, no.1 (March 1985), pp.12–26

Butters, S.B., 'Making Art Pay: The Meaning and Value of Art in Late-Sixteenth-Century Rome and Florence', in M. Fantoni, L. Matthew and S. Matthews-Grieco (eds), *The Art Market in Italy* (Modena, 2003), pp.25–40

Butts, B., and Hendrix, L. (eds), *Painting on Light: Drawings and Stained Glass in the Age of Dürer and Holbein* (exhib. cat., J. Paul Getty Museum, Los Angeles, 2000)

Caillet, J.-P., 'L'Antique dans les arts du Moyen Âge occidental: survivances et réactualisations', *Perspective*, 1 (2007), pp.99–128

Calkins, R., *Illuminated Books of the Middle Ages* (London, 1983)

Camille, M., *The Gothic Idol: Ideology and Image-making in Medieval Art* (Cambridge, 1989)

Campbell, C., and Chong, A., *Bellini and the East* (exhib. cat., Isabella Stewart Gardner Museum, Boston, and National Gallery, London, 2005)

Campbell, L., 'The Art Market in the Southern Netherlands in the Fifteenth Century', *Burlington Magazine*, 118, no.877 (1976), pp.188–98

—, *Renaissance Portraits: European Portrait-Painting in the 14th, 15th and 16th Centuries* (New Haven and London, 1990)

Campbell, M., 'The Campion Hall Triptych and its Workshop', *Apollo*, 111 (1980), pp.418–23

—, 'L'Oreficeria Italiana nell'Inghilterra Medievale con una nota sugli smalti Italiani del XIV e XV Secolo nel Victoria and Albert Museum', *Bolletino d'Arte*, suppl.43 (1987), pp.1–16

—, 'Gold, Silver and Precious Stones', in J. Blair and N. Ramsay (eds), *English Medieval Industries* (London, 1991), pp.107–66

—, 'An English Medieval Jug', in J. Luxford and M. Michael (eds), *Tributes to Nigel Morgan. Contexts of Medieval Art: Images, Objects and Ideas* (forthcoming)

Campbell, T.P. (ed.), *Tapestry in the Renaissance: Art and Magnificence* (exhib. cat., Metropolitan Museum of Art, New York, 2002)

Cannon, J., 'Dominican Patronage of the Arts in Central Italy: The Provincia Romana c.1220–c.1320 (unpub. Ph.D. diss., University of London, 1980)

—, '"Panem petant in signum paupertatis": The Image of the Quest for Alms Among the Friars of Central Italy', in P. Helas and G. Wolf (eds), *Armut und Armenfürsorge in der italienischen Stadkultur zwischen 13. und 16. Jahrhundert* (Frankfurt, 2006), pp.29–53

Canti, T., *O móvel no Brasil: Origens, Evolução e Características*, abridged ed. F. Castro Freire, G. Pedroso and R. Pereira Henriques (Lisbon, 1999)

Capella, Martianus, *Martianus Capella and the Seven Liberal Arts*, trans. W.H. Stahl, R. Johnson and E.L. Burge, 2 vols (New York, 1971)

Caponeri, M.R., and Riccetti, L. (eds), *Chiese e conventi degli ordini mendicanti in Umbria nei secoli XIII–XIV: inventario delle fonti archivistiche e catalogo delle informazioni documentarie. Archivi di Orvieto* (Perugia, 1987)

Cardanus, H., *La Metoposcopie*, trans. C.M. de Lavrendiere (Paris, 1658)

Cárdenas, A.J., 'Alfonso's Scriptorium and Chancery: Role of the Prologue in Bonding the *Translatio Studii* to the *Translatio Potestatis*', in R.I. Burns (ed.), *Emperor of Culture: Alfonso X the Learned of Castile and His Thirteenth-Century Renaissance* (Philadelphia, 1990), pp.90–108

Carruthers, M.J., *The Book of Memory: A Study of Memory in Medieval Culture* (Cambridge, 1990)

—, 'Inventional Mnemonics and the Ornaments of Style: The Case of Etymology', *Connotations*, 2, no.2 (1992), pp.103–14

Cash, M., *Devon Inventories of the Sixteenth and Seventeenth Centuries*, Devon and Cornwall Record Society, NS 11 (Torquay, 1966)

Castelnuovo, E. (ed.), *Niveo de Marmore: L'uso artistico del marmo di Carrara dall'XI al XV secolo* (Genoa, 1992)

Castiglione, B., *The Book of the Courtier*, trans. G. Bull (London, 1967)

Castle, J., 'Amulets and Protection: Pomanders', *Bulletin of the Society for Renaissance Studies*, 17, no.2 (May 2000), pp.12–18

Cavallo, S., 'Health, Beauty and Hygiene', in Ajmar-Wollheim and Dennis (2006), pp.174–87

Cavendish, G., 'The Life and Death of Cardinal Wolsey', in R.S. Sylvester and D.P. Harding (eds), *Two Early Tudor Lives* (New Haven and London, 1962)

Cellini, B., *The Autobiography of Benvenuto Cellini*, trans. G. Bull (Harmondsworth, 1956)

—, *The Treatises of Benvenuto Cellini on Goldsmithing and Sculpture*, trans. C.R. Ashbee (New York, 1967)

Chambers, D.S., *A Renaissance Cardinal and His Worldly Goods: The Will and Inventory of Francesco Gonzaga (1444–1483)* (London, 1992)

Chambers, D., and Pullan, B., *Venice: A Documentary History* (Oxford, 1992)

Champion, P., *Louis XI*, 2 vols (Paris, 1927)

Chastel, A., 'Signature et signe', *Revue de l'Art*, 26 (1974) [special issue: *L'Art de la Signature*], pp.8–14

Châtillon, J., 'Thomas Becket et les Victorines', in R. Foreville (ed.), *Thomas Becket* (Paris, 1975), pp.89–101

Cheetham, F., *English Medieval Alabasters: With a Catalogue of the Collection in the Victoria and Albert Museum* (Oxford, 1984)

Cherry, J., 'Heraldry as Decoration in the Thirteenth Century', in W.M. Ormrod (ed.), *England in the Thirteenth Century: Proceedings of the 1989 Harlaxton Symposium* (Harlaxton Medieval Studies I; Stamford, 1991), pp.123–34

—, 'Containers for Agnus Deis', in C. Entwistle (ed.), *Through a Glass Brightly: Studies in Medieval Art and Archaeology Presented to David Buckton* (Oxford, 2003), pp.171–83

Childs, W.R., 'Imports of Spanish Pottery to England in the Later Middle Ages', *Medieval Ceramics*, 17 (1993), pp.35–8

Chrétien de Troyes, *Arthurian Romances*, trans. W.W. Comfort (London, 1975)

Christie, A.G.I., *English Medieval Embroidery* (Oxford, 1938)

Churchill, S., and Bunt, C., *The Goldsmiths of Italy: Some Account of their Guilds, Statutes and Work* (London, 1926)

Cicero, *On Moral Obligation: A New Translation of Cicero's 'De officiis'*, trans. J. Higginbotham (London, 1967)

Cioni, E., *Scultura e Smalto nell'Oreficeria Senese dei Secoli XIII e XIV* (Florence, 1998)

Cipolla, C.M., *Before the Industrial Revolution: European Society and Economy 1000–1700* (3rd ed., London, 1993)

Clanchy, M.T., *Abelard: A Medieval Life* (Oxford, 1997)

Clapham, E.W., 'The Excavations of Lesnes Abbey', *Proceedings of the Woolwich Antiquarian Society*, 15 (1910), pp.155–61

Clark, G., 'The Long March of History: Farm Laborers' Wages in England 1208–1850' (1999); published online at <http://www.econ.ucdavis.edu/faculty/gclark/papers/long_march_of_history.pdf>

Clarke, G., *Roman House—Renaissance Palaces: Inventing Antiquity in Fifteenth-Century Italy* (Cambridge, 2003)

Clifton, J., 'Vasari on Competition', *Sixteenth Century Journal*, 27, no.1 (1996), pp.23–41

Coffin, D.R., 'Pirro Ligorio on the Nobility of the Arts', *Journal of the Warburg and Courtauld Institutes*, 27 (1964), pp.191–210

Cohn Jr., S., *The Cult of Remembrance and the Black Death* (Baltimore, 1992)

—, 'Burial in the Early Renaissance: Six Cities in Central Italy', in J. Chiffoleau, L. Martines and A. Paravicini-Bagliani (eds), *Riti e Rituali nelle Società Medievali* (Collectanea 5; Centro Italiano di Studi sull'Alto Medioevo, Spoleto, 1994), pp.39–58

Cole, M., 'Cellini's Blood', *Art Bulletin*, 81, no.2 (June 1999), pp.215–35

Colin, J., *Cyriaque d'Ancône: Le voyageur, le marchand, l'humaniste* (Paris, 1981)

Colish, M.L., *The Stoic Tradition from Antiquity to the Early Middle Ages* (Studies in the History of Christian Traditions; Leiden, 1990)

Comnena, A., *The Alexiad*, trans. E.R.A. Sewter (Harmondsworth, 1969)

Connell, S., 'Books and their Owners in Venice 1345–1480', *Journal of the Warburg and Courtauld Institutes*, 35 (1972), pp.163–86

Contadini, A., *Fatimid Art at the Victoria and Albert Museum* (London, 1998)

—, 'Middle Eastern Objects', in Ajmar-Wollheim and Dennis (2006), pp.308–21

Contreni, J.J., 'The Carolingian Renaissance', in W. Treadgold (ed.), *Renaissances Before the Renaissance: Cultural Revivals of Late Antiquity and the Middle Ages* (Stanford, CA, 1984), pp.59–74

—, 'The Carolingian Renaissance: Education and Literary Culture', in R. McKitterick (ed.), *The New Cambridge Medieval History*, II: *c.700–c.900* (Cambridge, 1995), pp.709–57

Cook, G., *Mediaeval Chantries and Chantry Chapels* (rev. ed., London, 1963)

Cooper, D., 'Devotion', in Ajmar-Wollheim and Dennis (2006), pp.190–203

Cooper, M., *They Came to Japan: An Anthology of European Reports on Japan, 1543–1640* (Berkeley and Los Angeles, 1965)

Cormack, R., *Byzantine Art* (Oxford, 2000)

Corney, A., 'Wax', in M. Trusted (ed.), *The Making of Sculpture: The Materials and Techniques of European Sculpture* (London, 2007), pp.21–34

Corrozet, G., *Les Blasons Domestiques* (Paris, 1865)

Courcelle, P., *Recherches sur les 'Confessions' de saint Augustin* (2nd ed., Paris, 1968)

Cowdrey, H.E.J., *The Register of Pope Gregory VII 1073–1085: An English Translation* (Oxford, 2002)

Cowen Orlin, L. (ed.), *Material London ca.1600* (Philadelphia, 2000)

Crépin-Leblond, T., 'Dressoir ou buffet', in *Le dressoir du Prince: Services d'apparat à la Renaissance* (exhib. cat., Musée nationale de la Renaissance, Château d'Écouen, Paris, 1995), pp.26–9

Crépin-Leblond, T., and McNab, J. (eds), *Une Orfèvrerie de Terre: Bernard Palissy et la céramique de Saint-Porchaire* (exhib. cat., Musée nationale de la Renaissance, Château d'Écouen, Paris, 1997)

Cropper, E., 'On Beautiful Women, Parmigiano, *Petrarchismo*, and the Vernacular Style', *Art Bulletin*, 58 (1976), pp.374–94

—, 'The Beauty of Woman: Problems in the Rhetoric of Renaissance Portraiture', in M.W. Ferguson, M. Quilligan and N.J. Vickers (eds), *Rewriting the Renaissance: The Discourses of Sexual Difference in Early Modern Europe* (Chicago, 1986), pp.175–90

Crowley, R., *A Briefe Discourse against the Outwarde Apparel and Ministering Garments of the Popishe Church* (Emden, 1566)

Curran, B., and Grafton, A., 'A Fifteenth Century Site Report on the Vatican Obelisk', *Journal of the Warburg and Courtauld Institutes*, 58 (1995), pp.234–48

Cutler, A., 'The De Signis of Nicetas Choniates: A Reappraisal', *American Journal of Archaeology*, 72, no.2 (1968), pp.113–18

—, '"Roma" and "Constantinopolis" in Vienna', in P. Hutter (ed.), *Byzanz und der Westen: Studien zur Kunst des europäischen Mittelalters* (Vienna, 1984), pp.43–64

—, *The Craft of Ivory* (Washington, D.C., 1985)

—, 'Suspicio Symmachorum: A Postscript to Dale Kinney's "A Late Antique Ivory Plaque and Modern Response"', *American Journal of Archaeology*, 98 (1994a), pp.473–80

—, *The Hand of the Master: Craftsmanship, Ivory and Society in Byzantium (9th to 11th centuries)* (Princeton, 1994b)

—, 'On Byzantine Boxes', in A. Cutler, *Late Antique and Byzantine Ivory Carving* (Aldershot, 1998), No.XVI

—, 'I Bizantini davanti all'arte e all'architettura greche', in S. Settis (ed.), *I Greci: Storia, Cultura, Arte, Società* (Turin, 2001), pp.629–72

Dallington, R., *A Survey of the Great Dukes State of Tuscany* (London, 1605)

D'Arms, J.H., 'Performing Culture: Roman Spectacle and the Banquets of the Powerful', in B. Bergmann and C. Kondoleon (eds), *Studies in the History of Art*, 56 (1999), pp.301–19

Davies, G., 'The Trecento Tomb of the Beata Chiara Ubaldini Reconsidered', *The Sculpture Journal*, 18, no.1 (2009), pp.5–21

—, '"Omnes et singuli aurifices": Guild Regulations and the Chalice Trade in Central Italy ca.1250–1500', in H. Maginnis and S. Zuraw (eds), *The Historical Eye: Essays on Italian Art in Honor of Andrew Ladis* (Athens, GA, forthcoming)

Davies, N., and Moorhouse, R., *Microcosm: Portrait of a Central European City* (London, 2002)

Davis, C., 'I Bassorilievi fiorentini di Giovan Francesco Rustici. Esercizi di lettura', *Mitteilungen des Kunsthistorisches Institutes in Florenz*, 39, no.1 (1995), pp.92–133

— (ed.), *Giorgio Vasari: Descrizione dell'apparato fatto nel Tempio di S. Giovanni di Fiorenza per lo battesimo della Signora prima figliuola dell'Illustrissimo, et Eccellentissimo S. Principe di Fiorenza, et Siena Don Francesco Medici, e della Serenissima Reina Giovanna d'Austria (Firenz, 1568)*, (Heidelberg, 2008); published online at <http://archiv.ub.uniheidelberg.de/artdok/volltexte/2008/425/>

Davis, N.Z., *The Gift in Sixteenth-Century France* (Oxford, 2000)

Davis, R.C., *Shipbuilders of the Venetian Arsenal: Workers and Workplace in the Pre-Industrial City* (Baltimore, 1991)

Davis, W.S. (ed.), *Readings in Ancient History: Illustrative Extracts from the Sources*, II (Boston, MA, 1913)

Depping, G.B. (ed.), *Réglemens sur les arts et métiers de Paris rédigés au XIIIe siècle: et connus sous le nom du Livre des métiers d'Étienne Boileau* (Paris, 1837)

Derolez, A., *The Palaeography of Gothic Manuscript Books* (Cambridge, 2003)

Deshman, R., *The Benedictional of Aethelwold* (New Jersey, 1995)

Desmaze, C.A., *Les Métiers de Paris* (Paris, 1874)

Despautère, J., *Ars versificatoria* (Paris, 1516)

Didi-Huberman, G., *Devant le Temps: Histoire de l'Art et Anachronisme des Images* (Paris, 2000)

Diemer, D., *Hubert Gerhard und Carlo di Cesare del Pelagio*, I (Berlin, 2004)

Diffie, B.W., and Winius, G.D., *Foundations of the Portuguese Empire 1415–1580* (Oxford, 1977)

Dini, B., 'l'Industria Serica in Italia. Secc. XIII–XV', in S. Cavaciocchi (ed.), *La Seta in Europa sec XIII–XX* (Florence, 1993), pp.91–123

Dollinger, P., *The German Hansa* (London, 1970)

Donato, M.M. (ed.), *Le Opere e i nomi: prospettive sulla 'firma' medievale in margine ai lavori per il 'Corpus delle opere firmate del medioevo italiano'* (Pisa, 2000)

Dorini, U. (ed.), *Statuti dell'Arte di Por Santa Maria del tempo della Repubblica* (Florence, 1942)

Douet-d'Arcq, L., *Nouveau Recueil de Comptes de l'Argenterie des Rois de France* (Paris, 1874)

Drees, C. (ed.), *Der Christenspiegel des Dietrich Kolde von Münster* (Werl, 1954)

Du Sommerard, A., *Musée des Thermes et de l'Hotel de Cluny: Catalogue et description des Objets d'art de l'Antiquité, du Moyen Âge et de la Renaissance* (Paris, 1881)

Duemmler, E. (ed.), *Poetae Latini Medii Aevi*, II: *Poetae Latini aevi Carolini (2)* (Monumenta Germaniae Historica; Berlin, 1884)

Dufay, B., et al., 'l'atelier parisien de Bernard Palissy', *Revue de l'Art*, 78 (1987), pp.33–57

Duffy, E., *The Stripping of the Altars: Traditional Religion in England 1400–1580* (New Haven, 1992)

—, *Marking the Hours: English People and their Prayers 1240–1570* (New Haven, 2006)

Dujarric-Descombes, A., 'Jean d'Asside, Évêque de Périgueux et son mausolée (1169)', *Bulletin de la Société Historique et Archéologique du Périgord*, 28 (1901), pp.53–72

Dunbabin, K.M.D., *The Roman Banquet: Images of Conviviality* (Cambridge, 2003)

Durand, J., and Laffitte, M.-P. (eds), *Le Trésor de la Sainte-Chapelle* (exhib. cat., Musée du Louvre, Paris, 2001)

Durandus, G., *Rationale Divinorum Officiorum* [Books I–IV], ed. A. Davril and T.M. Thibodeau (Corpus Christianorum Continuatio Medievalis 140; Turnhout, 1995)

—, *The* Rationale Divinorum Officiorum: *The Foundational Symbolism of the Early Church, its Structure, Decoration, Sacraments and Vestments by Guilielmus Durandus* [Books I, trans. J.M. Neale and B. Webb; III, trans. T.H. Passmore; IV, trans. R. Coomaraswamy] (Louisville, 2007)

Eames, P., 'The Buffet and the Dressoir' in P. Eames, *Furniture in England, France and the Netherlands from the Twelfth to the Fifteenth Century* [*Furniture History*, 13] (1977), pp.55–72

Eco, U., *Art and Beauty in the Middle Ages*, trans. H. Bredin (New Haven and London, 2002)

Effenberger, A., 'Images of Personal Devotion: Miniature Mosaic and Steatite Icons', in Evans (2004), pp.209–14

El-Cheikh, N.M., 'Byzantium Through the Islamic Prism from the Twelfth to the Thirteenth Century', in A. Laiou and R. Mottahedeh (eds), *The Crusades from the Perspective of Byzantium and the Muslim World* (Washington, D.C., 2001), pp.53–69

Enenkel, K., de Jong-Crane, B., and Liebregts, P. (eds), *Modelling the Individual: Biography and Portrait in the Renaissance, With a Critical Edition of Petrarch's Letter to Posterity* (Amsterdam and Atlanta, GA, 1998)

Erickson, A.L., 'Family, Household, and Community', in J. Morrill (ed.), *The Oxford Illustrated History of Tudor and Stuart Britain* (Oxford, 1996), pp.90–118

Erlande-Brandenburg, A., *The Cathedral Builders of the Middle Ages* (London, 1995)

Esch, A., 'Roman Customs Registers 1470–80: Items of Interest to Historians of Art and Material Culture', *Journal of the Warburg and Courtauld Institutes*, 58 (1995), pp.72–87

Espinas, G., and Pirenne, H., *Recueil de Documents Relatifs a l'Histoire de l'Industrie Drapière en Flandre*, I (Brussels, 1906)

Esteras-Martín, C., 'Silver and Silverwork, Wealth and Art in Viceregal America', in J.J. Richel and S. Stratton-Pruitt, *The Arts in Latin America 1492–1820* (exhib. cat., Philadelphia, 2006), pp.178–227

Ettinghausen, R., 'The Taming of the *Horror Vacui* in Islamic Art', *Proceedings of the American Philosophical Society*, 123, no.1 (1979), pp.15–28

Evans, A. (ed.), *La Pratica della Mercatura* (Cambridge, MA, 1936)

Evans, E.C., 'Roman Descriptions of Personal Appearance in History and Biography', *Harvard Studies in Classical Philology*, 46 (1935), pp.43–84

—, *Physiognomics in the Ancient World* (Transactions of the American Philosophical Society, NS 59, no.5; Philadelphia, 1969)

Evans, H.C. (ed.), *Byzantium: Faith and Power (1261–1557)* (exhib. cat., Metropolitan Museum of Art, New York, 2004)

Evans, J., *Magical Jewels of the Middle Ages and the Renaissance, Particularly in England* (Oxford, 1922)

—, *A History of Jewellery 1100–1870* (2nd ed., London, 1970)

Evans, M., '"The Italians, who usually pursue fame, proffer their hand to you": Lucas Cranach and the Art of Humanism', in B. Brinkmann (ed.), *Cranach* (exhib. cat., Städel Museum, Frankfurt and Royal Academy, London, 2007), pp.49–61

Farago, C.J., *Leonardo da Vinci's* Paragone: *A Critical Interpretation with a New Edition of the Text in the Codex Urbinas* (Leiden, 1992)

—, 'Vision Itself Has its History: "Race", Nation, and Renaissance Art History', in C. Farago (ed.), *Reframing the Renaissance: Visual Culture in Europe and Latin America 1450–1650* (New Haven, 1995), pp.67–88

Farmer, D.H., *The Oxford Dictionary of Saints* (5th ed., Oxford and New York, 2003)

Farquhar, J.D., 'Identity in an Anonymous Age: Bruges Manuscript Illuminators and their Signs', *Viator*, 11 (1980), pp.371–83

Fear, A.T., 'Prehistoric and Roman Spain', in R. Carr (ed.), *Spain: A History* (Oxford, 2000), pp.11–38

Ferguson, W.K., *The Renaissance in Historical Thought* (Cambridge, MA, 1948)

Fermor, S., *The Raphael Tapestry Cartoons* (London, 1996)

Fernandez-Armesto, F., *Millennium* (London, 1995)

Ferrari, M.C. (ed.), *Thiofridi Abbatis Epternacensis, Flores Epytaphii Sanctorum* (Corpus Christianorum Continuatio Mediaevalis 133; Turnhout, 1996)

Ficino, M., *Three Books on Life*, trans. C. Kaske et al. (New York, 1989)

Finlay, R., 'The Pilgrim Art: The Culture of Porcelain in World History', *Journal of World History*, 9, no.2 (1998), pp.141–87

Flandrin, J.-L., 'Seasoning, Cooking and Dietetics in the Late Middle Ages', in Flandrin and Montanari (1999), pp.313–27

Flandrin, J.-L., and Montanari, M. (eds), *Food: A Culinary History from Antiquity to the Present*, English ed. by A. Sonnenfeld (New York, 1999)

Fleischer, J., 'Living Rocks and *Locus Amoenus*: Architectural Representations of Paradise in Early Christianity', in N.H. Petersen et al. (eds), *The Appearances of Medieval Rituals: The Play of Construction and Modification* (Turnhout, 2004), pp.149–65

Fletcher, J., 'Marcantonio Michiel: His Friends and Collection', *Burlington Magazine*, 123 (August 1981), pp.453–67

—, 'The Renaissance Portrait: Functions, Uses and Display', in *El retrato del Renacimiento*, ed. M. Falomir (exhib. cat., Prado, Madrid, 2008), pp.430–37

Fletcher, J.M.J., 'Bishop Richard Beauchamp 1450–1481', *Wiltshire Archaeology and Natural History Magazine*, 48, no.168 (1938), pp.161–73

Flood, F.B., *The Great Mosque of Damascus: Studies on the Makings of an Umayyad Visual Culture* (Leiden, 2001)

Foerster, R., *Scriptores Physiognomonici Graeci et Latini*, 2 vols (Leipzig, 1893)

Fogg, S. (ed.), *An Album of Medieval Art* (London, 2007)

Foister, S., 'Paintings and Other Works of Art in Sixteenth-Century English Inventories', *Burlington Magazine*, 123 (May 1981), pp.273–82

Forestié, E. (ed.), *Les Livres de Comptes des frères Bonis, marchands montalbanais au XIVᵉ Siècle*, 1 (Paris, 1894)

Fortini Brown, P.F., '*Renovatio* or *Concilatio*? How Renaissances Happened in Venice', in A. Brown (ed.), *Language and Images of Renaissance Italy* (Oxford, 1995), pp.127–56

—, 'Behind the Walls: The Material Culture of Venetian Elites', in J. Martin and D. Romano (eds), *Venice Reconsidered: The History and Civilization of an Italian City-state 1297–1797* (Baltimore, 2000), pp.295–338

—, *Private Lives in Renaissance Venice: Art, Architecture and the Family* (New Haven and London, 2004)

Fowler, H.N. (ed.), *Plato I. Euthyphro, Apology, Crito, Phaedo, Phaedrus* (London, 1966)

Fraenkel, B., *La signature: Genèse d'un signe* (Paris, 1992)

Freedman, P., *Images of the Medieval Peasant* (California, 1999)

—, *Out of the East: Spices and the Medieval Imagination* (London and New Haven, 2008)

Freshfield, E.H. (ed.), *Roman Law in the Later Roman Empire* (Cambridge, 1938)

Frisch, T.G., *Gothic Art 1140–1450: Sources and Documents* (Toronto, 1987)

Frisi, A.-F., *Memorie Storiche di Monza* (Milan, 1794)

Fuhring, P., '"Colligite fragmenta, ne pereant": The Ornament Prints in the Columbus Collection', in M.P. McDonald, *The Print Collection of Ferdinand Columbus (1488–1539): A Renaissance Collector in Seville*, 1: History and Commentary (London, 2004), pp.206–20

Gaborit-Chopin, D., *Ivoires Mediévaux V–XVᵉ siècle* (Paris, 2003)

Gai, L., and Savino, G., *L'Opera di S. Jacopo in Pistoia e il primo statuto in volgare (1313)* (Pisa, 1994)

Gardner, J., 'Nuns and Altarpieces: Agendas for Research', *Romisches Jahrbuch der Biblioteca Hertziana*, 30 (1995), pp.28–57

Gardner, V.C., '"Homines non nascuntur, sed figuntur": Benvenuto Cellini's *Vita* and the Self-Presentation of the Renaissance Artist', *Sixteenth Century Journal*, 28 (1997), pp.447–65

Gasparri, S., *Prima delle Nazioni: Popoli, Etnie e Regni fra Antichità e Medioevo* (Rome, 1997)

Gauricus, Pomponius, *De sculptura* (1504), trans. A. Chastel and R. Klein (Paris, 1969)

Geary, P.J., *Furta Sacra: Thefts of Relics in the Central Middle Ages* (Princeton, 1978)

—, 'Sacred Commodities: The Circulation of Medieval Relics', in A. Appadurai (ed.), *The Social Life of Things: Commodities in Cultural Perspective* (Cambridge, 1986), pp.169–91

—, *The Myth of Nations: The Medieval Origins of Europe* (Princeton, 2002)

Geraud, H., *Paris sous Philippe le Bel* (Paris, 1837)

Geuenich, D., et al. (eds), *Libri Memoriales et Necrologia, Nova Series*, 1: Supplementum: Die Altarplatte von Reichenau-Niederzell (Monumenta Germaniae Historica; Hannover, 1983)

Ghiberti, L., *I Commentarii (Biblioteca Nazionale Centrale di Firenze, II, I, 333)*, ed. L. Bartoli (Biblioteca della Scienza Italiana 17; Florence, 1998)

Gilbert, C.E., 'A Preface to Signatures (with Some Cases in Venice)', in M. Rogers (ed.), *Fashioning Identities in Renaissance Art* (Aldershot, 2000), pp.79–87

Gilbert, C.H., 'The Archbishop on the Painters of Florence', *Art Bulletin*, 41 (1959), pp.75–87

Ginzburg, C., 'The Conversion of the Jews of Minorca (417–418): An Experiment in the History of Historiography', in M. Aymard (ed.), *Biedni i Bogaci* (Warsaw, 1992), pp.21–31

Glanville, P., 'Tudor Drinking Vessels', *Burlington Magazine*, 127, no.990 (September 1985), pp.19–22

—, *Silver in Tudor and Early Stuart England: A Social History and Catalogue of the National Collection 1480–1660* (London, 1990)

Glixon, J., 'The Polyphonic Laude of Innocentius Dammonis', *Journal of Musicology*, 8, no.1 (1990), pp.19–53

Goldschmidt, A., *Die Elfenbeinskulpturen aus der Zeit der karolingischen und sächsischen Kaiser VIII–XI Jahrhundert*, 1 (Berlin, 1914)

Goldthwaite, R.A., *Wealth and the Demand for Art in Italy 1300–1600* (Baltimore, 1993)

Golombek, L., 'The Draped Universe of Islam', in P. Soucek (ed.), *Content and Context of the Visual Arts in the Islamic World* (University Park, PA, 1988a), pp.25–50

—, 'The Function of Decoration in Islamic Architecture', in M.B. Sevčenko (ed.), *Theories and Principles of Design in the Architecture of Islamic Societies* (Cambridge, MA, 1988b), pp.35–45

González Jiménez, M. (ed.), *Diplomatario andaluz de Alfonso X* (Seville, 1991)

Goodall, J.A., 'Two German Drinking Vessels in the Society's Collection', *Antiquaries Journal*, 70, no.2 (1990), pp.440–1

Goodman, A., *Loyal Conspiracy: The Lords Appellant under Richard II* (London, 1971)

Googe, B., trans., *Fovre Bookes of Husbandry, Collected by M. Conradus Heresbachius* (London, 1577)

Gordonio, B., *Lilio de medicina: Edición crítica de la versión española, Sevilla 1495*, ed. J. Cull and B. Dutton (Madison, WI, 1991)

Goss, C.W.F., *Sir Paul Pindar and His Bishopsgate Mansion* (Cambridge, 1930)

Gotfredsen, L., *The Unicorn*, trans. A. Brown (London, 1999)

Grabar, O., *The Formation of Islamic Art* (New Haven and London, 1973; 2nd ed., 1987)

Grafton, A., 'Panofsky, Alberti and the Ancient World', in I. Lavin (ed.), *Meaning in the Visual Arts: Views from the Outside* (Princeton, 1995), pp.123–30

—, *Leon Battista Alberti: Master Builder of the Italian Renaissance* (London, 2000)

—, 'José de Acosta: Renaissance Historiography and New World Humanity', in J.J. Martin (ed.), *The Renaissance World* (London, 2007), pp.166–88

Les Grandes Chroniques de France: Chronique des Règnes de Jean II et de Charles V, ed. R. Delachenal, 4 vols (Paris, 1910–20)

Grant, L., 'Naming of Parts: Describing Architecture in the High Middle Ages', in G. Clarke and P. Crossley (eds), *Architecture and Language: Constructing Identity in European Architecture, c.1000–c.1650* (Cambridge, 2000), pp.46–57

Greatrex, J., *Biographical Register of the English Cathedral Priories of the Province of Canterbury c.1066–1540* (Oxford, 1997)

Greco, A. (ed.), *Vespasiano da Bisticci: Le Vite*, 2 vols (Florence, 1970–76)

Greenhalgh, M., *Donatello and his Sources* (New York, 1982)

—, *The Survival of Roman Antiquities in the Middle Ages* (London, 1989)

Grieco, A.J., 'Food and Social Classes in Late Medieval and Renaissance Italy', in Flandrin and Montanari (1999), pp.302–312

—, 'From Roosters to Cocks: Renaissance Birds and Sexuality', unpublished paper presented to the Joint Annual Meeting of the Renaissance Society of America and the Society for Renaissance Studies, United Kingdom, Cambridge, England, 7–9 April 2005

Grossi, M.L., 'Le botteghe fiorentine nel catasto del 1427', *Ricerche Storiche*, 30, no.1 (2000), pp.3–56

Gutiérrez, A., 'Cheapish and Spanish: Meaning and Design on Imported Spanish Pottery', *Medieval Ceramics*, 21 (1997), pp.73–81

Hackenbroch, Y., 'A Set of Knife, Fork, and Spoon with Coral Handles', *Metropolitan Museum Journal*, 15 (1980), pp.183–4

Hageneder, O., and Haidacher, A. (eds), *Die Register Innocenz' III*, IV (Graz, 1964)

Hahn, C., 'The Voices of the Saints: Speaking Reliquaries', *Gesta*, 36, no.1 (1997), pp.20–31

Hale, J., *The Civilization of Europe in the Renaissance* (London, 1994)

—, *Renaissance Europe 1480–1520* (2nd ed., Oxford, 2000)

Hall, E., *The Vnion of the Two Noble and Illustrate Famelies of Lancastre & Yorke* (London, 1548)

Hall, J., *Dictionary of Subjects and Symbols in Art* (London, 1974)

Halsall, G., 'The Barbarian Invasions', in P. Fouracre (ed.), *The New Cambridge Medieval History*, 1: *c.500–c.700* (Cambridge, 2005), pp.35–55

Hamburger, J.F., 'Art, Enclosure and the *Cura Monialum*: Prolegomena in the Guise of a Postscript', *Gesta*, 31 (1992), pp.108–34

—, *Nuns as Artists: The Visual Culture of a Medieval Convent* (Berkeley, Los Angeles and London, 1997)

Hamburger, J., and Suckale, R. (eds), *Krone und Schleier* (exhib. cat., Ruhrlandmuseum, Essen, and Kunst- und Ausstellungshalle, Bonn, 2005)

Hamnett, M., *Fashioning A Self: Issues of Identity Surrounding Women's Dress in England 1590–1640* (unpublished MA thesis, Victoria and Albert Museum / Royal College of Art, London, 2004)

Hantschmann, K., 'Die Majolikasammlung des Bayerischen Nationalmuseums und die Sammlung Pringsheim', in S. Glaser (ed.), *Italienische Fayencen der Renaissance: Ihre Spuren in internationalen Museumssammlungen* (Nuremberg, 2004), pp.21–54

Harding, V.A., 'Documentary Sources for the Import and Distribution of Foreign Textiles in Later Medieval England', *Textile History*, 18, no.2 (1987), pp.205–18

Haren, M., *Medieval Thought: The Western Intellectual Tradition from Antiquity to the Thirteenth Century* (2nd ed., Basingstoke and London, 1992)

Harper, J., 'Turks as Trojans; Trojans as Turks: Visual Imagery of the Trojan War and the Politics of Cultural Identity in Fifteenth-Century Europe', in A. Kabir and D. Williams (eds), *Postcolonial Approaches to the European Middle Ages: Translating Cultures* (Cambridge, 2005), pp.151–82

Harrazi, N., 'Chapiteaux de la grande Mosquée de Kairouan', *Bibliothèque Archéologique*, 4, no.1 (1982), pp.145–6

Haskell, F., *History and its Images. Art and the Interpretation of the Past* (London, 1993)

Haskell, F., and Penny, N., *Taste and the Antique: The Lure of Classical Sculpture 1500–1900* (London, 1981)

Hasse, D.N., 'King Avicenna: The Iconographic Consequences of a Mistranslation', *Journal of the Warburg and Courtauld Institutes*, 60 (1997), pp.230–43

Havinden, M.A., *Household and Farm Inventories in Oxfordshire, 1550–1590* (Historical Manuscripts Commission, JP 10; London, 1965)

Haydocke, R., *A tracte containing the artes of curious paintinge caruinge & buildinge written first in Italian by Jo: Paul Lomatius painter of Milan* (Oxford, 1598; facsimile repr. [n.p.], 1970)

Hayward, M., 'The Packaging and Transportation of the Possessions of Henry VIII, with Particular Reference to the 1547 Inventory', *Costume*, 31 (1997), pp.8–15

—, *The 1542 Inventory of Whitehall*, 2 vols (London, 2005)

—, 'Scarlet, Murrey and Carnation: Red at the Court of Henry VIII', *Textile History*, 38, no.2 (2007), pp.135–50

Heather, P., *The Goths* (The Peoples of Europe; Oxford, 1996)

—, 'The Creation of the Visigoths', in P. Heather (ed.), *The Visigoths from the Migration Period to the Seventh Century: An Ethnographic Perspective (with discussion)* (Woodbridge, 1999), pp.41–92

Heck, C., 'Schongauer', Grove Art Online. Oxford Art Online <http://www.oxfordartonline.com/subscriber/article/grove/art/T076738> (accessed 26 September 2008)

Heckscher, W.S., 'Relics of Pagan Antiquity in Mediaeval Settings', *Journal of the Warburg and Courtauld Institutes*, 1 (1937–8), pp.204–20

Hedeman, A.D., 'Making the Past Present in *De Senectute*', in D. Areford et al. (eds) *Excavating the Medieval Image: Manuscripts, Artists, Audiences* (Aldershot, 2004), pp.59–80

Henderson, J., *Piety and Charity in Late Medieval Florence* (London, 1994)

—, *The Renaissance Hospital: Healing the Body and Healing the Soul* (New Haven and London, 2006)

Henisch, B.A., *Fast and Feast: Food in Medieval Society* (Pennsylvania and London, 1976)

—, *The Medieval Calendar Year* (University Park, PA, 1999)

Herlihy, D., 'Bubonic Plague: Historical Epidemiology and the Medical Problems', in S.K. Cohn (ed.), *The Black Death and the Transformation of the West* (Cambridge, MA, 1997), pp.17–38

Herodotus, *The Histories of Herodotus of Halicarnassus*, trans. H. Carter (Haarlem, 1958)

Heslop, T.A., 'Attitudes to the Visual Arts: The Evidence from Written Sources', in Alexander and Binski (1987), pp.26–32

Hinton, D.A., *Gold and Gilt, Pots and Pins: Possessions and People in Medieval Britain* (Oxford, 2005)

Hoch, A., 'Duecento Fertility Imagery for Females at Massa Marittima's Public Fountain', *Zeitschrift für Kunstgeschichte*, 69, no.4 (2006), pp.471–88

Hodges, R., and Whitehouse, D., *Mohammed, Charlemagne and the Origins of Europe: Archaeology and the Pirenne Thesis* (London, 1983)

Holanda, F. D', *Do Tirar Polo Natural*, ed. J. da Felicidade Alves (Lisbon, 1984)

Holgate, I., 'Giovanni d'Alemagna, Antonio Vivarini and the Early History of the Ovetari Chapel', *Artibus et Historiae*, 24, no.47 (2003), pp.9–29

Hollingsworth, M., *The Cardinal's Hat: Money, Ambition and Housekeeping in a Renaissance Court* (London, 2004)

—, 'Coins, Cloaks and Candlesticks: The Economics of Extravagance', in M. O'Malley and E. Welch (eds), *The Material Renaissance* (Manchester, 2007), pp.260–87

Holly, M.A., 'Witnessing an Annunciation', in T. Gaehtgens (ed.), *Kunstlerischer Austausch. Akten des XXVIII Internationalen Kongresses fur Kunstgeschichte, Berlin, 15.–20. Juli 1992* (Berlin, 1993), pp.713–25

Horace, 'On the Art of Poetry', in Aristotle, Horace, Longinus, *Classical Literary Criticism*, trans. T.S. Dorsch (London, 1965), pp.79–95

Horden, P., and Purcell, N., *The Corrupting Sea: A Study of Mediterranean History* (Oxford, 2000)

Horton, M.C., 'Early Muslim Trading Settlements on the East African Coast', *Antiquaries Journal*, 67, no.2 (1987), pp.290–323

Hoving, T., 'The Sources of the Ivories of the Ada School' (unpub. Ph.D. diss., Princeton University, 1960)

Howard, M., *The Early Tudor Country House: Architecture and Politics 1490–1550* (London, 1987)

Huggett, J.E., 'Rural Costume in Elizabethan Essex: A Study Based on the Evidence from Wills', *Costume*, 33 (1999), pp.74–88

Hugh of St-Victor, *The Didascalicon of Hugh of St Victor: A Medieval Guide to the Arts*, trans. J. Taylor (New York, 1961; repr. 1991)

Hughes, A., Dom, O.S.B., 'In hoc anni circulo', *Musical Quarterly*, 60, no.1 (January 1974), pp.37–45

Hughes, D.O., 'Sumptuary Law and Social Relations in Renaissance Italy', in J. Bossy (ed.), *Disputes and Settlements: Law and Human Relations in the West* (1983), pp.69–99

—, 'Distinguishing Signs: Ear-rings, Jews and Franciscan Rhetoric in the Italian Renaissance City', *Past and Present*, 112 (1986), pp.3–59

Hunt, A., *Governance of the Consuming Passions: A History of Sumptuary Law* (Basingstoke and London, 1996)

Hunt, E.S., *The Medieval Super-Companies: A Study of the Peruzzi Company of Florence* (Cambridge, 1994)

Husband, T., and Hayward, J., intro., *The Secular Spirit: Life and Art at the End of the Middle Ages* (exhib. cat., Metropolitan Museum of Art, New York, 1975)

Immacolata Bossa, M. (ed.), *Chiese e conventi degli ordini mendicanti in Umbria nei secoli XIII e XIV. Inventario delle fonti archivistiche e catalogo delle informazioni documentarie. La serie Protocolli dell'Archivio notarile di Perugia* (Perugia, 1987)

Isidore of Seville, *Etimologías: Edición Bilingüe*, Spanish trans. by J. Oroz Reta and M.-A. Marcos Casquero (Biblioteca de Autores Cristianos 433; 2nd ed., 2 vols, Madrid, 1993–4)

Israel, J.I., *The Dutch Republic: Its Rise, Greatness and Fall 1477–1806* (Oxford History of Early Modern Europe; Oxford, 1995)

Itier, B., *Chronique*, trans. J.-L. LeMaitre (Paris, 1998)

Jackson, A., and Jaffer, A. (eds), *Encounters: The Meeting of Asia and Europe 1500–1800* (exhib. cat., Victoria and Albert Museum, London, 2004)

Jacobs, L.F., *Early Netherlandish Carved Altarpieces 1380–1550: Medieval Tastes and Mass Marketing* (Cambridge, 1998)

Jacobus de Voragine, *The Golden Legend: Readings on the Saints*, trans. W. Granger Ryan, 2 vols (Princeton, 1993)

Jalabert, D., 'Fleurs peintes à la voûte de la chapelle du petit-Quevilly (Seine-Inférieure)', *Gazette des Beaux-Arts*, 43 (1954), pp.5–26

James, L., '"Pray Not to Fall into Temptation and Be on Your Guard": Pagan Statues in Christian Constantinople', *Gesta*, 35, no.1 (1996), pp.12–20

James, M.R., *On the Abbey of St Edmund at Bury* (Publications of the Cambridge Antiquarian Society, 1895)

Jardine, L., *Wordly Goods: A New History of the Renaissance* (London, 1998)

Jeffreys, E.M., 'The Attitudes of Byzantine Chroniclers towards Ancient History', *Byzantion*, 49 (1979), pp.199–238

Jenkinson, A., and other Englishmen, *Early Voyages and Travels to Russia and Persia*, ed. E. Delmar Morgan and C.H. Coote, Hakluyt Society, nos 72 and 73, 2 vols (London, 1886)

Johnson, G., 'Art or Artefact? Madonna and Child Reliefs in the Early Renaissance', in P. Motture and S. Currie (eds), *The Sculpted Object 1400–1700* (Aldershot, 1997), pp.1–24

—, 'Approaching the Altar: Donatello's Sculpture in the Santo', *Renaissance Quarterly*, 52, no.3 (1999), pp.627–66

—, 'Touch, Tactility and the Reception of Sculpture', in P. Smith (ed.), *A Companion to Art Theory* (London, 2002), pp.61–74

Johnstone, P., *High Fashion in the Church* (Leeds, 2002)

Jones, R., and Penny, N., *Raphael* (New Haven and London, 1983)

Jopek, N., *German Sculpture: A Catalogue of the Collection in the Victoria and Albert Museum* (London, 2002)

Joubert, L., *La Premiere et Seconde Partie des errevrs Popvlaires, touchant la Medecine & le regime de santé* (Rouen, 1601)

Jugie, S., and Fliegel, S.N. (eds), *L'Art à la Cour de Bourgogne: Le mécénat de Philippe le Hardi et de Jean sans Peur (1364–1419)* (exhib. cat., Musée des Beaux-Arts, Dijon, 2004)

Juřen V., 'Fecit Faciebat', *Revue de l'Art*, 26 (1974) [special issue: *L'Art de la Signature*], pp.27–30.

—, 'Politien et la théorie des arts figuratifs', *Bibliothèque d'humanisme et Renaissance*, 37, no.1 (1975), pp.131–140

Kallendorf, C., *In Praise of Aeneas: Virgil and Epideictic Rhetoric in the Early Italian Renaissance* (Hanover, NH, and London, 1989)

Kamen, H., *Empire: How Spain Became a World Power 1492–1763* (Harmondsworth, 2002)

Kauffmann, C.M., 'The Bury Bible (Cambridge, Corpus Christi College, MS. 2)', *Journal of the Warburg and Courtauld Institutes*, 29 (1966), pp.60–81

—, *Victoria and Albert Museum: Catalogue of Foreign Paintings*, 2 vols (London, 1973)

—, *Romanesque Manuscripts 1066–1190* (London, 1975)

Kaufmann, T.D., *Court, Cloister & City: The Art and Culture of Central Europe 1450–1800* (London, 1995)

Kavaler, E.M., 'Renaissance Gothic in the Netherlands: The Uses of Ornament', *Art Bulletin*, 82 (2000), pp.226–51

Keene, D.J., and Harding, V., *Historical Gazetteer of London before the Great Fire: Cheapside; parishes of All Hallows Honey Lane, St Martin Pomary, St Mary le Bow, St Mary Colechurch and St Pancras Soper Lane* (London, 1987)

Kelley, D.R., 'Something Happened: Panofsky and Cultural History', in I. Lavin (ed.), *Meaning in the Visual Arts: Views from the Outside* (Princeton, 1995), pp.113–22

Kemp, M.J., 'Leonardo da Vinci: Science and the Poetic Impulse', *RSA Journal*, 133 (February 1985), pp.196–214

—, '"Wrought by No Artist's Hand": The Natural, the Artificial, The Exotic, and the Scientific in Some Artifacts from the Renaissance', in C. Farago (ed.), *Reframing the Renaissance: Visual Culture in Europe and Latin America 1450–1650* (New Haven and London, 1995), pp.176–96

—, *Behind the Picture: Art and Evidence in the Italian Renaissance* (London, 1997)

—, '"Your Humble Servant and Painter": Towards a History of Leonardo da Vinci in his Contexts of Employment', *Gazette des Beaux-Arts*, 140 (2002), pp.181–94

Kennedy, K., 'In Sickness and in Health: Alfonso X of Castile and the Virgin Mary in *Cantiga* 235', *Galician Review*, 1 (1997), pp.27–42

—, 'Fame, Memory, and Literary Legacy: Jorge Manrique and the "Coplas por la muerte de su padre"', in M.B. Bruun and S. Glaser (eds), *Negotiating Heritage: Memories of the Middle Ages* (Turnhout, 2008), pp.103–16

Kent, D., *The Rise of the Medici: Faction in Florence 1426–1434* (Oxford, 1978)

Kernodle, G., 'Renaissance Artists in the Service of the People: Political Tableaux and Street Theaters in France, Flanders and England', *Art Bulletin*, 25, no.1 (1943), pp.59–64

Kessler, H., 'The Function of *Vitrum Vestitum* and the Use of *Materia Saphirorum* in Suger's St Denis', in J. Baschet and J.-C. Schmitt (eds), *L'Image: Fonctions et usages des images dans l'occident médiéval* (Cahiers du Léopard d'Or 5; Paris, 1996), pp.179–203

Kilerich, B., 'Physiognomics and the Iconography of Alexander', *Symbolae Osloenses*, 63 (1988), pp.51–66

King, D., 'The Inventories of the Carpets of King Henry VIII', *Hali*, 5, no.3 (1983), pp.293–302

—, 'Embroidery and Textiles', in Alexander and Binski (1987), pp.157–61

Kinney, D., 'A Late Antique Ivory Plaque and Modern Response', *Journal of American Archaeology*, 98 (1994), pp.457–72

Kitzinger, E., 'Interlace and Icons: Form and Function in Early Insular Art', in R. Spearman et al (eds), *The Age of Migrating Ideas* (Edinburgh, 1993), pp.3–6

Klapisch-Zuber, C., 'Plague and Family Life', in M. Jones (ed.), *The New Cambridge Medieval History*, VI: *c.1300–c.1415* (Cambridge, 2000), pp.124–54

Klibansky, R., Panofsky, E., and Saxl, F., *Saturn and Melancholy: Studies in the History of Natural Philosophy, Religion, and Art* (London, 1964)

Klinger, L., and Raby, J., 'Barbarossa and Sinan: A Portrait of Two Ottoman Corsairs from the Collection of Paolo di Giovio', in E.J. Grube (ed.), *Arte veneziana e arte islamica: Atti del primo simposio internazionale sull'arte veneziana e l'arte islamica* (Venice, 1989), pp.47–59

Knapp, D., 'The Relyk of a Seint: A Gloss on Chaucer's Pilgrimage', *ELH*, 39, no.1 (1972), pp.1–26

Knives and Forks in the Netherlands, 1500–1800 (exhib. cat., Gemeentemuseum, The Hague, 1972)

Koechlin, R., *Les Ivoires Gothiques Francais*, I (Paris, 1924)

Koenigsberger, H.G., *The Habsburgs and Europe 1515–1660* (London, 1971)

Koldeweij, A.M. (ed.), *In Buscoducis 1450–1629: Kunst uit de Bourgondische tijd te 's-Hertogenbosch. De cultuur van late middeleeuwen en renaissance* (exhib. cat., Noordbrabants Museum, 's-Hertogenbosch, 1990)

Koreny, F., 'Notes on Martin Schongauer', *Print Quarterly*, 10, no.4 (1993), pp.385–91

Krahn, V., 'I bozzetti del Giambologna', in B. Paolozzi Strozzi and D. Zikos (eds), *Giambologna: gli dei, gli eroi* (Florence, 2006), pp.44–61

Krautheimer, R., 'The Carolingian Revival of Early Christian Architecture', *Art Bulletin*, 24, no.1 (1942), pp.1–38

—, 'Ghiberti and Master Gusmin', *Art Bulletin*, 29, no.1 (1947), pp.25–35

Kren, T., and Evans, M. (eds), *A Masterpiece Reconstructed: The Hours of Louis XII* (exhib. cat., Victoria and Albert Museum, London, 2005)

Kren, T., and McKendrick, S. (eds), *Illuminating the Renaissance: The Triumph of Flemish Manuscript Painting in Europe* (exhib. cat., J. Paul Getty Museum, Los Angeles, 2003)

Kristeller, P.O., 'The Modern System of the Arts: A Study in the History of Aesthetics, Part I', *Journal of the History of Ideas*, 12, no.1 (1951), pp.496–527

Krleza, M. (ed.), *The Gold and Silver of Zadar and Nin* (Zagreb, 1972)

Kubiski, J., 'Orientalizing Costume in Early Fifteenth-Century French Manuscript Painting (Cité des Dames Master, Limbourg Brothers, Boucicaut Master, and Bedford Master)', *Gesta*, 40, no.2 (2001), pp.161–80

Laing, A., *Lighting: The Arts and Living* (London, 1982)

Laistner, M.L.W. (ed.), 'Notes on Greek from the Lectures of a Ninth Century Monastery Teacher', *Bulletin of the John Rylands Library*, 7 (1922–3), pp.421–56

Lalaing, A. de, 'Primer viaje de Felipe 'el Hermoso'', in J. García Mercadal (ed.), *Viajes de Extranjeros por España y Portugal*, 3 vols (Madrid, 1952–62)

Lambertenghi, G.P., *Codex Diplomaticus Langobardiae* (Historiae Patriae Monumenta 13; Turin, 1873)

Landau, D., and Parshall, P., *The Renaissance Print 1470–1550* (New Haven and London, 1994)

Landauer, C., 'Erwin Panofsky and the Renascence of the Renaissance', *Renaissance Quarterly*, 47, no.2 (1994), pp.255–81

Langland, W., *Piers the Plowman*, trans. J.F. Goodridge (Harmondsworth, 1959)

Lardeux, A. (ed.), *L'Europe des Anjou: Aventure des princes angevins du XIII^e au XV^e siècle* (exhib. cat., Abbaye Royale de Fontevraud, 2001)

Laureati, L., and Onori, L.M. (eds) *Gentile da Fabriano and the Other Renaissance* (Milan, 2006)

Laurioux, B., *Le Moyen Âge à Table* (Paris, 1989)

—, 'Table et hiérarchie sociale à la fin du Moyen Âge', in C. Lambert (ed.), *Du manuscrit à la table: essais sur la cuisine au Moyen Âge et répertoire des manuscrits médiévaux contenant des recettes culinaires* (Montreal and Paris, 1992), pp.87–107

Lawrence, C., 'Bubonic Plague: Extinct Disease or Present Danger?', *Nursing Mirror*, November 24 (1977), pp.13–16

Le Fournier, A., *La decoration d'humaine nature et a ornement des dames, compilé et extraict des tres excellens docteurs et plus expers medecins tant anciens que modernes* (Paris, 1530)

Le Goff, J., *La Naissance du Purgatoire* (Paris, 1981)

—, 'What did the Twelfth Century Renaissance Mean?', in P. Linehan and J. Nelson (eds), *The Medieval World* (London, 2001), pp.635–47

Lebecq, S., 'Routes of Change: Production and Distribution in the West (5th to 8th century)', in L. Webster and M. Brown (eds), *The Transformation of the Roman World AD 400–900* (exhib. cat., British Museum, London, 1997), pp.67–78

Leclercq-Marx, J., 'Signatures iconiques et graphiques d'orfèvres dans le haut moyen âge. Une première approche', *Gazette des Beaux-Arts*, 137 (2001), pp.1–16

Lecoq, A.-M., '"Finxit": Le peintre comme "fictor" au XVI^e siècle', *Bibliothèque d'humanisme et Renaissance*, 37, no.2 (1975), pp.225–44

Lecoy de la Marche, A., *Extraits des comptes et mémoriaux du Roi René* (Paris, 1873)

Lee, R.W., 'Review of *English Medieval Embroidery*', *Art Bulletin*, 23, no.2 (1941), pp.183

Legner, A., 'Der Alabasteraltar aus Rimini', *Städel-Jahrbuch*, NS, no.2 (1969), pp.101–68

— (ed.), *Rhein und Maas: Kunst und Kultur 800–1400*, II (exhib. cat., Schnütgen Museum, Cologne, 1972)

— (ed.), *Ornamenta Ecclesiae: Kunst und Künstler der Romanik*, I: *Katalog* (exhib. cat., Schnüttgen Museum, Cologne, 1985)

Leguay, J.-P., 'Urban Life', in M. Jones (ed.), *The New Cambridge Medieval History*, VI: *c.1300–c.1415* (Cambridge, 2000), pp.102–23

Leonardo da Vinci,, *Leonardo da Vinci's Treatise on Painting*, trans. A.P. McMahon, 2 vols (Princeton, 1956)

Leoni, M., 'Considerazioni sulla fonderia d'arte ai tempi di Donatello. Aspetti tecnici del gruppo della Giuditta', in L. Dolcini (ed.), *Donatello e il restauro della Giuditta* (exhib. cat., Palazzo Vecchio, Florence, 1988), pp.54–7

Lethaby, W.R., 'The Broderers of London and Opus Anglicanum', *Burlington Magazine*, 29, no.158 (1916), p.74

Levi, G., 'Il Cardinale degli Ubaldini', *Archivio della Società Romana di Storia Patria*, 14 (1891), pp.231–303

Lévi, G., 'Le Juif de la légende', *Revue des Études Juives*, 20 (1890), pp.249–52

Lévi-Provençal, E., *Histoire de l'Espagne Musulmane*, 3 vols (Paris, 1950)

Lewis, M.W., and Wigen, K.E., *The Myth of Continents: A Critique of Metageography* (Berkeley, 1997)

Lida de Malkiel, M.R., *La idea de la fama en la edad media castellana* (Mexico City, 1952)

Lieb, N., *Die Fugger und die Kunst im Zeitalter der hohen Renaissance* (Munich, 1958)

Lightbown, R.W., *Secular Goldsmiths' Work in Medieval France: A History* (London, 1978)

—, 'l'esotismo', in F. Zeri (ed.), *Storia dell'arte italiana: Parte terza: Situazioni momenti indagini*, III: *Conservazione, falso, restauro*, series ed. G. Bollati and P. Fossati (Turin, 1981), pp.443–87

Lindley, P., 'The Black Death and English Art: A Debate and Some Assumptions', in W. Ormrod and P. Lindley (eds), *The Black Death in England* (Stamford, Lincs, 1996), pp.125–46

Lindow, J.R., *The Renaissance Palace in Florence: Magnificence and Splendour in Fifteenth-Century Italy* (Aldershot, 2007)

Lipsmeyer, E., 'Devotion and Decorum: Intention and Quality in Medieval German Sculpture', *Gesta*, 34, no.1 (1995), pp.20–27

Lloyd, G.E.R., 'The Hot and the Cold, the Dry and the Wet in Greek Philosophy', *Journal of Hellenic Studies*, 84 (1964), pp.92–106

Lobera, A. de, *Libro del regimiento de la salud* (Valladolid, 1551)

Loomis, R.S., 'Edward I, Arthurian Enthusiast', *Speculum*, 28 (1953), pp.114–27

Lopez, R.S., 'Silk Industry in the Byzantine Empire', *Speculum*, 20 (1945), pp.1–43

López de Corella, A., *Secretos de philosophia y astrologia y medicina y delas quatro mathematics sciencias* (Zaragoza, 1547)

López Pita, P., *Documentación Medieval de la Casa de Velada: Instituto Valencia de Don Juan*, I; *1193–1393* (Fuentes Históricas Abulenses 52; Ávila, 2002)

Lowden, J., 'On the Purpose of the Sutton Hoo Ship Burials', in D. Buckton and T.A. Heslop (eds), *Studies in Medieval Art and Architecture Presented to Peter Lasko* (London, 1994), pp.91–101

Lowry, M., *The World of Aldus Manutius: Business and Scholarship in Renaissance Venice* (Oxford, 1979)

—, *Nicholas Jensen and the Rise of Venetian Publishing in Renaissance Europe* (Oxford, 1991)

Luard, H.R. (ed.), *Matthaei Parisiensis Monachi Sancti Albani, Chronica Majora*, IV (Rolls Series; London, 1877)

Lucian of Samosata, *Lucian: A Selection*, trans. M.D. Macleod (Warminster, Wiltshire, 1991)

Lund, N. (ed.), *Two Voyagers at the Court of King Alfred* (York, 1984)

Lüttenberg, T., 'Le tissu comme aura: Les fonctions des tentures à la cour d'Aragon et à Barcelone (s.XIV^e–s.XV^e siècles)', *Mélanges de l'École Française de Rome: Moyen Âge*, III, no.1 (1999), pp.373–92

McClendon, C.B., *The Origins of Early Medieval Architecture: Building in Europe, A.D. 600–900* (London, 2005)

MacCulloch, D., *Reformation: Europe's House Divided 1490–1700* (London, 2003)

McGrath, E., 'Humanism, Allegorical Invention, and the Personification of the Continents', in H. Vlieghe, A. Balis and C. Van de Velde (eds), *Concept, Design and Execution in Flemish Painting (1550–1700)* (Turnhout, 2000), pp.43–71

Machiavelli, N., *The Prince*, trans. G. Bull, intro. A. Grafton (London, 2003)

McKean, J.M., 'Sebastiano Serlio: An Introduction to the Writings of Sebastiano Serlio, the Begetter of the Coffee Table Book', *Architectural Association Quarterly*, II, no.4 (1979), pp.14–27

McKendrick, S., 'The Great History of Troy: A Reassessment of the Development of a Secular Theme in Late Medieval Art', *Journal of the Warburg and Courtauld Institutes*, 54 (1991), pp.43–82

Mackenney, R., 'The Guilds of Venice: State and Society in the *Longue Durée*', *Studi Veneziani*, NS 34 (1997), pp.15–44

McKitterick, R., 'Nuns' Scriptoria in England and Francia in the 8th Century', *Francia*, 19 (1989), pp.7–10

Maclean, I., 'Girolamo Cardano: The Last Years of a Polymath', *Renaissance Studies*, 21, no.5 (2007), pp.587–607

McNiven, P., 'The Problem of Henry IV's Health, 1405–1413', *English Historical Review*, 100 (1985), pp.747–72

Maginnis, H.B., 'The Craftsman's Genius: Painters, Patrons, and Drawings in Trecento Siena', in A. Ladis and C. Wood (eds), *The Craft of Art: Originality and Industry in the Italian Renaissance and Baroque Workshop* (Athens, GA, and London, 1995), pp.25–47

—, *The World of the Early Sienese Painter* (Pennsylvania, 2001)

Mallet, J.V.G., *Xanto: Pottery-Painter, Poet, Man of the Italian Renaissance* (exhib. cat., Wallace Collection, London, 2007)

Mango, C., 'Antique Statuary and the Byzantine Beholder', *Dumbarton Oaks Papers*, 17 (1963), pp.55–75

—, 'Discontinuity with the Classical Past in Byzantium', in M. Mullett and R. Scott (eds), *Byzantium and the Classical Tradition* (Birmingham, 1981), pp.48–58

Mann, V., 'Romanesque Ivory Tablemen' (unpub. Ph.D. diss., New York University, 1977)

Manrique, J., *Poesía*, ed. V. Beltrán (Barcelona, 1993)

Manual de mugeres en el qual se contienen muchas y diversas reçeutas muy buenas, ed. A. Martínez Crespo (Salamanca, 1995)

Manuel, J., *El Conde Lucanor o Libro de los enxiemplos del Conde Lucanor et de Patronio*, ed. J.M. Blecua (Madrid, 1969)

Marbode of Rennes, *'De Lapidibus' Considered as a Medical Treatise*, ed. and trans. J.M. Riddle (Sudhoffs Archiv 20; Wiesbaden, 1977)

Marchand, E., 'Reproducing Relief: The Use and Status of Plaster Casts in the Italian Renaissance', in D. Cooper and M. Leino (eds), *Depth of Field: Relief Sculpture in Renaissance Italy* (Bern, 2007), pp.191–222

Markham, G., *The English Housewife*, ed. M.R. Best (Kingston, 1986)

Marks, R., and Williamson, P. (eds), *Gothic: Art for England 1400–1547* (exhib. cat., Victoria and Albert Museum, London, 2003)

Marquardt, K., *Eight Centuries of European Knives, Forks and Spoons: An Art Collection* (Stuttgart, 1997)

Marti, S., Borchert, T.-H., and Keck, G. (eds), *Charles le Téméraire 1433–1477: Faste et Déclin de la Cour de Bourgogne* (exhib. cat., Brugge Museum and Groeningemuseum, Bruges, 2008)

Martín Gonzalez, J., 'Obras artísticas de procedencia americana en las colecciones reales españolas. Siglo XVI', in *Relaciones artísticas entre la Península Ibérica y América* (Valladolid, 1990), pp.151–70

Martines, L., 'The Renaissance and the Birth of Consumer Society', *Renaissance Quarterly*, 51, no.1 (1998), pp.193–203

Martino da Canal, *Les Estoires de Venise: cronaca veneziana in lingua francese dalle origine al 1275*, ed. A. Limentani (Florence, 1972)

Marx, B., 'Medici Gifts to the Court of Dresden', *Studies in the Decorative Arts*, 15, no.1 (2007), pp.46–82

Matchette, A., 'Credit and Credibility: Used Goods and Social Relations in Sixteenth-Century Florence', in M. O'Malley and E. Welch (eds), *The Material Renaissance* (Manchester, 2007), pp.225–41

Mathews, T.F., *The Clash of Gods: A Reinterpretation of Early Christian Art* (Princeton, 1993)

Matthews-Grieco, S.F., 'Marriage and Sexuality', in Ajmar-Wollheim and Dennis (2006), pp.104–19

Mauss, M., *The Gift: The Form and Reason for Exchange in Archaic Societies*, trans. W.D. Halls (London, 1990)

Meckseper, C., 'Magdeburg und die Antike - Zur Spolienverwendung im Magdeburger Dom', in M. Puhle (ed.), *Otto der Grosse: Magdeburg und Europa* (exhib. cat., Kunsthistorisches Museum, Magdeburg, 2001), pp.367–80

Meersseman, G.G., *Ordo Fraternitatis: Confraternitate e Pietà dei Laici nel Medioevo*, 3 vols (Italia Sacra 24–26; Rome, 1977)

Meiss, M., *Painting in Florence and Siena after the Black Death: The Arts, Religion and Society in the Mid-Fourteenth Century* (Princeton, 1951)

—, *French Painting in the Time of Jean de Berry: The Late XIVth Century and the Patronage of the Duke* (London, 1967)

Melikian-Chirvani, A.S., 'Silver in Islamic Iran: The Evidence from Literature and Epigraphy', in M. Vickers (ed.), *Pots and Pans: A Colloquium on Precious Metals and Ceramics in Muslim, Chinese and Graeco-Roman Worlds, Oxford 1985* (Oxford, 1986), pp.89–106

Meller, P., 'Physiognomical Theory in Renaissance Portraits', in M. Meiss et al. (eds), *The Renaissance and Mannerism* (Studies in Western Art 2; Princeton, 1963), pp.53–69

Mellinkoff, R., *Outcasts: Signs of Otherness in Northern European Art of the Late Middle Ages*, 2 vols (Berkeley and Oxford, 1993)

—, *Antisemitic Hate Signs in Hebrew Illuminated Manuscripts from Medieval Germany* (Jerusalem, 1999)

Mendel, L.B., and Underhill, F.P., 'Is the Saliva of the Dog Amylolytically Active?', *Journal of Biological Chemistry* 3, no.2 (1907), pp.135–43

Merlini, E., 'La Bottega degli Embriachi e i cofanetti eburnei fra Trecento e Quattrocento: una proposta di classificazione', *Arte Cristiana*, NS, no.76 (1988), pp.267–82

Mews, C.J., 'Orality, Literacy and Authority in the Twelfth Century Schools', in C.J. Mews (ed.), *Reason and Belief in the Age of Roscelin and Abelard* (Aldershot, 2002), chapter one (unpaginated)

Meyvaert, P., '"Rainaldus est malus scriptor Francigenus": Voicing National Antipathy in the Middle Ages', *Speculum*, 66, no.4 (1991), pp.743–63

Michael, M., '"The Little Land of England is Preferred Before the Great Kingdom of France": The Quartering of the Royal Arms by Edward III', in D. Buckton and T.A. Heslop (eds), *Studies in Medieval Art and Architecture Presented to Peter Lasko* (London, 1994), pp.113–26

Miedema, N.R., *Die Mirabilia Romae: Untersuchungen zu ihrer Überlieferung mit Edition der deutschen und niederländischen Texte* (Tübingen, 1996)

Migne, J.-P. (ed.), *Patrologiae Cursus Completus, Series Latina*, XLIX: *Joannis Cassiani Opera Omnia, Tomus Prior* (Paris, 1846)

—, *Patrologiae Cursus Completus, Series Latina*, CLVIII: *Anselmus Cantuariensis* (Paris, 1853)

—, *Patrologiae Cursus Completus, Series Latina*, CCXIII: *Sicardus Cremonensis* (Paris, 1855)

Milanesi, G., *Documenti per la storia dell'arte senese*, 2 vols (Siena, 1854)

Milburn, R., *Early Christian Art and Architecture* (Aldershot, 1988)

Miller, E., 'Prints', in Ajmar-Wollheim and Dennis (2006), pp.322–31

Minnis, A.J., *Medieval Theory of Authorship: Scholastic Literary Attitudes in the Later Middle Ages* (2nd ed., Aldershot, 1988)

Mitchell, D., 'Coverpanes: Their Nature and Use in Tudor England', *Bulletin du CIETA*, 75 (1998), pp.81–96

Molà, L., 'l'Industria della Seta a Lucca nel tardo Medioevo: emigrazione della manodopera e creazione di una rete produttiva a Bologna e Venezia', in S. Cavaciocchi (ed.), *La Seta in Europa sec. XIII–XX* (Florence, 1993), pp.435–44

—, *The Silk Industry of Renaissance Venice* (Baltimore, 2000)

—, 'States and Crafts: Relocating Technical Skills in Renaissance Italy', in M. O'Malley and E. Welch (eds), *The Material Renaissance* (Manchester, 2007), pp.133–53

Mommsen, T.E., 'Petrarch's Conception of the "Dark Ages"', *Speculum*, 17, no.2 (1942), pp.226–42

Monnas, L., '"Tissues" in England During the Fifteenth and Sixteenth Centuries', *Bulletin du CIETA*, 75 (1998), pp.62–80

Montanari, M., 'Diete monastiche', in M. Montanari, *Alimentazione e cultura nel medioevo* (Rome, 1988), pp.63–105

Monticolo, G., *I Capitolari delle Arte Veneziane sottoposte alla Giustizia e poi alla Giustizia Vecchia, dalle origine al MCCCXXX* (Rome, 1896)

Montoya Martínez, J., 'El concepto de "autor" en Alfonso X', in A. Gallego Morell, A. Soria and N. Marín (eds), *Estudios sobre literatura y arte dedicados al Profesor Emilio Orozco Díaz*, III (Granada, 1979), pp.455–62

Morineau, M., 'Growing Without Knowing Why: Production, Demographics, and Diet', in Flandrin and Montanari (1999), pp.374–82

Mortet, V., and Deschamps, P., *Recueil de textes relatifs à l'histoire de l'architecture et à la condition des architéctes en France au moyen âge*, 2 vols (Paris, 1911–29)

Moryson, F., *An Itinerary containing his ten yeeres travell throvgh the twelve dominions of Germany […]* (London, 1617)

Moskowitz, A., *Italian Gothic Sculpture c.1250–c.1400* (Cambridge, 2001)

Motture, P., with Martin, G., *Bells & Mortars and Related Utensils: Catalogue of Italian Bronzes in the Victoria and Albert Museum* (London, 2001)

—, 'Making and viewing: Donatello and the Treatment of Relief', in P. Curtis (ed.), *Depth of Field: The Place of Relief in the Time of Donatello* (exhib. cat., Henry Moore Institute, Leeds, 2005), pp.18–29

—, 'Donatello a Padova: pratica di bottega e scambio artistico', in D. Banzato et al. (eds), *Mantegna e Padova 1445–1460* (exhib. cat., Museo Civici agli Eremitani, Padua, 2006), pp.109–20

—, 'Agostino di Duccio and Carlo Crivelli: Playing with Two and Three Dimensions', in D. Cooper and M. Leino (eds), *Depth of Field: Relief Sculpture in Renaissance Italy* (Bern, 2007), pp.149–67

Motture, P., and Hamnett, M., catalogue entry for Antico's *Meleager*, in F. Trevisani and D. Gasparotto (eds), *Bonacolsi l'Antico: Uno scultore nella Mantova di Andrea Mantegna e di Isabella d'Este* (exhib. cat., Palazzo Ducale, Mantua, 2008), pp.192–3

Motture, P., and Syson, L., 'Art in the *Casa*', in Ajmar-Wollheim and Dennis (2006), pp.268–83

Mueller, R., 'A Foreigner's View of Poor Relief in Late Quattrocento Venice', in M. Aymard (ed.), *Biedni i Bogaci* (Warsaw, 1992), pp.55–64

Müller, J., 'The Eye of the Artist: Hans Holbein's Theory of Art', in M.W. Roskill and J.O. Hand (eds), *Hans Holbein: Paintings, Prints and Reception* (Studies in the History of Art 60; Washington, D.C., 2001), pp.141–53

Müller, T., *Sculpture in the Netherlands, Germany, France and Spain 1400 to 1500* (Harmondsworth, 1966)

Muratorio, L.A., *Antiquitates Italicae Medii Aevi sive Dissertazioni*, IV (Arezzo, 1774)

Muratova, X., 'Vir quidem fallax et falsidicus sed artifex praeelectus: remarques sur l'image sociale et littéraire de l'artiste au Moyen Âge', in X. Barral i Altet (ed.), *Artistes, Artisans et Production Artistique au Moyen Âge*, I: *Les Hommes* (Paris, 1986), pp.53–72

Muscat, N., 'Ministerium Fratrum' published online at <http://franciscanstudies. e-tau.org/articles/Ministerium_Fratrum.pdf> (accessed 14 April 2008)

Muthesius, A., 'Silk in the Medieval World', in D. Jenkins (ed.), *The Cambridge History of Western Textiles* (Cambridge, 2003), pp.325–54

Nagel, A., and Wood, C.S., 'Toward a New Model of Renaissance Anachronism', *Art Bulletin*, 87, no.3 (2005), pp.403–15

Nees, L., *A Tainted Mantle: Hercules and the Classical Tradition at the Carolingian Court* (Philadelphia, 1991)

—, 'Art and Architecture', in R. McKitterick (ed.), *The New Cambridge Medieval History*, II: *c.700–c.900* (Cambridge, 1995), pp.809–44

—, 'On Carolingian Book Painters: The Ottoboni Gospels and its Transfiguration Master', *Art Bulletin*, 83, no.2 (2001), pp.209–39

Neudoerffer, J., *Ein Gesbrechbüchlein zweyer schüler, wie einer der andern im zierlichen schreyben untherweyst* (Nuremberg, 1549)

Newett, M.M., *Canon Pietro Casola's Pilgrimage to Jerusalem in the year 1494* (Manchester, 1907)

Newton, S.M., *Fashion in the Age of the Black Prince: A Study of the Years 1340–1365* (Woodbridge, 1980)

Nichols, J., *Illustrations of the Manners and Expences of Antient Times in England…* (London, 1797)

Nickel, H., '"The Judgment of Paris" by Lucas Cranach the Elder: Nature, Allegory, and Alchemy', *Metropolitan Museum Journal*, 16 (1981), pp.117–29

Nitze, W.A., 'The Exhumation of King Arthur at Glastonbury', *Speculum*, 9, no.4 (1934), pp.355–61

Nola, R. de, *Libro de guisados, manjares y potaies intitulado Libro de Cozina* (Logroño, 1529; facsimile, Madrid, 1971)

Noomen, W., 'Le Vilain Asnier', in W. Noomen (ed.), *Nouveau Recueil complet des fabliaux (NRCF)*, 10 vols (Assen, 1933–98)

Norman, D. (ed.), *Siena, Florence and Padua: Art, Society and Religion 1280–1400* (London, 1995)

Nuttall, P., *From Flanders to Florence: The Impact of Netherlandish Painting 1400–1500* (London, 2004)

Nutton, V., 'The Fatal Embrace: Galen and the History of Ancient Medicine', *Science in Context*, 18, no.1 (2005), pp.111–21

Oakeshott, W., *Classical Inspiration in Medieval Art* (London, 1959)

O'Dell, I., 'The Monogrammist WF', *Print Quarterly*, 10, no.4 (1993), pp.400–401

Odetto, G., 'La Cronaca Maggiore dell'Ordine Domenicano di Galvano Fiamma. Frammenti Editi.', *Archivum Fratrum Praedicatorum*, X (1940), pp.297–373

Olivar Daydí, M., 'La vajilla de madera y la cerámica de uso en Valencia y en Cataluña durante el siglo XIV (según los inventarios de la época)', *Anales del Centro de Cultura Valenciana: Anejo número*, 2 (Valencia, 1950)

O'Malley, M., *The Business of Art: Contracts and the Commissioning Process in Renaissance Italy* (New Haven and London, 2005)

Oman, C., 'The Jewels of Saint Albans Abbey', *Burlington Magazine*, 57, no.329 (1930a), pp.80–82

—, *Victoria and Albert Museum Catalogue of Rings* (London, 1930b)

—, *Medieval Silver Nefs* (London, 1963)

Onians, J., *Bearers of Meaning: The Classical Orders in Antiquity, the Middle Ages and the Renaissance* (Princeton, 1988)

Orosius, P., *Seven Books of History Against the Pagans*, trans. I. Woodworth Raymond (New York, 1936)

—, *The Seven Books of History Against the Pagans*, trans. R. Deferrari (The Fathers of the Church 50; Washington, D.C., 1964)

O'Rourke Boyle, M., *Senses of Touch: Human Dignity and Deformity from Michelangelo to Calvin* (Brill, 1998)

Orsi Landini, R., et al., *Moda alla corte dei Medici: Gli abiti restaurati di Cosimo, Eleonora e don Garzia* (exhib. cat., Galleria del Costume di Palazzo Pitti, Florence, 1993)

Orsi Landini, R., and Niccoli, B., *Moda a Firenze 1540–1580: Lo stile di Eleonora di Toledo e la sua influenza* (Florence, 2005)

Osborne, J. (ed.), *Master Gregorius: The Marvels of Rome* (Toronto, 1987)

Osheim, D.J., 'Conversion, *Conversi* and the Christian Life in Late Medieval Tuscany', *Speculum*, 58 (1983), pp.368–90

Osma, G.J. de, *Apuntes sobre Cerámica Morisca, Textos y Documentos Valencianos*, I: *La Loza Dorada de Manises en el año 1454* (Cartas de la Reina de Aragón a Don Pedro Boil; Madrid, 1906)

—, *Los maestros alfareros de Manises, Paterna y Valencia* (Madrid, 1908)

Østrem, E., 'Deus Artifex and Homo Creator: Art Between the Human and the Divine', in S.R. Havsteen et al. (eds), *Creations: Medieval Rituals, the Arts, and the Concept of Creation* (Turnhout, 2007), pp.15–48

Overgaauw, E.A., 'Where are the Colophons? On the Frequency of Datings in Late-Medieval Manuscripts', in R. Schlusemann, Jos. M.M. Hermans and M. Hoogvliet (eds) *Sources for the History of Medieval Books and Libraries* (Groningen, 1999), pp.81–93

Page, S., *Astrology in Medieval Manuscripts* (London, 2002)

Page, W. (ed.), *A History of the County of Hampshire*, V (Victoria County History, London, 1912)

Pagliara, P.N., 'Vitruvio a testo a canone', in S. Settis (ed.), *Memoria dell'antico nell'arte italiana* (Turin, 1986), pp.7–88

Palazzo, E., *Liturgie et Société au Moyen Âge* (Paris, 2000)

Palencia, A. de, *Uniuersal vocabulario en latín y en romance*, 2 vols (Seville, 1490)

Palissy, B., *De l'Art de Terre de son vtilité, des esmaux & du feu* (Paris, 1991)

Palumbo-Fossati, I., 'L'interno della casa dell'artigiano e dell'artista nella Venezia del Cinquecento', *Studi Veneziani*, NS 8 (1984), pp.109–53

Panofsky, E., '"Nebulas in pariete": Notes on Erasmus's Eulogy on Dürer', *Journal of the Warburg and Courtauld Institutes*, 14 (1951), pp.34–41

—, *The Life and Art of Albrecht Dürer* (4th ed., Princeton, 1955)

—, *Renaissance and Renascences in Western Art* (Stockholm, 1960)

Paoletti, J.T., 'Familiar Objects: Sculptural Types in the Collections of the Early Medici', in S.B. McHam (ed.), *Looking at Italian Renaissance Sculpture* (Cambridge, 1998), pp.79–110

Paravicini-Bagliani, A., *I Testamenti dei Cardinali del Duecento* (Miscellanea della Società Romana di Storia Patria 25; Rome, 1980)

Parker, E.C., 'Master Hugo as Sculptor: A Source for the Style of the Bury Bible', *Gesta*, 20 (1981), pp.99–109

Parker, E.C., and Little, C.T., *The Cloisters Cross: Its Art and Meaning* (London, 1994)

Partearroyo, C., 'Alfombras del Museo Nacional de Artes Decorativas', in *Alfombras españolas de Alcaraz y Cuenca, siglos XV–XVI* [catalogue of the collection in the Museo Nacional de Artes Decorativas] (Madrid, 2002), pp.73–115

Pelling, M., 'Appearance and Reality: Barber-Surgeons, the Body and Disease', in A.L. Beier and R. Finlay (eds), *London 1500–1700: The Making of the Metropolis* (London and New York, 1986), pp.82–112

Pelus-Kaplan, M.-L., 'Foreign Merchant Communities in Bruges, Antwerp and Amsterdam, c.1350–1650', in D. Calabi and S.T. Christensen (eds), *Cultural Exchange in Early Modern Europe*, II: *Cities and Cultural Exchange in Europe 1400–1700* (Cambridge, 2007), pp.132–53

Perry, J.P., 'Practical and Ceremonial Uses of Plant Materials as "Literary Refinements" in the Libraries of Leonello d'Este and His Courtly Literary Circle (Angelo Decembrio's *De politia litteraria* Book 1, Part 3, and Book 2, Part 21)', *La Bibliofilía*, Anno XCI.2 (1989), pp.121–73

Pesez, J.M., 'Obscure et enfumée: la maison paysanne au Moyen Âge', *Fasciculi Archeologiae Historicae*, 2 (1988), pp.79–83

Petrus de Abano, *Tractatus de uenenis*, in Arnaldus de Villanova (1475)

Piattoli, R., 'Un mercante del Trecento e gli artisti del tempo suo', *Rivista d'arte*, 11 (1929), pp.396–437

Piccolpasso, C., *The Three Books of the Potter's Art / I Tre Libri dell'Arte del Vasaio: A Facsimile of the Manuscript in the Victoria and Albert Museum*, trans. R. Lightbown and A. Caiger-Smith, 2 vols (London, 1980)

Pino, P., *Dialogo di Pittura*, ed. S. Falabella (Rome, 2000)

Piponnier, F., 'Purchases, Gifts and Legacies of Liturgical Vestments from Written Sources, in the Fourteenth and Fifteenth Centuries', *Costume*, 31 (1997), pp.1–7

—, 'From Hearth to Table: Late Medieval Cooking Equipment', in Flandrin and Montanari (1999), pp.339–46

Pisanelli, B., *Trattato della Natvra de' Cibi e del Bere* (Venice, 1586)

Plesch, V., 'Memory on the Wall: Graffiti on Religious Wall Paintings', *Journal of Medieval and Early Modern Studies*, 32, no.1 (2002), pp.167–97

Pliny, *Natural History*, trans H. Rackham, W.H.S. Jones and D.E. Eichholz, 10 vols (London and Cambridge, MA, 1958–62)

Pohl, W., 'Introduction: Strategies of Distinction', in W. Pohl and H. Reimitz (eds), *Strategies of Distinction: The Construction of Ethnic Communities (300–800)* (Leiden, 1998), pp.1–16

Poke, C., 'Jacques Androuet I Ducerceau's "Petites Grotesques" as a Source for Urbino Maiolica Decoration', *Burlington Magazine*, 143 (June 2001), pp.332–44

Politiani, A., *Miscellaneorum Centuria Prima* (Siena, 1994)

Pon, L., 'Michelangelo's First Signature', *Source: Notes in the History of Art*, 15, no.4 (1996a), pp.16–21

—, 'Michelangelo's Lives: Sixteenth-Century Books by Vasari, Condivi, and Others', *Sixteenth Century Journal*, 27, no.4 (1996b), pp.1015–37

—, *Raphael, Dürer and Marcantonio Raimondi: Copying and the Italian Renaissance Print* (New Haven, 2004)

Pontano, G., *I Libri delle Virtù Sociali*, ed. and trans. F. Tateo (Rome, 1999)

Pope-Hennessy, J., 'A Relief of Europa', *Victoria and Albert Museum Yearbook*, 4 (1974), pp.11–19

Pope-Hennessy, J., and Lightbown, R.W., *Catalogue of Italian Sculpture in the Victoria and Albert Museum*, 3 vols (London, 1964)

Powell, T.E., 'The Three Orders of Society in Anglo-Saxon England', *Anglo-Saxon England*, 23 (1994), pp.103–32

Power, E.E., *Medieval English Nunneries, c.1275 to 1535* (Cambridge, 1922)

Prescott, A. (ed.), *The Benedictional of St Aethelwold: A Masterpiece of Anglo-Saxon Art* (facsimile, London, 2002)

Preyer, B., 'The Florentine *Casa*' in Ajmar-Wollheim and Dennis (2006), pp.34–49

Princely Magnificence: Court Jewels of the Renaissance, 1500–1630 (exhib. cat., Victoria and Albert Museum, London, 1980)

[Pseudo-Aristotle], *Pseudo Aristóteles, Fisiognomía y Anónimo, Fisiólogo*, ed. and trans. T. Martínez Manzano and C. Calvo Declán (Biblioteca Clásica Gredos 270; Madrid, 1999)

Pyhrr, S.W., and Godoy, J.-A., *Heroic Armor of the Italian Renaissance: Filippo Negroli and His Contemporaries* (exhib. cat., Metropolitan Museum of Art, New York, 1999)

Quivigier, F., 'Benedetto Varchi and the Visual Arts', *Journal of the Warburg and Courtauld Institutes*, 50 (1987), pp.219–24

Rabelais, F., *Pantagruel: Edition critique sur le texte de l'édition publiée à Lyon en 1542 par François Juste* (Paris, 1997)

Raby, J., 'Cyriacus of Ancona and the Ottoman Sultan Mehmed II', *Journal of the Warburg and Courtauld Institutes*, 43 (1980), pp.242–6

—, 'The European Vision of the Muslim Orient in the Sixteenth Century', in E.J. Grube (ed.), *Arte veneziana e arte islamica: Atti del primo simposio internazionale sull'arte veneziana e l'arte islamica* (Venice, 1989), pp.41–6

Raby, J., and Yücel, Ü., 'Chinese Porcelain at the Ottoman Court', in R. Krahl, *Chinese Ceramics in the Topkapi Saray Museum, Istanbul: A Complete Catalogue*, ed. J. Ayers, 1 (London, 1986), pp.27–54

Rackham, B., *Catalogue of Italian Maiolica*, 1 (London, 1940)

Radcliffe, A., 'Antico and the Mantuan Bronze', in D. Chambers and J. Martineau (eds), *Splendours of the Gonzaga* (exhib. cat., Victoria and Albert Museum, London, 1981), pp.46–50

—, 'The Forzori Altar Reconsidered', *Donatello-Studien: Italienische Forschungen*, 3, no.16 (1989), pp.194–208

Radzikowski, P., and Radzikowska, D., *Reise beschreibung Niclas von Popplau Ritters, bürtig von Breslau* (Cracow, 1998)

Rapisarda, S., 'A Ring on the Little Finger: Andreas Capellanus and Medieval Chiromancy', *Journal of the Warburg and Courtauld Institutes*, 69 (2006), pp.175–91

Rearick, R., 'Nicolò Pizolo: Drawings and Sculptures', in N. Salmazo (ed.), *Francesco Squarcione 'Pictorum Gymnasiarcha Singularis'* (Padua, 1999), pp.177–94

Recht, R. (ed.), *Les Bâtisseurs des Cathédrales Gothiques* (exhib. cat., Hall d'Exposition de l'Ancienne Douane, Strasbourg, 1989)

Recueil d'Anciens inventaires imprimés sous les auspices du comité des travaux historiques et scientifiques: Section d'Archéologie, 1 (Paris, 1896)

Reddaway, T.F., *The Early History of the Goldsmiths' Company 1327–1509* (London, 1975)

Redford, S., 'The Seljuqs of Rum and the Antique', *Muqarnas*, 10 (1993), pp.148–56

Reece, R., 'Coins and Medals', in M. Henig (ed.), *A Handbook of Roman Art: A Survey of the Visual Arts of the Roman World* (London, 1983), pp.166–78

Reiffenberg, B. de, ed., *Mémoires de J. du Clercq* (2nd ed., III, Brussels, 1836)

Ribeiro, A., *Dress and Morality* (London, 1986)

Ribeiro, A., and Cumming, V., *The Visual History of Costume* (London, 1989)

Richa, G., *Notizie Storiche delle Chiese Fiorentine*, II (Florence, 1754–62)

Richardson, B., *Printing, Writers and Readers in Renaissance Italy* (Cambridge, 1999)

Richardson, C., *Clothing and Culture 1350–1650* (Aldershot, 2004)

Richeome, L., *Trois discovrs povr la religion catholiqve, des miracles, des saincts & des Images* (Bordeaux, 1597)

Robertson, J.C., *Materials for the History of Thomas Becket*, 1 (Rolls Series; London, 1875)

Robin, F., 'Le luxe de la table dans les cours princières (1360–1480)', *Gazette des Beaux-Arts*, 86 (1975), 6th series, pp.1–16

Rodini, E., 'The Language of Stones', *Museum Studies*, 25, no.2 (1995) [special issue: *Renaissance Jewelry in the Alsdorf Collection*], pp.17–28

Rogers, J.M., 'Carpets in the Mediterranean Countries 1450–1550. Some Historical Observations', in R. Pinner and W.B. Denny (eds), *Oriental Carpet and Textile Studies*, II: *Carpets of the Mediterranean Countries 1400–1600* (London, 1986a), pp.13–28

—, 'Ottoman Luxury Trades and their Regulation', in *Osmanistische Studien zur Wirtschafts- und Sozialgeschichte. In memoriam Vančo Boškov* (Wiesbaden, 1986b), pp.135–55

—, 'Plate and its Substitutes in Ottoman Inventories', in M. Vickers (ed.), *Pots and Pans: A Colloquium on Precious Metals and Ceramics in Muslim, Chinese and Graeco-Roman Worlds, Oxford 1985* (Oxford, 1986c), pp.117–36

—, 'Ornament Prints, Patterns and Designs East and West', in C. Burnett and A. Contadini (eds), *Islam and the Italian Renaissance* (Warburg Institute Colloquia 5; London, 1999), pp.132–43

Rojas, F. de, *Celestina*, trans. J. Mabbe (1631), ed. D. Sherman Severin, (Warminster, Wiltshire, 1987)

Romanini, A.M., 'Une Statue Romaine dans la Vierge de Braye', *La Revue de l'Art*, 105 (1994), pp.9–18

Rouse, R., and Rouse, M., *Manuscripts and their Makers*, 1 (London, 2000)

Rubin, M., *Corpus Christi: The Eucharist in Late Medieval Culture* (Cambridge, 1991)

Rubin, P.L., *Giorgio Vasari: Art and History* (New Haven, 1995)

Rudolph, C., The *'Things of Greater Importance': Bernard of Clairvaux's* Apologia *and the Medieval Attitude toward Art* (Philadelphia, 1990)

Ruiz, T.F., *From Heaven to Earth: The Reordering of Castilian Society, 1150–1350* (Princeton, 2004)

Rummel, E. (trans.), *Scheming Papists and Lutheran Fools: Five Reformation Satires* (New York, 1993)

Runciman, S., *The Sicilian Vespers* (Cambridge, 1958)

—, 'Byzantine Trade and Industry', in M.M. Postan and E. Miller (eds), *The Cambridge Economic History of Europe*, II: *Trade and Industry in the Middle Ages* (Cambridge, 1987), pp.132–67

Russell, P., 'Arms versus Letters: Towards a Definition of Spanish Fifteenth-Century Humanism', in A.R. Lewis (ed.), *Aspects of the Renaissance: A Symposium* (Austin and London, 1967), pp.47–58

Sachs, H., *Engentliche Beschreibung aller Staende auff Erden* (Frankfurt am Main, 1568)

Salerno, L., 'Seventeenth-century English Literature on Painting', *Journal of the Warburg and Courtauld Institutes*, 14 (1951), pp.234–58

Sansterre, J.-M., 'Le moine-ciseleur, la Vierge et son image: Un récit d'Ekkehart IV de Saint-Gall', *Revue Bénédictine*, 106, nos 1–2 (1996), pp.185–91

Sarazin, J.-Y., 'Marginality and Justice in 1500: The Theft of Sacred Objects in Châlons en Champagne', *Viator*, 34 (2003), pp.308–27

Sauerländer, W., 'The Fate of the Face in Medieval Art', in *Set in Stone: The Face in Medieval Sculpture*, ed. C.T. Little (exhib. cat., Metropolitan Museum of Art, New York, 2007), pp.3–17

Savonarola (Hieronymo da Ferrara), *Tractato della Humilita* (n.p., ?1497)

Scappi, B., *Opera divisa in sei libri… con le figure che fanno bisogno nella cucina & alle Reverendissimi nel Conclave* (Venice, ?1570)

Scarisbrick, D., *Tudor and Jacobean Jewellery* (London, 1995)

Schannat, J.F., *Vindemiae Literariae; hoc est veterum monumentorum ad Germaniam sacram praecipue spectantium. Collectio Prima* (Fulda, 1723)

Schapiro, M., 'The Place of the Joshua Roll in Byzantine History', *Gazette des Beaux-Arts*, 35 (1949), pp.161–76

—, 'On the Aesthetic Attitude in Romanesque Art', in M. Schapiro, *Romanesque Art* (London, 1977), pp.1–27

Scheffers, H. (ed.), *Das Lorscher Evangeliar: Kommentar* (Vatican City, 2000)

Scheyer, E., 'Eine pariser Alabaster-Gruppe um 1430', *Schlesiens Vorzeit*, NS, no.10 (1933), pp.35–42

Schmitt, J.-C., 'The Ethics of Gesture', in M. Feher, (ed.), *Fragments for a History of the Human Body*, II (New York, 1989), pp.129–47

Schofield, J., *Medieval London Houses* (New Haven and London, 1994)

Schroder, T.B., *The Art of the European Goldsmith: Silver from the Schroder Collection* (New York, 1983)

Schupbach, W.M., 'A Venetian "Plague Miracle" in 1464 and 1576', *Medical History*, 20 (July 1976), pp.312–16

Schutjes, L.H.C., *Geschiedenis van het bisdom 's-Hertogenbosch*, 5 vols (St Michiels-Gestel, 1870–76)

Schwarz, H., 'The Mirror in Art', *Art Quarterly*, 15, no.2 (1952), pp.96–118

Scott, B. (ed.), *Hildeberti Cenomanensis Episcopi Carmina Minora* (Leipzig, 1969)

Sears, E., 'Ivory and Ivory Workers in Medieval Paris', in P. Barnet (ed.), *Images in Ivory: Precious Objects of the Gothic Age* (exhib. cat., Detroit Institute of Arts, 1997), pp.18–37

—, 'Craft Ethics and the Critical Eye in Medieval Paris', *Gesta*, 45, no.2 (2006), pp.221–38

Seeck, O. (ed.), *Auctores Antiquissimi*, VI, part 1: *Q. Aurelii Symmachi quae supersunt* (Monumenta Germaniae Historica; Berlin, 1883)

Segre, C., and Ossola, C., *Antologia della poesia italiana: Duecento* (Turin, 1997)

Selare, R., 'A Collection of Saliva Superstitions', *Folklore*, 50, no.4 (December 1939), pp.349–66

Sempere y Guarinos, J., *Historia del Luxo y de las Leyes Suntuarias de España*, 2 vols (Madrid, 1788)

Semple, S., 'A Fear of the Past: The Place of the Pre-Historic Burial Mound in the Ideology of Middle and Later Anglo-Saxon England', *World Archaeology*, 30, no.1 (1998), pp.109–26

Seneca, *17 Letters*, trans. C.D.N. Costa (Warminster, Wiltshire, 1988)

Serrano y Sanz, M., 'Documentos: II–Inventarios aragoneses de los siglos xiv y xv', *Boletín de la Real Academia Española*, 3 and 4 (February 1916), pp.89–92; (April 1916), pp.224–5; (April 1917), pp.207–23; (June 1917), pp.341–55; (October 1917), pp.517–31

Settis, S., 'Continuità, distanza, conoscenza. Tre usi dell'antico', in S. Settis (ed.), *Memoria dell'antico nell'arte italiana* (Turin, 1986), pp.375–488

Shalem, A., *The Oliphant: Islamic Objects in Historical Context* (Leiden, 2004)

Shearman, J., *Raphael's Cartoons in the Collection of Her Majesty the Queen, and the Tapestries for the Sistine Chapel* (London, 1972)

Shepherd, R., 'Art and Life in Renaissance Italy: A Blurring of Identities?', in M. Rogers (ed.), *Fashioning Identities in Renaissance Art* (Aldershot, 2000), pp.63–77

Silvestrelli, M.R., 'Un dipinto, uno stemma, una città', *Esercizi – Arte, Musica, Spettacolo*, 9 (1986), pp.38–41

Simeoni, L., *Gli Antichi Statuti delle Arti Veronese secondo la revisione Scaligera del 1319* (Monumenti Storici pubblicati dalla R. Deputazione Veneta di Storia Patria; Venice, 1914)

Smith, A.M., *Ptolemy's Theory of Visual Perception: An English translation of the Optics with Introduction and Commentary* (Transactions of the American Philosophical Society 86, part 2; Philadelphia, 1996)

Snodin, M., and Howard, M., *Ornament: A Social History since 1450* (New Haven and London, 1996)

Snodin, M., and Styles, J., *Design and the Decorative Arts 1500–1900* (London, 2001)

Soler del Campo, 'Los trofeos de Lepanto en la Real Armería', in *Oriente en Palacio: Tesoros asiáticos en las colecciones reales españolas* (exhib. cat., Palacio Real, Madrid, 2003), pp.45–57

Soler i Palet, J., 'L'art a la casa al segle xv', *Boletín de la Real Academia de Buenas Letras de Barcelona*, 61 (January–March 1916), pp.289–305

Soly, H., and Blockmans, W.H., *Charles V, 1500–1558 and His Time* (exhib. cat., Kunsthal De Sint-Pietersabdij, Ghent, 1999)

Somers Cocks, A., 'The Status and Making of Jewellery, 1500–1630', in *Princely Magnificence* (1980), pp.3–7

Southwick, L., 'The Armoured Effigy of Prince John of Eltham in Westminster Abbey and Some Closely Related Military Monuments', *Church Monuments*, 2 (1987), pp.9–21

Spallanzani, M., 'Fonti archivistiche per lo studio dei rapporti fra l'Italia e l'Islam: le arti minori nei secoli xiv–xvi', in E. Grube (ed.), *Arte veneziana e arte islamica: Atti del primo simposio internazionale sull'arte veneziana e l'arte islamica* (Venice, 1989), pp.41–6

—, *Maioliche Ispano-Moresche a Firenze nel Rinascimento* (Florence, 2006)

Spufford, P., 'Trade in Fourteenth-Century Europe', in M. Jones (ed.), *The New Cambridge Medieval History*, VI: *c.1300–c.1415* (Cambridge, 2000), pp.155–208

—, *Power and Profit: The Merchant in Medieval Europe* (London, 2002)

Staley, L. (ed.), *The Book of Margery Kempe* (London, 2001)

Stallybrass, P., and Jones, A.R., 'Fetishizing the Glove in Renaissance Europe', *Critical Inquiry*, 28, no.1, *Things* (Autumn, 2001), pp.114–32

Staniland, K., 'The Great Wardrobe Accounts as a Source for Historians of Fourteenth-Century Clothing and Textiles', *Textile History*, 20, no.2 (1989), pp.275–81

—, *Medieval Craftsmen: Embroiderers* (London, 1991)

Stechow, W., *Northern Renaissance Art, 1400–1600: Sources and Documents* (New Jersey, 1966; repr. Illinois, 1989)

Stiegemann, C., and Wemhoff, M. (eds), *799: Kunst und Kultur der Karolingerzeit. Karl der Grosse und Papst Leo III in Paderborn*, II (exhib. cat., Museum in der Kaiserpfalz, Erzbischöfliches Diözesanmuseum, Paderborn, 1999)

—, *Canossa 1077: Erschütterung der Welt. Geschichte, Kunst und Kultur am Aufgang der Romanik*, II: *Essays* (exhib. cat., Museum in der Kaiserpfalz, Erzbischöfliches Diözesanmuseum, Paderborn, 2006)

Stratford, N., 'Three English Romanesque Ciboria', *Burlington Magazine*, 126 (April 1984), pp.204–16

Stratmann, M. (ed.), *Scriptores*, XXXVI: *Flodoard von Reims, Historia Remensis ecclesiae* (Monumenta Germaniae Historica; Hannover, 1998)

Studer, P., and Evans, J., *Anglo-Norman Lapidaries* (Paris, 1924)

Suger, Abbot, *On the Abbey Church of St-Denis and Its Art Treasures*, ed. and trans. E. Panofsky (2nd ed., Princeton, 1979)

Sundt, R.A., '"Mediocres domos et humiles habeant fratres nostri": Dominican Legislation on Architecture and Architectural Decoration in the 13th Century', *Journal of the Society of Architectural Historians*, 46, no.4 (1987), pp.394–407

Swarzenski, G., 'Deutsche Alabasterplastik des 15. Jahrhunderts', *Städel-Jahrbuch*, I (1921), pp.167–213

Syson, L., 'Circulating a Likeness? Coin Portraits in Late Fifteenth-Century Italy', in L. Syson and N. Mann (eds), *The Image of the Individual* (London, 1998), pp.113–25

—, 'The Medici Study', in Ajmar-Wollheim and Dennis (2006), pp.288–93

— (ed.), *Renaissance Siena: Art for a City* (exhib. cat., National Gallery, London, 2007)

—, 'Witnessing Faces, Remembering Souls', in *El retrato del Renacimiento*, ed. M. Falomir (exhib. cat., Prado, Madrid, 2008), pp.415–21; Spanish text 'Testimonio de rostros, recuerdo de almas', pp.23–39

Syson, L., and Gordon, D., *Pisanello: Painter to the Renaissance Court* (London, 2001)

Syson, L., and Thornton, D., *Objects of Virtue: Art in Renaissance Italy* (London, 2001)

Taburet-Delahaye, E., 'L'Orfèvrerie au poinçon d'Avignon au XIVᵉ siècle', *Revue de l'Art*, 108 (1995), pp.11–22

Tachau, K.H., 'God's compass and 'Vana Curiositas': Scientific Study in the Old French 'Bible Moralisée'', *Art Bulletin*, 80 (March 1998), pp.7–33

Tait, H., 'Venice: Heir to the Glassmakers of Islam or Byzantium?', in C. Burnett and A. Contadini (eds), *Islam and the Italian Renaissance* (London, 1999), pp.77–104

Tanner, M., *The Last Descendant of Aeneas: The Habsburgs and the Mythic Image of the Emperor* (New Haven, 1994)

Tescione, G., *Il Corallo nella storia e nell'arte* (Naples, 1965)

Thamara, F. de, *El Libro de las Costumbres de todas las gentes del mundo y de las Indias, traduzido y copilado* (Antwerp, 1556)

Theophilus, *The Various Arts*, trans. C.R. Dodwell (London, 1961)

Thirion, J., *Le mobilier du moyen âge et de la renaissance en France* (Dijon, 1998)

Thompson, A., *Cities of God: The Religion of the Italian Communes 1125–1325* (Pennsylvania, 2005)

Thomson, R.M., 'The Date of the Bury Bible Re-examined', *Viator*, 6 (1975), pp.51–8

Thornton, D., *The Scholar in His Study: Ownership and Experience in Renaissance Italy* (New Haven and London, 1997)

Tierney, B., 'The Decretists and the "Deserving Poor"', *Comparative Studies in Society and History*, 1, no.4 (June 1959), pp.360–73

Tolley, T., 'Monarchy and Prestige in France', in K. Woods, et al. (eds), *Renaissance Art Reconsidered*, III: *Viewing Renaissance Art* (London, 2007), pp.133–70

Tomasi, M., 'Contributi allo Studio della Scultura Eburnea Trecentesca in Italia: Venezia', *Annali della Scuola Normale Superiore di Pisa*, 4, no.1 (1999), pp.221–46

—, 'Baldassare Ubriachi, le Maitre, le public', *Revue de l'Art*, 134 (2001), pp.51–60

—, 'Chiesa, Città e Popolo: Arche di Santi e Beati in Veneto e in Friuli nella prima Metà del Trecento' (unpub. Ph.D. diss., Scuola Normale Superiore di Pisa, 2002)

—, 'Miti antichi e riti nuziali: sull'iconografia e la funzione dei cofanetti degli Embriachi', *Iconographica*, 2 (2003), pp.126–45

Torres Balbás, L., 'Arte Hispanomusulmán hasta la caída del califato de Córdoba', in *Historia de España Menéndez Pidal*, V: *España Musulmana (711–1031): Instituciones, Sociedad, Cultura* (7th ed., Madrid, 1996), pp.331–788

Tracy, C., *English Medieval Furniture and Woodwork* (London, 1988)

Trexler, R., 'The Magi Enter Florence: The Embriachi of Florence and Venice', *Studies in Medieval and Renaissance History*, NS, no.1 (1978), pp.129–213

The Trotula: An English Translation of the Medieval Compendium of Women's Medicine, ed. and trans. M.H. Green (Philadelphia, 2002)

Tuohy, T., *Herculean Ferrara: Ercole D'Este, 1471–1505, and the Invention of a Ducal Capital* (Cambridge, 1996)

Turner, J., *Spice: The History of a Temptation* (London, 2005)

Tusser, T., *Five Hundred Points of Good Husbandry* (London, 1638)

Ullmann, W., *The Growth of Papal Government in the Middle Ages* (3rd ed., London, 1970)

Valentini, R., and Zucchetti, G. (eds), *Codice Topografico della Città di Roma*, III (Rome, 1946)

Vallejo Triano, A., *Madinat al-Zahra: Official Guide to the Archaeological Complex* (Seville, 2006)

Van de Meerendonk, L., *Het klooster op de Eikendonk te Den Dungen, Bijdragen tot de Geschiedenis van het Zuiden van nederland*, II (Tilburg, 1964)

Van Houts, E., 'The Norman Conquest through European Eyes', *English Historical Review*, 110, no.438 (1995), pp.832–53

Van Os, H., 'The Black Death and Sienese Painting: A Problem of Interpretation', *Art History*, 4 (1981), pp.237–49

Vandersall, A.L., 'The Relationship of Sculptors and Painters in the Court School of Charles the Bald', *Gesta*, 15, no.1 (1976), pp.201–10

Vandewalle, A. (ed.), *Les Marchands de la Hanse et la Banque des Medicis* (exhib. cat., Cour Provinciale, Bruges, 2002)

Vandi, L., *La trasformazione del motivo dell'acanto dall'antichità al XV secolo: ricerche di teoria e storia dell'ornamento* (Bern and Oxford, 2002)

Varazze, I. da [Jacobus da Voragine], *Legenda aurea*, ed. G.P. Maggoni, 2 vols (2nd ed., Florence, 1998)

Vasari, G., *The Lives of the Artists*, trans. J. Conway Bondanella and P. Bondanella (Oxford, 1991)

Vauchez, A., *Sainthood in the Later Middle Ages* (Cambridge, 1997)

—, 'The Church and the Laity', in D. Abulafia (ed.), *The New Cambridge Medieval History*, V: *c.1198–c.1300* (Cambridge, 1999a), pp.182–203

—, 'The Religious Orders', in D. Abulafia (ed.), *The New Cambridge Medieval History*, V: *c.1198–c.1300* (Cambridge, 1999b), pp.220–55

Velasco de Tarenta, *Tractatus de epidemia et peste*, in Arnaldus de Villanova (1475)

Verger, J., 'The Universities and Scholasticism', in D. Abulafia (ed.), *The New Cambridge Medieval History*, V: *c.1198–c.1300* (Cambridge, 1999), pp.256–76

Vernet, A., 'L'Inondation de 1296–1297 a Paris', *Memoires de la Fédération des Sociétés Historiques et Archéologiques de Paris et de l'Ile de France*, 1 (1949), pp.47–56

Vespasiano da Bisticci, *Vite di Uomini Illustri del Secolo XV* (Florence, 1938)

Viaje de Turquia (La odisea de Pedro de Urdemalas), ed. F.G. Salinero (Madrid, 1986)

Viajes de extranjeros por España y Portugal en los siglos XV, XVI y XVII, colección de Javier Liske, trans. F.R. (Madrid, 1878)

Victoria and Albert Museum, *Guide to the Collection of Carpets* (London, 1931)

Videira Lopes, G., *Cantigas de Escárnio e Maldizer dos Trovadores e Jograis Galego-Portugueses* (Lisbon, 2002)

Villena, E. de, 'Arte cisoria', in *Obras completas*, ed. P.M. Cátedra, 2 vols (Madrid, 1994)

Vince, A., 'The Origin and Development of the Decorated Medieval Jug', in W.M. Ormrod (ed.), *England in the Thirteenth Century: Proceedings of the 1989 Harlaxton Symposium* (Harlaxton Medieval Studies 1; Stamford, 1991), pp.209–25

Vincent, N., *The Holy Blood: King Henry III and the Westminster Blood Relic* (Cambridge, 2001)

Vitruvius, *Ten Books on Architecture*, trans. I.D. Rowland (Cambridge, 1999)

Vives, J.L., *Instrvction Christiana, donde se contiene como se ha de criar vna donzella hasta casarla* (Valladolid, 1584)

Volbach, W.F., *Avori di Scuola Ravennate nel V e VII Secolo* (Ravenna, 1977)

Von Saldern, A., *German Enamelled Glass: The Edwin J. Beinecke Collection and Related Pieces* (The Corning Museum of Glass; New York, 1965)

Von Wilckens, L., 'Schmuck auf Nürnberger Bildnissen und in Nürnberger Nachlaßinventaren', in *Wenzel Jamnitzer und die Nürnberger Goldschmiedekunst 1500–1700* (exhib. cat., Germanischen Nationalmuseums, Nuremberg, 1985), pp.87–105

Vryonis, S.P., 'Byzantine Society and Civilization', in H.C. Evans and W.D. Wixom (eds), *The Glory of Byzantium: Art and Culture of the Middle Byzantine Era A.D. 843–1261* (exhib. cat., Metropolitan Museum of Art, New York, 1997), pp.4–19

Ward-Jackson, P., 'Some Main Streams and Tributaries in European Ornament from 1500 to 1750. Part 1', *Victoria and Albert Museum Bulletin*, 3, no.2 (1967), pp.58–71

Watson, K., 'Giambologna and his Workshop: The Later Years', in C. Avery and A. Radcliffe (eds), *Giambologna: Sculptor to the Medici* (exhib. cat., London, Victoria and Albert Museum, 1978), pp.33–41

Watson, R., *Illuminated Manuscripts and their Makers* (London, 2003)

—, *Catalogue of Illuminated Manuscripts in the Victoria and Albert Museum* (forthcoming)

Watts, W.W., *Catalogue of Chalices* (London, 1922)

Webster, J., *The Labours of the Months in Antique and Medieval Art to the End of the Twelfth Century* (Princeton, 1938)

Weiss, R., 'Jan van Eyck and the Italians', *Italian Studies*, 11 (1956), pp.1–15

Weitzmann, K., 'The Heracles Plaques of St Peter's Cathedra', *Art Bulletin*, 55, no.1 (1973), pp.1–37

Welborn, M.C., 'The Errors of the Doctors according to Friar Roger Bacon of the Minor Order', *Isis*, 18, no.1 (July 1932), pp.26–62

Welch, E., 'Naming Names: The Transience of Individual Identity in Fifteenth-Century Italian Portraiture', in N. Mann and L. Syson (eds), *The Image of the Individual: Portraits in the Renaissance* (London, 1998), pp.91–104

—, 'Public Magnificence and Private Display: Giovanni Pontano's *De splendore* (1498) and the Domestic Arts', *Journal of Design History*, 15, no.4 (2002) [special issue: *Approaches to Renaissance Consumption*], pp.211–27

—, 'Painting as Performance in the Italian Renaissance Court', in S.J. Campbell (ed.), *Artists at Court: Image-Making and Identity, 1300–1550* (Boston, 2004), pp.19–32

—, *Shopping in the Renaissance: Consumer Cultures in Italy 1400–1600* (London, 2005)

—, 'Art on the Edge: Hair, Hats and Hands in Renaissance Italy' published online at <http://culturalscience.org/FeastPapers2008/EvelynWalshpP.pdf> (accessed 2008)

Wentzel, H., and Mitchell, C., 'Portraits "á l'antique" on French Mediaeval Gems and Seals', *Journal of the Warburg and Courtauld Institutes*, 16, no.4 (1953), pp.342–50

Westermann, M., 'A Monument for Roma Belgica: Functions of the Oxaal at 's-Hertogenbosch', *Nederlands Kunsthistorisch Jaarboek*, 45 (1994), pp.382–446

Wheeler, J., *Trade Secrets: Renaissance Recipes and Formulas* (London, 2009)

Whitney, E., *Paradise Restored: The Mechanical Arts from Antiquity through the Thirteenth Century* (Transactions of the American Philosophical Society 80, part 1; Philadelphia, 1990)

Wilk, C. (ed.), *Western Furniture 1350 to the Present Day in the Victoria and Albert Museum London* (London, 1996)

Williams, H., 'Monuments and the Past in Early Anglo-Saxon England', *World Archaeology*, 30, no.1 (1998), pp.90–108

Williamson, P., 'The Fifth Head from Thérouanne, and the Problem of its Original Setting', *Burlington Magazine*, 124, no.949 (1982), pp.219–24

—, *Catalogue of Romanesque Sculpture* (Victoria and Albert Museum, London, 1983)

—, *The Medieval Treasury: The Art of the Middle Ages in the Victoria and Albert Museum* (London, 1986a)

—, 'Objects from a Medieval Treasury', *V&A Album*, 5 (1986b), pp.272–81

—, *Northern Gothic Sculpture 1200–1450* (London, 1988)

—, *Gothic Sculpture 1140–1300* (New Haven, 1995)

—, *Netherlandish Sculpture 1450–1550* (London, 2002)

—, *Medieval and Renaissance Stained Glass in the Victoria and Albert Museum* (London, 2003a)

—, 'On the Date of the Symmachi Panel and the So-Called Grado Chair Ivories', in C. Entwistle (ed.), *Through a Glass Brightly: Studies in Byzantine and Medieval Art and Archaeology Presented to David Buckton* (Oxford, 2003b), pp.47–50

—, *Catalogue of Medieval Ivory Carvings in the Victoria and Albert Museum*, 1, (London, forthcoming)

Williamson, P., and Motture, P. (eds), *Medieval and Renaissance Treasures from the V&A* (exhib. cat., Art Gallery of Ontario, Toronto, 2007)

Wilson, T., 'Early Sixteenth-Century Spoons', in C. Ellory, H. Clifford and F. Rogers (eds), *Corpus Silver: Patronage and Plate at Corpus Christi College Oxford: A Collection of Essays* (Barton-under-Needlewood and Oxford, 1999), pp.248–64

Wilson, T., and Sani, E.P., *Le maioliche rinascimentali nelle collezioni della Fondazione Cassa di Risparmio di Perugia*, 2 vols ((Perugia, 2006–7)

Winter, P.M. de, 'A Little-known Creation of Renaissance Decorative Arts: The White Lead Pastiglia Box', *Saggi e Memoria de Storia dell' Arte*, 14 (1984), pp.9–42 and 103–31

Wintroub, M., *A Savage Mirror: Power, Identity and Knowledge in Early Modern France* (Stanford, CA, 2006)

Wittkower, R., 'Individualism in Art and Artists: A Renaissance Problem', *Journal of the History of Ideas*, 22, no.3 (1961), pp.291–302

Wohl, H., 'Review of *Donatello Studien*', *Art Bulletin*, 73, no.2 (1991), pp.315–23

Wolters, W., 'Zu einem wenig bekannten Entwurf des Cristofero Sorte für die Decke der Sala del Senato im Dogenpalast', *Mitteilungen des Kunsthistorischen Institutes in Florenz*, 10 (1961), pp.137–44

Wood, J.M., *Women, Art and Spirituality: The Poor Clares of Early Modern Italy* (Cambridge, 1996)

Woodcock, T., and Robinson, J.M., *The Oxford Guide to Heraldry* (Oxford, 1988; paperback ed. 1990)

Woods, K., *Imported Images: Netherlandish Late Gothic Sculpture in England c.1400–c.1550* (Donington, 2007)

Woolgar, C.M., *The Great Household in Late Medieval England* (London and New Haven, 1999)

Yates, F., *Astraea: The Imperial Theme in the Sixteenth Century* (London, 1975)

Yorke, J., 'Casket' in *Western Furniture 1350 to the Present Day in the Victoria and Albert Museum London*, ed. C. Wilk (London, 1996), pp.34–5

Zafran, E., 'Saturn and the Jews', *Journal of the Warburg and Courtauld Institutes*, 42 (1979), pp.16–27

Zammit-Maempel, G., 'Fossil Sharks' Teeth: A Medieval Safeguard Against Poisoning', *Melita Historica*, 6, no.4 (1975), pp.391–410

Zampieri, G., *I Sepolcri Padovani di Santa Giustina: il sarcofago 75-1879 del Victoria and Albert Museum di Londra e altri sarcofagi dall'Basilica di Santa Giustina in Padova* (Rome, 2006)

Zerner, H., *Renaissance Art in France: The Invention of Classicism* (Paris, 2003)

Zuraw, S., 'Mino da Fiesole's Forteguerri Tomb: A 'Florentine' Monument in Rome', in S.J. Campbell and S.J. Milner (eds), *Artistic Exchange and Cultural Translation in the Italian Renaissance City* (Cambridge, 2004), pp.75–95

Zutshi, P.N.R., 'The Avignon Papacy', in M. Jones (ed.), *The New Cambridge Medieval History*, VI: *c.1300–c.1415* (Cambridge, 2000), pp.653–73

Zwierlein-Diehl, F., '"Interpretatio christiana": Gems on the Shrine of the Three Kings in Cologne', in C.M. Brown (ed.), *Engraved Gems: Survivals and Revivals* (London, 1997), pp.62–83

PICTURE CREDITS

GLOSSARY

alla domaschina: 'Damascus style'; used of ornament with an Islamic or Near Eastern aesthetic, though not necessarily crafted there

all'antica: 'after the Antique' or distant past; in the classical style of Greece and Rome

arabesque: an intricate, all-over ornamental style based on flowing lines, natural forms and geometric shapes

architrave: in classical architecture, the lower part of the entablature (q.v.)

bezel: the setting holding a gemstone in a ring or other piece of jewellery

cabochon: a precious stone that has been polished rather than cut into facets

cameo: an engraving on a shell, gem or other stone where the background is a different colour from the design

chasing: a process of adding decoration to a metal object by engraving or embossing

cloisonné: a type of decoration using enamel or stone inlay, in which the different units are separated by metal strips that form closed cells (from French *cloison*, 'partition')

cristallo: a soda-based, colourless type of glass made only in Venice and Liguria

cuir bouilli: cured leather soaked in water, formed over a mould and baked hard; used to make strong, light and waterproof objects

entablature: the upper section of a classical architectural order (above the column capitals), consisting of an architrave (q.v.), frieze and cornice

fire-gilding: a hazardous method of gold-plating, using a mixture of gold and mercury

frit: a glassy substance used in pottery, sometimes made up of the separate ingredients of glass but sometimes including actual glass, fused and powdered before mixing with clay

grisaille: a method of painting in shades of grey, often to imitate stone

hardstone: coloured or semi-precious stones (in Italian, *pietra dura*); in the 16th century, cut in shapes and fitted together to form patterns or images.

intaglio: an engraving technique in which the design is sunken or cut into the material

knop: a rounded knob, often ornamental

lancet: a narrow window with a pointed arch

mihrab: a niche in the wall of a mosque which indicates the direction of Mecca, towards which Muslim worshippers must face during prayer

niello: a black inlay made from silver or copper sulphides, which is fused to an object by firing

plate: vessels or cutlery made of gold or silver

predella: a plinth beneath the main body of an altarpiece, often painted or sculpted with small scenes

protome: a representation of the foremost or upper part of an animal, used as decoration

retable: a decorative panel standing behind the altar, bearing appropriate subject matter – an altarpiece

tessera: a small tile of marble, glass or other hard material used as the basic unit in mosaics

travertine: a type of limestone found in Italy, used for building from Roman times onwards

INDEX